D0442962

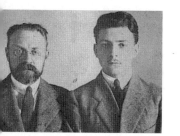

Matisse

FATHER & SON

Cⁱᵉ Gⁱᵉ TRANSATLANTIQUE

Mon cher papa.

Je n'ai pas eu le temps de
t'écrire depuis ma dernière
lettre te parlant du projet
Brummer. Tes télégrammes
m'ont fait réflechir. Lorsque
j'ai vu que rien ne me retenait
plus à Paris que cette idée
seduisante mais dont la réa-
lisation m'aurait forcément
retardé mon départ en me
créant des responsabilités

BY JOHN RUSSELL

Matisse FATHER & SON

The story of Pierre Matisse, his father, Henri Matisse, his gallery in New York, and the artists that he introduced to America – among them, Joan Miró, Alberto Giacometti, Balthus, and Jean Dubuffet. Based upon unpublished correspondence

HARRY N. ABRAMS, INC., PUBLISHERS

To The Memory
Of Pierre Matisse
1900–1989

Table of Contents

Acknowledgments

When Eugene Victor Thaw suggested around 1992 that I might like to work on the Pierre Matisse Archives – a seventy-years' hoard of letters, part private, part professional – I had no second thoughts. Like Molly Bloom, though in quite another context, I said "Yes I will Yes."

My wife, Rosamond Bernier, had been a friend of Pierre Matisse since her days at Sarah Lawrence. When her work first took her to Paris, Pierre sent her to see his father, Henri Matisse. They were friends thereafter. In the 1980s Pierre had asked her to record interviews with him "for the sake of history." (She has kindly allowed me to quote from those interviews in this book.)

I myself had known Pierre since David Sylvester introduced me to him in 1965. There are echoes of his conversation in my book, *The World of Matisse,* which came out in 1969. After Pierre's marriage in 1974 to Maria-Gaetana von Spreti, the four of us had traveled together in France, in Russia, and elsewhere. Pierre had been my best man at our wedding in 1975. All these friendships had held firm.

The archives were already in perfect order at the Pierre Matisse Foundation. Its Director, Olive Bragazzi, had worked with Alfred H. Barr, Jr., on his classic study of Matisse, first published in 1951. Never was there a letter missing, or out of order. Late arrivals (which were many) were slotted into place. Seconded by Lily Farkas, Alessandra Carnielli, Margaret V. Loudon, and Andrea Farrington, Mrs. Bragazzi ran a tight ship with a light hand. In the years to come there was hardly a day on which I did not call on her for advice. No such call went unanswered. In 1997, the archives were donated to The Pierpont Morgan Library by the Pierre Matisse Foundation.

It soon became clear that this could not be a book of Selected Letters, numbered, footnoted and cautiously trimmed. Every correspondence had its own dynamic, its own shape and its own imperious direction. It was life itself, caught on the wing and complete. Narrative, not tabulation, was what these letters needed.

I owe much to my longtime friends and colleagues at Harry N. Abrams, Inc., Paul Gottlieb, Robert Morton, Judith Hudson, and especially to my editor, Ruth A. Peltason, who saw the book through all its phases and made sense of every one of them.

For other invaluable contacts, I am grateful to William S. Lieberman, David Sylvester, Louise Bourgeois, Jack Flam, Margit Rowell, Jacques Dupin, Dominique Symusiak, and Dominique Fourcade, among others. I owe special thanks to Maria-Gaetana von Spreti Matisse, for her continual support.

Last and above all, I have to thank Rosamond Bernier. There is hardly a page of this book that does not somewhere echo both her delight in the subject and the range of her firsthand experience of the people, and the period, with whom I had to deal. She made this book, in every sense, a labor of love.

A Note from the Author

Pierre Matisse has a double claim upon posterity. For close on sixty years, and in the context of twentieth-century European art, he did as much as any dealer in New York to shape the taste of American museums and collectors.

In the case of four major artists – Joan Miró, Balthus, Alberto Giacometti, and Jean Dubuffet – he showed them in New York before anyone else. He nurtured them, fostered them, and placed their work in the museums and the private collections that mattered most. He treated them not as business contacts, or as clients, but as friends with whom he had a close and continuous relationship. Nor did he ever claim to have "made" them. "My artists made me," he said flatly.

In relation to those four artists, and to many others (among them, Chagall, Rouault, and Yves Tanguy), private letters, totaling well into four figures, have survived. I have had the exclusive right of perusal, in this context, and I may add that many of them are letters in which nothing is held back.

Pierre Matisse was both fortunate and unfortunate in being the son of one of the greatest French painters who ever lived. Himself born in 1900, he was aware from an early age of the fear of penury that haunted his father. It has long been supposed that Henri Matisse did not wish his son Pierre to become a dealer. "Anything but that!" the legend said. It is also often believed that Henri Matisse did as little as possible to help his son.

It emerges from their voluminous correspondence, which extended from 1920 until the death of Henri Matisse in 1954, that these suppositions are entirely unfounded. Henri Matisse did all that he could to help his son in the gallery. He was also ever ready to come up with some sardonic advice when Pierre's competitors were trying to do him down. Even by French standards, the life of the Matisse family was fraught with emotional problems. All such matters were discussed by Henri Matisse in his letters to Pierre Matisse, who eventually became his closest, and sometimes his only, confidant.

Pierre from his middle twenties onwards replied with a freedom and a candor that belie his reputation for diffidence. In time, Henri Matisse was to write and say to Pierre, "What would become of me, if you were no longer here?" This was a duet of equals, and a father/son correspondence of a very high order.

This book is both a professional history and a family history. The two cannot be disentangled, and it is difficult to say which is the more absorbing.

<div align="right">J. R.</div>

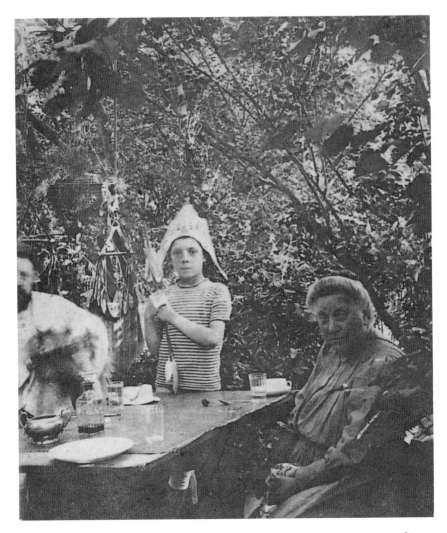

Henri Matisse, Pierre, and Henri Matisse's mother. Clamart, n.d. Matisse's painting, *Portrait of Pierre* (1909), was based on this photograph.

A Checkered Childhood, 1900–1920

Pierre Matisse was born in Bohain-en-Vermandois, in the flatlands of northern France and not far from Valenciennes, on June 13, 1900. The second son of Henri Matisse and his wife, Amélie Parayre, he had an older brother, Jean, born in 1899, and a half-sister, Marguerite, born in 1894.

This may sound like a traditional family structure – well-balanced, well-paced, and potentially close-knit. But Pierre's was not a conventional childhood. For several years, his parents were too poor to keep their children together. The infant Pierre was cared for by his grandmother in Bohain, or by a wet nurse in the neighboring town of Busigny, while his father and mother lived and worked in Paris. When he was not quite three years old, he had bronchial pneumonia and nearly died of it. In 1902 and 1903, misfortunes not of their own making befell his mother's parents and made their name notorious throughout France. When Henri Matisse and his family retreated to Bohain, they were met with a universal obloquy.

As to Pierre's relations with his father, there is an accepted legend, most of which will be challenged in this book. But it is important to know that Pierre Matisse was not simply a Matisse. By way of his mother, he was also a Parayre. To that extent, he had in his early years the equivalent of a dual citizenship.

The Parayres came from a little town called Beauzelle, near Toulouse, where their father had been a schoolteacher. Not everyone found Beauzelle fascinating – Henri Matisse's son-in-law, Georges Duthuit, once described it as "all sky and stagnation" – but the Parayres were remarkable people.

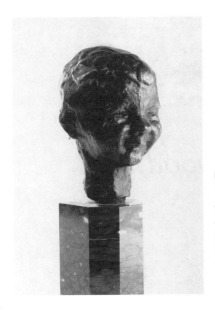

Henri Matisse. *Head of a Child (Pierre Matisse)*. 1904–5. Bronze, 6⅜" (16.4 cm). The Baltimore Museum of Art. Cone Collection, formed by Dr. Claribel and Miss Etta Cone of Baltimore, Maryland 1950.425

They had fine looks – their women were said to have "the look of Spanish queens" – and they believed that they could bring about a better France. Every one of them, in their different ways, set about it as soon as they could. Pierre's future aunt, Berthe Parayre (1876–1945), was to be a distinguished pioneer in the field of women's education in France. She was also a tender and a reassuring presence for Pierre when he was very young. Amélie Matisse's father, Armand Parayre (1844–1922), was a man of darting and often dazzling intelligence. Initially as an inspired primary-school teacher, and later as the editor and managing director of an activist Republican newspaper called the *Avenir de Seine et Marne,* he came to the notice of many an important political figure.

Among them were Georges Clemenceau, the greatest French statesman of the day, and the young socialist député, Marcel Sembat, who was to be an important patron of Henri Matisse at a time when he badly needed one. Henri Matisse's father- and mother-in-law, Armand and Catherine Parayre, were models of open-mindedness and absolute trust. As a son-in-law, and in worldly terms, Henri Matisse had nothing to recommend him. At the time of his marriage, he was a failed painter who had no money of his own. He was also what would now be called the single father of his daughter, Marguerite, although he had formally acknowledged his responsibilities towards her in 1897. There was no indication that he would ever be able to support a family. But Armand and Catherine Parayre did not for a moment hesitate to make him welcome.

The Parayres operated at that time within a social, intellectual, and political context of which Henri Matisse had had no previous experience. They stood for free thinking, for the separation of church and state, and for the secularization of the French educational system. Monarchists, Bonapartists, and reactionaries of every kind were to be shown the door, and a free, equal, and fraternal society would come into being. For many years the Parayres had been friendly with Senator Humbert, a veteran of French politics who was the self-styled grand seigneur of Beauzelle and later became the French Minister of Justice.

It so happened that Armand Parayre had taught Frédéric Humbert, the senator's son, when he was in school in Beauzelle. It also happened that Catherine Parayre had been on intimate terms in childhood with Frédéric's future wife, who was born Thérèse Daubignac. (Frédéric's wedding in Beauzelle in 1878 had been the single most spectacular event in the town's history.) Eventually, Armand and Catherine Parayre became respectively the confidential factotum of and (hardly less important) the social secretary of Senator Humbert's son Frédéric and his flamboyant wife. Their roles may not sound very important, and (fortunately for them) they knew very little of their employer's activities. But they were nonetheless at the epicenter of a certain Paris. The Humberts had ramified and often mysterious financial activities, into which many of the most prominent people in France had become involved, often in ways that they hoped would never be known. There were also thousands of small investors all over France who had put their trust in the Humberts.

The Matisses of Bohain and the Parayres of Beauzelle had outwardly nothing in common, and there was no reason why Henri Matisse and Amélie Parayre should ever have met. But in October 1897 Henri Matisse went to a wedding in Paris and happened to sit next to Amélie at the uproarious banquet that followed. Henri Matisse at that time was not yet the professorial figure of legend. He was known as a prankster, as a ribald and anti-clerical songster, and as someone who had once broken up a café concert performance just for the hell of it.

Amélie was then twenty-five years old. There was no banal flirtation between them, even when the wine flowed, but each recognized the other as true metal, and when they got up from the table she held out her hand to Henri Matisse in a way that he never forgot. Nor was Amélie deterred by the downturn in his affairs. When he told her that he already had a daughter, she said, "Don't worry about that." She saw in him what she most wanted as a lifetime's companion – someone who would always go his own way, regardless of what others might think of it.

Hers was a family in which unpopular causes were often espoused. She was an archetypal straight arrow, and it moved her deeply when Henri Matisse said

to her, "Mademoiselle, I love you dearly, but I shall always love painting more."
As for Henri's daughter, Marguerite, Amélie saw to it that she was loved, cherished, and cared for as an integral member of their family.

The Parayre connection was very much to the fore in the wedding ceremony, which was held in January 1898 in a fashionable church in Paris – Saint-Honoré-d'Eylau. Amélie's dress came from the great couturier Worth (doubtless as a present from Madame Humbert). Amélie's witnesses were high officers of state. Henri's witnesses were good men and true, but they were not there for show.

If Pierre in his first years had few of the comforts, either moral or material, of a settled family life, it was because it was in Paris, if anywhere, that Henri Matisse's career would take off. To return to Bohain would signal an ignominious defeat.

If he was spared that defeat, it was largely because of the Parayres. Amélie's Aunt Noélie and two of her brothers ran a successful women's shop called the Grande Maison des Modes. Before her marriage, Amélie had shown a gift for designing, making, and modeling hats for a fashionable clientele. In June 1899 she found a partner and opened a shop of her own on the rue de Châteaudun. This allowed Henri and herself to live, with Marguerite, in a tiny two-room apartment on the same street.

Armand and Catherine Parayre at this time had put their whole energies at the service of Frédéric and Thérèse Humbert. Not only had Armand entrusted the Humberts with his private fortune, such as it was, but he had refused to accept a salary for his services. It was believed all over Paris that Thérèse Humbert would one day come into a gigantic amount of money, and Armand Parayre thought it an honor to serve Frédéric, whose election to the French Parliament he had done much to bring about in 1894.

His confidence was widely echoed. Investors would pour money into any scheme that the Humberts promoted. Jewelers were delighted to give Madame Humbert unlimited credit. Private loans, no matter how large, were rarely refused. Public figures by the dozen were drawn into the Humberts' orbit and never got out of it. Armand and Catherine Parayre virtually lived with the Humberts, whether in Paris or in the country near Fontainebleau. The Humberts could ask anyone they liked to their table, and very few of them refused. Nor did it escape their guests that the Humberts lived like royalty.

All this was a long way away from the high-minded brainstorming sessions at Beauzelle, but it never seems to have occurred to Armand Parayre that there might be something overblown, not to say putrid, about the Humberts and their festivities. If the chief of police came to dinner, and the leader of the Paris bar,

and if the president of France and the prime minister had been there the week before, who could imagine that it was all a fraudulent charade? Certainly not Armand Parayre who, with his brother and two of his brothers-in-law, was in charge of the savings bank that the Humberts had founded in 1893.

But then, in May 1902, iniquities of which the Parayres knew nothing were reported in the French press. Henri Matisse's father-in-law had worked in good faith for Frédéric Humbert, only to find that his employers were confidence tricksters and swindlers on a monumental scale. Humbert and his wife had got out of France just in time, leaving Armand Parayre to face not only a national scandal but, quite possibly, a prison sentence.

Ruin and disgrace stalked society at every level. Madame Humbert's jeweler on the rue de la Paix killed himself. One of Frédéric's brothers was found hanged. More than one related murder was suspected. *Parayre* and *pariah* became synonymous. When Armand Parayre took refuge with his daughter Berthe in Rouen, the police kept a twenty-four-hour watch on the house. To say that the Parayres "lost everything" would be an understatement. Not only were they ruined and ostracized, but when the Humberts were found in Madrid and brought back to Paris in chains, the case took on a new dimension. As their presumed accomplice, Armand Parayre was charged with complicity in fraud and forgery and imprisoned in the Conciergerie.

At that point, it was not the Parayres who kept the family together. It was Henri Matisse. Thanks to his early years in a lawyer's office, Henri Matisse was able to busy himself to great effect in the organization of his father-in-law's defense. When all about him lost their heads, burst into tears, and felt more than sorry for themselves, Henri Matisse dealt with their problems one by one. He got Frédéric's uncles to stop blowing off steam to no purpose. He dealt with newspaper editors and forced them to retract their wilder accusations. He negotiated with the prosecuting magistrate and got permission to confer with Armand Parayre and to help him prepare for his days in court. To every detail of an immensely complicated case, he brought qualities of clarity and dispatch. Nor was he at all intimidated by the new world with which he had to deal.

In a matter of weeks, Armand Parayre was acquitted of all charges. On January 31, 1903, he was provisionally released. For Henri Matisse, this must have been deeply satisfying. He had proved himself not only as a full member of the Matisse/Parayre family, but as its only effective member at a time of trial and torment. It is a very curious fact that although the entire episode had been entirely creditable to Henri Matisse, it was never straightened out in print until Hilary Spurling published *The Unknown Matisse*.

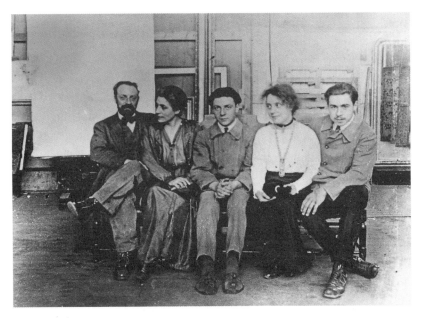

Henri and Amélie Matisse, Pierre, Marguerite, and Jean. Clamart, c. 1915

Marguerite, Pierre, Henri, and Jean at Robinson. n.d.

The ordeal had taken its toll, in more than one way. His doctors ordered Henri Matisse to go to Bohain and take two months' complete rest. Aunt Berthe still had her job in Rouen, but she had been diagnosed as having lung troubles that might indicate the early stages of tuberculosis. Amélie had lost both her hat shop and the apartment on the rue de Châteaudun. For the first time, Henri, Amélie, and the three children were united in Bohain, having nowhere else to go.

It was not a happy visit. Not long before, Henri Matisse's father had suffered heavy financial losses from the failure and disgrace of one of his wife's relations in Le Cateau. Bohain in winter smelled awful and looked awful.

Local investors both big and small, all the way from Bohain to Lille, had lost every penny that they had risked with the Humberts. Henri was derided all over town as "that idiot Matisse." Pierre somehow picked up the rumor that his father would have to give up painting altogether and take a job as adviser to one of the more upmarket weavers in Bohain. The weavers in question had few rivals in France, and they were rightly proud of their status. But the children were by now old enough to sense that in other respects this had been a grim place in which to grow up. At home there was, moreover, the perennial problem that Pierre once outlined with characteristic brevity to Rosamond Bernier: "My grandfather loved his son, and his son loved him, but they couldn't get through to one another. My father never talked about that, but I think that it made him very unhappy. My father worried about me. As we say in France, 'Little children, little worries. Big children, big worries.' And it's true. Children don't think about it. They don't know how much their parents worry about their existence, their future, their direction in life. Young people take things for granted. They only think about themselves. My father often worried about Marguerite, Jean, and myself."

That "they couldn't get through to one another" was to be a recurrent agony for the Matisse family. But Pierre in boyhood seems to have tussled with it in silence, if at all. When Henri Matisse began to do well as a painter, and the family could live together at Clamart, near Paris, Pierre was mildly obstreperous. If it was raining, he would walk up the street in the gutter on his way to school in hopes of catching a cold and having to stay at home.

But then he was never a show-off student. When he went to the Lycée Montaigne in Paris, the good students in class sat in the front row, and the bad ones in the back row. Pierre and his friend, the future painter Yves Tanguy, sat side by side in the back row until Tanguy was expelled for sniffing ether.

Pierre was not expelled, but he didn't win any prizes, either, and his parents thought it was time for him to shape up. His brother, Jean, was at that time in a boarding school in Noyan, where the headmaster was known to Tante Berthe.

Very soon, Pierre was put on the train to Noyon.

It was a disagreeable experience for him. His brother was older, stronger, and more violent than he was. When they fought – which was all the time – Pierre always got the worst of it. Humiliations of that sort are never forgotten.

There were better times, though. In 1911 Tante Berthe was appointed director of the Ecole Normale Supérieure in Ajaccio, Corsica. Pierre and his sister Marguerite enjoyed going to see her there, and at the age of twelve he was allowed to dance the mazurka for half an hour every evening with some of his aunt's more favored pupils. Privileges of this sort were to have a fateful result when he returned to Ajaccio at the end of World War I.

Time passed, though not – as far as Pierre was concerned – in an obsessedly purposeful way. In 1918 he was due to be called up for military service. At that particular stage in World War I, it was relatively agreeable to be sent to man the guns in a large fortress. This was arranged, therefore. But no sooner had Pierre arrived at the fortress in question than he caught the Spanish influenza that was raging in Europe. "I was there with six other men," he said later, "and I was the only one to come out alive." Seconded to the tank corps, he hurt his back and was sent to work as a driver at headquarters. It was safe and relatively easy work, much coveted by well-connected young men.

After the war ended in November 1918, Pierre still had two years' service to fulfill. He summed them up to Rosamond Bernier in his most laconic style: "It was in Paris. You were sent from office to office. I would go home for lunch. Then I started painting. It didn't turn out to be anything. I had a love story, the way young people do. I was in the office that dealt with demobilizations. The adjutant in charge made me very angry because he was always calling me by the most filthy names. So when I saw his application for demobilization on my desk, along with hundreds of others, I put it at the bottom of the pile. It stayed there for six months."

Thus revenged on Authority, Pierre set out on his life as a grown man.

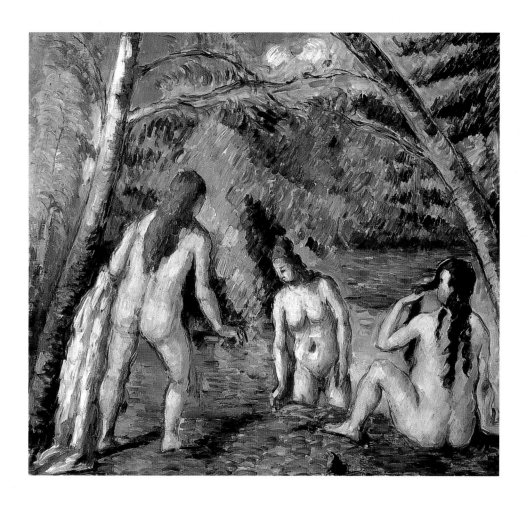

Paul Cézanne. *The Three Bathers (Les Trois Baigneuses)*. 1876–77. Oil on canvas, 20½ x 21½" (52 x 54.5 cm). Ville de Paris. Musée du Petit Palais. Gift of Henri and Amélie Matisse

Henri Matisse bought Cézanne's *Three Bathers* of 1876–77 from Ambroise Vollard in 1899. His wife, Amélie, supported him wholeheartedly in what was then a reckless commitment. The painting became the moral center of the Matisse household, and was regarded as such by Pierre.

Hard times notwithstanding, no member of the family would ever hear of its being sold. Eventually, in 1936, Henri Matisse gave the painting to the Musée de la Ville de Paris du Petit Palais. It hangs there today, with Henri and Amélie Matisse named as its joint donors.

All the other works here reproduced in color passed through the Pierre Matisse Gallery. The first portfolio gives a general idea of their variety.

PLATE I

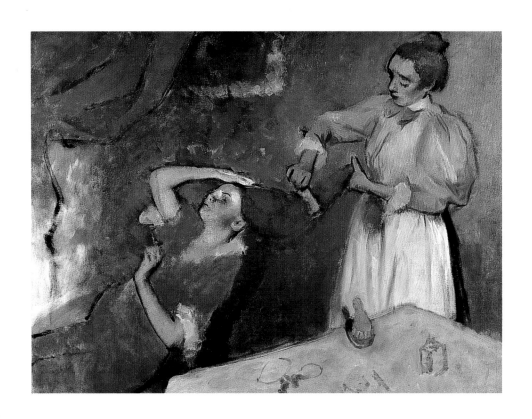

Edgar Degas. *The Coiffure (La Coiffure).* c. 1896. Oil on canvas, 45 x 57½" (114.3 x 146.1 cm). The National Gallery, London

PLATE 2

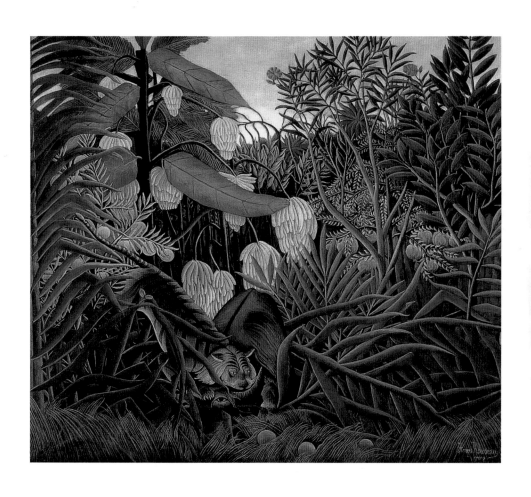

Henri Rousseau. *The Fight of a Tiger and a Buffalo.* 1908. Oil on canvas, 66⅞ x 74⅜" (170 x 189.5 cm). The Cleveland Museum of Art. Gift of the Hanna Fund, 1949.186

PLATE 3

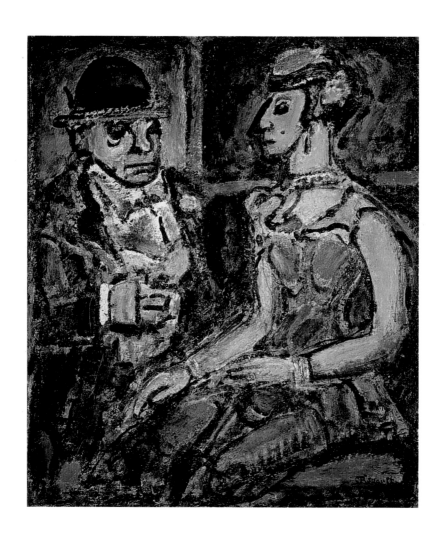

Georges Rouault. *The Manager and
the Circus Girl.* 1941. Oil on canvas,
39¾ x 32⅞" (101 x 83.5 cm).
The Jacques and Natasha Gelman
Collection

PLATE 4

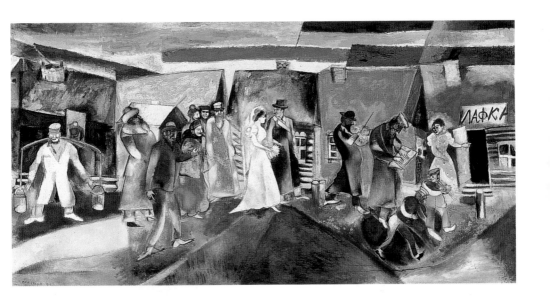

Marc Chagall. *The Wedding* (*La Noce*). 1910. Oil on linen canvas, 39¼ x 74¼" (99.5 x 188.5 cm). Musée national d'art moderne. Centre Georges Pompidou, Paris

PLATE 5

Giorgio de Chirico. *The Philosopher's
Conquest*. 1914. Oil on canvas,
49 ¼ x 39" (125.1 x 99.1 cm). The
Art Institute of Chicago. Joseph
Winterbotham Collection, 1939.405.
© Foundation Giorgio de Chirico/
Licensed by VAGA, New York NY

PLATE 6

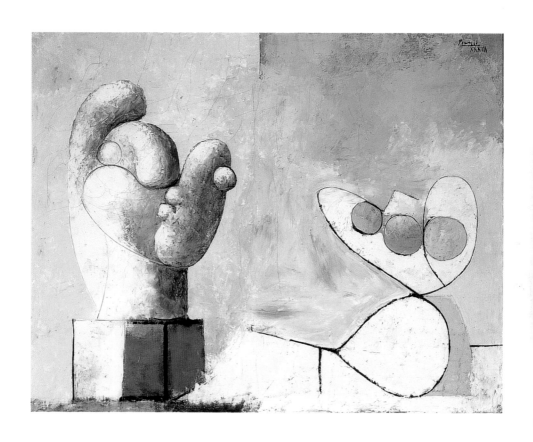

Pablo Picasso. *Plaster Head and Bowl of Fruit.* 1933. Oil on canvas, 28⅞ x 36¼" (73.4 cm x 92.1 cm). Courtesy the Fogg Art Museum, Harvard University Art Museums. Gift of Mr. and Mrs. Joseph Pulitzer, Jr.

PLATE 7

André Derain. *Still Life with Pumpkin (La Citrouille).*1939. Oil on canvas, 40 x 52" (101.6 x 132.1 cm). Santa Barbara Museum of Art, California. Bequest of Wright S. Ludington

PLATE 8

The Young Pierre, 1920-24

In Paris in 1920, one of the luckier young men around was Pierre Matisse. Tall and slender, with a potential for very good looks, he had not yet been demobilized from the French army. He might well, in fact, have been doing garrison duty in the French provinces or serving in Germany in the French army of occupation.

But, thanks to strings pulled at a high level, he had been seconded to relatively undemanding duties in the prime minister's office in Paris. The work was light. He had some spare time. Paris was Paris, and he made good use of it.

As the second son of Henri Matisse, he had seen many a great painting in progress. This was the case in the little house that the Matisses rented in Issy-les-Moulineaux, not far from Paris, and it was also the case in their very small three-room apartment at no. 19, quai Saint-Michel in Paris. Not only had he been around when masterpieces grew, day by day, but he himself had figured in more than one of them – above all in *The Painter's Family* (1911), now in the Hermitage in St. Petersburg, and in *The Piano Lesson* (1916), now in the Museum of Modern Art in New York. In 1920 – the year he turned twenty on June 13 – he went to the galleries in Paris. At Bernheim-Jeune, the gallery in which his father had shown since 1909, he saw a show of Cézanne. As he had been raised with a wonderful Cézanne *Bathers* that his father had bought from Ambroise Vollard in 1899–1900, he had something of Cézanne in his bloodstream, and he immediately singled out the *Old Woman with Rosary* of 1895–96, which now has a place of honor in the National Gallery in London.

He was also able to go, through the kindness of Diaghilev himself, to the

Father and son. Marseille, 1916

first performance in Paris by Diaghilev's Ballets Russes of a ballet called *Le Chant du Rossignol*, which had music by Igor Stravinsky, choreography by Léonide Massine, and décors and costumes by Henri Matisse.

Henri Matisse had been anxious that Pierre should see it. "I can already see that your mother won't want to go," he wrote, "but she's quite wrong. I gather from Marguerite that the public doesn't care for Derain's ballet (*La Boutique Fantasque)* because they don't think it brings anything new. If my ballet turns out to have its audacities, maybe they'll let me off easily. I'm ready for anything, but all I really ask is that I should like it myself."

Pierre had, in a sense, been in on the project from the day in 1917 on which Diaghilev and Igor Stravinsky had come to his parents' house at Clamart, just outside Paris. "I was there by chance," Pierre said to Rosamond Bernier many years later. "It was spring, the windows were open, and I could hear when Stravinsky played his ballet all through on the piano."

Matisse took a lot of trouble with the *Chant du Rossignol*. He went with the choreographer Léonide Massine to the Musée Guimet in Paris to get the costumes right for the Chinese warriors, and he went to the Victoria & Albert Museum in London to look over the Chinese carpets and porcelain. He also created some rather spectacular painted wooden jewelry for the dancers to wear. And he wanted the color to have a delicate French dosage, as distinct from the avalanche of color that the audience expected from the Ballets Russes.

But alas! *Le Chant du Rossignol* was a failure, and one for which everyone concerned shared the blame. The scene painter, Vladimir Polunin, said that Matisse

had never known what he wanted. The dressmakers said that they couldn't under-
stand his sketches. Tamara Karsavina, who had the role of the live Nightingale
(as opposed to the mechanical one), said that on the first night the feathers moulted
off her costume. As for the women dancers, Matisse said to the painter André
Masson, many years later, that they had refused to wear his wooden jewelry
and had brought their own from home instead. "Matisse was still hopping mad,"
Masson remembered. The *Rossignol* had been intended to stay in the repertory
for three seasons, but after a very few performances it was dropped.

At the first performance, Pierre stood with his father at the back of the orches-
tra stalls. "He was very nervous," Pierre remembered, "and he kept saying to me,
'Go on – clap!' But I did not like to be conspicuous."

As an aspirant painter, Pierre Matisse had already sold a picture or two. The
Salon des Indépendants was within his reach. And, like many another young
French painter before him – his father among them – he was making conscien-
tious copies in the Louvre.

There, too, he was lucky. He had the support and encouragement of André
Derain, who had just turned forty and was regarded at that time as one of the lead-
ing French painters of the day. Perhaps fearing that Pierre would never get out from
under his father's influence, Henri Matisse had asked Derain to keep an eye on him.

This was not a perfunctory request. Nor was Derain a mere acquaintance of
Henri Matisse. They had met briefly in 1898, when the eighteen-year-old Derain
was studying art in Paris at the Académie Camillo, where Eugène Carrière oversaw
his efforts. The son of a prosperous dairyman in the little town of Chatou, on the
river Seine not far from Paris, Derain was able in 1900 to rent what had once been
a restaurant at the water's edge. This he shared with his painter-friend Maurice
de Vlaminck. In March 1901, the two of them went to see a show of van Gogh at
the Galerie Bernheim-Jeune in Paris. While there, they ran into Henri Matisse.

This was a very low point in Matisse's financial and professional career.
With a wife and three little children to keep, he had no money and no prospects.
His father had cut off his allowance. But never would he agree to sell the Cézanne
Bathers that he had bought from Ambroise Vollard, in part with his wife's dowry.
His wife, Amélie, wholeheartedly supported him in this, by the way, though the
money would have been more than useful. In the self-portrait etching that dates
from these years, Matisse has the look of a man who had never been young and
would very soon be old.

It was at this terrible time that he and Derain became friends. Though Derain
was the younger of the two by a decade, he made a great impression upon Matisse.
With his huge gangling frame and his readiness to join in whatever prank was

proposed by his friend Vlaminck, he did not seem cut out to be a favorite younger friend of Matisse. He had, moreover, a histrionic side that was quite alien to Matisse. In 1924 Derain was to play a cameo role in *La Fille de l'Eau,* a movie directed by Jean Renoir. (He was cast as a Parisian barkeeper, and his every wink carried conviction.) In 1935, he was photographed in costume as Louis XIV and had both the looks and the weight for the part.

What Henri Matisse prized in Derain was that he had a natural intelligence of the first order. (When still at school, and aged fifteen, he had won first prize in the natural sciences.) He knew how to look, how to read, and how to think. He had a wide-ranging intellectual curiosity. From physics to philosophy, and from medieval symbolism to the poetry of his own day, he could pick up the conversation and run with it. As for art – well, there was no stopping him, and he shared Matisse's unbounded admiration for Cézanne and van Gogh. His was exactly the kind of affectionate collegial understanding that Matisse needed. After Matisse had been down to spend a day with Derain and Vlaminck in Chatou, Vlaminck said, "He looked ten years younger by the time he went back to Paris!"

No sooner was Derain free of the army in September 1904 than he returned to Chatou and at once got into contact with Matisse. Could Matisse come and persuade Derain's parents to let him study painting? Thanks to their cream buns, which were all the rage in Chatou, they could well afford to help their

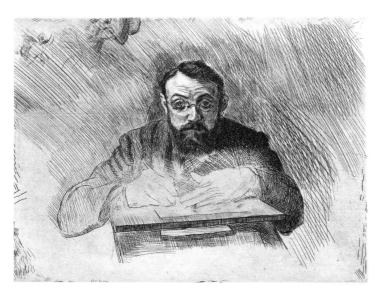

Henri Matisse. *Henri Matisse Etching.* 1900–3. Drypoint, printed in black, composition, 5⁵⁄₁₆ x 7⅞" (15.1 x 20.1 cm). The Museum of Modern Art, New York. Gift of Mrs. Bertram Smith

son. A visit from an older and established painter could be decisive.

Henri Matisse at the time did not feel established, though he certainly felt older. But he knew what it was like for a young man to have to deal with parents who doubted his vocation. So did his wife, Amélie. Derain's appeal could not go unanswered. Henri Matisse dressed up like a person of substance. Amélie Matisse played her part to the full. When they arrived at Chatou, after the eleven-mile journey from Paris, they looked like headmaster and headmistress. Derain's parents were awestruck. All objections were waived. Derain went to the Académie Julian in Paris, though his friend Vlaminck saw this as a surrender to an outmoded tradition.

Henri Matisse never lost sight of Derain's interests. While visiting Chatou in January 1905, he urged both Derain and Vlaminck to show in the Salon des Indépendants, which was to open on March 24. Nothing loath, Derain got eight of his paintings into the Salon and sold four of them. (Three were bought by a major Russian collector, Ivan Morosov.)

Meanwhile, in February, Matisse introduced Derain to a great and immensely wily dealer, Ambroise Vollard. To be taken on by Vollard could be a life sentence – as Matisse's classmate Georges Rouault, for one, was to find out – but it was also a brevet of very high quality. (Vollard had, after all, given Paul Cézanne his first exhibition in 1895.) Vollard liked to take his time, and for the moment nothing came of the introduction, but he didn't forget it, either.

On June 25, 1905, Matisse wrote to Derain and urged him to come and work in Collioure, a little harbor town on the Mediterranean, not far from the Spanish border. Matisse and his family had been installed there since the middle of May. The blond light was perfection – hardly a shadow in sight – and there were wonderful plunging motifs looking down towards the sea.

Derain lost no time. On June 28, he checked in at the Hôtel de la Gare in Collioure, and he stayed until the end of August. Young Pierre was fascinated by him and was soon allowed to ride everywhere on Derain's powerful shoulders. Even more important was that, as Matisse had foreseen, Derain's visit was vital to the development of his work. "I've been working unbelievably hard with Matisse," Derain wrote to Vlaminck. "He is much more extraordinary than I expected, especially when it comes to clear thinking and psychological speculation. I also think he was surprised that I had thought so much about color."

Matisse tended to downplay the importance of Derain in this brief phase of his own career. "I wasn't exactly surprised by what Derain and Vlaminck were doing," he said, "because we were basically on the same track at that time. But I was moved to find that these very young men shared some of my convictions." What he did not say was that it had been absolutely invaluable for him to have Derain in Collioure.

For quite some time, Matisse had wanted to shake off, once and for all, the ideas that had been originated by Georges Seurat and propagated after his death by Paul Signac. Signac had taken a fancy to Matisse and his work. In the summer of 1904, he had invited Matisse to stay in his very comfortable house in Saint-Tropez. But, as Matisse said later, "It didn't suit me at all." Signac's friends and neighbors believed that the future of painting still lay with the scientific application of color and the domination of the dot as the unit of expression. Matisse, by contrast, liked to work with the rich, savory movement of the laden brush. That movement brought energy, definition, and a potential for crescendo, and Matisse wasn't going to give it up.

He had gone along with his host in Saint-Tropez to the extent that he painted an elaborate beach scene called *Luxe, Calme et Volupté*. (Signac bought it when it was shown at the Salon des Indépendants in 1905.) But he wanted quite another kind of painting and when he and Derain were together in Collioure they perfected it.

It was a new experience for Matisse to work as one with another painter, and one with whom he could discuss everything in the world, when the day's work was over, and never hear a silly or an insufficient opinion. These were ideal conditions, and they were never to recur.

At the Paris Salon d'Automne in October 1905, Matisse and Derain teamed up to enormous and lasting effect. Matisse was deeply distressed by the hatred that was aroused by his *Woman with a Hat*. For Derain, on the other hand, the show was very much to his advantage. Two days before it closed, Ambroise Vollard came to his studio, looked carefully at what there was to see, and said, "I'll take the lot." (Reportedly he bought eighty-nine paintings and eighty drawings. The only thing that Derain kept back was a copy after Ghirlandaio.) Vollard also sent Derain to London, later in the year, to paint whatever pleased him.

It was doubtless with the year 1905 still in his mind that Matisse in 1920 asked Derain to keep an eye on his son. Derain by then had long discarded Fauvism. Whether in landscape, with the human figure, or in still life, he was producing paintings that were firm in their modeling, strict in their color, and austere in their construction. Conceivably he would convince Pierre Matisse that this was, if not the only way to go, at least a valid alternative.

In sending Pierre to Derain, Henri Matisse was making over to his son an important part of his own past life. He was counting on Derain for wise guidance, but he was also counting on him for continuity. What if history were to repeat itself, and Pierre were to be formed and shaped, as an artist, by the man who had been closer to his father, at a vital moment in his life, than any other colleague?

History did not work out like that, but Derain did his best. On November 8, 1920, Pierre wrote, "This afternoon I went to see Derain in his studio. He couldn't

have been nicer, and he gave me a lot of advice about my painting, and especially about my copying in the Louvre. He thought that I had chosen a difficult painting to copy, and one that would give me a lot of trouble. He also told me that when I painted still life I should simplify the subject as much as possible and – here he was very insistent – that I make my compositions from memory and synthesize as little as I could. He said he would come to see me in the Louvre one of these days. When I said good-bye to him, he said, 'Come back whenever you like. Don't hesitate. My door will always be open to you.'"

Two weeks later, Pierre wrote that Derain has been as good as his word, and had come to the Louvre to see him at work. As he had forecast, Pierre had his troubles with the royal portrait he had chosen. "When Derain came again, at the end of November, he urged me to warm up the figures and to paint very freely – the king's hands, in particular. The glazes in the draperies and in the page's *collerette* were bothersome."

Towards the end of the seance, Henri Matisse's friend Bischoff had joined them. ("He didn't have anything extraordinary to say," was Pierre's only comment.) Then they all three went to the Place Saint-Michel and had an aperitif. "Derain and Bischoff talked painting. So I took my leave." Many an ambitious young man would have hung around to hear them out, but that was not Pierre's way. The acquaintance would appear to have gone no further. Derain's door may well have been "always open," as he had said, but Pierre never liked to impose himself.

Meanwhile it was a minor but persistent problem in the early relations between father and son that Henri Matisse would not give up the idea that it was still possible for Pierre to master the violin. It was almost an obsession with him that a man who could play the violin would never starve.

He himself had struggled for years to make an acceptable sound, in hopes of being able to support his family by playing in the gutter if no one wanted to buy his paintings. He even painted himself playing the violin, as if that would have a magical effect.

Pierre had been saddled in adolescence with the burden of trying to succeed where his father had failed. When he was called up for the army in 1918, he thought that his troubles with music were over. But not at all: by 1920 they had started all over again. He had what was purportedly a good violin, and one that had not come cheap. He took lessons once a week, and he practiced every day. But, like his father before him, he was never going to make it.

This was a problem that had to be solved. Would a more expensive violin help? Neither of them really knew one violin from another, and they might be cheated. Meanwhile, Pierre did not like to say, "Enough is enough."

As an aspirant painter, he fared much better. Though not eligible to send to the Salon d'Automne in 1921, he kept his father closely informed about every painting that he undertook. Not only did he write about them, but in many cases he sent little sketches of them for his father's information and possible approval.

He also began to speak freely, and almost as an old campaigner, about the ins and outs of the Parisian art world. He had a particular contempt for Louis Vauxcelles, a critic best known to posterity for having coined the names not only of "Fauve" and "Fauvism," but of "Cubism" and "Cubist."

On October 31, 1921, he wrote to his father that "We are beginning to read what has been written about the Salon d'Automne. Some kind of record must be accorded to L. Vauxcelles, whose article of yesterday is enclosed with this. You will find his eulogies of Marquet and Othon Friesz (!!!!). One or two more paintings must have entered his private collection."

In January 1922, he himself showed in the Salon des Indépendants. The day before the opening, he reported to his father: "The painters have been grouped in alphabetical order, to avoid the formation of individual coteries. It works very well. I am well placed, in the room that follows the one I was in two years ago. The general effect is good, though I have one painting full of shadows.

"Among those present, and lording it over a large group of artists, was Louis Vauxcelles. I saw Kisling, Favory, Galanis (whom I talked with), Lipchitz, Hayden, and others. Monsieur Vauxcelles was casting a cold eye on his victims. I saw young Favory come running towards Vauxcelles from the other end of the gallery. He had a cigarette in his hand. He put it delicately between the lips of the critic, who simply said, 'How dare you offer me a cigarette in front of all these people!'

"Galanis rushed up to know what Vauxcelles thought of his pictures. Everyone was dying to get hold of him. They caught his eye, took him by the arm, clutched at his elbow. . . . It was a squalid and disgusting display.

"Galanis wanted to speak to Luc-Albert Moreau about me, but I told him not to. I saw Maximilien Luce, who told me that my paintings needed more work and that I was showing twenty years too soon.

"André Lhote is showing two nudes, in the manner of the *Demoiselles de la Seine*. But then you will soon be back in Paris and can see what it's all about."

That same week in January 1922 had already been remarkable for one of the rare letters between father and son in which Madame Matisse cuts a lighthearted, not to say exuberant, figure. It is an entirely different family situation that suddenly presents itself.

Pierre wrote on January 25 that they were all looking forward very much to Henri Matisse's return to Paris. "I think that it is Mama who is the most impa-

tient among us. When I left the house after lunch the day before yesterday she was still getting over an indisposition and her legs were still very weak. But when I came back in the evening I saw Mama dancing to the gramophone and singing 'Something came for me! Something came for me!!!' And at once I saw the little painting – a true jewel – that gave her such intense pleasure and completed her cure. With every day, she is more impatient for your return.

"As for myself, my situation is still the same. We expect to move out at short notice and join the ministry of justice on Place Vendôme, which I would prefer to the rue François Premier. But nothing is settled as yet."

This letter marks the end of the long period in which Pierre wrote to his father regularly in a fair round hand and in the guise of an industrious apprentice. Throughout that period he was the archetypal good son. If he did not hear from father every week or so, he would say, "What's become of you?" He was attentive to his father's every word. If he rebelled, it was in secret. If he had ambitions beyond those which were integral to his family, he concealed them. If he had close friends, male or female, they were never mentioned. If he had unexpected and possibly unpopular opinions of his own, no one in his family knew of them.

Nor is it clear from these early letters that he had any particular future in mind for himself. As a young painter, he was conscientious, but he did not manifest a readiness to live or die for painting.

There had been a moment when it seemed that he might join the French foreign service in one of two capacities. He could become one of the corps of couriers who escorted the diplomatic bag from one country to another. Or he could become a full-time career diplomat and be appointed somewhere abroad.

Nothing came of either of these projects, but there was something infectious about the delight with which he reeled off the names of the capital cities of Europe, one by one, and went on to say that North and South America were also possibilities. "I wouldn't turn down a tour of the United States," he said. It took some fixing, but as of December 1924, the whole of the rest of his life was to turn upon just such a tour.

Meanwhile, there was seemingly a two years' gap in the correspondence between father and son. Letters, if written, were either not kept or put somewhere out of sight. One reason for this may well have been that, as Pierre said to Rosamond Bernier many years later, he got engaged to be married. "I was 22," he said, "I don't know why my family let me do it. If they had been more strict, they could have stopped it."

This was not a Parisian romance. It burgeoned in Ajaccio, in Corsica, where Pierre's aunt, Berthe Parayre, was still headmistress of the local school. Pierre

and his brother Jean went there for a vacation after Pierre was demobilized. Pierre was painting at his aunt's. The young woman in question lived directly across the street. Visitors from Paris had a certain cachet in Corsica, and all the more so if they were related to Pierre's Aunt Berthe. As Pierre remembered it, "We visited Spanish-style, at night on the edge of the wall. It was quite romantic. But we never thought about the future. It started in the summer. It lasted through the winter. We got married in the spring. So there I was, newly married to the daughter of an Inca princess. Supposedly, her mother had been the wife of a very rich Indian. When she was widowed, my father-in-law immediately brought her to Corsica. In Ajaccio she was quite sequestered, in Corsican style. She could hardly speak French. My father-in-law had an open carriage with two horses, but as he hardly ever went out he used to rent it, complete with a coachman.

"We were married in one of the side chapels in Notre Dame in Paris, and my father lent us his apartment in Nice for the honeymoon. After that, we had nowhere to stay. Before long, as people used to say, 'the wet got into our shoes.' After three months, it was not working at all, and finally we broke up."

Given that under French law his wife could have prevented him from leaving the country until due provision was made for her, any plans for an American tour had to be on hold. It must be said for Henri Matisse that at this time he gave Pierre judicious advice, without scolding. And when Pierre was truly ready to go to America, nothing was put in his way.

"Tante" Berthe Parayre as the director of the Ecole Normale. Ajaccio, n.d.

An American Dream, 1924–25

In the winter of 1923–24, Pierre was working for the Galerie Barbazanges in Paris. This was not an anonymous hole-in-the-wall of the kind in which D.-H. Kahnweiler had operated on the rue Vignon, not far from the Madeleine, from 1907 onwards. It was part of a heterogeneous collection of buildings that belonged to a great couturier, Paul Poiret.

The property stood on a roughly triangular piece of land on the Right Bank of Paris that bordered on the rue du Faubourg Saint-Honoré, the rue de la Boétie, the avenue d'Antin, and the rue du Colisée. It included, at no. 26, avenue d'Antin, a late-eighteenth-century town house that Paul Poiret used as the headquarters of his couture business.

Poiret also owned a smaller but very covetable space in back of his great house. It faced onto the rue du Faubourg Saint-Honoré, which then as now was a particularly elegant street, in which diplomatic and governmental overtones were combined with a long row of discreetly ruinous shops.

In 1911 or thereabouts, Poiret leased the ground floor of no. 109, rue du Faubourg Saint-Honoré to an art dealer called Henri Barbazanges. As a location, it had many advantages. Quite apart from the passing trade on the delectable street, there was a little shop next door that sold Poiret's perfumes. There was also a side door that allowed free access from the town house to the gallery, and vice versa. Even during World War I, when art-world activity in Paris, as elsewhere, was much diminished, the Poiret complex had had its hours of glory. (One of them was the Salon d'Antin, in July 1916. Organized by the critic André

Salmon, this included the first-ever showing of Picasso's *Demoiselles d'Avignon*.)

Henri Barbazanges clearly had big ideas for his gallery. (A later tenant credited him with having built the very large, windowless, top-lit room in the back gallery.) But in 1923 he turned the gallery over to his associate, whose name was Hodebert. The change was made known in October of that year in a magazine called *Les Arts à Paris*. "M. Barbazanges is giving up his business," the mention began. The Parisian art world would miss him, but there was good news. Not only could M. Hodebert himself be depended upon, but he was believed to have hired as his assistant the son of "a great painter of the rising school." Much good would come of this.

This was, therefore, a space with a history all its own, even if it was relatively inconspicuous at the time when Pierre went to work there. It was his first experience of the day-to-day gallery life in which the rest of his professional career was to be spent, and before long he began to enjoy it. He made a sale or two, in Hodebert's absence, and he learned how to say the right things to potential clients.

He also had some amusing encounters that might be very useful. One of them was with Henri-Pierre Roché, a man of many parts, a friend of Marcel Duchamp, Brancusi, and others, a past master of the ménage à trois, and the future author of a novel called *Jules et Jim,* which was to give an incomparable picture of what it was like to be young and in and out of love before 1914.

Roché knew his way about the art world, both in Europe and in the United States, and he had been instrumental in helping a New York lawyer called John Quinn to form what was at the time the most important American collection of recent French painting and sculpture.

On January 11, 1924, Pierre wrote to his father that "Among the clients who came trickling back after the Christmas holidays was a big man, rather American in style, who asked me in very good French for the prices of one or two pictures. I felt that I knew him, but I didn't like to ask who he was. When he was just about to leave I finally asked if he was not Monsieur Henri-Pierre Roché. When he said 'Yes' I told him who I was, and we had quite a chat. He is going to bring us some big American collectors, and we hope to do some good business together."

Roché might have been just being polite. But on January 1, 1924, he had already written to John Quinn to say that "I have been to Barbazanges and made friends again with Matisse's son, who is chief employee there. We shall know all exciting things at once through him by phone."

From what Roché wrote to Quinn it is clear that "Barbazanges" (now Hodebert) was in a very good way of business, and that Roché was already sending news of "exciting things" in the gallery's current stock. "He has a Daumier,

Les Lutteurs, of which I shall send you a photo, and a wonderful huge, half-earnest caricature of Puvis de Chavannes by Toulouse-Lautrec." (This was the hilarious *Parody of 'The Sacred Wood' by Puvis de Chavannes,* which Toulouse-Lautrec had produced in 1884.) Roché went on to say that "he also has a first-class van Gogh, *The Hospital in Arles,* of which I also ordered a photo." All this suggests that in 1924 Pierre Matisse was well placed to learn the art business at first hand (and at close quarters).

But Pierre also heard rumors that angered and distressed him. In an undated letter to his father, he said, "Yesterday, and again today, I have heard it said that Paul Guillaume is installing an apartment in which he wants to hang some wonderful paintings. Among them, he would like to have three or four Matisses. He has already found one at Georges Bernheim's.

"G. B. knew what Guillaume was after. Yesterday he called him and said that he did, indeed, have some very beautiful Matisses in stock. But he simply didn't dare to tell him the prices. It was ridiculous, he said. Matisse was forcing him to ask outrageous prices, and there was just no arguing with him.

"Today, Hodebert went to see Jos Hessel. Among many other Matisses, he saw *The Music Lesson.* Hessel was asking 40,000 francs for it. Hodebert said to him 'Are you out of your mind? Or am I?' The answer was the same. 'Matisse sets his prices so high that we no longer dare to show his pictures.' And it is perfectly true that neither at Georges's, nor at Hessel's, nor at Bernheim-Jeune's is there a Matisse in the window.

"I find it rather disgusting. They are putting it about that you are forcing up your prices. They buy one of your pictures for 6,400 francs and try to sell it for 40,000. When the clients are horrified, the dealers can say that it's all your fault. That's their game. Hessel isn't stupid, of course. He just puts the pictures aside. But they want to start a wave of feeling against you in hopes that you will be intimidated."

He also told his father that "By the way, the dealers are putting it about that for lack of new paintings there will be no Matisse show this year. The little comedy continues."

Henri Matisse was not intimidated. Neither was he surprised. He knew that dealers played hardball. "My dear Pierrot," he wrote, "Don't upset yourself about the dealers. Under my agreement, I keep eight paintings a year, of my own choice. If they don't behave well, I have the upper hand. I can take my pick of the year's output and sell them elsewhere at the price laid down in my contract. If the dealers want to stockpile them, they will find it very expensive. If they manage to sell some at very high prices, that cannot be bad. When my contract expires,

I shall not renew it and I shall sell my paintings in whatever way I like. If you can find out what Bernheim-Jeune is asking for my paintings, I should be interested. So I embrace you, and I hope that you will make a lot of sales to Barnes."

At the end of this letter was a note from Henri Matisse to Pierre's mother: "My dear Amélie,

From my heart, I embrace you.

Do write to me – just for half an hour in your day – it's not very much."

It was by now several years since Pierre Matisse had said that he wouldn't turn down a visit to the United States. By 1924 he was planning to go, not as a member of the French foreign service, but as someone who wanted to make his name as an art dealer.

Only in the last days of 1924 was Pierre Matisse ready and able to leave for New York. Before leaving, Pierre sat down to write a potentially momentous letter to his father. It was on the subject of what he was going to do when he got to America. Whether in the art world or anywhere else, there was a great American tradition of starting at the bottom and working one's way up. But there was also an American tradition of making good sense and thinking ahead.

As to that, Pierre Matisse had got a great deal of advice from a brother of Joseph Brummer, who was already established as a major dealer in New York. As an apprentice sculptor, Joseph Brummer had enrolled in the school that Henri Matisse had run in Paris from 1908 till 1911. As he had no money, Matisse paid him to keep the school clean and in order. He was therefore well disposed towards the Matisse family, and they towards him. In 1924 the Brummer gallery in New York had had an important show of Matisse – his first in New York since 1915.

Brummer's brother agreed to see Pierre Matisse and gave him a panoramic rundown of the situation in New York, and indeed in the United States in general. Pierre reported this to his father, almost word for word. Brummer told him that he simply had to arrive in New York with pictures to sell. As he could not speak English fluently, he would be crazy to arrive there empty-handed, and with nothing to recommend him except that he was the son of Henri Matisse. "Never forget," he said, "that in America money is the mainspring." If Pierre began work as a minor employee in an art gallery, nobody would pay any attention to him. He had to make it on his own. Once he was typed as a minor employee, he would never be accepted as an independent dealer.

First impressions were all-important. "I cannot present myself simply as my father's son. But if I, Pierre Matisse, arrive with a batch of really important paintings, I can knock on any door in New York and be made welcome. In the United

States, there is not the distance between a young man and an older one that we have in France.

"Between business in France and business in America there is a basic difference. If in France we have something good to sell, we wait for the clients to come by. In America, you have to go out and find them.

"For that, I need at least fifteen really good paintings. Even before they get there, I must make the rounds of the galleries and see what they have. Then I must pay calls on some collectors and tell them what a fantastic exhibition I'm going to have. 'Never forget,' Brummer said again, 'that the United States is the heartland of bluff and untruth. Bluff, above all!'

"He tells me I shall find it easy to get along with the dealers, and that his brother will let me have my exhibition in his gallery. It will be a good advertisement for him. I shall get talked about. I shall exist as myself. That is the only way to get on. There is a great future in the States for a courageous young man. But you have to put your whole self into it. You have to arrive with every possible advantage and hold your own against everything and everyone. American jealousy is terrible, and it has none of the outward politeness of French jealousy."

Undeterred by this rapid-fire freshman orientation, Pierre Matisse laid out his plans. "It seems to me that I could easily borrow on commission fifteen or so paintings by Renoir, Cézanne, Sisley, Pissarro, Monet, Gauguin, Seurat, etc., plus one or two moderns like Utrillo and Derain."

This did not seem to him a daunting, let alone an impossible, list for an aspirant dealer who had virtually no capital. On he went, without drawing breath. "Brummer urged me to be very economical, since life in New York is terribly expensive. He thought that I should do well to arrive with $2,000, but that with $1,000 (20,000 francs) and the paintings I could just make a go of it if I lived in a boardinghouse and counted every penny. If I sold paintings in the exhibition, I should leave at once and not squander my profits. I could then have an exhibition every year. But he was most insistent that I should be always the boss, and never an employee. And, young or old, it's business that matters."

Brummer also said that Pierre should have two or three of his father's paintings to sell, plus – if possible – two or three others that were not for sale but that would give the show more substance.

Then he came to the point. He would like to get started. Did his father approve of his plans, or did he not? If he did, Pierre could start immediately with Hodebert and go on to the Bernheims, Paul Guillaume, Jos Hessel, and others. He would pay the transport in every case, and the dealers would pay the insurance.

This seemed to him the best way to begin. Marguerite and his mother were

of the same opinion. Could his father please cable in reply, or write at once?

Two days later, Pierre wrote to his father again. After further thought he had decided to enlarge the scope of his exhibition at both ends to include Corot, Redon, Picasso, and Braque. Meanwhile he was anxiously waiting for a reply to his first letter.

This second letter crossed with one from his father. In spite of the scale of Pierre's ambitions, his lack of practical experience, and his limited command of the English language, his father was not immediately discouraging. Of the implacable and legendary hostility, in this context, of father to son, there was never a trace.

"My dear Pierre,

"Your letter deals with a very important matter. Initially I was wholly in agreement with it. But on thinking it over I said to myself that quite heavy expenses would be involved. You must not fall on your face with a venture of this sort.

"You are young and, as you know, you don't always think things through. You must also make quite sure that you can have the Galerie Brummer on the terms that Brummer's brother outlined. You must see him again to make sure of that. He may have got carried away by the conversation without consulting his brother.

"Could you see him again and tell him that you have told me of your plans and that I thank him for his wise advice? And then tell him that I should like to know if his brother is really willing to lend you his gallery? Or part of it? As for my own work, you should deal with the Bernheims. Don't let them give you anything that is not for sale. That's as far as I can go at the moment. Think the whole thing over for a few more days before speaking to the dealers."

Henri Matisse also pointed out that Pierre's in-laws were in a position to prohibit, or at any rate to delay, Pierre's journey to America. "Don't get involved," he said. "You have a lawyer. Let him sort it out.

"Be nice to your family," he said finally. "Keep in constant touch with me, and above all don't do anything without telling me."

On November 9, 1924, Pierre told Hodebert of his intentions and gave notice that he would leave the gallery at the end of the month. This was clearly a blow to Hodebert. But not only did he take it well, he floated the idea that Pierre should be his representative in New York. When Pierre said that he was determined to be king in his own castle, no matter how small it might be, Hodebert suggested that they should remain in confidential contact to their mutual advantage.

He also offered Pierre an introduction to Dr. Barnes, with the idea that Barnes might be glad to have him on the staff of his foundation. Pierre said that he'd rather not. Such was the authoritarian nature of Barnes that he would never be able to be his own man.

Pierre went back to see Hodebert a day or two later, taking his sister Marguerite with him. This was meant to be the first stop on a tour of the Paris dealers who might help him to realize his dream of a sensational debut in New York. Henri Matisse had had his doubts about the practicality of that idea, and he had said so to Pierre in more than one cable. Pierre had taken due note of those cables. But it was left to Hodebert to give it the coup de grâce.

As Pierre wrote to his father when he was already on the liner *Savoie* and headed for New York, "Hodebert told me to put the idea out of my mind. To begin with, none of the Paris dealers would lend me paintings of real quality for a long period. Paintings of quality are hard to come by, in any case, and it costs a lot of money to keep them. Even if I managed to have some French paintings, Knoedler and Durand-Ruel would at once put on shows that I could not possibly compete with."

So Pierre did not pursue the idea further, seductive as it was. When he left for New York on the *Savoie*, he had none of the heavy responsibilities that would have been involved. But when, just a few years later, he had his own gallery under his own name in New York, a part of that dream was fulfilled in the anthologies of French painting that he was to put together, year after year. Meanwhile he had a great deal to learn in, and about, New York.

A Novice in New York, 1925

December 22, 1924, was Pierre Matisse's first day in the city of New York, which was to be the center of his operations for the next sixty-five years. Christmas week is not the best time to make business appointments with strangers in a city in which you have very few contacts and can barely speak the language. But all that and much else was taken care of by Walter Pach, a longtime New Yorker who knew the local art world inside out.

Pach had first met Henri Matisse in Italy in 1907, when Matisse was staying with Michael and Sarah Stein at their villa near Fiesole. In 1913 he was one of the prime movers in the Armory Show in New York, and in 1914 Matisse engraved a tiny portrait of him that has proved to be his passport to posterity. Pach was startled to find that Matisse made the etching directly on the plate in exactly five minutes. But it is a small marvel of observation and understated wit. Anyone can see from it that Walter Pach was bright, inquisitive, and a born networker.

The *Savoie* arrived early on a very cold morning. The Statue of Liberty was fogged out. In the Hudson River, plaques of ice jostled one another from pier to pier. Most people who had any sense were still indoors. But Walter Pach was waiting at the dock for Pierre Matisse and at once took charge of all his arrangements. He took him to the bank. He fixed him with somewhere to stay (in Washington Square, at $12 a week, with a French-speaking Swiss landlady). They ate together in a little Italian restaurant. ("It cost $1," Pierre wrote to his father, "but I'm looking for something cheaper.") Then they forthwith made a tour of the dealers. One of their stops was at the Montross Gallery, where Henri Matisse had had an exhibition in 1915.

Walter Pach had had a lot to do with that show, and a copy of the catalogue was waiting for Pierre. So was Montross himself, a genial old person who showed him his Matisse prints and some watercolors by Cézanne. Though cordiality itself, he made a point of telling Pierre where to go to get English classes for nothing.

All the dealers made Pierre welcome. One of them had as a partner the Czech conductor Josef Stransky, who in 1911 had had the daunting task of following Gustav Mahler as conductor of the New York Philharmonic. After Stransky had shaken Pierre's hand warmly, Pach said to him in private that it was "all bluff!," thereby confirming Brummer's opinion of New York.

The next day they had a date at the Brummer gallery. Pierre had not as yet said anything to anyone about his eventual ambitions. Joseph Brummer told him simply and plainly that the art business in New York was not easy. There was always hope for young people, but it was not just a matter of working hard and not giving up. Luck could be the decisive element.

Brummer also told him to keep it in mind that Americans did not look on pictures as an investment. They thought of them as money spent on something that they liked, but as money gone for good nonetheless. In New York, they never wanted to spend money on art. But when they went to France, they had already set aside so and so many thousands of dollars to spend on pictures that they liked. (When they got them back to New York, they never looked at them.)

There were exceptions. There was a German who had arrived in New York and had German and French prints and drawings to sell. He worked out of a little apartment on the fifteenth floor somewhere, and yet he had made a go of it.

In these matters, Pierre Matisse was new, but he was not dumb. After less than forty-eight hours in New York, he had plenty to think about. To get on in New York, it was clearly important to stick around, rather than to come in like a comet and go back to France as soon as possible. Brummer advised him to see if Montross would take him on. Pach and Pierre should also pay a call on Knoedler, and on Durand-Ruel. Later, he should call again by himself and eventually bring the conversation round to his ambitions.

This proved to be mistaken advice. Established galleries in New York were not going to take on a young man who as yet had nothing but his father's name to recommend him. Even if they hired him, and he turned out to have exceptional qualities, they would see to it that his identity was merged with that of his employers. Yet how was he to establish that identity with no capital, no stock, and no contacts? (He had brought with him, as a matter of fact, a number of paintings that he had kept with him in his cabin, but he was taking his time before showing them to anyone.)

Pierre wrote home a great deal, those first weeks, and every time a transat-

lantic liner arrived from Europe he hoped that the next day would bring him a reply. On Christmas Eve, 1924, he wrote to his mother that in New York the art world was a tougher place than it was in Paris. But, thanks to the ubiquitous lunch counter, he could eat for as little as thirty-five cents, coffee with milk included.

A now-vanished New York came to life in his first letter to his father. It was a city of the giants, he said, a city out of the novels of H. G. Wells. Activity was frenetic. Time was money. In subway and bus, conversation was minimal. (A handshake, and then silence.) On the streets, the traffic was orderly and disciplined. Automobiles went their noiseless way. On Wall Street, thousands of men milled around, each sunk in his own thoughts. America was the heartland of the custom-built automobile. One in every seven people had a car. He felt well – "Remember," he said, "that New York is a seaport" – but there was just too much to think about, let alone to write about. "I cannot order my sensations," he said, like a true Frenchman.

Walter Pach never ran out of ideas. There was the upcoming dispersal of the collection of John Quinn, the New York lawyer who was once rightly described as "America's greatest adventurer in the field of the arts." Without Quinn, neither T. S. Eliot's "The Waste Land" nor James Joyce's *Ulysses* might have got into print. Quinn had been behind Ezra Pound, in his early days, and behind Joseph Conrad. Since 1904 he had been persona grata in the Dublin of W. B. Yeats, Lady Gregory, and the short-lived J. M. Synge. (On his first visit to Dublin, Yeats had had breakfast with him every day and stayed on to talk.)

Quinn also knew France and French art from the inside. No one but he could have got Constantin Brancusi to set foot on a golf course, let alone to address the ball. (The foursome also included the composer Erik Satie, in a black suit and black bowler hat.) Working entirely from his current income as a lawyer, Quinn had bought some of the finest of recent French paintings – among them one of Cézanne's portraits of his wife, a self-portrait by van Gogh, *The Circus* (1891) by Seurat (and the small version of his *Les Poseuses*), the *Sleeping Gypsy* (1897) by the Douanier Rousseau, the *Blue Nude* (1907) of Matisse, and Picasso's portrait of Wilhelm Uhde (1910). He had also bought deeply into both American and English painting.

After Quinn's death in 1924, the question of what should be done with his multifarious collections was much debated. Eventually, Joseph Brummer was asked by Quinn's executors to liquidate them in whatever way seemed to him best. Brummer by this time was in a very big way of business, but when faced with a collection that totaled in the low four figures even he needed time. There would eventually be a cameo role for Pierre Matisse in these mammoth undertakings, but that was still quite some way in the future.

Meanwhile, Pierre was pondering an idea put to him by Joseph Brummer's brother. It was at the opposite extreme from the all-star exhibition of French masters that he had dreamed up for Pierre in Paris. It had to do with a famous department store that had an "art department" and needed someone to run it.

It didn't sound very distinguished, and it wasn't. But Walter Pach knew one of the directors of the store and would speak to him about it. Pierre would have to buy low-level mass-market paintings and attractive objects from Europe. He could do it, and with salary and commissions it would pay very well. Nothing else was coming his way, and he had noticed that New York dealers normally ran their own show. Pleasant as they had been to him, there were no offers of employment.

After the two days of Christmas, he would start looking again. Meanwhile, "You have no idea," he wrote to his father, "how alone one can feel here, in my position – so far from home, so abruptly, and in an atmosphere that is alien to me."

By December 27, the situation was looking brighter. The department store was not for him, as he had foreseen, and he had turned it down. "It was just as well," he wrote to his father, "because my next meeting was with a bookseller who has a little gallery in his shop. He suggested I should make exhibitions there that would be 'organized by Pierre Matisse.' American bluff shows its true worth. He would have liked you to choose some young painters for him, but I told him that that was out of the question. Be assured that your name will play no part in it.

"So, to get things moving soon, he asked me to make an exhibition of your lithographs, with some drawings and watercolors. No paintings, though we would hope to have some later. He will pay all the expenses, let me have the gallery for nothing, and take half the profits. I have asked Marguerite to get the prints ready, and to ask you if we could also have some drawings. To make a good show, we should need at least ten.

"As this is my debut in New York, the work has to be well chosen and, if I may so put it, not too familiar. If this arrangement works well, it will be the best possible solution for me. I should keep my independence. I should have a future in New York without being beholden to anyone. And I should have my first exhibition in short order."

To have got so far in exactly five days (two of which were taken up with Christmas) was a classic example of the importance of luck in New York. It could also be said that Pierre Matisse had a certain gift for New York bluff, in that he had encouraged the bookseller, whose name was Eberhard Weyhe, to hope for future shows of watercolors, pastels, paintings, and sculptures by Henri Matisse.

Weyhe lived for books and prints. The two stories of his shop were a labyrinth of rickety shelving, overcrowded bookcases, portfolios filled to bursting, and

pieces of library furniture that looked all set to tumble down through the ceiling. The staff knew where every last book could be found. Prints by the hundred were there for the gleaning. Prices were always fair, and visitors were welcome to stay all day and go home empty-handed.

Pierre went ahead. Pach was to write a preface for the catalogue. Would his father make a little drawing – an emblem, merely – for the cover? Or even a tiny self-portrait? In due course Henri Matisse said that he was well pleased with the invitation card, the preface by Pach, and the catalogue itself.

The time passed rapidly. The show opened on March 14. On March 25, Pierre reported that two drawings and five lithographs had already been sold. He had held a tea party in the gallery, "with everything except a jazz band." He had some new contacts, too.

In the matter of sales, whether small or large, Henri Matisse always took *Matisse contra Mundum* as his motto. The son of a small businessman, he had had to count every penny in his first years as an artist. Now that Pierre was setting up in business in the heartland of high rollers and big spenders, he, too, should watch every penny.

On April 20, 1925, he made himself completely clear on that point. "Your exhibition closed on April 6," he pointed out. "Your letter, just received, was dated April 7. We have heard nothing from you, except that it went very well and had a great success. Many things were sold.

"But, as I have already told you, you have to tell us 'I have sold X drawings for X dollars apiece, and so many lithographs for X dollars apiece. The dealers took one third or 50%. The dollar is worth X francs at present. Therefore I have sold for a total of X francs.' If you do that, we shall know exactly what happened, and as soon as possible. This must be done NOW AND ON ALL FUTURE OCCASIONS.

"I hope that my remarks will by now be out of date and that your letter will make everything as clear as we could wish."

Pierre at that point was exploring the possibilities of having shows in Texas. Ever prompt with sound financial advice, his father said that "In matters of this sort you must always try not to pay your own travel expenses. Couldn't you give some lectures on French painting? All you have to do is to pick out some good stories from the books, here and there, and work them into a lecture. I think you would have a great success. Start talking about it!

"Talk to Pach, if you think that he would help you without being paid for it. Or you could always ask the people for whom you are arranging the exhibition to get Pach to come and give a lecture.

"In any case I think that you could perfectly well do it yourself. You could

announce it as a controversial lecture. I think that that would go down well with the Americans. Maybe it would be better to discuss it with the dealers than with Pach."

It was at that time a widespread illusion among European visitors to the United States that the lecture market was virtually inexhaustible. It did not seem to them that either previous experience or an original turn of mind was needed. A foreign accent, a certain self-assurance, and a sprinkling of famous names would always do the trick. But Pierre did not see himself as a potential lecturer.

In writing to his mother, Pierre liked to give the impression that he had already got the measure of the big new city and was ready to face it down. "Prices here have absolutely no rapport with prices in Paris," he said. "In Paris you are regarded as a thief if you deviate from the current level of prices. In New York, the more money you ask for, the more people respect you."

In his imagination, Pierre would race ahead to his next exhibition but one. This was to be a replica, more or less, of what he had planned when he was working for Hodebert in Paris. It was clear that he saw his career in part as a family affair. Marguerite was to assemble the paintings and send them off to New York. Henri Matisse was to give him as many paintings as he could. Even his brother-in-law Georges Duthuit would be asked to guarantee Pierre's bank account in New York in the sum of $300. As for the contents of the exhibition, it would include "three or four paintings each" from Picasso, Matisse, Derain,

Pierre with his mother. Clamart, c. 1926

Braque, Bonnard, Marquet, Segonzac, Vlaminck, and Dufy. Once again, it was left to Marguerite to get hold of them.

Meanwhile, he turned down yet another of Walter Pach's ideas, which was that he should become director of a college museum that was in upstate New York.

"Independence before all things!" was Pierre's motto. As a first step towards it, he took a larger and more conveniently situated room. Thanks to that American novelty, the Murphy bed, he could receive his clients in an atmosphere of decorum. (When apprised of this, Henri Matisse said that he had more than once seen American movies in which beds of that sort had been put to comical use.)

Meanwhile, however, Pierre was doing no business. "Money flies away at an incredible rate," he wrote to his father. "Yet I have to spend it. Everything here depends on contacts, and even a cup of tea or an ice cream costs money."

Much as he tried to put up a good front, it was becoming clear to Pierre that in plain terms he was reduced to selling minor examples of his father's work from a rented room. When American dealers approached him, it turned out to be because they saw him as a means of access to Henri Matisse. This was true at every level, and the cumulative effect of it could be very depressing. Projected exhibitions in other parts of the country came to nothing. There was a time when Pierre walked the length of Madison Avenue in search of an empty shopfront that he could rent even for a few days.

In Chicago, and as "the son of Henri Matisse," he was personally very welcome. He was invited to the opera, and to dinner dances, and in general made a fuss of. But as a dealer he was not taken seriously. There was a painful occasion on which he installed a little show in his hotel room for quite some days and exactly one person came to see it.

There was also the fact that in New York the art market was seasonal. There were no more than six or seven months in the year in which business could be counted upon. But the bills kept coming, year-round. What to do? To teach French, or drawing, off-season in the house of a California millionaire might be convenient. It could even be agreeable. But it might also cause him to lose face.

In dark moments towards the end of his first year in New York, Pierre sometimes thought of giving the whole thing up. He had too often been regarded as "Mr. Matisse, Jr." – a personable and welcome spare man, rather than as someone who was eager to make his way in a highly competitive business. Sometimes it crossed his mind that he didn't even like that particular business.

This did not happen often. But, when it did, he thought that he might do better to drop the whole thing and go to sea. This had been an intermittent fancy of his in adolescence, when the family was living in Collioure. But in the fall of

1925 it had a renewed magic. To be a radiotelegraphist in a ship that traveled the world was suddenly very seductive.

Unlike the purser of a transatlantic liner, who was on call virtually at all hours of the day, even when the ship was in harbor, the radiotelegraphist had fixed hours at sea. The moment the ship docked, he was free to go ashore. There was a school in New York that offered an eight-month course at the end of which opportunities were open and waiting. Pierre loved ships, and he loved the sea, and in later life he liked nothing more than to crisscross the Mediterranean in his own boat. It also tempted him that work could be found for a radiotelegraphist on big sailing ships that sailed from Dunkirk to Australia and back.

Meanwhile his correspondence with his parents had taken a new turn. No longer the docile youngster, he was shaping up as a mediator in family situations that were already complicated and would before long become even more so.

Although barely twenty-five at the time, Pierre had begun to act with an affectionate candor in times of trouble. Much in those troubles was owed to a distinctive family trait. Almost without exception, the Matisses had very strong feelings. What they did not have was the power to release those feelings in conversation.

Three separate examples of this problem came Pierre's way in a four-month period in 1925.

On June 25, when Henri Matisse was alone in Nice and feeling rather sore, Pierre wrote to his mother and urged her to patch up their relations. "If you can only turn towards him a little, as if it came quite naturally, you will find that his state of mind will change as much as his nature and his nervous temperament will permit. If you speak gently to him, you will achieve much more than if you come straight out with your discontents."

Amélie Matisse gave Pierre a prize example of the family fear of confrontation when she wrote to him in September 1925 and described a visit that she had made to her sister, Pierre's Tante Berthe. Amélie and Tante Berthe had had a serious falling-out. Amélie thought that she ought to go and see Tante Berthe and make friends again. She sent a telegram. Tante Berthe agreed to her coming. But when Amélie got there, permafrost prevailed. No embrace was offered. Nor was there any exchange of family news.

Next day, things were slightly better. The two of them went to the school of which Tante Berthe was headmistress, and into the town of Pau. But nothing was as it had formerly been. "I was bent on having it out with her before I left," Amélie wrote to Pierre. "But I was treated almost as a stranger. We both avoided the subject, each hoping that the other would begin. It was really for her to broach the matter. But I saw that she would never understand me. So I left as I

had come, without saying a word."

On October 21, Pierre's diplomacy was called upon once again when he wrote to his father and said, "I have had a letter from Marguerite. She seems to be very much distressed by something that you wrote to her from Sta. Maria de Vesubie. What can you have said to her? You must not be too harsh. She is hyper-sensitive, and at this moment she is caught between two fires, struggling this way and that – and fighting for her own survival, too. If nobody is willing to give in, the house will become a hell on earth and we shall none of us be on speaking terms. And a lot of good that will do!"

Intimations of that sort were never welcome to Henri Matisse, and he must have made this clear to Pierre. On December 8, 1925, Pierre assured his father that there was no change whatever in his feelings for him. Nor would there ever be. Life was too short for misunderstandings on that subject. "But," he said, "life presses ever more heavily upon us, and we get too entrenched in our ideas. It is a great mistake for us to stay apart and suffer in silence. Your children feel for you exactly as they always did. I could almost say that these misunderstandings arise precisely because we love one another too much. It is because we are proud, and because we think well of ourselves, that none of us ever likes to give way. And the day will come when we shall regret it."

Henri Matisse was to be more than seventy years old before he came round unequivocally to that point of view. But it had been put to him with lucidity and good sense by Pierre, at a time when he was less than half his father's age. Already he was shaping up for the role in which he was to excel – that of his father's indispensable confidant.

Marguerite Matisse Duthuit. n.d.

A Turn for the Better, Maybe
1926–31

In middle life, Henri Matisse was about as un-Bohemian as a man can be. He never wasted his time. He never hung out with dubious characters. He never woke up with a hangover. He liked to measure his days to the last minute and come in on time, like a Swiss express.

He had also always hoped that his family would be a model of conjugal well-being. When interviewed by an American journalist in 1913, he had said, "Do tell the American public that I am a normal man. I am a devoted husband and father. I have three fine children. I go to the theater, and I ride horseback . . . just like any other man."

All his life long, he craved that normality. In 1924 it was still his dearest wish that he himself, his wife, Amélie, his daughter, Marguerite, and his sons, Pierre and Jean, should live in peace and unity. By that time, however, it was already clear that, like most other families, they would not score ten out of ten in that respect.

When Pierre was about to leave for the United States in December 1924, he wrote to his sister Marguerite that he knew very well that his own very early marriage had affected his father's health.

But he also knew that there was a fault line in the family life of the Matisses, and that that fault line would be fatal to Henri Matisse's hopes and ambitions for them.

"When we are together at home," he wrote to Marguerite, "we cannot talk, or express the least opinion of our own, without setting a match to dynamite. The explosion distorts our every least thought. So you will forgive me if I remain

silent about matters on which it is so difficult to give one's opinion. I hope that one day I can speak more freely at home.

"After all, we are father, mother, brothers, sister, sons, and daughter. Just wait and see what it will be like when we are all married!"

What Pierre said then, every member of the family was to say, or to think, in years to come. Though he was only twenty-four at the time, he already saw straight.

Meanwhile Henri Matisse's children were dealing as best they could with their matrimonial situations. Pierre was working on a Corsican divorce. Marguerite's marriage to Georges Duthuit was to prove by no means idyllic. Jean had not married anyone, and his father feared that he might never get round to it. What to do? A family council was convened, and Pierre was kept closely informed.

In the mid-1920s, the classic maneuvers of the arranged marriage were still in style. Amélie and Marguerite went to work. "As you know," Henri Matisse wrote to Pierre in February 1926, "it was envisaged that Jean might marry Mademoiselle M . . . y through the intermediacy of Madame H(ervieu). When I was last in Paris, your mother, Marguerite, and I took tea with Madame M . . . y and her daughter. The young woman is about as tall as I am. She is slim and has beautiful eyes. But her complexion has many blemishes, and she appeared to be wracked by nervous anxiety.

"As her mother had told us that she wanted to paint, I opened the conversation by asking her if this was the case. She put her nose in the air and said, 'Oh, no! Certainly not!,' as if the idea were beneath her. She then said abruptly that

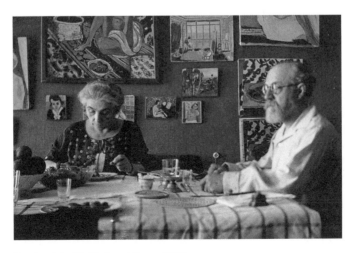

Henri and Amélie Matisse. Nice, c. 1929

she couldn't stay any longer, because she had a Latin lesson that could not be put off. So we took our leave.

"On the way back, I said that she looked as if she already knew the ways of the world. Marguerite said that she looked as if she had knocked around the town for years. I said that I should much prefer the young woman we had seen the day before. Marguerite seemed to agree. Your mother said nothing."

Henri Matisse the matchmaker then warmed to his task. His candidate was the daughter of a cousin of his friends the Rodocanachis and of a German woman painter. She was an accomplished student of literature who had done well in all her exams and was working towards a doctorate. She also had a gift for drawing.

He went on to say with an evident relish that "In physical terms, she is tall and well built, rather long in the arms and the legs, and with gestures like those of a little dog. She is intelligent, sweet in her ways, and rather shy. When she and her mother are together, they carry on like two sisters. They don't have any money. Jean seems to like her.

"Marguerite will ask her to lunch with her mother and Jean. If Jean were really to be taken with her I should speak to him very seriously. He talks such childish nonsense that he really needs to be in good and serious hands.

"He even said to me the other day that he thought he would like to change his entire way of life and run a business of some sort. He really thought he could do it. 'What makes you think so?' I said. It turned out that when he was in the army he had been the sergeant in charge of a team of chauffeurs. That caused him to think that he knew how to manage men.

"'I don't want to live like a pauper,' he said. I need not say more. Nor did I have anything to say to him about it. He has really done nothing much of anything this year, except to move house. It would be better if he did not think of himself as a great artist. . . ." Nothing more was heard of an arranged marriage.

Jean Matisse may have talked "childish nonsense," from time to time, in his father's view. But in the matter of the arranged marriage, and of marriage in general, he was neither blind nor stupid. In letters to Pierre, he more than once confided his ad hoc and strictly practical arrangements. "I have a nice girlfriend," he wrote in April 1925, "and we share the housework on ideally equal terms. She is from the Beaux-Arts, but in spite of that she can give me good advice about my work." In February 1927, he was perfectly well aware of the arranged marriages that were being hatched, or unhatched, on his behalf. "I'm not married yet," he wrote to Pierre. "The person under discussion is rather gloomy. She has beautiful eyes, but carries the whole world upon her shoulders, like someone who

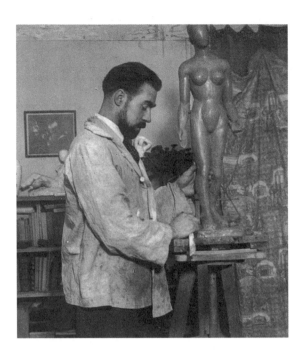

Jean Matisse, 1927

has suffered a lot. I've not even met her yet, but she will soon come to tea with Mama. Madame H. will certainly come on strong with me about the marriage.

"But – and here's a great secret! Not a word to anyone! – there's another possibility. She is the little Agelasto Cocoli, the niece of the Rodocanachis. I like her, but I haven't said so to anyone. Meanwhile, I have a Manon of my own, but I have to watch out, because she wants to get married. I dread the consequences. I just want her company, but . . . that's always how it starts. I keep in reserve a porto flip, or a cocktail."

Meanwhile, Pierre had made fast friends in New York with Valentine Dudensing, whose father owned the Dudensing Gallery. A photograph of them both in a snowbound Manhattan shows two brisk and lively young men, well dressed and well favored.

It suited them both that they should become not only friends but associates. Dudensing genuinely liked Pierre, but he also dreamed of having direct access to Henri Matisse. He had noticed that Pierre's little show at the Weyhe Gallery had attracted a degree of notice that was out of all proportion to its size. The *New York Times* had saluted Henri Matisse as "a master of genius and of high, almost supreme talent." The *New Yorker* had said, "We never tire of Matisse." With lithographs at $25 apiece, you could get "something from the hand of a master for a *couvert* charge."

Pierre for his part was not at all averse to being part of an established gallery in New York. So there was soon talk of exhibitions that Pierre could mount at the Dudensing Gallery, and in particular of a group show that would include Matisse, Braque, Derain, Bonnard, Vlaminck, and Marie Laurencin.

On April 27, 1925, that show opened at the Dudensing Gallery, with "Pierre Matisse presents . . ." written clear for all to see. At a time when New York had no lack of newspapers that covered art exhibitions, it had remarkably good and lengthy reviews. "One of the best-assembled exhibits of the winter" was one summing-up. Another said that "For all-round excellence no paintings in town compare with those now at the Dudensing Gallery." In all these notices, Pierre Matisse was given full credit. One critic attributed the show's "unmistakable quality of authenticity" to the fact that Pierre Matisse was "the son of the master himself."

All these were good signs. He had arrived in New York as almost nobody, and when he sailed for France in May 1925, left as almost somebody. It was noted in the newspaper *PM* that he had been seen off on the boat by the Dudensings, by Nicholas Muray, the photographer and lover of Frida Kahlo, and by Miguel Covarrubias, the Mexican cartoonist.

But, nice as it was to have amusing friends and a mention in *PM,* it didn't pay any bills. Buoyancy was not among the young Pierre's more conspicuous traits. Nor did he have the nature, or the gifts, of an itinerant salesman.

What he needed was to be part of a serious gallery in New York, with his name on the door, somewhere to show pictures, a storeroom, and a small but exemplary backup staff. He also needed a telephone, though initially he hated to use it. When he had none of those things, his spirits went way down.

In October 1925, when he was back in the States, he wrote to his father and said, "God damn it! How can I ever make money in this profession? I've spent a small fortune on this show, I have my hotel bill to pay, and I have to buy a round trip ticket to Chicago, where I hope to make 'un peu de money.'"

At that time, Henri Matisse was rather gloomy, too, and in ways that will undeceive anyone who thinks that when in Nice he led an easy and undemanding life. As often, he reported to Pierre in detail on the state of his health, and his working habits.

"I don't have a lot of energy. But I exercise every morning. Both my belly and the fat on my haunches have considerably diminished. But there are still two rolls of fat beneath my navel that need to be got rid of. They are an enemy that has to be beaten back. I'm doing quite well, but it's a bore. Overtaking the boredom takes a lot of energy.

"The weather has been awful since you left. I have a painting on the easel

that I can't finish. Because of the scaffolding outside, I need some sun to be able to see in my studio. And I don't get more than one decent afternoon a week – if that. I work on in spite of not being able to see what I'm doing. I try to make some composition drawings. But it's like every year – getting back to work is the very devil. It would make more sense to work less every day, but not to stop altogether.

"At the moment I work every day from 2 to 7 P.M., with a break for tea. I start downstairs at 2 and paint until 3:30 at latest (I can't see anything after that). Then I go upstairs and draw till 7. I have filled a big album that I brought with me. There are three drawings in it that I have worked on for the last three weeks, each of them for half an hour at a time. Once the work is under way it's not a bad idea to add just a little every day.

"I also make line drawings, quite quickly. They seem to me almost like snapshots, though I can measure the time spent on them by playing Beethoven symphonies on the gramophone. I know that more than one of them took more than one side – four minutes – because I had to get up and stop the needle before I had finished the drawing.

"After that I go to dinner. That takes till half-past eight. Then sometimes I go for a walk and look in on a friend till ten o'clock."

At this point in their long-distance dialogue, Pierre suddenly had what he thought was wonderful news. On November 23, 1925, he was in the Pearson Hotel in Chicago and hanging his little show (drawings by Millet, Renoir, and van Gogh, with a group of Redons) when he heard from Valentine Dudensing that he had left his father's gallery and was going to set up on his own at 43 East 57th Street in New York, just across the way from the Brummer gallery.

Radical changes resulted. It was agreed that they would work together. Pierre took a small apartment in a hotel at 14 East 60th Street in New York at $140 a month. "Don't calculate how much that is in francs," he wrote his parents. "You'll only scare yourselves unnecessarily. I have a living room, a bedroom, and a bathroom. It's in the most fashionable part of town, it's ideal for my activities, and it's a bargain. The moment you set foot in the lobby, people rush forward to relieve you of your hat, your overcoat, and your walking stick. A band plays downstairs in the hotel from 4 P.M. onwards every day. Between the velvety sobbing of the saxophones and the dynamic beat, Charleston-style, of the trombones, I find it all terribly amusing. In fact, I am very happy.

"Dudensing and I are wildly excited about our prospects in business. You would laugh to see us talking it all over, making long lists of figures, calculating this and that. It's a critical moment for both of us – he with his new gallery, and I with my exhibitions coming up."

48

As a matter of fact, the scene as pictured by Pierre did not make his father laugh. He did not care at all for the image of two young men cackling over big sums of money that they had not yet made and very well might never make. It was abhorrent to him. Art dealing and euphoria did not sit well together, in his experience. Calm, caution, and prudence were the essentials.

Yet this was undeniably a very good moment for recent French painting in New York. In January 1926 Brummer opened a so-called Memorial Exhibition of work from John Quinn's estate at the Art Center on East 56th Street. Virtually everything in this was for sale.

The show was remarkable above all for its big room of European painting. We can judge of its effect from the sketch that Pierre sent to his father on January 9, 1926.

Seurat's last painting, *The Circus,* already bequeathed to the Louvre, had pride of place on one wall. Next to it were two paintings by Odilon Redon and a self-portrait by van Gogh. On the wall that faced the visitor was Matisse's majestic *Variations on a Still Life by de Heem* (1915). To the left of it were Dunoyer de Segonzac and Marie Laurencin. To the right were Gauguin and the Douanier Rousseau. (The Rousseau was the *Sleeping Gypsy,* now in the Museum of Modern Art in New York. It was Quinn's last great purchase before he died, bought at the insistence of Henri-Pierre Roché.)

The room was completed by two large early Picassos, a Derain, and one of Cézanne's portraits of his wife. (The Cézanne, the van Gogh, and the Gauguin *Promenade au Bord de la Mer* had been bought from Ambroise Vollard in 1913.) In the middle of the room was a sculpture by Brancusi.

Pierre was quite carried away by the occasion. "Beside your still life," he wrote to his parents, "the Seurat looks pale, the Segonzac looks black, the Gauguin looks flat, and the Picasso and the Derain look like two gouaches that have been squared up and enlarged."

This was his first experience of art dealing in New York on the grand scale and in conditions of urgency. Brummer had priced the Matisse still life at $9,000 and a second Rousseau (not the *Sleeping Gypsy)* at $15,000. Seeing Pierre's enthusiasm, he agreed to let him have the pair of them for $22,400. Almost immediately, Pierre found a buyer for them. Everyone was delighted. Pierre said that he felt he had "taken the ball on the bound." Brummer was impressed by the rapidity of the sale. Pierre's bank was not displeased, either, to find that a check for $2,000 had suddenly refloated his account.

The buyer in both cases was Mrs. Alden Carpenter, the wife of the American composer whose score for the ballet *Krazy Kat* had briefly aroused the curiosity

of Diaghilev. Mrs. Carpenter had her own identity as president of the Arts Club in Chicago, which in the 1920s was the most progressive exhibiting society in the United States. This was clearly a valuable contact.

Pierre's new association with Valentine Dudensing gave him an ongoing association with a real gallery that had a real name. At first it seemed to him – and indeed it was – all gain. He thought it axiomatic that dealers in Paris would now be more likely to send paintings for the high-level mixed shows that he had always wanted to mount.

In particular, he had hopes of Bernheim-Jeune as collaborators. They had, after all, been his father's dealers since 1909. Their present contract with him would expire in September 1926. They would certainly wish to renew it. It would surely be in their interest to send Pierre some good paintings on sale or return?

And, sure enough, they were all smiles. Matisse? By all means. They would send six paintings. Bonnard, Vuillard, Derain? No problem. All seemed set. But when the list of paintings arrived, it turned out that four of the six Matisses were on loan from private collections and not for sale. The two others were tagged with impossibly high prices. As those prices were not negotiable, the paintings were in effect tagged Not For Sale. The insurance on the six paintings would amount to $30,000. As for the paintings by Bonnard, Vuillard, and Derain, they were priced very high, at between $4,000 and $6,000.

Writing to his parents, Pierre said that he had rejected all the Matisses, which were clearly not for sale. "For the others, I stipulated a reduction of 20%, explaining that they knew nothing about the American market. Doubtless they thought that they could just sit back and twiddle their thumbs while their paint-ings found buyers at no matter what price. I told them that if the prices were not reduced, nothing would be sold. That would not encourage me to approach them again. I did not remind them that they had expressed themselves as ready to work with me. But doubtless they will get the point."

On February 16, 1926, Henri Matisse wrote back that he was not at all sur-prised. "You know how little I like the Bernheims," he said. "Of course, they have the money to sit tight and profit by the efforts of smaller dealers. That is a fact of life by which you, in your turn, will benefit one day. You are lucky that the gentlemen in question are not at all dynamic and are represented by a young man who does not yet know his way around."

Throughout the year 1926, something became more and more clear to Pierre. To be "the son of Matisse" gave him entrée to a certain American society. But it did not help him at all in his relationships with Parisian dealers.

Nor could he count on his father's old friends and classmates. Bonnard was

always polite to Pierre Matisse, but fundamentally he never did anything to help him. "As for your buying some paintings by Bonnard," Pierre's father wrote, "I think that he might allow it if he got quite a lot more from you than he does from the Bernheims. Go straight to the point. Tell him that you will pay to him, directly, what the Bernheims would charge you (inclusive of their markup)."

Bonnard asked Pierre to come over, but any hopes of an ongoing association were dashed when Bonnard said that as of the following year Bernheim-Jeune was to join forces with Germain Seligman in a gallery in New York. This being so, they would count on being Bonnard's representative in the United States. Bonnard was not going to make exceptions for Pierre Matisse, either then or later. (Even when Pierre had sent him parcels of food at the end of World War II, when food around Nice was in very short supply, Bonnard sent him a short note of thanks and invited him to "come by one day and choose a little drawing.")

Pierre saw the Bernheim-Jeune/Seligman venture as very bad news. As he said to his father, New York was the only place in which he could sell French paintings on a stable and regular basis. If Parisian dealers were going to open in New York, they would be in direct competition with him. It was obvious that they wanted to put him out of business.

In such matters, Henri Matisse came from way back. He replied that, on the contrary, it could be to everyone's advantage if more dealers showed good French paintings. More dealers meant a bigger buzz, and a bigger buzz could lead to a bigger trade all round.

As for Henri Matisse, he was ready to help Pierre Matisse in one way or another until the day of his death. But he was not going to give Valentine Dudensing the exclusivity of his work in New York. Throughout the years of their association, Dudensing wanted Pierre Matisse to secure from Henri Matisse, if not the coveted exclusivity, then other, smaller but still substantial favors.

Henri Matisse would never hear of it. It was not, as many people have said since, that he did not want his son to do well as a dealer. It was because, after thirty years in business, he was not going to sign away his American future to anyone. Like his father, he was a tradesman from the north of France. He knew the value of what he had to sell, and he intended to get it, down to the last penny. Pierre did not, as yet, have his own gallery. Valentine Dudensing's name, not Pierre's, was on the pretty Art Deco letterhead. And it was Dudensing, not Pierre, who was out front in the gallery, making a good name for himself, while Pierre was busy shopping in Europe for half the year.

What this meant was that Pierre's work went unnoticed. People who went to the Valentine Gallery (as it soon came to be called) did not ask for Pierre Matisse.

Most often, they did not even know about Pierre Matisse. They asked for Dudensing, and they got him, all smiles.

When James Thrall Soby (later one of the pillars of the Museum of Modern Art) began to collect Matisse, he went to see Dudensing. Quite soon, he had bought seven Matisses. But it was not until he parted company from Dudensing in 1931 that Pierre Matisse recovered his identity and became, thereafter, the prime source of the key paintings by de Chirico, Miró, Balthus, Tanguy, and Dubuffet that Soby bequeathed to the Museum of Modern Art in 1979.

There was, in fact, a clear division of labor between the two associates, and one that was formalized in April 1927. It was agreed that Pierre Matisse would spend half the year in Europe. He would buy, and Dudensing would sell. He would get his expenses, plus an agreed commission on the price of whatever he bought.

This was not altogether a bad arrangement from Pierre's point of view. He had money to spend, and he could charge up every penny of his expenses. He could race off to Berlin, or to Stockholm, at short notice. (His papers included many a fine specimen of the travel voucher in its early days.) Thanks to the meticulous archiving of his expense accounts, we can follow him as he sails back and forth, first class, on the French liner *Paris*. If he makes a quick business trip to Berlin, we know how, when, and why. If he goes to Nice and back, we know the number of his wagon-lit. If he takes people to lunch on business, the expenses figure as a round sum under the invaluable French rubric of "*frais de représentation*."

These were years in which Pierre Matisse lived well when in Europe. He bought some very good paintings. ("Cheap pictures don't sell" was a piece of folk wisdom frequently imparted by Dudensing.) He made a sizable income. He got to know all the dealers. He heard a great deal of gossip, most of it ill-natured, but not without some use. He built up a working art library. He found an apartment in Paris that either he or Dudensing could use when they needed to.

In the context of stock for the gallery, Valentine Dudensing could not complain of his partner, except that he never got quite enough of Matisse. "Buy Nothing but Matisse," one cable to Pierre read. (In January 1927, the gallery had an entire exhibition of paintings [1890–1926] by Henri Matisse.) Later in that year, Pierre Matisse was the impresario for an exhibition of recent paintings by Henri Matisse, Georges Braque, Pierre Bonnard, Raoul Dufy, Albert Marquet, Jean Marchand, André Dunoyer de Segonzac, and Marie Laurencin. Over the next few years, he bought consistently from Paul Guillaume, Paul Rosenberg, Bernheim-Jeune, and others. In 1929, for instance, he bought paintings by Braque, Modigliani, de Chirico, Redon, Derain, Utrillo, Matisse, and the Douanier Rousseau, plus some sculptures by Henri Laurens. He also bought a painting by Henri-Edmond

Cross from Agnew's in London. As their joint sales totaled $211,605 in 1928 and $304,573 in 1929, it cannot be said that either of them had dragged their feet.

And at a time when it came in very handy indeed, Pierre Matisse got a loan from his father of 300,000 francs (about $1,750). Henri Matisse would have preferred to make the loan (which was for a year, at twelve percent interest) to Pierre only, rather than to Dudensing/Matisse. In fact he did not want to lend money to Dudensing at all. But Pierre pointed out that he and Dudensing were equal partners in an enterprise of which Dudensing was the sole owner by law. Dudensing would pay his full share of the interest on the loan. Besides, he said, the heavy work was done by Dudensing in the gallery. "If I were to do the selling in New York, things might not go nearly as well."

His experience in America had already taught him that even very good paintings do not necessarily sell themselves. As to that, the last word (and one still valid) had been spoken by Jeanne Robert Foster, John Quinn's dearest friend in his last years. "Selling paintings is an art," she said, "and it depends on a skillful whetting of the buyer's appetite, a certain amount of withholding, an intensive publicity, the element of surprise, the element of rivalry and of rarity, and a certain psychological something called personality." Pierre had not yet mastered the whole of this keyboard.

Henri Matisse never got over his reticence in the matter of Dudensing. Dudensing was sharper, quicker, and much more experienced than Pierre. But dealers were dealers. Why should Dudensing be a golden exception? It was better to be on one's guard. The key moment in Henri Matisse's attitude towards Pierre's associate was reached when he ended a letter to Pierre with the words, "You may give my compliments to Dudensing, if it seems to you to serve any purpose."

So he could not have been too surprised when he heard from Pierre that his relationship with Dudensing had suddenly taken a new turn, and one that the young Matisse did not at all care for. Dudensing had told him, in effect, that he was no longer to buy paintings on sight. All purchases had to be confirmed by Dudensing after receipt of a photograph.

Not only was this deeply offensive to Pierre on a personal level, but it would do great damage to his standing in Paris. It was one thing to walk into a gallery, look over the stock, and buy on the spot. A ten days' enforced hesitation was quite another matter. For one thing, it made it clear that Pierre was a subordinate who could not act on his own. For another, it would deprive him of the vital tactical advantage of being able to negotiate in the heat of the moment.

He was furious, and he showed it. Was it that Dudensing found him not up to the job? Was his taste defective? Or his skills inadequate? If he was not to

have a free hand in Paris, Dudensing might as well work from photographs with-
out making use of Pierre's services.

Dudensing replied that Pierre had, as always, his entire confidence. The
problem was that Pierre had a French eye and a French taste. French taste and
American taste were two different things. Dudensing had to sell to Americans, and
he knew what their tastes were. Even then, he added, it was devilish hard work
to make a sale. That was why he did not want Pierre to buy paintings that appealed
to French taste but might not please Dudensing's customers.

Already in 1927, Dudensing felt that too many other galleries in New York
were trying to copy the formula with which he and Pierre were doing so well –
that of the first-rate anthology of recent French painting. "Everywhere you go,"
he wrote, "you see Matisse, Derain, and Vlaminck." The critics had had enough
of it. The local American painters resented the French domination. It was impor-
tant to have Giorgio de Chirico and Joan Miró as counterweights.

But in spite of all this, Dudensing when writing to Pierre had been his opti-
mistic, hyper-energetic self. The gallery was doing quite well – sales were up, up,
up. (And by implication, he himself was a master salesman.)

Much of this could doubtless be defended. But from Pierre's point of view it
contributed to a general and progressive dissatisfaction that dated back to the
summer of 1927, mere months after their partnership had commenced. That year
had begun with what now looks like an unqualified triumph for Pierre Matisse
in his capacity as an organizer of exhibitions.

The exhibition of his father's work at the Valentine Dudensing Gallery in
January 1927 had included among much else *The Moroccans* (1915–16), *The White
Plumes* (1919), *The Moorish Screen* (1921), and the more recent and memorably
audacious *Decorative Figure on an Ornamental Ground* (1925–26). All four are
now in major museums. For a young gallery, this show was a remarkable event.
People came in the hundreds, and it could not possibly have been brought off
without Pierre Matisse.

His new adventure had begun very well, therefore. On February 8, 1927,
he wrote to his father that the show had been crowded for five weeks on end. As
a dealer, he should have been ecstatic about the sales. But as a member of the
Matisse family, and one who had been raised with great paintings around him,
he grieved to see some of them go. They were not ordinary paintings. Nor was
his an ordinary family. Even though he had chosen to be in the business of selling
pictures, there was something wrenching about these particular transactions.

On that point, he wrote to his father not as a dealer but as a son: "I was dis-
tressed to read your cable about the odalisque in green pantaloons and the model

in a pink-striped dress. I so much enjoyed having those paintings here that I felt almost remorseful when I saw them go, even though I had almost nothing to do with the sale of them.

"I hope that this double disappearance will not get me into trouble at home. I know how important your paintings are to our family. Every one of them has been a milestone in our life together and an enrichment of our communal existence. It is only when they are no longer there that we realize how important they have been. This may be selfishness. A painting, like a book or a piece of music, has to go out and take its place in the world.

"But I can never forget the day, in Clamart during the war, when for the first time I realized what an importance the Cézanne *Bathers* had assumed in what was at that time the little circle of my life. Do you remember how spontaneously, and with a single voice, we rejected the idea of sending it to the Bernheims for sale?

"Doubtless this was in part because we were so used to seeing it. But it was also that, with its going, we should have lost an indispensable part of our family. As children, we knew nothing of the sacrifices that the Cézanne had represented for you both. Nor had we been witnesses to the steadfast faith that Mama had manifested. But we had a horror of seeing the family dismembered, and of the dispersal, piece by piece, of all the things that had held it together.

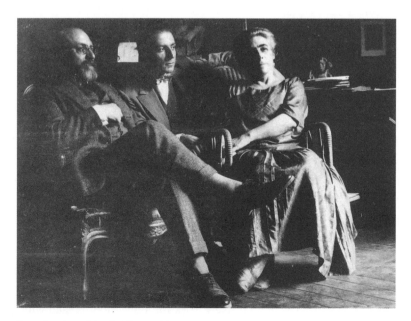

Henri, Pierre, and Amélie Matisse. Montparnasse, c. 1932

"It is that same horror which – in spite of all the material arguments – still stops you from getting rid of the house in Clamart once and for all. For my part, I hope with all my heart that you will postpone that decision."

This was on more than one count an amazing letter. When face-to-face with his father, Pierre might never have poured out his heart so freely. On both sides, the family fault line would have prevented it. Nor could his father have answered with an equivalent freedom. The very importance and the very privacy of the subject would have sealed his lips.

This was, after all, a matter almost of life and death to the family life of the Matisses. The paintings on the wall, whether in Clamart or elsewhere, were not just an agreeable garnish. They *were* the family. By their depth of feeling, and through the harmonious interplay between them, year after year, they acted out the inde-structible happiness that elsewhere eluded the Matisses, old or young. As much as his father, Pierre mourned for that lost happiness, and would continue to do so.

His father did not forget that long letter. When Pierre was back in France that summer of 1927, Henri Matisse asked him, almost casually, how long he meant to stay in the art business. But when the two of them were face-to-face, the subject went into the deep freeze. Never one to have, or to affect, a Neapolitan spontaneity, Pierre took almost six months to reply. Even then, he did it on paper, and by mail.

On December 14, 1927, he sat down in Paris and wrote to his father. "I didn't know how to answer your question last summer," he said, "though I had already been thinking about it. I was waiting, looking around, and entertaining one idea after another. Among other things, I thought of starting a farm and raising animals.

"But now I think I have the right idea. What if I were to translate English books into French? It would keep me in touch with the ideas of the day. You don't have to be a creative genius, but you need a certain discernment, and with that a particular kind of sensitivity.

"Above all, I could devote myself to intellectual activity, instead of giving it up – or, at the least, making a dangerous compromise and steeping myself in work that takes all my time and has nothing to do with the life of the mind."

It was not that he felt at all degraded by what he had done in business. It was simply part of a general disenchantment with America. "That first year," he said, "I almost felt myself turning into an American. Since then, I have calmed down, and if I wanted to put down roots it would certainly not be in America."

What he had in mind was to go to New York for a few months each winter. Apart from that, he would stay in his Paris apartment. He would study English

at university level. He would read. He would hone his skills as a future translator, and he would be happy. What did his father think?

Their correspondence at that time was much concerned with a new rowboat that Pierre was to buy on his father's behalf. Its length, weight, dimensions, and price were minutely discussed. It was to be for one person only. Matisse had had a long history as a single sculler, and he didn't want to have anyone else bouncing around in his boat. He was at the time within a few days of his fifty-ninth birthday, but he was as devoted as ever to the ideal of physical culture, and a whole new happiness was expected to result from the purchase.

So the boat came first. But when he learned about Pierre's new idea, Henri Matisse replied by return mail. The picture business was, in his view, unlike any other business. It was one in which, as he did not fail to point out, Pierre had been blessed with unique advantages. Business in general was as all-absorbing as it was risky. Imponderables abounded. By implication, he did not think that Pierre was temperamentally suited to raise cattle, let alone to excel in corporate competition.

As for translation – well, as he said flatly, "There's no money in it." On the other hand, the idea pleased by its prudence. Pierre would have to master the French language in depth, which could do him nothing but good. It might even lead to higher things. If money was not Pierre's main consideration, he might like to remember the fable of the hare and the tortoise.

After this qualified endorsement, Henri Matisse turned to other matters. Pierre had heard from the dealer Jos Hessel that it was going around in Paris that Henri Matisse had lost all taste for the world and intended to enter a monastery.

Henri Matisse. Lac d'Annecy, c. 1928

Great nonsense, his father said. People had picked up from a word or two that he had said in Paris about the advantages of a cloistered life. When he had told Bonnard of the rumor, Bonnard had roared with laughter and said, "That's Paris for you! If I tell someone I have a cold, they go all over the town and tell everyone that I'm at death's door."

It was at moments such as this, when idiotic rumors were current but did no harm, that Henri Matisse was at his most resilient. And with some reason. By the year's end, arranged marriages for Jean were out. Pierre was doing quite well in the picture business and no longer dreamed of living from translation. Nor was there any further talk of his taking early retirement.

Henri Matisse could also look back on the Carnegie International of 1927, in which he had won first prize in October. (All five of the paintings he showed there were lent, incidentally, by Bernheim-Jeune.)

And then he would shortly take delivery of the exemplary scull that Pierre had found him. Both he and Pierre had prefaced this in 1927 by becoming members of the Club Nautique de Nice, which was a short walk from his apartment on the Place Charles-Félix. Never was money better spent, and by 1931 Henri Matisse was down on the club's books as owning not one but two boats, one of which was categorized as "a racing scull."

Not bad for a man in his sixties?

Dr. Barnes: Patron or Pest?
1930

The ordered and regular life of Henri Matisse took a completely new turn after he had been awarded the first prize for painting at the Carnegie International in Pittsburgh in October 1927.

For the new turn in question, several practical reasons could be adduced. He had lately moved to the top floor of no. 1, Place Charles-Félix in Nice, with all that that involved in the way of a new space and a new, brighter light in his studio. When working in the Hôtel de la Méditerranée from November 1918 onwards, he had enjoyed the way in which the light off the sea came into his room – as if, he said, "from below, like footlights."

But in the second half of 1921 he settled into the first of a series of rented apartments at no. 1, Place Charles-Félix. This was one of the older, grander, and, from a scenic point of view, the more advantageous buildings in Nice. Matisse gradually improved his situation there until by 1927 he could feel himself on top of the world, with panoramic views of the Baie des Anges and the quai des Etats-Unis. An enormous window confirmed this status.

He had lost (or was about to lose) the model Henriette Darricarrère, with whom he had worked since the autumn of 1920. It was very, very difficult for him to replace someone with whom he had had such a long-running and unclouded rapport. Henriette was not only a beautiful woman, but a practiced dancer and violinist who had also studied art. The violin, the upright piano, the white ballet dress were not "props," in any theatrical sense. They were natural to Henriette. Her face never bored him for a second. Nor did the long

series of odalisques have to be "set up." They were a natural extension of Henriette's nature.

For whatever reasons, his career as an easel painter slowed almost to a halt about this time. The easy, generous, unhesitant odalisques of the middle and late 1920s were gone, never to return. And when he tried to get back to the easel in the autumn of 1929, the painting in question – the *Yellow Dress* (1929–31) – took forever and was almost a parody of bourgeois decorum.

It was also relevant to his emotional disarray that in the spring of 1928 Amélie Matisse moved into no. 1, Place Charles-Félix. They had not lived together for quite some time, and the prognostics were none too good. By January 1930, she had come to be regarded as a permanent invalid.

So when Henri Matisse was invited to go to Pittsburgh in September 1930 as a member of the jury for the next Carnegie International, he didn't hesitate. In fact, he decided to go on his own to the United States, quite independently of the Carnegie's invitation. His plan was to go to New York, and from there across the United States and on to Tahiti. The trip was to last nearly four months, from February 27, 1930, until his return in mid-June. Before sailing to Tahiti, he would visit New York, Chicago, Los Angeles, and San Francisco.

Never before had he made such an elaborate, ramified, and far-ranging journey on his own. In one or another of its aspects, it was to affect him for the rest of his life.

His first days in New York in 1930 were widely talked about at the time, and Henri Matisse did not stint in his enthusiasm for a metropolitan scene that came to him as an agreeable shock. The great American cities gave him a sense of freedom and liberty that he had never known in Europe. "In the Musée de Cluny in Paris," he said on his return to his friend Tériade, "we are in the grip of walls whose proportions were dictated by the Middle Ages. In the châteaux of the French Renaissance, we already breathe more easily. But when we have American skyscrapers all around us, the huge spaces that are at our disposition give us a heightened sensation of liberty."

In reading of these and other amiabilities to which he gave expression during and after his American journeys, we should perhaps remember that Henri Matisse in the United States was an honored guest who was passed from place to place and from person to person. His son Pierre did not for a moment see his remarks as a sign of a new and lifelong commitment.

In September 1930, Matisse returned to New York on the *Mauretania*. After fulfilling his duties on the Carnegie jury in Pittsburgh, he had stopped off in New York and went to see the Barnes Collection in Merion, near Philadelphia. Dr. Barnes had been buying Matisses since 1912. Matisse, of all people, should have

the right to visit the Foundation. It was to be a fateful occasion.

Once encountered face-to-face, Barnes in relation to Henri Matisse was to be part bulwark, part ball and chain, part pain in the neck. After 1933 the relationship flagged somewhat. But until that time Barnes had been a wholehearted enthusiast for Matisse, who was also in his way a very good judge of quality. Dr. Barnes was delighted to meet him, and the initial appointment was set for the morning of Saturday, September 27, 1930.

Matisse liked and admired the Barnes Foundation. Quite apart from the very high quality of much that was on show, he was delighted by the candor and the straightforwardness with which it was installed. There was no "presentation," no showmanship, no fancy lighting. Matisse even liked the promiscuity with which great works of art were shown out of context and in company with objects that differed from them both in kind and in date. This was – to quote from Matisse's pocket diary – "the only sane place" for the display of art that Matisse had as yet seen in America.

Dr. Barnes had insisted on seeing Matisse as man to man, and with no witnesses. He could be rough and rude and violently dismissive, but on this occasion he glowed with admiration. By the time that René d'Harnoncourt – later to be a mainstay of the Museum of Modern Art in New York – had come to drag Matisse away to a formal luncheon in Philadelphia, Dr. Barnes would have liked him to cancel all his other engagements, get his luggage out of the car, and settle in with the Barneses.

He had also invited him to paint a very large mural for the three lunettes that stood above big French windows in the main gallery of the Foundation. It was a tricky assignment, in that the space in question was almost, but not quite, divided into three by broad pendentives that came down from the ceiling and stopped just in time to allow the composition to flow uninterruptedly across the entire breadth of the allotted space. The essential task, therefore, was to ensure that the mural did not seem to start and stop. The action had to be seen to be continuous, irrespective of the pendentives.

It was a further problem that the walls were partly round, as well as flat. A template was made in order to give Matisse – as was then hoped – all possible information in this regard.

The location was not ideal, in that the decoration would be too high to be seen properly from the room below. Not every visitor might want to climb up to the narrow loggia from which it could be seen at eye level. The decoration would also have its back to the daylight, but Matisse had ideas as to how all that could be overcome (or even exploited).

As a career move, the commission had many attractions. Henri Matisse had never been given so free a hand on so large a scale. The fee of $30,000, to be

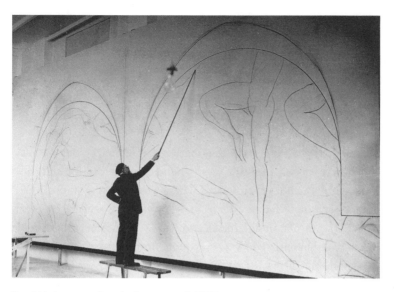

Henri Matisse at work on the Barnes mural, 1930

paid in three installments of $10,000, sounded like a solid sum, at a time when solid sums were not easy to come by. But if we compare it with the $15,000 that Barnes paid in February 1931 for just the central panel of the *Three Sisters* (1917), it may seem that Barnes drove one of his harder bargains when Henri Matisse agreed to paint the enormous and very tricky mural for just $30,000.

Quite apart from the money, there was the fact that Henri Matisse had been born into an age, and a country, in which mural painting had an important moral function. There was not a big city in all France that had not called upon large-scale mural paintings to set the tone of civic life. Many of the murals in question may now look stilted and faintly ridiculous. But at the time they came with an important lesson: painting mattered. In Paris, for instance, it mattered very much in the Ecole des Beaux-Arts, where Paul Delaroche in 1841 had completed a huge, many-figured hemicycle that was intended as a hymn to the highest of human achievements. It also mattered very much in the library of the Chambre des Députés, where Eugène Delacroix had made it possible for the legislator to find inspiration in the examples set for him by (among others) Aristotle, Orpheus, Herodotus, Alexander the Great, Adam and Eve, the exiled Ovid, and St. John the Baptist. It was thanks to painting, in both these cases, that minds could be set in motion.

Henri Matisse had never been offered an opportunity of this sort in his native country, though the tradition of the civic mural was not extinct. But the Barnes Foundation was almost, in its peculiar way, his second homeland. Dr. Barnes had

bought many of his greatest paintings, from *The Joy of Life* (1905–6) to the *Red Madras Headdress* (1907), the *Interior with Goldfish* (1912), the *Seated Riffian* (1912–13), the *Three Sisters* triptych (1917), and the *Music Lesson* (1917).

The monumental *Music Lesson* can be read, as Jack Flam has suggested, as a farewell to the notion of a united family life. There is, in any case, a faintly stunned expression on Henri Matisse's face in the photograph that shows him reunited after many years with the *Music Lesson* in the Barnes Foundation.

It may also have been relevant to Henri Matisse's decision that Dr. Barnes was writing a book about Matisse and his work, as to the eventual influence of which Matisse had misplaced hopes. But, in the end, the arguments all seemed to favor his acceptance of the Barnes commission. So he took the job, the agreement was signed in December 1930, and the first payment of $10,000 was made forthwith.

The Barnes decoration was not to be installed until May 1933. Pierre had nothing to do with its initial phase, but he was soon to be privy to many of its vertiginous ups and downs. He came to know Dr. Barnes almost too well, both face-to-face and through letters from his father. He also learned a great deal about the power plays of the art world, which held an obsessional fascination for Dr. Barnes.

Pierre had ideas of his own about the ideal dealer/client relationship. Needless to say, that ideal could not always be reached and in some cases might just as well be left for dead. A collector who was himself a full-time mentor was not likely to want to be led, persuaded, or nurtured. This was the case with Dr. Albert C. Barnes. Indisputably a collector on a very grand scale, Barnes saw his Foundation not as an exalted pastime but as a teaching institution in which he had lifetime tenure as master of studies.

Pierre naturally had hopes that, as the son of Henri Matisse, he might one day be on good terms with Dr. Barnes. It had also occurred to Dr. Barnes that Pierre was worth knowing (or, at any rate, worth using). In November 1931 he needed photographs of the great paintings by Matisse that had been in Russia since before 1914. He asked Pierre Matisse to get them for him, and Pierre Matisse did. Dr. Barnes was duly grateful. Pierre, meanwhile, had thought it a good moment to offer Dr. Barnes three paintings by his father. They were a landscape done in Collioure in 1907, a land-and-seascape done in Etretat in the summer of 1921, and a large interior done in Nice in the 1920s. Priced respectively at $2,500, $4,500, and $20,000, they would have tempted many an enthusiast for Matisse. Pierre Matisse added that he would be ready to make terms for deferred payment. By return mail, Barnes said, first, that he always paid cash and, second, that he was "overspent." (He did, however, buy the Etretat for $3,500 in February 1932.) Pierre then wrote to Dr. Barnes and asked if he could come to see him. He had

news from Nice of his father's progress with the Barnes decoration, and he also had news of Maillol and his monument to Blanqui, the French revolutionary and radical thinker. Dr. Barnes asked him over forthwith. On November 29, 1931, Pierre wrote to his father: "I spent the day of Sunday with Barnes at the Foundation. I got there about eleven in the morning. He showed me his new paintings, which are very well installed. Then he took me home for an excellent lunch. After that, I took photographs of him in several of the Foundation's rooms. He was as happy as a king. Unfortunately he stiffened up and took an unbecoming pose every time I picked up the camera, and there was no way to loosen him up."

Next came an incident that was to cast a long shadow. "During the afternoon the three Pinto brothers came to make the sketches that you had asked for." Pierre Matisse did not care for the Pinto brothers, either as artists or as handymen. Dr. Barnes, by contrast, had a total faith in them, had paid their way on study trips to Europe, and thought that as painters they were the predestined heirs of Matisse. Henri Matisse was naturally anxious to reconfirm the exact size of the pendentives that divided the long wall of his mural. "I could have done the sketches just as well myself." Pierre said. "They got into a terrible mess, trying to get the figures exactly right. As I knew what you wanted, I showed them how to measure the shape and the size of the areas that would be covered by the pendentives."

The mural was to be just under seventeen feet high at its central point and around forty-five feet wide. As Henri Matisse needed to have it accurate to the nearest centimeter, this was a nervous business. He had spent month after month, climbing up and down ladders in a rented building in Nice and working with cut-and-painted paper, rather than with oils on canvas. This was not, by the way, either a whim or a gratuitous experiment. At an early stage in his work for Dr. Barnes, Matisse had produced a long series of sketches in oils. Now preserved at the Musée Matisse in Cimiez, they have an exuberant physicality that could perfectly well have been enlarged to sumptuous effect. But Matisse did not want to add one more enormous oil painting to a room that was already full of them. He wanted a mural that would distance itself immediately from the great paintings (among them Matisse's own Seated Riffian and the large version of Seurat's Les Poseuses) that were hung beneath it. It would not be "on the wall." It would be the wall. Wall and image would be one, and indivisible.

To achieve that, the mural must have no untidy edges and no inexplicable gaps. Henri Matisse had worked from a template traced directly from the wall and supplied to him by Barnes. According to Jack Flam, who has researched this matter on more than one occasion, Matisse "apparently overlooked two pieces of paper that were supposed to be attached to it and thus misjudged the width of the pen-

dentives between the lunettes." He also forgot to bring the architect's blueprints with him and had to have them sent over from the Foundation in March 1931.

Both the size and the unprecedented character of the Barnes mural were a source of hyper-anxiety to Henri Matisse. That anxiety was compounded, moreover, by the combustible nature of Barnes himself. He longed to come to Nice and see how the work was getting on, but Matisse would not agree to that. (Barnes did not even know, as yet, that the mural was being prepared with the use of cut and colored papers.)

It was therefore a catastrophe of the first order when it was discovered in February 1932 that Matisse had worked to dimensions that were slightly but irrevocably mistaken. There was no question of adjustments, minor or major, that would save the situation. The whole thing had to be begun again, all over.

Pierre Matisse was told of this by Dr. Barnes's henchman, the dealer Georges Keller. Keller had come by the Pierre Matisse Gallery, ostensibly to say good-bye before leaving for France. But it is safe to assume that, as one professional to another, it did not displease him to bring some really bad news. "Barnes is leaving by boat today," Pierre wrote to his parents, "and of course Keller is with him. Barnes is said to be terribly distressed by the news. He said to Keller last Sunday that it was the great tragedy of his life. Keller is wondering what will happen to the present decoration, which was so near to completion. This question must be preoccupying Barnes also. If he wants to buy it, as well as the new version that Papa has to begin all over again, be sure to ask the right price. Don't make the mistake you made with the little odalisque – the one lying down – for which we set the price far too high. And don't let Keller and Bignou get too involved in this whole question. Also, please don't forget that Barnes repeats himself all over town and never gets anything quite right. If possible, don't let Keller see the present decoration. I don't quite believe what Keller says, though he has a veneer of niceness. I believe him to be hatching a plot with Barnes, and there's nothing that he wouldn't try to do to exploit our present situation and persuade Barnes to turn his mind to deals that would be more profitable to Bignou and himself."

Later in that same letter, Pierre returned to the problem of Keller. "On thinking it over," he said, "I think that Barnes will never be able to endure the idea that his is not the only decoration by Matisse on that subject. Yet he cannot ask the artist to destroy the first version. You simply must make Barnes keep his mouth shut about whatever is decided between you. As you well know, the moment he takes a fancy to someone he blurts out whatever is on his mind. You could cable to him on the boat and ask that when he comes to see you in Nice, he must come by himself. In any case, I hope and pray that the problem will not be beyond solution."

On March 3, 1932, Pierre wrote that he had been to take leave of Barnes on the boat before he left for Europe. "He was clearly not expecting me, as he had asked Keller not to tell anyone about the fatal mistake. So I told him that you cabled to me about it. He was in a great state of agitation as to what would become of the first version. He is afraid that when he gets the second version people will say that the first was the better of the two. Nor does he want to lose the amazing bargain that he got when you and he settled for $30,000 for the first one.

"Even so, it would not surprise me if he has thought it all out and already has a proposition in mind. He went on and on about the 'responsibility of the artist,' and about the benefits that will come your way when his book on your work comes out. He also went on and on about how much he had done for you and all the trouble that your mistake has caused him.

"I'm afraid that he may take a brutal line about what he calls his 'rights' in this matter. He may think that we shall hold him up to ransom if he wants to buy both versions. And of course Bignou and Keller will want to have other and more profitable fish to fry. Doubtless he has told you that your *The Painter's Family* (1911) from Moscow was for sale in Berlin. All things considered, therefore, it would be better not to press him too hard if it comes to fixing a price." (*The Painter's Family* is still in Russia, along with the many other Matisses that were bought by Serghei Shchukin or Ivan Morosov before 1914.)

On his return from Europe, Dr. Barnes invited Pierre and his wife, Teeny, Matisse to come and listen to what was called at that time "a negro chorus" on April 17, 1932, and to "refreshments" afterwards. (This was, by the way, Dr. Barnes's favorite mode of entertainment, and one to which he responded with his whole being. The music in question was in his opinion the finest that America had ever produced, and he was often inspired to rise to his feet and sing out, full-voiced, with the chorus.)

It was a recurring problem for Pierre that he ran out of money just at the time when he was planning his annual shopping trip in Europe. ("Cash and carry" was the standard formula on those trips.) In 1932 conditions in the United States were about as bad as they could be. Sales had been few. Not everyone, by any means, paid up on time. As he had lately been a guest in Dr. Barnes's house, Pierre felt able to write to him on May 7, 1932, and say that he was "in desperate need of money" and would sell any painting in his inventory at cost. As ever, Dr. Barnes was prompt and brief in his reply. He had just bought "important paintings" in Europe and was, as before, "overspent." Without a word of sympathy, he stamped and mailed his letter. On July 20, 1932, Pierre tried again. An unnamed friend of his had some very fine paintings for sale. Would Dr. Barnes

care to see photographs? No, said Dr. Barnes. He never bought from photographs. He made it to clear to Pierre that as he already had fifty paintings by Matisse – and was later to add another fifteen – he did not feel in need of any suggestions as to how best to round off his Matisse collection.

On August 7, 1932, Henri Matisse wrote from Paris that he had had an aperitif with Dr. and Mrs. Barnes at their hotel. They had both been very nice to him, and Barnes was in high spirits at having bought a very good still life by Cézanne for very little money. He had heard from Etienne Bignou that Dudensing was trying to sell it to Stephen Clark. So Barnes said to Bignou, "I'm very glad for Clark. I don't need the picture, so it is much better that it goes to Clark." At the very last minute, when Bignou was leaving, Barnes offered them a price very much – but very much – lower than what Bignou was asking. Those were days in which a firm offer, however small, was often welcome. The next morning, the picture was his. He insisted on giving the commission that had been promised to the previous owner.

When Henri Matisse brought up the subject of his *Guitarist* (1902–3), Barnes said that he already had several paintings like it at the Foundation. Not to be put off, Henri Matisse said that "it was a very strong picture, and full of energy, like Cézanne's bathers." This, too, was in vain. "Barnes told me that he was about to buy another Cézanne and did not want to put money aside for anything else until he knew what the Cézanne would cost. So I left it at that, though his was not a good reason. He also told me that he had finished his book on my work, and was very pleased with it and would give it to his publisher the moment he reached New York. He went on to say that, both in his book and in a lecture, he had said that Picasso had no sense of color at all.

"Keller had brought for Barnes an invitation from Picasso to come to lunch at his house in the country. Barnes had refused. Picasso apparently was bitterly hurt that Barnes did not like his work. Bignou wanted Barnes to buy a big early (Blue period) Picasso of a man and a pregnant woman – *La Vie*, it is called. Barnes told me that he had got about ten Picassos already and that that was quite enough. Compared with Derain, Othon Friesz, and the others, Picasso was an artist, but

"He added that his book includes a new chapter on 'Matisse and His Contemporaries.' In it, he gives Derain a good kick in the *** and says that Picasso is just a travesty of Matisse. 'You'll enjoy that,' he added. Barnes also said that a major art gallery in Paris was going to close. I wondered if it could be Bernheim-Jeune, who are doing no business at all, but he said that the name was confidential. I told him of the rumor in Paris that the Galerie Petit would be closing. 'Not before January,' said Barnes. If I'd spent longer with him, I should have learned a lot more. But I did tell him that you had gone back to New York in very good spirits."

Where the Paris art market was concerned, Barnes had been a vigorous player since 1912, when he bought no fewer than six Cézannes from Ambroise Vollard and others. By 1923 he was so well known that dealers would stand in line outside the Hôtel Mirabeau on the rue de la Paix, where he was staying. Paul Guillaume, a great dealer of the day, was later reported as saying, "That man had such an appetite for painting and sculpture that he could forget about eating and sleeping. And he could keep that pace up for a month or more when he was in Paris."

Not only did Dr. Barnes love to hear the news of the art world, but he loved to be first with it. This craving amused and sometimes tantalized Henri Matisse. After all, Henri Matisse was himself in the art world, and in the art market. And he would put up with a good deal of self-importance, duplicity, and pure bluff for the sake of what he could hear from no one else.

On August 17, 1932, Henri Matisse wrote to Pierre from Nice, and said that he had been so exhausted in Paris that he couldn't even remember the news about Barnes. "Eventually I remembered that one of them was the big Cézanne still life, but what the other one was I simply couldn't remember. I began to doubt that it had ever existed. Then when my strength came back I remembered that it was the *Terres Rouges*. So, with the two Cézannes he had bought from Georges Bernheim, that made four beautiful Cézannes.

"I forgot to tell you that during the forty-five minutes that I spent with Barnes in his hotel, he told me that he had given a check to Bignou and Keller in the amount of the commission owed to Cézanne's son. Later on, I told him that people were saying that Bignou and Keller were going to become partners. He made no comment."

Henri Matisse already knew that Barnes, Bignou, and Keller had just made a little tour of Brittany. Barnes had told him that he was paying his way (the gas included) in order not to be under any obligation to Bignou and Keller. But it seemed to Henri Matisse that someone – either Barnes or Bignou – was using that little journey to cook up something advantageous to himself. As he said to Pierre, "Barnes is capable of going in with B. and K. on conditions that would make him the master of the art market. For instance, he would have the right to buy pictures at a profit to himself that would be decided in advance. That would be very bad for me, since Barnes is at the moment my only client. It is a pity that I don't have Stephen Clark as a counterbalance. It strikes me – business being what it is, and what we know it to be at this moment – that you might be able to reach Barnes by way of Dudensing, if you were to reopen relations with Dudensing (strictly as between one dealer and another).

"If, for instance, a painting were available in London, or in Paris, and if you were convinced that Clark only listens to Dudensing, then something might be

done on those lines. It is a common practice among dealers. And if you worked with Dudensing, you would at least know whom you were up against. I do not presume to influence you, but it seems to me that in view of the relationship between Barnes, Bignou, and Keller, it's worth thinking of."

Those were desperate times for business, but it does not seem that Pierre was tempted by the idea of a rapprochement with Dudensing.

At that moment Matisse had another offer of a large-scale decoration in the United States. On November 25, 1932, he wrote to Pierre that he had been approached about Radio City Music Hall in New York. "I gather that they have commissioned three decorations from José-Maria Sert and are in negotiations with Picasso. I am going to write and say that I cannot possibly do it, because they ask for delivery by next May."

As may already be clear, Matisse did not like to commit himself to a week away from home with someone he did not know well and in a place that he did not know at all.

But when Dr. Barnes asked him to join him for a week in Majorca, in January 1933, he thought it politic to say yes. They had much to talk about. He was almost ready to hand over the revised Barnes decoration. He intended to go to Philadelphia to oversee its installation. And, after all, Barnes was Barnes – an admirer of twenty years' standing and a still-active client on a very grand scale. And this was a time at which clients, major or minor, were in short supply.

On January 15, 1933, Henri Matisse wrote to Pierre from Palma, Majorca. The boat from Marseilles had been small and uncomfortable, and he had been seasick for fourteen hours straight. Not unnaturally, he said: "I don't know if I did right in accepting his invitation. I rather dread the prospect of a week with Barnes, who is so hyper-active and so highly strung. I'm rather tired at the moment and I'm just getting over an influenza attack that kept me indoors for a week. I wasn't up to writing to you, much as I wanted to.

"Then again there is your mother's illness, which gets no better. We all of us have our troubles, and mine are heavy right now. I am old and tired after forty years of work to which I gave my all. I need my strength to complete the huge task that I have in hand – not to mention the illustrations for Mallarmé that are very important to me."

Yet it is also worth noting that Barnes was an eager and untiring student of the Parisian art world. In that context, Henri Matisse was never one to look on the bright side, and these were undeniably terrible times. "The auction sales are over," he wrote to Pierre, "and they seem to have gone quite well. But paintings went way down. Really important Bonnards went for 20,000 francs (or even

less). The Bernheims did nothing to keep the prices up. Bonnard is furious about it. Have you heard that the Galerie Société Bernheim-Jeune is going to go into liquidation? It was supposed to happen at the end of last year. Barnes will know. The newspapers talked of the Galerie Petit being turned into a garage. They also said that it might be taken over by the Parisian auctioneers as a venue for their big sales. Barnes will put me straight."

It was a further setback that Henri Matisse had to wait another forty-eight hours in Palma before Dr. Barnes arrived. He had wanted to do more work on the big new decoration before Barnes came to Nice to see it. Barnes had hoped to spend six days in Majorca, which was why he had invited Matisse to join him. After that, he had meant to go for a week to Spain. This would have left Matisse free to peel off and go to see his son Jean at Tossa. ("He needs cheering up.") After that he could pay a call on Maillol in Banyuls. But now he foresaw that Barnes might be discouraged by the likelihood of a revolution in Spain. "If he doesn't go to Spain, I'll take the fast train to Nice and forget about both Jean and Maillol. In any case I want to get to Nice before he does."

As it turned out, Majorca was in every way a failure. While he waited around for Dr. Barnes, the cold and the damp were too much for Matisse. He felt ghastly. Barnes arrived at noon on a Monday and had to drive fifty miles each way to get his mail from an hotel at the other end of the island. Henri Matisse could think only of getting home as soon as he could. So he took the boat on which Barnes had arrived, and by 9 A.M. on the Tuesday he was in Cannes.

It had been a matter of some agitation to Henri Matisse that Barnes had really no idea what his big decoration would look like, or of how much it differed from the earlier paintings by him that were in the Foundation. He was also rather alarmed that he might have exasperated him by leaving Majorca so abruptly. So it was a great relief to him that when Barnes finally arrived in Nice and saw the decoration, he seemed to be very pleased with it. "He also congratulated me on having got out of Majorca.

"He saw the decoration, and he liked it. He even urged me to leave it as it is. No painting is ever finished, he said, but this one had been taken far enough. In spite of that, I'm going on with it, but for a few days at the most."

While he was in Nice, and after he had seen the big decoration, Dr. Barnes began to drop in on the Matisses (especially at mealtimes). They didn't like to stand on ceremony with him, but to be with Barnes in private for hour after hour was to be exposed without warning to questions that were really none of his business. "Barnes was very curious," Henri Matisse told Pierre, "as to how many servants we had, and how much they were paid. I have to say that he's often like that. But,

given the state of crisis that is now almost universal, I was particularly aware of it.

"He's a monster, of course. He left it to me to pay 65 francs for the consular charges and 30 francs for the packing. Then he asked me how much he owed me for my stay in Majorca and for . . . At that point he stopped, obviously wondering about my other travel expenses. I said, 'You owe me nothing! I just had two days at the hotel for 15 pesetas a day.' Actually it cost me 400 francs to get to Majorca and 1,900 francs to get back to Nice. I would just as soon not have gone at all, and he ought to have paid me back, but . . . you have to take him as he is.

"He also brought me his book about me. Have you seen it? It should bring a lot of favorable attention in America. I have not read the text, but I have an idea what it's like. I'm sure that it is influenced by Leo Stein. It's dedicated to Leo by the way, whom Barnes describes as his 'initiator.' I said, 'How could you do that? Leo Stein is an idiot. Sarah Stein is the only person in that family who has any feeling for art.' Barnes said, 'I spoke to Mrs. Stein once. She's stupid.' I told him he was mistaken. 'In any case,' he said, 'it was Leo who first drew my attention to your paintings.'

"He told me that Bignou and Dudensing had jointly bought the *Coffret Chinois* and the still life. Barnes had bought it from from Bignou, who took only a small profit. Apparently Bignou buys for Barnes on a 5% commission. On what he bought for Barnes when Barnes was in Paris he made 200,000 francs [$10,000].

"He told me that the Galerie Petit has definitely closed. Bignou lost six million, as did the Bernheims. He told me that Rosenberg had sold for 500,000 francs [$25,000] a painting by Cézanne that he had bought for three times as much. He also told me that when he went to see the Bernheims, before the summer, they had offered Barnes some paintings from their own private collection. 'Make us an offer,' they said. He wouldn't." Bad times in the market brought out a feral side in Barnes's nature. As Henri Matisse put it, "When other dealers offered him paintings at a fair price he said, 'I'll give you half,' and they agreed to it."

Barnes followed the market very closely. He also relied on Etienne Bignou to let him know of anyone who was desperate for money and would be ready to sell at no matter how low a price. Barnes himself had recently asked Pierre Matisse if his father was short of money. Henri Matisse knew perfectly well what Barnes was up to. Nor did he give Barnes any reason to think that he was in difficulty. Barnes meanwhile was almost begging Henri Matisse to sell him a certain little painting. 'It's superb!' he kept on saying. 'Just a jewel! When I am dead, and you also, it must be given to the Foundation.'" Matisse was inclined to give way. "Hoping to make him forget my gaffe at the time of the exhibition in 1931 at the Galerie Petit, I thought it over. On the following day I said, 'Would you really like to have that painting? You seem to love it.' 'Yes, I would,' said Barnes. 'How much is it?'

'50,000,' I said, 'or whatever you like.' After a moment's reflection he said, 'Done!' I then said that I had not wanted to sell it, but as it was for the Foundation, . . . that was different and I'd be glad to see it there. 'Yes, yes,' he said, 'it's just made for the Foundation. And I think that in the light of recent prices at auction, 50,000 is about right.' Barnes also told me that Bignou was preying upon dealers who were known to be in need of money. So it was an enormous comfort to me to know that you have been making some sales."

From there, Henri Matisse went on to suggest the ideal strategy for Pierre Matisse at this point in his career. "If you could work regularly with some clients who are not also clients of either Bignou or Dudensing, you could survive until the end of the present crisis. I should be all the more delighted because Barnes had spoken about you without saying anything much. I told him, among other things, that you had sold a life-size sculpture by Maillol to Stephen Clark. He was quite surprised. I thought afterwards that maybe I ought not to have mentioned it, because you had not told him about it. He tells Keller everything, and maybe one should not go into details."

Henri Matisse then turned to the subject of his painting, *The Yellow Dress*. "I should have been glad to talk about it," he wrote. "But he didn't seem to remember anything about it. So I didn't go on. I think that you are right – more so than you knew – and that there is nothing you can do with Barnes as long as he has Bignou and Keller as his henchmen.

"Your mother and I are rather annoyed that he may think I sold him the little picture because I was short of money. I really did it simply to give him pleasure."

Writing to Pierre on February 27, 1933, Henri Matisse led off with the words "DATE YOUR LETTERS!" (a recurrent complaint). Thereafter, he had both good news and bad news. The good news was that, although Barnes had regarded his decoration as finished, Henri Matisse had not stopped work on it. "I think I'm at the end now," he wrote, "but it has gained a great deal in amplitude since Barnes left. And, no matter what it costs me (in every way), I simply have to carry my ideas through to their conclusion."

And the bad news? There was no shortage. On account of a fall in the strength of the dollar against the franc, he had lost quite a bit of money on the last check that Barnes had sent him. What if Roosevelt were to be re-elected and a terrible inflation were to follow?

In a more general way, he was consistently appalled by the general situation and the dangers that might befall his family. Take his son Jean, for instance. He was always behind with his rent. He was living in a village near Collioure. He ought to be saving 1,000 francs a month by not being in Collioure. But, even so,

he always left it till the very last moment and then cabled for help. He had hoped that Maillol would give him work, but instead of just saying No, Maillol went on putting it off for reasons that were more and more implausible.

Then there was Marguerite. Albert Skira had had grandiose plans for a new publication in which Marguerite was to have an important role. But these were appalling times for publishers, big or small. Henri Matisse had heard that even the Editions de la Nouvelle Revue Française in Paris – the flagship of French intelligence – was going into liquidation. In any case, he did not believe a word that Skira said. All his backers had dropped him. Marguerite would have had to give her entire energies to his madcap scheme, and for no foreseeable reward.

Even the city of Nice was wracked by foreboding. This was carnival time. It was raining. What would happen to the fireworks? As for the Niçois, they didn't care a hang about the carnival. Their thoughts were elsewhere. Finally, and as always, there was Dr. Barnes. Matisse did not want to send him a photograph of the decoration,

Letter from Henri Matisse to his son discussing the despatch of the Barnes decoration to New York, 1933

because it was changing all the time and he did not want to send something that would be obsolete. What were people saying about his book on Matisse? What kind of publicity value would it have? Matisse himself had found it "very German."

It was not until April 23, 1933, that Henri Matisse wrote to Pierre and said that the decoration was finished at last. He had cabled to Barnes to say that he and the decoration would arrive in New York, on board the liner *Rex,* on May 11.

There should, thereafter, have been a period of general jubilation. Matisse had put forward a colossal effort. His client had claimed to be pleased with the result. The mural had been painted for a specific location, as to which Matisse had taken every conceivable aspect into consideration. Much as he would have liked it to be seen in Paris on its way to the United States, he had yielded to the apparent eagerness of Dr. Barnes. The three components of the mural had each its separate crate, made to Matisse's instructions. The crates were ready, the *Rex* had steam up, Matisse had his passage booked. A word of "Welcome aboard!" from Dr. Barnes would have seemed appropriate, much as he disliked squandering money on Western Union.

No such word was forthcoming. "DO NOT CUT DECORATION BRING IT IN ONE PIECE" was what Dr. Barnes actually sent, just a few days before the *Rex* was to sail. The cable made no sense, in that the painting could not possibly have been sent "in one piece" at short notice, or indeed at any notice, given its unique dimensions. Had this cable a hidden meaning, Matisse asked himself? Was it an attempt on Barnes's part to impose ridiculous conditions upon a great artist? At that point, Matisse remembered a disquieting episode that had occurred in Nice. Barnes had said, in an aside to Mrs. Barnes, that if he did not like the mural when it finally arrived, he would not feel obliged to install it, but would just "put it aside." Once he had bought it and paid for it, it was for him, and not for the artist, to say what should be done with it.

We should bear in mind that this was the largest painting that Matisse had ever undertaken. To a degree, and on a scale that had had no precedent in his work, it was "site specific" – made, that is to say, for a particular location. Variables and imponderables were built into it and could not be discounted until the mural was installed.

The project had had a long and painful history. The upshot of it all was not "another Matisse." It was a new kind of Matisse. Neither Matisse nor Barnes could be sure of its success until it was installed in the Foundation. Hyper-anxieties were integral to this situation. When Barnes got a dismissive review for his book on Matisse, it left him blind with rage. If Matisse asked him to pay up as soon as he could because the dollar was going down against the franc, that did not sweeten his temper, either. Matisse had been exasperated by the comments, spoken or implicit, of a self-styled representative of Dr. Barnes who had been nosing around

the studio in Nice. Was it possible that this young person had reported unfavorably to Merion about Matisse's methods of work on the mural?

Apprehensions of this sort had a demoralizing effect. But, as Henri Matisse put down his pen and looked up at the mural, he said to Pierre, "When I see the mural before me, I find it simply superb. Come what may, I am satisfied with what I have done. I can't wait to see it installed above the clear glass doors, just as I had always intended it to be. It will function as the sky above the foliage that visitors can see through the doors when they look across from the loggia on the 2nd floor. But . . . my dear Pierre, I shall need a strong stomach to get through the next days with honor."

Initially, all went well. The *Rex* docked on time. On Saturday, May 13, the canvases were laid out on the floor and were ready for stretching. Barnes had wanted this to be done by his former chauffeur and handyman. It did not improve his humor that Matisse insisted on taking up the hammer himself. It was a moment of high emotion, and the danger point of the nervous excitement with which he had been living for so long. Nobody was going to mess with his canvases.

Almost at once, however, it became clear that the work was too much for Henri Matisse. In short order, he had what Dr. Barnes called "a slight heart attack." Writing to Pierre in relatively humane terms, he said that his father had recovered after a glass of whisky and a comfortable rest, but that a local heart specialist had found that his father "was in need of absolute rest for a long period and must not do any work whatsoever." Barnes went on to say that "when a man reaches your father's age it is necessary for him to readjust his life to changed conditions that advancing years bring on." Henri Matisse at the time was sixty-three years old.

Jubilations were not forthcoming. The mural went up, as planned, and it was a perfect fit. But every one of Henri Matisse's wishes had been disregarded. He had asked that the large and intrusive paintings below the mural should be removed, but they weren't. He had asked for the footling little sculptured frieze beneath the pendentives to be removed, but it was still there. He had also asked particularly that clear panes of glass should be used for the windows above the French doors. The sight of the greenery in the garden was fundamental to his ideas as to how the mural should be seen. There, too, his ideas were ignored. Frosted glass was still in place.

Nothing of any note marked the occasion, except that Dr. Barnes gave a three-hour lecture on the mural to his students. European-style festivities had not been planned. There was no reception, no formal opening, no gathering of grandees, no convivial dinner. One of the major achievements both of twentieth-century art and of twentieth-century patronage was to pass unnoticed. Access to the Foundation was much more difficult then than it is today. There was a sense in which

the mural had not so much been put on public view as sequestered.

Henri Matisse himself had no doubts about the success of the mural. It seemed to him to have lost its identity as a painted canvas and become "a rigid thing, heavy as stone, and one that seemed to have been spontaneously created at the same time as the building." To his friend Simon Bussy he said that "it is of a splendor that one cannot imagine until one sees it."

It has to be said for Barnes that he was not honor bound to like the mural. Every patron lives with that possibility. But Dr. Barnes had never before had to deal with it. Every single thing in the Barnes Foundation had been chosen by him and approved by him. This mural was by Henri Matisse, who was the living artist most acclaimed on the walls of the Foundation. Barnes had commissioned it, and once it was installed he was obliged to complete the agreed payment of $30,000. Something about it was alien to his nature. Yet it was now as much a part of the Foundation building as the French limestone with which it was built. He could not "put it by," as he had said to his wife in that celebrated aside.

Barnes could be one of the most difficult men who ever lived, but he was true to his nature. He could not say that Matisse had made him a masterpiece. When pushed by Pierre, in later days, he would say that, yes, the mural had made him understand Matisse better and that, yes, some of his friends had been very impressed by it. But there was something withheld, something grudging, and something devious about whatever he said to Henri Matisse on the subject. Nor did he pay any attention to Matisse's complaints. It cannot surprise us that at the earliest possible moment Pierre drove his father back to New York, and that Henri Matisse was never again to set foot in the Foundation.

Henri Matisse grieved. He had foreseen, all too well, that large and heterogeneous oil paintings did not live well with even larger murals. He also knew that through no fault of his own the poetical effect of his particular mural had been, and would forever be, sold short. Where it should have been the ideal mediator between indoors and outdoors, it was just a very big something that was difficult to see.

He had not forgotten how Dr. Barnes had said to him, on their first meeting, that he wanted Matisse to paint "as if for himself alone." Nor could he have forgotten that as recently as March 1931 Barnes had written to tell him that the new installation of Matisse's *Three Sisters* triptych in the Barnes Foundation was "as fine as any wall I have ever seen in any gallery."

When writing to Pierre, he revealed his true feelings. For two years he had knocked himself out for Barnes, and with what result? "If he had treated a cobbler the way he has treated me, the cobbler would have given him a black eye." Pierre said in reply that Barnes was nothing but "a jumped-up boor. Fortunate

are the future generations," he wrote, "who will never know what he was like." This was the single most unpleasant experience of Henri Matisse's professional life, and he never forgot it.

Despite the mutual, though unspoken, disappointments of the previous year, Barnes in 1934 seemed to be taking a benign interest in the Pierre Matisse Gallery, which had just moved to new quarters on the seventeenth floor of the Fuller Building. He came by to take a look, found that Pierre Matisse was out, and wrote on November 18, 1934, to congratulate him. There was not a space in New York to equal it, he said. And he went on to urge Pierre to show the work of three American painters, the Pinto brothers, whom he regarded as the natural heirs to Henri Matisse.

Pierre knew Barnes too well to question that claim. He said merely that in view of the "delicate and tense" situation that existed between American and European painting he had always concentrated on the School of Paris.

In general, Barnes remained amiable enough, in an intermittent way. In April 1939, after a five-year interval, he invited the Matisses to another evening with the "negro chorus" and to supper afterwards. He also bought three small paintings by Joan Miró from the gallery. But he seems to have been unmoved by a letter from Teeny Matisse, dated November 8, 1939.

World War II had begun in September, and Pierre Matisse was in France in the French army. As the father with Teeny of three children, he could have had an exemption, but he had neglected to make his fatherhood known to the French authorities. Teeny Matisse was left in charge of the gallery in New York, and although she had a first-rate business head, the affairs of the gallery were what she described as "desperate and involved." If there was a reply from Dr. Barnes, it has not survived.

He did, however, come by the gallery in April 1940, when Joan Miró was having an exhibition there. He also brought the celebrated movie and stage actor Charles Laughton to see it, saying that because of the number and the kind of people who came to Laughton's house in Hollywood, it could be the best advertisement that Miró had ever had.

In 1941, after Pierre and Teeny had bought a farm in New Jersey – sixty miles from New York on Route 22 – there were renewed politenesses. But Barnes was still armor-plated against all professional initiatives on Pierre's part. When offered a superior group of pre-Columbian figures in February 1941, he said only that he "could not find a suitable place for any of them." In plain terms, Barnes the patron, Barnes the on-again, off-again friend, and Barnes the potential client had been a bust.

On His Own at Last,
1931–39

By November 1931 Pierre Matisse at last had his own gallery, under his own name, in New York. Master in his own space, he could do things his own way, assume all the risks, and answer to no one but himself. He could imagine no greater happiness.

As to what kind of a gallery it would be, much had still to be worked out. There is no such thing as an infallible formula for a great gallery, or even for a successful one. Every gallery has had the mark of a way of life specific to itself.

At Thomas Agnew & Sons in London, visitors have carried on since 1817 as if they had dropped in by invitation at a great English country house. Across the street at Colnaghi's, when a fine scholar called James Byam Shaw was in charge of drawings after World War II, the hard sell had never been heard of. "Just treat the place like a club," he would say. "Come by any time and feel free to go through the boxes."

The question of privacy is almost infinitely flexible. There are galleries in New York in which the owner does business behind locked doors and twinkling computer screens. At the opposite extreme was the Leo Castelli Gallery in SoHo, where the inner sanctum was laid out like an airline ticket office to which access was free and immediate.

Appearances can deceive, moreover. There are galleries that always draw a crowd, and there are others in which nothing ever seems to be going on. But the crowd doesn't necessarily buy, and the gallery in which we never see as much as a cat may be doing very well indeed with just five or six clients, all of whom have pictures sent home on approval.

There are very gifted dealers whose favorite words seem to be "I'm terribly sorry, but that's not for sale." Others have cocktail parties at every opening and work the room like candidates for political office. Yet others, more discreet, have delicious little lunches upstairs at which business is never mentioned and the food is served by well-bred young women handpicked in London and shipped over for the purpose. And then there are dealers who double as houseguests, spare men, and upmarket traveling salesmen. All these methods have their masters (and their failures, also).

In matters such as these, Pierre Matisse had his own ways, right from the beginning, and he kept to them. In no matter what company, Pierre the dealer had an air of reserve, and sometimes almost of severity. In private, he had stores of wit, irony, and deadpan high spirits that could surprise and delight. In dealing with clients, he had unexpected powers of adaptation. He was himself, unalterably, but he knew exactly when to hold back, when to give way just a little, and when to make the unexpected offer that clinches the deal.

He also learned to excel at the multiple transactions by which a client would buy five, six, or even seven paintings at a time. The point of these complicated activities was that the batch cost quite a bit less than the total of the individual sales prices. What is called in America "the beauty part" was that ideally both parties to the deal would be convinced that they had got the better of the other.

Early on, Pierre decided that he was going to find the artists he really believed in and stick with them. He would deal with them directly, rather than patrol the secondary market, in which their work would already have passed from hand to hand. If he could have exclusive rights to their representation in the States, so much the better. Concurrently, he would make up his mind as to which collectors were truly serious, and in a low-keyed but pertinacious way he would coax them to come to the gallery.

In later years, regular visitors would be greeted warmly by Walter Gordon, the longtime and indispensable handyman. After more than thirty years in the gallery, he had perfect pitch where Pierre Matisse was concerned, and Pierre valued him very highly. Once inside, visitors might glimpse the young ladies of the gallery, each intent on her duties in the open office area. Eyes were rarely raised from their work, but there was an almost subliminal awareness that visitors had arrived. It was not in Pierre Matisse's nature to glad-hand them. But he was somewhere there, noiseless (and, from his point of view, preferably wordless). He never presumed to intrude. But if visitors showed the kind of interest that sets up an unmistakable and strictly atmospheric buzz, he would eventually come into view, as if taking an unmotivated stroll round the show. All this was in itself a civilized

achievement, and one that he was to develop over more than half a century.

It did not deter Pierre that in 1932 the times were brutally inauspicious. The economic situation of the United States could hardly have been worse. Collectors would almost hide under the sofa to avoid being tempted to buy. Works of art that had been sent out on approval came back in short order. Paintings bought long ago had not yet been paid for. (One big dealer claimed that in the previous year he had been owed a million dollars and had recovered exactly $2,000.)

Was this perhaps not the best time to open a gallery? Common sense might have said so. Yet there was a momentum to Pierre Matisse's activity that outlawed the injunction "Wait and see!" By March 1931 he had finally severed his association with Valentine Dudensing. "All is over between Dudensing and myself," Pierre wrote to his father on March 17.

If anything can be guaranteed to maximize bad feeling between one human being and another, it is a separation that calls for the equitable distribution of assets held in common. But in this case Solomon himself could hardly have made a neater division of the stock. On one side, as on the other, the names were the same, almost without exception. So were the numbers. So was the estimated value. Pierre's share was valued at $38,802.76. It included works by Georges Braque, Giorgio de Chirico, Charles Despiau (a sculptor then much admired), André Derain, Raoul Dufy, Marie Laurencin, Henri Matisse, Amedeo Modigliani, Pablo Picasso, and Maurice Utrillo. The sale prices, as distinct from the valuation, totaled $72,075.

Pierre's half share in the stock of the Valentine Gallery had become, in effect, the initial stock of the Pierre Matisse Gallery, which he was determined to open as soon as possible. It would be enlarged by purchases to be made in Europe during the summer. In addition, Dudensing was to pay Pierre Matisse the equivalent of 750,000 francs before the end of 1932. But, like every other dealer, he was owed a great deal of money, and it was not every day, or every week, that a promised check was truly "in the mail."

In February 1931, for instance, the Valentine Gallery was owed $8,000 by Duncan Phillips, $5,500 by Stephen C. Clark, and $44,150 by James Thrall Soby. These were not disreputable debtors. Duncan Phillips, the founder with his wife, Marjorie, of the Phillips Collection in Washington, D.C., was probity itself. Stephen Clark had bought around twenty Matisses over the years. He was proud of them, and he intended to leave them to the Metropolitan Museum. In November 1929, Pierre had suggested to Henri Matisse that he might make a little drawing for Stephen Clark as a superior Christmas card. Soby was to leave great paintings to the Museum of Modern Art. (He was also to pioneer the buying of Balthus, among much else, from Pierre Matisse.) Public collections in the

United States would be the richer for the activity of these three men. But this was a catastrophic moment, nationwide.

If Pierre was determined, even so, to press forward with his gallery, it was in part because, as of November 3, 1931, there was to be a major retrospective of Henri Matisse at the Museum of Modern Art in New York. Organized by Alfred H. Barr, Jr., this would be a landmark in the status of Matisse in the United States. Pierre was constantly in touch with Mr. Barr, and with many of the collectors who were being tapped for loans. This was a time at which he had a useful and conspicuous role in New York, and it could only be advantageous if his gallery were to open during the run of the show.

And where would his gallery be? Not at street level, quite certainly. Then, as now, to have people walk in off the street cost money. It would open quietly, moreover. Those were not yet the days of the public relations blitz and the black-tie opening. Neither delicious food nor strong drink would be served. Pierre Matisse had no spare money for amiable vanities, and his overhead had to be minimal. His was a bare-bones operation. Even so, he was not going to have an anonymous walk-up in a dreary location. He was going to stay as near as he could to the northeast corner of 57th Street and Madison Avenue. As far as the buying and selling of art was concerned, this was then the magnetic center of Manhattan.

The ideal was, beyond a doubt, the Fuller Building, a forty-story Art Deco classic that had gone up as recently as 1929 at 41 East 57th Street. The Fuller Building was luxurious then, and it is basically luxurious now, but the Depression years were hard times all over Manhattan, and Pierre Matisse had no trouble renting two rooms in the Fuller Building for less than $200 a year. (In time, he was even to get a reduction.) They were small rooms, and they were on the seventeenth floor, but the address was just right. The rooms had a beautiful north light, and they looked out towards Central Park on one side and over the Ritz Tower on the other. Pierre Matisse loved the building, and he was still in business there (though in more spacious premises) fifty-eight years later.

He also had his plan of action, though not all of it was as yet in place. His gallery was necessarily very small. He had not yet assembled the corps of clients who would fan out far and wide and carry the good news that here was a gallery with a great future. Nor had he assembled the corps of gallery artists whose careers he could shape, both to their advantage and to his own. But what he did have was a coherent view of what his gallery should be, and of how he should run it.

Before he left for Paris, there had been a certain amount of encouraging activity for the not-yet-opened Pierre Matisse Gallery. He had sold to the Boston

Museum of Fine Arts a Matisse – a seated model, done in 1904 on the quai Saint-Michel – and an unidentified Braque. "There wasn't a wide margin of profit," he said, "but it came to a tidy sum."

Having chosen his gallery space, Pierre Matisse went back to Paris in April 1931. It was in part a shopping trip, and one that concentrated above all on Henri Matisse. Thanks to a certain flatness in the market, he had been able to go to the sale rooms in Paris and buy a little landscape, done at Collioure, a rather somber and heavily-worked view of the quai Saint-Michel, two heads of the violinist Eva Modocci, and a head of a Moroccan woman.

He was also offered a portrait of his sister Marguerite in a hat, done in 1914 in the studio on the fourth floor at no. 19, quai Saint-Michel. "They're asking 50,000 francs for it," he said, "and I'm going to try and find a client for it before I buy it myself." Next, he bought some terra-cottas by Henri Laurens. "They're really very cheap if you get the dealer's price, and they're terribly nice. It's rather as if Maillol had looked at Picasso and couldn't get him out of his head."

Even in Paris, where doomsters were in a majority, Pierre was encouraged by one or two marks of goodwill. His banker offered to lend him 750,000 francs to spend on further purchases for stock. (Thanks to a loan from his father, he had not needed to touch it as yet.)

But, on his return to New York, Pierre Matisse realized that the financial crisis was, if anything, even worse than the year before. Gone forever – so it seemed – were the glory days when Dudensing would tell him that business was "hot, hot, hot!" and that profits were way up, up, up. With his gallery just about to open, Pierre had some good things to sell. But who would buy them? When the Pierre Matisse Gallery opened on November 14, 1931, people were not exactly waiting to beat down the door. (The new gallery was "off the beaten path," said the *New Yorker.*) What Pierre had to show would today be the making of any new gallery. But, as he wrote to his parents, the problem was that people did not yet realize that he was there at all.

Visitors, though few, were undeniably distinguished. It is not every new gallery in New York that had as its first paying customer A. Conger Goodyear, the president of the Museum of Modern Art, who bought the head of a Moroccan woman that Pierre had bought in Paris in the summer. Stephen Clark had come by, but jibbed at the price of a Maillol marble. Samuel A. Lewisohn had looked in, too, but he had told Pierre that he had lost so much money that he despaired of being able to buy anything more, ever again. As for Dr. Barnes, he had shown no sign of life, but then he never liked to be prodded.

The Matisse exhibition at the Museum of Modern Art was drawing what at

that time was considered a mighty crowd – 5,785 people in its first week – but they did not overflow into the Pierre Matisse Gallery. "And yet I would have offered them famine prices!" said Pierre to his parents. There were days in which the telephone never rang, the door stood open to no purpose, and Pierre dreaded that one of his rivals would find him eating lunch out of a brown paper bag.

Henri Matisse knew that this situation, if prolonged, could mean disaster for the gallery. He had already lent Pierre money for his summer purchases, and on November 28, Pierre found that his father had sent a further $2,000 to the credit of Pierre's account in the bank. "I send you my warmest thanks," he wrote, "for this further loan, which arrived at a critical moment. I was almost down to my last two or three thousand francs."

At this point, a new problem presented itself. The opening in 1931 of the Whitney Museum of American Art was the talk of a certain New York. As Pierre put it, "We are somewhat – or, rather, very much – the victims of a ferocious campaign of support for American modernism. French art, on the other hand, is being bitterly attacked. All the papers are full of articles on shows of American art, whereas ours are barely mentioned. That does not affect your show at the Modern Museum, which is packed. But it does mean that, for the moment, French art in general has vanished."

This particular rivalry is not yet extinct. As between Paris and New York, cordialities now flourish at curatorial level. But at another, more visceral level of national self-regard and self-assurance, Francophobia is alive and well in New York. "Paris is dead," people like to say. In Paris, equally, the notion that New York "stole the idea of modern art" after 1945 still has some support.

Pierre's policy, then and later, was to show what he believed to be the best European art and wait until people got the point. Meanwhile, the immediate outlook remained bleak. In January 1932 he wrote to his father that "Business has been disastrous, and right now there isn't any at all."

Prosperity was still in the far distance. For the year 1932 the gallery's net sales totaled $12,967, and the net losses for the year were $3,265. During the first four months of 1933, the net losses were $6,322. At any other time, this might have looked like a prelude to disaster. But Pierre Matisse was not in business for a fast fortune. Nor did he wish to go down in history as a demon salesman and pioneer of the megadeal. He saw his role as that of a matchmaker who would foster work that he loved and see that it found the best possible home.

In 1932, and again in 1933, business began to pick up. In 1932, a bronze and eleven drawings by Maillol were sold (one of them to Henry McIlhenny, an inspired collector from Philadelphia). Of the eleven Matisses that Pierre bought

in November–December 1932, every one was sold by April 1933. In November 1933, Duncan Phillips bought a major Rouault, *The Clowns*. James Thrall Soby came back very strongly in the context of the metaphysical paintings of Giorgio de Chirico. In 1934 he was so impressed by de Chirico's *Enigma of a Day* (1914) that he later called it "the single most vital progenitor of what we now recognize as surrealist art."

This was the ideal situation for Pierre Matisse. In relation to his clients, what he enjoyed above all things was to be both merchant and mentor. He had a profound emotional commitment to his artists, and where possible he liked to pass it on to his clients. He also liked to make a sale, and he liked to see a check (especially if it came on time, which was not always the case). Nor did he begrudge the minuet of negotiation that might or might not end in the cutting of a deal.

Other things being equal, he preferred not to sell to people for whom he had no respect. Even less did he like to sell to his rivals in the trade. What he really liked was to work consistently with collectors that he knew well. Already in the 1930s he established ongoing relations with people as different from one another as James Thrall Soby (from 1933), Wright Ludington (from 1934), Edward G. Robinson (from 1935), Walter P. Chrysler, Jr. (from 1935), and Joseph Pulitzer, Jr. (from 1936). To them were later added Samuel A. Marx from Chicago, and his wife, Florene (later Mrs. Wolfgang Schoenborn), Leigh Block, later president of the Art Institute of Chicago, Joseph R. Hirshhorn, the founder of the museum in Washington, D.C., that bears his name, G. David Thompson from Pittsburgh, and to a lesser extent Jacques Gelman from Mexico and Giovanni Agnelli from Italy. Collectors in his field did not come any stronger than these.

Pierre Matisse never looked out for people who bought on a whim, and still less for people who "came in off the street." Talking to Rosamond Bernier late in his life, he singled out the Samuel A. Lewisohns in that context. "Lewisohn's father had started his collection with a German dealer who did not have a gallery, but brought great paintings. When the father died, the son took over. They had copper mines in Latin America. They loved music, and were friends of George Gershwin. They had a house on Fifth Avenue with paintings by Gauguin and van Gogh, and the children followed suit, buying 20th-century pictures. They were very good customers. We could live on them till the end of the year."

Discerning clients were fundamental to the long-term plans that Pierre had for the gallery. This was not simply because of the financial support for which some of them could be counted upon. It was because, through them, the work of Joan Miró, Alberto Giacometti, and Jean Dubuffet – not to mention others – would become a part of the imaginative climate of the United States. Pierre did not want his artists to

come into town, like a traveling circus, and go away again. He wanted them to stay.

A prime catch, in that context, was James Thrall Soby, a loyal and longtime patron of the gallery. He did not need to be led to the new and the good. He was the complete professional, whether as a curator, a collector, a writer on art, or an exhibition organizer. In all these contexts, he was Mr. Modernism. Convivial by nature, he had known Alberto Giacometti in Paris since the early 1930s. In 1933 he was a pioneer among American enthusiasts for Balthus. He could describe exactly how Joan Miró had once danced the tango at a gallery opening – "with not a slide, nor a figure, nor the least step forgotten." Later, he was to sit side by side with Piet Mondrian in the early 1940s as a member of the jury that chose the artists for Peggy Guggenheim's forthcoming exhibitions. He was to know Brancusi well in Paris after World War II, and he was one of Marcel Duchamp's two witnesses when Duchamp became an American citizen in 1955.

When buying a picture, he had a dead-center sense of honor. When taken to call on Giorgio Morandi in Bologna, he asked that seraphic and undemanding master of still life if he could buy a recent painting that he especially liked – and, if so, what it would cost. Morandi named a figure that was absurdly small. Soby could not help saying that dealers in Milan were asking almost exactly a hundred times as much for comparable paintings by Morandi. "Talking about prices makes me nervous," said Morandi. "If you go on objecting, I'll cut the price in half."

Soby also had a sense of joy in life that made him an irresistible and not seldom ribald companion. After a visit to the Matisses in New Jersey, he wrote that "I noticed that the New Jersey air is a decided aphrodisiac. Noticed anything unusual?" (That same letter ended with the salutation, "Best to you, sentiments distingués, sexual triumphs!")

His own house in Farmington, Connecticut, was one to which all manner of people were delighted to go. It is documented in photographs that the guest in the library might be the architectural historian Henry-Russell Hitchcock, dressed on that occasion by the great Parisian couturier Lanvin. The stranger on the roof might be a visiting architect – none other than Le Corbusier. The man in the backyard might be Salvador Dalí, and the man on the lawn might be the painter and sculptor Jean Arp, to which both Dada and Surrealism owed much. As for the spirit of the Museum of Modern Art in its early years, it flourished in Farmington.

Pierre Matisse had opened a correspondence with Soby as early as March 1932. This might have been no more than foresight. Soby was already known both as a collector and as a friend of A. Everett "Chick" Austin, who had turned the Wadsworth Atheneum in Hartford, Connecticut, into the most lively and inventive museum of the day.

Despite his tweedy and bespectacled look, Soby had a level of sophistication that made him a delightful and far from teetotal companion. ("That punch!," Matisse wrote to him after a visit to Hartford.) He was also someone who, in all his dealings, went at once to the top. (When anxious to learn to take photographs, for instance, he went to work with Walker Evans, a true poet of the lens.) Pierre Matisse was willing, on Soby's behalf, to go beyond the normal gamut of his interests. When Soby told him in 1935 that he was in the market for "Bérards of any period," Pierre busied himself forthwith and came up with a portrait of Jean Cocteau and a double portrait of Christian Bérard himself sitting on a beach.

Soby later gave the double self-portrait to the Museum of Modern Art, which also acquired on its own account the portrait of Cocteau. In the straight-faced councils of the Museum, Christian Bérard – painter and stage designer – is at most a marginal figure, and neither of these paintings is often, if ever, on view. But Bérard personified Paris in the theater before 1939, and his sets had an aerial frivolity that never cloyed. His was not an immortal art, but it had a miniature magic that was like no one else's.

Soby was in many ways the ideal collector for Pierre Matisse. So far from needing to be introduced to the work of Giorgio de Chirico, Joan Miró, and Balthus, he already admired them all hugely. He was to be closely connected with the Museum of Modern Art, directly or indirectly, for more than thirty years. (In 1946, as chairman of the Museum's acquisitions committee, he proposed that the Museum should acquire Matisse's great *Piano Lesson* of 1916.) At his death in 1979, the Museum received a bequest from Soby that transformed its Surrealist holdings.

He bought his first Miró from the Pierre Matisse Gallery in 1935. In that same year, by his own account, he walked through the gallery "like a man gone crazy with lust" when he saw the exhibition of de Chirico's paintings of the "metaphysical period" that Pierre had put together. He bought four paintings from that show and would have bought more if he could have afforded them. In 1940 he bought three more paintings from Pierre's second de Chirico show, and in 1955 he organized the de Chirico retrospective at the Museum of Modern Art and wrote the catalogue for it. He was, in fact, a full partner to Pierre Matisse in his feeling for the work of de Chirico's great period. (Of the sixty-nine illustrations in Soby's monograph on de Chirico, thirty-three had passed through the Pierre Matisse Gallery.)

As for Joan Miró's big *Self-Portrait* of 1937–38, Soby would almost have killed to possess it. In 1939 he heard from Pierre, who was in Paris at the time, that the picture was for sale. Soby by his own account telephoned to every Western Union office within fifty miles of Farmington until he found one that would cable Paris to confirm the deal.

"I have waited nine years to get this picture," he wrote to Pierre. "And that, you will admit, is longer than Ophelia waited for Hamlet to make up his mind." He also found the right phrase for one aspect of the self-portrait when he said that it "contains a virtual anthology of the cryptic and sometimes indefinable forms on which Miró's fame was first made."

Soby was not fazed by impropriety. If the boy on the far left in Balthus's *The Street* (1933) was up to mischief beneath the short skirts of the girl next to him, Soby had no more than a momentary anxiety when he brought it back from Paris and went through the American customs. (He had taken the precaution of concealing the Balthus by covering it, within its frame, with a same-sized painting of no conceivable interest.)

He also put himself on the line when he wanted to say something that was way ahead of its time. In his foreword for the catalogue of the Balthus exhibition at the Pierre Matisse Gallery in 1938 he said, "I do not think it presumptuous to call Balthus's *The Street* the kind of epoch-making picture that Géricault's *The Raft of the 'Medusa'* was." This went far. But how well it bears out what Soby said a few years later – that "Criticism is the art of affection. I like to write only about people whom I admire enormously and say why I think they are good!"

Others among Pierre's collectors were decorum itself. With Wright Ludington, client and dealer were "Mr. Ludington" and "Mr. Matisse" throughout a long relationship that was exceptionally cordial. Beginning with *The Rose Tower* by Giorgio de Chirico that he bought in March 1939, Ludington was a regular and reliable client of the gallery. As a payer, he was prompt. In July 1943, while serving in the American army, he bought two paintings by Yves Tanguy, two gouaches by Miró, and Matta's *Journal du Séducteur*.

It was also in 1943 that Pierre Matisse wrote to him and said that "Few people are fortunate enough to know as much as you do about what they like in painting." Unlike some other clients, Ludington was ready to buy work with which he did not yet feel entirely comfortable. When he saw the Matta show at the gallery in March 1945, he wrote to Matisse that "They are cruel, vicious pictures, but amazing and stunning. One of them is quite terrible, but also quite beautiful," he added. "I would feel even happier about it if it were not for the sexual details."

Ludington never lost contact with the gallery, even though difficulties of every kind beset the art trade towards the end of World War II. (In April 1945, Pierre wrote to Ludington that it was so difficult to find lumber for packing cases that he was having to have paintings rolled for despatch.)

Ludington never closed his mind to unfamiliar art. In 1946 he bought Wifredo

Lam's *Parade Antillaise* and *Le Chant des Osmoses*. In 1948 he bought two gouaches that Dubuffet had painted in El Goléa.

Once the war was over, Ludington resumed what was clearly an agreeably ample mode of life. (His summer itinerary included Claridge's in London, the Hotel Meurice in Paris, the Baur au Lac in Zurich, the Goldener Hirsch in Salzburg, the Grande Bretagne in Athens, and the Bristol in Vienna.) Pierre Matisse, on the other hand, could not take such a leisurely attitude. In September 1950, he wrote from Paris to say that "Never have paintings of high quality been so hard to find. Private owners hold on to them as a form of insurance against the future. But my upcoming anthology will put·57th Street in a rage."

In June 1951, he wrote that "They say that money is the nerve system of war. The same goes for the picture business." Ludington remained a very good client, but when he wanted to pay $10,000 cash in 1953 for Rouault's *The Wrestler* Pierre held out for $10,700 and got it. In March of that year, Ludington also bought Raoul Dufy's sumptuous *Harvest* for $15,000.

Ludington had planned to build a big house in Santa Barbara to show off his collection. When the "Hesperides House" (his name for it) was ready, it turned out that he really did have a great many very good paintings. Half museum in style, and half grand hotel, the house was the epitome of an America that was riding high and enjoying every moment of it.

At the time when the Pierre Matisse Gallery opened, both the name and the face of Edward G. Robinson were known to every man and woman in the United States who went to the movies. *Little Caesar* in 1930 had made him the actor of first choice for the tough, taut, and unsparing tales of criminality in which Hollywood excelled.

What was less well known was that Edward G. Robinson really loved painting. He didn't pussyfoot around, either, any more than he was indecisive on the screen. He liked the big statement. Cézanne's *The Black Clock* (c. 1870) was an archetypal Robinson possession. It had a great history. Cézanne had given it to Emile Zola, the novelist and critic, in whose apartment it would seem to have been painted. At the Salon d'Automne retrospective of Cézanne in 1907, it had inspired a great poet, Rainer Maria Rilke. It was the standard by which Edward G. Robinson the collector was judged.

Pierre Matisse opened his campaign by writing to Robinson in February 1935 and offering a "white" Utrillo of 1913–14 for $3,500. Robinson replied that he never bought a picture without seeing it first, but that he would try to come by. In January 1937, Pierre dropped off at Robinson's apartment a painting called *L'Homme à la Veste*. It was by Vincent van Gogh after J.-F. Millet. Done in

Saint-Rémy in 1889, it had been reproduced by Meier-Graefe in a biographical study of van Gogh, published in New York in 1922. This was a family purchase in that Pierre had put in $4,000, and his father and mother had put in $6,000 each. It had been on loan to the museum in Utrecht from a well-known Dutch collection, but it was basically unknown elsewhere. Pierre also ventured to remind Robinson that van Gogh did not regard his variants after Millet and others as mere copies, but as authentic expressions of his own self. Nothing came of this offer.

Relations between Edward G. Robinson and the Pierre Matisse Gallery were complicated by the fact that Robinson was simply too busy in Hollywood to take time off and get on the train to New York. But Pierre's blandishments finally paid off in May 1937, when Edward G. Robinson bought a Picasso – *La Mise au Tombeau* – from Pierre for $7,000. Robinson was delighted with it. When he finally got to New York for three days in January 1938 he fancied, and finally bought, the *Head of an Old Clown* and the *Woman with Hat* by Georges Rouault. He also bought – a rare triumph for Pierre – André Derain's *Jolie Modèle*.

It was also in May 1937 that Pierre floated before Edward G. Robinson the possible sale of the *Dance (I)* of 1909 by Matisse, which later became one of the crown jewels of the Museum of Modern Art. The fortunes of this enormous and indisputably historic painting are one of the more curious episodes in the history of collecting. Today it is one of the most familiar images in the whole of twentieth-century art. But in 1937 it was almost entirely unknown. Not seen in public since the Berliner Secession of 1913, it had for many years been rolled up in one or another of Henri Matisse's studios. In 1930, when Roger Fry published a monograph on Matisse, he was not able to discuss *Dance, Musique, Conversation,* or any of the other groundbreaking Matisses that had been in Russia since before 1914. There was therefore no agreed or accepted context in which the first version of *Dance* could be presented to the American public. And when Pierre Matisse said that it was much more important in the history of art than Picasso's *Demoiselles d'Avignon,* it may well have seemed like a dealer's hyperbole. In any case, Edward G. Robinson did not rise to the bait. Nor did the Museum of Modern Art, or any of the other museums to which he offered it. Possible private buyers were intimidated by its sheer size (8 feet 6½ inches by 12 feet 9½ inches). Consigned in 1936 by Henri Matisse to Pierre for $9,500, it did not find a buyer until 1939.

With time, a true friendship developed between Pierre and Edward G. Robinson. If Robinson came to Paris, exceptionally, Pierre made a point of looking after him. When the Robinsons went to the south of France, Henri Matisse received them in Nice. (When Mrs. Robinson asked after his health, he some-

what disconcerted her by saying, "I feel just fine! Every morning when I wake up I want to strangle something.")

In June 1938, when Pierre was in Paris, he wrote to Robinson that "Pictures in Paris are very scarce." The franc had gone down. People were demoralized, and with good reason, by the international situation. By November 1938, after Britain and France had given in to Hitler in Munich, that situation was undeniably much worse.

Yet, by his own account, Pierre's professional life in New York was in excellent shape. Of his current exhibition of sixteen paintings and nine drawings by Henri Matisse, he wrote to Edward G. Robinson that it was having a colossal success. "I've even had to charge admission," he said, "which I've never done before. Never before has a group of paintings as fine as this been shown anywhere."

In private life, Edward G. Robinson was nothing like the prototypical tough guy that he played on the screen. But, when fired up, he loved the to-and-fro of bargaining. A painting he coveted very much in Pierre's show was Matisse's *Odalisque with Magnolia*. This was lent to the show by Gaston Bernheim de Villers (as Gaston Bernheim now liked to call himself). He wanted $17,000 for the picture and not a penny less. Robinson offered $11,000 cash. Bernheim wouldn't hear of it. Robinson then offered $14,000. Pierre told Robinson that the owner was holding out for $17,000 and that after January 5, 1939, the picture would no longer be on the market. No deal was done.

Both dealer and client did better with the very important painting by Matisse called *The Dinner Table*. Subtitled by Matisse *Getting ready for dessert (still life)*, this had been begun in the autumn of 1896 and finished in the spring of 1897. Matisse was then in his late twenties, and his teacher, Gustave Moreau, had urged him to attempt a large and ambitious subject. *The Dinner Table* measures 39⅜ by 51½ inches and shows a servant bent over a table that is filled almost to overflowing with the makings of a sumptuous dessert. Matisse did not stint on the fruit, the flowers, the wine, the glasses, the flatware, the decanters, and the silver. The white of the tablecloth and of the servant's cap and apron have also an important role. As for the servant, she is no mere amiable cipher but a fine-looking young woman who is giving her very best.

The Dinner Table, which had belonged to Ambroise Vollard, has the kind of bravura quality that Renoir brought to his *Luncheon of the Boating Party* in the Phillips Collection in Washington, D.C. But it is also a painting in which the long fuse of the twentieth century has begun to burn. It was exactly the kind of Matisse with which Pierre would eventually have liked to target a major museum.

Edward G. Robinson also became an enthusiastic collector of "primitive" art from Africa and Oceania. He was, in fact, a collector with genuine weight. It

was a bad day for Pierre, as well as Robinson, when a divorce settlement compelled him to sell off his collection.

A more difficult client was Walter P. Chrysler, Jr. Chrysler had a lot going for him. He had the name, he presumably had the fortune, and he had the instinct for a major purchase (or, on occasion, a whole batch of them). As against that, he treated his dealers as Edwardian young men of fashion had treated their tailors. He was, in other words, a very slow payer. In January 1935, he bought a Juan Gris from Pierre "for cash." No check came. In March he broke an appointment to call on Pierre. On May 27 he sent a check for $100 "on account." To get money out of Walter Chrysler was like pulling teeth with a shoehorn. In 1937 he agreed to buy a Picasso *Mother and Child* (1923) from Pierre "for cash" ($8,000). In July 1938 Pierre cabled from Paris to ask if Chrysler could possibly pay his debts because Pierre needed money for a very big deal. A first payment of $1,500 "on account" arrived on January 1939.

A huge collector can be allowed huge liberties, no matter how discreditable it may be to take them. The art business is not one in which payment in full by return can be counted upon. Not to pay on time is a subdepartment of power. Even so, Pierre was taking a risk when he negotiated with Walter Chrysler in January 1939 for the sale of no fewer than four remarkable paintings.

They were: 1. The first version of *Dance (I)* (1909) by Henri Matisse, priced at $12,000; 2. A Picasso *Grey Nude* of 1905, from the Gertrude Stein collection; 3. A Matisse of 1910, *Seated Nude (Olga)*, which had been in a private collection in Russia; 4. *The Chauffeur* (1918) by Joan Miró. These four paintings could have been the nucleus of an exemplary new museum of modern art. As the asking prices for them totaled $28,000, and as Chrysler was to pay $19,500 for the lot, it cannot be said that he was robbed. And, for once, he paid up in full by the end of May 1939.

But alas! The Chrysler collection did not turn out well. There were wonderful things in it, but there was also an ever higher proportion of dreadful things. By 1962 Chrysler was telling John Canaday of the *New York Times* that he owned between 3,500 and 3,800 paintings and drawings and over 1,000 sculptures. When a large selection from them was shown first in Provincetown, Massachusetts, and later, in October 1962, at the National Gallery in Ottawa, it was universally agreed that nearly half of them looked like nothing and had come from nowhere. Pierre meanwhile had set his sights on a younger generation. That is why he took immediate note in 1936 of the predicted arrival on the art scene of Joseph Pulitzer, Jr., who at the time was still at Harvard. Paul J. Sachs, Harvard's ranking authority in such matters, had said, "Watch out for Pulitzer. He'll have a great collection one day."

This was not a perfunctory forecast. By his own account, Pulitzer at Harvard

was "inspired by the high level of intellect, dedication, commitment, and enthusiasm for art" that he found in the Fogg Art Museum among both faculty and students. Paul J. Sachs stressed the importance of firsthand contact with original works of art, and he did not stint on the rigors of an essential connoisseurship. But (again in Pulitzer's own account) Sachs also tolerated "eccentricity, individuality of taste, and a wide variety of approaches."

Pulitzer came along at a time when an informed taste for twentieth-century art was hard to form and hard to find. The map of the century's art had yet to be drawn. Many of its pioneers were not yet celebrities. Kandinsky in Paris, Mondrian in London, Max Ernst in New York had virtually no constituency, even when they came there to live. There were very few serious books. The catalogue raisonné was still unknown in that context. Modern art was the concern of a small and almost secret society. Curiosity had to be aroused, therefore, and ignorance laid to rest. That was the task before Pierre Matisse.

In the case of Joseph Pulitzer, he lost no time. On February 17, 1936, when Pulitzer was still only twenty-two, Pierre opened a correspondence that was to last for many years. He found out at once that although Pulitzer had not yet come into his inheritance as the prospective owner and editor of the *Saint-Louis Post-Dispatch,* he had a first-rate head for business and knew how to make up his mind.

Unknown to Pierre, Pulitzer had already begun to buy substantial works of twentieth-century art. He had in his rooms in Harvard's Eliot House a painting by Modigliani that he had bought in February 1936 from the Valentine Gallery in New York. *Elvira Resting at a Table* (1919) was not a beginner's picture. It was subtle, freighted with deep feeling, and with none of the immediacy that people look for in a "typical Modigliani."

Nor did the young Pulitzer bring to it a beginner's attention span. "Here in one picture," he said later, "were several threads woven together in a way to engage a young person who had been studying the entire span of art history." Among them, in his view, were "the Italo-Byzantine Madonnas of Modigliani's homeland, Sienese linear elegance, African sculpture, and Cézanne's brushwork."

Many years later, Pulitzer's classmate Sydney Freedberg – by then a pre-eminent historian of Italian Renaissance painting – said that "It was an amazing experience to see in the room of a Harvard undergraduate a picture that would have done great credit to the Fogg, or to any other major museum." Freedberg went on to say that "the young Joe Pulitzer must have been the object of some special near-divine protection. He had been endowed with every privilege a young man could have: high intelligence, fine sensibility, a rare sense of style, and, above all, a profound human goodness; and, to support all these, a consid-

erable but not spoiling wealth. To cap it off, an eccentric play of genes between his illustrious grandfather's quite bizarre countenance and a beautiful maternal line had given young Joe a remarkably handsome face – much more than movie-star handsome; men and women alike would turn to stare at him in the street. Further, he had an utterly unself-conscious air of aristocracy – to which, in terms of our American society, he was certainly entitled. As an older man he reverted, but only a little, towards the looks of his father and grandfather, so that if he no longer seemed a Greek god he made a very handsome Roman Senator."

In correspondence with Pierre Matisse, Joseph Pulitzer soon made it clear that he had learned the lessons of Harvard. He never bought from photographs. He insisted on having the complete previous history of every painting that Pierre submitted to him. He took note of everything that Pierre had to say, and in time he developed almost filial feelings for him, but he had a mind and a taste of his own.

It was not in his nature to be monopolized by any one gallery. On the contrary, he would go anywhere and see anything, whether in the United States or in Europe, with a perfect impartiality. He never stopped learning, and after his second marriage, in 1973, to Emily Rauh Pulitzer, he took on a whole new raft of enthusiasms.

He could never be hurried. As he described his approach to collecting, it was "leisurely and cautious, often waiting for new forms to be developed and settled and become accepted, or at least compatible with traditional or classical art – or modern works which we now regard as classical."

Matisse and Pulitzer took a little time to get used to one another. Pulitzer said No to a Braque still life in 1936, but Yes to another that Pierre put forward in 1938. He knew that Pierre was deeply committed to Joan Miró, and he didn't at all mind that he was given the full story about Miró's *The Farm* and how much it meant to Ernest Hemingway.

But he simply wasn't ready. Even in 1940 he turned down the offer of Miró's *Carneval d'Arlequin,* a key painting in the artist's career. It was not until much later – till 1967, in fact – that he was ready to pay $180,000 for two Mirós.

Pulitzer in his middle twenties was ready and able to tackle paintings that might have disconcerted even a seasoned senior collector. At twenty-three, in 1937, he bought from the Pierre Matisse Gallery the *Plaster Head with Bowl of Fruit* (1933) by Picasso. (He had, by the way, taken Picasso as the subject of his senior thesis at Harvard.) This was a tough picture, by any standard. On the left, the plaster head was treated with a terrible intransigence, as if it was not a human head at all but a knobbed and aberrant cylinder that had tied itself into a knot. On the right, both bowl and fruit were weightless and all but formless. At first glance, they and the head were irreconcilable.

Yet this was the kind of Picasso for which Pulitzer had expressed a strong preference. It was, that is to say, "one of the pictures that has wound up a search of his, rather than one of the transitional pieces that may have been more exciting and more expressionistic, but less resolved." It was the finality of the *Plaster Head with Bowl of Fruit* that compelled him to buy it.

In December 1938, Joseph Pulitzer showed both the breadth and the sureness of his ambition by buying from Pierre Matisse an important painting by Henri Matisse that had only lately left the studio. This was the *Conservatory* of 1938. Though it is actually quite small (28 ¼ by 23 ½ inches), it is a painting in which Matisse was feeling his way towards the major decorations that he hoped would find conspicuous homes in the United States and redouble his American reputation.

It introduces a favorite motif of his at that time – a pair of young women sitting indoors at their ease. Photographs taken at the time show that it went through at least twenty modifications, but the end result is ample, spacious, and quite fearless. There is a potted plant with five gigantic leaves. At the top left corner there is a voluptuous drawing on a deep red background. In the top right corner is a not quite legible canvas that is lopsided and left undefined. On the floor is a dog, asleep on a rug that rhymes with the red of the picture-within-the-picture at the top left corner of the canvas. This is a composition that could be five or six times its present size and not look blown up. Like Picasso's *Plaster Head with Bowl of Fruit, The Conservatory* was a painting in which a search was completed.

Meanwhile, in 1939, an exceptional opportunity came Pulitzer's way. The Galerie Fischer in Lucerne, Switzerland, was to auction a large number of works of art from German museums. Among them was a Matisse dated 1908 and called *Bathers with a Turtle*. It was a monumental painting, formerly owned by Karl-Ernst Osthaus, a staunch supporter of Matisse and the founder of the Museum Folkwang in Essen. This was a purchase with which a young man still only twenty-six could subtly readjust the idea of Henri Matisse as it existed in the United States.

Should he go to Lucerne? "Yes, certainly," said Pierre Matisse. And, what was more, he offered to go along and do the bidding. Together with another dealer, Curt Valentin, Matisse and Pulitzer sat up front at what was essentially a disreputable sale. The works of art on offer had been taken by force from German museums. But there was an argument for getting them out of the Nazis' orbit. The Matisse, in particular, was a landmark in Matisse's development. From that point of view, it belonged with the other major Matisses in which the United States was already so rich and would one day be a great deal richer. There was also a certain rightness about the idea that Matisse's son would make the winning bid and get the picture safely away.

And that is what happened. Pierre raised his hand. The gavel fell. *The Bathers*

with a Turtle was soon on its way to the United States, where it is now in the St. Louis Museum as a gift from Joseph Pulitzer, Jr. And so it turned out that in the front row of the Galerie Fischer in Lucerne, on June 30, 1939, the Pierre Matisse Gallery and Joseph Pulitzer, Jr., between them made a little bit of history. Pulitzer the collector came of age. The Pierre Matisse Gallery said good-bye to the doldrums of the early 1930s. A major Matisse of a kind and a date not often met with in the United States was brought into the American canon.

Good news of any kind was very rare in the summer of 1939, and at the time of the auction in Lucerne the outbreak of World War II was only nine weeks away. It was at this dreaded moment in time that Phase One of the Pierre Matisse Gallery was brought to completion.

By "Phase One" I mean the period during which Pierre Matisse defined his intentions and to a considerable extent realized them. He was looking for collectors with whom he could have an ongoing and if possible a lifelong relationship. He wanted to plan his exhibitions minutely and oversee every detail of their installation. His catalogues, though slender to begin with, showed both a rare gift for design and an ambition on Pierre's part to lead, one day, a double life as a publisher.

In all these respects, his professional life was lived in public. But there was also a sense in which he was a private dealer who worked with his own artists, and with his own collectors, and had his dreams for all of them.

By 1939 he had made an exemplary start with his collectors, even if not all of them were to stay the course. Others would come along later. As for the gallery artists, it goes without saying that their doyen and perpetual president was Henri Matisse. He was never under contract to the Pierre Matisse Gallery. Nor did he ever give Pierre any kind of exclusivity. But Pierre for many years was privy to his father's every move as an artist, and Henri Matisse's one-person exhibitions in 1934, 1936, 1943, and 1945 had landmark status.

By 1939 Pierre Matisse also already had links with three of the four artists whose reputations he was to make in the United States. He had shown Joan Miró in 1932, 1933, 1935, 1936, 1938, and 1939. He had shown Balthus in 1938 and 1939. He had begun to show Alberto Giacometti in 1937, and was preparing a full-scale retrospective of his work, known and unknown, when World War II came along and severed their relations until 1945. (Giacometti meanwhile was living in Switzerland and was not allowed to return to Paris.) The only big new artist who was not already in place by 1939 was Jean Dubuffet, who at the time was in business as a wholesale wine merchant in Paris and did not emerge as a major exhibiting artist until the end of the war. Once he was aboard, in 1946, the team was complete and a new chapter in the history of art dealing could begin.

The Programme in Place, 1934

By 1934, after only three years in business, the Pierre Matisse Gallery had put together as inventive a programme as could be found anywhere in Manhattan. There had just been an exhibition of new paintings by Joan Miró, with catalogue essays by Ernest Hemingway and James Johnson Sweeney. The New Year began with twenty-six paintings made between 1918 and 1929 by Henri Matisse. There followed, in succession, watercolors by Raoul Dufy, mobiles by Alexander Calder, "The Art of Oceania," which consisted of sculptures and textiles, and a show of etchings by a Spanish artist, Quintanilla.

It was an exemplary menu: three important European painters, a one-of-a-kind American who was still little-known, a plunge deep into the southern seas, and a Spanish artist for whom Ernest Hemingway and John Dos Passos stood tall in the catalogue. (Quintanilla at that time was a political prisoner in a Spanish jail.)

The Miró show included *The Farm* (1921–22), of which Ernest Hemingway said that "After Miró had painted *The Farm* and James Joyce had written *Ulysses* they had a right to expect people to trust the further things they did even when the people did not understand them and they have both kept on working very hard. If you have painted *The Farm* or if you have written *Ulysses* and then keep on working very hard afterwards you do not need an Alice B. Toklas !!!" Of *The Farm*, which belonged to him, Hemingway said, "I would not trade it for any picture in the world."

The Matisse exhibition of January–March 1934 was one that Henri Matisse had initially discouraged. At a time when other dealers were being forced to offer

Henri Matisse. *Portrait of Pierre.*
1909. Oil on canvas, 16⅛ x 13"
(41 x 33 cm). Private collection

PLATE 9

Henri Matisse. *Bathers with a Turtle.*
1908. Oil on canvas, 70½ x 86¾"
(179.1 x 220.3 cm). The St. Louis Art
Museum. Gift of Mr. and Mrs. Joseph
Pulitzer, Jr.

PLATE 10

Henri Matisse. *Dance (first version)*.
1909. Oil on canvas, 8'6 ½" x
12'9 ½" (259.7 x 390.1 cm). The
Museum of Modern Art, New York.
Gift of Nelson A. Rockefeller in
honor of Alfred H. Barr, Jr.

PLATE II

Henri Matisse. *Artist and Goldfish*.
1914. Oil on canvas, 57¾ x 44¼"
(146.5 x 112.4 cm). The Museum of
Modern Art, New York. Gift and
Bequest of Florene M. Schoenborn
and Samuel A. Marx

PLATE 12

Henri Matisse. *Studio, Quai St. Michel.* 1916. Oil on canvas, 58¼ x 46" (147.9 x 116.8 cm). The Phillips Collection, Washington, D.C.

PLATE 13

Henri Matisse. *Piano Lesson.* 1916.
Oil on canvas, 8'½" x 6'11¾"
(245.1 x 212.7 cm). The Museum of
Modern Art, New York. Mrs. Simon
Guggenheim Fund

PLATE 14

Henri Matisse. *Interior with a Dog.*
1934. Oil on canvas, 61 x 65¾"
(154.9 x 167 cm). The Baltimore
Museum of Art. Cone Collection,
formed by Dr. Claribel Cone
and Miss Etta Cone of Baltimore,
Maryland BMA 1950.257

PLATE 15

Henri Matisse. *The Conservatory
(Composition)*. 1938. Oil on canvas,
28¼ x 23½" (71.8 x 60 cm). Private
collection

PLATE 16

paintings at giveaway prices, he did not care to seem to be in competition. Nor did he wish to appear to be taking up the challenge of Picasso. Above all, he did not want an exhibition that would seem to be "more of the same."

Conceivably it was also in his mind that the Barnes decoration had been taking all his time and that he would not have any new easel paintings to show. This might suggest that, as some people would be happy to say, his career was coming to a halt.

On August 10, 1933, Pierre set out plans for a show that could not fail to be opportune. His father would be shown in majesty, with just six large paintings from a sharply defined period (1918–29). Most of them would be unfamiliar to the New York audience. There would be loans from Stephen C. Clark, Samuel A. Lewisohn, Mrs. Marie Harriman, Mrs. Abby Aldrich Rockefeller, and Miss Claribel Cone, among others. The show would have both style and substance.

Opposition ceased. On the opening day, and because Pierre Matisse at that time never sent out invitations, nobody came. But on the second day there were six hundred visitors, and after that it was pandemonium. Even Dr. Barnes had made himself agreeable.

The case of Alexander Calder was entirely different. Pierre had never before shown an American artist. This was due primarily to the undeclared war of nerves that existed between New York and Paris in the art world of the day. In the 1930s, European artists were believed by their colleagues in New York to have altogether too much attention among American collectors, curators, and critics. In this matter, people had always taken sides. The 1930s were in many ways the heyday of American modernism, but for glamour, prestige, and an intoxicating change of

Pierre with Alexander Calder, c. 1934

scene, Americans almost without exception still preferred to go shopping in Paris.

Pierre was neither unresponsive nor unfair, but he saw no reason to step barefoot into that particular basket of crabs. Quite apart from that, he had been born French. He was raised French. He looked French. He thought in French. When he wrote a letter, his every comma was French, even when his English had become very good. And his name, after all, could not have been more French.

So when Alexander Calder wrote to him on February 14, 1934, and asked if Pierre would feel like giving him a show of his *objects* – the name of *mobile* had not yet been suggested to Calder by Marcel Duchamp – Pierre said that his allegiance had always been, and was still, to "the so-called School of Paris."

In that context, destiny might have seemed to deal Calder a fistful of the wrong cards. In many ways, he was immensely and irreducibly American. His sculptor-father had left an unforgettable and ever-visible mark on the great city of Philadelphia. Calder himself was married to a great-niece of a major American novelist, Henry James. He had studied engineering at the Stevens Institute of Technology. In its glory days, he had studied painting at the Art Students League in New York under George Luks, John Sloan, and Guy Pène du Bois.

These were all-American beginnings. Yet he had also been a familiar figure in Paris since 1926. He was a close and admired friend of Joan Miró. In 1930 he had paid a memorable visit to Piet Mondrian in his studio in Paris. He loved French ways, French food, and French company. He was later to put down roots in France, near Tours, and live there for much of the year.

He loved French shirts, too, and he once asked Pierre to bring back from Paris "six or eight blue flannel shirts (the largest size, no. 44) of the kind I often wear. They come from 'Au Soleil,' on the Avenue du Maine, just across from the Rue de la Gaïté, and they cost about 25 francs each." (Red shirts of the same material were later to take precedence.)

It may also have helped that Calder's work was at the time in a category all its own. When he went to see Mondrian in 1930, he thought at the time, as he said later, "how fine it would be if everything moved, though Mondrian himself did not approve of that idea at all." Calder was an engineer, as much as an artist, and many of his mobiles could be dismantled and taken away in a shopping bag. Once erected, they were aerial, weightless, and continually on the move. Every least zephyr gave them a new configuration. (Wind-powered works began in 1932.) Calder was truly "one of a kind," and he brought just what Pierre needed to complete his dance card for the year.

So the Matisses went to spend a weekend with the Calders in Roxbury, Connecticut. It went very well. "Do come again whenever you like," Calder wrote.

("For days," he added.) A fast friendship developed between them. "Fast" was the right word in every sense. Calder's first letter was mailed on February 14. His first show in the gallery show opened on April 6, complete with a preface by James Johnson Sweeney that began with the words "The evolution of Calder's work epitomizes the evolution of plastic art in the present century."

As an installationist, Pierre Matisse had few rivals among twentieth-century dealers. Installation, in his case, comprised not only the placing and spacing of the work in the gallery, but the look of the catalogue. By turns luxurious and laconic, vestigial and artfully seductive, his catalogues revealed him as someone who regarded every show as a production. Overworked as the word may be, he saw each exhibition as a *Gesamtkunstwerk* in which visitors were by turns guided and left alone, spoken to and wreathed in silence. Every fraction of an inch counted.

Calder's idea of installation was distinctly less formal. He suggested that if he could come in the middle of the night on Saturday, March 31, he could soon get the job done. "Bring your camera," he said, "for it will look funny. And don't forget to let me know whether you have A.C. or D.C. current." Calder was to have in all eight exhibitions with Pierre Matisse. They did not at first make any money. (The clients' list that Calder had provided for his debut was later nicknamed "the pseudoclients' list.")

The friendship between the two families was to hold firm for almost ten years. In December 1934 Louisa Calder knitted a pair of gloves for Teeny Matisse as a New Year's present. Sandy Calder was completely himself, at all times, even to the point of signing off one letter with the words, "Our love to Teeny, and for yourself a good kick up the ass!" No offense was taken.

There was also a period during which Calder had a second identity as the impresario of his own model circus, every last detail of which was made and operated by himself. His audiences adored it, but it sometimes posed problems for the housekeeping. There was also a moment at which he decided that his mobiles looked their best when hung from the ceiling.

All these in themselves were engaging, and often lovable traits. Sandy Calder was virtually everyone's favorite human being. But when he came to the gallery and set to work with hammer and pliers, Pierre could never quite conceal his apprehension. In 1935, when he offered Calder a second exhibition, Pierre said, "I would be glad to put the gallery at your disposition, but I have very little money to spend, if any, on expenses, catalogue, mailing, etc. How about taking care of these?"

"There is also," he said, "another condition, and that is that there won't be any wall cracking, or floor nailing, or ceiling busting, and I have to be sure that my carpet is not going to be eaten up by your wild menagerie. This because

I think it would be a nice idea to give a circus performance with maybe a few improvements in the acts. Do let me know what you think about it."

Given the wary tone of this offer, Calder may well have seized the excuse that Louisa Calder was due to give birth in Roxbury on or around May 1, thereby putting all other thoughts out of mind.

The season also inaugurated a new enthusiasm for which Pierre Matisse had high hopes. Calder notwithstanding, he did not really want to show living American artists. Yet he did not, at the moment, have quite enough first-rate European artists on whom he had a special lien. What he needed was another sphere of interest.

What was then called "primitive art" was ideal for this purpose, and all the more so as it had already a high a status in France. In Pierre's native country, it had been prized since the first years of the century by painters, sculptors, and poets. One and all found in primitive art a source of imaginative energy that they had found nowhere else.

These in general were one-on-one encounters – lightning-flashes of perception, often born of quiet hours in the Musée Ethnographique (closed in 1935) in the by now long-vanished Trocadéro in Paris. They could happen in the Louvre, as when Picasso in March 1906 came upon some Iberian statues that had recently been excavated less than fifty miles from his birthplace in Andalusia. Revelations could also turn up in the trade, as happened when Matisse and Derain, among others, made their first purchases of African masks.

What was even more to the point, at the time when Pierre Matisse began to plan his exhibitions of primitive art, was the new status, worldwide, of what might be called colonial (or, later, ex-colonial) art. This new status was especially conspicuous in France. Even more to the point, for Pierre Matisse, was the fact that it had attracted a large number of connoisseurs. In 1927 the Galerie Surréaliste in Paris had mounted a show of primitive art from America. In 1928 Georges-Henri Rivière – a pioneer in the matter – had curated an exhibition of "Ancient Art from America" for the Musée des Arts Décoratifs in Paris. There were in all 1,250 pieces in the show. Some came from museums – among others, the Musée du Trocadero in Paris and the National Museum of Archaeology in Mexico City. The lenders numbered not only prominent members of the Parisian trade but independent enthusiasts – among them André Breton, the author, among much else, of the First and Second Surrealist Manifestoes. One of the prime movers in the Dada movement, Tristan Tzara, worked with Christian Zervos on the special number of *Cahiers d'Art* on Oceanian art that came out in March–April 1929. Tzara was to be an enthusiast for African tribal art until well into the 1960s.

This wave of interest – partly scholarly, partly aesthetic, partly commercial – was destined to grow ever more intense.

By the year 1930, a Parisian dealer, Stephen Chauvet, estimated that there were close to a hundred and fifty private collectors of "primitive" art in Paris. In 1930 the Hôtel Drouot held eleven catalogued auction sales – sales of importance, in other words. In one of those sales, a *masque en écaille gravé* from the Strait of Torres was sold for 21,700 francs, thereby setting a new record for a "primitive object." In the same year, when the dealer Charles Ratton lent forty-one pieces of African and Oceanian art for a major show at the Galerie Pigalle, his loans were insured for 793,500 francs.

French collectors were clearly looking for aesthetic quality, as much as for anthropological or scientific interest. An object that could be put on the wall to stunning effect was much in demand, and priced accordingly. It would soon be the dealer, as much as the governmental expedition, who would scour the Oceanian world for prime specimens of "primitive" art. (One such dealer was Pierre's colleague in Paris, Pierre Loeb. In 1929 he sent out a one-man expedition to what was then Dutch New Guinea.)

In the summer of 1931, there had been held in Vincennes, on the outskirts of Paris, an international exhibition that was devoted to the successes, and thereby to the validity, of the colonial principle. Great efforts had been made by the French authorities. The newly completed Musée des Colonies was regarded as the most modern museum building in France. The general director of the exhibition was Marshal Lyautey, who for much of his career had been the incarnation of the French imperial idea. Lyautey wanted to emphasize that on the one hand there was the old France, the France of Europe, and that on the other hand there was "the young France, the France across the seas," which mustered in all a hundred million citizens, spread over five continents.

The general idea was that, thanks to the wisdom and the high intentions of the old France, the indigenous peoples of the "France across the seas" might one day reach a level of civilization to which they could not otherwise have aspired. That they had once had a civilization of their own was never so much as mooted. Meanwhile, in the words of Marshal Lyautey, the old and the new France were one and indivisible.

But there were signs, that same summer, that those who lived under the French flag beneath distant skies did not necessarily wish to be either one or indivisible. The French colonial system was in trouble in Algeria, in Tunisia, in Morocco, and in the mandated territories of Syria and Lebanon. Before long, there would be more serious trouble in Indochina. Even in Paris itself, there were intellectuals –

mostly from the far left, with many of the Surrealists among them – who called for a boycott of the Colonial Exhibition. The origins, the ownership, and the eventual status of primitive art were hot subjects, and destined to get hotter.

So it was none too soon for Pierre Matisse to stake a position. Charles Ratton, the foremost French dealer in the field, was interested in the potential of an American market. Furthermore, primitive art had American connotations that would help to balance Pierre Matisse's own Eurocentric preferences in contemporary art. Primitive art had flourished in both North and South America. Before long, the words *Ancient Art of America* were regularly to appear next to *Modern French Paintings* when Pierre Matisse defined the scope of his gallery in four-line ads.

In a time when primitive art was still often thought of in terms of "golliwogs" and "totem poles," Pierre was careful to keep a delicate balance between French and American educated opinion. In the catalogue of the Oceanic exhibition that he put on in October–November 1934, there were prefaces by Frederick R. Pleasants of the Peabody Museum and Georges-Henri Rivière from Paris. The sculpture and textiles on view came from many places – the Sepik River, New Mecklenbourg, Admiralty Island, the Marquesas Islands, Easter Island, the New Hebrides, and British New Guinea among them. Pleasants was not one to go overboard, but he said among much else that the show "brings an aesthetic experience far greater than the mere presence of by-products of savagery."

Georges-Henri Rivière went into detail. Of the textiles in the show, he said that they were made from the bark of trees in the islands of the Pacific. The fig tree, the breadfruit tree, the mulberry tree – all were pressed into service. The bark was laid down on wood and beaten flat with mallets. "A kind of paper results," he said, "like Chinese or Japanese paper, but thicker. On this paper, the artist draws with wooden sticks, stained with earth colors. The motifs vary from place to place.

"This is an art," he went on, "that does not aim to copy nature. It aims to renew nature, using a code of signs that is very close to the idioms of modern western art. We find in this art, in its first freshness, the magic realism with which the painters most representative of our century have got back on track. The art of painting in western Europe was thereby spared from a definitive bastardization – with on the one hand a lifeless academicism and on the other a servile naturalism."

In 1935 Pierre had a show of Peruvian art, all of which came from Charles Ratton. Many of the pieces had been shown earlier that year in a show called "Tapestries from Ancient Peru" at the Musée des Gobelins in Paris. Comment in the New York press was guarded. One reviewer said that "This is patently not an exhibition to excite, at a first glance, anyone but the specialist. Yet even the layman can enjoy its brilliance of design and its rich, though reticent color."

Pierre's stockbooks indicate that his interests ranged from Cambodia to the Gabon, and British Honduras to Vera Cruz. They also indicate that there was a lot of what might be called crossover or emigrant trade, in that many an enthusiast for modern European art developed a liking for primitive art.

Pierre's exhibition programs had got the gallery a good name. Yet neither then nor later did he have either the manner or the temperament of a hustler. (Stephen C. Clark, one of the major American collectors of the day, once went so far as to say that "I doubt that Matisse will make a go of it – he's too honest.")

But by March 1934 Pierre wrote to his father, "My gallery is getting more and more popular. If only I can last, all will go well. I get many compliments about my exhibitions – the installation, the quality of what I have to show – but sales are few, and they take forever to bring off. The first flicker of interest has to be coaxed along."

As to that, Henri Matisse had firm opinions. "A picture is never sold," he said, "until it's been paid for. An offer may have been made and accepted, but collectors are so dependent upon every last turn and twist in their private affairs that they can always find a way to get out of it."

By 1934 Pierre Matisse had long ceased to be the industrious apprentice. He was able to speak to his father plainly and freely. Their exchanges were marked by a new level of confidentiality. He became, in fact, his father's closest confidant. It was not that Henri Matisse told Pierre "everything." It was that he told him almost everything, and that there was plenty of it.

Their exchanges were subject to what now seem to us to be archaic restraints. Telephoning by satellite was still way off in the future. So was the fax. Telegrams sent through Western Union cost money and were anything but confidential. Mail between New York and Europe was entrusted to a small number of transatlantic liners. There were days when no boat was scheduled to leave New York. A German liner, the *Bremen,* was the vessel of first choice. Not to have the schedules at hand was to risk a long delay. In spite of all this, the correspondence between father and son picked up both speed and weight. Letters of twelve and thirteen closely written pages were not uncommon.

This was a difficult time for Henri Matisse. He had not completed an easel painting since 1929. A. E. Gallatin, a major collector of living art, had said that Matisse "had never done anything good since Moscow." (Matisse had been to Moscow in 1911 to see the many paintings of his that were owned by Russian private collectors.)

It had always been an agony for him to start painting again after a time away from the easel. Having to do the Barnes decoration twice over had left him

completely exhausted. It also left a residue of self-doubt that was nonetheless obsessive for being quite irrational. It was not his fault that the first of the Barnes versions did not quite fit the given space. Nor was it his fault that the specific discipline that powered the Barnes decoration had to be practiced for so much longer than could have been foreseen. With never a laden brush in sight, nor the smell of paint on the palette and fresh from the tube, the Barnes decorations had formed habits that were not easy to shake off.

This was the more infuriating in that Henri Matisse was eager to make a triumphant return to easel painting in the Salon des Indépendants of 1934. It was vital to him, but he couldn't decide quite how to do it. On March 28, 1934, he gave Pierre a detailed account of his problems, and of how he hoped to solve them.

After twenty or more sessions of work on the *Woman in a White Dress* (1933–34) he caught pneumonia at the beginning of January 1934. As soon as he could, he went back to the painting for another full week. "The bouquet of flowers had good qualities," he wrote to Pierre on March 28, 1934, "but the composition did not come together as it should."

Then there was "a big square painting with a lot of vegetation" (*Interior with a Dog/The Magnolia Branch* [1934], now in the Baltimore Museum of Art) "that also had good qualities, but I had to rework more than one of the colors.

"The red floor had to be changed. I made part of it gray. I also had to rework the dog. It turned into an experimental picture, and one that was very useful to me, because I need to have my mind continually on the move.

"I was not doing all this for my amusement. I did it because the *Interior with Dog* looked thin, and almost superficial, for so large a surface." (It measured 61 by 65 ¾ inches.) "I had to pull it together. So I covered the red floor with some painted paper that had been left over from my Barnes decoration. It then seemed to me that, whereas the complementary red of the floor had dominated and immobilized the movement of the green branch, the branch had suddenly recovered all its former energy.

"So I kept the gray paper by me. What remained was the green of the branch, the violet of the back wall, the blue of the curtain, and the blue of the big vase on the table. The red of the book and the red of the roses sang out strongly and in tune. I kept the picture as it was for a fortnight, and then Simon Bussy came to see me. He admired the richness of the painting, with its red floor. Then, while he went in to see your mother, I thought that my painting was well constructed from the point of view of the choice of colors and the way they interacted with one another. But I also felt that the final effect was meager, and that I was capable of a much greater richness of color. I missed that. So I put back some of the gray elements on

the floor. When I called to Simon Bussy to come and see it, he was amazed. He looked at it hard before lunch, and again after lunch. Then he said, 'It's better. So leave it as it is.' What I had done was that I had achieved a greater sensation of space. The picture was not empty. It was simply made with materials that were less rich than I should have liked – with colored pigments, in other words.

"Too much was sacrificed. It was like line drawing, or etchings made with a drawn line. That's not enough for me. I need a richer idiom. That's why I am glad that the illustrations I am to make for James Joyce's *Odyssey* [sic] are to be lithographs. I shall be obliged to build my forms with something other than arabesques. I shall need values that range from black to white. It will demand a big effort, but I have to do it. When I wanted to remain in complete command of the Barnes decoration, I had to simplify my ways of working, all the time. And now, unless I am to dwindle to nothing, I have to recover what I discarded. I cannot stay with my habitual gamut of color.

"It will be worth the effort, but my state of health leaves so much to be desired. Yet if I cannot recover all my old qualities in a renewed and strength-ened form, my career will be over."

Another obstacle had to be made clear in this long letter.

"To continue with my work, I need complete calm. I cannot go on living as I have lived for a long time now – haunted by a mortal disquiet that pursues me day and night. Your mother is better, in certain respects, but she is in a state of total nervous exhaustion. She has to be kept quiet and untroubled at all times. The least anxiety kills her.

"Both Berthe and I were deeply concerned about her this last winter. Her state of mind was completely transformed. She detested everyone – myself, above all. She had fits of rage that even she herself found frightening. For weeks, she and I met only at mealtimes. We ate together, but never a word passed between us. She could not bear to hear me speak. (The doctor had told me to let her lead the conversation, but there never was any conversation.)

"Then she took a dislike to this house. We had to put her in Berthe's apart-ment for a month. I stayed here alone, completely disheartened. Since she came back, things have been a little better. But she cannot endure distress of any kind. Everything must be kept from her. She is like a little girl. Even when she is rela-tively well, as she is at this moment, the least little thing can destroy her. She is gravely, truly gravely ill.

"This is the atmosphere in which I have to work."

Henri Matisse said a great deal in this letter – more, perhaps, than he would have said to anyone else – but he did not say everything.

Ever since he painted his *Conversation* (1908–12), which is now in the Hermitage in St. Petersburg, he had ranked very high as a poet of matrimonial stasis. Who was the pajamaed husband in *Conversation*, if not Henri Matisse? And who was the wife who sat in judgment upon him, if not Amélie Matisse?

A key element in his life, and an entirely new one, was that in October 1934 a young Russian emigrée called Lydia Delectorskaya was hired as a paid companion to Amélie Matisse.

When Henri Matisse first came to know "Madame Lydia," as he always called her, she was only twenty-two. Born in Tomsk, in Siberia, she had lost her father and mother in childhood. Taken to Manchuria by one of her aunts, she had been to school in Harbin.

In late adolescence, she had arrived in Paris, knowing not a word of French. On the rebound from a mistaken marriage, she went down to Nice. For six months, in 1932–33, she worked for Henri Matisse as a studio assistant when he was completing the second version of his decoration for the Barnes Foundation.

When the work was all done, her employment lapsed. But when Amélie Matisse needed someone who would be a combination of nurse and paid companion, she was asked if she would take it on.

"Yes," she said. Hired at first by the day, she later became a fixture in the apartment. Her work was exemplary. But her duties took on a new dimension when Henri Matisse suddenly began to look at her in a new way. Almost at once, he asked her to pose for him.

This did not at first conflict with her duties for Madame Matisse. When Amélie Matisse went to stay with her sister Berthe at Beauzelle, Madame Lydia escorted her. But very soon she was also taking on the multiple role, where Henri Matisse was concerned, of favorite model, secretary, and studio manager.

This was a joyful development, in that it was with paintings and drawings of Madame Lydia that Matisse overcame whatever had obstructed his return to easel painting. But it was also an ominous development, in that Henri Matisse spent much of every day in the company of a very beautiful young woman who had become indispensable to his activity as an artist and was to remain so until his death. On the matrimonial front, this was anything but auspicious. The problem was to haunt him for the rest of his life and cause a great deal of trouble in his family.

Meanwhile, Henri Matisse may well have come to think that the United States was a very promising market for his work. He had won the first prize at the Carnegie International. There had been the Barnes commission, not to mention the many marvelous easel paintings dated between 1905 and 1924 that Barnes had also acquired.

There was also a recent transaction that Pierre Matisse had fostered. This was the purchase by Miriam Hopkins for 55,000 francs of the Matisse *Odalisque with Magnolia* of 1924. Miss Hopkins was one of the most admired movie actresses of the day. She was planning to devote a whole room in her house to the painting. Pierre had always been anxious to break into the Hollywood market.

The projected illustrations for James Joyce's *Ulysses* seemed to fit well into the American perspective. George Macy of the Limited Editions Club in New York had asked Matisse during the summer of 1933 if he would make illustrations either for *Manon Lescaut* or for any other work of classic literature that might appeal to American bibliophiles.

Matisse liked to have a book on the go, by way of an insurance against inactivity elsewhere. James Joyce himself had given him a free hand. (Both were agreed that the illustrations should be in no way anecdotal.) The fee seemed adequate. If there was an American market for fine books, all the auguries were good. Besides, Pierre was right there in New York and could look after his interests.

As it turned out, the *Ulysses* project had built-in dissatisfactions. To begin with, it was essentially a dialogue of the deaf. There is no sign that anyone concerned with the project had actually read *Ulysses* from beginning to end. When the subject was first mooted, Matisse asked his friend and neighbor Simon Bussy what the book was like. Bussy asked his wife, Dorothy, who was a sister of Lytton Strachey and a close friend and translator of André Gide. She said that *Ulysses* was a whole universe in itself, and one in which Matisse would be free to pick out

Sketching in the Louvre, 1932

whatever suited him. To read the book, even in the French translation, would be a colossal task. The Bussys did not have it in French, or even in English ("too expensive," Bussy said). But she could give him an outline of the Homeric analogies that Joyce had explored in *Ulysses.*

Writing to his daughter Marguerite on March 13, 1934, Matisse said that he intended to work from Homer, rather than from Joyce, whose turn of mind did not seem to him to lend itself to illustration. Discarding, therefore, the chance of referring directly to Leopold Bloom and Stephen Dedalus in their surroundings derived from Dublin, Matisse settled for Calypso, the Sirens, the Cyclops, Nausicaa, Circe, and Penelope.

Once the contract was signed, he went straight to work. He looked around for a male model who could stand in for Ulysses emerging from the sea. He went to the nearby Mont Boron to find a landscape with rocks and eucalyptus trees that would suit for Ulysses. When in Paris, he went to the Concert Mayol and sketched a young woman acrobat who walked down a staircase on her hands. (She was to turn up in "Circe.")

Joyce had not seen the sketches, any more than Matisse had read *Ulysses,* but the two men agreed on the telephone that Matisse was on the right lines and should go ahead. There were to be six lithographs, plus a large group of sketches. The plates were to be printed in Paris.

Initially, Matisse rather enjoyed himself. Ulysses blinding Polyphemus suited him very well. So did the Mediterranean estate that doubled as Joyce's Ithaca. So, also, did the naturalistic brothel scene. One by one, the sketches were got ready. Thereafter, problems abounded. The lithographic studio in which Matisse worked in Paris proved to be quite inadequate for his intentions. He therefore abandoned the lithographic stone and turned to copper plate. After he had taken great trouble to choose a typeface that would go with his illustrations, it was vetoed by Macy as being far too big for such a mammoth text. Not one, but three or four stout volumes would be needed. Worse still was Macy's decision that the printing of both text and images would have to be done in New York. To have it done in Paris would cost four times as much.

Other problems also gave big trouble. In his illustrations for the poems of Mallarmé in 1932, Matisse had had total control of a sumptuous edition. It had been limited to 145 signed and numbered copies. Image and typography were as one. The book was meant to seduce a bibliographical elite, and it succeeded. By way of preface, Matisse would say only that "This is what I did after reading Mallarmé with pleasure."

But the books put out by the Limited Editions Club were not aimed at a

handful of moneyed connoisseurs. It catered to a large mixed American public that liked its books to be immediately accessible. This was a plainer, tougher, more straightforward operation than the ones to which Matisse was used. The bottom line was never forgotten. George Macy saw no reason to pay up until he had in his hands the making of a salable product.

Already on October 5, 1934, Pierre wrote to his father that "Macy would like to know exactly to what section, or to what scene, in *Ulysses* each one of your etchings will correspond. Without finding fault with the fact that the images are drawn primarily from Homer's *Odyssey*, he insists that each image should also correspond to a specific incident in *Ulysses*."

Pierre went on: "My dear Papa, you must bear in mind that, as I have told you from the beginning, this publication is addressed to a public that is much less refined than the one to which you are accustomed in Europe. The book must be as uncomplicated as possible. Doubtless it is for that reason that you have not yet received any money."

Not to have got his money was a matter of mounting aggravation to Matisse. James Joyce had been paid. Why hadn't he? How could he get on with his other work? Frantic letters were followed up by frantic cables. Not until December 1934 did Macy come up with the money.

It was a further grief to Henri Matisse that he didn't like the way the book had worked out. The etchings had been wretchedly printed in the United States. They were too gray, they lacked intensity, and they were as if swallowed up in the book. Matisse never admitted the illustrated *Ulysses* to the canon of "his" books. Nor did he ever speak of it.

What with Dr. Barnes at the beginning of the year and Mr. Macy at the end of it, this was a difficult time for Pierre Matisse in his role as the honest broker between French and American expectations.

But the news from Henri Matisse at year's end was reassuring. Loyal as he always was to some of his contemporaries, he very rarely caught on to artists younger than himself. But in the case of Joan Miró, he bestirred himself. He went to see the new works on paper that Miró was about to show with Pierre Matisse in New York. He wrote at once to say that they showed an enormous progress. They had been shown to Braque, Léger, Picasso, and André Breton, all of whom had been impressed.

As for himself, "I give all my time to painting," he wrote to Pierre, "and I've gone deeper, and more fully, into color." And, sure enough, Matisse in 1935 would be back in top form as a painter in oils on canvas. In that context, at any rate, the time of trial was over.

Joan Miró Comes Aboard,
1932–40

One of the best things that ever happened to the Pierre Matisse Gallery was that Joan Miró came aboard in November 1932. He stayed there for more than half a century. With hindsight, the alliance seems so absolutely and inescapably right that we have trouble working out why it had not come about sooner.

Joan Miró (1893–1983) was precisely the kind of artist whom Pierre Matisse most wished to represent. In 1932, at thirty-nine, he was in midcareer and continually reinventing himself.

Already at twenty-four, as a landscape painter in his native Catalan countryside, he had proved himself with what James Johnson Sweeney called "the palette of his earliest recollections: the magentas, olives, and deep blues of primitive Catalonian church murals and the gay raw reds and yellows of the peasant artisan."

In *The Farm* of 1921–22, he proved that he could excel as an encyclopedist of the given fact. "Everything that appears in the painting was there," he said many years later. "Nothing was invented." (He liked to quote what Poussin had said when someone asked him how he had managed to go so far in his paintings. "I neglected nothing," said Poussin.)

But also, as in *The Tilled Field* and *Catalan Landscape (The Hunter)* of 1923–24, Miró could mate fact with fancy in ways that he summed up in 1923 in an almost telegraphic message to his painter-friend J. F. Rafols:

"Hard at work and full of enthusiasm. Monstrous animals and angelic animals. Trees with ears and eyes and a peasant with his Catalan cap and his rifle, smoking a pipe.

"All the pictorial problems resolved. We must explore all the golden sparks of our souls. Something extraordinary! The Acts of the Apostles and Brueghel. (Forgive the irreverent comparison!)"

Miró could work small, as in the little works that were to come to the Pierre Matisse Gallery by the dozen in 1937 and found many admirers, and he could work big, as in *The Birth of the World* (1925), without losing his sense of scale. By the time that he wrote to Pierre Matisse in 1933, there was every reason to suppose that he had a virtually unlimited potential. His every exhibition could be a landmark.

It was also in Miró's favor that in all his dealings he was exact, prompt, and entirely reliable. He could lay out a plan of work for a year ahead and keep to it in its every detail. He did not disdain commissions, large or small, and always brought them in on time. He knew how to pace himself – sometimes way up in an empyrean to which he alone had access, and at other times adopting the slow, patient, unchanging ways of the archetypal workman. "In this way," he was to say to Pierre Matisse one day, "I never get overtired, which would be a handicap." (He used the English noun, by the way.)

Yet the rapport between Pierre Matisse and Miró's work had not been instantaneous. Pierre once told Rosamond Bernier that when he first saw Miró's work it did not attract his curiosity. "And then in 1928 his dealer Pierre Loeb gave me a painting as a bait. There was a blue star and a red dot. I thanked him and put it away in a closet. I just didn't get it.

"Then one day I went to the Salon des Indépendants in Paris. I suddenly became indifferent and suspicious. I thought that none of those paintings meant anything. I was disgusted and saturated by the avalanche of meaningless art.

"I came home, terribly depressed. I took everything off the walls. In the closet I saw the Miró. It was a composition that had a precision all its own. There were no empty words. Miró wanted to do the maximum with the minimum. I didn't need to know what it was about. It was a revelation. Life was bursting out everywhere."

It was with Joan Miró that Pierre Matisse was able, for the first time, to shape the American career of a major European artist. This was his true métier, and the one towards which he had been gradually making his way. Instead of shopping around, or working in concert with other dealers, or haunting the sale rooms, or taking works of art on consignment, he would have exclusive rights of representation in North America. He also had an agreed share of the artist's new work, year by year. Once he had those rights, he put them to work in whatever ways were best for the artist and best for himself. The artists would have a certain security, and Pierre would have freedom of action, with no rivals in that particular field.

It was a privilege, and one that could be expensive, even if the sums involved

now seem almost laughably small. But as a way of life it was incomparably more satisfying than the traditional role of the "art broker."

Joan Miró's work had been handled for some years by Pierre Loeb, a dealer of Pierre's own generation who had opened the Galerie Pierre in Paris in 1924, when he had just turned twenty-seven. Gifted with magnetic powers peculiar to himself, he made friends with Pablo Picasso at the opening of the first-ever show at the Galerie Pierre.

Picasso at that time was not under contract to any gallery, and he allowed Pierre Loeb to make landmark shows of his work, old and new, in December 1927, February 1935, April 1937, and January 1939.

In June 1925, Pierre Loeb gave Miró his first solo exhibition in Paris. The opening was at midnight on June 12, and it came to have legendary status, both for the quality of the work on the walls and the idiosyncratic mix of enthusiasts for Miró who crowded into the gallery and later spilled onto the street. The honor roll of Miró's supporters, as specified on the invitation card, amounted to a Who's Who of painters, poets, men of the theater, and all-around leaders of opinion. Dealer and artist between them had mustered Paul Eluard, André Breton, Max Ernst, Michel Leiris, René Crevel, Benjamin Péret, and Antonin Artaud, among many others.

Pierre Loeb had also included Miró in the landmark show of "La Peinture Surréaliste" in November 1925. He could not have had better company in that context, since the lineup included Pablo Picasso, Jean Arp, Giorgio de Chirico, Paul Klee, Max Ernst, André Masson, and Man Ray. In 1930 and 1931, Pierre Loeb had been an energizing force behind Miró's exhibitions at the Valentine Gallery in New York. By any standard, he had a nose for the new. From 1926 onwards, he had Miró under contract.

Ever since 1928, Miró had wanted to get firmly established in the American art scene. Pierre Matisse had given him a show in New York in 1932, but in international dealings he was still very much Pierre Loeb's protégé. And then, in 1933, the Depression hit hard among Parisian dealers. Pierre Loeb had organized a big Miró show at the Right Bank Galerie Georges Bernheim. Hopes had been high, but on November 5, 1933, Miró wrote to Pierre Matisse and said, "Pierre and I were very well pleased with the show. Morally, it was a great success, and one that may be a landmark in my career. But it did very little business. Pierre told me," Miró went on, "that you might like to have a follow-up show of my work in New York? If business was better, I would come to New York myself, but with things as they are I must, alas, give up that idea.

"However, the Ballets Russes de Monte Carlo will be in New York in December and January. I have done the scenery for a ballet called *Jeux d' Enfants*,

with music by Bizet. It might be – as was the case in London – a good time to show my work. If you are interested, I could send a list of people who might like to hear about the show."

Short notice withstanding, Pierre was certainly interested, and the show duly opened in his gallery on December 29, 1933. Miró's list of people to be invited included A. E. Gallatin, Katherine Dreier, and Galka Scheyer among collectors, Georges Antheil and Edgard Varèse among composers, Alexander Calder and Jean Hélion among artists, and Ernest Hemingway (who was in Africa at the time) by way of back-up. (Next time round, the name of "Ezra Pound, Rapallo" was added.)

None of the people on the list would seem to have bought a picture, but Pierre had a long patience in such matters. Miró was delighted with everything to do with the show, except that Pierre had given the name *Composition* to one of the paintings. "I should have preferred it to be called simply *Painting*," he wrote, "because *Composition* has overtones of abstract painting in a dogmatic or superficial sense." This was not simply quibbling, either. Lines of battle were drawn at that time between pure abstraction, on the one hand, and the poetic image on the other.

In March 1934, the relationship between Miró and Pierre Matisse took a new turn. Times were bad, all over Europe. There was among thoughtful people an almost universal and well-founded fear that the entire continent of Europe would shortly be on the skids and quite possibly never recover.

For this and other reasons, Miró was anxious to have a firm base in the American market. Pierre Loeb, for his part, could no longer bear the entire brunt of his contract with Miró. Under the terms of that contract, Pierre Loeb got Miró's entire output for exactly 2,000 francs a month. How would Pierre Matisse like to be one of four partners who would each pay 500 francs a year? The new partners would have the benefit of Loeb's long years of spadework, and he had persuaded Miró to be modest in his demands.

Pierre didn't like the idea at all. (As it happened, another Parisian dealer, Pierre Colle, had already made overtures to Pierre Matisse about the Miró contract.) The idea of four partners, each knowing the others' business, was abhorrent to him. He had worked on good terms with Pierre Loeb for years, but in this matter he wanted to be the dominant partner. He cabled on March 21, 1934, that he would take fifty percent of the contract, with an option on a further twenty-five percent.

To make it quite clear, he wrote and said that "I don't want anyone else to be in with us. I want to be alone, where America is concerned, and to have as little competition as possible. I need the absolute agency for America, and you are not to sell directly to the United States, where there are very few Miró collectors. I should not care to share the Miró contract with anyone else, and that is why I

asked you to give me all the shares that you could not take care of yourself."

By May 2, 1934, the agreement was almost completed. Pierre was delighted to have the exclusivity in America of such a marvelous artist. "But we must not forget," he wrote (in English), "that although Miró is widely known, a very little number of his followers dare to buy his pictures. I have to see my way through before I can engage in a contract of this sort. Miró's reputation in the United States is based on a certain sensationalism as a result of the picture you sold to Mr. Gallatin (*The Dog Barking at the Moon* [1926]) and it will require great efforts on my part to combat the public's views."

Pierre may well, by the way, have thought it just as well that Miró lived in Europe. To deal on a day-to-day basis with artists who live next door, more or less, and can drop in at any time, calls for a particular temperament. Pierre was devoted to his artists, but he liked to work at his own pace and in his own way, rather than to be on call every hour of the day. Nor did he like his artists to be within easy reach of the poachers.

The fact that he was not often in the same city as Joan Miró during their fifty-year association is not something of which posterity will complain. Miró in his letters to Pierre expressed himself freely, concisely, and altogether to the point. Without those letters, we should know him less well.

On April 29, 1934, Miró wrote to Pierre Matisse and said, "I am very happy, my dear Matisse, to let you have a share in my output. The United States seems to promise a happy future for us all. You know that for a long time now I have had the friendliest feelings for you, as well as for your brother-in-law and for Madame Duthuit, not to mention my admiration for Henri Matisse. I should be truly happy to share my output between you and Pierre Loeb, a close friend of long standing.

"Even so, I am well aware that it is not easy to handle my paintings. It calls for almost as much courage as it takes for me to paint them. Above all, we must all three – Pierre Loeb, you, and myself – be guided by an absolute faith. As the son of a very great painter, you know better than I what it means to lead the life of an artist. You have witnessed both the long struggle and the eventual triumphant success.

"I have envisaged the terms of this contract as very modest, given the difficulty of these present times and the sacrifices that we shall all have to make, each in his own way, until success comes our way.

"Pierre Loeb, on his side, has always sustained me with great courage. He has never let me down. When conditions in Europe became more and more difficult, we thought of you as someone who would work with us and thereby open a new phase in our offensive. I have no doubt that the three of us will always work together in the closest collaboration."

As often the Pierre Matisse Gallery functioned almost as a family collective. Marguerite Duthuit sometimes deputized in Paris for Pierre when the time came for the gallery to choose its share of the new work. In 1937 Georges Duthuit interviewed Miró at length for Christian Zervos's magazine, *Cahiers d'Art*. Henri Matisse would drop by Pierre Loeb's to see what Miró had been doing. He also kept in close touch with Pierre about Miró's fortunes in New York.

In terms of their experience as young men in Paris, Pierre Matisse and Joan Miró had very little in common. As biographers often say, "They might have . . ." or "They could have" But in almost every case, the fact is that "They didn't"

Between 1920 and 1925, Pierre Matisse had still been feeling his way. He did not enjoy, or perhaps even crave, a dazzling acquaintance of the kind that Miró so rapidly acquired and almost always kept. What he would eventually do with himself remained uncertain. He had, moreover, an inborn diffidence and was still the Pierre Matisse who got up from a café table at which he was sitting with André Derain because he thought that he might be in the way.

Joan Miró had a vastly richer and more varied experience of Paris in the first half of the 1920s. Admittedly he was seven years older than Pierre and therefore more sure of himself. But, in terms of lasting friendship and vivid acquaintance, few people had been as lucky as he.

During his youth and early manhood, Miró's native Barcelona was one of the more cosmopolitan cities in Europe. During World War I, this characteristic was heightened by the status of Barcelona as a hospitable refuge from the war. There was a particularly enterprising dealer called Josep Dalmau, who already in 1912 had been showing Juan Gris, Marcel Duchamp, and Fernand Léger. Miró was to meet Dalmau in 1916. In 1917 Dalmau introduced him both to Marcel Duchamp and to Francis Picabia, who had just arrived in Barcelona from New York and was editing and publishing a particularly lively avant-garde magazine called *491*.

In that same year, Ambroise Vollard organized a very large exhibition of French art in Barcelona. Miró made acquaintance at first hand with the work of Courbet, Manet, Degas, Monet, Cézanne, Gauguin, Seurat, Bonnard, and Vuillard. When Diaghilev's Ballets Russes visited Barcelona in November 1917, Miró got to see *Parade*, the controversial ballet in which Picasso had lately collaborated with Erik Satie, Léonide Massine, and Jean Cocteau.

In 1918 Dalmau gave him the first solo exhibition of his career. (It consisted of no fewer than sixty-four paintings, plus drawings.) "Don't worry," he said to Dalmau, "your gallery will be big enough. What I've done is interesting, but incomplete. I think that when I get to be 70 I shall do really good work."

When he first went to Paris in March 1919, Miró was not entirely without

contacts. It was not every young man who arrived in Paris at that time with a present for Picasso from his mother – and that present a delicious cake, baked with her own hands. As Miró's biographer, Jacques Dupin says, Picasso welcomed Miró "like a younger brother." He was delighted to own Miró's self-portrait of 1919, and before long he also acquired the majestic portrait of a Spanish dancer – a collocation of dignity, brio, and bounce – that Miró painted in Paris in 1921. Picasso kept both of these paintings, all his life.

On this first, brief visit to Paris, Miró was too shy, too reticent, and too stunned by the whole experience to come to terms with the great city. World War I had come to an end as recently as November 11, 1918. As yet, the convalescence of Paris had hardly begun. Wounds not yet healed were still a source of terrible pain, and bad dreams still omnipresent. On every hand, a vast and embittered struggle was in progress, with no "brave new world" in sight.

It was not in Miró's nature to experience that tormented Paris as a spectator, an onlooker, or a cultivated tourist. He wanted to be in Paris as a participant, and as a struggler among other strugglers. "It is an aberration," he wrote to his painter friend Ricard in Barcelona, "to let the days go by and wait for things to get better. I don't give a damn about tomorrow. It's today that interests me. To put it another way, I'd rather be a failure, an utter and total failure, in Paris than make a splash in the stinking waters of Barcelona."

There was much for Miró to disentangle in Paris. Although Picasso could not have made him more welcome, there was something about the atmosphere of his studio that Miró found deeply depressing. "Everything there is done for his dealer, and for the money," he wrote to a friend. "A visit to Picasso is like calling upon a ballerina who has lovers round the block."

Even so, he couldn't wait to get back to Paris. And when he did get back there, in March 1921, he had a run of good luck that was almost miraculous. Paris at that time was still a city in which poets "held court" in cafés. One of those poets was Max Jacob, the poet and friend of Picasso and many others. Jacob held his receptions every Wednesday afternoon at the Café Savoyard, way up in Montmartre. Where other poets might have left newcomers to fend for themselves, Jacob introduced every one of them like a music hall master of ceremonies. He was funny, he was mischievous, and he was agreeably debonair.

On this particular Wednesday, Joan Miró presented himself. He had not a perfected social presence, he was not a "brilliant talker," and he was short of stature and rather timid. One of the other people in the group was a painter called André Masson. Masson remembered later that he and Miró went up to one another, on their own. "Why is it that painters recognize one another as such before they're

even introduced?" Masson said in 1972, when Miró was seventy-nine and Masson was seventy-six.

But they did recognize one another, and on the way downtown it emerged that both of them were to have studios at no. 45, rue Blomet. Masson had just rented his, and Miró was to have the use of one that belonged to a Catalan sculptor called Pablo Gargallo, who spent part of the year in Paris and the rest of the year in Barcelona.

This proved to be very good luck for Miró. The rue Blomet was a little street in the fifteenth arrondissement, with both blue-collar and no-collar affiliations. "The rue Blomet belonged," Miró said later, "to the ordinary people of Paris." No. 45 had an entrance hall, a live-in concierge, a courtyard with a lilac bush. Apart from that, it was a tumbledown place. There were artisans who made a terrible racket. There was an academic sculptor who specialized in monumental figures of the recently deceased. In Miró's studio, the stove that he had bought in a flea market didn't work. "But," as Miró said in 1977 to Dupin, "the rue Blomet was a decisive place, a decisive moment for me. It was there that I discovered everything that I am and everything that I would become."

In this, André Masson was the key figure. Though he was three years younger than Miró, he had already survived one of the century's more terrible adventures. For two years he had fought as a French soldier in some of the longest and most harrowing battles of World War I. Wounded in the chest in April 1917, he was abominably treated by French doctors who eventually sent him to a mental hospital. "My ego had been pillaged forever," he said later.

But, by the time Miró met him, Masson's generous, all-embracing intellectual capacities were entirely restored. He loved ideas, and he loved to share them. In that context, his high spirits remained irresistible until well into his eighties. (Clement Greenberg was to say in 1953 that "André Masson's presence on this side of the Atlantic during World War II was of inestimable benefit to us.") Gifted young people liked nothing better than to spend time with him and his young wife in the rue Blomet. Nor did they see any limit to his potential. After Michel Leiris – later to become famous as an autobiographer, ethnographer, and authority on tribal art – had had dinner with the Massons in October 1922, he wrote in his journal that "André Masson is, with Picasso, the greatest painter now living. He must have discovered among his brushes the key to the Terrestrial Paradise that the Almighty had somehow mislaid. He is also the most delightful painter that I know. After dinner, we simply couldn't stop laughing."

"Our studios were in adjoining rooms," Miró said in 1977 to Jacques Dupin. "Each of us could hear everything that went on in the other's place. It

was very noisy in his and very quiet in mine. Masson lived with his wife, Odette, and his small daughter, Lili, in the midst of indescribable disorder and filth. Masson worked at night as a proofreader for the *Journal Officiel*, and he went to bed at dawn."

Miró's studio was quite unlike any of the others at no. 45. He did all his own housekeeping. He waxed and polished the floor. He had whitewashed the walls. His canvases were neatly arranged. His brushes were perfectly clean. He was compulsively tidy. The studio was "like a ship's cabin," Miró said, but one brightened by a collection of brilliantly colored little popular figures from Majorca. He was bone-poor at the time, often lived on radishes, and could only afford to lunch out once a week. But whenever he went out he wore a monocle and white spats.

It was the charm of no. 45, rue Blomet that it was not at all sectarian. (It was, by the way, within earshot of the Bal Nègre, the first black dance hall in Paris.) Gifted people of all kinds and many allegiances came there. There were also some regulars who were not especially gifted and did not become famous. But they contributed by the very fact of their good humor, their alertness, and their sociability.

The poet Robert Desnos remembered that among all the people who came to no. 45, rue Blomet there was never anyone who put on the dog, or spoke ill of the others. "Brotherhood and mutual confidence were the mark of those young people," he said.

Masson would often send his visitors to call on Miró, but to little effect. One of them was D.-H. Kahnweiler, who had opened his tiny gallery in the rue Vignon, near the Madeleine, in 1907, and promptly shown Picasso, Braque, Derain, and others. He looked conscientiously at everything, went away without a word, and never came back. Jacques Doucet, the first owner of Picasso's *Demoiselles d'Avignon,* was also taken to see Miró. He, too, had nothing to say. But, once outside, he said to Masson "Your neighbor is completely crazy!"

Someone who was more encouraging was Pablo Picasso. By 1924 he was married to Olga Kokhlova, and lived in style on the rue de la Boétie, just off the Champs-Elysées. But he came down on the metro, all the same, and got out at the Volontaires station-stop like everyone else. When he had looked at what Miró had done, he said, "After me, you are the one who is opening a new door."

Someone who pushed on that "new door" and kept it wide open was Tristan Tzara, the pioneer Dadaist whom Miró acknowledged in 1931 as having been "one of the first to see and like my painting." Another was a Belgian collector and connoisseur called René Gaffé, who bought heavily into Miró, Max Ernst, and René Magritte. In May 1928, Miró had a show at the Galerie Georges Bernheim in Paris. This was the high point of Pierre Loeb's loyal and whole-

hearted sponsorship of Miró. It may be significant that when Miró gave his first-ever interview to a Catalan newspaper, *La Publicitat,* in July 1928, he said that "One of the things I am most interested in now is broadening the international representation of my work."

But after the American stock market crash of November 1929, the long ordeal of the Depression, and the triumph of Adolf Hitler in Germany in January 1933, the world looked very different. In October–November 1933, Miró had another show at the Galerie Georges Bernheim. Like the previous one, it was organized by Pierre Loeb. On November 5, Miró wrote to Pierre Matisse that although it had not done much business, the eighteen paintings on view had been greatly admired.

Once he was assured of Pierre's interest, Miró set out in detail the formidable program of work that he had in mind for the next year. "You will see," he said, "that I am still working very hard and in many different ways. Allow me to say that you don't have to worry about any of it. I cannot live without working. Even when I don't seem to be working, I am thinking of what I shall do next.

"Please be kind enough to confirm that as of April 1, 1934, and for one year you will take three-quarters of my production. The other quarter is reserved for Pierre Loeb. In return, I am to receive two thousand francs (2,000 frs) on the first day of every month – 1,500 francs from you, and 500 from Pierre Loeb.

"At the end of this first year, the contract can be renewed from year to year, subject to three months' notice on either side. As of April 1, 1935, I reserve the right to increase Pierre Loeb's share in my output to 50%, if that is his wish."

The teamwork between Pierre Matisse and Joan Miró was ideally smooth. If Pierre had a client who wanted a painting by Miró with a dog barking at a kite in the sky, Miró was happy to go along, always provided that the inner rhythm of his seasonal activities was not disturbed. The canvas should be roughly 29 ½ by 23 ⅝ inches, but the image could be vertical or horizontal or even square, if the client preferred it that way. The painting in question was to be one of Miró's most popular images.

The scale of Miró's activity can be judged from the list that he submitted to Pierre in April 1936. He would bring with him to Paris fifty watercolors and gouaches, each 15 ¾ by 13 inches, fifty drawings in *encre de Chine,* watercolor, et cetera, of the same format, twenty-four drawings in Conté crayon, collage, et cetera, each on a sheet of *papier Ingres,* 10 paintings, "60 figure" French canvas, done with a single black line, 10 objects (or object/paintings) and 12 paintings, on average 21 ¾ by 13 inches.

In all, therefore, 156 works of one kind or another were to be divided between

Pierre Matisse and Pierre Loeb on the occasion of Pierre Matisse's upcoming visit to Paris. In addition, Miró expected to finish another twenty-five paintings during the summer and would like these to be considered for his forthcoming exhibition in New York. The paintings in question, though related to the others, would be outwardly quite different. "I hope," he said, "that all these details will help you to prepare an offensive for the fall season."

Though small in stature and known for the twinkle in his eye, Miró knew how to look after his own interests. In that same letter of July 14, 1936, he asked Pierre to look into an invitation that he had received from "Mme. P. V." to take part in a group exhibition in London. He had just shown in London, apparently with great success, but he didn't like what he had heard of the group in question.

"They sound to me to be all too like the imbecility of the Abstraction-Création Group. And there are two women painters among them! The whole thing has a bad smell. Please take care that we don't get caught up in it. The time has come when we can say 'To hell with democracy!' and 'To hell with being nice!'" (It would seem likely that the "group" was the London Group, and that "Mme. P. V." was Paule Vézelay, herself an artist [a "woman artist," no less] and a longtime fixture on the London art scene.)

In July 1936, Miró's attention was focused above all on the show that Pierre Matisse had scheduled for him in December of that same year. He had not forgotten the promised *Dog Barking at a Kite in the Sky*. Once it was finished, he would work on the poster for his New York show. He also wrote to Pierre, "Before you leave Paris, please let me know the exact dimensions you have in mind for the invitations, because I want them and the poster to have something in common. I'll send both the poster design and the invitation design with the paintings. It will be the simplest solution – more especially in the present circumstances."

And what were those "present circumstances"? Nothing less than the revolt of the Spanish armies in Morocco, led by General Franco. This was, in effect, the beginning of the Spanish civil war, which was to last until March 1939 and end in the establishment of a fascist regime under Franco.

All this was many years ago, and many wars ago, too. Of those who still feel its brand in their very bones, few now remain. It signaled the beginnings of a multinational ordeal that would last for many years, the world over. Whether in Barcelona, or in his family property in Montroig, not far away, Miró was at the ringside of these beginnings. Like many another native of Catalonia, Miró regarded the rest of Spain more or less as a foreign country, and Spanish as more or less a foreign language. An imposed authority – civil or military – was suspect by its very nature.

Even so, he had his wife and his young daughter to think of, and in August 1939 there was a good deal of back and forth with Pierre Matisse about the hazards of holding currency – French francs and Spanish pesetas, especially – in stressful times. Pierre was not too worried about that – in fact, he thought that the situation could eventually calm down and that "all would be for the best" – but he did set up a bank account in New York for Miró, and he also agreed to send the monthly allowance in dollars.

Meanwhile, Franco or no Franco, Pierre had an offensive of his own to plan. First, he brought forward Miró's show in New York to November 30, with a view to profiting by the interest that would be aroused by the major exhibition of "Fantastic Art, Dada, Surrealism" at the Museum of Modern Art. Miró would be well represented in that. But the truly important thing, for Pierre, was that Miró's show at the gallery would go off, as he put it, "with a very big bang."

"I intend," he wrote, "to make a really alluring catalogue, like the one for the Picasso exhibition at Zwemmer's in London." For the cover of that catalogue, he needed to use Miró's signature, exactly 4¾ inches wide. Ever attentive to the esthetics of avant-garde publication, he wanted the cover to look something like the cover of *Transition* magazine.

Next he asked not only for an exact list of the exhibits, but for a breakdown of that list by categories. This applied especially to the works that were part painting, part sculpture, and part collage. To many visitors, these would look odd, not to say freakish. Presentation was vital. Should they be framed? If so, how? He liked his shows to have a rational unity in that regard. There was nothing that he disliked more than a show that looked like a magnified tag sale, no matter how distinguished some of its elements might be.

On August 29, 1936, and without a word about the advances of Franco's army in southern Spain, Pierre spoke of a problem that only Miró himself could solve. He had brought back with him from Paris Miró's *Rope and People, I* (1935). Destined for the Museum of Modern Art show, it was a painting of three human beings, every one of them in a state of great distress. Superimposed upon the painted image was a length of thick rope, partly frayed. In the heterogeneous subject matter of the Museum show, this could be said to need, if not "explanation," a certain guidance. This was 1936, not 1999, and the map of this particular phase in art was still a matter for discussion.

There was also the upright construction called simply *Object*. This was a compound assemblage that included a stuffed green parrot, and, hanging by a string, a stuffed silk stocking with velvet garter, a doll's paper shoe, a man's black derby hat, a celluloid fish, an ancient engraved map, and cork ball dangling from

a string. *Object* was reproduced and remarked upon with varying degrees of ponderous ribaldry in newspapers throughout the United States.

This posed problems. "As I see it," Pierre said, "the Surrealist movement has just about run its course. I am afraid it will now fall into the hands of those who merely exploit it. Yet this has been, after all, one of the most important movements in art since the end of the war.

"It is therefore of the highest importance that the authentic artists, whether or not they are or have been Surrealists, should tell us exactly what is the sense of the three-dimensional objects that have played a part in their work. If they do not do this, other, fantasticated interpretations may come to be accepted.

"If I am to give a sane and rational account of these works, I have to know how these objects relate to your two-dimensional work. You are to my mind a born painter. Such is your painter's gift that I should be very grateful if you could tell me what is the exact purpose of these three-dimensional works. This would help me to head off misunderstandings."

Miró replied without delay. To begin with, he announced the imminent dispatch of twenty-six paintings, each of them 42½ by 31⅛ inches, on Masonite ("a very solid material").

Next, he agreed that surrealism had gone as far as it could possibly go. "It is now the arrivistes and the weaklings who are going to profit by it. It is up to dealers like yourself to watch out for them, in spite of the momentary commercial advantages that they may offer.

"You ask me about the objects, and how I come to make them. This is what happens. I feel myself magnetized by a particular object. There is nothing premeditated about it. After that, I feel myself drawn towards another object. When the two are put together, their contact produces a poetical shock, a mutual and immediate infatuation. It is this need for one another that makes the poetry work on our emotions. Without this human, living element, it wouldn't work at all.

"My work has nothing whatever to do with Freud, or with the theoretical, ideas that people have claimed to see in it. If it has an existence that is entirely its own, it is a human and a living existence. It has nothing to do with 'literature' or 'intellectuality.' Work of that sort is born dead, already rotting and destined to disappear in short order.

"Don't give too much importance to what I say. You know me well enough to see that I am simply writing to you as a friend. I am not laying down the law. That would be absurdly pretentious."

As the opening date of the New York show grew nearer, Miró opened his heart to Pierre Matisse. On November 16, 1936, he wrote: "I must begin by telling

you how deeply grateful I am for all the trouble that you have taken to see to the security of my little family in the event that an accident befell me.

"I must also tell you how moved I am by the courage and the enthusiasm with which you have organized my forthcoming exhibition. When backed by someone as active and as far-seeing as yourself, it should cause a sensation."

Every detail of the show engaged his attention. In particular, the dispatch of the new series of paintings on Masonite might have posed problems. The Masonite itself was like granite, in Miró's view, but the paintings also include passages that involved the use of stones and areas of heavy sand. "Don't worry," he wrote to Pierre, "if stones fall off here and there. *That is what I intended. Losses of that kind will make the paintings look less like 'objects of beauty.' In exchange, they will take on a whole new power. The surface of the paintings will look like a battered old wall with a great potential for eloquence.*

"May I suggest that when you frame the Masonite paintings you go all out for a maximum simplicity and severity? They should not look in any way 'artistic.'"

As this letter did not arrive until two days before the show was to open, Pierre could not act upon Miró's injunctions. But meanwhile he had sold a recent Miró to Walter Chrysler and had himself donated to the Museum of Modern Art the *Rope and People, I* (1935), which was to figure in the "Fantastic Art, Dada, Surrealism" show, which opened on December 7, 1936.

It should have been a happy time for Joan Miró, but it wasn't. In a rare moment of ill-humor, and on December 14, 1936, he wrote to Pierre Matisse as follows: "I should be obliged if you would send me by the next boat a few catalogues for myself. I realize how much effort and hard work you put into this exhibition, but it should not be forgotten that I am the one who painted the pictures. It seems to me that this should be the point of departure for everything else.

"Permit me to point out that the signature that you have put on the front page has absolutely nothing to do with mine? You have only to look at the original to see that.

"Also, I am surprised to see that you have not included any of my recent pictures. Allow me to say that in my opinion this was a big mistake. In this age of pederasts and snobs, you should have hit really hard. I had worked with enthusiasm, and with complete faith in this exhibition, in the belief that the ensemble of the show would be simply sensational. I am very much hurt that you did not back me up by showing the full range of my work, thereby delivering the K.O. to the whole gang of those useless, effeminate, and impotent people.

"The catalogue is rather too reminiscent of the French flag. If you had sent me a cable, we could have shown the new paintings for a few days in Paris,

where they would have caused a great stir. I could also have been spared all the work that I did for the catalogue – the gouaches, the outsized signatures, etc. – none of which was used."

There followed a further list of things either not done or not sent, and a final word about money. "In the future, please take care to send my monthly check on the first day of every month. Now that my wife and daughter are coming here, I have obligations that I absolutely cannot neglect. Furthermore, the financial situation of my family in Catalonia has completely changed since the revolution. It is I who have to help my mother and my sister, who has been widowed since the recent events." This letter ended not with Miró's customary and affectionate salutation, but with a severe "I shake your hand."

Pierre saw Miró's outburst as a tumult of confusion. In point of fact, the Masonite paintings were in the show, and one of them had already been sold to Walter Chrysler. He had sent reviews, catalogues, and photographs. If he had not used the catalogue material that Miró had sent him, it was because it arrived some time after the catalogue had been printed.

New York was not like the rue de Seine in Paris. A quiet and understated catalogue like the ones put out by Pierre Loeb in his Galerie Pierre would not have gone down well on East 57th Street. The New York catalogue had been warmly approved by James Johnson Sweeney, a close friend of Miró and an acclaimed arbiter of taste. Pierre hoped that, instead of being thrown away, it would have a long shelf life in libraries all over town.

"Do not torment yourself," was the refrain of Pierre's reply. No one knew better than he that a major exhibition was a major source of anguish for every artist. Not to have news was torture. Silence, even if unintended, bred suspicion. But, before long, Miró was delighted by the photographs of the show, sales were satisfactory, all thoughts of betrayal were banished, and the Matisse/Miró relationship held firm.

By January 12, 1937, Miró was full of plans for the coming year. He had a whole slew of big new paintings in mind. He also had about a hundred unfinished canvases that he had left behind in Barcelona. "It was in Barcelona that work came naturally to me," he wrote to Pierre. "In Paris, I cannot improvise. But now that I cannot get back to Barcelona I have decided to attempt something entirely different and paint some very realistic still lifes. Whether I can succeed remains to be seen. We are living through such appalling times, and what is going on in Spain is terrifying beyond all imagination. Meanwhile I'm going to go as deep as I can into the reality of everyday objects. It may get me started."

Pierre had an absolute faith in Miró's creative energies. But he was not convinced of his gifts as a controversialist. He remembered the terms in which Miró

had spoken of rivals and possible enemies in the Parisian art world. And when he heard that Miró might give Christian Zervos an extended interview for *Cahiers d'Art,* he didn't care for it. "I've thought a lot about the Zervos proposal," he wrote. "I wonder if you really need to go into battle in this way, and all the more so as it won't really serve any purpose. Every intelligent person agrees with you about the Parisian art world. They all agree with what you would say. The others will never change. They want from life what they want from art – to be amused, but with elegance. They pass from one buffoon to another. Everything else is 'boring' and 'too serious' in their view. I tell you all this, my dear Miró, because it is dangerous for a painter to take part in controversies of this sort. It is in his paintings that a painter can speak out. Look at Picasso, for one! He never speaks 'on the record.' He never gives an interview. His painting is all the stronger for it."

What eventually appeared in *Cahiers d'Art* was an interview that Miró had granted to Pierre's brother-in-law, Georges Duthuit. Miró said among other things that men of letters were "among the worst enemies of MAN. They should be treated as criminals and punished accordingly."

Meanwhile, as of January 1937, Miró was at work on the promised still life in which he was "to go deep into the reality of everyday objects." At that time he had no studio of his own. For that and other reasons, he often went back to the Ecole de la Grande Chaumière to draw from the model, as he had done in 1919. Even the time limit that was set to each session satisfied his need to get back to the plainest, most limited, and most dutiful aspect of making art.

It is also possible, as Jacques Dupin suggests, that Miró in his middle forties remembered how the great Antoni Gaudí, the presiding genius of Barcelona, would sometimes slip into the drawing class at the Cercle Sant Lluch in which Miró, then aged twenty, was a student.

For lack of a studio, he looked for a small, enclosed, and undistracting place in which he could sit, month after month, within touching distance of his subject matter. A space of that sort was found for him on the mezzanine of the Galerie Pierre in the rue des Beaux-Arts. In this way he made sure that he was locked in with his subject, with nothing else to look at. The picture was on a big scale – 32 by 45 inches – and it would take him until May 1937 to complete it. "I'm doing it directly," he wrote. "I am never out of contact with my subject, even for a minute. I've set out the elements on a table. They consist of:

An empty bottle of gin, wrapped in paper tied up with string.
A big apple.
A fork, stuck into the apple.
The end of a loaf of black bread.

An old shoe.

I'm going to take this subject just as far as it will go – every inch of the way. What I want is that it should hold its own beside a still life by Velásquez.

"It has something of *The Farm* and something of *Table with a Glove* (1921), but it is not as anecdotal as *The Farm* and it is more powerful than the other one. There is nothing sentimental about it. It has a realism that has nothing to do either with photography or with the kind of realism that has been exploited by some of the surrealists. It is reality itself, profound and passionate.

"To look nature in the face and dominate it is enormously exciting. It is as if, with just the power of your own two eyes, you were able to make a panther drop dead at your feet in the middle of the African bush.

"This down-to-earth approach, this clearing of the ground, will give me new possibilities. As I had already suggested to you, the idea has been on the stove in my mind for some time. Recent events have made it inescapable. It comes from an inner necessity, and not from any wish to show off and prove that I can paint. That would be mere pretentiousness – playing at art, in other words."

On March 21, 1937, Miró wrote to say that the still life would soon be finished. "I am totally absorbed by it. I believe that it will be, with *The Farm,* the best thing that I have done – though I hope to do better still later."

The *Still Life with Old Shoe* (1937), as it eventually resulted, is not the masterpiece of unaltered objectivity, with every trace of the world outside cleared away, that Miró had suggested. Nor did Miró consciously intend it as his *Guernica.* As he said in 1978, it was when leaving a bistro in Paris that he saw the broken bottle wrapped in paper on the ground, with the word "Gin" by way of identification. He asked his wife to go and buy an apple. But when he stuck the fork into the apple he was not thinking about the way a soldier sticks his bayonet into the body of an enemy. He did it because that was the way to eat an apple. Nor did he intend the crust of bread to symbolize hunger. He had simply wished, while living through terrible times, to "ground himself" in realism.

But, as he wrote to his American friend James Thrall Soby, who was to organize his second New York retrospective in 1959, "I later realized that, without my knowing it, *The Old Shoe* did contain images rooted in cruelty – above all, perhaps 'the bottle, like a burning house' that spread its flames across the entire surface of the canvas. But all this was done without the slightest conscious thought, and with absolutely no narrative or literary intention."

In the case of Miró, Pierre Matisse had made up his mind to target the ideal location for the paintings that came his way from 1933 onwards. He saw them not so much as objects of commerce, but as children ready for adoption. Thanks

to this, and to the presence within the Museum of Modern Art in New York of a long series of fellow enthusiasts for Miró, the Museum was to acquire, either directly or later, and whether by purchase, by gift, or by bequest, an incomparable series of works by Miró. From the *Table with Glove* (1921) to the *Woman with Three Hairs Surrounded by Birds in the Night* (1972), they are, in effect, a museum within the Museum, and a monument to Pierre's professional qualities.

High in the canon of the Museum of Modern Art's holdings is the *Self-Portrait* (1937–38). This was a monumental undertaking – it measures 57 ½ by 38 ¼ inches – and it was in many ways as much a human landscape as a "likeness." "I am presenting myself as three times life-size," Miró wrote to Pierre. "If I can bring it off in the way that I hope for, it will be the most sensational thing that I have ever done. I use the word 'sensational' in its profound sense, and without affectation. It will be thoroughly worked through, and very detailed, without scamping the big masses and the the major volumes. It's devilish hard work, I can tell you."

On December 5, 1937, Miró wrote that "I work on my portrait every morning. It will be more important, and more representative, than *The Farm*. It's hugely ambitious, but by sheer hard work I hope to bring it off."

By February 5, 1938, Miró thought that after more than one discarded start the drawing was really coming together – "so much so, in fact, that it will sum up my whole life and have a place of its own in the history of painting."

On March 4, he regarded the portrait drawing as finished. "I have now turned the portrait to the wall for a few days so that I can start painting it with my eyes refreshed. I think it will be the most important work of my life."

The big self-portrait drawing was done in a room in the apartment that Miró had rented on the rue Auguste-Blanqui from the expatriate American architect Paul Nelson. Discussing it in 1961 with Rosamond Bernier, he said, "I wanted it to be very precise. I took one of those magnifying mirrors that people use for shaving and I held it up in various positions around my face, drawing everything I saw very meticulously."

The use of this mirror resulted in an overall intensity that would have been difficult to achieve in any other way. It was as if Miró were clambering over terrain that broadened and bulged in unpredictable ways and in unexpected places. Though intended initially as a preliminary drawing that would eventually be painted over, Miró came to realize that it was a major achievement in its own right.

As was his usual custom, he already had a large series of new drawings and gouaches in mind. Furthermore, he was also learning how to make prints. He foresaw, quite rightly, that printmaking would be highly congenial work and give him all kinds of new ideas.

Meanwhile, Pierre Matisse always tried to get a great early Miró whenever one presented itself. The world news might chill the blood. The gallery might have zero visitors. The fall season of 1937 had been bad, and the beginning of 1938 was even worse. Money was short. Even so, Pierre did not hesitate to buy from Pierre Loeb the *Spanish Playing Cards* of 1920 that he had always coveted. "I am putting together a little collection of your earlier work," he wrote to Miró on March 11, 1938.

Pierre at that time was sending Miró $165 a month for a two-thirds share in his output. Given the size of that output, the payment sounds merely nominal today. But in stable times it would have been just enough to keep Miró and his family afloat. These, however, were not stable times. Miró could never put money in the bank against an emergency. Even a dentist's bill could give him sleepless nights. Conditions in New York were such that Pierre's checks did not always go out on time.

But the fascination of Miró's work never failed. "It is always an extraordinary moment," he wrote to Miró on March 11, 1938, "when I open a new package of your work." Where the work was concerned, he had the "absolute faith" of which Miró had spoken the year before. And when the time came for them to renew their contract, Pierre asked that he should continue to have a two-thirds share for the following year.

"I need that share," he wrote. "Undeniably, it is in America that your work is most highly regarded. In Europe, it is known, but the possible terrain is now reduced to France, England, and Scandinavia. Here, I have the whole American continent as your market. Unfortunately, Pierre Loeb was wild with rage, last year, that I should have a contract with you. Since then, our relations have deteriorated to a degree that I find extremely painful."

The problem would before long be resolved – "blown away" might be more to the point – by the upshot of World War II. (Pierre Loeb, who was Jewish, did not wait to be rounded up, but made his way to Cuba.) But it was a continuing anxiety for Pierre that the more successful some of his artists became, the more eager were some of his colleagues to take shares in them. This applied in a lesser degree to the magazine editors who liked to get in first with their work. Zervos's *Cahiers d'Art* had always backed Miró, and eventually there was to be trouble when Zervos's wife, Yvonne, opened a little gallery in Paris and wanted to have a show – "just a little one" – of recent works by Miró. "For the love of God," Pierre was to say to Miró, "don't get tangled up with those people. I need everything that you can possibly give me."

What was much more on Miró's mind was a last-minute commission from

Joan Miró. *Portrait of E. C. Ricart.* 1917.
Oil and pasted paper on canvas,
32⅛ x 25⅞" (81.6 x 65.7 cm). The
Museum of Modern Art, New York.
Florene May Schoenborn Bequest

PLATE 17

Joan Miró. *The Tilled Field (La Terre labourée)*. 1923–24. Oil on canvas, 26 x 36½" (66 x 92.7 cm). The Solomon R. Guggenheim Museum, New York (FN 72.2020)

PLATE 18

Joan Miró. *The Potato*. 1928. Oil
on canvas, 39¾ x 32⅛" (101 x
81.6 cm). The Jacques and Natasha
Gelman Collection

PLATE 19

Joan Miró. *Rope and People, I.*
1935. Oil on cardboard mounted on
wood, with coil of rope, 41¼ x 29⅜"
(104.7 x 74.6 cm). The Museum
of Modern Art, New York. Gift of the
Pierre Matisse Gallery

PLATE 20

Joan Miró. *A Star Caresses the Breast of a Negress*. 1939. Oil on canvas, 51 x 76½" (129.5 x 194.3 cm). Tate Gallery, London

PLATE 21

Joan Miró. *The Escape Ladder*
(L'échelle de l'évasion). 1940.
Gouache, watercolor, and brush
and ink on paper, 15¾ x 18¾"
(40 x 47.6 cm). The Museum of
Modern Art, New York. Helen
Acheson Bequest

PLATE 22

Joan Miró. *Symbols and Love
Constellations of a Woman (Les
chiffres et constellations amoureux
d'une femme)*. 1941. Watercolor
and gouache, 18 x 15" (45.6 x
38 cm). The Art Institute of Chicago.
Gift of Gilbert W. Chapman,
1953.338

PLATE 23

Joan Miró. *The Red Sun*. 1948.
Oil on canvas, 35⅞ x 28" (91.2 x
71.1 cm). The Phillips Collection,
Washington, D.C.

PLATE 24

the Spanish Republican government to paint a majestic pendant for Picasso's *Guernica* for the Spanish Pavilion at the upcoming Paris World's Fair. As the commission arrived in late April and the exhibition was to open on July 12, time was very short. All trace of the painting has now been lost, but it is clear from photographs that Miró's majestic upright figure of a solitary *Reaper* must have held its own against the commotions of *Guernica*.

What was also very much on Miró's mind was the "decorative frieze" that he had just completed for the three children – Paul, Jackie, and Peter – of Pierre and Teeny Matisse. This was for the nursery in New York. As it was made to measure – 31 inches high and 10 feet, 4 inches wide – it was nothing if not "site-specific." Its arrival in New York was delayed by the fact that there were passages in it that were so heavily painted that they just refused to dry. ("A devil must have passed by," said Miró.)

"It's had a great success in Paris," Miró wrote to Pierre. "Picasso was wild about it and said it was one of the best things I had ever done. I myself like it, but it may be too dramatic for your purpose. It was painted during the agonizing times that we have been living through. I think that the children would end by liking it. If not, just keep it as a picture and I'll make them another one. Once it's installed, please let me know if it works well with the rest of the room. I couldn't quite make out, from the plan, what was needed. In any case, just let me know. It is with the greatest pleasure that I would make something that makes the whole room look just right."

Now in the Toledo Museum of Art, the frieze was not at all the traditional nursery fare. Sweet dreams played no part in it. It was, in fact, just right for its apt but nightmarish title: *Woman Haunted by the Passage of the Bird-Dragonfly, Omen of Bad News*. Pursuit and persecution were its leitmotifs. The figures were monstrous, the space claustrophobic, the panic all-pervading. But as a portrait of Europe in 1938 it was exactly right.

As to its effect upon the Matisse children, of whom the eldest was then six years old, a recent enquiry revealed marked divergences. Paul remembers it as high up on the bedroom wall. No attempt had been made to light it. He at that time was more interested in what he himself was making on the floor than in any aspect of the family environment. "I don't have any memory of being upset by the picture in any way," he said recently, "but I remember liking it as I would like a good story. You couldn't look at it for long without starting to imagine the interesting relationships between the principals."

Paul said further that "I was never actually introduced to the picture in any meaningful way. It simply arrived, and it was left up to us to deal with it in whatever way we wished."

Peter, on the other hand, thought that the painting had altogether too many teeth, quite apart from its other rather daunting components. After Paul had been sent to the Arizona Desert School, the Miró kept Peter awake at night. Classic remedies were put into action. Teeny Matisse consoled him, kept a light burning in the room, and left the door open.

Jackie Matisse had quite another reaction. She remembered it not simply as dramatic, but as energizing. In fact, she loved it. She remembered it, however, as being called *The Battle of the Sea Monsters* – a family invention – rather than as the more intimidating and lugubrious title by which it is now known. As the painting could not possibly be construed as a battle between sea monsters, multiple misapprehensions – some of them protective – must have been at work. In any case, the frieze left its mark, and one as to which those concerned are alive and well and glad to tell the tale.

Miró had powers of concentration that were almost miraculous. He also believed against all the odds that the Spanish Republic cause would triumph. But, even so, his condition, and the condition of his wife and daughter, were getting more precarious by the hour. It was no longer safe for him to go even to Barcelona. Foreign residents in France might have a difficult time, even if the German armies were held back (as was confidently supposed) by the Maginot Line. There might be air raids a hundred times worse than the one that had destroyed Guernica in May 1937. It might also become impossible for him to get money from New York.

It was with all this in mind that Pierre Matisse suggested on October 31, 1938, that Miró and his family should pick up and go to Mexico. The Mexican government was well disposed towards Spanish Republicans, and if they took a boat that went directly to Mexico they would have nothing to worry about.

But, as it happened, Miró had been invited by his friend Paul Nelson to decorate the dining room of his house in Varengeville, not far from Dieppe. When he went on a scouting visit in March 1938, he was captivated by the brilliant yellow of the hundreds of daffodils. He had never before experienced the unassuming northern landscape. He even liked the irritable sea that foamed and grumbled somewhere below. It was all so totally foreign that he felt that he could dream his dreams and spin his magic webs without interference. To have Georges Braque as a neighbor was no handicap, either. And, despite what he had said about "men of letters," he enjoyed having the novelist Raymond Queneau – one of the most brilliant Frenchmen of his day – not far away.

In this way it came about that when World War II began on September 3, 1939, Miró and his family were in a rented house in Varengeville called "Le Clos des Sansonnets." Writing to Pierre on September 15 he did not refer at all to the

war, but simply said, "My life has gone back to normal in every respect. My work goes well. Next time I go to Paris, I'll work on the proofs of my prints."

On October 24, there was still no mention of the war. "All is well here," he said, "I work all the time. The countryside is marvelous at this moment, with the green of the leaves and the trees all flaming red. It's fairyland. It's been years since I worked in such close contact with Nature and her eternal laws. I can concentrate completely, with none of the wasting of time and energy that cannot be avoided in Paris."

In November 1939 Pierre Matisse and Joan Miró began to work on the new situation that would arise if Pierre Loeb were no longer able to sustain his share of Miró's output. (Pierre Matisse was at that time in France, but about to leave for New York.) On the third, Miró wrote that he would like Pierre Matisse to be in sole charge of his affairs.

Naturally, this did not please Pierre Loeb. It also meant a further financial responsibility for Pierre at a time when the market in New York was dead in the water. On December 14, 1939, Miró politely reminded Pierre Matisse that he was owed $1,210. Could something be done, and fast?

The war in western Europe was at that time an eerie nonevent. When Miró went to Paris, he wrote that "Paris is getting to be its old self, little by little. The galleries are reopening. Exhibitions are opening as usual. Zervos has put on a

Exhibition catalogue cover, March 1940, Pierre Matisse Gallery. Detail from *The Farmer's Wife* (1922–23) by Joan Miró

very good mixed exhibition that includes a group of my own works. Morale is very good from every point of view."

Back in Varengeville, Braque had been to see Miró's new work and liked it very much. Until the onset of the German advance through Holland and Belgium, and thereafter through France, Miró was ideally happy in Varengeville. In April 1940, he wrote to Pierre that "This long sojourn in the country has done me an immense amount of good. Being alone here has enriched me continually. I should like to have enough years ahead of me to realize the most important of my projects."

He was also very happy to receive the catalogue of the Miró show that Pierre had lately put on in New York in March 1940. This was of early paintings, done between 1918 and 1925. "You deserve all my compliments," he wrote. "It is a truly magnificent catalogue. You have put it together quite marvelously. The colors you have chosen are both sober and powerful. It speaks throughout for the ideas that I have tried to express in my work. The danger in all such things is to fall back upon what looks 'nice.' You have made something that is beautiful, and that is entirely different."

Joan Miró at that time was so absorbed in a new series of paintings that he could notice nothing else. On January 20, 1940, he had begun the series of *Constellations* that were to cause a sensation when Pierre Matisse showed them in New York. On February 4, he wrote to Pierre that although they were small – 15 by 18 inches – "they give the impression of large frescoes."

By the time the German armies invaded France in May 1940, nine of the *Constellations* were already finished. A tenth was completed on May 14, by which time it was clear that there would be no stopping the Germans. To the very end of his stay in Varengeville, Miró kept a watchful eye on the landscape. "The countryside here is wonderful right now," he wrote to Pierre on May 2. "The apple trees are just beginning to blossom, and the light is very soft."

Not until May 20 did the Mirós give in, say good-bye to the apple blossoms, and take the last train out of Dieppe to Paris. From there they made their way eventually to Palma, Majorca, where Miró painted thirteen more *Constellations*. (The last in the series was completed in September 1941.)

From then until January 1945, when the *Constellations* were first shown in New York at the Pierre Matisse Gallery, nothing was known of them. But, as will be seen in a later chapter, it was with the revelation of the *Constellations* that the association between Joan Miró and Pierre Matisse reached its apogee. There were to be thirty more Miró shows at the Pierre Matisse Gallery, but it was with the *Constellations* that history would be made.

The Poetics of Balthus, 1935–88

It was in the summer of 1935, in the Galerie Pierre in Paris, that Pierre Matisse first met the painter who at the time called himself simply Balthus.

Not only did he make his acquaintance, but he saw several paintings by Balthus that had been left in the gallery. "It was quite a shock," he said many years later. But he made up his mind on the spot that Balthus was someone he very much wanted to show in New York.

In this, he was absolutely right. In the Paris of the mid-1930s, Balthus was an elusive but unmistakable figure. His first exhibition, at the Galerie Pierre in 1934, had caused a stir, not least because one of the exhibits, a painting called *The Guitar Lesson,* had suggested a lesson of quite another kind. He was also known as a stage designer much in favor with his friend Antonin Artaud, the stricken genius of the French theater in the 1930s and the inspiration of the so-called Theater of Cruelty. In 1936 his portraits of André Derain and the Vicomtesse de Noailles were not so much "portraits," in any traditional sense, as monodramas – concise playlets that could have been staged with only minimal additions.

Balthus at that time was in every way the personification of that perennial Parisian phenomenon – the brilliant young man who could go anywhere and captivate a lot of very clever people. But as a painter for the long haul? On a regular roster? That was not easy. The few paintings that Balthus produced went directly either to the Galerie Pierre or to his friend Pierre Colle. But Pierre Matisse was not deterred. Keeping the project on a very light rein, he was able to give Balthus his first one-man show in New York in 1938, with others to follow in 1939,

1949, 1957, 1962, 1967, and 1977. Every one of these exhibitions was a considerable event.

The life of Balthus calls for some disentangling. Born in Paris in 1908, he was the son of Erich Klossowski, a Polish-born art historian of high quality who doubled as a stage designer. His mother, born Elisabeth Dorothea Spiro, was a painter of Russian Jewish origin who took the working name of Baladine. (Balthus's maternal grandfather was both a cantor in Breslau and a prolific composer of religious music.) The twists and turns of European demography decided that when World War I broke out they were German citizens. In 1914 they moved to Berlin, where Erich Klossowski had a considerable success at the Lessingtheater.

In 1917 Balthus's parents began to live apart, and he went with his mother and his older brother to Switzerland, living first in Bern and later in Geneva. They had very little money, and Baladine had no market for her work. At the age of eleven, Balthus made a series of forty ink drawings that were ostensibly about the adventures of his cat (the first of many cats, by the way, in his later work). But, as Sabine Rewald has pointed out in her study of Balthus, their real subject was the imaginary situation of a little boy who lived in a big house in the country with servants round the clock.

It happened that a great poet, Rainer Maria Rilke, became deeply fond of Baladine. In 1921 she and her two sons went back to Berlin, which was their primary home until July 1923. In the late summer of that year, Balthus was taken to Beatenberg, in German-speaking Switzerland. (For the rest of his life the apple green Swiss uplands were to have magical overtones for him.) In March 1924, the sixteen-year-old Balthus went to Paris, where he enjoyed the affectionate patronage of Rilke and had entrée to the worlds of art, literature, and the theater at a very high level. In 1925–26 Rilke made it possible for Balthus to spend a study year in Italy, after which he returned to Beatenberg for an extended stay.

In many ways, therefore, his adolescence and early manhood were almost uniquely privileged. How many schoolboys got to show their paintings to Pierre Bonnard, Albert Marquet, and Maurice Denis? Or to sit in on the building of the sets for a historic season of ballet (the Soirées de Paris) in 1924? Or to be welcomed by André Gide at a time when Gide was one of the most famous writers in Europe? Or to have Rainer Maria Rilke pick up the tab for month after month in Florence, Arezzo, and elsewhere?

Yet Balthus belonged nowhere and had never had a firm base. Though distinctly a Pole, both in looks and in bearing, he had never had Polish nationality. (He never set foot in Poland, by the way.) When he was taken to Berlin in 1914,

it was as a refugee from a country in which he would soon be an enemy alien. When he left Berlin in 1917 he was, in effect, a refugee from terrible times that lay ahead. To all appearances, he cared nothing for the rich Jewish culture that he could have inherited from his mother's family. He spoke (and wrote) perfect English and idealized a certain long-vanished England, but he could never be persuaded to go there. Throughout his life, he preferred not to paint under his real name. Nor could he bear to have people poking into his origins. If asked about them, he would say, "Balthus is a painter of whom nothing is known."

On the green uplands above Beatenberg in the Bernese Oberland, the homeland of neutrality, he seemed to be at peace with himself. Elsewhere, he was restless, with a lifelong craving to live in a big house of his own and to bear a big name that was not the one with which he had been born. Even his studio in Paris from 1936 onwards was in a location – the Cour de Rohan – that bore the name of one of the great ancestral families of France.

It was to the Cour de Rohan that Pierre Matisse addressed his proposals for an ongoing collaboration between Balthus and himself. If these negotiations did not advance rapidly, it was because Balthus always ranked high among the very good letter writers who cannot bear to write. He had a very elegant hand, and he also had a command of limpid and idiomatic English. (So perfect was this that Pierre Matisse sometimes replied to him in English.)

But he took his time. In March 1938, he wrote to Pierre Matisse and said, "I no longer even dare to excuse myself for having left you so long without news, and you have been nice enough not to complain. Alas! That's how I am. My inability to write gets me into troubles and complications from which I am the first to suffer."

To this Matisse replied: "Your letter was a surprise, and I may say a most agreeable one. I never expected you to reply in your own hand. You warned me of that. When writing to you I felt that I was addressing an imaginary personage. Thank you for dissipating that illusion."

Balthus in general did not write letters unless he had something important to put right or something important to ask. For this reason his letters to Pierre Matisse, though few in number, are very telling. Between March 1938 and the summer of 1967, the dossier in the Pierre Matisse Gallery Archives consists of exactly twenty-seven communications – scraps included – from Balthus. (After 1967 the telephone took over.) But it was always worth the wait, and for the rest of his life Pierre Matisse was in high expectation at the idea of seeing a new painting by Balthus.

His patience was rewarded in March 1938, when Pierre Matisse got to show Balthus in New York. Balthus had just turned thirty and was in full output and

on top form. It was his first-ever exhibition outside of France. For anyone who knew how to read it, the New York show was a major event. With *The Street* (1933), *Cathy Dressing* (1933), *André Derain* (1936), *The Vicomtesse de Noailles* (1936), and *Joan Miró and his Daughter Dolores* (1937–38), much of the gamut of Balthus's achievement to date was represented. Landscape was missing, but that was put right in 1939, when the enormous painting called *The Mountain* (1937) dominated Balthus's second exhibition at the Matisse Gallery.

Meanwhile, *The Street* stood for the Parisian townscapes that were to find apotheosis in *The Passage du Commerce Saint-André* (1952–54). In *Cathy Dressing*, overtones of *Wuthering Heights* (for which Balthus had made a series of drawings in 1934–35) were combined with likenesses of Balthus himself and his fiancée, Antoinette de Watteville. In *André Derain,* Balthus gave a hallucinatory progress report on the painter whom he had known since his first youth as a friend and sometime mentor. In *Miró and his Daughter,* Balthus gave his own particular spin to the father/daughter relationship, with nothing missing of what is now called "body language." Nor did any nuance of costume go unrecorded.

By contrast, it was almost as a prisoner awaiting arraignment that the twenty-eight-year-old Balthus portrayed the Vicomtesse de Noailles. Who but he could have imposed that bare and penurious background and that resolutely unfashionable mode of dress upon the granddaughter of the woman on whom Proust is said to have modeled – in part, at any rate – his Duchesse de Guermantes?

This was a show that Pierre Matisse had in his blood. André Derain had been very kind to him when he was in Paris as an aspirant painter. Joan Miró was a close friend of Pierre Matisse, who had been showing him in New York since 1930. Except for one momentary incident, their relationship as dealer and artist got away to an excellent start. A passing mention by Matisse of the preface to the catalogue to his first show had brought an immediate reply from Balthus. "I beg you not to print a foreword of any kind. If there is one thing that I hate more than anything else in the world, it is an exhibition preface." Matisse replied that alas! it was too late. The preface was already in print and, in any case, it was indispensable, since the American public had no idea how to look at unfamiliar pictures and needed all the help they could get.

The exhibition vindicated Matisse's strategies as a dealer. *Miró and his Daughter* was bought for the Museum of Modern Art in 1938. Alfred Barr, the museum's founding director, bought the portrait of André Derain for an American collector, and it was bequeathed to the museum in 1944. James Thrall Soby, a pillar of the museum in its early years, bequeathed *The Street* to the Museum of Modern Art at his death in 1979.

Given his long-term perspectives, it is likely that by the end of this first show Pierre Matisse was already looking forward to the retrospective exhibition of Balthus that would eventually be held in 1956 at the Museum of Modern Art. He loved nothing more than to see major paintings move from his gallery to great museums with minimal delay.

The almost immediate consecration of Balthus in New York was precisely what Matisse always hoped for. It was, moreover, followed up in time by the arrival in the Metropolitan Museum in 1975 of the life-size *Nude in Front of a Mantel* (1955), which Matisse had sold in 1957 to Robert Lehman, and the arrival in 1982 of *The Mountain*, which Matisse had kept by him for more than forty years.

Of the fifty-one paintings in the Balthus retrospective at the Metropolitan Museum in 1984, twenty-eight had been shown at the Matisse Gallery. Beginning with the very early Paris landscape, *The Quays* (1929), which Balthus had given to Pierre Matisse as a present, they ranged all the way through to the late 1970s. If we set aside for the moment the museum retrospectives in New York (1956–57), London (1968), and Paris (1966 and 1983), it can be said without a doubt that during the lifetime of Pierre Matisse more major paintings by Balthus were put on public view at his gallery than in any other place. They were not annual exhibitions, but every one of them had weight. The last, in particular, was one of the most memorable gallery exhibitions of the 1970s.

If Matisse got the major paintings, almost always before anyone else, it was not because he offered Balthus professional advancement of a kind that he could not have got elsewhere. Initially, it was in part because people in Paris had been scared off by what was thought to be a pornographic element in an exhibition at the Galerie Pierre in 1936. But basically, Matisse got them because he loved them, and because Balthus knew that. It was also because he was not afraid to buy big pictures that might not be easy to sell. And there was, finally, the fact that he had been raised in the milieu of art and artists. Balthus knew that, and he prized it. ("After all, you know," he once said to me, "he is the son of Matisse.")

Pierre Matisse was also very sensitive to Balthus's ambitions for himself. On May 8, 1938, just a few weeks after the end of his first exhibition in New York, Balthus wrote and said, "I have a proposition to put to you, and I hope that you will give it your closest attention. I need a rather large sum of money to buy a house of which the owner is in America. Would you be willing to buy a group of eight large paintings of mine? Four of them – *Patience, Les Beaux Jours*, a big nude in an interior, and *Two Girls Playing Cards* – could be delivered this summer. The other four will be ready sometime next winter. Would you take each of them at the price you offered me last year for *Les Beaux Jours*?

137

Balthus, 1957. Photo: Loomis Dean

"We have found a house in the Jura that would allow me to come back to life again. For the two years now that I have been wandering around, separated from Antoinette and the children, I have had no life at all. This is my chance to escape from the incoherent, absurd, dreamlike and, in a word, catastrophic situation in which our life has bogged down. Unfortunately, this house cannot be rented. We have to buy it. After having paid quite a large sum by way of deposit, we realize that we cannot for the present lay our hands on the rest of what we need. The matter is urgent, in that the owner is harassing me for the remainder of the purchase price. I should be very grateful if you would tell me as soon as possible whether this proposition is within the domain of possibility or whether you reject it out of hand and with horror."

Matisse did not reject it. He had, in fact, already floated the idea of further purchases from Balthus. Times were not easy, but when he wanted to go in deep with a new artist, nothing stopped him. By September 1938, Balthus and his family were installed in a château not far from Belley, in the Ain, and Pierre Matisse was being urged to go and see them there. From the address, and from the fact that the house was difficult to get to and had a single-digit telephone number, we may assume that it was a genuine château in a place where intruders would be few.

Pierre Matisse had realized early on that Balthus had very firm views about where he wanted to live. He did not covet a conventional villa somewhere south of the Alps, even if the villa in question was outside Florence. The Provençal

mas, though in high favor with writers and painters, was not in favor with him. Nor were the dressed-up farmhouse, the deconsecrated country church, or the train station at which the last train had long ago been and gone. He was not like other people, and he did not want to live like them, either.

In the case of the house near Belley, destiny was against his staying there long. First there was the Munich crisis in September 1938, when World War II might have broken out at any moment. ("The pseudo-war cut me off from all my resources," Balthus wrote to Matisse in November 1938.) So far from settling into a long period of uninterrupted work, he begged Matisse to pay him forthwith for the enormous painting called *The Mountain*.

And in September 1939, when the war really did break out, Balthus was called up for military service and posted to Alsace. On December 13, 1939, Pierre Matisse sent news of him to Chick Austin, director of the Wadsworth Atheneum. "Balthus, worst luck, was in it from the very beginning, picking up remains after the battles until it got the best of him. Now he is in Switzerland, trying to recuperate after being temporarily discharged." (The battles in question were not identified.)

Thereafter, there was no word from him to Pierre Matisse until June 11, 1946. The letter was written from the Villa Diodati, near Cologny, on the Lake of Geneva, of which the most distinguished previous tenant had been Lord Byron in 1816. The Villa Diodati is three stories high and arcaded on the ground floor. It has some pretty Louis XVI salons inside, and the main rooms upstairs have access to an elegant balcony of wrought iron that wraps itself round the house. Prints of the time often show Byron at work on that balcony, but the scene may be apocryphal. Byron did not like the lakeside weather ("such stupid mists, fog and perpetual density"), and he felt ill and unsociable for much of the time he was there. Balthus had nothing against the august association, and even more so as he believed himself to have connections with a Scottish family, the Gordons, of which Byron was the most celebrated member.

But he wanted to be, if not a king in his castle, at any rate the lord of his own manor. In his first postwar letter to Matisse, he wrote that he had come back to the Villa Diodati from Paris, "just to move out. But where to move to? For the past three months we have searched the whole of France – everywhere but in Paris, that is – for a roof. The wandering life kills me – and kills my work."

Questions of real estate were important to Balthus, and they turn up repeatedly in the correspondence with Pierre Matisse. To reinvent his environment was a lifelong obsession of his. In a new house, he was a new man. This was not a matter of social climbing. It was a matter of exorcising the nomadic life, sometimes touched by poverty, that he had led in boyhood and adolescence.

Pierre Matisse was well aware of that craving, and for forty years after World War II he was to see Balthus in and out of more than one big house. One of them – the Villa Medici in Rome – was the property of the French government, which appointed him as its director in 1961. Others were rented, borrowed, or bought.

Meanwhile, the friendship between Matisse and Balthus was in very good shape, thanks to Matisse's unfailing solicitude and his readiness to buy new major pictures as soon as they were finished (and sometimes sooner).

There was one small problem, though. Much as Matisse delighted in big paintings like *The Living Room* (1941–43), *The Game of Patience* (1943), and *The Golden Days* (1944–45), they were not easy to sell. If he was not to be badly out of pocket, he needed smaller paintings to fill out a New York show. He would also have liked to have a few more drawings, and he often felt that others got them first.

In May 1948, he was dismayed to hear that Balthus might be having a show in Paris that would be mainly of medium-size paintings. If this were true, American enthusiasts – all of them clients of Pierre Matisse – would be able to buy up precisely the paintings that Matisse had hoped to show in New York in 1949. This was really too much, he said. Very few dealers did as much as he for the work that they defended and admired. He did not do it primarily to coin money, but he didn't want to be made to look a fool, either.

Two years later, in 1950, the aftershock of this letter made itself felt when Balthus blew up in a way that could not have been foreseen and did not at first seem to make any sense. It happened in the following way. When he and Pierre Matisse were lunching together in Paris, Balthus suddenly asked Matisse to pose for his portrait. Pierre Matisse was the last person on earth to expect this gesture, and he was so astonished that for a moment he did not know what to say. Balthus understood his mumblings to imply that he did not want to pay for the portrait.

This displeased Balthus very much. On the following day he wrote to say that he was "profoundly disgusted" by Matisse's reaction. "After all these years," he said, "you still don't know whom you're dealing with. The very spontaneity of your reaction made me realize – as I had suspected ever since we first met again after the war – that you are really no longer interested in my work, apart from its business potential. This was already evident to me when you wrote to me about the big paintings of mine that you had bought.

"Do not think that I hold this against you. I am out of fashion. So much the worse for the fashion. To put us at our ease, I hereby set you free with a full heart, and once and for all, from any obligation to buy or show my work. This is not a

strategic maneuver. You have no rival. No other New York dealer has made me a tempting offer. Decidedly, the atmosphere of the Modern Art – Alfred Bar [sic], etc. – inspires in me the liveliest aversion. I have no wish to figure among samples of the latest novelties. I simply want to fulfill my own destiny as a painter, and to say what I have to say on the scale that suits me. It may be large, or it may be small. What matters are my inner necessities. All other considerations are completely alien to me."

He then signed off with the assurance that his old affection for Matisse was still intact, and that he hoped he would still accept the unfinished sketch for a portrait of his daughter Jackie.

A catastrophe, one might have thought. A deep wound had been exposed, too late for healing. But Pierre Matisse had known since his childhood that artists are highly combustible people and that a soft answer can turn away wrath. So he wrote a letter of that sort. Sure enough, Balthus wrote back at once to say that he had been mistaken. "Let us forget the whole thing – you, that you were the target of my thunderbolts, and I, that I ever launched them. Quite possibly a recent attack of malaria has intensified my inborn susceptibility, the dark side of my character, and my feelings of isolation. Maybe I shall turn into Jean-Jacques [Rousseau]. . . ."

After that, all went well. In November 1950, when Balthus was invited to stay with the Caetanis in Sermoneta, near Rome, Balthus asked for the loan of Matisse's automobile to make the trip. ("I don't know how long I'll stay," said Balthus in characteristic style. "Maybe a week or two. Or maybe all winter if it suits me to work there.")

In 1953 an important change occurred in Balthus's living arrangements. A group of French dealers and collectors banded together to buy some of his paintings. In return, they made it possible for him first to rent and later to buy the Château de Chassy in the gaunt, not to say forbidding, landscape of the Morvan. Built in the fourteenth century (and remodeled in the seventeenth), Chassy was not a beguiling house, but Balthus liked its keep-your-distance aspect. Shut up in Chassy, painting the views from the windows, looked after by two exemplary Italian servants, and with his young niece by marriage, Frédérique Tison, as an obliging model, Balthus was to do some of his best work there. It had doughty round towers, walls that could have withstood bombardment, and high narrow windows. The neighboring farm people gave him a variety of Poussinesque motifs. It is to Chassy and its surroundings that we owe the *Landscape with a Cow* (1959–60) that is perhaps the most august of all Balthus's French landscapes.

As time went on, there were matters as to which Balthus moved closer to

the orthodoxy of life in the international art world. So far from abominating the catalogue preface, he began to treat it as a desirable embellishment, always provided that the authors were of a stature acceptable to himself. This was especially the case when the Museum of Modern Art had its Balthus retrospective in the winter of 1956–57.

What to do about that catalogue? It was at a late stage that Balthus began to think about it. What about André Malraux, the great name of the day? What about Pierre Jean Jouve, the novelist, and Yves Bonnefoy, the poet? Alberto Giacometti would be ideal, but would he ever get around to it? What about a florilegium of painters and poets who were friendly with Balthus? Or would that be too much like a collective obituary? Albert Camus had written an exemplary preface for the Pierre Matisse Gallery in 1949, but that could not be used again. Nothing was quite right, and nothing went quite right. Malraux would have tried to write ten lines on *The Passage du Commerce Saint-André*, but that painting was not in the show. Jouve couldn't do it in the time given. Giacometti excused himself. Bonnefoy's text was not yet available.

And then there was the question of James Thrall Soby, who was in charge of the catalogue on the museum's behalf. What was he going to say? Would he go nosing around in matters that were none of his business? Would he want to include a photograph of Balthus? Soby had taken some himself, much to Balthus's dismay. And then there had been Irving Penn, who had given a photograph of Balthus to American *Vogue* without Balthus's permission. "There is something of the Moslem in me," Balthus wrote. "I don't like people to make use of my image when I don't want them to. The only photographs I can stand are ones that are the nearest to anonymity. I like them to be as vague and unrevealing as possible. I am, in short, the sworn enemy of what is practiced today."

He came back and back to the Soby problem. Soby had been Balthus's first collector in the United States. But that did not give him leave to disobey Balthus's wishes. "I beg him to leave out all the biographical details that are so much in fashion today. Ancestry, parentage, mode of life, etc. – all that seems to me completely superfluous. Just tell the public that I was born in Paris and that I am 46 years old. That should be quite enough." (As a matter of fact, he was going on forty-nine, but he did not choose to admit it.)

"When I am dead – which may be quite soon – and if people still care about my painting – which is not sure – all that will be none of my business. But while I'm alive. . . .

"I use my given name as my painting name because it is only in my painting that I want to exist. It enrages me when people like Jim Soby want to know

about my patronymic. Since he is interested, I will give the details here, but I see no point in printing them.

"The Rola Klossowskis (if latinized, the name is Klossowski de Rola) are an ancient Polish family, of which the male members have the rank of Count. (Rola means 'glebe,' and Kloss means 'an ear of corn.') The Rola coat of arms was created in the year 1044 on the occasion of a family marriage. At the moment, eighty families – none of them related to one another – are entitled to bear that coat of arms. The ancient Polish nobility was grouped in clans (like the Scottish clans), and the families who made up those clans bore the crest of the head of the clan. There is another family, the Klossowskis de Ruys, who are not related to us.

"So that's where the 'de Rola' comes from. That ancient nobility has fallen very low today. Except for myself, of course. But all that has nothing to do with painting."

Was that "Except for myself" a joke? Or was it put forward in parenthesis as a matter of common knowledge? As to that, the jury has yet to come out. In any case, this letter would appear to be the definitive account of Balthus's beliefs.

According to Pierre Matisse's recollection, it was in the mid-1950s – not long after his father's death in 1949 – that Balthus began to style himself the Comte de Rola. It is possible to regard this as an amiable foible, or even as a justified

Balthus with Frédérique, c. 1957.
Photo: Loomis Dean

regression towards eleventh-century Polish practice. But it should be said that his father never seems to have wanted to be anything but Dr. Klossowski. His mother regarded the usage as an absurdity. Pierre Matisse was one of those who never went along with it, preferring to the last (in 1967) to address his letters to Monsieur Balthus Klossowski de Rola. But they did not quarrel about that, or about anything else.

Balthus lived in Chassy until 1960, when negotiations began for his appointment as director of the French Academy in Rome. That appointment came through in February 1961, and once again there began a whole new phase in Balthus's career. To be master of the Villa Medici was in a way the apotheosis of his craving for a truly great house. It was a place of enormous beauty, though somewhat run down from many years of institutional use. It had just about the finest location in Rome. Velásquez had painted in the garden. Ingres had worked there. Berlioz had written music there.

Furthermore, much could be done with it. The interior had to be redone, from top to bottom, with a total disregard for anything but esthetic considerations. If there was nowhere the feeling of an office, so much the better. The garden was a wreck, and also had to be redone. Balthus went to Rome in two minds. Would all his time be taken up with the house? Would the Rome prizewinners, and the pensionnaires in Florence, be a further burden? What about the exhibition schedule that would bring the Villa Medici back into the mainstream of Roman life? What about the projected state visit of General de Gaulle? When would he ever get to work?

As time went on, and especially after he began to work with casein tempera instead of oils, Balthus took longer and longer to finish his paintings. As early as 1956, he wrote to Matisse from Chassy and said, "What is a 'finished' picture, after all, given what we now know about painting?"

In the context of that remark, *The Turkish Room* (1963–66) took no time at all. The great struggles of the sixteen years in Rome were with the formidable *Card Players* (1966–73), the *Japanese Figure with a Black Mirror* (1967–76), and *Katia Reading* (1968–76). There was really no reason why these paintings should ever have been called "finished." Nor is it any belittlement of them to say so. To be not quite finished had in itself an open-ended magic, whereas to be what people call "finished," in conventional terms, would be simply to have cut off the current.

Balthus in later life was of course a different person and a different artist from what he had been in 1938. In 1938 Pierre Matisse was taking a flyer on work that was virtually unknown in New York. By the time he left Rome in 1977 and set up house in a very large chalet near Gstaad, in Switzerland, Balthus had no lack of takers.

In view of his ever-more expensive habits and his seignorial expectations, Balthus would have been foolish not to avail himself of the demand for his paintings in France and elsewhere. When his prices went very high indeed in the 1980s, it was not always clear to whom the pictures would be consigned if they ever got out of the studio.

But it was Pierre Matisse who negotiated with André Malraux in 1967 for the acquisition of *The Turkish Room* for the Pompidou Center in Paris. And at the time of the retrospective at the Metropolitan Museum in New York in 1984–85, it was Pierre Matisse who had to field, and where possible to neutralize, the verbal missiles that Balthus fired off in the direction of the museum. Would Pierre raise hell? Shut down the show? Get this or that person fired? Call a press conference and act as Balthus's spokesman?

"None of the above" was his answer, and it called for all his reserves of tact. But the perilous moment passed. With the years, Balthus became more accessible to some of the younger people who came to pay their respects. Abandoning the Moslem in him, he gave a lengthy interview on film by Gero von Boehm. He allowed an old friend, Henri Cartier-Bresson, to photograph him. He lived to see the twenty-first birthday party of his elder daughter by his second wife, Setsuko Ideta. And in the last photographs of him and Pierre Matisse together (taken in Switzerland in 1988) we have a vespertinal image: two elderly European gentlemen, each leaning on a cane, who after a fifty years' friendship have not run out of conversation.

With Pierre (on the right), at Rossinières, 1988.
Photo: François Rouan

Alberto Giacometti:
A Man from Maloja, 1936–50

"What a life I have, thanks to you!" —Alberto Giacometti to Pierre Matisse, 1947

The last months of the year 1936 were marked by a development that would eventually stand high in the annals of the gallery. This was the rapprochement between Pierre Matisse and Alberto Giacometti. Thanks to interruptions owed to World War II, it was to take a long time to mature. Nearly twelve years were to pass before the Pierre Matisse Gallery could mount a major retrospective exhibition of Giacometti's sculptures, paintings, and drawings. Both that exhibition in 1948 and the catalogue that came with it would become a part of art history. A dealer's gallery had done the work of a major museum.

Pierre Matisse and Alberto Giacometti could have got to know one another as students at the Académie de la Grande Chaumière, where they were classmates in the early 1920s. In generational terms, they were a perfect fit. Matisse had been born in 1900 and Giacometti in 1901. They had both been around art and artists from boyhood onwards. (Both Alberto's father, Giovanni Giacometti, and his godfather, Cuno Amiet, were prominent figures in Swiss art.)

Given the easygoing atmosphere of the Grande Chaumière and the conviviality of nearby Montparnasse, Pierre Matisse and Alberto Giacometti might well have become friends. But the odds were much against it. Giacometti had been born and raised in the many-mountained Val Bregaglia in the canton of Grisons in Switzerland. This was a place all its own, much cut off from the rest of the world. An Italian dialect was in everyday use. French was rarely if ever heard. Alberto had learned French in

school, but when he arrived in Paris in January 1922 he still had trouble speaking it. His French fellow students made no effort to help him. (They were "like a wall," he said later.) Neither then nor later was Pierre Matisse gregarious.

There were further basic obstacles. Pierre Matisse was studying painting, whereas Giacometti was studying sculpture with Antoine Bourdelle. Neither of them was a model of attendance at the school. There was a time when Giacometti stayed in his hotel room for months on end, drawing a human skull that he had bought for the purpose. At other times he simply took off for Stampa, the village in the Bergell Valley where he had been raised and where his mother was to live until her death in 1993.

For all these reasons, it was unlikely that the young Pierre would ever have had an ongoing relationship with the young Alberto. The jump start was never in his nature. Even with Yves Tanguy, the painter and exact contemporary who had been in the same class as Pierre at the Lycée Montaigne in Paris, the friendship had not been maintained.

By 1921 Pierre's future friend Joan Miró (admittedly, seven years his senior) was already known to a particularly brilliant and heterogeneous group of poets and painters. By 1923 Yves Tanguy was lodging on terms of equality with two of the cleverest and most high-spirited young men in town. Never did Pierre Matisse's fortunes take off in that way.

Giacometti. *Woman Reclining.* 1929. Bronze, 10⅝ x 17⅜ x 6¼" (27 x 44 x 16 cm).
Private collection

So quite some years were to pass before Pierre Matisse, then an art dealer in New York, was to proposition Alberto Giacometti, then a sculptor much talked-of in Paris, as to whether they could work together to their mutual advantage. Giacometti himself dated his breakthrough in Paris to the year 1928. By then, Pierre Matisse was installed in New York. Their correspondence did not get under way until 1936. But the association, once formed, lasted until Giacometti's death in 1966. Even in the last weeks of Pierre Matisse's life, he was bidding on the telephone for major sculptures by Giacometti that came up at auction.

In his many letters to Pierre Matisse, Giacometti was the complete professional on matters of business. There was no rhetoric, no fluff, and no fat. He never hedged, never digressed, never faked. All questions were answered clearly and completely. Facts and figures were up front. What he had to say about his work was always to the point.

It is plain from the earliest of the surviving letters from Alberto, which is dated August 24, 1936, that the two men were already on a very good footing. Writing from the high-lying village of Maloja, where the Giacomettis had a summerhouse, Giacometti touched on one subject after another without ever a word wasted. In particular, he spoke of a sculpture that Pierre Matisse had chosen for the gallery. Pierre had sent him some photographs of it that had been taken in Paris.

Giacometti liked photographs of his work to be exactly what he wanted, and he could say – and said exactly, on this occasion – where they fell short. The sculpture was of a young woman walking. Giacometti wrote that "the one taken from above is very interesting. One might think that she was walking very fast along a beach. The ones taken in profile, and from the back, are also very good. But in the one taken from the front, the proportions are distorted. She looks too tall. It would have been better if her feet had been shown planted firmly on the ground. The light is very pretty, though."

The sculpture in question had a curious history. It was a plaster that dated from 1932 and was originally a headless and armless figure of a young woman. When it was shown in a Surrealist exhibition at the Galerie Pierre in Paris in June 1933, under the title *Mannequin,* it had been augmented by a head that was made out of the neck, scroll, and pegs of a cello. It had also been given a pair of arms, one of which ended in a claw, and the other in a bunch of feathers.

These additions were painted black. They were the work not of Alberto Giacometti, but of his younger brother, Diego, who was to serve Alberto almost as a second self until the day of his death. They could be removed at will. As a result of these changes, what had had a delicate perfection took on an antic oddity. The oddity has dated and been discarded, but the perfection has not.

By his own account, Pierre Matisse saw this sculpture in Giacometti's studio in 1935 and suggested it would do very well without the additions. It should be put back, in other words, to the angelic simplicity that can be seen in photographs that were made of it by Brassaï in 1932.

Giacometti agreed to that. But this was high summer, and he was in Stampa, and the plaster was in Paris. His thoughts were elsewhere. "It's very calm and very beautiful here," he said, "and I've quite recovered from Paris. There is wonderful granite here in Maloja, and I've begun work on a head. Hard as it is, it's very agreeable to work with, and I'm getting on quite fast. Maybe I'll manage to do two of them. I'll send you some photographs.

"I've no news from Paris, and I don't imagine there's much going on there. Up here, it's as if one was out of the world. I see nobody. If only the days didn't go by so quickly!

"I'll write again as soon as I'm back in Paris. You will have the statue very soon, as was agreed."

Two weeks later, when he was still in Switzerland, Alberto sent a picture postcard of the mountains above Maloja. "As to the price of the sculpture that I am sending you, I am entirely agreeable to your suggestion that it should be 3,000 Frs (for me). In fact, I think that we had already settled on that figure.

"It has been so beautiful, these last days, that I couldn't resist going up into the mountains. It was tremendous."

Even when he was back in Paris, the promised plaster did not come in on time. But Giacometti had taken great care to make a plinth that would suit the piece perfectly and do away with all the inconveniences that might have arisen in that connection. "I'm sorry to have taken so long," he wrote, "but I couldn't help it. I hate to part with a piece that is not what I wanted it to be, and all the more so if it's going far away and there's nothing I can do about it."

In his next letter he said that "a lot of people think that it may be the best thing that I've ever done. But I see its defects so clearly. I see what prevents it from being a real sculpture. I hope to go further before long."

Pierre Matisse wanted to be sure that Giacometti had no involvements or encumbrances that would get in the way of the exclusivity that he wanted to have in the United States. Hadn't he shown in New York with Julien Levy in December 1934? Yes, Giacometti said, but there had never been any formal agreement between them. Julien Levy had stopped coming to his studio. Nor did he show any interest in buying the work. (Julien Levy in his memoirs said that although the Giacometti sculptures in his show had been priced at from $150 to $250, few people had liked them, and nothing had been sold.)

For the future, therefore, Giacometti was completely free. And, he wrote, "As regards the sculptures that I shall make from now on, I shall be delighted to give you both the first refusal and the exclusive right to represent me in America. There will be no possible doubt as to where we stand in that respect. It would give me the greatest pleasure if you would agree to this. And, by the way," he added, "I should be very grateful if you would buy the sculpture that is now ready. The money would be very helpful at this moment."

By October 1936, Pierre Matisse was clearing the ground for what would become a lifelong relationship with Giacometti. There was the question of the household objects that Alberto had designed in collaboration with his brother, Diego. Since 1930 they had been selling these objects primarily through Jean-Michel Frank, an interior decorator much admired at that time. Their bronze lamps, chandeliers, chairs, tables, and firedogs soon had a very high recognition factor.

It might have been thought that, in comparison with Alberto's sculptures, they were not quite serious. But Alberto himself did not accept that point of view and said that, on the contrary, the two activities sometimes fed off one another. This point of view was more and more widely accepted until, in 1985, the new Picasso Museum in Paris was furnished entirely with objects made by Diego Giacometti. Pierre did not at first handle the household objects, but he enjoyed them, had some at home, and would place orders for them on his clients' behalf. In 1948 he took over the exclusivity of their sale in the United States.

Meanwhile, in 1936, the standing figure was on its way to New York, in company with a batch of new paintings by Miró, with whom Giacometti was on very good terms. In New York, James Johnson Sweeney had seen a photograph of it and wanted to reproduce it – perhaps in *Transition*. Giacometti himself thought that it might look well in another material; and, when cast in bronze, it did in effect have quite another kind of elegance.

Apart from Miró, Giacometti claimed to be seeing almost nobody. He was working hard, but slowly. "Every day," he wrote, "I have to deal with difficulties that I had never noticed before." Pierre Matisse wrote back to him on November 10 that he, too, had been wondering what medium would suit the standing figure best. "We need something rather precious," he wrote, "to go with the subtlety of the statue. Stone seems to me rather clumsy. Marble would be too cold, and alabaster too flimsy. We need a material that has the tenderness of plaster, but would be more distinguished in its effect. What do you think? Has anyone ever made sculpture out of stucco?" Pierre also wondered if the heads could be made in a stone that was both tender and slightly chalky. "There must be stones of that sort," he wrote, "and in pretty colors."

Pierre was very careful to "walk in step," as he put it, with Alfred Barr, who had gone to see Giacometti in Paris every year since 1934. There was a question of his buying a small head by Giacometti for the Museum of Modern Art.

Giacometti wrote back almost at once to say that he was delighted that Pierre still liked the sculpture and was not disappointed with it. "Now that I am so busy with my new pieces," he wrote, "I can no longer remember exactly what it's like. When it was still here I worked on it every day and could never really see it from a distance. But I felt that the time had come to stop. I now feel that marble is the only right medium for the standing figure. My instinct had always told me that, and I think that we can perfectly well avoid the coldness that marble sometimes has. I think that any calcareous stone would be too porous for this piece. It would be all right for a more massive sculpture." (In the end, the standing figure was cast in bronze by its first owner, Peggy Guggenheim.)

In January 1937, Alberto Giacometti made his debut at the Pierre Matisse Gallery. His *Walking Woman* was shown with work by Brancusi, Henri Matisse, Juan Gris, Pablo Picasso, Georges Rouault, Joan Miró, Pierre Bonnard, Aristide Maillol, and Charles Despiau. He was delighted with the catalogue, with the check that had come in on time, and with Pierre's enthusiasm. "And I'm in such good company!" he said with his habitual modesty. "I wonder how I shall look beside Maillol and Despiau. They are two big men, after all." Sixty years later, it may seem to us that Giacometti had nothing to worry about on that score.

Back in Paris, much was being said about the upcoming international exhibition of modern art. "People everywhere are beginning to talk about the Exhibition," Giacometti wrote to Pierre. "Something or other will come of it. A great many painters and sculptors are going to contribute. We shall have something new to look at!" And he signed off by saying, "Thank you again for putting my sculpture in with that group. . . ."

The surviving correspondence between Alberto Giacometti and Pierre breaks off at this point and does not pick up again until November 1946. Nothing untoward can be inferred from this. The archives may be at fault, but the relationship was not. Pierre Matisse was at Giacometti's studio in Paris in June 1938, and again in September. These were difficult times for Giacometti in his work. "From 1935 onwards," he said later, "I never made anything the way I wanted it – not even once."

In October 1938, Alberto Giacometti – a lifelong noctambulist – was knocked down at night on the Place des Pyramides in Paris. His right foot was crushed. After two nights in the Hôpital Bichat and a week in a very good clinic near the Buttes Chaumont, he was able to leave the clinic and go home on crutches.

With the approach of World War II, there could in any case be no question of

the comprehensive exhibition that Pierre Matisse had hoped to have in New York. Not until the fall of 1946 could he go to Geneva, where Giacometti had been working since 1941 in a penitential little room in the Hôtel de Rive. (Giacometti's mother, nephew, and brother-in-law spent much of the war years in Geneva.)

He had been working from memory, rather than from the model. "To my terror," he wrote to Pierre Matisse before his exhibition in 1948, "the sculptures became smaller and smaller. Only when they were very small did they have a likeness. Yet their dimensions revolted me. Tirelessly I began again, only to end up several months later at the same point. A large figure seemed to me false and a small one equally unbearable. And then often they became so small that with one touch of my knife they disappeared into dust. Yet it was only when they were small that head and figures seemed to me to have a bit of truth."

Twenty-five years later, this progression seemed perfectly logical, and the more so in combination with the relatively gigantic plinths that Giacometti designed for the tiny sculptures. But when Pierre first saw them he was considerably disturbed. What was he to do with such freakish little tinies? On November 13, 1946, their correspondence was reopened with a letter from Giacometti that was meant to put Pierre's mind at ease. "Don't be too worried about the sculptures you saw!" it began. "Their appearance was misleading. I've been working in the studio since you left, until the day before yesterday. When you saw the sculptures they were only beginnings. Now they're quite different. I can finish them quite soon, but I have to take a short holiday first. The largest of them is now about 48 inches high, without its plinth. That's twice as much as before, but I think that it's really coming on very well.

"I simply cannot bear the idea of casting these sculptures in bronze before they are more or less what I want them to be. I hate to keep you waiting, but I think that when they are finished you will like them very much. That's what matters. I'm going to get myself together and go back to Paris. I shall write to you, and I hope to see you there soon. By the way, there is no danger that I shall make so many standing figures that people will not be able to tell one from another. It will be enough to make 2 or 3 (or 1 or 2!)."

There was never any question that Pierre did not wish to proceed with the association that had been formed ten years earlier. By the summer of 1947, when Pierre had been to see Giacometti in Paris, plans were under way for a major exhibition at the Pierre Matisse Gallery in January–February 1948.

When Pierre outlined the project, Giacometti was awed. "Everything that you tell me gives me very great pleasure," he wrote, "but I find it a bit scary, too. . . . In any case, I am delighted with our agreement, and I only hope that my work will stand up to it."

What Pierre had agreed to take on was in more than one way a considerable challenge. This was not an exhibition like the one of Miró's *Constellations*, which consisted of exactly twenty-three works on paper, shown in rotation. It was likely to consist of twenty or more sculptures, large and small, dated between 1925 and 1947. Some would be in bronze. Others would still be the original plasters. They were in a succession of styles that could baffle even a well-disposed visitor. There were early poetic objects with titles like *Woman with Her Throat Cut* and *Disagreeable Object (for throwing),* and there were later sculptures that presented the human figure in terms of a slenderness never encountered in nature.

Quite a few of the new sculptures would have to be cast in bronze by Alexis Rudier in Paris. In some cases, the original plasters would be shown. All this would then have to be shipped to New York. There would probably also be paintings and drawings, and a very ambitious catalogue. The exhibition would call for a large investment, which might or might not pay off in time.

There was the further complication that Giacometti was not as well known in New York, whereas among the ten or eleven people whose opinion counted in Paris, Giacometti had been someone to watch since 1928.

But even in Paris, after World War II, his work had never been given a full-scale show. In 1946 his friend Pierre Loeb had announced an exhibition of his paintings and drawings, but this seems never to have taken place. (Giacometti had signed a contract with Pierre Loeb as early as 1929.) In 1947 one or two of his small sculptures were shown in Paris and (during the summer) in Avignon. But the international market for new art had not yet taken shape. New York was terribly far away. For the modish Parisian, it might as well have been Kamchatka.

But what was the alternative? In Paris, Pierre Colle, Alberto's first champion in 1934, was dead. Pierre Loeb, yesterday's tastemaker, could no longer contemplate major undertakings. In New York, opinion would rally to Giacometti in time, and James Thrall Soby would come up in 1955 with one of the best things ever written about him – that his most apparently insubstantial figures "magnetize the surrounding air and light, attracting to themselves an inexplicably poetic nimbus." But meanwhile there was as yet no such thing as a free, multinational market for contemporary art. Giacometti would be coming to New York as a man on his own. "Scary" was the right word for it. But basically there was nowhere else to go.

The project called for the closest possible cooperation between artist and dealer. Pierre Matisse had no full-time representative in Paris, and Giacometti had to deal not only with Rudier and with Lénars, the shipper, but with all the paperwork that was involved in the dispatch of so large and miscellaneous a consignment. It was he who went, for instance, to the Ecole des Beaux-Arts to

expedite the formalities for each and every sculpture that was exported.

Long letters to and from Pierre were also essential. Giacometti's were written – sometimes in cafés – on small sheets of the cheapest possible paper. He used a succession of pauper's pens, each equipped with a nib long overdue for the trash can. Spectacular blots resulted. But his urgency never failed to come across, whether the subject was the size of Rudier's bills, or a matter of technical finesse, or the anxieties of not hearing back from Pierre as fast as he would like.

In the dealer/artist relationship, high tension is built into any large-scale joint endeavor. Each commits (or should commit) his whole self. Each craves the other's entire and exclusive attention. The dealer can't wait to see the work, and the artist agonizes over any sign, real or imagined, of doubt or discontent on the dealer's part. Misunderstandings are bound to occur, and all the more so if the dealer is running his own ship and has a full season's exhibition program to look after, and clients to coax, and obligations to fulfill, month by month.

In 1948, for instance, Pierre Matisse was to have solo exhibitions by Joan Miró, Wifredo Lam, Marc Chagall, and Jean Dubuffet. All of them needed attention. To be more precise, they needed handwritten letters from Pierre.

Pierre did not always reply by return. Sometimes a letter would lie unanswered for weeks. There was a moment in November 1947 when Giacometti was almost drowning in anxiety. "Your long silence worries me," he wrote to Pierre. "You must be discontented with me, but I don't understand why. There are just two things that I did wrong. I was sick for ten days. I couldn't even stand up.

"The other thing is that my letters to you were too long and too confused. This was largely due to my condition. But in spite of being ill, I did not fall behind my schedule by even one day. I kept to the dates you gave me." And, finally, "I don't know what else to say until I have your news. I am very impatient to hear from you."

Pierre replied by return that if he had not written sooner, it was from pressure of work. Giacometti had no reason to reproach himself. On the contrary, he was to be congratulated on having kept all his promises. This particular peril passed, therefore.

Fundamentally, all went very well in this respect between Pierre and Alberto. The preparations in Paris were burdensome in many ways, but Giacometti took pleasure in the skill and the rapidity with which Alexis Rudier went to work. Rudier did not come cheap, admittedly. The big figure of a standing man was going to cost 50,000 francs. "But it's much better than I had expected," Giacometti wrote. "When it's standing upright, instead of lying on the floor, and in a big space on quite a high plinth it looks infinitely better than the plaster. And when you look at it from far away, it doesn't come apart! It looks even better."

As for the price, Giacometti knew that Pierre might shudder. "But," he said,

"no one else could have done it as well. Valsuani would have asked twice as much. I know that Picasso paid 400,000 when his *Man with Lamb* was cast, and as a task it was much less delicate."

Quite apart from that, he went on, "You have rendered me an immense service in allowing me to have these casts made. For the last year, I could never have afforded to have one made at my own expense. I don't dare to say that I'd like to offer you a cast of your own choice among those that have been made. But I hope that, if we sell one, you will keep whatever would have been my share in the price and put it towards the cost of the first three sculptures. I'd also like to give you one of them. You cannot know how much all this has helped me in my work. I have made great progress since we began to work together."

Sometimes there were ideas that just didn't come off. At one point in the preparations, a *Torso of Picasso* in bronze was penciled into the wish list. But Giacometti wrote: "I'm sorry, but you can't have the Picasso. I think that the torso has certain qualities, but I can't hurry it along to be in time for the show. Picasso would be furious with me if I were to show it without letting him see it first. It would also be very, very disagreeable for me if people thought (as some of them undoubtedly would) that I had included the Picasso in hopes of getting some publicity for myself. That would ruin all my pleasure in having the show."

Giacometti was also very precise about the patination of his bronzes. As he could not go to New York himself, he gave Pierre concise instructions. When he was about to send the *Man Walking* and the *Woman I,* both dated 1947, he said that both of them were better than he had expected. The *Woman,* in particular, held its own even from a distance, even though it was to a certain degree still a sketch. "Close to," he went on, "the *Woman* is a block of stony-textured metal. The material itself is very beautiful. Neither of these sculptures should be patinated. They are much better as they are, and there are no other sculptures quite like them. They should just be varnished, to avoid oxidization. The varnish will last a long time. Then, little by little, they will patinate themselves."

By October 1947, the exhibition was coming on well. "Don't worry any more about the exhibition," Giacometti wrote. "I'll have everything ready for you. But some of them will have to be shown as plasters. Madame Duthuit gave me 60,000 francs for the bronzes. I'll write to you this coming Sunday and let you know exactly where I stand. Right now I can hardly stay awake. What a life I have, thanks to you! It's the best thing that could possibly happen to me."

As to what would finally be in the show, and how it would look, letters and cables continued to go back and forth. On October 13, Pierre wrote that after looking at the gallery again, he had decided that the show would need three or

four more big pieces. The painter Matta thought that there should be plenty of space between them. Others thought that they should be bunched together. There was also a minority opinion that to have both bronzes and plasters in the same show would lead to confusion. There were, and there are to this day, connoisseurs who think that the original plasters could have an eloquence and an immediacy that were lost in the casting process. Others thought that they would look unfinished, not to say uncooked, in the company of the bronzes.

Matta and his then-wife, Patricia (Patricia Kane O'Connell), were both of some importance in this matter. Matta had had solo exhibitions at the Pierre Matisse Gallery in 1942, 1944, 1945, and 1946. He also appeared in eleven group exhibitions between 1941 and 1989. As a personality, he was brilliant and incisive and never at a loss for a provocative opinion.

Herself likewise a fiery particle, Patricia was among other things a gifted photographer who liked nothing better than to photograph Giacometti's work in the studio. She came early. She stayed late. Often it was through her most recent photographs that Pierre got his first reliable information as to what the new work was like. She was also very good at sending sequential reports on works that were still in progress and changing from day to day.

During the run-up to the Giacometti exhibition of January 1948, Matta and his wife acted as trusted advisers and intermediaries. (It was Matta, reportedly, who suggested the tall narrow vaginal slit on the cover of the catalogue, which allows just a tantalizing peek at the naked figure of a young woman inside.) "Ask Matta and Patricia," Giacometti would say when questions of installation were being discussed.

Meanwhile, Giacometti himself had worked so hard to be on time for the show that his normal procedures had had to be accelerated. By working through Armistice Day (August 11), he would have the sculptures for the show all ready to go. "These last three days," he wrote, "I've made such great progress that the bronzes already have an ancestral look, as if I had made them 20 years ago instead of last month. But it is thanks to my having made them that I have taken such a great step forward. In spite of the defects of those bronzes I am not sorry to have had them cast. They look all right and it was essential that something of that stage in the work should survive. They will be justified by what is to come next."

The problems of the size and height of the plinths were complicated by the fact that Giacometti did not know the height of the rooms in the gallery. As for the ensembles, he urged Pierre to do as he thought best. "Pay no attention to what I say," he wrote. "You could look it over with Matta and Patricia, if you like."

Giacometti in general was more than punctilious in all his dealings, and not

least with himself. When Pierre asked him to send a signature for reproduction in the catalogue, it turned out that this was not an easy matter for him. "It's always the same with my signature," he wrote to Pierre on January 4, 1948. "I don't like to sign my name. In fact, my relationship to my name is not at all clear. My name is something of a stranger to me. (My first name may be a little closer to me.) I have often thought of finding myself another name, but I've never found one. So I'll stick with it for the present – or perhaps forever. Who knows?"

By January 1948, it was none too soon to submit copy for the catalogue of the then-imminent retrospective exhibition of Giacometti at the Pierre Matisse Gallery. This catalogue was remarkable on two quite different counts. First, it included a handwritten and hand-illustrated concise autobiography by Giacometti himself. This was to be for the next fifty and more years the document of first choice for anyone who wanted to understand what Giacometti was up to.

Second, the catalogue had a long essay by Jean-Paul Sartre, who at the time was regarded as the foremost all-rounder among French intellectuals. As philosopher, novelist, playwright, essayist, political activist, editor of the influential monthly, *Les Temps Modernes,* and occasional art writer, he was the nonpareil of the day. He and Giacometti had been friends ever since Sartre introduced himself in the Café de Flore in Paris during the war. That he should contribute to the catalogue was regarded as a considerable coup, even by people who had never read a word of his voluminous writings.

Like many another writer, large and small, Sartre was not always ideally prompt. More than once, in the fall of 1947, he had told Giacometti that his text would be ready "in a day or two." But it was not until January 2, 1948, that Giacometti wrote, "Here, at last, are the preface and my own text. I am very sorry to have kept you waiting for so long, but I only got Sartre's preface yesterday and I am sending it off at once. As you will see, it's very long. But I myself like it very much."

"I allowed myself to complete (on page 5) a phrase of mine that Sartre quotes. By leaving out half of that phrase, he changes the sense of it. Naturally I don't care for that. If it is to be quoted at all, I want it to be quoted in full.

"In another envelope," he went on, "I enclose my own text, with the little drawings and the annotated list of works. I have also sent for dispatch almost fifty drawings, and a few prints, for you to choose from, and – ah yes! – two little paintings, two little figurines, and a minuscule head. I hope that they will all reach you as soon as possible.

"Tomorrow I am going to Maloja in the Engadine. I simply have to go there. It's the only way I can get myself ready to make more sculptures. Right now, I can't make anything. This is not because I don't know what I want to do. It is

because it is physically impossible. I'll do my best to send you some drawings from there. I'll write to you, too.

"What I most want is to get some brushes in Zurich that I need and can't get in Paris. I don't know what else to say this morning except that I am happy to be able to send you these two texts."

The show opened on time, and on March 3, 1948, Pierre gave an overview of the fortunes of the exhibition. Choosing his words carefully, as he always did on such occasions, he wrote that "For myself, I am very content with the results of the show. The general impression was excellent. It was talked about all over New York. Some were for and some were against, as is natural, but it was a stimulating discussion. The timid and the crafty were afraid that it would do harm to their own footling activities, and they were violently against. So were the 'professional sculptors.' Ozenfant's review will make you laugh. He sides with the 'professional sculptors' – Lipchitz, Mary Callery, Maria Martins, etc.

"But what delighted me was the reaction of an American public that had not gone the way of the cretins. They found in your work a kind of expression for which they seemed to have been waiting. As for the critics, they'll come round in time. It is difficult for them to drop their little habits and their ingrained theories.

"Between you and me, the preface by Sartre, which I liked very much, antagonized the critics. Sartre's brand of mental agility caught them quite unprepared and put them in a rage. To have a catalogue preface that is addressed to the general public often antagonizes the critics." This was, if anything, an understatement. American critics did not want to take lessons from someone who seemed to them to be simply one more French verbalizer, no matter how deft he might be. Henry McBride, for instance, was anything but a redneck philistine. Nor was he indifferent to French art and French literature. He could look, and he could read, but when he was all through reading Sartre's four thousand-word essay, he could not resist quoting some lines by Jacques Prévert. Prévert had been in and out of major art (and major movies), but he didn't like people to come on too strong, especially if they were the heroes of the day.

This is what Prévert had written:

"Tout le monde parlait,

Parlait, parlait:

Personne ne jouait."

Or, roughly speaking:

"Everyone was talking,

Talking, talking:

but nobody joined in the game."

McBride also said that "these are the queerest sculptures that have ever come to us with such high recommendations."

Giacometti himself took all this perfectly well. "In spite of everything," he wrote, "I am not sorry that Sartre wrote the preface (or study) in which he said many good things. If the public is baffled, that seems to me to be perfectly normal. The same is true of the artists (and there are bound to be many of them) who are not convinced (to say the least!). You and Patricia have given me enormous pleasure with the catalogue. I don't know how to say it, or how to thank you enough."

As a matter of fact, there were some inspired passages in Sartre's preface, though their oracular idiom was not easy to render into English. Long acquaintance had led Sartre to see Giacometti as "the contemporary, by preference, of the man of Les Eyzies and the man of Altamira. In that drastic youthfulness of nature, and of men, neither the beautiful nor the ugly yet existed. There was no such thing as 'taste,' and no one who possessed it. And there was no criticism: all that was still in the future."

By lining Giacometti up with the cave painters of Les Eyzies and Altamira, Sartre distanced him from the art talk of his own day. "I do not know," he went on, "if we should regard him as a man who wants to impose a human stamp on space, or as a rock that is about to dream of humankind. Or, rather, he is both the one and the other, and the mediation between them."

Later, Sartre said that "after three thousand years, the task of Giacometti, and of the contemporary sculptor, is not to enrich our galleries with new works. It is to prove that sculpture itself is possible. To prove it by sculpting, as Diogenes proved movement by walking. To prove it, like Diogenes, against Parmenides and Zeno."

He also knew how to evoke the unforgettable oddity of Giacometti's plasters in their initial stage. "The first things you see in his studio," Sartre said, "are strange scarecrows made of white crusts curdled around long red strings." He also produced what is the most memorable one-line comment ever made about Giacometti's standing figures: "This is sculpture that cuts the fat off space." And, finally, he was absolutely right when he foresaw that after Giacometti's death every last trace of his life in the studio would be coveted. "Men will come to his studio," he said, "to strip it, and carry off all his works, even to the plaster that covers the floor." Every least mark on the wall would also be taken away and preserved.

Meanwhile, Thomas B. Hess, the most discerning American critic of the day, said in *ARTnews* that "This is one of the newest, most exciting shows of modern sculpture that this reviewer has ever seen."

Of the very small sculptures that disconcerted many visitors, Hess said that "They are fixed in space and hold the spectator, too, to the one spot where they are immediately grasped, realized and wholly astonishing."

Another seasoned observer of the New York scene, Dore Ashton, said that "Nobody, I think, has lately provoked more discussion than Giacometti. For us, Giacometti is the bridge to the artistic thought of postwar France. The unmistakable existentialist serious artists and writers enriched the local art scene with an element that was completely unknown to it."

Clement Greenberg, then the critic of *The Nation,* had a dissenting opinion. The most recent work struck him as "a sad falling-off. Gone is the bold-rough geometry that gave Giacometti's former flights of imagination their former motive power; gone the audacious inventiveness that shocked the spectator's vision, only to stabilize it on a higher and securer level." Giacometti's work from 1925 to 1934 was, in Greenberg's opinion, "on the whole, a success. It is style," he wrote, "that makes such consistency possible, a style borne up by the pressure around him of great contemporaries, and also by the faith in the future, that he shared with most of them. His projects for public places, and tunnels, his cages and strangled women, his figures and heads, ultimately aimed at a reconstitution of the world upon a more sincere basis – a new sincerity that will no longer conceal what are, humanly speaking, the arbitrary absurdities of the present world." But the newer sculptures seemed to Greenberg to "constitute nothing more or less than a retreat to the statue, to the monolith." As it happened, the most recent works in the show (all done in 1947) included the Gogolesque *The Nose,* the *Head of a Man on a Rod,* and the figure of a woman feeling her way called *Night.* None of these can be construed as a "retreat to the statue," or to have anything to do with the monolith.

On the contrary, *The Nose* and the *Head of a Man on a Rod* are like no two sculptures ever made before. This is a nose that has broken free from the rest of the body. Though confined to a cage and tethered by a vertical string, it can thrust itself this way and that, as if to monitor the world outside with its infinitely intrusive apparatus.

The head of a man on a rod has the immediacy of an experience of life and death relived at the closest possible quarters. As for *Night,* there is nothing of either statue or monolith in the uncertain, wavering movement of the woman as she gropes her way along a narrow path, raised quite some way from the ground. In all three of these pieces there is a hallucinatory element that after fifty years is more startling, and more individual, than it seemed in 1948.

Pierre sent the good news that seven bronzes from the show had been sold. All of them dated from 1947. They included *Man Pointing, Tall Figure, Tall Figure* (half size), two small bronze figures, and *Night.* With characteristic moderation, Pierre said that, as this was a first solo exhibition, and one held in a very unfavorable economic situation, the results were "not bad." Not everybody had as yet

paid up, but that was nothing to worry about. The lenders had included Pierre Matisse himself, James Johnson Sweeney, Philip Johnson, Matta, his wife, Patricia Echaurren, Julien Levy, and two sculptors, Mary Callery and Maria Martins.

These last were two formidable women. "Do see what you can do about Mary Callery," Pierre wrote to Giacometti. "She's simply FURIOUS with you. Every woman has a dangerous tongue when she wants to make use of it. Besides, she's a sculptor. Maria Martins is also wild with rage about the show, and all the more so because she did everything but tie me down hand and foot to make me give her a show. She had it at Julien Levy's, thanks to Marcel Duchamp's intervention, and she didn't sell a thing."

Giacometti himself, still in Stampa, was delighted that so many people had been to his show in New York, but "no sooner do I think of it than I long to be back in Paris and at work on my sculptures. Everything that I have done so far is just a beginning. None of it was as truly realized as I had hoped. They still didn't give what I want to give. But that is a stage that has to be gone through, and I am grateful that – thanks to you – they exist. I have worked hard here and I think that it will be enormously helpful for my sculptures. I also think that I see better what I should do with my paintings and sculptures. For that, I had to work from nature again. Despite her 76 years, my mother has posed for me every morning, every afternoon, and sometimes even on Sundays. In the end I think that I came to understand the business of big and small, near and far. It is the relationship with reality that has plagued me for years and made an idiot of me. Now I'm starting to see how I should deal with it in terms of color. And color, indirectly, is very close to sculpture, too. I have to get going very fast with all that.

"As for money, and for prices, all I want is to have something in hand for the next few months. This business of the 5,000-franc note going out of circulation may eat into what I have (and I'm not the only one). Would that be possible? Meanwhile I long to give you some sculptures that are better than those you have had already.

"That's all. I'm going to post this letter and go to bed."

By February 25, 1948, Giacometti was back in Paris. Eager as he had been to get back to the studio, even he felt the discomforts of postwar Paris in midwinter. The snow, the slush, the mud, and the pervasive damp – all made him miss the fine weather and the well-warmed house that he had just left in Stampa.

"But today," he wrote, "except for my wet feet, I'm already used to it and delighted to be in my studio. Unlike when I came back here a year ago, I found that there were sculptures here that I was very anxious to go on with.

"I am very glad that you have decided to extend the exhibition. That must be a good sign. But *what about the critics?* I'd love to read what they have to say.

I saw a review in *Time* with two photos. It seemed to me all right, with one passage that was even very good. Here in Paris everyone wants to have the catalogue, and those who have seen it find it very, very good. Tériade especially. It seems that Mme Callery was displeased not to have had her sculpture before the exhibition. But all that can be straightened out. I myself prefer her sculpture to have been seen first in the exhibition. (I have five or six pens here, each worse than the last. It's difficult to find one that I can make any sense with)."

There followed a discussion of the twenty-two very small sculptures that Pierre had seen grouped together. Giacometti did not want to sell them to Pierre. "I'd prefer you to accept the entire group as a gift," he wrote. "That would give me very great pleasure. Just tell me when and how I should send them. I'd prefer to make money on other things – the bronzes, perhaps. At this moment I need money badly – in fact, I've hardly anything left – and I need money to keep working, and also to live, these next three months. (That's as far ahead as I can see, right now.) These last two months did me a lot of good. I no longer need to destroy anything, and by the end of March I shall have new things all finished. They will be better – in fact, much better – than the last plaster that you have."

On March 12, 1948, he returned to the subject of the New York reviews. "They're not as bad as I had thought. Where they try to wound, I take it in good part. Besides, they are long, which always helps! And so long as they don't harm the exhibition, I don't care what they say (this time round). Besides, I cannot expect other people to think highly of work which I myself regard as incomplete. In any case, it is not necessary that they should immediately understand what they have not seen before.

"As for my colleagues, I don't want to talk about them. Lipchitz, for instance, is well known for being eaten up by jealousy. Maria Martins came to see me here every day, and was profuse in her admiration. Perhaps there is a personal reason for her present behavior. The only way to answer one's colleagues is to do better work. That's what I intend to do, and we'll see what comes of it."

He also touched on a subject that would call for delicate handling. "Some time – and not too far away – I'd like to have an exhibition in Paris. It is a very long time since I had one, and I need to have one now to show people who I am and what I've been doing. *Horizon* in England and *L'Art de France* are anxious to have articles about my work. Sartre will publish his preface in *Les Temps Modernes*. But the important thing is that the sculptures should be seen. Don't you agree?

"That's enough for today. I must go out and make my way through the mud. I shall see Miró tomorrow. Tonight Georges Bataille is giving a lecture on Surrealism."

Giacometti was right, in that it was high time that he had a substantial solo exhi-

bition in Paris. He was forty-seven years old. He had lived primarily in Paris since 1922. Among the semisecret society of Parisians who lived and breathed for new art, he ranked very high. But he had not had a solo exhibition in Paris since 1934, and much of what he had done since then had never been seen there. From every point of view, this was becoming ridiculous. And, although few men have ever cared so little about money, there was the fact that he had never been able to put a penny away.

Pierre Matisse, meanwhile, had nurtured his work in ways that Giacometti was the first to acknowledge. He would say, as he had said in letters to Pierre, that Pierre had made the work possible. If the idea of an exhibition in Paris had never been mooted, it was in part because, after World War II, the international market for new art had been slow to take shape.

It had taken a long time for Pierre to assemble a comprehensive show for New York and to produce a catalogue worthy of the occasion. Even then, it was something of a gamble. The art world at that time was still made up largely of handwritten letters, local telephone calls, and the dispatch of major works of art by slow-moving steamboats.

But a new kind of art world was about to begin. There would be feelers from all over. Poachers would be on the prowl. Big money would turn up from quarters previously unknown or untapped. Sooner rather than later, Giacometti would have to be shown properly in Paris. But when, and where, and by whom? These problems would have to be addressed.

By mutual agreement, any serious discussion was postponed until Pierre Matisse came back to Paris in the summer of 1948. Giacometti, meanwhile, was his undemanding self. If Rudier raised his prices for casting, Giacometti offered to reduce his share of the profits accordingly.

But already in March 1948 the Galerie Louise Leiris had shown interest. A few weeks later, Giacometti wrote to Pierre and told him of the recent opening of the Bar Catalan. "It was a lot of fun. An enormous crowd, almost everybody one knows in Paris, and altogether very gay." He also wrote that "everyone is reading Sartre's preface about Giacometti, which has just come out in *Les Temps Modernes*."

But the real news was that he truly felt that for the first time he was about to make sculptures that he would regard as complete. He could do it, but . . . he had to have a little money.

"I am writing to you because I have desperate need of your help. Without it, and without it very soon, I shall be in big trouble. I hate to say this, but what else can I do? I'm really getting somewhere."

On April 26, 1948, the problem was made more acute by Pierre's apparent failure to reply. (His letter was mislaid en route.) As on other occasions, it was

not due to indifference. It was due to the problems of attending to a full stable of first-rate artists in a time of economic uncertainty and with none of the colossal backing that became available when the best new art turned out to be one of the better investments of the day.

The second half of 1948 and the first months of 1949 were also marked, as is discussed elsewhere, by a succession of major events in the Matisse family. Relations between Henri Matisse and his son Jean did not improve. Pierre had to tell his father that he was leaving Teeny, his wife of nineteen years, and intended to marry Patricia Echaurren, the wife of Matta. Louise, the wife of Jean Matisse, had told her parents-in-law that she was asking for a divorce. In January 1949, Louise Matisse died, alone, in a hospital in Paris.

From these events, great misery resulted. Pierre never spoke of them, except in family discussions, but they were continually on his mind. His habitual silences could be misread. "Why don't you write to me?" Giacometti wrote. "I wait for your news every day. Nothing arrives, by no matter what means. I don't know what to think of it, and I simply don't understand this long silence. Have you had my letters? I did everything that I had to do. The bronzes are ready. I have a bill from Rudier for 175,000 francs, inclusive of 10% tax. The details are enclosed with this.

"Meanwhile, I have to borrow money to live! And I do sometimes think, *just a little,* of this curious and rather disagreeable situation. I work as hard as I can. It's very difficult, and very tiring, and it takes a long time. But I have to do it. The heads are the most important thing for the moment, in spite of my longing to go back to the figures.

"But do write to me at once! Let me know what's happening! Do not leave me without a word!

"Most affectionately

Alberto"

Of their encounters in Paris in the summer of 1948, nothing can be learned from the archives. Yet it is difficult to believe that they did not discuss what had been achieved by the exhibition in New York, and what its long-term effects would be. Important exhibitions do not end when the work comes down. There are the people who remember them. There are the reviews, yellowing in scrapbooks. There are the sales, if any, that get the work out into the world. There is also a multifarious buzz of comment and conjecture. This may die down and die out, but it may also resurface in terms of obsession and loss. "Never again," people will say, "shall we see all these works together." It was in terms such as those that many visitors remembered the Giacometti exhibition at the Pierre Matisse Gallery in 1948.

That same buzz may also, of course, find outlet in terms of envy and greed. Rival dealers come by to see what's in it for them. Big bucks are talked of, together with up-to-the-minute auxiliary benefits. The late 1940s were the early but crucial years of the big new gallery with its big new promises.

Alberto Giacometti was one of the least mercenary of men. His needs were few. He spent little or nothing on himself. He did not want to "live well." He liked to see his friends, very late in the evening and sometimes well into the night. He genuinely and wholeheartedly loved women, and was particularly susceptible to fine-looking young Englishwomen who spoke good French. From his school days onwards, he was a supremely intelligent reader. In all these matters, he lived not for show, but for love and friendship.

He was also very loyal. He was devoted to Pierre Matisse, and he would never have wished to have anyone else as his dealer. The experience of his exhibition had put him in the best possible frame of mind for his work. In the summer of 1948 it seemed that no limits need be set to his ambition. On August 18, 1948, however, Giacometti wrote to Pierre that he had a number of things to say and wanted to say them as briefly as possible.

"I should very much like to work with nobody but you in New York. But this can only be possible if we keep to the conditions that I outlined to you when you were here. You do not seem to realize that except for what I make from my work I do not have a single penny either in New York or (contrary to what certain people say) in Switzerland. Not only do I have no savings, but I still have debts that I cannot pay.

"It is essential that I can count *absolutely* on getting a certain amount of money from you. I suggested that you should send me half of what would come to me when something is sold. (Nothing could be more fair than that.) That sum is not to be considered as an advance, but as payment of a debt. I do not ask that it should be paid all at once. It is the most amicable arrangement that we could make, and it is only possible on a basis of mutual confidence.

"If you do not agree to it, I shall be obliged to sell my work as and where I can, provided that every sale is firm and that payment is made at once. This is the only basis on which I could make a living. Three people have offered to buy the portrait of Diego on which I am working now. They will buy when it is finished, and they would even pay for it now. This coming fall, I shall let people see the work I have here with a view to preparing an exhibition. (Maeght would also show my work, if I wanted him to, according to what his director told me.) Pierre Loeb, who was here, would also like to have some sculptures and some paintings.

"Sidney Janis came twice to the studio. He is very interested and would like

to buy three sculptures and make an exhibition with paintings and drawings as well. He would also like to have the *Three Men* for his private collection. (We should jointly agree to that, don't you think?)

"I told Janis that I could do nothing in the United States without going through you.

"Please write to me at once about all these matters and about how we are to continue in the future." This letter ended with the words *"Soyez gentil!"* (Be nice!)

Pierre lost no time in replying on August 23, 1948. "After reading your letter attentively, I am all the more sorry that my last letter to you was mislaid. Please let me know at once what we need to pay Rudier for the bronzes he is to cast, so that I can make my calculations. For the bronzes already cast, please send me the list.

"You will have money by *September 15*. I cannot tell you exactly how much, but it will be at least 100,000 francs. Once I have completed my calculations I will let you know whether I can agree to your proposition. If, as you say, I am not obliged to pay you the sums in full, I think that that can be arranged.

"Let me know how much you will need each month. I don't mean the minimum. I mean the amount that would be possible both for you and for me. On my side, if I had enough money (from successful deals, etc.). I'd try to meet all my obligations more rapidly.

"So I'm waiting for your reply. I am not surprised that other people should want to buy your work, now that I have started the ball rolling. In our strange profession, there are always people who profit by others' efforts. Thank you, though, for what you said to Janis. He is one of those who wait for others to pull the chestnuts out of the fire.

"So there it is, dear Alberto. I hope very much that we can reach an arrangement that will satisfy us both."

On August 28, 1948, Giacometti wrote to say that he, too, wished their association to continue and had never intended to speak about money in an aggressive, let alone a brutal way. He regarded their conversation in his studio as one of the happiest that they had had during their long friendship. "And," he said, "the fact that we talked about money leaves me all the more free to think about other things."

Among the "other things" that had never been discussed in detail between them was the exact role in Giacometti's career of the standing lamps, vases, and other household objects on which he and his brother Diego had been collaborating since 1930. After Jean-Michel Frank had died (by his own hand) during World War II, they worked through a decorator in Paris called Adnet, who headed a company called "Arts de France." Diego was essential to their joint activity. Not only could he bring Alberto's projects to fruition, but he knew all the specialized craftsmen

in the Marais in Paris who did much of the work. (Diego himself did the final touches.) "I can only produce these objects," he wrote to Pierre on November 3, 1948, "because Diego takes total charge of the work. The objects interest me almost as much as the sculptures do, and there are moments at which the two are related."

At that time, Giacometti in Paris was finding it difficult to "get through" to Patricia Matta, or to see her on the day-to-day basis that he had come to count upon. As a friend, she was important to him. As a photographer, she was for him the recording angel of first choice, where his work was concerned. To lose touch with her made him almost frantic.

"I don't understand, right now, what she is thinking, where she's at, or what she wants to do. I can't even make sense of the way she uses words." In writing about it to Pierre, he was anxious to make his position quite clear. "Please do not think," he wrote, "that there is any kind of conspiracy between Patricia and me. It is true that I have a great feeling of friendship for her, but I have even stronger feelings of friendship for you. This makes any thought of conspiracy quite out of the question." This letter was dated November 29, at exactly the time when Pierre was drafting a letter to his father in which he named Patricia as his intended wife. (They were married in Jersey City, just across the Hudson River from New York, on October 28, 1949.)

Giacometti himself had a charge of energy and renewed self-confidence that was to come out very strongly in November 1950, when he had his second show with Pierre Matisse in New York. The year 1950 was also a landmark in other ways, some of them joyous, some of them not. On July 19 Alberto was married to Annette Arms, whom he had first met in Geneva in 1943. She had followed him to Paris in July 1946.

In 1950 he also had his first retrospective exhibition at the Kunsthalle in Basel. *The Square,* a sculpture made in 1948–49, was bought by a great museum, the Basler Kunstmuseum. In New York, Pierre Matisse at first despaired of getting enough work for a second major exhibition. But in the end he got sixteen bronzes, six paintings, and some drawings, together with a catalogue in which Giacometti once again had much that was memorable to say.

The show included a number of sculptures that were evocative in quite a new way. Giacometti was not at all sure what they should be called. "The titles I gave you yesterday just won't do," he had written to Pierre. He did not like fancy or "poetical" titles. He preferred titles that were bald and nonevocative.

A sculpture that he originally named *Composition with Seven Figures and a Head* was in the 1950 show. So was one called simply *Four Women on a Base.* These titles – *appellations* may be a better word – gave nothing away. The seven figures differed enormously in scale but had in common a slender

and hieratic presence. The head sat by itself, a little apart.

It was the particularity of this piece that in terms of traditional perspective made no sense. Each of the figures had its own space, and there was no apparent relationship between them. Not only were they disorienting, but they simply stood there, tall almost beyond belief, and challenged the observer to adapt to them.

In a letter to Pierre (reproduced in facsimile in the catalogue), Giacometti told how this sculpture came about. "In March and April of this year," he said, "I sketched out, every day, three figures. I also sketched out some heads. I stopped before I had quite arrived at what I was looking for. Yet I couldn't destroy those little sketches. They were still there, standing upright, and I didn't want to leave them on their own, lost in space.

"I began by making a composition with three figures and a head. I made it almost in spite of myself (or, rather, it made itself before I thought of it). Almost immediately, I wanted to do something less rigid with them. But what? I couldn't decide.

"A few days later, I cleared the table and laid the figures down on the floor, at random. They formed two groups that seemed to correspond to what I was looking for. I set up the two groups on platforms, leaving them just as they were, and I worked on them, leaving both their positions and their dimensions unchanged.

"To my amazement, the one with nine figures reminded me of a clearing – like a meadow grown wild, with trees and shrubs on the edge of a forest – which had always fascinated me.

"As for the group with seven figures and a head, it reminded me of a corner in a forest that I knew well in my childhood. The trees were tall, with slender, high-reaching trunks that had no branches until almost at the top. Behind them blocks of granite could be glimpsed. They always seemed to me like people who were out for a walk and had stopped to talk among themselves."

As for the *Four Women on a Base,* it is the absolute antithesis of the re-imagined forest glade. In perspectival terms, it has an implacable regularity. We see the four women up front and head-on, straight and stiff, as they offer themselves for sale in the evening in a little room on the rue de l'Echaudé, just off Saint-Germain des Près. Not only do they stare us down at close quarters but, as Giacometti said, "they look almost menacing."

In another sculpture in the show, *Four Figurines on a High Base,* this experience was turned inside out. It was in the Sphinx, a well-known place of pleasure in its day, that Giacometti sat quietly at the opposite end of the room from the four women who, once again, stood as straight as grenadiers and waited for the evening's trade to begin. Unlike the room in the rue de l'Echaudé, this was a spacious affair. Between

Giacometti and the four women, a perfectly polished parquet floor seemed to stretch away forever. "It impressed me just as much as the women did," Giacometti wrote, "and although I wanted to cross it, I just couldn't." The women seemed to him to be as inaccessible as the four figures who are set on high in the sculpture.

A less agreeable aspect of the year 1950 was that the question of Giacometti's representation in Europe arose in a form that was not welcome to Pierre Matisse. This was due to the intrusion of Aimé Maeght, who had made up his mind to get Giacometti away from Pierre. In the summer of 1950 he invited Pierre and Patricia to dinner in Paris. Pierre wrote to his father as follows: "As I did not exactly want to spend an entire evening with Maeght, I excused myself – on the pretext that Paul and Jackie were joining us – and asked if we could come to lunch instead. On Monday we picked him up at his gallery. He told us, with a great show of pseudo-courtesy, that he had ordered a little cold luncheon at his house, thinking that it would be cooler there, etc., etc. . . .

"When we went into the dining room, we found his secretary there (the one whose portrait you made). She was waiting for us, dressed as if for the seaside – off the shoulder, with deep décolleté, effusive but not quite at her ease. 'Well now!,' Maeght said to her, after introducing us, 'I quite forgot that I had asked

Giacometti. *Quatre femmes sur socle.*
1950. Bronze, 29⅞ x 16⅜ x 6¾" (76 x 41.5 x 17 cm). Alberto Giacometti Foundation, Kunsthaus, Zürich

you to join us at lunch!' (Not the best way to put her at her ease!) Four places were laid. The maid began to serve a bit of this and a bit of that. Maeght was not quite comfortable, as if he didn't know what to talk about and was waiting for me to indicate what tone he should take.

"He would doubtless have liked to pass himself off as a dashing young man who had a pretty mistress. I did not encourage this, knowing that he would have reacted with his well-known vulgarity. The service left much to be desired. There were only some very small spoons. But he did not want to ask the maid to get bigger ones, and asked his secretary to go and get them. This she declined to do, as if it were below her station.

"Finally the maid told him in a disagreeable and rather aggressive way that he should have remembered that Madame Maeght had taken the larger spoons with her to Cannes. Both Maeght and the young woman were clearly discomfited.

"I was absolutely right to have not wanted us to go out at night with him. He had planned it all – a little supper, a *boîte de nuit,* champagne. While his secretary would have lavished her charms upon me, he would have set to work with Patricia.

"Anyway, when lunch was over he left for Cannes, after inviting Patricia and me to spend several days at his villa!!! But he didn't fail to try to make trouble between Giacometti and me. He told me that Giacometti had been to see him to

Pierre in Giacometti's studio. Photo: Fred Stein, New York

ask if he could have an exhibition in the Galerie Maeght. Would I be agreeable to this? Miró had taken him to call on Giacometti, and he had asked the director of the Galerie Maeght to tell Giacometti that there was nothing he would like better than to have an exhibition of his work next spring.

"It's always the same – a string of lies in which he entangles person after person, creating an atmosphere of universal suspicion. This allows him to set them all to quarreling. Meanwhile he gets what he wants for himself. He did the same with Chagall."

There would never be any love lost between Pierre Matisse and Aimé Maeght. But the Galerie Maeght in the 1950s was the gallery in which almost every artist worth having ended up, almost without knowing it. Pierre Matisse had to work with Maeght in the matter of Miró. He had had to work with him in the matter of Chagall. The last thing that he wanted was to work with him in the matter of Giacometti. It was he, Pierre Matisse, who had coaxed Miró along since 1933. He had taken on Chagall in New York during World War II, at a time when Chagall was delighted to have a gallery that was in full operation. He had worked with Giacometti in ways that Alberto had acknowledged as essential to his career.

It has to be said for Maeght that when the Parisian art world was more or less dead after World War II he picked it up and carried the best part of it uphill to the rue de Téhéran, which stands on appropriately high ground on the right bank of the Seine.

As a human being, he was neither engaging nor unfailingly truthful. In the 1960s, when I had occasion to go to the Fondation Maeght in Saint-Paul de Vence, I asked if he had known Henri Matisse during the war. "But of course!" he said. "I knew him well, and I saw to it that he never lacked for the best cuts of beef, lamb, and veal." (Maeght at that time was in the food business in Nice.) Some years later, I repeated this exchange to Pierre Matisse. "That was very nice," he said, "except that my father at that time was a vegetarian."

For much the rest of his life, Pierre Matisse had to have business relations with Aimé Maeght. There was the share of the agreement with Joan Miró. And, after some unpleasantness, there was the share of the agreement with Alberto Giacometti. (From 1951, Giacometti showed with Maeght in Paris.) In time, he also became the permanent signature-presence in the Fondation Maeght, near Saint-Paul de Vence. There were also occasions on which Maeght tried to undercut Pierre's position in New York by selling Giacometti sculptures to another New York dealer.

All this was vexatious, but there was never any doubt as to which of the two had a more profound emotional commitment to both Miró and Giacometti. Pierre was true metal, and both Miró and Giacometti knew it.

A Gruesome Year,
1939

In the second week of the year 1939 the life of Henri Matisse took a turn for the worse. Radical changes resulted. By the end of 1941, Matisse the horseman, Matisse the single sculler, and Matisse the long-distance walker in the lobby of the Hôtel Régina had vanished from the scene. So had Matisse the husband and companion for more than forty years of Amélie Parayre.

In a letter to Pierre, written in the Hôtel Régina in Cimiez and dated January 2, 1939, Henri Matisse had feigned to be in very good humor. He had lately sent off the overmantel that Nelson Rockefeller had commissioned for his New York apartment. He was to have an exhibition in Chicago at the end of the month. In his scenery and costumes for Léonide Massine's new ballet, *Le Rouge et le Noir*, he had drawn to great effect on motifs from his big Barnes decoration. The ballet was due for its premiere in Monte Carlo in May 1939. Pierre had just sold a painting that Matisse especially liked – "the dog painting," he called it – and would doubtless sell others in Chicago.

His domestic news could not have been better. He and his wife were very happily settled in Cimiez. The apartment was finished at last. They were rid of the workmen. "We live way above the fogs," he wrote, "and we are both well. Let us hope that this will continue."

In reality, there had been, and there would continue to be, deep trouble between him and Amélie Matisse. Ever since the events of August 1938, which put the whole of France on alert for the possible outbreak of World War II, Madame Matisse had been in a state of acute and cumulative nervous anxiety.

When war had seemed imminent in September 1938, she left Paris and stayed with her sister in the country. When that particular danger was out of the way, their apartment in the Hôtel Régina in Cimiez, just above Nice, was not yet ready. They had to live for a month in a hotel across the way. It was as if everything, and everyone, were conspiring to stop her having anywhere that she could call home.

When they finally got into the Hôtel Régina, her disquiets continued. The workmen had been against her. With one exception, her own servants were against her. She saw Henri Matisse only at mealtimes, when they faced one another in silence, with never a word spoken between them.

Above all, she resented the presence of Lydia Delectorskaya. In her capacity as secretary, studio manager, and all-purpose factotum to one of the great French painters of all time, Lydia was beyond criticism. She was disinterested to a degree rarely met with among those who have been in daily and confidential contact with a major artist. But she was also a very beautiful young woman who was many years younger than Madame Matisse.

At the same time, Lydia Delectorskaya took her full share of the task of looking after Amélie Matisse. She would go into her room, day after day, and try to satisfy her every wish. Far from calming Madame Matisse, this was derided as an insolent intrusion.

Neither Matisse nor Tante Berthe – a regular visitor at that time – knew what to do, or what would come of it all. So they decided that Madame Lydia should go back home to her family, on the pretense that one of her uncles was ill.

Madame Matisse didn't believe a word of that. As it happened, Madame Lydia had taken with her a very heavy suitcase, filled with papers. Those papers were needed in order to complete, on Henri Matisse's behalf, a legal declaration that would shortly become due.

When Madame Matisse asked the servants about the suitcase, they at first claimed never to have seen it. When pressed further, they told Madame Matisse that their orders had been "not to tell Madame." At that, Madame Matisse began to allege that Henri Matisse had smuggled valuable documents out of the house.

"Eventually," Henri Matisse wrote to Pierre, "the doctor came and made it possible for her to sleep. When she woke up, she was as sweet as could be with everyone and seemed to have forgotten her idée fixe – which was to get rid of Lydia. Berthe and I lived through terrible days. . . ."

Henri Matisse thought – and was to be proved right a hundred times over – that without Lydia Delectorskaya at his side he would never be able to continue with his work. "Your mother knows," he wrote to Pierre, "that without Madame Lydia here I could never have painted the Rockefeller overmantel. I need her to

set up the studio, to keep it clean, and to be ready with the colors that I need, hour by hour. I count on you to back me up in that, and I only hope that your mother will be more conciliatory.

"My Dear Pierre," he went on, "for more than a month we have not known how to go on living. Your mother must never know that I have told you this. My doctors were very much disturbed at the state of cerebral tension that I had got into. They told me that I might have had a stroke. That meant nothing to her. She was like a woman possessed. Watch out for tomorrow! I hope that all will go well."

In that context, all never went well again. Henri Matisse could not exist without Lydia. Amélie could not live in the same apartment with her. One of them had to go, and as far as Henri Matisse was concerned it was not Lydia. "At my age," he wrote to Pierre, "and given the poetical nature of my work, she is essential to me."

It was decided between Tante Berthe and Henri Matisse that Lydia would no longer live in the house, but would come in every day to fulfill her manifold duties. Once this was settled, his health was much improved. His fits of nosebleeding stopped. His blood pressure was almost normal. But after a disagreeable scene with Madame Matisse, his pulse rate was almost doubled (from 60 to 100) and it was only after an hour's walk with his old friend Simon Bussy that it went back down to 68.

There were other problems. Matisse was not someone who could simply go out and paint, the way another man would go out and play golf. What he called his *poétique* – the inner impulse that led him to pursue one idea at a time, until he had exhausted it – was all-important to him.

The overmantel for Nelson Rockefeller was based on an idea of that sort – a duet for two beautiful young women, neither of whom would quite make sense without the other. It was an idea that he would be glad to take further. Pierre Matisse had cabled that Rockefeller was interested in a second decoration. Maybe he would like a sequel, while Matisse was still high on his idea? As to that, it really was "now or never," before his imagination began to flag. But although Rockefeller cabled that "We are thrilled and pleased beyond words with your painting," he had not asked for a successor.

Meanwhile, Pierre had been to see the overmantel in the Rockefeller apartment. It made a glorious effect. But the room was not yet finished, let alone lived in, and no further decisions had been made. Moreover, Pierre had heard that Fernand Léger was in the running for the second Rockefeller commission (if there was one). His father asked him to keep trying, though it was very difficult to get through to Rockefeller. If the price was too high, Pierre could come down

a little, but Matisse would be very sad to be outmaneuvered, and this was a time at which he had quite enough annoyances already.

Nelson Rockefeller never came back for more. Not only did he commission the second decoration from Fernand Léger, but he did not allow the first one to have publicity of the kind that might have led to other commissions for Matisse. "He won't do anything," Pierre wrote. "These are calm people, and on the chilly side."

Matisse was not deterred, however. In spite of all his domestic troubles, he went ahead with a further duet for two beautiful young women and completed it in the first week of April 1939. Though not as big as the Rockefeller overmantel (it measured 45 by 45 inches, as against 9 feet by 6), it closed the cycle of that particular *poétique* and was soon bought by the Albright-Knox Gallery in Buffalo. "It means something quite special to me," he wrote to Pierre, "because it sustained me during one of the cruelest and most painful moments of my life."

Matisse would have liked the new painting to be known as *The Guitarist*. But that title was already attached to a painting, dated c. 1902–3, of Madame Matisse in Spanish costume and bent over a guitar. So *Music* it was, and *Music* it has remained. He loved this painting, and had hoped that it would refute the opinion, which he believed to be widely current, that he had gone downhill as an easel painter. He would have liked to show it in Paris, but he was afraid that if war broke out it could be destroyed in an air raid. Couldn't Pierre at least get Dr. Barnes to come and see it in New York?

Well, Pierre could try, but Dr. Barnes liked to come to the gallery of his own accord and at whatever moment suited him. Couldn't it go on exhibition, then? No, not really, because it was already sold and Buffalo was anxious to have it. At moments such as this, Matisse would have liked the world to fall in with his every wish. But the world wouldn't.

Meanwhile, Madame Lydia was back at Cimiez, with the status of "an ordinary employee" who came in the morning and left when her work was done. Madame Matisse did not accept this. "But," Henri Matisse wrote to Pierre, "I am going to tell her that I swear by all that I hold sacred that my conscience is clear. My relations with Lydia are strictly and honestly those of artist and model. Perhaps even your mother will admit that the widely acclaimed high quality of my recent paintings owes something to Lydia's services. At my age, inspiration is fragile. I have on my side Tante Berthe, Simon Bussy, the doctor – everyone around me, in other words. But your mother still insists that if Lydia continues to work for me she will leave the house."

On January 26, 1939, Henri Matisse wrote to Pierre that by chance, and without meaning to eavesdrop, he had read a line or two that Madame Matisse

had been busily typing. He quoted it in full: "This affair was prepared long ago. Everything had been envisaged, even down to my departure from the house. For that reason . . ."

"I don't know what happened to the rest," he said. "Meanwhile, your mother has been seeing a lawyer – she won't tell me his name – who treats the whole problem as an everyday business transaction. How our assets will be divided, I cannot say. But she has already made me open a little safe, of which half the contents were hers. So, yesterday morning – I am writing this at 5 A.M. – I gave her a considerable sum in gold currency and dollar bills.

"If she secures the separation of our assets – which in any case are impossible to value – I shall be condemned to make her an allowance as well. . . . There is no doubt that she is motivated by a deep-seated and long-lasting rancor that she is at last able to satisfy.

"My dear Pierre, since the end of last September, our house has been a hell on earth. How can I possibly have painted that Rockefeller decoration? I realize now that I really am very gifted. Luckily, I have that satisfaction."

An irreparable situation went one stage further when Madame Matisse carried out her threat and left Cimiez with Marguerite on March 6, 1939, and took the train to Paris. She was never to return. According to the nurse who went with her to the station, she showed no sign of distress. Their luggage had been sent on ahead, and they did not warn Henri Matisse that they were leaving for Paris.

"Your mother left me these lines (dictated no doubt by her lawyer).

"Dear Henri (I had addressed her as Dear Amélie):

I have received your letter.

I am leaving for the reasons that you know of.

I, too, hope that we shall find the calm that we need and that you will be able to pursue your work in peace and quiet.

A. Matisse

That's all. It does not correspond to my letter, though it is her reply to it. There is a difference of tone."

It soon became clear that at this perilous moment in his career, Henri Matisse did not feel that he was getting from his children the kind of moral support, let alone approval, that he felt he deserved.

On March 7 he wrote to Pierre, "I am still completely discouraged by this cyclone that my children seem to understand better than I do. They don't know, and they don't seem to care to know, how badly I have been battered. I hope that on board ship, on your journey home, you found it restful to be among people who were outwardly normal. Of course, one never knows what other people are

really like, but I think it very rare for so small a thing to bring such devastation upon an unfortunate man whose work has done so much for others."

Meanwhile, and for the first time in forty years, Henri Matisse was, in effect, on his own. At first, he was rather thrown by it. "But then," he wrote to Pierre, "I made peace with my situation. I experienced moments of total tranquillity. As long as those moments continued, I savored a calm that I would wish to go on forever."

The calm was interrupted by rumors from Paris. "Your mother has been spreading as much scandal as she can," he wrote to Pierre. "As she can prove nothing, scandal is her only resort. It works, too. In London everyone says that I have run off with my secretary. I don't know what they are saying in America, but they'll get on to it soon enough.

"She said to an American woman, Mrs. Heyman, whom she had met while taking the waters, that 'My husband has been unfaithful to me with Madame Lydia for years. Everyone in Paris knows it.' Mrs. Heyman comes from San Francisco and has friends there to whom she often writes about her 'brilliant friend, M. Matisse.' Now she has big news for them.

"This same lady saw Tante Berthe and said to her, 'Now really, my dear, why didn't you tell me?' When Berthe told her that it was nonsense, Mrs. Heyman said, 'But it's all over Paris.' Everyone treats this tissue of lies as proof positive.

"When you next write, please send Berthe a word. None of you ever do, when you write. It's very unjust. Even when she was not well, Berthe came here every day for five years. Now she is repudiated by her own family for refusing to accept something that she knows to be untrue. You all know that she had a calming effect on your mother, and you also know that that was not easy. You must admit that after a long life of hard work she is being cruelly treated by those who should owe her their affection."

It was around this time that Henri Matisse began to realize that he simply couldn't get through the rest of his life without his son Pierre. For this reason he was morbidly sensitive to every nuance, real or imagined, in Pierre's letters.

There was a letter in which Pierre didn't even bother to ask how he was. In that same letter, Pierre had spoken of what he regarded as a tactical error in a vital letter from Henri Matisse to his wife. Henri Matisse took this as part of a conspiracy among his children to get him to give himself over, bound hand and foot, not only to Madame Matisse but to Justice itself.

And then there had been a letter to him from Marguerite and Jean. "I saw no reason to reply to it on my knees and with a rope round my neck," he wrote to Pierre. "Doubtless that will have wounded them deeply!"

Furthermore, Madame Matisse had written to Pierre and asked for a list of the paintings by Matisse that were in Pierre's possession in New York. Also she wanted to know how much money he had in the bank there.

Pierre had complied with these requests. Henri Matisse meanwhile was beside himself. Even before the legal separation was finalized, she was out to ruin him completely. He was on his back, helpless, and his family didn't even blush to see it. "What gratitude, my God!"

And then there was this public scandal, based upon nothing at all! He was not Sacha Guitry, who had left his wife, abandoned the conjugal domicile, lived openly with another woman, and didn't care who knew it. In this case he, Henri Matisse, was the one wronged. People said that public opinion was against him in Paris, and in London, too. But when public opinion was based upon falsehood, and the truth finally came out, it was the family who would be disgraced for having stood aside. Why didn't Pierre go to London and say that his father had not run off with his secretary?

He, Henri Matisse, after fifty years of honest work, was being "literally poisoned" by the atmosphere in which he lived. As to the cataclysm that had overcome him, even Pierre seemed unable to grasp it. "You will never understand me!," said Henri Matisse.

"Just bear in mind that in this matter the suffering is not entirely on one side, and that I am living in the depths of disillusion. And then there's this talk of war. I hope that Roosevelt won't be in too much of a hurry. All my paintings are packed and ready to go."

Pierre Matisse did not reply in kind, but on May 7, 1939, he tried to bring his father gently back to matters of mutual interest by describing, among other things, the opening of the enlarged Museum of Modern Art in New York. It had lots of marble, he reported, and "all modern comforts." A place of high honor was reserved for Matisse's great *Dance* of 1909, which had come to the Pierre Matisse Gallery in 1936.

Nelson Rockefeller had replaced A. Conger Goodyear as president of the Museum. "Doubtless his influence will be reactionary and nationalistic. His family is not very keen on advanced art. I don't know how he will reconcile his personal tastes with those of the Museum."

Pierre did, however, say – as if in an aside – that "I have tried in every way to persuade Mama not to sue for divorce. I also believe that she has hired a lawyer in Paris, and I only hope that he is intelligent and understanding."

At this point there is, for whatever reason, a gap in the correspondence until October 1939. Henri Matisse at that time was living in the Hôtel Lutétia in Paris.

Pierre, for his part, had been mobilized in the French army. (He would have been exempted, as the father of three children, if he had not forgotten to register that fact with the French authorities.)

Henri Matisse had been disturbed by Pierre's exhausted appearance when they last met. He urged him at once to consult a good doctor. If he were armed with a certificate to the effect that his heart was tired, and if he took care to wear his decorations, it might impress the army doctor. He himself had done just that in 1914, and it had worked very well.

If not actually released from the service, he might be sent to the family reserves or otherwise made more comfortable. "You owe it to your family not to stay where you are," he said. "Do not leave your future in the hands of fate. Take it into your own hands, if you can. I could help you to get an exit visa," he went on. "I'd come to Paris to help you with that. If Chagall could be useful, you must tell him that he can have an exhibition at the Gallery – but not until you are back in New York. He will get the point.

"Remember that after a tiring day a hot bath is bad for the heart. That is why you were so inattentive yesterday evening. Another thing. Don't rely on aperitifs, or on wine with your dinner, to raise your spirit. In time, you will pay a heavy price for them. Remember that your family needs you. Remember your liver, too – if you abuse it, it'll play hell with you later.

"I was glad to know that your absentmindedness was not the result of a barrier between us. I was beginning to despair of ever making you understand me. It would be terrible, if so. For what would it mean to me? I have my work, of course. But it's not enough. I should be walled up in an invisible prison. One can work in prison, as Courbet did, but it may become unbearable."

Practical to the last, he added that "Your concierges are elderly people. They must be light sleepers. But give them an alarm clock, if they don't have one. Give them a good tip, too. That'll make them remember to wake you up."

When Henri Matisse got back to Nice later in October, there were changes in the Hôtel Régina. "Here I am in Nice," he wrote. "The ground floor of the Régina is full of Moroccan soldiers who wash their shirts, their underclothes, and their caps in the water that runs down the edges of the sidewalk. (They dry them on the railings.) They sleep in the majestic dining room of the hotel. In the daytime, when they are not at exercise, they sit on the sidewalk in little groups and play games. They play cards, or lotto. Their sergeant told me yesterday that he had just given them their pay – 2,000 francs – and that the only ones who had a penny left were those who had stolen from the others."

Given his status as the poet laureate of North African manhood, Henri

Matisse could hardly complain of the Moroccans' presence, and he didn't. "They are undeniably picturesque," he said. "But I'm not sure that I'll stay here. I'll think it over for ten days.

"I often think of you. I could see that you have troubles, though you never said much about them. I hope they won't get worse and that, on the contrary, you will soon see the end of them."

On the first day of November, a new problem presented itself. Tante Berthe had come by to warn Henri Matisse that his wife now had it in mind to come to Cimiez and make big trouble for him. This was not to be taken lightly. Someone should tell Marguerite, who at the time was living with her mother in Paris, that it was up to her to dissuade her mother from any such attempt – or, at the very least, to warn Henri Matisse by cable if Amélie were to set out for Nice.

He, Henri Matisse, could not write to Marguerite in this matter, because his letter might fall into his wife's hands. So Pierre should take action in his stead. Pierre should go to Paris and speak to Marguerite.

Meanwhile he would stay in Cimiez indefinitely. His work would suffer if he had to leave. The place suited him. So did the climate. The rain-soaked Atlantic coast did not suit him. Algeria and Morocco were out of the question at the moment. But if he heard that Amélie were on her way to Cimiez, he'd pack up at once and go almost anywhere.

This letter crossed with one from Pierre to say that he had seen his mother in Paris on November 8. As far as he could see, there was for the moment nothing to worry about. His mother had been furious when she learned that Henri Matisse had re-engaged Madame Lydia as his secretary. A tantrum was to be expected and, sure enough, it was forthcoming. But she seemed to pull herself together.

By November 16, when Pierre wrote again, he had had his father's letter about the possibility that he might suffer harm at the hands of his estranged wife. Pierre did not believe this. Amélie Matisse would say anything – no matter what – when the fancy took her, but he did not believe that she would come to Nice, let alone put her threats into action.

Pierre went on to take what might be called the commonsense view. The best way to put an end to his mother's continual rages was to see to it that the machinery of separation went forward, free from conflict, in a spirit of amicable collaboration and with readiness to safeguard the interests of both parties.

And by the way, he added, "my mother would be glad if you would send back the watch chain that had belonged to her mother. You have apparently worn it for a long time. You have only to send it to Marguerite at my mother's Paris address."

Given that Henri Matisse believed himself to be an innocent party who was

being torn in pieces by his wife while his children stood by and did nothing, he could not be expected to like this letter. And he didn't.

His reply to Pierre stood out even in a year full of convulsive events.

To begin with, there was the watch chain. "It was a present to me, if I remember, from my mother-in-law, a woman whom I loved and admired. She understood me, just as she understood her daughter. I had worn it for forty years. Naturally I sent it to Paris by the next mail. For her to ask for it back was an act of pointless and excessive cruelty. It pains me that you should have agreed to pass on her request without comment.

"Then you speak of avoiding 'conflicts,' and of 'working together in a spirit of amicable collaboration and safeguarding the rights of both parties.' How can you believe me capable of unfairness in the matter of the separation? I should consider it immoral. Even if someone advised me to be 'unfair,' I would never dream of it. Have you any idea what you were saying? Or of how deeply you have wounded me? I only hope that you will not be as misunderstood by your own children as I am misunderstood by mine. Every lawyer – even your mother's – has recognized that where my work is concerned I should have priority. Is that why you think it possible that the proposed division of our assets would not 'safeguard the interests of both parties'?

"I could have hired an officially qualified expert in such matters. He would have done whatever I asked him to do. He could have recommended a choice that was much in my favor. But if you consider how I conducted myself in such matters, all my life long, you cannot imagine that I would have stooped so low.

"Well, there it is. That's what I have to tell you, and it makes my heart bleed to do it.

"Two other things caused me pain. You said to the lawyer, 'My father does not want a separation, because he is an interested party and does not wish to see his studio split up.' To which my wife said, 'He's just playacting.' I feel as if I were walled up by those two false judgments.

"How can my children say that I think only of myself? I am gagged, not once but twice over, by those two judgments. If you accept them, I cannot persuade you otherwise.

"I realize that this is a strange way to say good-bye. But all this is so painful that I cannot moderate my language. Yours is not an easy position, I know. But even so you cannot forget what I have been, and what I continue to be.

"But I nonetheless embrace you with all my heart, and in hopes that one day you will understand me. Bon voyage, and don't fail to let me know at once when you reach New York."

In those last lines, we sense immediately that Henri Matisse would never willingly "say good-bye," as he had put it earlier. Nor did he. In the letters that followed, there was at first an unspoken agreement to tread ground on which no trouble could come. Pierre described his journey back to New York by way of the Azores. His father described how his friend and neighbor Pierre Bonnard had been snowed up in his house at Le Cannet. Even the family news was represented as good. Father and son were back on track.

Father and Son in 1940

In the fateful year 1940, long letters passed between Henri Matisse and his son Pierre. For much of the time, Henri Matisse was short of a male voice to talk to, and in writing to Pierre he felt completely at ease.

Henri Matisse at that time had an immense amount to say on a very unpleasant subject: the legal settlement that was being worked out between Amélie Matisse and himself.

Already on December 17, 1939, the un-Christmassy topic had arisen. Henri Matisse could not have made his attitude more plain. "Your mother has asked for the legal separation to be made formal on January 10. Marguerite will come here on December 20. She will look into the question of our real estate. She will also make a list of what is to stay here. (Most of the pictures will be in the Banque de France in Paris.) It is my wish that she and I will draw up a detailed inventory from which your mother can choose what interests her. It seems to me useless to bring the lawyers into it, unless we want to spend as much money as possible. (Even those who would profit by it regard that as ridiculous.) My lawyer, Maître Gassin, agrees."

His views, though exemplary and well intended, did not prevail. Given the strength and the tenacity of the feelings on the other side, a long struggle could not be avoided. There was, after all, a great deal at stake. Every painting, every drawing, and every print by Henri Matisse entered into it. So did every bank account under either of their names, or under their joint names, whether it was in New York, in Paris, or in Nice. Every strongbox was open to inspection. And every stick of furniture, no matter how humdrum, had to be listed and valued.

There were also questions of rumor, and of innuendo. Imputations lurked, like antipersonnel mines, on terrain that would normally have been harmless.

Old hatreds were brought up to date, and old sores reopened. It was only to his son Pierre that Henri Matisse felt able to speak freely about his hurts, his grudges, and his grievances.

The question of the lawyers was fundamental. On January 11, 1940, Henri Matisse said, "Why can't we settle this thing without bringing in the lawyers? They cost a fortune. If I have to sell some pictures, at this moment and in the conditions now prevailing, it will be disastrous. It is exactly what Paul Rosenberg wanted to avoid.

"But your mother thinks only of revenge. If she ruins me, she ruins you and ruins herself as well. In wartime, given my age, the uncertainties of my production, and the difficulties that I have in working, your mother's behavior will be catastrophic for all of us. It is so alien to the prudence that has always led me to hold on to my paintings and drawings.

"You wrote to me recently that the best thing I can do is to find satisfaction in my work, because everyone in Paris is against me. But all those who know what she has really done find it monstrous. Whose advice does she take? The lawyers', who think only of their own profits? If you could hear what my lawyers say – and they are humane and levelheaded – you would not go on telling me that 'Maman is thinking of her grandchildren.' No one – not even her own lawyer – can persuade me of that." Madame Lydia was never named in their correspondence, but there is no doubt that Amélie Matisse saw her as a demonic force that still had a terrifying role to play.

"Your mother's lawyer in Nice told her that it was her right to suppose whatever she liked. She went ahead and did it, full steam ahead. But nothing that she feared has come to pass. There is no reason to suppose that I am in the hands of a scheming woman who will inherit all that I have, or of a thief whom I have not recognized as such. 'The less I leave for him, the less he will leave to her,' she seems to say to herself. In so doing, she will destroy us all.

"We do not have enough money to support all the obligations that I have. The time to sell things is when you don't need to sell them. Otherwise, people simply take advantage of you."

When that subject was in abeyance – which was not often – the tone of his letters was roomy and conversational. It was as if he and Pierre were sitting side by side and they were talking things over at their leisure. His own health was a subject of which Matisse never wearied, and on February 15, 1940, he detailed the exercise schedule that he had devised for himself in Cimiez at a time when he was not well enough to go out on horseback. "After my siesta in the afternoon," he said, "I walk up and down the glassed-in hall of the Régina for exactly 3,300

meters. I cover the distance in exactly 40 minutes. In the evening, after dinner, I do another 2,000 meters." This formula delighted him.

In that same letter, he gave Pierre some advice about how to keep in trim. "As for your idea of taking regular physical exercise," he said, "riding a horse is the best possible workout. Rowing is also very good. When I went out in a single scull every day, it brought me an ideal relaxation. When the weather was too bad for me to take out my canoe, I did absolutely nothing during the hour that I had set aside for it. Once the time was up, I was myself again. It was a true case of automatic suggestion.

"If I have forced myself to be on time, and to keep to the same schedule every day, it is because I was born disorderly. I never did anything unless I really felt like it. I left things lying around when I no longer had any use for them, and I never made my bed unless I had to change the sheets. I think that as you get older, and when you look back on your father and his ways, you will find that there were people who let themselves go more than I did. That is exactly the way I thought about my own father. I wish I could tell him so now, but it's too late. That's how it is with the generations.

"When I came back from Tahiti, I couldn't go rowing, because with the Barnes decoration I had to go up and down a ladder all day and that used up all my strength. The only way I could get to relax was by shooting at targets with my rifle. During the second or two when I aimed the gun, it drove everything else out of my head. Today, I have nothing except my work.

"I lay down on my bed to read your letter." (Pierre had described his discomfiture at having come back from Mexico with several sculptures that turned out to be fakes.) "You and I have not always agreed on this subject, but I believe that we learn by experience. Do you remember that I once asked you for how many years you thought you could profit by your experience of life? You said, 'Four years, maybe?' And I said that I had been working at it for thirty years and was still learning. You didn't want to hear it. The younger one is, the smarter one believes oneself to be.

"What happened to you is nothing extraordinary. I don't believe there is an art dealer – no, not even Brummer – who has not been in your position. The same is true of artists. Courbet had a collection of master paintings, and every one of them was a fake. Imagination and sensibility had misled him. If you want to be sure that a painting is authentic, it is more important to study it with a magnifying glass, or at close quarters, than to stand way back and gaze at it. Another form of insurance is never to buy a picture, regardless of its price. This makes you see more clearly and stops you from getting carried away. Photographic enlargements can also be very helpful.

"I myself bought a big painting by de Dreux in the belief that it was by Courbet. (It had been in Courbet's studio.) I also bought some little Courbets

that had a story attached to them, but they, too, were fakes. I also have on my conscience a faked Romanesque capital.

"What amazes me in cases of this sort is that the people who buy fakes don't realize from one day to another that the object that meant so much to them has actually nothing to give. It's rather like the story of love. The poets who have written best and most often about love were no good at it, most of the time. Baudelaire never had a really beautiful woman. Verlaine's love scenes may have been powdered and perfumed like a Watteau, but he went to bed with a pack of broken-down camels that the rest of us wouldn't touch with a pair of tongs."

Meanwhile the problems of the settlement continued to arouse misgivings and misunderstandings. It was not the style of the Matisse family to come straight out, in such matters. When Marguerite came to Nice with her mother's art expert, Maître Bellier, to make an inventory of the furniture, she stayed a week. Not for a moment was Madame Matisse mentioned between father and daughter.

Even in the correspondence between Henri Matisse and Pierre, there were moments at which ancient grievances – perhaps founded, perhaps not – came back to life. Was it not true, Henri Matisse asked on April 8, 1940, that around a year earlier Pierre had been disgusted by what he believed to be his father's attitude towards his mother? "When you and your brother were in Nice," Henri Matisse said, "you thought only of your mother. My situation meant nothing to you."

In the matter of the settlement, Pierre had tried to act as the honest broker and disinterested intermediary. As this letter shows, his father sometimes thought that he inclined to take his mother's side. Amélie Matisse, for her part, believed that Pierre would stick with his father through thick and thin.

The division of assets was scheduled for May 2, 1940, in Paris. Henri Matisse was delighted, meanwhile, to hear that Edward G. Robinson had bought from Pierre what can be considered as the earliest major Matisse – *The Dinner Table* (also known as *La desserte*) of 1896–97. "Robinson is beginning at the beginning," Henri Matisse wrote to Pierre. "If he were to go on and buy a painting from every one of my periods, that wouldn't be at all a bad thing."

It might seem remarkable that World War II had dropped out of sight in the Matisse correspondence. There was, in fact, something almost eerie about its invisibility. It was almost as if the whole thing had been a gigantic charade. When Henri Matisse traveled up to Paris in good time for the legal activities on May 2, he counted on finding Paris much as usual – all things considered – and a normal train service from Paris to Nice when his work was over.

Until May 22 or thereabouts, by his own account, he worked with Marguerite for three hours every day in the vaults of the Banque de France on the rue de

Rivoli. These were the days during which it became ever more evident that the French army was no match for the Germans.

This was also the time at which Matisse was walking along the rue de la Boétie when, quite suddenly, he came face to face with Pablo Picasso. We must remember that this was a time at which nothing was thought of except the imminent defeat of France. Picasso raised his hand. "It's the Ecole des Beaux-Arts all over again!" he said. By this he meant that the French army (or its leaders) had been no better at making war than the Ecole des Beaux-Arts had been in fostering art.

Henri Matisse does not seem to have been panicked by the German advance. "I was rather stunned by what was going on," he wrote to Pierre. "The days seemed to last a long time, and yet in the end they slipped away without our noticing how or why."

What could be more important to him, after all, than the fair division of his work of the last forty and some years? But then there came an afternoon when he was advised to take shelter for a whole hour in a cold, deep, and humid shelter on the rue de Rivoli. "As it was a hot day," he wrote to Pierre, "and as I was already running with sweat, I dreaded an attack of bronchial pneumonia. I decided that this was no life for me. It was time for me to get out of Paris."

First, he made sure that both Marguerite and Louise had enough money to leave town. Louise did not want to leave at once because she still had a lot of orders for her work, fragile as it was. Henri Matisse then made his way on his own to Bordeaux, which was besieged by refugees from Paris, many of whom had to sleep in their cars for lack of anywhere else to go.

"The first night I stayed with a brother-in-law of Paul Rosenberg's. Then the concierge at the Royal Gascogne Hotel promised me a room, for 80 francs a night. He wouldn't say where it was. (The owners were away, etc., etc.) At nine in the evening he took me there. I soon realized that I was in a *maison de passe,* called Chez Suzanne. There were just myself, an old lady, and her daughter. I suppose that her usual clientele had been turned away. Every room had elaborate toilet arrangements. Over the bidet were two white enamel plaques of the kind that usually warn the traveler not to drink to excess. But these plaques gave advice as to how to avoid venereal diseases. In particular, women visitors were urged to take a close look – but discreetly – at the genital organs of their male clients. Above the plaques, there was a well-chosen stock of standard remedies. I wrote to Rosenberg, who knows the Mayor of Bordeaux. He has already reported my experience, and told him that it was deplorable that refugees should be put up in such places.

"I left at six A.M. the next morning to take the train to Saint Jean-de-Luz. I simply cannot tell you what the station in Bordeaux was like. But at least I knew

I would have a room when I got to Saint-Jean-de-Luz. The painter Borès, a friend of Tériade, had been there since September. I had sent him a cable, and he told me I could have a room.

"So here I am in Ciboure, 38, quai Maurice Ravel. It's just a hundred yards from Ravel's birthplace. I think of him whenever the church bells ring out, almost next door. It's not by Ravel, but he must have heard it all the time. There's also a stone fountain nearby that he must have known. All that gives me from time to time a feeling of peace and tenderness.

"I have a room that has windows with verandas, in the Basque manner. It's just a few yards from the channel that leads out towards the sea from the harbor of Saint-Jean-de-Luz. When I look out, I can see the little steamboats that come and go. They are all painted a pure ultramarine blue with a little chimney that is painted pure vermilion. They bring back sardines, anchovies, and mackerel. Unluckily the weather is not too reliable for my work. Two days of sunshine, and then 4 days of mist and rain.

"Can you imagine that I was all set to spend a month or two in Brazil – Rio de Janeiro. I had my ticket for an Italian ship that sails from Genoa on June 8. Then, when I was afraid that I might not be all done with Marguerite in the Banque de France, I put it off till June 24. Then, after what happened, I had to ask for my money back. I'm sorry not to have gone, because it was the kind of complete change that I wanted before getting back to work in Cimiez in October."

Henri Matisse still thought that life would go on much as before, once the formalities of the armistice had been completed. "This winter – if it's still possible – I might go to Portugal. I already know Spain well – I spent a winter in Seville, and I've never been so cold – and I'm rather afraid of Portugal, as it's on the same latitude. Or I might go to Morocco – Marrakech, perhaps."

This long letter from Ciboure ends with family news. With hindsight, a reference to Marguerite means more than may have seemed likely at the time. "She could have left Paris," her father said. "But she preferred to stay there. Her son is living with Madame Jolas near Vichy. Marguerite wants to make herself useful. This probably suits the banked-up ardor that is within her. She says that at last she is alone, and can do what she likes, and make the most of it."

As it happened, both Madame Matisse and Marguerite left Paris in short order, though both returned later. Madame Matisse went to stay with her sister at Beauzelle, and Marguerite also left temporarily to fetch her son Claude, who had been in Montpellier. To get to Montpellier she had had to drive hundreds of miles across the high ground in the Auvergne, with the Germans not far behind. Claude and his mother then made their way to Beauzelle. Marguerite's

way of "making herself useful" led her in 1944 to join a Resistance network, where she did invaluable and perilous work. From this, as will be seen, there eventually resulted a most hideous ordeal.

By June 18, the charms of Ciboure were wearing a little thin, and Henri Matisse was once again in a state of great agitation. Wild fancies seized him and would not go away. In a recent cable from Pierre there had, for instance, been a passage that his father simply could not understand. "MARMILLOT TAKEN PRISONER," it said. Henri Matisse had never heard the name. Could this be in code? Was it a way of saying that the ship in which two of his paintings were on their way to New York had been sunk?

It was nothing of the kind. Marmillot was the name of the husband of one of Teeny Matisse's stepsisters. He had been captured while serving in the French army. But this took time to sort out, and meanwhile Henri Matisse's anxieties went on a downward spiral. Was he to lose everything that he had hoped to preserve for his children? He would have liked Marguerite to go to the strong room in the Banque de France in Paris and get out – at the very least – the two Cézannes and the Renoir. But he was too late. Since the armistice he could not rely even upon the diplomatic bag, though William Bullitt – the American ambassador of the day – was still in Paris.

The news from Nice was all about the impossibility of getting either milk or meat. The English had occupied Corsica, people said, and the Italians were going to occupy Nice by way of reprisal. Sense and nonsense cohabited in these items of news, but Henri Matisse succeeded to a remarkable degree in keeping in touch with the movements of his family at a time when everyday life in France had virtually come to a halt. Telegrams stuffed with family news seemed to reach him even if they had to be readdressed. Even the Greek torso that had followed him throughout his adventures had caught up with him after a wildly expensive taxi ride.

He now knew that Louise, with her two children, was in Bordeaux, where there was still a firm demand for her work. Jean was at Moissac, not too far away, and would join her after he was demobilized. "Now that we have good news of all our family," he wrote to Pierre, "I'd like to get back to work. But with this nomadic life, and the state of the daily news, it's difficult. When I get back to Nice, everything will be better. But when shall I get back? And how? With no trains running, and the current cost of a taxi?"

Before long, Henri Matisse had to be on the move again. He was lucky enough to get away, early one morning, from the neighborhood of Saint-Jean-de-Luz on June 27. By that same evening the area had been occupied by the Germans. After a day-long search in which every possible lodging was already overbooked, his

taxi left him at the Hotel Ferrière in Saint-Gaudens.

Naturally enough, he did not enjoy his stay at Saint-Gaudens. Writing to Pierre, he mentioned the "emphatic statue" of Augustus Saint-Gaudens, "whose son we know of." But mainly he stayed in his room at the ghastly hotel, or trailed around the streets in search of anything at all that might interest him. More than once he went to the train station, only to find that there was no chance of his getting a seat.

Week after week of non-dietary food had upset his stomach. "My eyes are better," he said to Pierre, "but my inside isn't." What he described as "enteritis," which came with a fever, may well have been a warning signal of the problems for which he was to be operated on at the outset of 1941.

But by June 30, Henri Matisse was at last able to make plans for his return to Nice. The local commissaire in Saint-Gaudens had business in Carcassonne and would take him in his two-seater, leaving the luggage to follow by a freight train. To get on a train to Marseilles, he would have to wait ten days in Carcassonne and board the train at 2 A.M. But by then, nothing would deter him.

While they were in Marseilles, he and Madame Lydia went to the movies. Walking back afterwards to the Hotel Terminus, around 10 P.M., there occurred one of the phantasmagorical episodes that had a way of happening at a time when France was like a jigsaw puzzle that had fallen off the table and onto the floor. As they were passing a café, Henri Matisse suddenly heard his name called.

Before him stood Madame Jolas, a friend of his daughter Marguerite. Madame Lydia discreetly withdrew, leaving Madame Jolas to give Henri Matisse some news that at first very much displeased him. In brief, his daughter Marguerite was also in Marseilles, and was making arrangements for Claude to go to New York with Madame Jolas, who would be responsible for his education. Claude's father, Georges Duthuit, was already in New York.

As Henri Matisse put it to Pierre, "The argument for this was that no one knows what the future will hold for French children in France. In winter, they might starve. At first I was absolutely furious that I had not been consulted. But then I calmed down. The next day I saw Marguerite and Claude. She told me that she had sent me a telegram to Nice, proposing that she should bring Claude to me there.

"So Claude will go with her and her two daughters to New York. He will live with her, and she will take responsibility for him. She will try to open a bilingual school again. If she can't do this, Claude will go to the lycée in New York. Marguerite will go back to Beauzelle and stay with her mother. I stayed on in Marseilles as long as they did. I was careful to avoid any subject that would cause her to bring out her claws, and I have to say that she could not have been nicer."

Henri Matisse took it for granted that Pierre would act as a surrogate step-father and deputy-grandfather for Claude during his stay in the United States, and in this he was perfectly correct. It was not long before Claude wrote home to say that he and Pierre had become best friends. Moreover, there "were many questions on which we were in agreement." This delighted Henri Matisse, who had been tempted to regard Claude as "a little David Copperfield."

In that same letter, Henri Matisse endowed Pierre with yet another solemn obligation. "This is a subject," he wrote, "that I have felt about deeply for a long time. After my death, it is my wish that where inheritance is concerned both you and Jean will treat Marguerite, and treat Claude also, as if she were not your stepsister but a full sister. By this I mean that after the legal division of my estate is completed, both of you will make up to Marguerite, and to Claude, a share in the estate that is equal to your own. As you know, I have always done more for you and Jean than I was obliged in law to do. I count on you both to do as I have done. Disregard the law, therefore, and do what I ask in memory of me."

One of the few people whom Henri Matisse saw after he arrived back in Nice on August 25, 1940, was the novelist and playwright Henry de Montherlant. Montherlant at this point in time was not everyone's favorite Frenchman. Not only had he kept working throughout the occupation of France – his *Reine Morte* was a great success at the Comédie Française – but he did not distance himself from the Vichy regime. When he and Henri Matisse had lunch in Nice, he said wryly that half his friends had asked, "Why aren't you still proud of Marshal Pétain?" while the other half said, "Why didn't you get out of the country while you still could?"

"He served in the war, though he didn't need to, and he was hit by several shell splinters in his thigh. He told me extraordinary stories of what he had seen. He likes to be mysterious, and I don't want to cut him short."

Henri Matisse and Henry de Montherlant had been on amiable terms since the winter of 1935–36, when Montherlant had asked him to illustrate his novel *La Rose de Sable*. Matisse had turned down that idea, saying that the novel was complete already and that there was really nothing in it that called out for illustration, or would be heightened by it. Montherlant was a gifted persuader, however, and August 1940 was a time at which Matisse welcomed the company of a gifted writer who genuinely admired his work. (On September 8, he made two lithographic portraits of Montherlant, with a view to providing a frontispiece for one of his books.) The association continued throughout the occupation, and in 1944 Montherlant's *Pasiphaë* was published by Fabiani in Paris with no fewer than 147 linocuts by Matisse.

If Henri Matisse had felt comfortable in the apartment of his old friend and classmate, the painter Simon Bussy, he would never have lacked for fascinating

company. But he couldn't bear to go there when the Bussys had guests. "I hardly ever see Bussy," he wrote to Pierre in that same very long letter. "There are always people there – men of letters, André Gide, etc. It's a world that I know little about, and I prefer to stay at home. I could have gone to tea with them, but I can't make conversation with their friends, or feel at ease with them. Needless to say, they know nothing about painting. And then they are so preoccupied with the war, and with politics. All that tires me out, and it doesn't interest me, anyway."

But in the studio, and by September 1, 1940, Henri Matisse was raring to go. He wrote a seven-page letter to Pierre, on the assumption that it might become impossible to send another. The frontier between occupied and unoccupied France had been closed for a month. Sixty million letters were said to be blocked at the border. This situation might get worse, in which case France would no longer be one nation.

Meanwhile, Henri Matisse grieved not to have had a letter from Pierre. Jean Matisse had told him that a letter from Pierre to his mother had arrived while he, Jean, was at Beauzelle. "Marguerite had told me in Marseilles that there was nothing special about that letter and that it mainly showed concern for her welfare. She also added that you had given no sign of life since you left for the United States.

Henri went on to say that, "In the war of 1914 it was the women who came out of it on top. They had played an important role, and they didn't forget it. But in this war it was the men who puffed themselves up in the family circle. Compensating for the failure of their efforts in the army, they make themselves as unpleasant as possible when they get back home. I know of a similar case here. So it was a great satisfaction to me to know that you had had an affectionate letter from your mother."

In spite of his feelings about Jean, his father passed on to Pierre some news that suggested that Jean and Louise might soon do quite well in the south of France. "Jean left Beauzelle, leaving his car behind (for lack of petrol), and came down to Cagnes with his friend Marrot (a friend of Louise, who deals in textiles), and their decorator friends. Louise has a commission for her ceramics. And because their client Chaussebourg in Cannes (he bought all kinds of things from them) is a prisoner of war, his wife has asked Marrot and Louise to help her reopen their shop, redesign the installation, and give it the look of modern art. (I hope they'll stay friends.) Marrot has also bought a little house with a bit of land, and is going to pay Jean to make it habitable. They hope that with what I give them they will be able to manage. I have sent Jean some furniture from here."

Passing for a moment to the news of the Pierre Matisse Gallery in New York, Henri Matisse said, "I am delighted that the big decoration, *Music*, has found such a good home, as has also the *Quai St. Michel with Lorette*, which is a pic-

ture of which I think very highly indeed. People say that all my best paintings are in Moscow, but this one is an exception. Also, please compliment Teeny on having sold *The Rumanian Blouse* to Cincinnati."

In France, and gradually, news of friend after friend was coming in. Picasso was an exception, but Henri Matisse thought that he must be in Switzerland, where he had taken his son to see a doctor.

It irritated Henri Matisse that the magazine *Beaux Arts* in Paris had printed a whole page of the names and current addresses of writers and artists – "Nobodies, one and all," he said, "and there wasn't one that I'd ever heard of."

As to his dietary needs, he hadn't had any coffee or sugar from Pierre. But it didn't matter, because he was now forbidden to drink coffee. He only drank tea, and had sugar enough for that. "I eat meat twice a week, and for the rest of the time I eat only pâtes and vegetables, and that's quite enough. So you don't need to bother about me."

It had taken him a long time to mention his work, but when he at last began on it he had important things to say. "As for me: I'm trying to start work again. Before I got back to Nice, I thought of painting flowers and fruit, and once in the studio I made several arrangements that might have suited for still lifes. But in the day-to-day anxieties we have here – we might be occupied, on no matter what pretext, from one day to the next – I can't (or I don't dare to) work at such close quarters with objects that I have to animate all by myself and with the feelings that I bring to them.

"So I have made arrangements with an agency that supplies movie companies with bit players and extras. They are to send me their prettiest young women. If I don't engage them, I give them 10 francs for their trouble. So I have three or four pretty young women who pose for me – one at a time – for drawings. Three hours in the morning, and three hours in the afternoon. So there I am, in the middle of my flowers and my fruits, and I get acquainted with the materials of still life without making an effort and almost without being aware of it. Sometimes I find a motif – a corner of the studio that has its own expression, even if it is beyond me, or beyond my strength. And I wait for the moment of infatuation that is bound to strike in time. All this drains my vitality."

What he needed at that moment was the inspiration of a new model. In the matter of Henri Matisse's models, Lydia Delectorskaya had naturally seen a great deal of them come and go. In her book, *Contre Vents et Marées: Peintures et Livres Illustrés de 1939 à 1943*, she outlines with her habitual concision the strategies that he employed or disemployed in this context. He did not particularly prize the "great beauty." Still less did he prize the "beauty queen." Nor did a spectacular physique necessarily attract him. When urged to try an acrobatic dancer whose looks were

widely admired, he said, "I really couldn't deal with those steel muscles."

When professional models applied, he would normally take their names and addresses, saying only that for the moment he was too busy. Other times, when faced with an acclaimed beauty, he would try his hand at a pencil drawing ("That commits one to nothing," he would say). But more than once he broke off the session, left the studio for a moment, and said to Madame Lydia, "Just pay her off! She's unbearably stupid."

What he wanted was someone who had an inner life and an awakened spirit. He liked her body to have a harmony of its own. From that point of view, Madame Lydia said, there was no standard criterion. There could be defects, and there could even be deformations, if they were integral to the model's "global expression."

An example of this was Nézy-Hamide Chawkat, whom Matisse spotted in the street in Nice in September 1940. Though still young enough to be chaperoned everywhere by her governess, she had an irregular but (to Henri Matisse) an irresistible cast of feature. He presented himself to her governess and gave her his card in case she would agree to let the young woman come to pose.

It turned out that she was the great-granddaughter of Abdul Hamid II, Sultan of Turkey. Permission for her to pose was forthcoming, and she came from time to time over a period of more than a year. Within a few weeks of their first meeting, she served as the model for some widely varying but always intensely expressive drawings. By October 4, her well-sugared person had encouraged him to complete, after nine months, the painting called *The Dream,* which had gone through quite a few radical changes. In just a week or two, the newcomer Nézy had released him from an agonizing situation.

Always drawn towards the Orient, Henri Matisse was fascinated by the sumptuous irregularities of Nézy's face and person. Madame Lydia suggests, however, that he did not use her as a model as often as she would have liked. In any case, she suddenly announced, on August 31, 1941, that in two months' time she was going to Albania to get married. The time limit so inhibited Henri Matisse that he never again asked her to pose.

In September and October 1940, Henri Matisse spent quite a lot of time in rumination about his health, his looks, and where he should spend the rest of life. Nice at that time was not ideal. Quite apart from the uncertainty about its future, it was inconvenient for everyday life. The last tram up to Cimiez left at 8 P.M., which made it difficult and expensive to have dinner in town. The town itself had its sinister side (or so it seemed to him). He couldn't even take a taxi to see Pierre Bonnard at Le Cannet without spending a fortune (in prewar terms.) He began to ship his furniture to Beauzelle. ("Better that it should be there than

sit here and be looted!," he said to himself.) He even shipped things that he had always enjoyed and would miss. As he wrote to Pierre, "At least your mother cannot say that I am robbing her blind!"

Eventually his whole life was concentrated in the studio and in his bedroom. Even then he occasionally wondered, "Should I be happier somewhere else?" As is well known, he was determined never to leave France for good. In a famous formulation (used more than once) he said, "If everyone of any worth leaves the country, what will become of France? I should feel myself a deserter, if I left."

His age began to weigh upon his thoughts. On September 18, 1940, he wrote to Pierre and said that he had been to see Bonnard, who was painting very well and with even more color than before. "He and his wife both looked much older," he said. "Of course they are 72 or 73 years old, and at that age the years leave their mark. Looking at myself, I see changes all the time. My hair and my beard get whiter. There is a new hollowness about my features. My neck is more skinny, and so on. Of course I have taken some hard knocks these last two years. And right now it is very unpleasant to watch so many of my possessions being sent away."

It was a consolation to him at that moment that he had at last finished *The Dream* and was pleased with it. "It was a big adventure," he wrote to Pierre. "All my paintings are adventures, which is what makes them interesting. As I never let them out till they are finished and successful, I am the only one who has lived through the risks. When I began it, months ago, *The Dream* was a very realistic picture, with a beautiful dark young woman asleep on my marble table among some fruits. Now she has turned into an angel, fast asleep on a violet surface – the most beautiful violet I ever saw. Her skin is rose-pink, her flesh is full and rich and warm. The corsage of her dress is a pale sweet periwinkle blue and her skirt is emerald green with a little white in it. All this is supported by a luminous jet black. The visible embroidered sleeve belongs to the Roumanian blouse in the painting that Teeny sold to Cincinnati. In reality they are black and orange, but I made them green instead. I won't say that this painting made me forget everything else, but at least it brought me some relief."

Towards the end of September 1940, Henri Matisse had news from Pierre of Claude's arrival in New York. He was settling in well. "What you tell me about Claude gives me great pleasure," Henri Matisse wrote. "But it did not surprise me. I knew that I could rely upon you."

In October 1940, Henri Matisse heard from Pierre that Mills College in California had invited him to be their honored guest and to accept a visiting professorship.

Not wishing to turn it down out of hand, but still being convinced that he should remain in France, he gave the matter serious thought. "My dear Pierre,"

he wrote, "My health allows me to work 4 hours – 4 good hours – a day. I now sleep better at night. Provided I have a vigorous rub at 4 or 5 in the morning I can go to sleep again until 7. That is enough for me, and it is a great improvement. But any kind of journey is terribly tiring for me. I have recovered from my recent upheavals, but it took a long time. When I think that it is only six weeks since I got back to Nice I can hardly believe it. I started work at once, and I kept going. Every moment now seems precious, and it helped me to forget the news. As always, I had great trouble getting really started, because with every new beginning I have a new understanding of myself. I have reached an extremely important stage in my development, and I cannot take time away from it.

"Of course there are restrictions here. But they correspond exactly to what I need. The meat ration is exactly as much as I should eat in any case. I don't drink coffee. I drink water. To eat fish once a week, I go to a restaurant.

"And the future? I'm waiting for it. No matter what happens, I shall not budge from here. My standing is such that I would be respected. After two years, I am beginning to feel at home in this apartment. I have lived through terrible times here, but at my age I am not going to put down roots somewhere else. I have sent to Beauzelle everything except what I need to work, eat, and sleep. All of it arrived safely. There were many things that I should have liked to keep – among them my phonograph records and my African textiles – but at least your mother will see that I have not treated her as she had formerly expected. I even sold thirty of my birds last week. So I shall just stay here and see what happens. I read the *Nice Matin* every morning – just the headlines, like an American in a hurry. If I were to leave France, I'd have to liquidate everything here in Cimiez, not to mention what I have in Paris."

The idea of absence as desertion still haunted him. France had somehow to be kept in being, and although it was outwardly functioning reasonably well, it was already forbidden, as Matisse saw it, to have ideas of one's own.

There was also another important reason not to go to the United States. Life without Madame Lydia was unthinkable. "I could not go," he wrote, "with my secretary-nurse. Even if that were possible, it would cause complications – gossip and calumny – that would have poisoned the air for me."

Eventually, he sent a cable to Pierre that summed up what he wanted to say to Mills College. "NO THANK YOU AM ALL RIGHT HERE IN EVERY WAY AND TOO OLD FOR DIFFICULT JOURNEY HM."

He had decided to stay on in Nice, with all its drawbacks. Even when he went to a café in town with Henry de Montherlant, he could suddenly feel cold and dread what might come of it. "Montherlant insisted," he wrote to Pierre, "that I should put on his raincoat before I came back to Cimiez, and so I did."

The fall was outwardly uneventful. In Nice, as elsewhere, people waited around, not knowing what would happen. As there was no demand at that time for Matisse's paintings, that particular pressure was relaxed. But he could not enjoy his relative liberty. On the contrary, as he wrote to Pierre, "the news depresses me, it's raining, and the light this afternoon is as dismal as I am myself. And, by the way, if Claude doesn't come to see you, do go sometimes and pick him up from school."

At a time when he had no money coming in from any quarter, Henri Matisse was alarmed to find that Pierre had sent money both to Tante Berthe and to his brother Jean. He himself was sending his wife 7,000 francs a month, and Marguerite and Jean 3,000 francs each. What could have possessed Pierre to start giving away money that he should have kept for his own family? Did he not have three children who would cost more and more as they got older? Could Tante Berthe not manage on her pension?

"It is because of my anxieties about my family's needs that I am really a prisoner in France," he wrote. "I did not put that among my reasons for saying no to Mills College. I still have to watch over them all as carefully as I have done all my life. I can still be useful, and I realize that the members of my family have never learned how to ensure their future security."

Going back to Pierre, he said, "For that reason, I often think of you with apprehension and wonder how you will last out. I never mention this to you. Yet when I am writing to you it always comes first in my thoughts."

Pierre replied on November 10. He saw no reason to regret having sent money to family members who might need it, then or later. It came from his private account. He could afford it, since business was looking up and he had made several important sales – among them, the Matisse *Studio, quai Saint-Michel,* to Duncan Phillips. He was allowed for the moment to send $90 a month to family members in France. If they didn't need it at once, they could put it by. Berthe had been seriously ill. Her pension was barely enough for her needs. Jean and Louise could use a little capital. His daughter Jackie had been given a scholarship by her school in the United States, thereby reducing her fees. His father had no need to worry about him, and even less need (Pierre put it politely) to preach.

Pierre's run of professional good luck continued when, in October 1940, he bought at auction in New York the majestic *Still Life after Jan Davidsz. de Heem's "La desserte,"* which his father had painted late in 1915. (The subject meant a great deal to Henri Matisse, who had copied the original painting by de Heem in the Louvre in 1893.) Roughly six feet by seven, the painting had been in the collection of John Quinn. Pierre had originally thought of buying it for his own

stock, with the help of a loan from George Acheson. But on the morning of the sale he was asked by a client of his – Samuel A. Marx in Chicago – to bid for the painting.

Pierre wrote: "I spent the afternoon with my client, to be sure that his enthusiasm would remain intact. I was afraid that with the approach of the presidential elections and the rumors of war the sale might come to nothing. I myself was anxious to support the picture, which belonged to an American collector who had refused to lend it to your show at the Galerie Petit in 1931. I will spare you all the back-and-forth that went on before the painting was put on the stand. I got more and more strung up as I stood on one side of the room, sitting high on a balcony, with my client on the other.

"It had been agreed that when the bidding reached $8,000, my client would make a sign with his handkerchief until it was time for me to start bidding. The figure in question was reached in no time. Dudensing was sitting very near to my client. Teeny and I sat in the second row, just behind Keller (the associate of Bignou). I was nervous that I might misinterpret my client's signals and perhaps not get the auctioneer's attention.

"The painting was finally knocked down to me at $10,400 dollars. I thought, mistakenly, that my client had dropped out at $10,300 and that someone else had got it. But when one of the employees came up to me with a piece of paper in his hand for me to sign, I realized that I had bought it for myself. I felt quite giddy at the idea that I had tied up so large a sum of money on the painting. This may not be a very nice thing to say to you, but you will understand my emotions.

"Anyway, the confusion vanished, everything was settled, and everyone was happy – and I above all, since on the following day there were already two offers of a higher price for the picture. But my client didn't want to give it up, even at a profit.

"The painting was incredibly dirty, but I am having it carefully cleaned. Its brilliance of color makes a great effect. The Museum of Modern Art wanted it, but as usual it had not the courage of its convictions." (The painting is now in the Museum of Modern Art in New York, to which it was bequeathed by Samuel A. Marx and his widow, Florene Schoenborn.)

By November 28, 1940, Henri Matisse was feeling noticeably better. The reason for this was that he had at last got back to painting still life. No longer did he have to rely on the human figure to negotiate between him and the fruit, the flowers, and the household objects that stood in for all the rest of the world.

One result of this was that his reserves of fun – never overflowing – were replenished. Writing to Pierre, he drew a summary picture frame. Inside it were

two proverbs that he had found in a magazine called *Marie-Claude*. They were prompted by the current rationing of food in France. One said that "Overeating kills more people than the bayonet," and the other that "People who overeat dig their graves with their teeth."

In the letter itself, he passed on some news about Picasso. "I hear that he gave Max Pellequer a photograph of a painting of mine that Picasso had bought a few months ago (or maybe a year) from Vollard. He even made a sketch of it with some indications of color, and asked that it should be sent on to me. It seems that Picasso is just as he always was – a true Bohemian, taking his meals here, there, and everywhere. But it seems that Dora Maar is no longer with him. He is still worried that our national misfortunes will make the public turn away from cubism. I forgot to ask what kind of pictures he was painting. It exasperated him that he could no longer go to his strong room at the bank. But that has now been settled and he can go and see the pictures that he has there. Pellequer's news of life in Paris, though not actually bad, did not make me want to go back there. I forgot to tell you that Pablo says that he will never – on any account – leave France. I was very glad to hear it."

Now that he could no longer count on Nézy-Hamide Chawkat ("My princess," as he called her), he was determined to move directly into still life. He had in hand a substantial subject that featured an enormous seashell, a coffeepot, a faience jug, a coffee cup, and some fruit. To get it all quite right was devilish work. He made individual pencil drawings of every component. He laid color sketches for them on paper and arranged them on a canvas. "The problem for me," he wrote to Pierre, "is to find the right relationship between drawing, color, and my feelings."

The big subject proved so tiring that in late November and early December he turned to something less exacting. "I'm painting some oysters," he wrote to Pierre. "Quite straightforwardly, with no 'arrangement.' For the moment, it's somewhere between Renoir and Manet."

For the record, he made a large drawing of himself at work, with the oysters on the table, together with the knife, the jug, the napkin, and the little vase full of Christmas roses, all of which would figure in one or another of the still lifes that he completed (according to Madame Lydia's precise dating) between November 22 and December 6, 1940.

On December 2, he wrote to Pierre: "There's been a change. My oysters have become captivating, like flowers. And you are not to tease me, please. Since November 22, I've been working every day. The painting is already a feast of color. I manage just one session a day, beginning at 9:30 or 10 A.M. and going on till

2:30 or 3. Then I have lunch and take a siesta, and at 4 o'clock I sometimes (or often) go down into Nice and see a movie. I come back at 8 P.M. on the last tram. Today after my nap I took a walk in the monastery garden to get a bit of air and watch the wonderful last hour of this marvelous day.

"We're having superb weather, with roses galore and nasturtiums still in flower. But I was troubled on my walk by something in my painting – the napkin – that I didn't think was right. So, when I got back, I looked at it, and with just one big sweep of a charcoal stick, I changed the entire balance of the picture. And tomorrow I'll get to work on it. I wish I could begin now. I had made a great mistake in the composition by making the near edge of the table run parallel to the lower edge of the stretcher, as in fig. 1.

"What I did was this (see fig. 2): I redrew the napkin, so that it has sharp angles and corners instead of being round. I also realized that what made me uneasy was that the right angle of the table duplicated the right angle of the stretcher. In reality, the table sits straight in front of me, but when I turned it up and away from me, I felt that it worked much better."

The crystal jug was painted a delicate violet. The yellow handle of the knife rhymed with the yellow of the two lemons. The central area of blue was "generously painted." The irregular pink areas were painted a whitish pink "with just a touch of vermilion." The four red areas at each corner of the picture set the note of irregularity that was sounded throughout. As a way of getting back to still life, this would have been hard to beat – not least for the saltwater white of the oyster shells. The *Still Life with Oysters* is now in the Kunstmuseum in Basel, Switzerland.

As far as the work of Henri Matisse was concerned, the last weeks of 1940 could not have been more promising. But eight words from an earlier letter to Pierre were to prove prophetic: "My eyes are better. But my inside isn't."

Exiles in New York, 1939–45

Pierre Matisse did not run after publicity, but there were times when publicity ran after him. That is what happened in March 1942 when the Pierre Matisse Gallery in New York opened a show called "Artists in Exile." The title came fraught with pathos. So did the timing. This was a moment at which no one could foresee the eventual upshot of World War II. Still less could anyone foresee its aftermath. The word "exile" had sharp teeth, therefore, and the exhibition did not lack topicality.

Pierre had come into the gallery on the Sunday before the opening in order to hang the show in peace. As he wrote to his father on March 1, "I stayed in town to hang the exiles' show today, instead of tomorrow. I took this precaution because all the exhibitors are right here in town. You know what they are like. They'd insist on giving me advice, and making sure that their own painting had a very good place. There is Ozenfant, whom I knew in the last war, Léger of course, and Chagall, Lipchitz, Masson, Zadkine, Tanguy, André Breton (who has sent in a poem-object), and Mondrian, abstraction's holy man. They number fourteen in all, and I got them together for a group photograph. As most of them didn't speak to one another when they were in France, I was afraid there would be trouble when they were all thrown together. But, as you can see from the enclosed photograph, all went well."

The Pierre Matisse Gallery bore a great European name, and it had always specialized in European artists. By association, and from the moment that "Artists in Exile" began to be talked about, the idea got around that for artists

who had come from Europe as exiles and refugees, the Pierre Matisse Gallery was a combination of safe house, clearinghouse and coffeehouse. Uprooted artists who had no place else to go in New York could drop their bags there, check their mail there, meet their friends there, send out for "coffee and Danish," and talk the day away there under the indulgent eye of Pierre Matisse.

This was not at all Pierre's intention. "For one thing," he would say later, "so many of them disliked one another. For another, they never stopped talking." Disagreeable scenes might ensue, and arguments that got nowhere. As a scene of sociability, the Pierre Matisse Gallery in World War II was not meant to rival the Café de Flore in Paris or the Caffé Greco in Rome. Even less was it meant to replicate that wartime standby, the raffish "French pub" in London's Soho. It was a gallery, and a quiet one.

Something of this came out in the famous group photograph that was taken by George Platt Lynes of the fourteen exiled artists who were included in the show. In no sense were they a band of brothers. But they did all agree to huddle together before the camera. (André Breton, the poet, critic, and author of the Surrealist Manifestoes, was represented in the show as a part-time artist.)

Group portrait of the artists featured in Matisse's exhibition, "Artists in Exile," March 1942. From left to right, front row: Matta, Ossip Zadkine, Yves Tanguy, Max Ernst, Marc Chagall, Fernand Léger; back row: André Breton, Piet Mondrian, André Masson, Amédée Ozenfant, Jacques Lipchitz, Pavel Tchelitchev, Kurt Seligmann, Eugene Berman. Photo: George Platt Lynes

This was the epitome of what later came to be called "a photo opportunity." Given the variety of age, instinct, outlook, nationality, and relative achievement that was in question, the show was necessarily the aesthetic equivalent of alphabet soup. It was not likely that the fourteen artists in question would ever again be in the same room at the same time. Not only were they a tight fit in the space available, but solidarity was minimal. And yet, for an uneasy quarter of an hour, along with other unlikely conjunctions, André Masson sat next to Piet Mondrian, and Marc Chagall sat between Max Ernst and Fernand Léger. There was zero eye contact. Unsmiling, they sat stiff and still and stared straight ahead.

This was a one-time-only ecumenical exhibition, and it came with an ideally generous preface to the accompanying catalogue by James Thrall Soby. "Welcome, and welcome again" were his concluding words. The show was remembered in the gallery for several reasons. It was the only occasion on which Max Ernst made a guest appearance on its walls. His *Europe After the Rain* (1942) was a portrait of a universal meltdown, part human and part arboreal. It was the most haunting image in the show, and the one that most perfectly summed up its subject. It was bought from the gallery by the Wadsworth Atheneum in Hartford, Connecticut.

Of the other exiled artists in the show, four were to have an ongoing importance for the gallery: Chagall, Tanguy, Matta, and Lam. The fact that they happened to be "exiles" was not decisive. They were artists who for one reason or another truly mattered to Pierre.

Marc Chagall had arrived in New York as a refugee in 1941. Pierre had always wanted to show Chagall, but Chagall had never quite said yes. But when he and his daughter Ida were both in New York in 1941, and Ida had managed to bring some of his paintings with her from Europe, Chagall was not quite sure what to do next. He began to ask around for advice.

Pierre Matisse told Rosamond Bernier quite some years later that two things had been in his favor. One was that when Chagall had had his first exhibition in Paris in 1923 at the Galerie Barbazanges-Hodebert, Pierre was learning the rudiments of art dealing in that very gallery. With 122 items in all, that had been a very big show for Chagall, and he had not forgotten the young man – a son of Henri Matisse, moreover – who had just begun work at the gallery.

That was the first piece of luck. The second one was that Chagall asked for advice from George Acheson, a New York banker who had been very helpful to the Pierre Matisse Gallery. Acheson recommended he go and see Pierre Matisse. They met, they talked, and Chagall gave Pierre his paintings on consignment. So for his first Chagall exhibition in October 1942, Pierre had exactly what he wanted.

With Marc Chagall, in front of
the painting *Double Portrait with
Glass of Wine*, 1941. Taken at
the exhibition Pierre gave Chagall
at that time. Photo: Fred Stein

He liked to hang his exhibitions on a Sunday, when the gallery was closed.
"And that's what I did with the Chagalls," he said later to Rosamond Bernier.
"They all fell into their places, like trained horses in a circus. The next morning,
Monday, Chagall, Bella, and Ida arrived. They were all ready to discuss the hang-
ing. But there was nothing that needed to be changed. They were stunned, but
happy." All went smoothly, and Chagall was to show with Pierre Matisse every
year from 1942 till 1948 and on ten further occasions between 1968 and 1982.

Chagall was often thought to be difficult, but in his relations with Pierre he
was easy, direct, affectionate, and admiring. When he received the catalogue for
his forthcoming show in 1944, he wrote from Cold Spring-on-Hudson and said,
"As we cannot as yet see the paintings on the wall, let us at least admire the
catalogue. It is a masterpiece. So sumptuous a black, paired with so delicate an
ivory, and with the distance between each line so exactly measured – it's almost
like music . . . If only the paintings look well!"

In the case of Yves Tanguy, there were memories that went back to Pierre
and Tanguy's shared schooldays, even though Tanguy had for many years led an

uproarious life of which Pierre knew nothing at firsthand. As of the day of his dismissal from the Lycée Montaigne for sniffing ether, Tanguy had explored the rough edges and the lower depths of Parisian life. With his long lanky stance, his penetrating gaze, and the hair that stood straight up on his head at all times of day, he was the archetypal wanderer. He drank all night, sang songs picked up in disreputable bars, and had a latent violence to which on occasion he gave way. Sailors and the sea had played a great part in his family's history, and summers in his native Brittany gave him the freedom of huge-horizoned seascapes. All this notwithstanding, he read, looked, and thought, mating his memories of things seen with an insight into ancient legends and no less ancient ribaldries.

At eighteen, by his own account, he had joined the merchant marine and spent a year and a half as an apprentice officer. During that time he had visited South America – Brazil and Argentina – and also the coasts of Africa, Portugal, and England. To be a ship's officer, even at a junior level, is a disciplined and responsible activity. Tanguy's life to date had been both undisciplined and irresponsible. Yet, once at sea, he had clearly drawn upon a second self. Not for the last time, once having decided what he wanted to do, he went ahead and did it.

Back in France in 1920, Yves Tanguy was called up for military service. Hardly was he inside the barracks in Lunéville than he assumed a completely other persona. His fellow-beginners were struck with wonder and awe, not unmixed with fear, when they saw him collect every spider in sight (and they were many) and eat them in a sandwich. Thereafter, his every move simulated insanity. His was, in fact, a day-long rebellion against a soldier's duties. Anyone else would have been severely punished, but Tanguy's aberrations all but convinced his medical examiners.

When the bed next to his fell vacant, at first no one dared to take it. But then his luck held, and he had as his neighbor one of the most gifted Frenchmen of his generation. This was Jacques Prévert, who in later years was to have more readers than any other living French poet. He was also to write film scripts – above all for *Le Jour se Lève* (1939) and *Les Enfants du Paradis* (1945) – that today have classic status. Even in 1920, he had a magical way with words and a wild fancy when it came to the subversion of authority. From that moment in the barracks, Yves Tanguy and Jacques Prévert were co-conspirators in a sustained attempt to undermine the very idea of military discipline.

Whereas Tanguy feigned to be congenitally insane in ways that often carried conviction, Prévert had quite another tactic. If given an order, he would argue that it would turn out to be a terrible mistake. Such was his labyrinthine make-believe logic that even a hardened sergeant could be seized by self-doubt. On

other occasions, he would accept the order and carry it out in reverse, thereby sabotaging the exercise. All this was done with a brio that never degenerated into outright disobedience.

Prévert and Tanguy were to be best friends in Paris in the 1920s, but there was a brief interruption when Tanguy once again transformed himself and applied for a transfer to the Chasseurs Afriques. Sent to the far south of Tunisia, not far from the Sahara, he eventually returned to Paris with the rank of sergeant and was then released from the army.

At the Gare de Lyon, Jacques Prévert was waiting for him. The chunky young soldier who had never yet achieved anything had turned into a fashionable dandy with a new great friend called Marcel Duhamel. In publishing, Duhamel was to be responsible for a historic shift in French taste when he persuaded hundreds of thousands of French readers to read a new kind of inexpensive crime novel – the "Série Noire" – that owed much to American popular fiction. With Duhamel, as with Prévert, Tanguy made an instantaneous impression.

No one ever forgot Tanguy's laugh. Marcel Duhamel once said to Tanguy's biographer Patrick Waldberg that "Yves's laughter was almost terrifying. His lower jaw seemed to break out of its socket. He opened his mouth so wide that you could have taken a big apple and put it inside it. His body was racked by spasms. I have never seen anyone laugh the way he did."

It was to be quite some years before Pierre Matisse was to tap into the strange amalgam of Yves Tanguy's experience of adult life. Tanguy in 1936 was already well known both as a painter and as an active participant in the politics of Surrealism. He had the approval of André Breton, which at that time could mean life or death to an upcoming young painter. In 1936 he was solidly represented both in "Fantastic Art, Dada, and Surrealism" at the Museum of Modern Art in New York and in the International Surrealist Exhibition in London. In March of that same year, he had a little show – his first in the United States – with Julien Levy in New York. He was a close friend of both Marcel Duchamp and Max Ernst. Paul Eluard had written a poem about him. In 1938 he had a show at Peggy Guggenheim's gallery, Guggenheim Jeune, in London.

When Tanguy made an approach to Pierre Matisse in the summer of 1939 it was not, therefore, as a beginner. Still less was it as a supplicant. It was as a man in love who just had to get to the United States. In August 1939, when World War II was clearly about to begin, Tanguy decided to act quickly. He was not eligible for military service in France. He had lately formed an attachment to an American painter called Kay Sage. There was no time to be lost. During the first days of mobilization in France, Tanguy sailed for New York. Kay Sage was there, and Pierre

Matisse was there. And Pierre Matisse did not let him down. When Tanguy arrived and had no money, Pierre helped him out. "You are a little angel," Tanguy wrote. A mere three months later, he had a show at the Pierre Matisse Gallery, for which James Johnson Sweeney wrote the preface in the catalogue.

Thereafter, letters between Pierre and Yves Tanguy did not exactly flow back and forth, and not all of them were dated. The passage of time was marked more by gossip than by hard news of his work. In July 1941, Max Ernst had arrived in New York after a night on Ellis Island. Tanguy wrote to Pierre Matisse from Hewitt Lake, Minerva, New York, and said that "Max Ernst is now said to be Peggy Guggenheim's consort no. 3,812."

Tanguy the correspondent picked up quite a bit of steam when he and Kay Sage went to Reno to get married. There was news of Reno, which they found very droll, and of friends in France. "We're getting to be quite at home in Reno," he wrote. "It's a kind of operetta country, where it is compulsory to disguise ourselves as cowboys. We have pink ruffled shirts. We don't as yet have ten-gallon hats and cowboy boots, but it may come to that. It's all very gay and very amusing. Very much like the West in the movies, too. The bars are magnificent. So is the landscape. And then . . . I must tell you that I've run out of money."

A day or two later, Tanguy told Pierre that he had to go to Mexico to get a permanent visa. "I have the Mexican authorization for this, but I have to make an obligatory deposit of $200. Perhaps, if the sale of that painting of mine is really firm, you could advance me $200? My dear Pierre, I hate to be such a pest. Tell me quite frankly, and please believe that I wouldn't bother you if it were not so urgent."

Pierre did as he was asked, and Tanguy wrote back at once. "Thank you a thousand times. I hated to ask you, but the complications of money, papers, and the divorce were driving me crazy. And then I am completely demoralized by the lack of news from France. Have you had any letters lately? Now don't be discouraged. In spite of the cowboys and the rodeos, I am back at work. We now have a former operating theater as our studio. Whether my inspiration will come from horses or from the surgeon's knife, I don't yet know."

The fate of their friends in France was a continual anxiety. "Thank you so much for sending me Charles Ratton's letter," Tanguy wrote. "I am very happy to know that they are at least alive. But for the rest I am far – very far – from sharing his optimism. I think that he is like someone who finds himself alone in the forest at night and sings to keep his courage up.

"Four days ago I had a letter from Jacqueline Breton that was dated July 22. She was at Royan, with Picasso and Dora Maar. Up till now, they have been able to lead a quiet life. Breton at that time was still mobilized in unoccupied France.

The news of the poet Benjamin Péret is not so good. He seemed to be in Rennes and having a very bad time – in the military prison, I'm afraid. Either these people know absolutely nothing about the general situation, or they have been told to keep up an optimistic front. Jacqueline even asked me quite calmly if we were thinking of going back to France this winter."

In August 1940, all arrangements in Reno were completed, and Tanguy was able to marry Kay Sage, live quietly in Connecticut, and settle down – so Pierre hoped – to make the most of a new studio there.

To this end, Pierre made an agreement with Tanguy by which Tanguy would receive $100 a month in return for a painting of medium size. If Tanguy found private clients for himself, he was free to sell to them at gallery prices.

In 1940 – his first complete year in the United States – Tanguy had a retrospective exhibition at the Wadsworth Atheneum in Hartford, Connecticut. This traveled later to the Arts Club of Chicago and the San Francisco Museum of Art. He had further shows at the Pierre Matisse Gallery in 1942, in 1943 (with Alexander Calder), in 1945, in 1946, and in 1950. (Pierre also gave Kay Sage a small show in June 1940.)

All this spoke for a certain stability. But there were signs that Tanguy was not completely himself as an American country gentleman. In Paris he had only to go down into the street to reenter a great city in which he was completely at home. He gave Woodbury, Connecticut, his best shot, but it sometimes depressed him that the only person he saw on an everyday level was the local blacksmith.

Nor did he want to change his mode of dress. According to the memoirs of Julien Levy, who had given him his first show in the United States, his new wife had taken him to Abercrombie & Fitch and bought him "a corduroy hunting cap, a jacket with leather shoulders, leather arm pads, and other piping and patches – in short, an elaborately tailored shooting jacket. For Christmas he received a double-barreled shotgun and a rifle."

Tanguy had had his dandy phase in the rue du Château, and he had very much enjoyed it. But when he changed his persona, he liked to make his own choices. In Connecticut, plain speech, plain ways, and everyday clothes, Breton style, were more natural to him.

His marriage, though happy, had brought complications. Kay Sage is often described to this day as "a rich American." She came of a very good family, but she no longer had anything like the amount of money that that phrase often implies. (Her previous husband had been an Italian prince who, in Pierre Matisse's words, "had swallowed up her fortune.") She would tell Pierre Matisse that his regular checks came as a lifesaver for them both, now that her dividends were

Yves Tanguy. *Fille au cheveux rouges.*
1926. Oil on canvas, 23¾ x 18"
(60.3 x 45.7 cm). Private collection

PLATE 25

Joan Miró. *Head of a Woman.*
1938. Oil on canvas, 18 x 21⅜"
(45.5 x 54.9 cm). Minneapolis
Museum of Art. Gift of Mr. and Mrs.
Donald Winston

PLATE 26

Alberto Giacometti. *Portrait of the Artist's Mother.* 1937. Oil on canvas, 23¾ x 20" (60.3 x 50.8 cm). Private collection

PLATE 27

Wifredo Lam. *The Reunion (La Réunion)*. 1945. Oil and white chalk on pasted paper on canvas, 60 x 83½" (152.5 x 212.5 cm). Musée national d'art moderne. Centre Georges Pompidou, Paris

PLATE 28

Yves Tanguy. *My Life, White and Black*. 1944. Oil on canvas, 35¾ x 29⅞" (90.8 x 75.9 cm). The Jacques and Natasha Gelman Collection

PLATE 29

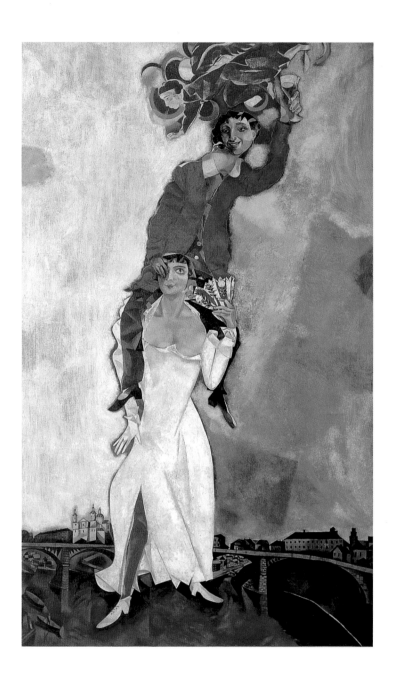

PLATE 30

Marc Chagall. *Double portrait au verre de vin*. 1917–18. Oil on canvas, 92 ½ x 54" (235 x 137 cm). Musée national d'art moderne. Centre Georges Pompidou, Paris

Marc Chagall. *Paris through the
Window (Paris par la fenêtre).*
1913. Oil on canvas, 53½ x 55¾"
(135.8 x 141.4 cm). The Solomon
R. Guggenheim Museum, New York
(FN 37.438). Gift, Solomon R.
Guggenheim, 1937

PLATE 31

Matta Echaurren. *Xspace and the Ego*. 1945. Oil on canvas, 5'9" x 15' (175.3 x 457.2 cm). Musée national d'art moderne. Centre Georges Pompidou, Paris

PLATE 32

diminishing. As for Yves Tanguy, he rarely failed to imply that it was more and more difficult, as he put it, "to make ends meet."

Among the Surrealists in New York, Tanguy was sometimes attacked for having – as was alleged – "sold out" to a decadent high life. Given the Surrealists' zero experience of Italian princes, this was an understandable error. But it was an error to which Breton would seem to have subscribed, in that although he had been very fond of Tanguy, he sometimes bad-mouthed him all over town. Even in the hushed surroundings of the Pierre Matisse Gallery, he had spoken ill of Tanguy in the presence both of Pierre and of Max Ernst. It was in part to avoid that sort of situation that the Tanguys had left New York and so rarely went back there.

Other problems made themselves felt. Tanguy at one time had been a colossal drinker. He had been known to challenge a friend to join him in drinking a whole bottle of brandy, glass by glass, and seeing who could stand up straighter at the end of it. When flown with drink, he sometimes continued the competition by taking his opponent by the ears and butting him, head to head. Not everyone enjoyed this, and one of the reasons for their going to Woodbury was that Kay Sage hoped to dry him out, without a harsh word spoken.

Relationships formed at school do not always last well, but as between Pierre Matisse and Yves Tanguy, the friendship held firm. When Pierre married Patricia Echaurren as his third wife in 1955, his witness was Yves Tanguy. After

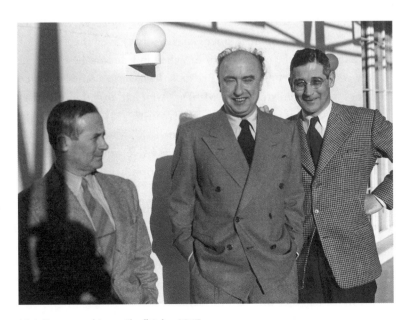

Miró, Tanguy, and James Thrall Soby, 1947

Tanguy died suddenly in that same year, it turned out to have been his last wish that his ashes would be spread over the bay of Douarnenez, in Brittany. After Kay Sage had died by her own hand, exactly ten years later, Pierre and Patricia Matisse went to Brittany and did as Tanguy had wished.

The precocious high-flyer among the new additions to Pierre Matisse's roster in 1942 was Roberto Matta Echaurren. Most often known simply as Matta, he had been born in Santiago, Chile, on the 11th day of the 11th month of the 11th year of the 20th century. He was of Spanish, French, and Basque extraction. (Echaurren is a Basque patronymic.) Educated in a Jesuit college in Santiago, he graduated at the age of twenty-one and forthwith decided on a mode of life that he was to follow forever afterwards. He would go everywhere, get to know everyone worth knowing, stay awhile, and then repeat the process elsewhere. For all this, he could not have been better equipped. He had matchless charisma. He could master whatever languages he fancied. Everywhere, he landed on his feet. But at the first intimation of boredom or routine, his spring-heeled fancy would deposit him elsewhere.

At twenty-one, he was in Italy, wondering how to paint. At twenty-two he was in Paris, with perfect French. Was he perhaps born to be an architect? He went to work for Le Corbusier. ("He never taught us anything," he said later. "As to the practicalities of his architecture, there weren't any.") In Scandinavia, he met with another major architect, Alvar Aalto. In the U.S.S.R., he spent two months designing windows for workers' housing. At twenty-three, he spent Christmas in Paris, where the Spanish poet García Lorca gave him a letter of introduction to Salvador Dalí. At twenty-four, when in London, he met René Magritte, who wrote to a friend of his in Brussels that Matta's paintings were "a thousand times more interesting than Miró's." Dalí had urged him to go and call on André Breton in Paris. "But you are a Surrealist!," said Breton, as soon as Matta had unwrapped his drawings. ("A Surrealist!," Matta said later. "I didn't even know what the word meant!") At twenty-five, still in Paris, he did odd jobs on the Spanish Pavilion for the 1937 exhibition, within sight and earshot of Picasso.

In 1938 he had four drawings in the International Exhibition of Surrealism at the Galerie des Beaux-Arts in Paris, for which André Breton and Paul Eluard were responsible. By May 1939, Breton felt able to say in *Minotaure* that "For a year now, every picture painted by Matta is a festive act in which all risks are taken and a pearl can turn into a snowball by incorporating within itself flashes of light of every kind, whether physical or mental."

It was an English painter, Gordon Onslow-Ford, who had urged Matta to

take up painting, as well as drawing. The eight or nine images that resulted were called "Psychological Morphologies." Often they were made with paint taken directly from the tube. Automatic impulses did the rest. Directionless, in a huge neutral space, ambiguous forms took their places but did not quite define themselves. Colors were spectral, lurid, and not seldom ghastly (in the dictionary sense). As for his talk, it was relentless, unending, unstoppable, and like no one else's.

By the end of the summer of 1939, Matta was a firm favorite of André Breton's. He had also taken enormously to Yves Tanguy and Kay Sage. Tanguy he regarded as, with Marcel Duchamp, the foremost artist of the day. Kay Sage was someone of whom, as he said later, "he could never think without smiling." With his prodigious verbal dexterity, he excelled at the collective word games with which the Surrealists amused themselves.

All this being so, Matta was happy in October 1939 to take Duchamp's advice, which was that he should go to New York on the ship on which Tanguy and Kay Sage already had reservations. When Matta arrived in New York by boat from Europe in October 1939, he had only just begun to paint in oils on canvas. He had no money, and he knew nobody, except for Kay Sage and Yves Tanguy. But that was very soon put right. In the winter of 1942–43, the young Matta used his studio for Saturday evening seminars, disguised as social occasions, at which Robert Motherwell, Jackson Pollock, William Baziotes, Arshile Gorky, and other American artists got an earful of Matta's mesmerizing powers of conversation.

Quite soon, he knew the painters, he knew the poets – even Robert Frost was to write on him in 1944 – and he knew the great savants. (It was with Meyer Schapiro that he was soon to discuss E. Monod-Herzen's *Science et Esthétique: Principes de Morphologie Générale*, which had come out in 1927.) Matta was never unnoticed for long.

The case of Wifredo Lam was unlike any other that Pierre Matisse had dealt with. When he took him on in July 1942 at the suggestion of André Breton, Lam and his German-born wife, Helena, were in Cuba, which they had reached by a circuitous route in June 1941. It did not deter Pierre that Lam knew almost no English and that he and his wife had very little hope of getting to New York. Helena Lam could express herself perfectly in French, and her letters to Pierre, though signed by Wifredo Lam, had a clarity and a precision that were owed to her scientific training.

Lam was to paint pictures for a show in November 1942 and send them off to New York. When they arrived, Breton would invent titles for them and write

the catalogue preface. It might have seemed rash, but Lam was just what Pierre needed to complete his house team, and Pierre committed himself completely.

Lam was not, after all, an unknown quantity. Nor was he a standard-issue artist. He was the wild card in the pack, and always had been. He had been born of a Cuban mother who was a mulatto with Spanish blood. His father was 100 percent Cantonese. In January 1938 his future wife, Helena, had been laboratory director for the Maxim Gorky Hospital (formerly named after the Holy Spirit) outside Barcelona. When it became clear that Barcelona would soon fall to the forces of General Franco, she left Spain, went to Paris, and checked into a little hotel on the quai Saint-Michel. Two weeks later she met Wifredo Lam in the entrance to the hotel. Lam had a delicate and an irresistible presence. They talked. Quite soon, they were having lunch, and he took her to see his paintings. She was hugely impressed.

One day he came to her room with a large package of paintings. "Wish me luck," he said, "I'm going to see Picasso." Hours later, he came back empty-handed. He and Picasso had hit it off. They had joked together in Spanish. Picasso had telephoned to Pierre Loeb, and in short order Pierre Loeb had bought all Lam's pictures.

Lam could then afford to take a large studio on the rue Armand Moissant, not far from Montparnasse. His future wife moved in with him. From being a seductive and mysterious nobody, Lam very soon became a seductive and quite well-known somebody. His visitors included many who called the shots in a certain Paris. This was in its way a magical transformation, but one with which Wifredo Lam was well able to deal, thanks to his angelic bearing and limited command of French.

His dealer Pierre Loeb described a meeting with Lam in 1938. "I was in a café called the Flore in a city called Paris, with Picasso and his immediate entourage. We were crowded together in the kind of oppressive atmosphere that signals the arrival of a cyclone. Picasso called out 'Lam!' and there you were – tall, slender, with your long arms ending in your long super-sensitive hands. You had an African face that had been drawn by a Chinaman who was all subtle refinement. And your very small head was crowned by a stylish cap, quilted with soft black wool. You knew only a few words of French and seemed to be very intimidated."

Pierre Loeb also remembered that when he said to Picasso that Lam was influenced by "negro art," Picasso rounded on him and said, "But that's his birthright! Lam IS a negro!" Picasso did not weary of Lam's company, and when he and Dora Maar left for Royan in the first days of World War II, it was with Wifredo Lam and Helena that they had lunch before going.

Lam's work seemed to Pierre Loeb to be in line with the evolution of the pre-

vious half century. During that time, Bonnard and Matisse had brought the great fireworks display of European art to a close. The time had come for others to invade the consciousness of the white race. Initially they had come from the Far East. Later came the Aztec and the Mayan, the African and the Papuan. "As to all that," Pierre Loeb said to Lam, "you have a great deal, a very great deal, to say."

But history then intervened in a more immediate form. As a result of the anti-Jewish laws that had come into force in France, Pierre Loeb was compelled to shut his gallery. Wifredo Lam decided to leave France. Helena had been interned in France in March 1940 as a German national, but was released after France had been defeated. Once they were reunited in Marseilles, Lam and Helena joined the very long line of those who were hoping to get out of France. André Breton and his family arrived in Marseilles in late September 1940, but it was not until March 24, 1941, that the Bretons and the Lams took passage for the New World and left, along with 350 others, on a converted freighter. (During the lengthy interim, Lam made illustrations for Breton's poem "Fata Morgana.")

On board ship, spirits were initially high. Conditions were reasonable. Everyone felt that they had personally outwitted Hitler. The company included writers, artists, and senior politicians from countries overrun by the Nazis. But it took till April 24 to get to Fort de France, Martinique, which at the time was a compulsory last stop on French territory. Refugees were herded into what had formerly served as a leper colony, but there also the company had compensations. (After a while André Masson and his wife arrived.) During their three weeks in Martinique, they also had a first glimpse of an authentic jungle, with baobabs, wild orchids, and voyager palms with their fans wide open. Lam drew ever closer to André Breton as he witnessed the depth of Breton's sympathy for the blacks. Once back at sea, the Bretons, the Massons, and the Lams called at one island after another until their ways parted and the Lams arrived in Cuba.

André Breton, for his part, went to see Pierre Matisse in New York and lavished his powers of persuasion on Lam's behalf. It took a while, but on July 10, 1942, Pierre wrote to Lam and offered him a show in November of that same year. It would be of gouaches only, because Lam could not yet afford to paint in oils on canvas. As Pierre was buying them outright at $30 apiece, it does not sound today like a heavy commitment. But this was less than a year after Pearl Harbor. Clients were few and dispersed. To launch a new name – and Lam had no public in the United States – took steady nerves.

As against that, it had always been Pierre's policy to buy outright, and in bulk. He also preferred to keep right on buying, year after year, and wait for his collectors to catch up. Sometimes the results were spectacular. Other times – as a

close friend and colleague said many years later – Pierre simply had to hold tight and swallow his losses.

In the case of Wifredo Lam, the first batch of gouaches that arrived from Havana came as a very pleasant surprise. "They are superb," Pierre wrote on September 18, 1942. "You have made great progress since I saw your show at Pierre Loeb's before the war. The color has become much stronger, and it has an unexpected variety. There is an astonishing freedom of invention in the forms, and some of the gouaches are truly moving." Doubtless even more welcome to the Lams was the news that Pierre had decided to raise Lam's prices and was therefore sending him a check for $250 instead of for $180. It was also agreed that although the gouaches in the upcoming show would still be Lam's property, he would receive $75 for every one that sold. Furthermore, Pierre asked to have exclusive rights "*en permanence*" for Lam's gouaches in the United States. He would have a second show of them in 1944, and he would guarantee to buy at least ten more on that occasion at $50 apiece.

This was naturally very good news to the Lams. Though still cheap by American standards, the cost of lodging and life in Cuba was going up fast. Lam was full of new ideas for pictures, and the secret rituals of life in the interior of Cuba were to give him many more. But to be so often on the move in Havana wasted both money and time, and this new letter from Pierre held out the promise of a more stable existence in quarters that would allow him to work on a larger scale. Meanwhile, he would refuse to show his work in Cuba.

Lam's first show with Pierre Matisse closed on December 5, 1942. Lam's letters on the subject went unanswered until February 9, 1943, when Pierre had some bad news to unload. With one exception, the critics had showed very little understanding of what Lam was about. The war was too much on everyone's mind. The many younger people who did like the work could not afford to buy it, even at a low price. Many of Pierre's other clients were away on military service and could not think of collecting.

"To sum up the situation," Pierre said, "I would say it is going to be a long pull and rather a difficult one, especially in view of the fact that progressive painting is left somewhat on the side." No other gallery had contacted Pierre about the show. He still intended to give Lam another show in 1944, but for the moment he would prefer not to be sent any more gouaches. Given that this letter must have come as a blow to Lam, he (and perhaps especially his wife) took it remarkably well. On April 1, 1943, there was a German steadiness of purpose in Helena's reply. Wifredo was not discouraged, Helena wrote. He quite understood the situation. He was working very hard. If Pierre managed to make any

sales, could he please send their share forthwith, so that he could realize his dream of working on a larger scale and in oils on canvas?

Meanwhile, Pierre was anxious that the second show should not seem to be "more of the same." He believed in Lam. He knew that Lam was in full evolution. He longed to see what would come of it. But, without a minimum of money, Lam would come to a halt. During the period from December 1942 to the end of July 1943, Pierre had sold three gouaches by Lam, with a total profit to the artist of $225. There was now talk of his painting very large pictures for the next show. Though loath to discourage him, Pierre was alarmed by the thought of gouaches five, six, or seven feet square. The notional New York collector lived at that time in apartments with small rooms. The idea of mounting these gouaches on canvas, framing them, glazing them, and storing them was disconcerting.

This problem came at a very bad moment. Conditions in New York were such that Pierre had to review his commitments, one by one. Meanwhile, the cost of life in Cuba in 1944 was three times what it had been in 1943. Lam dreaded having to move on and move down. He had in mind a very large painting called *The Jungle,* nearly eight feet high and over seven and a half feet wide, with which he hoped to break through the indifference of the New York public. To complete it, he needed to stay in one place and not run out of materials. Would Pierre give him a firm contract, to tide him over? Or could he guarantee a monthly payment, even temporarily?

Pierre pointed out in his reply that Lam's previous experience of working with a dealer had been in Paris before World War II. There was at that time a very lively Parisian public. Paris was also the natural place of rendezvous for dealers and collectors from all over the world. Even so, the major Parisian galleries only gave contracts to long-established artists with whose work they could count on recouping their money. New York had never been like that, and in the dark days of World War II conditions could not have been more unfavorable for work of any kind, let alone for the work of a younger artist. No dealer in New York who did not have a private fortune could dream of subsidizing a young painter. Pierre did, however, agree to send Lam $150 a month for the next six months.

Worse was to follow. Lam's second exhibition, in June 1944, did not sell well. In particular, the enormous *Jungle* did not find a buyer. Lam waited through July, August, and September in hopes of even a short letter from Pierre. None came. Finally, on October 19, 1944, Pierre wrote and said, "Here is my check for October. I do not know what I can suggest to you for the future, for I made very few sales from your exhibition, and my expenses here become more and more

onerous. You know that I have to make regular payments to Chagall, Miró, Tanguy, and Matta. To my great regret, therefore, I shall have to suspend our contract in the immediate future. It is not that I am no longer interested in your work – quite the contrary. I have many paintings of yours here, and they still interest me very much. But they are very hard to sell.

"If you wish to find another outlet for your work, I recommend you to try Mexico City. My friend Rufino Tamayo, whose work you will know, tells me that the art market is flourishing in Mexico City and that you could certainly do very well there. I could recommend you to the best gallery in the city. I will continue your monthly payments until January 1945, but after that I shall have to stop them."

Wifredo Lam was naturally appalled by this letter. His feelings, as passed on by his wife, were such that Pierre decided to continue his monthly payments until July 1945 in hopes that Lam would not feel that he had been abruptly discarded. Pierre hoped that he would be able to come up with another exhibition for November of that same year.

A check for $441 arrived in March 1945. It was followed at the end of April by a cable announcing the longed-for sale of *The Jungle* to the Museum of Modern Art. Lam wrote to Pierre and said, quite rightly, that "the acquisition of *this* picture by *this* museum is of the greatest importance and may lead to other good things in the future."

Pierre never quite lost touch with Lam. When he got to see him and Helena in Cuba – no matter how briefly – they had an immediate rapport. But before long Lam was no longer "an exile," any more than Matta was an exile as he raced all over the world. Putting down roots here and there, wreaking magic and mischief wherever he went, Matta was almost a new kind of human being. Lam, likewise, would turn up all over the place, never quite settling down forever. This was not the age of the exile in anguish. It was the age of the former exile for whom to move on at will was now a brevet of privilege. And the art world answered to a whole new gravitational pull and said, "Go ahead and do it!"

Life in a Defeated France, 1941–42

Henri Matisse had a great gift for plain speaking, though he did not always get to use it. But in 1941 he made the most of it in letters to his son Pierre. It was as if he wanted to set everything straight about his family, once and for all. It might also, by implication, be his last chance of doing so.

On January 10, 1941, a few weeks after his seventy-second birthday, he took a single sheet of paper and, without a word too many, he wrote down exactly what he wished to be done in the event of his death.

His estate was to be divided into three equal parts – one for his son Jean, one for his daughter Marguerite, and one for Pierre. If there were disagreements, they were to abide by the decision of their father's notary, Maître Dauchez. They were also to follow Maître Dauchez's advice as to the wise and prudent investment of capital.

In the event of the death or deaths of Jean, Marguerite, or Pierre, exact instructions were left as to what should be done. Henri Matisse counted on the goodwill of the survivors to see that his wishes were carried out to the letter. Not even the Code Napoléon could have been clearer or more concise.

Marguerite had cabled to Pierre that their father was unwell. But, even so, his letter must have been disconcerting. Worse was to follow, moreover.

Five days later, on January 15, Henri Matisse wrote again, and at length. This time, there was a warning, and it came in the first sentence.

"My dear Pierre,

"I am about to have a little operation. It is neither important nor dangerous. It is for diverticulitis. Any American doctor can tell you about it, because it seems to be quite common both in the United States and in Britain. It is an intestinal condition that is both congenital and hereditary."

There followed a summary drawing of an intestine distorted by bulges or pouches. Though purely diagrammatic, the drawing made its point. This was clearly something that had to be put right. The inflammations to which it gave rise were torturous, and they were becoming more and more frequent.

The doctors had told him that without "a little operation" he would never get better. His life could be in danger. The crisis might happen anywhere and at any time. Nor could he count on having the right surgeon to hand.

As in so much else, Henri Matisse was precise. "I did not care for the surgeon whom they recommended to me in Nice. Madame Lydia wrote to Marguerite – without telling me – that she, Marguerite, had to be with me at this time. And, sure enough, Marguerite got to the bottom of the matter with all the energy of which she is capable. I now have doctors in whom I have full confidence, and I am going to be operated on the day after tomorrow.

"I am not at all afraid. In fact, I feel completely detached from the whole affair. I do not think that my operation is a dangerous one. The doctors find that my organs are younger than my age, and they are confident that the results will be all that they could be.

"I have been for several days in a very good clinic, run by nuns who remind me of the paintings by Philippe de Champaigne in the Louvre. Marguerite and Madame Lydia are both with me – Marguerite accepted that because she believes that Madame Lydia is indispensable to me. So far, all goes well in that connection.

"I have put together, in a sealed box, everything that will be needed if the operation is not successful. In that event, Marguerite will give the box to your mother. As soon as the operation is over, you will receive a telegram (full rate) with the news. You will also receive from me a registered letter, a month later.

"The great defect of our family is a lack of candor, a fear of what ought to be said. I believe that this fear is owed primarily to the character of your mother, who likes to live quietly, from moment to moment, irrespective of what may come of it.

"Enough of that. I have had to put up with Duthuit's odious ways – I still go scarlet when I think of them – for the sake of Marguerite's peace of mind. Before my operation, I am going to speak to him frankly in hopes of reestablishing what is so much lacking in our family – a sense of togetherness."

This was clearly a moment at which Henri Matisse wanted to call the whole family to order before it was too late.

"As for Jean, he is sick with jealousy. I had wanted to talk to him about it the last time he came to see me, when I was in bed, a few days before I left home. But I was preoccupied by the surgeon, who wanted to go ahead with the operation as a matter of urgency (which it wasn't). So I had to keep quiet, especially as Jean is not the easiest of men to pin down.

"In our family, we have all grown up like people in a hurry, with no one to guide us. There was my work, and the peace that I had to preserve if I was to go on with it. And there was – I have to say it – the character of your mother. And what came of it all? Personalities that were egoistic, undisciplined, and went their own way without any consideration for others. I hope to God that you bring up your own children differently.

"At any rate, I have put all my own affairs in order, and especially as regards your mother, in case I do not survive the operation. If that should be the case, the papers will be given to her.

"If I am thought to have behaved badly, it is because my behavior has not been understood. But I count on the judgment of my grandchildren. They will understand that their grandfather had to defend the peace of mind that he needed if he was to continue with the work that has been his whole life.

"I am quite sure, by the way – and I am not reproaching anyone – that the emotions of the last two years have had a very bad effect on my intestine and may have led to the spasms that result from its deformation.

"That is why I have said that I love my family, truly, dearly, and profoundly, but from a distance. That remark is often, if not always, taken in a pejorative way. That is entirely wrong. A hyper-sensitive organism like mine can find human contacts unendurable and deeply wounding, even if the heart remains tender.

"I hope that I make myself clear. But please bear in mind that I am writing at 3 o'clock in the morning. (No: five o'clock.) I am going to write to your mother. The letter is not to be given to her unless the operation is unsuccessful. In this letter I shall say that since she left me – and she *did* leave me – I have never ceased to think of her. She has always been near to me. But she made me suffer so much that in spite of my profound affection for her I could never see her again. To do so would cause me unbearable pain. She called in question everything about me – my honesty, my affection for my family, and all the rest. I shall not of course go into that. I shall simply tell her that I continued to love her.

"If I tell you this, it is as a lesson. I do not wish you to endure stomach pains that may turn into diverticulitis. When your peace of mind is disturbed, think

of what happened to me. My last years have been unjustly poisoned by these problems, and my family has understood none of them.

"As for "Le Rêve," don't sell it for the moment. After I'm gone, you – or rather, your mother – can do what you like. Unlike her, I have not changed my will. What is mine will be hers. I have made my last wishes plain. I have written to her about Claude, and about how my estate should be distributed. A copy of my will has been sent to you yesterday by registered mail. Another copy will be at your mother's in your name in case the first one goes astray. I have written to Jean, to your mother, and to Marguerite, but these letters are only to be sent after my death.

"Don't be alarmed. I don't expect to die, but it is in my character to take every precaution. Marguerite says that I am like Louis XIV, who arranged his funeral in such detail that nobody could put one foot before the other without following his instructions.

"I hope that all will go well for you and that you will all stay together – or, rather, that a new degree of candor will bring you closer together. If you can only have a better understanding of what the others are like, you will realize that we all have to put up with the way we are made, and that it is unlikely that we shall ever be able to change it.

"Finally, I embrace you all – children and grandchildren – with all my heart. In spite of everything, I count on seeing you all soon.

"P.S. I wish to leave my painting of *Le Coquillage* to the museum on the quai de Tokyo and *La Dormeuse* to the Ville de Paris. Those are my last wishes. But don't be alarmed! Everything will be all right!

"P.P.S. You must tell Duthuit in plain language why you can only see him exceptionally and at your request. This can only flatter him. Leave him that, at least."

Henri Matisse then added a postscript to the censors who, since the fall of France in 1940, had scrutinized every letter that left France:

"I would respectfully ask the Postal Censor to bear in mind that this is written by a father to his son. As I am about to undergo a surgical operation it may be my last letter to him. This letter contains absolutely nothing that should hinder its arrival at its destination.

"I thank the Postal Censor for whatever attention he may be able to pay to this request."

Contrary to what Henri Matisse had written to Pierre on January 15, his operation was both important and dangerous. On January 1, and again on March 3, he had a minor pulmonary embolism. It was not for nearly four months that he was able to write again, on May 2, 1941. Much as he wanted to get back to Nice, he was still in Lyon, at the Grand Nouvel Hotel.

As regards his condition, he was characteristically forthright. Nor had he lost his gift for black humor, even though there was nothing to laugh about. This is what he wrote to Pierre Matisse from Lyon.

"At last I can write! Before the operation, I wanted nothing more than to write letters. They were an obsession with me. But now I find them difficult. They seem to take so long to reach you that my news would already be stale. I prefer to cable, but cables are so short and say so little, unless one has sensational news. My only sensational news is that although it is four months since I left Nice, I am still in Lyon.

"My operation must have been the same one that Bignou endured when they fitted him with an artificial anus. Between you and me, I, too, have one now. Not everyone who has drawn that particular ticket in the lottery likes to talk about it, though a surprising number of people make a discreet use of the ornament in question. I promised myself that I would never tell a soul, but I broke down and told one or two people, and they told their best friends, and so on. . . .

"I had to leave the clinic because there was no room for newer patients. I was well enough to come to this hotel. I was cured, except that I had to get used to wearing a special belt, which takes some doing.

"It's been a terrible business, my dear Pierre. It was immensely painful, and I was resigned to the idea that I would never get off the operating table alive. So now I feel as if I had come back from the dead. It changes everything. Time present and time future are an unexpected bonus. I came back from the operating table with my digestive tube intact – better than before, in fact, since they had cut away 14 inches of diseased intestine. I can eat whatever I like, and I digest it better than before, despite the inconvenience of not being able to manage by myself.

"While waiting for lunch today I had a look at myself in the mirror and this is what I saw. This is the first drawing I have made since my operation, which is why I use the sheet of paper on which I am writing to you. I don't think that the censors will suspect it of being anything but what it is.

"What goings-on, my dear Pierre! Thinking so often of you all, I tell myself that I must never stop writing to you while there is still time.

"I have no news of Marguerite, who left here six weeks ago. We were in Lyon for three months – not by ourselves – and everything went off perfectly. We both avoided all subjects with a potential for argument. I had intended to put my foot down and tell her why our family has such a horror of plain speaking. I meant to speak to her calmly and openly, with nothing kept back. (Keeping things back has done such terrible damage in our family.)

"Before my operation, I saw that as a duty that had to be fulfilled while I was still around. But those days were filled with doctors' talk. Could the operation succeed at my age? Wasn't I a little too fat? Belly fat is the surgeon's enemy. Because of my fat, pus formed in the wound and I had to go back to the operating table to have it scraped away with the scalpel. Marguerite was in touch with the doctors, and they talked so long and so freely that I never had a chance to speak to her.

"And then, in our family, we are always so anxious to be in agreement that we never dare to disagree. Whatever might cause discord has to be hidden. It's a very bad principle. When what has been hidden comes out later, it has an exaggerated importance. Those who had not been told about it take offense against those who have, and it gets worse and worse.

"When I came back to life after the operation, I took up the idea again. Thinking it over, I simplified it in my head, over and over again. It seemed to me perfectly reasonable. But both Marguerite and I had suffered a great deal. I waited until she and I had regained our strength before speaking out. I knew that she would not agree with me, and that there would be a conflict."

As to her marriage, Henri Matisse wrote, "We had all taken sides, one way or the other. I wanted to say to Marguerite what I wrote to you, and what you had so well understood. I wanted to write to Jean, too, on the same lines. But time was too short. And then it's not easy to make contact with Jean. He closes up outwardly and, I think, inwardly as well. When he's alone, he thinks things over – but only if they are what he wanted to hear."

A few days later, Henri Matisse was well enough to pass on the latest gossip from Paris. Picasso was making a sculpture of a cat. Derain was also making sculptures and making enormous cartoons for the tapestry makers at Aubusson. Braque had given up sculpture and gone back to still lifes. Josse Bernheim had died in Lyon. But by May 20 medical matters once again had priority. In the matter of Rouault (a regular preoccupation with Pierre) he was hoping to send Rouault some linseed oil. If he couldn't find any, Henri Matisse would send him some of his own *huile d'oeillette*. "I pity Rouault," he said, "because he has to be operated on for prostate cancer. Simon Bussy had the same trouble three years ago, and it's a considerable ordeal. But Bussy sailed through it and is now better than before.

"I always have to have someone to help me. Luckily Lydia is here now and could not be more devoted. But there are times when I can't bear it anymore and develop the foulest possible temper and can't bear to have anyone near me. I shout and yell at the slightest provocation. I said to the doctor 'I want to do as

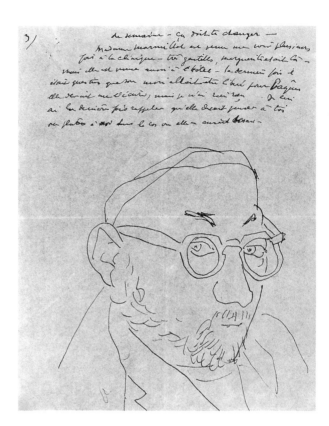

Henri Matisse drawing in a letter to his son, May 1941

I please and not have those two women – Lydia and Marguerite – to lead me by the nose.' I am so awful to them that they each go off into a corner of their own and cry their eyes out. 'It's because he's so ill,' they say to one another. 'He's never been like this before.'

"Do you know that in moments of lucid delirium – if there is such a thing – I actually make a joke of it all. 'Why should this happen to me, and not to someone else?' I say. 'What if I wanted to sell my body?' I'm surprised that I ever said it. But there it is. I have suffered a great deal, but here I am with my remedial braces. There was really no choice, if I wanted to stay alive. It's very humiliating, but I live with it, and I digest everything that I eat. If only I can do some good work again I shall be happy. So in a way I feel that I got off lightly.

"I want you to know that I'm not the only one in our family, either. Your mother, who was immobilized for 10 years, can get around perfectly well. Her doctor had predicted that when she was 70 she would walk better than he could. Insofar as he's already dead, he was perfectly right.

"Marguerite confirms what I say. When she went to see your mother, she found her standing outside the house. Along came a bus. Your mother climbed on board and went off to Toulouse. It's really miraculous.

"And now, my dear Pierre, what do you think of the collective madness that is ravaging both the Old World and the new one? Do you feel, as I do, that there is something foredoomed about it, and that the whole world is bent on destruction? I think of the forgotten cities of Moslem civilization in Iraq – ancient cities whose monuments are as fragile as they are precious. It is miraculous that they have survived to this day. I think of the mosques – Bassaruk, etc. – with their glazing still intact. These are some of the oldest monuments in the world. It will take just one bomb to reduce them to dust. And I think how troopships laden with soldiers are being hunted down to be sunk with all hands. It's simply horrible – and for what?"

Given that Henri Matisse did not often refer to World War II in its wider aspects, it has to mean something that among all the thousands of historical monuments that were endangered by World War II he was anxious above all about buildings that related to Islamic art. What he had seen of Islamic art in Paris at the Pavillon de Marsan in 1908, and in Munich in 1910, he had never forgotten.

Even so, and in that same letter, he came back in the end to the problems of his family. Not only were they intensely irritating in themselves, but they threatened the stability and the eventual happiness of the next generation. Claude Duthuit, then nine years old, was a case in point, and one that weighed upon his grandfather. He was at that time in New York, in Pierre's charge.

"You don't mention Claude in your letter," he wrote. "What is the matter with him? It is probably that you never see his father. Anyway, do what you can. It would give me real pleasure. He doesn't have any luck. As he is intelligent, what conclusions can he draw from his situation? Every single member of his family is on bad terms with one or more of the others. They are fond of him, and yet they can't get on with one another. God Almighty! What kind of a future can be in store for him? No one has taught him how to live with other people. Make sure that you teach your own children discipline. Don't be just a companion for them. Be their father at all times. It's not easy, but it's your duty. The very idea of duty has been discarded as an encumbrance, and you can see what has come of it."

On May 22, 1941, he felt well enough to take the night train to Nice. At 2 A.M. that morning, he had written to Pierre and recommended him, among other things, to read *The Patriot*, by Pearl Buck, who had won the Nobel Prize for Literature in 1938. In his view, the story had analogies with that of his own family and might throw light on their misfortunes.

Once back in Cimiez, Henri Matisse was in remarkably good spirits. Letters of as many as thirteen or twenty-one closely written pages could still get through to Pierre in New York, and his father made the most of that possibility. He was perfectly well aware of his medical condition. ("I am not a wounded man," he was to say to Pierre. "I am a mutilated man.") But to have come through at all was a joy to him.

Life in Nice was not too depressing, either. Until November 1942, when Hitler decreed that France was to be one single occupied zone, life south of Vichy was relatively tranquil. Any movement from one zone to the other was strictly controlled. Supplies of every kind were more and more hard to come by. The long-term outlook for French Jews was bleak, and even more so, immediately, was the outlook for Jewish refugees from other countries who were trying to leave France. Some Frenchmen and French women flourished at that time. Others were captured, interrogated, tortured, and killed for the sake of their country.

But there was also something called "interior emigration," which meant asking History to go away and come back another day. A famous and very gifted man in his seventies, not long out of hospital, could best serve his country by doing the work for which he had been born. He could also serve his country by staying there and resisting every opportunity to leave. That was Henri Matisse's point of view, and he lived up to it.

Lydia Delectorskaya posing for Henri Matisse. Nice, 1943–44. Photo: Henri Cartier-Bresson

In the late summer of 1941, he was visited by Varian Fry, the dauntless young American who made it possible for untold numbers of people to leave by ship from Marseille and find security on the other side of the Atlantic. Fry tried to persuade Henri Matisse to leave France and come to the United States until the war was over. "But," Fry said later, "in spite of the growing food shortages and the difficulty that he was already having in finding canvases and pigments, he said he preferred to stay in France. He was comfortable in his studio and able to work there, and he was not at all sure that he would be either comfortable or able to work in the United States."

Around that time, he was in remarkably good spirits. Writing to his painter-friend Charles Camoin in August 1941, he said, "You must excuse me, but there are times when I can't even write two words, and this is one of them. I have so many ideas for my work that I can't think of anything else. I feel so healthy, these days, that it scares me." And in January 1942 he wrote to another old friend, the painter Albert Marquet, and said that he seemed to have been granted a second life.

Something of that euphoria had got through to Varian Fry. "He was so warm, so simple, so direct, and in a sense so naive and childlike in his approach to the world and its problems," Fry said, "that I hated to leave him behind when I left France. In the days when there was a difference between occupied and unoccupied France, Matisse would never go back to Paris. 'I could never bear to live under the Boches,' he said."

In one of his very long letters to Pierre, Henri Matisse wrote on June 11, 1941, that "I have just had a walk in the garden near the Régina. I want you to know that I am very happy here. Once I can manage to forget my anxieties, present or future, I enjoy an absolute tranquillity. In the last two weeks I have been into Nice only twice, to see Jean and Gérard. On the day I got back here, Simon Bussy came from Roquebrune to see me, and he came back a week later. Otherwise I've seen nobody."

In that same letter he said, "I can still see straight and see clearly. I have some flowers in some vases, and some fruits (when I can find any) and one or two lemons. Still lifes used to cost nothing to put together, but now they are either out of the question or more expensive than a beautiful woman. Anyway, don't worry about me. I eat whatever I like, and I have no trouble digesting it. At the hotel in Lyon I used to have salmon mayonnaise (made with flour, not with eggs). Salmon at dinner is said to be indigestible, but I had no trouble and sometimes had it three times a week. Here I often have vegetable soup in the evening, and with no trouble at all. I'm back to my old weight and everybody is

amazed at how well I look. I have the little inconvenience that you know about, and sometimes I wake up in the night in a terrible temper about it. But that's soon over, and I dictate something or other to my night nurse. So there you are, my dear Pierre. I'm getting to be more of a philosopher, and sometimes I laugh out aloud, wholeheartedly."

But the future of life in the unoccupied zone in France was undeniably precarious. It also worried him that communications with the United States might be suspended for one reason or another. "What shall we do, my dear Pierre, if one day we can no longer write to one another? And how long might that last?" Theirs was the only stable relationship in the Matisse family. The situation at Beauzelle, where Amélie Matisse, Tante Berthe, and Marguerite were living at the time, was an inferno. "When Marguerite went back there, she did not even tell Berthe how I was. When Amélie Matisse was unwell and had to go to a clinic in Toulouse, she refused to let Berthe go and see her. If Marguerite meets Berthe in the street, she gives her the merest nod, in passing. If Marguerite ever replies to my letters, there is always a pinprick or two, here and there. And Berthe, who was devoted heart and soul to us all, is now despised by everyone except you.

"All this comes from a collective sickness of the heart. But can it be that I am responsible? Are my paintings responsible for those tight-shut, inhuman minds? Before my operation, I meant to talk plainly to Marguerite. I was going to tell her everything that I had hidden, always and since ever, so that I could have peace for my work. But then I realized that neither of us had the strength for such an encounter, and I put it off from day to day."

That particular conversation was still on hold. No one ever believed more firmly than Henri Matisse in the necessity of plain speaking. But when to schedule it? And how to begin? These were perennial questions. Yet there was, for the moment at any rate, one respect in which his family life in France was unexpectedly stable. Jean, his difficult first son, had settled nearby, in Antibes, and both he and his wife, Louise, were working hard and making a little money. Henri Matisse had enjoyed seeing their son, Gérard, when they were in Nice. They had a little house among the pines, with a spectacular view of the snow-capped Alps. There was the further advantage that in fine weather they could see the Régina in the distance. With a good telescope, Henri Matisse could almost have peeked into their living room, though not down to the basement in which Jean was later to harbor sticks of dynamite for the French Resistance. Relations between father and son were good, for the time being, and as Jean had asked to see what his father was doing, Henri Matisse did not like to refuse. "But," he said to Pierre, "I shall take every possible precaution to avoid touching him on

the raw. What a character!"

Ever since he was reestablished in the Régina, Henri Matisse was more than ever anxious to stay in contact with Pierre. "Do write to me as often as you can," he had written on August 30, 1941. "You are the only member of the family with whom I can communicate. Tell me about your plans for the farm. Is it big enough for you to live on? Can you make money on what you produce? You could always keep on the gallery. And please do keep writing. My life is not much fun. I didn't need all the things that have happened to me, and a moment or two of family happiness helps me to keep going."

As time went on, business in the New York art world ground almost to a halt. But in Paris, and on the Côte d'Azur, speculation was rampant, and people would pay no matter what. "There was a sale at Aix-en-Provence the other day," Henri Matisse told Pierre. "A little painting of mine, no bigger than your hand, done in Corsica, sold for 100,000 francs. Early drawings of mine fetched 15,000 apiece. Tiny Vuillards went for 50 and 60,000 each, and so forth. This is the golden age for artists."

He went on to say that "Some of them have the time to take trips, by invitation." Henri Matisse had taken a sardonic interest in the so-called goodwill visit to Germany and Austria in which a number of French artists had been persuaded to take part in October 1941. More than one of them had agreed to go on the understanding that in exchange they would be allowed to negotiate for the release of a considerable number of French prisoners of war. No such negotiations ever took place. The artists in question included André Derain, André Dunoyer de Segonzac, Maurice de Vlaminck, Othon Friesz, and Charles Despiau. One might infer from their expressions when they and their Nazi minders were photographed in the Gare de l'Est, on the way to Germany, that they already knew that they were making a most hideous mistake.

"What a crew!" said Henri Matisse afterwards. "It was lamentable. And now that it's turned out badly for them, they don't know how to excuse themselves for going. Some of them claim that they were forced into it. A likely tale!" What had been envisaged by, at any rate, some of them as a charitable mission was seen in France as a betrayal. Whatever their motives, their high-level tourism was forever held against them.

Henri Matisse had never written anything that could be called autobiographical. He wished his private concerns to stay private, with never so much as a slip of the tongue to reveal them. But when he was in hospital in Lyon, the time dragged. Distraction was welcome. And when the editor and publisher Albert Skira came to see him, Henri Matisse spoke freely and at length about his early days as a

painter. He was astonished at how much, and how clearly, he remembered. "Skira kept saying, 'But what a pity that you can't write all this down!' Marguerite was there, and the two of them went out to lunch and had one of those Lyonnais meals that would bring the dead back to life. He asked if I would allow the critic Pierre Courthion to come and talk to me and take notes of what I said.

"I agreed to do it," he told Pierre, "on condition that he brought a stenographer, so that I had a record of what I said. An illustrated book of memoirs might result, but I reserved the right to refuse to have it published." These putative memoirs were undeniably a long shot. They were also potentially dangerous if Henri Matisse were to "go public" with distresses and resentments that still rankled within him. Yet, for Albert Skira, the book might well be a surefire best-seller. But Henri Matisse drew back just in time.

"My sessions with Courthion made the time pass more rapidly," he told Pierre. "He stayed for several weeks, and I rather enjoyed letting myself run on. But I have to say that Courthion is not a very gifted writer, and he did some things that I did not at all care for. So I took the manuscript back and told Skira that he could not have the book. 'NO,' I said, in big letters.

"This was a catastrophe for Skira. He was leaving Paris and going to set up a publishing house in Geneva. He was counting on my 'memoirs' for his first season there, and he had already sold 5,000 copies. He was also negotiating for an American edition. He came to see me to ask why I wouldn't give him the book. I told him I would tell him face-to-face, man to man, and with no witnesses, but not in writing.

"When he arrived, I told him that on reading the manuscript I realized that I was a sick man when I agreed to do it and that the text showed this all too clearly. For that reason, I stuck to the letter of my contract, which said that I could refuse to publish the book even at the very last moment. Clearly he had invested a lot of money in the project, and I, too, had had my expenses. He took it very well, and asked me if I would make some illustrations for him. Somebody in Paris had asked me to illustrate Ronsard's 'Amours.' He was to pay all the expenses and take half the edition, leaving the other half to me. Given the uncertain value of money in these times, this was rather a good arrangement. So I offered the book to Skira on the same terms, and he was delighted (and grateful). 'It'll be the saving of us,' he said. 'We had spent a lot of money on publicity. Now we can say that we have the Ronsard instead of your memoirs, and nobody will think that we have quarreled.'"

The Ronsard project came at exactly the right moment. "Do you know," he wrote to Pierre on March 11, 1942, "that my illustrated Mallarmé is completely sold out, and that those who really want one have to pay between 40 and 50,000

francs if they can find someone who would rather have the money than the book. Even then, it's very rare."

Even more important was the fact that his work was shaping up well. A new portrait of his high-born Turkish model, Nézy-Hamide Chawkat, was very promising. "After four sessions, I could almost have thought of it as finished today," he wrote to Pierre. "It was delicious. But I always hope that every painting will bring me something new, and I think that that might happen with this one. It took a turn this afternoon that I had never taken before."

At that time, he was really on a roll. The still lifes that he painted in September 1941 had given him great pleasure. So did the drawings that would make up his *Thèmes et variations* in 1943. "I am not wasting my time," he wrote to Pierre. "I am glad to say that I have never had more ideas. From the point of view of my mental balance, my operation was quite extraordinary. It gave me a new equilibrium. It put my ideas in order. It gave me a second life. Unluckily that life cannot last for ever, though I keep a careful watch over both my health and my time.

"I get up at midday – sometimes I have already had lunch – and then I take a nap for an hour or so. Then I paint from the model for the rest of the afternoon. It was difficult in the short afternoons of winter, but I made the most of it. I lunched off tea and *biscottes* and had my real meal at dinnertime. I've been able to work a lot, even after nights when I had no sleep at all."

In the summer of 1942, the German sculptor Arno Breker had a big exhibition in Paris. Breker had a great name in Nazi Germany, and a visit to his studio had been an important stop on the goodwill tour. (Those who were there remembered that the studio was equipped with a full-size pipe organ, and that two live horses were on hand as models.)

"Our 'guests' have made a great thing out of this Breker exhibition," Henri Matisse wrote to Pierre. "Pomp, ceremony, and a big official banquet. They even went to fetch Maillol by car from Banyuls. Everyone sang the praises of Breker, the great traditional sculptor – 'Not since the Assyrians, the Egyptians, the Rodins, the Maillols, the Despiaus. . . . In Breker, we find the continuation of all that the great sculptors of all eras gave us in the past . . .'" To that, Henri Matisse added that the great sculptors of the past could not protest, because they were all dead. He also added that Despiau had published a book about Breker.

Life in the Régina had at that time an almost eerie stability. Henri Matisse was almost always at home. From May 1942 he was confined to his apartment until the middle of August because of a stone in his bladder that was more than bothersome. (Sometimes the agony was so intense that not even morphine could give him relief.) Neither he nor his doctors wanted another operation, but, mean-

while, he didn't dare to go out even for a drive. Still less could he take a train, since any form of vibration could be dangerous. A projected visit to Geneva to work with Albert Skira on his illustrations for the Ronsard poems had had to be canceled.

This was not an agreeable state of affairs, and he became subject to some perfectly comprehensible mood swings. On June 6, 1942, he was in very good spirits about Picasso. Picasso had lately been very attentive to Henri Matisse. There had been an exchange of gifts – a very good drawing by Matisse and an important painting on paper by Picasso – and Henri Matisse was quick to defend Picasso when a ridiculous rumor was current in New York.

There was absolutely no truth, he said to Pierre, in the story that Picasso was in a lunatic asylum. His health was excellent, and he was hard at work. "People may have confused him with his son, who is not very bright, but there is no question of the boy being put away – not yet, at any rate. It's disgusting, that rumor. It must have been started by the enemies of Picasso's paintings.

"The same rumor was launched about 20 years ago by people who said that, as a result of an infection that dated from his youth, Pablo had general paralysis of the insane. It is true that his son, who is now in Switzerland, has caused him a great deal of anxiety. Now that he is in Geneva, the boy goes to Skira's office every day and gets money for his immediate needs. He has been in a lot of scrapes, and has not changed his ways, either.

"Picasso pays dearly for his exceptional qualities," Henri Matisse wrote to Pierre. "But he leads a dignified life in Paris. He works, he doesn't want to sell, and he makes no demands. He still has the human dignity that his colleagues have abandoned to an unbelievable degree. Here is one example: before the 'goodwill visit' to Germany there was a big dinner at the Ritz. Derain was mad with rage when he saw that Vlaminck had also been invited. (He and Vlaminck had been enemies for the last twenty years.) Derain made himself very offensive to the wife of the important personage who was hosting the dinner. But in the end he and Vlaminck were reconciled, and they patted one another on the back, the way a horseman calms a horse. Both of them were undoubtedly blind drunk at the time. But they went off to Germany together. By the time they came back, they looked pretty ghastly. When Picasso met Derain in the street, he said, 'Good Heavens, how you've changed!' Others got to hear it, and repeated it to Derain when they saw him. He blushed deep red."

At this time, the Régina was turning into a mandatory way stop for visitors from Paris. They all put themselves out to entertain Henri Matisse, in hopes that he would sell them even a small painting. He didn't want to sell his paintings, and his visitors went away awed and impressed, but empty-handed. But he was

amused, and sometimes more than amused, to hear the gossip of the art world that they brought with them. Gifts did not affect him, however, and when Louis Carré sent him – not once but three times – three dozen *marennes,* he said to Pierre, "Those oysters cost 80 francs a dozen. But I had to tell Carré that my doctor had forbidden me to eat them, though in point of fact I can digest them perfectly well. He must be the despair of his competitors, who are not given to such flamboyant attentions. And he must despise them and rely on what he regards as the American way of doing things."

These visits had their comical side. There was a dealer who had decided to fortify his chance of acceptance by turning up with a youngish woman whom Henri Matisse described to Pierre as "a very expensive lady of the afternoon." They had arrived by taxi, and had told it to return at a certain time. When it was clear that no sale would be forthcoming, Matisse's visitor leaned over to his companion and said, "There's no point in our waiting for the taxi. Let's get out of here."

Just occasionally a phantom from his past would resurface, unheralded. One such was a painter called Bonhomme who had been a student with Henri Matisse in Gustave Moreau's class. "Thirty-five years ago," Henri Matisse wrote to Pierre, "he had gold-rimmed spectacles, sported a high-collared overcoat in the style of 1830, and had very personable manners. He took his painting very

Henri Matisse at the Régina, Cimiez, 1942

seriously, and in every way as a mystical experience. He studied Leonardo and Raphael in the Louvre, in search of the secrets in back of their paintings. But he never knew quite what to do, or whom to follow, and he ended up teaching school in Saint-Denis. There were 60 or 80 children in his class, and none of them cared a hang about drawing. All they wanted to do was to make fun of Bonhomme.

"And then Bonhomme died. A month or two ago I was in an antique dealer's and I saw a batch of watercolors that were very much like prettified Rouaults. They were really quite well done, with Rouault's forms and Rouault's sense of tone. But . . . they were no more than pretty, with none of Rouault's tragic sense. They had a faked-up Louis XV look, and would have been just right for the top of an expensive box of chocolates around 1930."

They were by Bonhomme. It was rumored that someone in Nice had no fewer than six hundred Bonhommes. Visiting dealers got to hear of them. Roland Balaÿ of Knoedler's came to the Régina and said, "It's amazing how like Rouault these things are, but they're not at all bad." "I thought he must have bought some," Henri Matisse said to Pierre, "but I didn't get into it." Even Albert Skira in Geneva told Henri Matisse that he had a client in France who had just paid him 100,000 francs for a bundle of Bonhommes.

"Why am I telling you all this?" Henri Matisse wrote to Pierre. "It's to give you an idea of what the art trade is like in France today. All the dealers from Paris come sniffing round here – Nice, Cannes, Lyon. There's so little of any real consequence to buy that they will snatch at anything.

"In Paris, Louis Carré now passes as no. 1. He is making a big splash with his exhibitions in the avenue de Messine. When he was in Golfe-Juan, he went to work on Rouault, who had told everyone else that the only new painting he had done was for me (and for you). In spite of that, Carré came back to Paris with a dozen Rouaults. When I saw a big Rouault reproduced in the *Figaro* and read that Carré was having an important Rouault show I couldn't believe my eyes. I knew that Rouault was working in a room lent to him by Fabiani, who had made a deal with the Vollard estate for 800 Rouaults. 'How could this show happen?,' I said to Fabiani. And he said, 'Rouault told me that they had been sold at the time of the exodus from Paris in 1940. So I just had to swallow the affront.'"

Henri Matisse at this time had his troubles. The agonies of pain that he endured from time to time were alarmingly like the ones that had brought him to the operating table in Lyon in 1941. He couldn't work. Nor could he get on good terms with his daughter Marguerite. "I write to her regularly," he said to Pierre, "but she doesn't answer. After a three months' silence, she sent me an express

letter that says nothing in particular. I suppose that when she's all through with her sulks she is terrified to have kept me waiting for so long. But at least I know that, even if I am detested, I am not forgotten."

When Henri Matisse was down, he was really down. At such times, the upheavals of the year 1939 came back to him with a terrible clarity. As he said to Pierre, "If my story were ever to be told in full – not that I would ever wish this to happen – it would amaze everyone who reads it. When I was dragged through the mud, I never protested. As time goes on, I realize more and more how I was misunderstood and unjustly treated."

At such times, a letter from his son Pierre was more than ever welcome. "I so much enjoyed your letter," he wrote in June 1942, "that I had an exceptionally good night. I slept four hours, almost without a break, from 2 A.M. to 6 A.M. Where tenderness is concerned, I haven't exactly been spoiled lately. I don't ask that anyone should feign it. What I ask for is peace from day to day – until peace takes on its final and definitive form."

For "peace from day to day," he could always count on his son Pierre, and on the transatlantic mails.

The War Ended, 1942–46

From October 1942 until July 1944, no letters between Henri Matisse and his son Pierre survive in the archives. During this period, World War II impinged more than once upon what had been the relatively secluded life of Nice and its inhabitants. In November 1942, Allied forces invaded Algeria. In July 1943, Mussolini was dismissed by the King of Italy and placed under arrest. By September 1943, the Allies were in control of Sicily. In September 1943, Italy surrendered to the Allies. After almost sixty years, these events read like an orderly progress, but at the time they were not foregone conclusions. There was also the possibility, much promoted at one time, that the Allies might invade southern France.

Altogether, therefore, the future of Nice was uncertain. That it would one day be renamed Nizza and fly the Italian flag no longer ranked as a possibility. And yet . . . it was a good time to take to the hills. And in June 1943 Henri Matisse did just that, by taking a villa called "Le Rêve" in a town called Vence that had a backdrop of manageable mountains. It was to be his main residence until January 1949. He was to spend most of his time there, and it was in Vence in 1943–44 that he worked on *Jazz*, the series of works on cut paper that was, in effect, a vividly abbreviated autobiography, much of which had never before been made public. *Jazz* was an autobiography, not of the life outwardly lived, but of the life of the imagination.

Vence itself was not a stimulating town, but it was in "Le Rêve" that Henri Matisse produced, one after another, the great late works in which his career neared its culmination. The epigrammatic assurance of *Jazz* was followed, that is to say, by the monumental drawings made with brush and ink on paper in 1947, and by

the equally monumental paintings of interiors in 1948. It was likewise in "Le Rêve," in 1948, that he conceived and began work on his contribution to the Dominican chapel that was to be consecrated in 1951. It was also in "Le Rêve" that he worked with the Dominican nun, Sister Jacques-Marie, whom he had known both as a nurse and as a model, and came to prize as a dearly loved friend. For an invalid in his late seventies, this was a sustained and prodigious achievement.

The house was later described as being "in the English colonial style," with palm trees, lemon trees, orange trees, pomegranates, and philodendrons with big *feuilles decoupées*. Indoors, Henri Matisse soon made it his own.

Rewarding and informative visitors were not as common in Vence, at that time, as they had been in Nice. But someone who quite often saw Henri Matisse in 1943–44 was Henri Cartier-Bresson, the photographer, painter, and draftsman who brought a luminous and fearless intelligence to everything that he undertook. In 1943 he had escaped from a German prisoner-of-war camp and was living near Loches, on the Loire, with other members of the French Resistance. From there he went to Lyon, to work with an organization that helped other escaped prisoners. He also thought of making little publications about writers and painters. With this in mind, he got hold of some false papers and made his way to Vence. From June 1943 onwards he was made welcome by Henri Matisse.

"Matisse paid no attention to me," Cartier-Bresson said. "He drew or painted. I took photographs." Matisse allowed him to take photographs quite freely, though he did not allow them to be published in wartime. "It is not right," he said, "for an

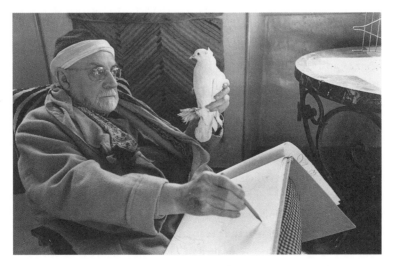

Sketching his beloved birds, in Vence, 1943–44. Photo: Henri Cartier-Bresson

artist's appearance to be made famous in wartime. Personal celebrity is out of place. I want to be recognized only for my work." Cartier-Bresson did not resent this point of view. If anything, he prized the opportunity "to deal with what is disappearing and can never be brought back to life." He was also privy to moments that were not "posed." Henri Matisse was very fond of his tame white Milanese pigeons, whose ruffled feathers kept him constantly amused. Not only did he let them out of their cages, but they allowed him to hold them, one by one, in his left hand, while he drew them, in pencil, with his right hand. Cartier-Bresson said later that the interrogation was mutual. Eyeball to eyeball, each looked the other in the eye.

As he was free to prowl around as he liked, Cartier-Bresson took photographs of a large panel that Henri Matisse later destroyed. It was a severe abstraction, in which primary forms were set out with strenuous juxtapositions of color. The colors were so bright that Henri Matisse had either to wear dark glasses or to cover the panel with a cloth to spare his eyes.

Henri Matisse took over "Le Rêve" just as thoroughly as he had taken his apartment in the Régina. But he had no wish to socialize in Vence, or to make new friends there. If it amused him to watch the young women on bicycles as they made their way, fleet upon fleet, to and from work, it was because the scene reminded him of the streets of Tahiti.

In 1943 life in "Le Rêve" had an Arcadian quality. But there came a time in June 1944 when, like everyone else, Henri Matisse stopped getting any news from Paris. The mails, the telephone, the telegraph – all were as if they had never been. France was once again the epicenter of World War II in western Europe.

These were eventualities that Amélie Matisse had always foreseen. After France was defeated in 1940 and the Germans occupied Paris, she had refused to leave Paris. "There may be something for me to do," she said. Though regarded for much of her life as a semi-invalid, she then acquired a new charge of energy and self-reliance. It was almost as if she were in training for an active, and quite possibly a dangerous, life. In a defeated France, she found a cause bigger than herself. Eventually she joined a Resistance network in Paris. (It was a Communist network, "because," as she said later, "they were the only ones that were properly organized.") Her daughter, Marguerite, and, quite separately, her son Jean also joined the Resistance.

In 1944 Marguerite Duthuit was arrested by the Gestapo and sent to prison. She had been crisscrossing France by railroad, as a courier, and was picked up in the city of Rennes. After she had been in prison for some time, she was put on board a train that was headed for a concentration camp in Germany from which very few prisoners had ever survived. As luck would have it, an air raid alert caused the train to make an unscheduled stop in open country. The French con-

ductors opened the doors and said to their passengers, "Jump, and run for it!" Marguerite was one of those who managed to get away, and hide out in wooded country in the Vosges until the Liberation.

Amélie Matisse spent six months in prison. She had worked primarily in Paris, as part of a network whose activity could be halted by even a single instance of carelessness or indiscretion. With characteristic ingenuity, the Gestapo had taken the clothes in which Marguerite had been arrested and sent them to Paris. A woman who worked for them and was of Marguerite's height was dressed in her clothes and sent to Amélie Matisse's apartment in the evening. With her, she had Marguerite's keys. When she let herself into the apartment, Amélie Matisse mistook her in the half-light for her daughter. She was caught with the evidence of her work all around her, arrested, and taken to prison, where she was held until Paris was liberated.

It has often been alleged that Henri Matisse was indifferent to the tribulations of his wife and daughter, did nothing to help them, and thought only of his work. This is untrue. Matisse in 1944 was, by any standards, an invalid. He could have died on the operating table in 1941. Not long after that, there had been "a red alert." So serious was his condition that he would have been back on the operating table in 1942 if he had not been so firmly against it.

When his wife and daughter joined the Resistance, he knew nothing of their activities, which by their very nature were secret. He was hundreds of miles away. Communications were in chaos. Two great fighting machines had summoned up a terminal savagery to determine the final upshot of the war. For months, his family knew nothing of the whereabouts of his wife and daughter. (Jean Matisse had made discreet enquiries of the Red Cross, and of the centers of detention that had been set up in and near Paris, without success.) It was not until a very late stage in the war that Henri Matisse began to get news of them. By his own account, in a letter to Charles Camoin dated September 6, 1944, he made contact with a member of the Red Cross in Rennes who had managed to send word to him that Marguerite was in prison there. But during the Allied invasion of France and the bitter fighting that often resulted, nothing was heard for certain about Marguerite's imprisonment.

But, so far from giving way to despair, Henri Matisse did all that could be done by a man in his condition. He made it possible for his doctor in Paris to try to find out, by all possible means, where the prisoners were detained.

When all other means had proved ineffective, Henri Matisse addressed himself to Sacha Guitry, the actor, dramatist, and moviemaker who had been a great favorite in France and elsewhere until the outbreak of World War II. It cannot be said that Guitry had always resisted the blandishments of "our guests," as Henri Matisse liked

to call them. Yet he was a man of goodwill who would take up the case of anyone from the world of the French arts who was in trouble. But he, too, got nowhere. Amélie Matisse and Marguerite Duthuit had vanished into a subworld all its own.

But when postal services were resumed, Henri Matisse in Vence wrote to Pierre Matisse in New York on January 15, 1945:

"My dear Pierre,

"You are very kind to ask about my diet, but at Vence I live very close to the land, and as I am mainly a vegetarian, that's enough for me.

"The question of Marguerite has caused me great anguish. I now know that she will come through. But what strong nerves she must have, and how important that strength will have been!

"Zervos wrote to me on Dec. 23rd last and said that he had seen Marguerite going into a concert. 'I was very surprised,' he said, 'at the physical change in her. I don't know what the state of her health may be, because we had very little time to talk, but her outward appearance was astonishing. Not only did she look younger than she had looked before the war, but there was a light in her face that made her beautiful – a supernatural beauty, in fact. Looking at her, I realized what suffering in the service of a great cause can do for a human being.'

"She was lucky enough to fall in with a doctor who was not a sadist and managed to stop her from being tortured. But for that, she would have died, like so many others whose faces had been burned with quicklime, inch by inch, or been tortured from head to foot with burning cigarettes. These tortures had been inflicted with a sadistic frenzy that is beyond all imagination.

"And to think that the Americans have trouble believing in it! I believe that they will soon be complimenting the Germans on their good manners!"

On February 12, 1945, Henri Matisse returned to the subject:

"Well now, dear Pierre, dear Teeny, dear grandchildren, there is one thing above all others for which we can be grateful. Despite all the misfortunes that have befallen so many others, and after two terrible wars, we are all alive and well. Your mother and grandmother went through terrible ordeals, but there is every reason to believe that they have come through them untouched.

"What has happened to Marguerite is a miracle. She has never looked so young. For years I have seen her absent herself from the present moment (poisoned, as that moment often was, by something or other). And now I have watched her in front of me, her eyes in mine, completely identified with her true self. I was so stupefied that more than once I sat looking at her, pencil in hand, longing to draw her and yet incapable of doing it.

"I was as if hypnotized – really hypnotized – by the memories that came flooding back within her, and by the power with which she put them into words. I could see and experience every one of the abominable scenes that she described to me with word and look and gesture. They are still vivid to me. A writer of genius could have made something extraordinary of it all. When I was with her I often thought that I was a witness to the most terrible of human dramas. It is only very rarely that one can participate so intensely in the experience of another human being.

"I stumble over my words, but perhaps you can get an idea of what it was like to sit with her from 3 until 7, every afternoon from the 16th to the 30th of January. After she left, I was a wreck for several days.

"I have not seen your mother, but I hear that she goes on foot to see her doctor. (Everyone walks everywhere, in Paris.) She walks from the rue de Miromesnil to the Place St. Germain l'Auxerrois and back again. She, too, has made a miraculous recovery. This, if ever, is a case in which good has come of evil."

On April 14, 1945, Marguerite wrote to Pierre and said that their mother felt very well and was full of life. She monitored the French radio every day for news of prisoners who had been released. Where they were fellow members of the Resistance, she was quick to spread the word. And although it was not in Marguerite's nature to harp on her experiences in prison, she did say to Pierre in that same letter that she had sometimes been sorry that her son Claude had been sent to the United States during the war. "Until, that is, I was arrested. Only then did I see the demoniacal pleasure that those fiends took in the idea that I had a son aged 13 whom they could round up and torture."

Of himself, Henri Matisse said to Pierre in January 1945:

"I'm still here. I concentrate on one thing only – my work, for which I live. I am happy to say that my curiosity never falters. Every day I realize how much I have benefited from my lifelong efforts. I was always haunted by my inability to pass on to others the best of what I felt. My health in general has never been better. My willpower is as strong as ever. I can tackle without hesitation whatever I want to do. I have done an immense amount of work since my operation. You will be amazed by it.

"It was essential for me to get on with that work. Four years ago I told my surgeons in Lyon that I needed three years of good health to complete what I wanted to do. I still have things to say that have never yet been said. I'm not saying that I can bring them to perfection – that would be too much. But I have moments of complete happiness in which nothing else exists for me.

"Yet I pay dearly for them. In the daytime, my body seems to weigh a ton and I have trouble getting around – 100 or 200 yards at a time is my maximum. And the nights are very painful. But luckily I forget all about those pains, no matter

how bad they were, when the daylight comes.

"I have made an experiment in a book of reproductions called *Thèmes et variations*. You may have heard of it. It reveals my feelings in cinematic form. The artist realizes his subject in terms of successive visions. It is as if a stone thrown into the water made a series of concentric circles. That is one way to give an idea of this book."

Henri Matisse had always monitored the progress of his contemporaries, or near-contemporaries, and as time went on, and one or another of them happened to die, he began to think it rather uncollegial. The exact circumstances of their deaths always preoccupied him.

In a letter to Pierre, dated March 18, 1945, he said that "Everything that was said about Maillol's death was quite wrong. I wrote to his son Lucien about it. People said that Maillol had been imprisoned in Perpignan. Lucien replied that his father had died by accident. Dr. Nicolas in Perpignan – the doctor who had looked after Dufy – had come to fetch Maillol for the weekend (Dufy was also invited). Going through Prades, the car skidded and ran at full tilt into a plane tree. Maillol went to a clinic for 8 days to recover. When his friends came to see him he laughed and joked with them. But then uremia set in and he died, almost without knowing it. A very beautiful death, Lucien said, which was a consolation.

"So there goes the oldest among us. It's a pity, because he was in good shape. I hope that his lieutenants will have better luck. They may be a little bit shaky but I hope that they can keep going. By 'lieutenants' I mean Bonnard, who is 79 and can still get around. He'd give himself another 20 years if it were not that he will soon be 4 times 20. And then there's – me. If I am minutely looked after and watched over, I hope to last a while longer.

"I've just painted (as a commission) a door and two shutters – about four meters in all. It took me several months and I am quite satisfied with it.

"I'm waiting for your visit. For the last two years I have refused to sell any paintings, so as to have some in reserve for you. But I've painted very few pictures, these last years. So you won't have many. I don't like to have to tell you this."

In May 1945, the second anniversary of Henri Matisse's arrival in Vence was marked, coincidentally, by his appointment as an "Honorary Member of the Mark Twain Society of St. Louis." Other honorary members included Franklin D. Roosevelt, King Leopold of the Belgians, Booth Tarkington, the Duke of Windsor, and Winston S. Churchill. Matisse was touched, though also mystified, by this mark of American esteem.

On May 14, 1945, Henri Matisse had the grimmest possible news to report about Pierre's aunt, Berthe Parayre. "Tante Berthe" had had a remarkable career in

the French educational system and had risen high in what was then largely a male hierarchy. She had also played an indispensable role in Pierre's early life. The news of her was that she had just been diagnosed as suffering from an inoperable cancer.

"And this has befallen Berthe!," Henri Matisse wrote, "poor Berthe, who gave her entire life to caring for others with such a signal devotion! How unjust it is that she should be so stricken! The affliction for which she was operated upon has come back again. (When they found out what it was, it was really too late to operate.) The cancer has already moved into the stomach, the esophagus, and the liver. The doctor was saying that he is happy for her that it has reached the liver, because it will go very fast and shorten her horrible agonies.

"I know that she would be happy to see you. She has a particular affection for you – and rightly so, in that she looked after you more than any of the others. And, besides, we all have a right to our preferences! Try to come over from New York. In any case, you can be sure that she will not lack for money. I am watching over that.

"Marguerite wrote to me on May 3 that 'B. is relatively better, in that she suffers less, but the cancer is too far gone to be operable. Generally, it goes quite quickly from this point onwards, but there are exceptions. This is not desirable, because it simply means that the patient has to suffer all the more.'

"Here is what the doctor says:

'I have heard from Madame Matisse and from Marguerite of the miserable plight of your poor sister-in-law. Judging from what you tell me, the situation is not one to despair of, in that cancer of the liver often develops with a disconcerting rapidity. Should you grieve? Thinking the matter through, in spite of your affection for her, and above all because of that affection, the answer is *no*. She will be spared the appalling and prolonged agonies that come from the stomach.'

"So that's how it is, my dear Pierre. It is bound to touch you deeply, because I know how you feel for her. I would wish her to have the great satisfaction of seeing you again. She has so often thought of you during the last sad years that she has spent alone at Beauzelle.

"Je vous embrasse très affectueusement.

"H.M."

After Germany surrendered to the Allies on May 7, 1945, a great deal had to be sorted out in France. On July 1 Henri Matisse made his first return visit to Paris. In December 1945, the Galerie Maeght put on an exhibition of paintings, sculptures, and drawings by Henri Matisse. Aimé Maeght would have liked nothing better than to represent Henri Matisse. But Henri Matisse did not encourage that,

though he knew that Maeght had big ideas and could afford to act upon them.

Quite apart from that, Henri Matisse wished Pierre to be on his guard in any contacts with Maeght. In particular, he urged him to be very careful if Maeght were ever to touch on the subject of Pierre's recent attempt to enter Spain illegally in order to take money to Miró. This is what he said in a letter dated November 2, 1945.

"Dear Pierre,

"I just want to say that I don't imagine you will talk about your recent adventure to Maeght. But if someone speaks to you about it, you would be wise just to laugh and even to deny categorically that you ever went there. Or you could say something like 'Whoever told you that?' or 'Parisians will say anything.'

"Of course, it depends on who you're talking to, and in what circumstances. But bear in mind that you can always deny it. It's almost obligatory, and you certainly have no reason to admit it."

The letter then ended with a piece of advice that could not have been better or more concisely put. "Never forget," said Henri Matisse, "that the person to whom you are talking may be a future enemy."

On his first visit to Paris after the war, Pierre duly went to see his father's exhibition at the Galerie Maeght. On December 9, 1945, Pierre sent him both a little map of the show and a lengthy account of it. Given his feelings about Aimé Maeght, he was scrupulously fair about the installation. This posed many problems, in that drawings, reproductions, and photographs all played a part in the show. His father had sent Pierre as his representative, and gave him carte blanche to tell Maeght if there were aspects of the show that he did not care for. But in fact there was nothing to complain of. Maeght had been perfectly straightforward with him, and Pierre did not want to hang around while Maeght was still working on the installation. He did, however, note that one painting had been bought by the French government, and that François Mauriac, the novelist and playwright, had bought a drawing. ("Maeght loves big names.")

"I could fault the gallery," Pierre said. "But that is a matter of decoration. The furniture of waxed oak is too 'modern style.' The fabrics, hangings, and curtains are too 'rich,' too much 'silk made in Lyon.' You don't feel that this is a place in which dealers go to work. It's more like a doctor's waiting room where the doctor wants to impress his patients.

"The little room in which favored clients are meant to feel at home is a total failure. It looks like a boudoir. The chairs and sofas are far too luxurious. It could have been a remarkable gallery, but from lack of taste and a fear of shocking their clientele of moneyed bourgeois, they've muffed it.

"They think that they are showing the art to its best advantage, but they're

doing exactly the opposite. The invitation cards were frankly awful. The posters were better – thanks, of course, to your drawing."

Henri Matisse was not at all displeased with that letter. He replied by return mail and said that it was just what he had expected. "The Galerie Maeght is like a man of fashion from Cannes who dresses in exactly the same way when he comes up to Paris. His idea of elegance is ridiculous."

Pierre's attempt to enter Spain illegally on Miró's behalf was still causing him trouble. "My lawsuit is going forward," he wrote. "The dossier was sent from Foix on Friday. I saw a young lawyer who works for Henri Laugier, and he told me that he is exasperated by the whole episode. I find no sympathy in that quarter, and Laugier doesn't want to be bothered with someone who is not in his own set (with Picasso, i.e.). Mother Cuttoli must think the same way. Now that I've made my mistake and the crime has been committed, they say that, if only I'd consulted them, they could have got me into Spain, etc.

"The story is getting around, too. Pierre Loeb heard it from someone – he wouldn't say who – who had said to him, 'As you're on the outs with P.M., I can tell you something that you'll enjoy.' The best thing is to laugh and make a joke of it. Anyway, I shall see Blumel tomorrow and things will start to move. So don't worry about it.

"Je t'embrasse affectueusement."

In January 1946, Pierre Matisse paid a visit to his father in Nice. It went wonderfully well. This is what Henri Matisse wrote to him immediately after he left for Nice airport on his way to Paris:

"My dear Pierre,

"A quarter of an hour after your departure, I found myself completely dumbfounded when it got through to me that you were no longer here.

"I at once called Air France. As you had just left the director's office, they could not reach you before you left. Nor did they know where you were staying. I really had nothing to say, except that I wanted to be with you for a moment before your plane left.

"If I had reached you I would have recommended to you an hotel and a restaurant. Le Ballon d'Alsace, rue (?) Geoffredo. The restaurant is honest and the prices are reasonable.

"I was really in a ridiculous state when I saw you leave, and absolutely wiped out after you had gone.

"I hold you close on your arrival in Paris, even if I did not do so before you left.

"Your father 'for life,'

H. Matisse"

On March 10, 1946, Henri Matisse wrote again:

"My dear Pierre,

"I have not written a word since you left, but I have been thinking about you, and about you all. Do not take my silence for indifference.

"For weeks, I have been in a wretched state. First, a bad case of flu that wouldn't go away. I was in bed for more than a week, and then I began to suffer from a series of violent intestinal spasms like the ones for which I was operated upon. I had to go to Nice for X rays, which was another exhausting ordeal. Luckily, the result showed that my intestines, and in fact my entire digestive tract, are in good shape.

"I then took belladonna and luminal to put me to sleep. They worked, but they had appalling side effects. I felt as if my head were a block of wood. I had no sensations, no reflexes that would allow me to draw. I responded to nothing. It was painful beyond belief. I was half dead.

"Today, after 48 hours without the doses, I'm coming back to life. Without work, I simply can't exist."

As life in France began to return to something like normalcy, old friends and acquaintances began to call on Matisse in Vence. One of them was Pablo Picasso, who had come to visit with his new companion, Françoise Gilot. Relations between Matisse and Picasso were outwardly cordial, but guarded. Pierre heard about the visits in a letter dated March 19, 1946.

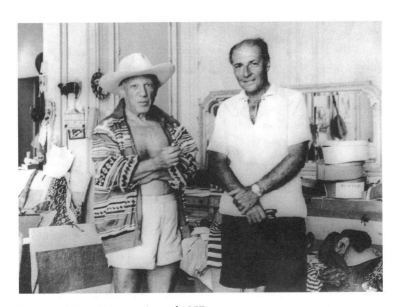

Picasso and Pierre Matisse, summer of 1957

"Dear Pierre,

"Three or four days ago, Picasso came to see me with a very pretty young woman. He could not have been more friendly, and he said he would come back and have a lot of things to tell me.

"He hasn't come back. He saw what he wanted to see – my works in cut paper, my new paintings, the painted door, etc. That's all that he wanted. He will put it all to good use in time. Picasso is not straightforward. Everyone has known that for the last forty years.

"Could you send me a package of Pillsbury's 'enriched Farina' and some canned langoustes – like the ones you sent once before – with some cocoa or coffee, some canned ham, some tins of sardines, some chocolate. Food has become very scarce again here. Send me the bills.

"My health is improving. I have Tériade here. I am going to see Bonnard to try to get you a painting."

In his capacity as Pierre's "father for life," Henri Matisse was anxious to say more, and tell more, than ever before. The fear of speaking out had been banished. This made it possible for him to confide many matters of extreme importance to Pierre, and to do it simply and straightforwardly. His letter went on as follows:

"If I am properly looked after, and take great care, I think that I can keep going for quite a long time, even though it is as if I had walked into a shellburst that blew away the walls of my stomach on my left side. As I no longer have the muscles that normally hold the left side of the stomach in place, I am seriously incapacitated. On top of that I am subject to spasms that give me great pain. In spite of all that, I live through moments of spiritual fulfillment that make all my sufferings worthwhile.

"Should I excuse myself for rambling on unrestrainedly about things that I have never spoken about before? If I let myself go so freely, it is because I have so often thought about you when I am alone, and when we could not talk things over together, and felt obliged to write as if all would go well.

"That is why I was so glad to get your last two letters.

"As to my work: I've been painting, and above all I've been drawing. I've made the very most of my expressive potential in drawing. It rather hampers me in painting, because in drawing I express myself completely and with subtleties that never cease to astonish me."

In his role as grandfather, Henri Matisse had never flagged. On March 18, 1945, he wrote to Pierre: "Although you are no longer here, I have continued with our shared intimacies: by looking again at the family photographs that Marguerite sent me. (Yours never reached me.) In my moments of leisure, I am

trying to make drawings from them. But they are rather too small for that. Don't you have any bigger prints (for the faces)? Or do you have negatives that are good enough for enlargement? 13 by 10 cm, for instance? I need to use the photo of the children in which they are like this. I really can't see them properly. You must have better ones in your collection.

"I have just had an attack of grippe of a kind that is quite spectacular. It comes with migraines, neuralgia, and conjunctivitis. For several days and nights, I had sand in my eyes and suppurations. My eyes are quite all right again, but it left me tired and depressed."

Pierre Matisse had always hoped to double as a publisher, while in no way curtailing his activity as a dealer. A well-made, well-designed, and well-printed book gave him enormous pleasure, and he was confident that a small private publishing house could be useful to the gallery, and vice versa. He had some new stationery printed up, with "Pierre Matisse Editions" at the top, and one of his first projects in 1945 was to bring out a book of his father's drawings. It would not be either as majestic or as luxurious as *Thèmes et variations,* which Martin Fabiani had brought out in France in 1943. But Pierre had in mind a book for the American public that would be done with all possible care within a limited budget.

On May 14, 1945, in the same letter that brought such bad news of Tante Berthe, Henri Matisse did his best for the project. "I am sending you 36 drawings, related to what you had in mind. I have no text to send you because I haven't written anything since *La Grande Revue* (in 1908). Please take great care of the originals, because they are some of my best drawings. Make that known to the printer when you entrust them to him.

"It is not easy to explain my normal stipulations about books that I illustrate. I have never worked on anything but a limited edition. Generally, I reserve half the edition for myself. I don't know how many copies you intend to print or how many you plan to have in the *édition de tête.* Nor do I know at what price you intend to sell them. So I cannot have an opinion about the terms that you offered.

"I have sent you the makings of a really good book. I hope that it will make you some money. Let me know what kind and make of paper you mean to use. For the frontispiece I have made you the only possible thing – a lithograph.

"As for the paper, I am waiting for some further possibilities, but I cannot report on them as yet, and I want to send you what you want as soon as possible. I don't think that the inconvenience of mechanical paper matters much. Any connoisseur will know at once that the drawing has not been made on a stone. The subject of these drawings is a free interpretation of my own head. What matters is the LIFE that is in them, and the truth of the forms, the liberty in the forms.

It's a kind of juggling – ever varied – but with the same source of inspiration."

"My idea is that there is something essential that has nothing to do with exactitude and yet is more truthful that what is exact. If you put fig leaves side by side, you will never find two that are absolutely identical. They are never the same, and yet they all come from the same tree. It is the essential that authenticates them.

"Perhaps you could characterize these drawings in a way that would serve both as a preface and as a presentation.

"There are [figure left blank] variations. They have to do with my face as I see it in a mirror. It would be interesting to reproduce every one of them, unless you think that the public would think that there were too many and get bored.

"By the way, I do not want to sell my drawings. On the contrary: some of the ones I am sending you have been kept in a secret place for many years, and I mean them to go back there until the time comes for me to join them.

"If you want to have an exhibition of them, I suggest that you have it before the book comes out. And see to it that your visitors can subscribe for the book while the show is still on. What you don't want is for them to open the book during the run of the show and see the difference.

"For your guidance, I should add that when I sell drawings to dealers I ask either 15,000 or 20,000 francs. I need not tell you that great care must be taken to see that the drawings are not damaged when the photographs are taken. Also, please remember that when the book is ready to be printed it is very important that the negatives should be destroyed. If this is not done, they may fall into criminal hands."

Another project that Pierre had in mind was a critical edition of his father's "A Painter's Notes." Ever since it appeared in *La Grande Revue* in December 1908, this long article had never lost a certain actuality. It had been discussed and rediscussed, generation by generation. It had been translated without delay into both Russian and German. It was still, in fact, very much alive, just as it is today. After nearly forty years, a comprehensive critical edition was overdue. But nothing came of it.

If Pierre Matisse Editions never became what is called "a trade house," it was not for lack of imagination or finesse on Pierre's part. Publishing on one's own, on no matter how small a scale, is both a full-time and a specialized activity. There were not enough hours in the day for him to attempt it. It was in the design of his exhibition catalogues, which he always oversaw in its every detail, that Pierre Matisse often touched perfection.

Miró Rediscovered,
1942–48

After the Germans invaded Normandy in May 1940, Joan Miró managed to get his family, his work, and himself back to Spain. It was not easy. He had no passport. But in Perpignan, where he was halted for a while, he came upon a Spanish consul who was anti-Franco. He issued a passport for Miró. In Figueras, just across the Spanish border, danger already lurked. As Miró said many years later, "I shook with fright when the Spanish police checked to see if my name was on the blacklist. My friend Joan Prats boarded the train before it reached its destination and suggested that instead of heading for Barcelona, I should go to Majorca, where everyone was against the Franco regime. Once I got there, all went well."

Meanwhile, in New York, Pierre Matisse looked after Miró's interests as best he could. He had exhibitions drawn from his stock at the gallery in March 1940, March 1941, and October 1941. At the Museum of Modern Art in November 1941, there was a Miró retrospective, organized and catalogued by James Johnson Sweeney, which later went to four other American museums. Pierre made some sales in the gallery, but it was difficult at that time to find takers for a large painting.

It was also difficult for Pierre to communicate with Miró, who was living mainly in Palma, Majorca, and even more difficult to send him money. It was forbidden to send more than $100 a month, plus $25 for each family member. Parcels of food, which had been routed through Lisbon, could no longer be sent. Letters, when written, might get lost, or take forever, or be confiscated by censors. Replies were equally unreliable. Correspondence turned into a yearlong duet in the dark, with questions unanswered and continuity lost.

By the spring of 1942, it was almost impossible for Miró to send any new paintings to New York. But on May 12, 1942, he wrote to Pierre to say how delighted he was to have received an old photograph of some mutual friends of theirs in Paris. "It made me feel," he said, "as if I were sitting outside the Deux Magots and sipping a glass of Pernod on a fine spring afternoon."

Whether in Palma, Majorca, or later in Barcelona, Miró by his own account lived in an almost total isolation. "It suits me perfectly," he wrote from Barcelona in June 1943. "I can live deep down in my thoughts about my work and how best to realize it. My painting is more concentrated, and more vigorous, because of that. I have a spacious and beautiful studio here, and that also helps.

"During the summer, at Montroig, I intend to make some sculptures. Not only will this be a complete change of activity, but it may open new possibilities for my painting, just as printmaking did. I dare to say that the ensemble of my work, this last year or two, will make a great impression. Let's hope that people can see it one day.

"What you ask – that I should send you some more paintings – raises many difficulties at this moment. We would have to be certain that they would reach you safely. We should also have to hope for an immediate and substantial financial return. As things now are, we cannot count on either of those conditions. I think it would be wiser if I simply concentrate on my work and make my way as best I can. If you wish, we can talk about our arrangements when we next see one another."

Miró and Henri Matisse at a café in Paris, n.d.

And when would that be? No one could say. But after Paris had been liberated by the Allied armies on August 25, 1944, there was reason to hope that the war in Europe would be over sooner rather than later. But a letter from Pierre in New York to Miró in Barcelona could still take several months. The normalities of international travel were still suspended. A distinct restlessness – first cousin to exasperation – could result. Before long, Miró was getting offers from dealers here and there, and especially from Paris. He remained loyal to Pierre, as Pierre was to him, but he had had a very slow four years, where money was concerned, and he wanted to get his future straightened out.

This was not simply a matter of convenience, or of vanity. When he was propositioned about having a big exhibition in Paris for the winter of 1945–46, he wrote to Pierre that he did not regard it as just another "artistic event." It was to have a profound reverberation. By showing his entire output for the years 1940–45, he would make it clear that "the things that we hold most dear" had survived. This had happened even in places, and at a time, when they had been trampled in the mud and exterminated. (That, he added, was still the case in Spain.)

In that context, he staked everything on being able to show the entire work of the wartime period. Photographs could not tell the story. Nor could a sample or two, here and there. He'd rather wait. "Quite apart from all that," he wrote to Pierre, on June 17, 1944, "you will understand that, as I now have no money, I prefer to maintain a considerable stock of paintings that will help me to get back on my feet again after the war. Once my debts are paid off, I can reclaim the position in life that is due to me.

"In the years that are to come, my work must have a primordial role. Now that I am fifty-one years old, I must play in the big time – to win or to lose, 'to be or not to be.' These past few years have been rough for me, and at this moment they are rougher still. So I simply have to take stock of my situation."

This was the first letter that Pierre had received from Miró since November 1943. It arrived not long after Clement Greenberg had written in *The Nation* for March 1944 that "Miró belongs among the living masters. He is the one new figure since the last war to have contributed importantly to the great painting tradition of our own day – that which runs from Cézanne through fauvism and cubism. During the last ten years his work has maintained a very high level with a consistency that neither Picasso nor Matisse has equalled. Painting as great as his transcends and fuses every particular emotion; it is as heroic or tragic as it is comic."

This encomium took on a renewed topicality when, in January 1945, Pierre received a large batch of paintings by Miró, together with some ceramics and litho-

graphs. These had been brought to New York, under diplomatic immunity, by a Peruvian diplomat who was stationed in Madrid. They were consigned to the Museum of Modern Art, to which the diplomat in question had been of service on other occasions, but in due time Pierre was able to take delivery of the package.

The paintings were of nothing less than sensational interest. The museum authorities had spoken of a rather large consignment of Mirós that measured "38 x 46 inches." Somewhat to his relief, Pierre found that the dimensions were actually in centimeters, not inches. The paintings in question were, in fact, the *Constellations* that Miró had begun in Varengeville on January 21, 1940, and completed in Palma, Majorca, on September 12, 1941. Here, if ever, was a group of new paintings that "transcends and fuses every particular emotion," and is "as heroic or tragic as it is comic."

Every one of the twenty-three *Constellations* called for concentration of the kind that is owed to the paintings that commemorate the reign (1628–58) of the Mughal Emperor Shāh Jāhan in India. Identical in size, they had a cumulative effect. Though produced during one of the most catastrophic periods in European history, they never refer to it directly. Once we know that the first ten of them were painted at Varengeville, in a room whose windows were darkened at night as a precaution against German air raids, we are free to suppose that coded references to that fact may be found in the first ten of the *Constellations*. When the titles refer to sunrise and starlight, we remember the nights in northern France during which these natural phenomena took on a new importance. If number 2 in the series is called *The Escape Ladder*, and if the scene portrayed is correspondingly frantic, we think back to the huge number of people in Europe who dreamed of such a ladder and were never to find it.

These paintings are not descriptive, but they are evocative to a very rare degree. The longer we look at them, the more we see. They are miniature arenas in which anything can happen. Their signals are beyond number, and every one of them has its own urgency. Yet they have no "focal point" and no "center of interest." They make their magic by drift, and not by an ordered progression.

After Miró got safely to Palma, there was a new openness about the *Constellations*. No longer did human figures stand on firm ground somewhere near the bottom of the paper. An allover whirring and whisking was paramount. Gravity was outlawed, as the always meaningful but now quite weightless images were launched upon the air. There was no end and no limit to the fascination of the *Constellations*, and they put the case, against all the odds, for the continuing quality of European painting.

When this show came down, Miró was more than ever the artist whom

Pierre Matisse most wanted to hold on to. Not merely had they sold very well indeed at $700 each, but they spoke for an energy that was not likely to subside. As for their continuing alliance, Miró had said more than once that if he and Pierre could only sit down together, face-to-face, they could soon reach an agreement. Come what may, Pierre had to see Miró. He was going before long to Paris for his first postwar visit. Miró could not as yet get to Paris. Yet they had to meet, and Pierre had to bring with him a substantial sum of money to refloat Miró's status with his creditors.

That is why, as between Pierre and Joan Miró, the dealer–client relationship took on an unprecedented character in October 1945.

While in Paris, Pierre decided that, although he had no Spanish visa, he would go to see Miró in Barcelona. Not only that, but he would take with him a large sum of money in American dollars. Both of these intentions were against the law, but he didn't care. Or, to be more precise, he was bent on making a new agreement with Miró, and he thought that the prize would be worth the risk.

To Rosamond Bernier, many years later, he described exactly what happened. "I talked it over with my sister Marguerite in Paris," he said. "She had been in the Resistance and she knew all the networks. I took a big tube of toothpaste, opened the bottom end, and slipped $3,000 inside it. She sent me to see a doctor in Foix, a little town in the Pyrenees, who knew a *passeur* – someone who could help refugees to leave France by crossing the mountains and avoiding the border patrols. We left Foix one morning and met him in the mountains. He did not speak a word of French. I did not speak a word of his dialect.

"We got across the mountains to Andorra, which was – and still is – a free state. Andorra was spiritually ruled by the Catholic Church. In all other ways, it was ruled by the gendarmerie. I had a stout pair of shoes, but they had taken such a beating that I bought a pair of sandals and went to the café. When I went back to the hotel, four policemen were waiting for me. They questioned me. The brigadier showed me how, in Algeria, they had 'made people talk.' He gave me a terrific blow in the stomach. They went through my luggage, found my toothpaste, said, 'Oh, that's the oldest trick in the book,' and took out the $3,000. This was a good day for them. When policemen or customs officers found money, they kept it. So I left Andorra, and they sent me back to Foix under a police guard."

Writing (in pencil) to his father from Foix, on October 23, Pierre said:
"My dear Papa,

This is the first time that I can write to you since I was arrested in Andorra. I was charged with having entered Andorra illegally, and with having hidden undeclared foreign money on my person. I am quite well and am waiting patiently

(as I have to) until I can appear before the *juge d'instruction* in Foix, where we arrived yesterday. I am also waiting for a lawyer, whom I have not yet seen. I hope that my luck will have changed since my arrest and that I shall be able to present myself as someone to be pitied. Do not upset yourself on my account, because everything is bound to turn out well. Teeny will look after the children and the gallery and all other immediate needs. I worry about you because I do not know whether you have gone back to Vence, as you intended. I hope you have, because the trains are very cold and you must look after yourself."

As the bearer of a famous name, Pierre had not, as yet, had too bad a time. "Over and over again, when I was being interrogated, I was asked if I was a relation of yours. One day when we were in the Pyrenees and stopped at a station, the local chief of police asked me into his office. On the table were *Les Lettres Françaises, Carrefour,* and several other publications. They all had reviews of the Salon d'Automne. We got talking. He was very agreeable, and we spoke of Collioure, which he knew well, and about the museum in which there was a painting of yours. As we were leaving Toulouse, there was a weekly paper – unknown to me – which reproduced a drawing of yours to go with an article on you by Diehl. I showed it to the police inspector who had me in custody. Even in the mountains near Andorra there was an inspector who knew the name of every painter I mentioned. He had been in the Resistance, was arrested, and taken to the rue des Saussaies, where Mama was taken after she was arrested.

"Luckily, what I shall remember above all from this unfortunate experience is the beauty of the countryside through which we traveled." Natural beauty notwithstanding, Pierre's troubles were not quite over. "Finally," he said to Rosamond Bernier, "they sent me to prison in Toulouse for trying to cross the border without papers. There was a famous member of the Resistance in Toulouse, and he was very nice to me, but the authorities were still suspicious of me. I had to stay three weeks in prison in Toulouse. I learned to sleep on my back on the bare wooden floor. Every morning at 6 A.M. we had to get up and wax the oaken floor for half an hour. There were all kinds of people there – so-called communists who had robbed farmers after the war after threatening to denounce them. There was a young Frenchman who had been a doctor's nurse in a German hospital where they had carried out experiments on prisoners.

"In time, I was released. And when at last I saw Miró again, I told him something of what I had done. He looked at me as if I were crazy and said, 'Who could have imagined doing such a thing?' He himself would never have tried to cross the border illegally. He had his work. He stayed there and waited. He was not moved by what I had done. He was just horrified at my stupidity in thinking

it up. He never mentioned it again, and nor did I."

This had been, from start to finish, a wonderfully imprudent adventure. Suspicion of one kind or another still stained every department of French life as part of the postwar traumas. Pseudo-friends laughed at Pierre's discomfiture. Lawyers refused to take his case. At least one grandee of the official art world would not vouch for his character. Another said, "If you'd only come to me, I'd have got you into Spain without all that trouble."

But the unpleasantness slowly dwindled. Miró, for his part, was as steadfast as ever in his affection for Pierre Matisse. In March 1946 he wrote asking for a photograph of Pierre and his family. In July 1946 Teeny Duchamp got permission to go to Spain. She visited Miró in Barcelona, and they discussed how Pierre could nurture Miró's still-unknown work of the wartime years. Miró then wrote to Pierre and said, "You cannot imagine, my dear Pierre, with what emotions I set eyes on Teeny again. It brought back the old times. She will tell you what happened, and what we talked about, but above all I felt, as I hope you also do, that if we work together on a human basis and in mutual understanding, it will be easy for us to collaborate. There are great obstacles to be surmounted, but I hope that we shall overcome them.

"We didn't waste our time, I can assure you! Allow me to offer you compliments of every sort in respect of Teeny. You have in Teeny an excellent partner, and one who is as intelligent as she is sensitive.

"In hopes of your visit, let me assure you, my dear friend, of my deepest affection and devotion."

Attached to this letter was a list of things to be done and ambitions to be nurtured. Friendly greetings were to be sent to a fellow-painter, Georges Braque, to a poet and controversialist, André Breton, to an editor and publisher, Christian Zervos, and to the ranking Parisian dealer in African and Oceanic art, Charles Ratton. There were faked Mirós to be run to earth. (In this context, Miró added that "the attitude of Pierre Loeb seems to be too easygoing.")

There was also an animated film that Miró had in mind, and frescoed murals that he would like to paint. He would like to have some of his sculptures made in editions. And what had happened to his tapestry designs for Madame Cuttoli? He would very much like to make some new tapestries. As for the lithographs in color that he had promised his friend Tériade for an edition of *Ubu Roi*, this was long and slow work, but well advanced.

With this one sheet of paper, Miró signaled that, as soon as the international art world was back in operation, he would be off and running. By August 1946 Pierre had offered to buy Miró's entire output for the years 1942–46, and to

make a contract for 1947–49. This was made even more clear in a letter to Pierre, dated September 3, 1946, and written in Montroig. His agreement with Pierre was not yet quite completed, but when other dealers made him propositions, he would now say categorically that Pierre was his representative. ("Hitherto, I have always given evasive answers.")

Miró never made the animated film, though few ideas could have seemed more promising. Nor did he ever paint in fresco on an enormous wall (or on a little one, either). But his priorities were just right. Miró in everyday life was not at all given to self-importance, but he had a clear idea of what he saw as his eventual position in the history of art. "I am not thinking," he wrote in that same letter, "of myself as an individual. That is irrelevant. What I want to say is that Picasso stands for a total revision of the whole of Western art as it had existed until our own day. He and Lautréamont are the great prophets of that hecatomb. My own work speaks for the future, but it remains related to the great civilizations of antiquity. As for all the things that are transitory – that is to say, secondary – it sweeps them away, once and for all.

"There is something that seems to me to be of the first importance, and I am glad to know from Teeny that you share my opinion. In the world that is to come, America, with its dynamism and its enormous vitality, will be all-important. That is why I have to be in New York at the time of my next exhibition. I need to make a direct and personal contact with your country. My work, like myself, will benefit from the shock of that revelation.

"I have in mind a short stay in New York. A month, or at most six weeks. It will be simply to make contact, unless I have to carry out a special commission of some sort, in which case I would stay as long as was needed. En route I shall stay for a short while in Paris, because neither you nor I can afford to offend the susceptibilities of our Parisian friends." Meanwhile, Miró said, he was working on sculptures in Montroig. "In the country, it gives one a rest from painting and freshens up one's ideas. I will send you some photographs of what I have done."

This crossed with a letter from Pierre, dated August 16, 1946, in which he spoke of the anti-European trend of the American art press. All were agreed that the School of Paris was finished, and that the modern American school would take over the leadership, and so forth.

As Pierre saw it, Miró had a double duty in this matter. Not only was his personal future at stake, but he had to come forward as the most important representative of the new European school. He could rely upon Pierre to present him in the best possible conditions. But to achieve that, Pierre had to have new paintings. It would be better to stick to paintings and leave the newer work –

sculptures or ceramics – for later. "If I can't show your sculptures this time," he said, "we'll show them next year."

This last remark made good strategic sense, but it cannot have pleased Miró. In the relationship between dealer and artist, any radical departure from the medium in which an artist has made his name is disconcerting. If a painter suddenly wants to make feature movies, or a sculptor sees himself as a stained-glass maker, every heart misses a beat.

Pierre Matisse had very much enjoyed the enigmatic three-dimensional objects that Miró had made in 1936–37. (He had, in fact, given one of the best of them to the Museum of Modern Art in New York, where for the past sixty years its fascination has remained intact.) After the great success of the *Constellations* in January 1945, Pierre may well have hoped that Miró would stick with painting. But the microcosmographies of the *Constellations* were the end of something, not the beginning of something. Neither the ecstatic fancy nor the ever-active curiosity of Miró could stay still.

Joan Miró was beginning to resent the limitations of traditional painting. He did not want to spend the rest of his life sitting in front of an easel or bent over a sheet of paper on which he was painting in gouache. There were limits to painting, and he did not wish to accept them.

Other ways of making art were not necessarily subordinate to painting. "It is in sculpture," he wrote in a notebook begun in Montroig in 1941, "that I shall create a truly phantasmagorical world of living monsters. What I do in painting is more conventional."

In 1942 Miró had been captivated by an exhibition in Barcelona of ceramics by Lorens Artigas. He had known Artigas since 1917, when they had both studied drawing in the Cercle Saint Luc in Barcelona. Their friendship had been renewed three years later, when Miró first arrived in Paris.

In 1944, when Miró began to work on ceramics, he insisted that Artigas should work with him as an equal partner. (As Jacques Dupin said in his monograph on Miró, "People forget there are no 'ceramics by Miró.' There are only ceramics signed jointly by Miró and Artigas.")

Initially, there were vases and plates made by Artigas and decorated by Miró. The relative gentility of these procedures did not last long, however. Working with Artigas on ceramics gave Miró untold pleasure, on several counts. His old friends in Catalonia were indispensable to him and could never be replaced. It was difficult to explain to Pierre Matisse, who had not yet been there, exactly why he identified so completely with Catalonia. It was not simply that he loved the look of it, or the company of people that he had known since childhood. It

is that he felt himself a part of every stone, every leaf, every insect, every handful of earth. It had been a matter almost of life and death to him to find a form of art in which he was at one with them. As he said to Rosamond Bernier in 1956, "Before starting work on ceramics, I sometimes painted directly on the enormous rocks that led up to the vinegar-red mountains."

Miró and Artigas disdained the commercialized apparatus of conventional ceramics. Miró by 1946 was working with acid and enamel on materials that he had found at random, here or there. What resulted broke all the rules, and got away with it. In the same conversation with Rosamond Bernier, in 1956, he described exactly how this came about. "In my ceramics, I use traditional materials, mostly: *chamotte,* sandstone clay, faience, lead glaze, pewter enamel, metallic oxides. When I let myself go, I completely ignore questions that are specific to the 'craft' of ceramics and use all the techniques and all the colors, according to where the work is taking me." It was with ceramics as it was with painting: even when the pieces were done very quickly, they called for a great deal of concentration and meditation beforehand.

The ceramics that Miró and Artigas produced together had an air of autonomy. Miró liked them to look as if they had come into existence of their own accord. By 1948 an infinity of possibilities had presented themselves to him. The very notion of ceramics had to be called in question. From this, there was to result a series of no fewer than 232 ceramic objects that Miró and Artigas made between February 1954 and May 1956. Given the depth of this long-harbored commitment, it was natural that Miró would have welcomed from the outset a greater show of enthusiasm on the part of Pierre Matisse.

If this was not forthcoming, it was because Pierre had found it hard to sell even the vases, with their relatively accessible character. On January 17, 1945, he told Miró that he hoped to sell the big vases at $1,300 each and the smaller ones at $900 each. But even after the success of the *Constellations* at that same time, it was very difficult to sell the ceramics. On June 12, 1947, he had to ask Miró to reduce the prices to $750 and $600 respectively.

On February 2, 1948, Miró wrote from Barcelona and said that as far as he and Artigas were concerned, Pierre was free to sell the ceramics at whatever prices seemed to him to be right. But, he went on, "although ceramics may not generally fall within the province of a picture dealer, they are a very beautiful form of art, and one with which it is possible to do very good business. We have every confidence in you, and we are sure that with your range of acquaintance and your entrepreneurial character, you will succeed with them."

As a riposte, this could not have been better put. But it was to be a recurrent

problem for Pierre that the American public simply did not respond to the Miró/ Artigas ceramics or even, in later years, to Miró's own sculptures, as they did to his paintings. In his reply to Miró's letter, he neither confirmed nor disputed the standing of ceramics in the hierarchy of fine art. But he said that the hoped-for sales of vases and other ceramics had not materialized and that, even if their prices were much reduced, it would still be very difficult to sell them.

On June 8, 1948, he made his position even more clear. "Before we go deeper into this kind of work, I would advise you to think twice. In any case, I shall not be able to include ceramics in our contract, which applies only to paintings, gouaches, etcetera."

When he began to make sculptures, Miró wanted them, like the ceramics, to have sprung directly from the physicality of the Catalan landscape. He dreamed of a special sculpture studio in the countryside – one in which he would feel, as he walked in the door, that he was actually going inside the earth. He also thought of that studio as a place in which his sculptures would be free to lead a phantas-magorical life of their own. They would be presences within the room, as distinct from paintings that sat flat on the wall.

Meanwhile, the big international cities of the postwar world were beginning to exert their pull. It had always been understood between Pierre Matisse and Joan Miró that in a newly liberated Paris, Pierre Loeb would be Miró's represen-tative. In a letter dated August 16, 1946, in which Pierre began to hammer out his agreement with Miró, he said, "Pierre Loeb will be with us every inch of the way." Pierre Loeb had, after all, been Miró's dealer in Paris from 1925. His roster of exhibitions between 1925 and 1939 is, to this day, a continual astonishment. He had given Miró his first solo exhibition in 1925. He had had in 1930 the first-ever exhibition devoted entirely to sculptures by Henri Matisse. He had given Balthus his first show in 1934. He had shown Fauve landscapes by Braque in 1938. He had shown Picasso over and over again, but always in sharp focus and in the context of a single brief period.

There was reason for Pierre Matisse to trust in Pierre Loeb, even after his long and involuntary absence from Paris. The two of them had often felt the same way before 1939, and they were likely to do so again. (Sure enough, among the artists whom Pierre Loeb took on after the war, both Jean-Paul Riopelle and Zao Wou-Ki were to be firm favorites – the one from 1954, the other from 1980 – at the Pierre Matisse Gallery in New York.) Pierre Loeb's was, moreover, the kind of entirely personal operation with which both Matisse and Miró felt comfortable. No one ever knew what he would do next. In his schedule, fancy ran free.

In 1931, for instance, he had had one of the most original shows of the cen-

tury. He had assembled fifty painters' palettes. The painters in question included Ingres, Courbet, Corot, Manet, Matisse, Marquet, Kisling, Soutine, and Braque. None of them was identified. The first visitor who identified them all correctly would receive a bronze by Giacometti. (The winner, by the way, was the sculptor Jacques Lipchitz.)

So both Joan Miró and Pierre Matisse were right to look forward to working again with Pierre Loeb. What they did not yet know was the extent to which Pierre Loeb had been wounded by his experiences during World War II. After France was overrun by the German armies in 1940, and after a puppet French government had been set up in Vichy, anti-Jewish laws were passed in 1941. Dispossessed of his gallery, Pierre Loeb decided that he, his wife, and his two young children should leave France. Time was short, and Marseilles was crowded with refugees from all over Europe whose one thought was to get away from France. Pierre Loeb and his family could not get into the United States. But on December 31, 1941, they left Marseilles on one of the last passenger boats that would be allowed to head for Cuba. That he was, in effect, evicted both from his gallery and from his native country, and then refused admission to the United States, were blows from which Pierre Loeb never altogether recovered.

Picasso had always been a staunch friend of Pierre Loeb, and when the Loebs got back to Paris in the fall of 1945, he at once helped him to reopen his gallery. Miró, for his part, had written to Pierre Loeb on August 30, 1945, and said, "You can absolutely count on me. I will be happy to do whatever I can to get your old gallery started again, and I'm sure that that will not take you long."

Miró had not, of course, seen Pierre Loeb for at least four years. As to what Loeb had seen, read, thought, and felt during those years, he knew nothing. Nor did Loeb know how he, Miró, had evolved.

So Miró's letter ended with a caveat. Though firm, it was gently put (or the other way round). It read as follows: "For many years, I have known that you have an open mind. I cannot ask you to discard all your preconceived ideas as to the nature of painting. I also know that you are not one of those who think that painting stopped with our predecessors. Their discoveries were dazzling, and what they did was wonderful, but the horizon before us is still open. And we – we, too – are moving forward, always forward."

Pierre Loeb may not have cared for the reference to his "preconceived ideas as to the nature of painting." Was this, perhaps, a way of saying that painting had moved on and left him behind? Like many of those whose very reason for living had been halted by World War II, he had one skin too few when it came to readaptation. The Parisian art world had irrevocably changed. As he was to say

in 1964 in an interview in the magazine *L'Express,* "Before the war, four out of five of the big dealers were Jewish. So were four out of five of the big collectors. After the war, all that was altered. Most of the dealers, and most of the collectors, had disappeared. Others had left France. I felt as if I had been invalided out of my profession, and I had no heart for it. The war has left its mark upon me, and I don't want to forget it."

But he did reopen his gallery, and he ran it until February 1964, when he knew that he had only a month or two to live. His had always been, as he said, a combative gallery, and he had no wish to recycle what he had done before.

Before long, however, rumor and innuendo were active in Paris. It was said that, so far from being "with Miró and Pierre Matisse every inch of the way," Pierre Loeb wanted out. Pierre Matisse had dismissed this, when writing to Miró, as mischievous gossip cooked up in the Café de Flore. But there was more to it than that. What had seemed to be an ideal arrangement was not working out at all well. The troubles came to a head when Pierre Loeb told Miró that he and Pierre Matisse had agreed to dissolve the association that they had formed in 1946.

Pierre Loeb's letter to Miró of December 6, 1947, read as follows:

"I have written many an urgent letter to Matisse, but he never answers. So this is what was decided, for reasons that he was to explain to you.

1. The contract is to be annulled.

2. You were to bring with you to Paris a certain number of paintings, pastels, etc., that would correspond to the batch of Surrealist works that I have sent back to him.

"I am counting (1) on your own friendship with me and (2) on the fact that you simply have in Paris both a market for your work and a dealer. 'Famous' as you may now be, we live in a time when painters whose work is not seen are soon forgotten. Let me know if Matisse has kept in touch with you about all this.

"Perhaps we could find another formula. For instance, you could give me whatever you have in Spain when you are there. That may be the best solution."

This solution did not commend itself to Miró. Nor had Pierre approved of a suggestion from Pierre Loeb that he should be allowed to have a limited number of paintings by Miró. They were to be of the quality that Loeb wanted, and in a size that he could sell easily. As Pierre pointed out on November 19, 1947, this would not satisfy Miró's wishes for his market in France. He wanted someone who would represent the whole range of his work, without exception. "What you suggest," Pierre said, "has all the advantages of a contract – including a first choice of the output – with none of the responsibilities that go with it. There is no reason for me to bear the whole responsibility for a contract such as Miró's."

The Matisse/Loeb axis had been stressful from its very beginning. On September 15, 1946, Pierre Loeb wrote to Pierre Matisse that the art market in Paris was near to stagnation. "Our colleagues have hardly bought anything. There is almost nothing on the market, and the formalities involved now take too long and are too complicated. Have you any news of Miró? I was told that you were negotiating with him, and I urged him warmly to conclude an agreement."

Thereafter, it was a running source of disquiet to Pierre Loeb that Pierre Matisse was not more communicative. On October 17, 1946, he wrote to Pierre that "Miró has no idea what we agreed on. I wish you would explain it all to him, as you may be seeing him soon. Also, when and where are he and I to settle our share-out, with you as our intermediary?"

In that same letter, Loeb made it clear that he felt he was being kept in the dark as to exactly what he would get from the next division of Miró's work between Pierre Matisse and himself. That was not a matter of disinformation, but of lengthy and inexplicable silences. On this occasion, Pierre Loeb resorted to capital letters. "PLEASE ANSWER," he wrote, "AND DON'T MAKE ME INSIST."

On October 28, 1946, an even more bothersome problem arose. "I am anxious," Pierre Loeb wrote, "to avoid any misunderstanding between us. But I cannot promise not to sell to American visitors who come by the gallery." His point was that it would be absurd if his gallery, which was to represent Miró, were to be the only place in Paris in which a visiting American could not buy a Miró. The essential thing was that Miró's prices should be kept at their agreed level. As Pierre Loeb and Pierre Matisse both paid the same prices for the work, Loeb was certainly not going to undercut Matisse when it came to selling it. Then as now, American visitors to Paris often fantasized about getting a lower price than was current in New York. But Pierre Loeb was not going to oblige them, and he did not feel that he should send them away empty-handed if they agreed to the full price. On a more general level, Loeb on October 29 ended another letter with the words "You owe me more information."

By the middle of November 1946 the partnership was headed for disintegration. Pierre Loeb clearly did not want to handle the entire range of Miró's work. A large-scale continuous obligation of that kind had never seemed to be in his nature. He was not, in short, into merchandizing. Where he excelled was in one-on-one relationships with gifted individuals whom he could nurse along.

At that very moment, for instance, he was very close to Antonin Artaud. As actor, director, poet, draftsman, and evangelist for the Theater of Cruelty, Artaud had left his mark, like a brand, on the imagination of his time. Released in 1946 after more than one long stay in psychiatric hospitals, he was in very poor health

and virtually penniless. Pierre Loeb opened his home to him. In short order, Artaud sat down at Pierre's Loeb's table and wrote his rightly celebrated long essay, "Van Gogh, Le Suicide de la Société."

Pierre Loeb said later that "almost every day, during the winter of 1946–47, Artaud could come and go as he wished. He did not have to speak to anyone. He could sit down and write, as if no one else were there. He could drink boiling hot tea. He could lie for hours on my bed, or sit hunched by the fire. He was good and quiet there, and nobody disturbed him."

In June 1947, Pierre Loeb had a large show of paintings, drawings, sculptures, and literary manuscripts that were to be auctioned at the Théâtre Sarah-Bernhardt. The proceeds were to go to Antonin Artaud, and those who took part included Jean-Louis Barrault, André Gide, Pablo Picasso, Jean Dubuffet, and Balthus. After what had been a noble demonstration of solidarity with the stricken giant of his time, Pierre Loeb put on a show of Artaud's own drawings. In the matter of Artaud, Pierre Loeb had done honor to his profession.

It would have been difficult, even so, for him simultaneously to attack on all fronts on Miró's behalf. On that point, there could be no compromise. Neither Miró nor Pierre Matisse would agree to a more limited representation. (Given their ambitions, they would have been crazy to do so.) Even so, it was a sad day for both Miró and Pierre Matisse when Pierre Loeb asked in December 1947 to be relieved of his share in the contract.

In professional terms, this raised a new and crucial problem. Miró at this stage in his career could not do without a dealer in Paris who would treat him as a major artist and bring him into the new postwar art world with every possible backing and support. Pierre Matisse was Miró's dealer of first choice, but he had other artists to look after, and he could not possibly double as Miró's representative in Paris.

Pierre was busy with Alberto Giacometti, who was to have what was, in effect, his first comprehensive retrospective anywhere at the gallery in January 1948. In 1948 he was also to have exhibitions of Marc Chagall, Miró, Wifredo Lam, Leonora Carrington, and Jean Dubuffet. Scheduled for 1949 were Henri Matisse, Miró (twice), and Balthus (prefaced by Albert Camus, at that time one of the most adulated writers in Europe).

None of these exhibitions came ready-made. As Pierre never delegated his responsibilities, they added up to a formidable workload. They called for time, and skill, and money. When works of art were sent to or from Europe, they still involved immensities of paperwork. They also called for the almost subliminal salesmanship in which Pierre specialized. There was a specific drumbeat, never

spelled out but ever-present, in the activity of the Pierre Matisse Gallery.

No one artist had the exclusivity of Pierre's time, or attention, or money. He was not by nature a banker, or an accountant, or an inspired student of the stock market. It is not even certain that he followed the ifs and buts of foreign exchange, though these could make life very difficult for European artists whose monthly checks were made out at the exchange rate of the day.

Another dealer might have hired more staff, but Pierre preferred to be the only man at the wheel. Necessarily, he from time to time had moments – long moments, sometimes – of divided attention. These could be unnerving. A case in point was the run-up, in the fall of 1946, to Miró's long-wished-for visit to the United States. Every aspect of it was troublesome. There were the American visas – not easily acquired, at that time – for Miró, his wife, and his daughter. There were the air tickets, and the reservations for the desired day. These were still the dark ages of intercontinental air travel. There were the recommendations from well-known Americans to be sought for. There was the dispatch from Europe of the works of art for Miró's upcoming exhibition at the gallery in May 1947. And there were bills to be paid, if not in advance, at any rate on the nail.

All these matters are routine today. But in 1946 they were bothersome beyond belief. Nor could the goodwill of fellow professionals always be counted upon. When Miró needed someone to vouch for him as a desirable visitor to the United States, he naturally thought of James Johnson Sweeney, who in 1942 had organized his first retrospective exhibition at the Museum of Modern Art and written the catalogue. In 1946 Sweeney was director of painting and sculpture at the Museum of Modern Art. Surely he, of all people, would help Miró to visit the United States and get to know the American museum scene?

Pierre told Miró not to count on it. "They don't like to take any responsibility," he wrote. "I had a taste of that when I wanted to go to France in the winter of 1944–45. My father was ill, and my mother and sister had been in the hands of the Gestapo. In your case I have advised Sweeney to ask you to come and restore the paintings of yours that they own. He'll do something, but exactly what it will be I cannot say."

It was also in character that Pierre insisted on taking care of the Mirós' journey to New York. He would choose the airline and the route and make the eventual reservations. Miró was disconcerted, therefore, when Pierre wrote only a few days later to ask if Miró had been to the TWA office in Barcelona and got the tickets. This question was all the more odd in that TWA had recently been on strike, worldwide.

It was a further complication that, as far as money was concerned, Miró was

absolutely at the end of his resources. When he and his family arrived in Lisbon for the connecting flight to New York, he would have hardly a penny in his pocket. It was therefore vital that Pierre would remember to cable him some money to Lisbon, c/o Thomas Cook.

All went well, in that respect, and Miró was free to concentrate on the first large-scale commission that Pierre had arranged for him in the United States. This was for a restaurant in the Terrace Plaza Hotel (now the Hilton) in Cincinnati. Pierre told him that this was a fashionable restaurant in a fashionable hotel. It was not too big – fifty tables in all – and it was circular in shape. The mural would get itself talked about all over the United States, and it could do Miró a great deal of good.

Miró had no idea what Cincinnati was like. Nor had he ever set foot in an American hotel. So his imagination ran free. As he had written to Pierre on October 13, 1946, he was longing to decorate a huge wall. "The idea of mural painting fascinates me, though it's a pity that I can't paint it in fresco. Anyway, I'll go and see the site. I feel that every mural painting should be made with its future environment in mind and in close collaboration with the architect. As for the fee," he went on, "I authorize you to negotiate in my name, on condition that I get a great deal of money. If I don't, I'd prefer to work away quietly at home."

Satisfactory terms were arrived at. On the eve, almost, of the Mirós' departure for New York, Miró wrote and said that, "I can do the decoration quite quickly and spontaneously, in one long single effort. But what takes time, in my case, is the wordless thinking it through that comes beforehand. I cannot foretell how long this period – the prebirth, as one might call it – will take. It is out of the question for me simply to make 'a big painting.' I cannot, of course, make a true mural painting – one painted directly on the wall, that is to say. I have to get steam up before I begin, and – as far as I can – I have to keep within the great tradition of mural painting."

Joan Miró and his wife and daughter arrived in New York on February 8, 1947. For obvious reasons, no letters relating to his activity in New York are in the Pierre Matisse Gallery archives. What would have gone into the correspondence went into day-to-day, direct, and unrecorded exchange. A longtime guest – in Miró's case, eight months – can be a great burden. But his visit was in every way a great success, as was the exhibition at the Pierre Matisse Gallery in which he showed paintings, gouaches, pastels, and bronzes from the hitherto unknown years of 1942–46.

This might have seemed like a cloudless year for Pierre Matisse. He had exhibitions like no one else's. He had a great surprise up his sleeve, in the Giacometti

retrospective. Was he not, in his profession, the luckiest of men? He didn't think so. "My Dubuffet exhibition is almost over," he wrote to his father at the end of January 1947. "I'm quite pleased with it. I sold one to Barnes. There were some lively conversational controversies. We all enjoyed ourselves. But now we don't have any fun at all. It is the moment of the great corrida. An American dealer has made what he considers to be a great coup by taking the plane to Paris and coming back with a dozen Picassos, fresh from the studio. You should hear the drums beat! Two weeks from now, the great Paul (Rosenberg) will open his own Picasso exhibition. Meantime, I have André Marchand! By accident! I'm rather nervous about it. This will be the month of Picasso. But in March, I shall have Miró. So my larder is not empty."

At this same time, Pierre was hoping to move his gallery to the fourth floor of the Fuller Building, where there were three big windows looking onto the street and a rent that was low enough to make him comfortable for several years to come. He took it, and was to stay there for the rest of his lifetime. The new rooms were spacious but discreet. Of "interior decoration" there was never a trace. Meditation was encouraged, thereby, and the visitor was left alone with the works of art.

There were distractions, even so, from mischievous tongues in the worlds outside. As Pierre put it to his father on February 17, 1947, "Sam Kootz has opened his Picasso show, but his friends here say that neither Picasso himself nor Kootz had any say in the choice of paintings. Picasso didn't want to be bothered with it, and told his secretary, Sabartés, to make the choice. In any case, the paintings are to the American taste – hard and dry, like champagne extra brut."

He did not for a moment doubt Miró's loyalty, but it stung him to hear a rumor from Paris that Picasso had picked up the telephone and urged Miró to sell directly to Sam Kootz. And then there were artists who were jealous of Miró's commission for Cincinnati. Worse still was the fact that, as he told his father, "I am having troubles with 'my' artists. They want to raise their prices, just at a time of crisis. It is very difficult to satisfy them when they act up like prima donnas. The result is that on the one hand they see me as a despicable dealer, a capitalist profiteer who exploits them. On the other hand – on 57th Street, among my distinguished colleagues – I am said to be a disgrace to my profession because I treat my artists too well and would rather be in their company than swap shop-talk with other dealers."

What gave him great pleasure, in spite of all this, was that he had just bought Henri Matisse's *Goldfish* of 1914–15. The subject matter of this pared-down and rigorous painting was intimately familiar to Pierre. The scene was the family

apartment on the quai Saint-Michel in Paris. As an adolescent, Pierre had known the cramped little room. He had known the scrolled railing outside the window. He had even known the two goldfish. The painting had belonged to the couturier Jacques Doucet, one of the great French collectors of the day, and Pierre was able to steer it in 1964 into the collections of the Museum of Modern Art.

Once Miró had had his first experience of New York, which he later likened to "a blow in the chest," he began to plan for the Cincinnati commission. This was to be the fulfillment of an ambition that Miró had confided, already in May 1938, to the magazine *XXème Siècle* in Paris. "As much as is possible," he had said, "I want to go beyond easel painting, which to my mind has only a limited ambition, and to draw closer to the mass audience of which I never cease to dream."

It was in the spirit, almost, of a Catalan Walt Whitman that he hoped to get acquainted with his American audience. Nor was it the least of Pierre Matisse's achievements that he had made it possible for Miró to attempt this multitudinous embrace on his first visit to the United States. The restaurant of the Terrace Plaza Hotel in Cincinnati may not have been the ideal venue for this undertaking, but Miró did not yet know that. Whatever it was, it presented itself to his imagination as a transatlantic wonderland. For the first time, he would address himself to a huge public and in the context of an archetypal midcentury American metropolitan building.

Rival fascinations were many during his first weeks in New York. But he was eager above all to settle into the long haul of the mural. By early April he and Pierre had been to Cincinnati and examined the site. It called for a circular mural that would measure exactly 8'6" by 30'8". On May 26, he bought the paints that he needed. He then began work in a studio on East 119th Street, in New York, that belonged to the painter Carl Holty. As he had foreseen, it took him quite a while to "get steam up" for the mural. But the final result, after almost four months, showed no signs of hesitation or second thoughts. As it was painted for a big restaurant, which is above all a place where people go to eat and drink and have a good time, tragic subject matter would have been out of place. Conviviality and well-being were fundamental to the creatures, human and other, in the Cincinnati mural. Even the bull is a paragon of good humor. There are echoes here and there of the *Constellations* of 1940–41, but the huge panorama had a relaxed and amply confident air. Comedy is everywhere present. No joke falls flat. What Miró had produced was, in effect, a salute to that great American institution, the parade. Its wordless motto was, Relax, and Enjoy Yourselves!

But when Miró and Pierre Matisse went to Cincinnati for the inauguration of

the mural, they realized that the restaurant simply wasn't right for it, and never would be. Eventually, and with the approval of the donor, it would be removed and taken to the Cincinnati Museum of Art, where it still is.

When Miró got back to Barcelona, he summed up on December 1, 1947, the effect of his long stay in the United States. "I loved it there," he wrote, "and it gave me a new strength and a new drive. All the same, I am not at all sorry to be back, even for a short visit. I go as often as I can to Montroig, and to the museum in Barcelona to see the Romanesque frescoes. They are truly an inspiration, and they make me forget, as I work away in complete isolation, the sad state of Europe, which I see as in deep trouble."

Meanwhile, Miró still had no dealer in Paris. Other dealers had been nibbling at his ankles for years. So far, he had always brushed them away. But it was his great wish to mark his return to Paris with a truly spectacular exhibition. Pierre Matisse had agreed to this. But who was to put it on, and where?

As always, Miró was courtesy itself. But he used plain words. "When I made over my entire output to you," he said to Pierre, "it was on condition that a major exhibition of my work would be held in Paris, this year. I know that this is very difficult to bring about, but it is a rule of life that if you want something enough – really enough – you can achieve it. Things that are easy don't interest me at all."

Pierre Matisse was overcommitted in New York, though still the dealer of first choice. Ever since Miró's return to Europe, however, he had had trouble staying in contact with Pierre. There were cables from Pierre that were never followed up. Miró had come to dread the words "letter follows" in any such cable. On February 18, 1948, he wrote to Pierre from Paris and said, "I am still waiting for the letter of explanation that was promised in the cable that you sent to me in Barcelona. As I cannot find my way in the fog, I have to know what has happened. I also want to know what has happened about the payment from Cincinnati, and about the monthly payments still owed to me. According to the contract that you signed, I should have received those payments by the end of the year."

Miró always signed off with "very affectionately," or words to that effect, when he wrote to Pierre, but he did not like to be kept waiting around. Problems of this sort were to continue. On July 7, 1948, Miró wrote again from Paris to Pierre. "I allow myself to remind you that when I arrive in Barcelona at the end of July, I shall need money. As you know, you owe me a large sum. I told a friend in Barcelona to expect $5,000 from you."

Meanwhile, there was a dealer in Paris who would like nothing better than to work with Miró, and he jumped at the chance. On February 21, 1948, Miró

wrote to Pierre Matisse from the Hôtel Pont-Royal in Paris and said that Aimé Maeght wanted to organize "a major exhibition" of Miró's work for June 1948. They had had long talks about it, and he, Miró, was in complete agreement.

The exhibition did not in the end take place until November 1948, but there was never any doubt that Aimé Maeght had big plans and would carry them through. He had the money, he had a large gallery on the rue de Téhéran on the Right Bank of the Seine, and he had unlimited ambition. He also had exceptionally gifted lieutenants – above all Louis Clayeux and the poet Jacques Dupin, who was to concern himself with Miró.

The Galerie Maeght was a prime example of a new kind of gallery that was soon to characterize the new big-name, big-money international art world. Aimé Maeght did not want to have the understated spaces, the single telephone line, or the unpretentious neighbors that had been the mark of galleries on the Left Bank. He wanted his gallery to have the air of a corporate headquarters, with a whole network of rooms in back where young people, well trained and well dressed, kept the lines open to clients the world over.

Later, when he opened the Fondation Maeght in Saint-Paul de Vence, and filled the house and its extensive gardens with work by his artists, he liked to give the impression that the Fondation had nothing to do with trade, or with the profits derived from it. It was to look like the plaything of a great gentleman, who graciously kept it open for the benefit of those who might otherwise never see anything like it.

Maeght came of a family that had done very well during World War II, selling food in Nice and elsewhere. As a neighbor, more or less, of Henri Matisse, he had attempted to pay court to him. Henri Matisse was not taken in by this, but he did not dismiss Maeght out of hand. "He is what he is," he had said to Pierre already in 1946, "but he has done certain things very well."

The great senior among Maeght's artists was Georges Braque, who showed with Maeght from 1946 until his death in 1963. Maeght had therefore the privilege of showing the meditative late *Studio* paintings of Braque. At those times, history was made on the walls of the Galerie Maeght.

Among Pierre's artists, Dubuffet did not care for Maeght and would never have dreamed of showing with him. Miró, however, was to show with him from 1948 until his ninetieth birthday in 1983. Giacometti was to show with him in Paris in 1951, 1954, and 1956. (He distanced himself from Maeght after Maeght had parted company with Giacometti's close friend and champion, Louis Clayeux.) Chagall showed with Maeght from 1954 onwards. Pierre Matisse was therefore to have quite a lot to do with Aimé Maeght.

The relationship, though never cordial, was on a regular and generally accept-able footing. Among its less acceptable moments, Pierre told Rosamond Bernier of the occasion on which Maeght asked if he could reinforce his inaugural show of Miró in Paris with some loans from Pierre's stock. Pierre agreed to this, only to find that when his paintings were shown at the Galerie Maeght "they put a red dot on each of them, as if they had been sold, and never told anyone that they belonged to me. What a nerve!" Thanks to Louis Clayeux and Jacques Dupin, the Galerie Maeght did very well by Miró. Once the Fondation Maeght was open in Saint-Paul de Vence, Maeght had two highly advantageous outlets for his work in France, and he made the most of them. (In the Foundation, there were strategic parties even more flamboyant than those in *The Great Gatsby.*)

As against that, Pierre Matisse retained absolute control in the United States and he, too, made the most of it. By the time that the Musée National d'Art Moderne acquired its first Miró in 1949 (as a gift from the artist), Pierre Matisse had placed Miró's work in museums and private collections all over the United States.

Furthermore, he had never forgotten that Miró was still anxious to undertake large public commissions in the United States. As Miró told Rosamond Bernier quite some years later, it was his dream that one of his major commissions would inspire a young man or woman to realize the American dream and become President of the United States. The particular commission that he had in mind at that time was in Wichita – which Miró pronounced as "Vish-ee-tah." (Whether this vision will come to pass is not for me to say. But, as will be seen, Pierre Matisse did his best to foster it.)

Meanwhile, the arrival of Aimé Maeght as Miró's representative in Paris was bound to have vibrations that were disagreeable to Pierre. Not only would Maeght quite naturally wish to give Miró a spectacular first show in his gallery, but he would have every right to sell to visiting Americans, many of whom might be Pierre's clients.

During the run-up to Miró's debut with Maeght in November 1948, there was between Miró and Pierre a degree of tension that could hardly have been avoided. On the surface, nothing was demonstrably amiss. But tempers were easily frayed, ancient grievances were freshened up and made new, and fear of the future was a subtext ever-present but rarely spelled out. In particular, Pierre's phases of inat-tention were exasperating to Miró. On September 22 he wrote to Pierre and said, "You do not appear to have the faintest idea of what I have to put up with in life. Nor do you seem to be willing to fulfill your obligations."

As to the first part of this, Pierre might well have replied in kind. His worries,

in one context or another, were at least as pressing as Joan Miró's. On September 29 he wrote to say that he had always loved Miró's work, and all the more so after the efforts that he had been making since 1932 on Miró's behalf.

"You may not realize," he went on, "how much our agreement in 1947 has cost me, what with the delay in the exhibition in Spain, on which I was counting, and the defection of our friend Pierre Loeb on the rue de Seine." To commit himself to the purchase of Miró's entire work since 1940 was, after all, a mark of extreme confidence – as had been, at the same time, his belief in Pierre Loeb as a predestined partner.

He went on: "Your letter makes me feel as I felt in 1947, when you were encouraged by someone who claimed to be my friend to make certain demands upon me. You spoke of Mr. Kootz, among others. You may not know that Mr. Kootz has abandoned his gallery and his artists and is now a private dealer. It grieves me," Pierre said, "to find myself in the same situation. I suppose it is the law of life that I must give way to those who are stronger and, above all, to those who have more money."

At that moment he seriously believed that Miró might drop him altogether – or, as he said, "eliminate" him. "Before you do that," he said, "I ask you to bear in mind the people that you will be dealing with, either in Paris or in New York. I shall have no alternative but to enter into competition with them. I am too well aware of the savagery of the art trade and of the people who are apparently close to you. If it comes to competition, you will be surprised to know how many Mirós I still have. The only way to defend myself – and I shall resort to it, if necessary – will have a disastrous effect upon the market. It would distress me very much – believe me in this – if I had no other recourse."

Miró replied to this on October 19. "You seem, my dear Pierre, to be very worried about my feelings for you. I should like nothing so much as to have my paintings represented forever by your gallery. But I have to find a more flexible way of managing my affairs. And I cannot envisage doing that in alliance with you until you have paid in full for the paintings that you have contracted to buy from me. I can well understand that these are difficult times for you. But I hope you will also understand that I have to be safeguarded against all eventualities."

But better times were on the way, and it is a matter of record that between 1948 and his death in 1989 Pierre Matisse had twenty-five exhibitions of Miró's work in New York. Every aspect of Miró's work was covered, and every exhibition was installed and catalogued with a distinctive and affectionate subtlety. It is by that record that Pierre's efforts for Miró should be judged.

The Case of Dubuffet, 1944–60

When Paris was liberated by the Allied forces on August 25, 1944, it was one of the happier dates in the history of the Western world. But when that initial euphoria was over, and the last ecstatic Parisienne had kissed the last Allied soldier, there was a great deal of sorting out to be done, and much of it was very unpleasant.

Old scores were settled with a savagery that disconcerted foreign observers who had known nothing at firsthand of life in occupied France. Whether justly or unjustly, revenge stalked the streets. Calumny went on the rampage. Everyday life was fraught with difficulties now almost unimaginable. When winter came, many Parisians, bone-cold and bone-weary, were in unheated apartments. Bribery and the black market infested every department of life, from the replacement of vital papers to the search for a cup of real coffee.

Mails were erratic, and the transatlantic telephone even more so. Reliable news was hard to come by. It was therefore something of an event when a letter from Charles Ratton in Paris reached Pierre Matisse in New York towards the end of 1944. Before World War II, he and Pierre Matisse had collaborated in more than one important exhibition of primitive art at the Pierre Matisse Gallery in New York. Ratton also had an almost infallible instinct for the new art of his own day. It was five years since Pierre Matisse had heard from him.

Dated November 6, 1944, Ratton's letter had its share of bad news. During the German occupation, people known to both Ratton and Matisse had been executed, put to work in German factories, or sent to rot in concentration camps. Since the liberation, the ancient saying that "man is a wolf to man" had

come up in lights, almost, on the streets of Paris. Fine historians of art like Georges-Henri Rivière and Marcel Griaule had been relieved of their posts. Artists, writers, publishers, and editors had been ostracized, sometimes with good reason, sometimes not.

But Ratton also reported that painters – "even the bad ones" – were selling better than ever before. Gromaire, Bazaine, and Lapicque – promising names at the time – had been signed up by the liveliest gallery in Paris. At least one prominent dealer, Louis Carré, was stocking up with Picassos at prices then regarded as unbelievable.

Among the new painters of the day, only one seemed to Ratton to be worth recommending. This was Jean Dubuffet, who at that very moment was having a show at the Galerie René Drouin. This was a conspicuous gallery, with premises almost adjacent to the Hotel Ritz in the Place Vendôme. Drouin had big ambitions, and he had a young associate, then new to the art trade, called Leo Castelli. Dubuffet's show had caused a tremendous stir. A few people liked it, but most were violently against. "Come over and see him, and don't wait too long," Ratton wrote. "You should sign him up. His work is truly sensational and – at last – it's something new. We get on well together, I often see him, and I've already spoken to him about you."

Given that this was Dubuffet's first show in Paris, and that it had only opened on October 20, 1944, this recommendation was ideally prompt. Nor could better advice have been given. But it is important to remember that Jean Dubuffet in 1944 was not "a young artist." Born in 1901, he was an experienced man of business who since 1930 had been following in his father's footsteps as a wine merchant in Paris.

He did not deal in great wines, but he knew men, women, and markets as well as, or better than, many a seasoned painter or sculptor. As an exhibiting artist, on the other hand, he had hardly begun. And, though much talked about, he was not much bought.

In any case, it was never Pierre Matisse's style to rush into an association. Not only did he need to know the work, but he needed to know the artist both as a friend and as someone with whom he might wish to work for a lifetime. "I did not 'make' my artists," he once said. "My artists made me."

Fifty and some years later, it seems obvious that anyone in New York who got the exclusivity of Dubuffet's work in the United States in the winter of 1944–45 would be onto a very good thing. But, at that time, Dubuffet was unknown in New York. In Paris his work, where known, was almost universally derided.

It was natural that the work of Jean Dubuffet should be bitterly contested in

Paris. In the convalescent capital of France, people wanted to believe in the continuing validity of the prewar School of Paris. The last thing that they wanted was to hear about painting that made the School of Paris in general look ridiculous. Nor did they want to be told by Dubuffet in print that the only new art worth looking at was the work of mental patients and obsessive autodidacts who knew nothing about museums and galleries and had never thought of selling their pictures. L'Art Brut, as Dubuffet called it, was produced by marginal men and marginal women who just happened to be authentic, free, and undeterred in their modes of expression.

If Dubuffet told the public that, when it came to making a woman's portrait, anthracite was every bit as good a material as the fanciest of oil paints, they thought that he was making fun of them. Nor could they believe that he would rather ride the subway and study his fellow passengers than go to the Louvre.

Pierre Matisse was not put off by any of that. But he had to think hard and long before taking on a major commitment. The contemporary art scene in New York in 1946 was tiny. True collectors were few. His Christmas exhibition in 1945 had been of "Paintings at Less Than $500." Museums were not yet the index of civic virility. Nor did gifts to museums earn for the donor either a tax deduction or an enhancement of social prestige. The international market in new art was almost a secret society, and one in which the major auction houses rarely meddled. As for "doing the galleries" in New York, it was by no means the mandatory pastime that it would one day become.

So Pierre Matisse took his time. But in October 1945 he wrote to Dubuffet and said, "I very much want to see your pictures." And when in Paris in December 1945, he bought nine paintings by Dubuffet. They were not little samples, either, and they included a large painting, 63¾ by 51⅛ inches, of a scene in the Paris Metro.

During the German occupation of Paris, and in relation to life as it was lived above ground, the Metro was in one sense a sanctuary in almost perpetual motion. But it was also a place in which Parisians could be hunted down and taken away, never to be seen again. Dubuffet masked that aspect of the Metro by using carnival colors. But just once, in 1943, he added a No Smoking notice in German that can still remind a thoughtful observer that these were potentially terrible times.

In general, Dubuffet during the German occupation of France paid no outward attention to the events of the day. But at the time of the Allied landings in France in June 1944, he made an almost subliminal reference to the coded messages that could be heard on the Allied radio. Painting after painting had to do with the small change of human communication. This was a time at which remarks like "Always at your service. URGENT," "George arrives tomorrow," "Still in good

health," or "Subway entrance Ledru-Rollin" could be a matter of life or death for those who heard them.

In February 1946, just a few weeks after his first purchases, Pierre Matisse began serious negotiations with Jean Dubuffet, thereby initiating an association that was to last until September 1960. For much of this long period, the relationship on both sides was both lively and committed. Dubuffet much appreciated Pierre Matisse's qualities as a dealer, as a friend, and as a correspondent. From one to the other and back again, running gags went on for years.

In all, four hundred fifty-four letters from Dubuffet are in the archives of the Pierre Matisse Gallery Archives, together with many handwritten copies or drafts of Pierre Matisse's replies. Dubuffet was a master of language. In print, he could make words get up off the page and dance. To open a letter from him was to be faced with a text – whether typed or handwritten – that came in a wall-to-wall format on the page. The prose style was propulsive, with never a hesitation. There were no loose words and no baggy ideas. If there had been first drafts or second thoughts, no one would have known it. The typewritten page was a thing of absolute and conclusive beauty.

Almost better was the handwritten page. The writing had nothing of the affectations of "calligraphy." Dubuffet did not want to ape the high styles of the Renaissance. He simply wanted to give of himself – clearly, completely, and without prevarication. And he succeeded.

The tone of the initial exchanges was cordial, but brisk. Dubuffet knew perfectly well that it was to his advantage that Pierre Matisse should be his representative in the United States. Not only had Matisse spent almost the whole of his professional life in New York but, in every sense, they spoke the same language. It was also relevant that Matisse had been born in 1900 and Dubuffet in 1901.

The artist–dealer relationship is on one level a commercial venture. But it can also result from a love affair, real or feigned, between the dealer and the work. That love affair takes a classic course. There is the initial attraction: the eye contact, par excellence. Then there is a mating dance of one kind or another. There are preliminary exchanges into which a certain skittishness can enter.

After a while, there should follow a moment at which the attachment takes on a whole new dimension. There is a formal courtship. Illusions may warm even the coldest and hardest of hearts. There is the equivalent of the prenuptial settlement. There is the exchange of vows. And then, finally, there is something akin to the long haul of matrimony.

As between artist and dealer, there are good days and bad days. Money is made or lost. What has been hoped for may or may not come to pass. As against

that, joint summers may be planned, or uproarious metropolitan reunions. Amiabilities and small human services may abound. Domesticities of one kind or another may run in tandem with business activity. (When Pierre Matisse in 1948 was asked to scour New York for a new needle for Madame Dubuffet's obsolete Singer sewing machine, he was delighted to do it.)

Jean Dubuffet in 1946 might have much to gain from his association with Pierre Matisse. The American market might prove to be a wonderland wide open to paintings that were unlike any that had been seen before. Quite possibly Matisse could shape for Dubuffet, in New York, the kind of career that had so far eluded him in Paris. A lifelong relationship between contemporaries, beneficial to both parties, might be developed.

Undeniably, Pierre Matisse was taking a risk by committing himself to an ongoing financial agreement with Dubuffet. He was under contract to buy works of art by Dubuffet for not less than 240,000 francs ($2,000) a year. It remained to be seen whether this was, or was not, a wise investment.

There was another difficulty. Ever since his first exhibition, Dubuffet had been represented in Paris by René Drouin. Drouin at that time had every appearance of doing well. André Malraux, a towering figure in his day, had been the first person to buy a painting from the Dubuffet show. Dubuffet had no wish to cut loose from Drouin, who was due to show (in May 1946) his most recent cycle of paintings, *Mirobolus, Macadam et Cie.*

But he had himself to think of. "In principle," he wrote to Pierre Matisse on February 1, 1946, "I should be delighted to work with you. I have not seen Drouin, but I have decided to treat with you directly and without consulting him. I met with Charles Ratton today and made the following proposition to him."

The essential of this was that Drouin should continue to be Dubuffet's sole representative in France, while Pierre Matisse would have exclusivity in the United States. Each in turn was to have first choice, every three months, of what Dubuffet had produced, and in return would undertake to buy work to the value of the agreed sum.

The price for any given picture was to be the same for both of them, subject only to any drastic fluctuations in the cost of living in France. The agreement was to be binding in France, for Drouin, and for Matisse in the United States. Elsewhere, Dubuffet reserved his rights.

As was to be expected, Drouin was not best pleased with the deal, but he went along with it. Matisse, meanwhile, did not fancy the three-monthly alternation that Dubuffet had in mind. As the son of a great artist, and the witness in boyhood and youth of his father's mood swings, he knew that there are ups and

downs in every painter's production. Stability cannot be guaranteed. The proposed agreement might be much to the disadvantage of one or another of the parties concerned. Would not a six-monthly alternation be more to the point?

Dubuffet had nothing against a six-monthly alternation. It was on this basis that the association between Matisse and Dubuffet was formalized. It led to exhibitions in New York in 1947 (twice), 1948, 1950, 1951, 1952, 1954, 1956, 1958, and 1959, with an after-echo of the long-severed alliance in 1973. Thanks to the quality of the work, and to quiet persuasion by Matisse behind the scenes, Dubuffet's paintings found their way with minimal delay into major American collections, both public and private.

During and after the run-up to Dubuffet's first New York show at the Pierre Matisse Gallery in January 1947, there were indications that he was getting irritated with René Drouin.

"Drouin's taste is not infallible," he wrote to Matisse on April 27, 1946, just a few days before *Mirobolus, Macadam et Cie* opened at the Galerie Drouin. On May 10 he wrote that his work did not look well in the Galerie Drouin. The proportions of the rooms were not good. The lighting was feeble and unfocused. The pictures were hung, unframed, on velvet – dark red in some of the rooms, greenish-yellow in others. "Please bear in mind for my show in New York," he wrote, "that my pictures look best on chalk-white walls, like the ones I have at home." As for the Parisian visitors, they were astonished and disconcerted and had no idea what to think. Dubuffet mentioned that after three paintings had been vandalized in the front room, the security force was doubled. Nothing had been sold.

In Paris, Dubuffet had no collectors, in the American sense. In all Europe, he had only one major collector, who was an exemplary Swiss from Solothurn called Josef Muller. But among men of letters he had many friends. They included Jean Paulhan, editor of the *Nouvelle Revue Française* in its great days before 1940. He also had Raymond Queneau, novelist and poet, Marcel Jouhandeau, novelist, Henri Michaux, poet and storyteller, Antonin Artaud, a figure of legend in the avant-garde theater, Jules Supervielle, poet, Francis Ponge, poet, Paul Léautaud, diarist, and Joë Bousquet, a bedridden sage who lived out his life in Carcassonne.

Dubuffet's friends were delighted to be given a drawing or a painting, but the readiness to write a check was rare among them. At the gallery, Drouin as a salesman did not rate at all. Apparently daunted by the uproar in the exhibition, he would leave town after the opening and wait out the troubles from a safe distance. Dubuffet in 1947 was so disconcerted by the scorn and contempt with which his work was regarded by the public that he almost decided never to have another gallery show in Paris.

277

Jean Dubuffet. *Portrait of Pierre Matisse.* 1947.
Charcoal on paper, 12⅜ x 9" (31.5 x 23 cm).
Private collection

Jean Dubuffet. *Pierre Matisse, portrait obscur.*
1947. Oil, sand, and gravel on canvas, 51¼ x
38¼" (130 x 97.3 cm). Musée national d'art
moderne. Centre Georges Pompidou, Paris

As a writer, on the other hand, he was riding high. Every word came crack-
ling off the page. "But the trouble is," he wrote to Pierre Matisse, "that the very
thought of writing gives me a stomachache. It is only when I am painting that I
am completely happy."

As the months went by, Dubuffet became more and more impressed by the
care and the imagination that went into Matisse's work in his gallery. Everything
was just right – the framing, the lighting, the hanging, the catalogue, the invita-
tion cards. In all such matters, Pierre Matisse was not simply the son of a great
artist. He was an artist himself, though he would never have claimed the title.

Upon a first show of the kind that Pierre Matisse was preparing for Dubuffet
in New York, much depends. It is the first step in a joint involvement that may
or may not go smoothly. As in marriage, traits of character that pass unnoticed in
courtship may make themselves all too evident. But as of January 7, 1947, when
Dubuffet's first New York show opened, both parties were delighted. New York
was a newfound land for Dubuffet, and he found an exotic magic even in the
names of William McKim, Saidie A. May, and Lee Ault, who had shown interest
in his work.

He had had what was at that time the inestimable advantage of being highly regarded by Clement Greenberg, who had written in June 1946 that Dubuffet's work "reveals literary leanings. But the literature, I admit, is of a superior order. . . . From a distance, Dubuffet seems the most original painter to have come out of the School of Paris since Joan Miró. If his art consolidates itself on its present level, then easel painting with *explicit* subject matter will have won a new lease of life."

On February 1, 1947, Greenberg wrote in *The Nation,* after seeing Dubuffet's first solo show at the Pierre Matisse Gallery, that he had "completely assimilated all that the School of Paris has had to teach since 1908. Three or four more paintings on the level of *La Promeneuse au Parapluie* of 1945 would suffice almost of themselves to make Dubuffet one of the major painters of the 20th century."

Naturally enough, the work also met with some resistance. One of Matisse's letters to Dubuffet ended with the words "I hear gnashing of teeth in the gallery, and I must go out and comfort the victims." But careful work behind the scenes had persuaded the right critics, the right curators, and some of the right collectors to come. The Museum of Modern Art had acquired the first of its many Dubuffets. All this was a considerable achievement, though Pierre Matisse himself would never have said so.

The years did not make Dubuffet's work much easier for the casual visitor. If it occasionally baffled or startled some of Matisse's favorite clients, that was because it was, in effect, a long series of affronts to established opinion. Dubuffet took the great standard subjects of painting and gave every one of them a whole new spin. He did it with portraiture, with the pastoral landscape, and with the wilderness landscape. He also did it with animal painting, with the female nude, with the tabletop still life, with the metropolitan garbage heap, and the possible variants of the bearded man. He did it with the Parisian shopping street, the misfortunes of a lost donkey, and the poetics of agoraphobia. He also did it with one-time-only subjects of a kind peculiar to himself. *Woman with Roasted and Rissoled Flesh* was one such, and *Man Pissing to the Right,* another. And there were confections that only he would have essayed – landscapes made of butterfly wings, for instance, and statuettes made of sponge.

Nothing in this antic procession was quite like anything that had been seen before. Portraiture, for instance, is a form of art as to which expectations had run on much the same rails for quite some time. But the portraits that Dubuffet made of his friends were not "likenesses." They were hallucinations that rang truer than true. This was portraiture that threw away the safety nets of measurement and exactitude that had been woven, skein by skein, for centuries. Complete and unmistakable human beings were set before us with the tics and oddities that were theirs,

and theirs only. "If a portrait is really to work for me," Dubuffet wrote in October 1947, "it has almost to go beyond portraiture."

The portraits had other surprises to spring. "There are no bright colors in my portraits," Dubuffet had written to Pierre Matisse on January 10, 1947. "There are only dirty, nameless colors, vaguely brownish or grayish or eggshellish. There are plenty of painters around who paint in a high key. My paintings are like my drawings – I use materials that are humble, poverty-stricken, and disreputable."

In 1947 Pierre Matisse was admitted to the distinguished fellowship of those who had been drawn or painted, more than once, by Dubuffet. As with everyone else, the images "went beyond portraiture." Dubuffet got beyond and behind any expectable likeness of Pierre Matisse. After doing that, he set free a Pierre Matisse who now looks to us more and more like the real Pierre Matisse – a man with a huge moonlike head and one skin too few who was a paragon of commitment to art that he loved. All his life long, and for those who knew how to find it, he kept that look.

Meanwhile, Dubuffet was well content with what Pierre Matisse had done for him in New York. But in February 1947, when the Dubuffets went to Algeria to escape the permafrosted Parisian winter, they had to sell their automobile to get there. Nonetheless, it was a happy moment in the relationship between Dubuffet and his dealer. Algeria in 1947 had still an authentic and uncorrupted strangeness. For the inquiring visitor from Europe, it was a seductive backdrop in which "the natives" were well disposed, unself-conscious, marvelously dressed, and given to painting their faces bright blue. Lili Dubuffet thought that the Arabs' houses looked as if they were made of whipped cream and plain chocolate. Dubuffet ate with the Arabs, dressed like the Arabs, and had bought himself a bolt of pink-sugar voile with which to build himself a headdress that would end up looking like pink nougat.

Subjects by the hundred presented themselves. The body language of which Dubuffet was so brilliant an observer in his native country found a whole new idiom in the Saharan sunshine. His working materials, on the other hand, left much to be desired. He had brought powdered colors that changed color completely when they dried. He had brought paper that swelled up, wrinkled, and lost its shape the moment it got damp. He had some gum arabic, and some gouaches, but it was the very devil to mix them to the right consistency. If the mix was too weak, the colors could not be fixed at all. If it was too strong, the paint would flake and peel off as soon as it was dry.

Meanwhile, he wanted to remember every footprint in the sand. He wanted to be quite sure of the way in which the palm leaves were attached to the trunk

of the tree. He wanted to master the foreshortening of the camel as it sat on the ground and stared at him. As for the fold and the fall of burnous and gandara, they were as important to him as they had been to Delacroix in 1832.

He marveled at the wild festivities that would sweep through a village without warning, and at the sense of ceremonial that asserted itself when he least expected it, and at the ability of the Arabs to "hang out" indefinitely. In a still unspoiled Africa, surprises were everywhere. In Tamanrasset, for instance, he saw blue-painted giants, mantled with black crepe, and each one of them armed with a Crusader's sword. Dubuffet wrote to Pierre Matisse that "they arouse the terror that we find in Sir Tristan, in the figure of the Commendatore in *Don Giovanni,* and in the phantom sorcerer. They couldn't be nicer or more courteous," he added, "but they're aloof, they don't say much, and they are really a very gloomy lot."

Even so, and with the help of some colored crayons that he picked up on the spot, he had completed two hundred and some little pictures by the third week of March 1947. He longed to get them home to Paris. And yet . . . what if the cloud-castle of his impressions of Africa were to collapse like a soufflé as soon as he was back in France? What if the worst were to happen and he forgot all about El Goléa? "But right now," he wrote to Pierre Matisse, "I want you to tell your clients that I have taken colossal pains to bring back some good pictures with me."

In a letter to Dubuffet, dated January 28, 1947, Pierre Matisse summed up the success of the New York show. "We have sold to the people we wanted to sell to. I shall surprise you by saying that I should have been very worried if the show had sold out. It is not in my nature to be in a hurry, and I prefer your work to make its way slowly."

This was Pierre Matisse's point of view, all his life long. He liked to see the right pictures hung in the right places, and he didn't mind waiting for it. It was not his ambition to have people walk in, unannounced, and snap up everything within sight. Neither the character nor the extent of his stock was ever discussed with strangers. If they came in, and if they were clearly serious, he might say, "Well, maybe I could show you one or two things."

But fundamentally, he thought that great pictures should live with other great pictures in places that he knew and approved of. If he gave the Museum of Modern Art in New York or the Art Institute of Chicago the first refusal of the new crop, that was his privilege. To be in a great museum was validation, and to have Dubuffet's 1947 portrait of his friend Joë Bousquet in the Museum of Modern Art was a step forward and upward in his career in the United States.

In the long run, this policy was proved right many times over. But in the short run, it caused problems, both for Matisse and for Dubuffet. Trouble – big, decisive,

irreparable trouble – was to come of it. In the first place, Dubuffet did not care for great museums. He saw them as sanctuaries of the high culture that he was out to discredit. What others saw as consecration was to him a form of entombment. It was the role of the museum to protect and preserve, whereas Dubuffet was an anti-preservationist.

The Museum of Modern Art was, in his eyes, a "detestable *conservatoire*" in which the visitor was given a totally false notion of art. It was high time that it forgot about overblown celebrities like Picasso and pseudo-painters like Kandinsky and concentrated instead on the artists whom he had marshalled under the banner of Art Brut.

When the Museum of Modern Art bought a painting by Dubuffet and sent him the museum's standard questionnaire for new acquisitions, he wrote to Pierre Matisse and said he had dutifully completed the "crackpot form." "If I restrained myself from saying what I thought of it, it was in order not to harm you in your business connections."

Quite apart from his contempt for high culture, Dubuffet had inherited from his years in the wine trade what might be called a wish to get rid of each vintage as soon as it was ready to go out into the world. Furthermore, he was a businessman by nature. A sale was a sale, and a check was a check. Year by year, almost, he had something completely new to offer, and in that context unsold stock had overtones of failure that he did not care for. Dubuffet and Matisse might be very good friends, both for the moment and for some years to come, but when it came to marketing there was a psychological divide between them that could never be bridged.

On his return from his first visit to Algeria, in April 1947, Dubuffet found himself disagreeably short of money. Could Pierre Matisse help him out, and as soon as possible? Could he double the amount of guaranteed purchases, thereby ensuring Dubuffet 480,000 francs a year, instead of 240,000?

The short answer was that Pierre Matisse couldn't. Times were difficult. The New York market for modern art in the the late 1940s (and for some time after that) was seasonal and intermittent. There were no black-tie auctions to whip up excitement. Possible buyers would take off in May and not come back until well into September. Other buyers were jumpy and undecided by nature and thought nothing of returning a picture and canceling the sale. Nor was there any sign of forthcoming improvement. In a presidential election year like 1948, people would sit on their hands, waiting to see which way the voting would go. In these conditions, there was a limit to the number of Dubuffets that he could absorb.

This particular crisis was averted when Dubuffet was able, against all

expectation, to sell the remaining shares in his wine business. So far from being worthless, as he had feared, they brought "a tidy little sum." There was no further talk, for the moment, of 480,000 francs a year from Pierre Matisse.

Even the loss of Dubuffet's automobile was put right by an incident that involved Florence Gould, the widow of John Jay Gould, the railway billionaire. Mrs. Gould loved France. She had a very comfortable house, and a very good chef, and she was home to lunch on Thursdays. Many were the artists and writers in those straitened times who jumped at the chance of a good meal and some amusing company.

On May 31, 1947, knowing that Dubuffet had had to sell his automobile, Mrs. Gould suddenly said that she would like to give him one. Nothing loath, and not tempted by what was then available in France, he said that he would settle for a Mercury four-seater convertible. Would Pierre Matisse send him details of the latest model? And would he try to have it sent over with two spare wheels and the requisite tires? These chores were undertaken forthwith.

Throughout their association, Dubuffet kept Matisse informed of all the ups and downs and ins and outs of his professional dealings in Paris. They were many, and on the whole they were short-lived and ended badly. Matisse had a front seat at that particular ringside, and he came to understood what Jean Paulhan had meant when he said of Dubuffet that "his fits of anger are violent, and his hatreds lasting. But they are usually so groundless that it would be a waste of one's time to try and forestall them."

In his business relations with Pierre Matisse, Dubuffet was attentive to every least detail. Not so much as a ten-cent stamp escaped his notice. He was scrupulosity itself, checking and rechecking his accounts page by page and calibrating every rise and fall in the rate of exchange for the franc and the dollar. If Pierre Matisse paid a bill twice over, as occasionally happened, Dubuffet was quick to point it out. "What terrible bookkeeping!" he would say.

As Pierre Matisse bought his Dubuffets outright from the artist, they were his property, and he felt that what he did with them thereafter was his own business and no one else's. Nor did he feel obliged to report what had, and what had not, been sold. The long-term impact of these convictions took several years to make itself felt. "I need 100,000 francs [$286] a month to live on," Dubuffet wrote to Pierre Matisse in January 1950. In December of that same year, he found that he had spent 350,000 francs on his working materials alone. To keep working and live decently, he needed 2,000,000 francs a year. For this and other reasons he liked to feel that his work was getting out in the world.

And was it? Well, the shows in New York were understated marvels of

presentation, and in their catalogues art and literature were dexterously mated. But as to what was the upshot of it all, Dubuffet for the most part had only generalities to go upon.

It had not always been easy going for Dubuffet in the United States. (Matisse was later to speak of the days when he had felt "like a man walking uphill with stones in his shoes.") Such were the diversity and the gleeful effrontery of Dubuffet's work that sometimes his dealer had to repersuade even the former enthusiasts who would walk in and say, "Well, this year he's blown it."

Dubuffet prized the special qualities that Matisse had brought to his task. Writing six days after the opening of the show in New York, which coincided with the tenth anniversary of their partnership, he said that, "I hope that the ten years of tenacious effort that you have given to the diffusion of my art will be rewarded by some sales." As always, he was dazzled by the catalogue. Poring over it in Vence, he had a sudden craving for the company of Pierre Matisse. "When are you coming?" he asked, "I need your company. You cannot believe how bored I am with the surly and hostile construction workers I have to deal with down here. A man needs to laugh from time to time! Are you in the mood for a good laugh? Always provided, of course, that sales will cover the costs of this fabulous catalogue! Come quickly!"

On days like that, dealer and artist were as one. Dubuffet could be both a master comedian and an ironist whose every word could strip the paint off the furniture. In both those contexts, Matisse could come to life in a way that would have astonished those who imagined him as reticent and undemonstrative.

Their friendship should have lasted until the death of Dubuffet in 1985, just as Pierre Matisse's friendship with Joan Miró was to last without a flaw until Miró died in 1983 at the age of ninety. But, already in 1956, the friendship between Matisse and Dubuffet was in trouble. By late September 1960, less than five years later, it was beyond repair, and Matisse put an end to it with one of the most terrible last lines ever addressed by one old friend to another.

On Dubuffet's side, two reasons for the eventual break were already clear. *Sales* was one key word. *Payment* was the other. Both words peeked round the corner in letter after letter. As to sales, Matisse did not pay much attention. From the very beginning, in January 1947, he had made it clear that sales, though important, were not his first concern. For Dubuffet, on the other hand, sales were very important indeed. He wanted his work to get about, and to be seen. He also wanted to know who had bought it, and where it was. By the mid-1950s it was an ongoing and cumulative grievance with him that Matisse would usually speak only in general terms of sales that had been made. But what were they? Who

were the buyers? It cannot be said that Pierre was often forthcoming in that regard.

There was also the question of monies due to Dubuffet. Pierre Matisse was probity itself, and he always paid up. But he did not always pay up on time. Not to get the check could be traumatic for Dubuffet, as for many another, and the subject came up more and more often in his letters.

Already on July 27, 1954, Dubuffet put it as plainly as he could. Once he had painted his pictures, he sometimes had to wait for months until Matisse came over and made his choice. Meanwhile, the currently favored dealer in Paris would also be kept waiting. After Matisse had made his choice, Dubuffet often had to wait once again, month after month, for payment. "You really should understand," he said finally, "that this cannot go on. I can well imagine that you have difficulties, but I have difficulties of my own, and I think that I am entitled to more consideration."

Sometimes the matter would be raised in a tone of affectionate puzzlement. "Now tell me, my dear Pierre, why don't you send me some money?" Sometimes it was sharper. "I need hardly say that your promised check has not come." To Dubuffet it seemed as if some deliberate strategy were behind it. There even came a time when he refused to send a new batch of his paintings until arrears of payment were made up. Meanwhile, every grievance would be spelled out, with varying degrees of exacerbation, and letter after letter, supplemented by cables, might bear upon a single transaction. "I am sick to death of these delays," he would say. These were not good auguries.

On Matisse's side, disquiet had a subtler face. Dubuffet hid nothing from Pierre Matisse of his long-running search for a reliable European representative. That he kept nothing back was in itself a mark of trust and affection. Matisse was his partner, his confidant, and the architect of his American reputation. But it was clear from the letters that Dubuffet in his Parisian activities was jumpy, changeable, and sometimes self-contradictory. What he had to say set up a subliminal vibration that disquieted Matisse.

It was natural that Dubuffet in his middle fifties should want to live in comfort and security. To achieve that, he had to be properly represented in Paris. Maneuvers to that end were getting nowhere. He would take up one person, and then another, and quite possibly a third, only to discard them (often for good reason) in short order. René Drouin, for one, would be derided in the late 1940s and picked up again in 1957, apparently as good as new. Others vanished forever. ("My trust was totally misplaced," Dubuffet would say.) If the people who courted him were close to the Parisian establishment, like Louis Carré, that put him off. If they had scruffy little galleries that they ran single-handed, he didn't

like that, either. If they fell asleep on the job, or conducted themselves oddly or disreputably in private life, he liked that even less.

What he needed was someone with solid backing who was bright, dynamic, good at business, and straight. He had to know the art world, and to devote himself full time to Dubuffet. A reasonable job description? Yes, but a hard job to fill. Meanwhile, the manhunt – no woman hunt was ever in question – had overtones of anxiety for Pierre Matisse. What if Dubuffet's readiness to change and to reject would in the end be applied to the Pierre Matisse Gallery? There had never been a hint of that. But in dark moments he may well have remembered what Michel Tapié had said in the catalogue to a show of Dubuffet's at the Matisse Gallery in January 1951 – that "like the big bad wolf, Dubuffet may very well tear you to bits." He had not done it yet, but the possibility remained.

Dubuffet's nervosity in Paris was powered, whether consciously or not, by the fact that Europe in the late 1950s was just about to throw off its bandages. The glory days of dealing in twentieth-century art might still be in the future, but radical changes were imminent. The talk was of art fairs, theme shows, long-running veterans like the Venice Biennale and newcomers like Documenta in Kassel. The Kunsthalle, or temporary exhibition space, was bursting out all over Europe. Governmental backing was replacing governmental indifference. Curators, dealers, art bureaucrats, collectors, critics, and publishers grouped and regrouped.

All this brought about a new kind of art dealing. Pirate and poacher were on the prowl. Takeover and buyout entered the folklore of the day. The black-tie evening auction, with its overtones of casino and prize fight, became the sortie of first choice. For the artist who was hot, huge new opportunities were offered. Some of them were chimerical. Others were more lasting. Meanwhile, and much as he had always scorned the star system in relation to living art, Dubuffet did not wish to pass up his share of those new opportunities.

He had an enormous potential. He never ran short of ideas, the level of his work to date was uncommonly even, and he knew how to touch the nerve of his time. Yet there he was, working away in Paris or in Vence, with no stable representative in Europe.

The problem had also its philosophical side. In the 1940s Dubuffet had been an archetypal and an implacable outsider. After a close look at the international art world, he came back and said, with the English poet Walter Savage Landor, "I strove with none, for none was worth my strife."

But as he got older, the international art world didn't look so bad, after all. It really was time he got into it. But who was to set that up and carry it through? Even with people with whom he was on terms of friendship, there was no guar-

antee of continuance. Michel Tapié, for one, was a familiar figure in the worlds of art and literature in Paris. He was a loyal champion of L'Art Brut, and for a time had looked after its practical interests. He was a gifted writer and a well-known critic. He knew about the world of the artist's book, which was one that fascinated Dubuffet. Besides, Dubuffet was fond of him. "Maybe Tapié would do?" he said to Pierre Matisse on one occasion. But it soon turned out that Tapié wouldn't do. He had no business initiative. Letters from possible clients were left unanswered (and, sometimes, unopened). From Dubuffet's perspective, Tapié was not so much a pragmatic impresario as a lovable but dithering esthete.

By 1956 Dubuffet's work was in demand in England, in Germany, in Holland, in Switzerland, and in Italy. There were offers of museum shows and gallery shows all over Europe. To choose, assemble, coordinate, catalogue, transport, install, and price whatever was for sale in those shows was a formidable task. Who was to do it? The post was still open. Meanwhile, and for the new-style dealer, Dubuffet looked like a peach ready for the picking.

Matisse was neither poacher nor pirate. He was a single-handed dealer, and no one could tell him what to do. But a single-handed dealer is like a single-handed publisher. He deals not in safety, but in what he loves. He has good times, and he has bad times, and in bad times there may just not be enough money to go round. At those times, other dealers might cut their prices to make a quick sale. Matisse never did that. He was Mr. Independence, and he meant to keep it that way. No matter what the rest of the world was up to, he kept coming with his exhibitions. Some were historic events. Others left no trace. All had their problems. His was a glorious role, but perilous.

In May 1956, a new and potentially formidable player made approaches to Dubuffet. This was the Galerie Maeght. Aimé Maeght was not loved in Paris, then or at any other time, but he was the prototypical mega-dealer. He had very handsome quarters on the rue de Téhéran, on the Right Bank in Paris, he had unlimited ambitions, and he had set the style of the house with four big bankable names – Braque, Chagall, Giacometti, and Miró.

In the summer of 1952, when Dubuffet had a show in Nice, the Maeghts came by to see it. Another visitor was the Maeghts' landscape gardener, a major figure in his profession who had been responsible for the Rothschild gardens in Saint-Jean-Cap-Ferrat. Aimé Maeght never did things on any but a grand scale, and when he invited the Dubuffets over to Saint-Paul de Vence, they agreed to go.

It did not suit them. There was just too much of everything. There was a garden with two thousand varieties of cactus. Lili Dubuffet said that was far too many, and that the Maeghts ran to excess in all things. There was too big a view,

she said. There were too many different kinds of garden – an Alpine garden, a garden for artichokes. . . . There were too many English lawns. There were too many pheasants, too many water lilies and lotuses, and too many Giacomettis. There were too many stone ruins, too many picturesque countrified walls, too many big pieces of furniture made of olive wood cut and carved in "primitive" style. There was too much opulence and too much "good taste."

There were also too many signs of exuberant good health in both the complexion and the waistline of Monsieur Maeght. "Lili is a great complainer, as you know," Dubuffet wrote to Pierre Matisse, "and a great contrarian, too." But in this instance I would lay money that the two of them were of the same mind. Dubuffet was so fired up by the seignorial mode of life at the Maeghts' that he ended his letter by saying, "I salute you and withdraw from your presence, walking backwards and bowing twenty times."

But Maeght the chatelain and Maeght the potential representative were two quite different propositions. Dubuffet was very much tempted by the Galerie Maeght's offer. This was, after all, a big-scale professional operation that would bring him a new degree of financial stability. "I cannot think of any gallery in Paris that would suit me so well," he said to Pierre Matisse. After lengthy reflection, he was very much inclined to say Yes. Would not Matisse agree that it would be better to have Dubuffet in a major gallery in Paris – one that would defend his prices properly and be adroit in the conduct of its business?

He knew, however, that Matisse did not care for Maeght and had had serious differences with him. Matisse had known Joan Miró since 1928. He had been showing him in New York since 1930. It grieved him very much that in 1948 Aimé Maeght should have drawn Miró into the orbit of a kind of art dealing that was quite foreign to Matisse.

Pierre Matisse and Alberto Giacometti were almost exact contemporaries. Matisse had had an agreement with Giacometti since 1936. In 1948 Matisse had an exhibition that was a landmark in the presentation of Giacometti. It was a small but exemplary retrospective of Giacometti's work from 1925 to 1947. It had been perfectly in accord with Giacometti's horror of flamboyance and pretention. So it was a grief to Matisse that Maeght should have, as it were, taken over Giacometti in Europe from 1950 onwards.

All this being so, it was not surprising that when Dubuffet asked in May 1956 if Matisse would be willing to share his output with Maeght on a 50-50 basis, Matisse said at once that there could be no question of it. Quite apart from their previous differences, Maeght had lately taunted him by saying that Dubuffet had himself made the first advances towards the Galerie Maeght. Matisse had also

Balthus. *Portrait of Pierre Matisse.*
1938. Oil on canvas, 50½ x 34"
(128.3 x 86.4 cm). Maria-Gaetana
Matisse Collection

PLATE 33

Balthus. *Joan Miró and His Daughter
Dolores.* 1937–38. Oil on canvas,
51¼ x 35" (130.2 x 88.9 cm). The
Museum of Modern Art, New York.
Abby Aldrich Rockefeller Fund

PLATE 34

Balthus. *The Mountain*. 1935–37.
Oil on canvas, 98 x 144" (248.9 x
365.8 cm). The Metropolitan Museum
of Art, New York. Purchase. Gifts of
Mr. and Mrs. Nathan Cummings,
Rogers Fund and the Alfred N. Punnett
Endowment Fund, by exchange, and
Harris Brisbane Dick Fund, 1982
(1982.530)

PLATE 35

Balthus. *The Turkish Room (La chambre turque)*. 1963–66. Casein and tempera on canvas, 70⅞ x 82¾" (180 x 210 cm). Musée national d'art moderne. Centre Georges Pompidou, Paris

PLATE 36

Jean Dubuffet. *Le métro.* 1943.
Gouache on paper, 14 ½ x 12"
(37 x 30.4 cm). Musée national
d'art moderne. Centre Georges
Pompidou, Paris

PLATE 37

Jean Dubuffet. *Apartment Buildings,
Paris*. 1946. Oil on canvas, 44⅞ x
57⅜" (114 x 145.7 cm). The Metro-
politan Museum of Art, New York.
Bequest of Florene M. Schoenborn,
1995 (1996.403.15)

PLATE 38

Jean Dubuffet. *The Coffee Grinder.*
1945. Plaster, oil, tar, and sand, on
canvas, 45¾ x 35" (116.2 x 88.9
cm). The Metropolitan Museum of
Art, New York. In Honor of Ralph F.
Colin. Gift of his wife, Georgia
Talmey Colin, 1995 (1995.142)

PLATE 39

Balthus. *The Street*. 1933. Oil on
canvas, 6'4¾" x 7'10½" (195 x 240
cm). The Museum of Modern Art,
New York. James Thrall Soby Bequest

PLATE 40

heard that he, Maeght, was confident that Matisse could be "eliminated." (Maeght had naturally denied ever having said anything of the sort.) If Dubuffet really felt that it was essential for him to go in with Maeght, then he should do it. But he, Matisse, would regretfully part company with him.

It must be said for Dubuffet that he did not hesitate. Once he knew of the depth of Matisse's feelings, he put his own inclinations aside and sent Maeght a polite letter that broke off the negotiations between them. Nor did he ever refer to what must at the time have been a serious disappointment to him.

So far from sulking, he soon allowed his sense of fun to bubble up from time to time in his correspondence with the Matisses. (He had, by the way, taken a great shine to Patricia Matisse.) In October 1956 Dubuffet teased the Matisses about what he liked to think of as their rackety vacations. "I beg you," he wrote to Patricia, "to arrange your life, and Pierre's, in such a manner that you are in bed by 10 P.M., like all people of good sense. And you should drink water, above all. Lots of water, and milk. Orange juice. And no more of those French-cancan vacations that you took this year. A few minutes' reading in bed, before you turn out the light, and a sound sleep until early the next morning. And, throughout the day, ginger ale, tonic water, Coca-cola. And from time to time, by way of distraction, a little visit to the Friars' Club." (Dubuffet feigned to see the Friars' Club in New York as the heartland of nonstop debauch.)

But the problem of payments deferred did not go away. If anything, it got worse. On December 6, 1956, Dubuffet felt obliged to write that "These delays are too long. I am exasperated by your stubbornness in systematically delaying your payments. Where in all this is the spirit of generosity, of goodwill, of true friendship? Is it perhaps a clever financial strategy? If so, it is one that may end by antagonizing those who have been disappointed once too often."

Maeght had been got out of the way, never to be mentioned again. But on January 28, 1957, a substantial new player of quite another kind made his first appearance in a letter from Dubuffet. This was Daniel Cordier, who had just opened a gallery on the rue Duras. Making use of an opening move that has worked well for many a young dealer, he had persuaded Dubuffet to let him buy a whole stack of drawings and gouaches, dating from 1942 onwards, that had sat in the gallery, largely forgotten and in no particular order. Dubuffet was delighted by Cordier, and by his intention to couple an exhibition of the drawings with a book on them. And who would write the text for that book? Cordier himself. He would certainly do it well, and the book should for the moment take precedence over any other publications.

In the same letter, Dubuffet spoke of the show of around fifty paintings,

fifty drawings, and a few sculptures that was due to open on August 1 at the museum in Leverkusen, near Cologne. "I suppose you would like to lend a few paintings?" he said. "Just let me know which ones."

This was a time at which Dubuffet had three galleries in Paris – Drouin, Larcade, and now Cordier – all of which were eager to have his work "in no matter what numbers." The demand was such, he said to Matisse a month later, that they had trouble keeping anything in stock. At last, he was riding high. He enjoyed the buzz – and why shouldn't he? – that surrounded his name in Paris.

That letter, dated February 28, 1957, was the 281st that Matisse had received from Dubuffet. He was therefore well able to decipher the signals that lay beneath its surfaces. He also knew that the question of payment was going to come up again and again. On February 8, Dubuffet had written to him and said, "You will doubtless agree that I have waited long enough for what you owe me for paintings bought on July 14 of last year."

In the new European context, Dubuffet made his decisions in Paris, and with Parisians. What if one day he came to regard New York as a trading outpost, three thousand and more miles away, to which only a minor importance need be ascribed? Individually, the forewarnings might be tiny: a mention here, and a mention there, of new dealers coming around like flies to a honey pot; an echo of sales racked up in Parisian galleries, or of major shows imminent in other European countries. In those major shows, and in other ways, Matisse felt that his role was much discounted.

In February 1957, there was also the fact that, whereas on other occasions Matisse had come to Paris in January for the distribution of the previous year's output, there was as yet no sign of his arrival. This was doubly tiresome for Dubuffet. The paintings were tied up at a time when they should have been on the market. Furthermore, his sales were primarily to Europeans, or to Americans who had come to Paris. Devoted as he was to Pierre Matisse, Dubuffet wanted to get the show on the road before the summer recess.

The month of March 1957 was marked by a further stage in the usefulness of Daniel Cordier. His book on Dubuffet's drawings was to be published by the Editions de Monte-Carlo, a publishing house that had been bought by the enormously wealthy Banque Worms, with which Daniel Cordier was on terms of personal friendship. In this and other matters, Pierre Matisse felt himself to have been put on one side "like a ten-year mistress," as he said to Dubuffet, in favor of youth and novelty.

A startling episode, early in that same year, was Dubuffet's break with Jean Paulhan. In the late 1940s, Paulhan, as the longtime editor of the *Nouvelle Revue*

Française, was a person of the first consequence in the French literary world. He and Dubuffet were fast friends. He had gone to Algeria to spend time with the Dubuffets. In October 1956 he was invited to spend a month with the Dubuffets in Vence. At least one of Dubuffet's best portraits was of Paulhan. He had written a text on Dubuffet's early gouaches of wartime scenes in the Paris Metro. Dubuffet had liked it. In 1958 plans were well advanced for it to be used for an album of reproductions of the Metro scenes. Pierre Matisse was the designated publisher. All seemed well.

And then, on February 27, 1958, Dubuffet said that Paulhan had made a whore of himself by accepting an official prize. He had been seen on French television with a glass of champagne in one hand and something to eat in the other. He was a person of no importance whatever. His former prestige had been dissipated. Nobody took him seriously any more, and above all when he wrote about art. His books had zero sales. To further his own advancement, he never lost an opportunity of boasting in the press about his close friendship with Dubuffet. No such friendship existed, and Dubuffet could no longer bear him. His preface must be dropped forthwith. Dump him!

Pierre Matisse did not mind what happened to the minor art dealers who were shown the door, but he did mind about Paulhan. He had had amicable dealings with him about the text. His own good name had been pledged. A promise was a promise. He would have to tell Paulhan of the cancellation. Besides, there was no one around who could do better with a subject that was already a part of French history. Would it not be wiser to put the project aside for the moment? That would be his advice. And then he added, in a phrase that Dubuffet will certainly have noted, "I am among those who know how to wait."

In the late 1950s, and in the general scheme of Dubuffet's career, the case of Tapié, and even of Paulhan, was a minor matter. More important was the announcement in March 1958 that Daniel Cordier had been appointed as Dubuffet's dealer in Paris. "I don't know if you have heard it already," Dubuffet wrote to Matisse on March 7, "but he now has massive financial backing. He will shortly be moving his gallery to very much larger premises. He is very active and has achieved brilliant results. But above all he is loyalty itself and I like him very much."

With those four sentences, a profound and irrevocable change came over the partnership of Pierre Matisse and Jean Dubuffet. Nothing could be, and nothing ever was, quite the same. It was not a question of dismissal. Matisse still had his share of the new paintings. Cordier never did anything that can be construed as unfair. But, while putting Dubuffet's house in order, he planned to begin work on the massive *Complete Works of Jean Dubuffet.*

In this way, Cordier would be to Dubuffet what Christian Zervos had been to Picasso: the creator of an indispensable work of reference to which collectors, curators, historians, and dealers would all need to refer. It was a lifetime's project, and one that might ensure for Cordier the next best thing to immortality.

At an early stage in this project, questions arose that led to a quarrel between Dubuffet and Matisse. Those questions did not relate to payments made or not made. They began with what might seem a harmless enough enquiry. To get the *Complete Works* under way, Cordier and his staff needed to know the title, size, date, and present location of every one of the paintings and drawings by Dubuffet that had entered the Pierre Matisse Gallery since January 1947. Until those lists were forthcoming, correct in their every particular, and with a photograph in each case, the *Complete Works* would not be complete and could not go to the printer.

As a matter of fact, Pierre Matisse did not care for the idea of the *Complete Works*. He did not want to reveal the inner workings of his gallery even to Dubuffet himself, let alone to anyone else. Even less did he want the history of his own holdings to be revealed to the public at large. Least of all did he want to reveal it to rival dealers. Those dealers would fall upon the *Complete Works* for information that would otherwise be protected by the traditions of professional secrecy. In every catalogue raisonné there are, of course, concessions to anonymity, in which the words *private collection* are made to work overtime. Many of the sales that Matisse had made were a matter of public knowledge, more or less. What was not known, and what he regarded as nobody else's business, was the fact that close on four hundred of the paintings and drawings that he had bought from Dubuffet were still in his own possession, or in that of the gallery.

Meanwhile Pierre Matisse did his best to comply with the request. Given flawless filing, computerization, and a fax machine running red hot, the project could have got away to a flying start. But there was no fax in 1958. The only available computer was as big as a house. The filing, both in Paris and New York, fell far short of perfection, and it soon turned out that the Paris/New York axis was not well documented. What had been sent was often a matter for discussion. Even more so was what had happened to it after its arrival. Even the total number of works involved was by no means always clear to both parties.

The more he learned about this, the more Dubuffet was dismayed. Pierre Matisse had, in principle, bought half his entire output since 1947. This had been a period of maximum productivity. Never was there the least hint of an assembly line. Every canvas counted. So did every sheet of paper. But where were they all? How much had been sold, and how much had Matisse kept in his reserves?

Already in 1958 Dubuffet had asked Matisse to send him a photograph of

everything that had been in his hands in New York. On March 20, 1959, he wrote to say that as nothing was reaching him, he assumed that the project had run out of gas. But on April 23 he acknowledged receipt of a batch of photographs. He also spoke of a possible exchange of pictures between them. "I prize the pictures that I have here," he said, "but I'd love to get my hands on an early one. The trouble is that I have no idea which ones you have." For this and other reasons, more photographs would be very welcome.

By the summer of 1959, when Dubuffet in Vence was not far away from Matisse in Saint-Jean-Cap-Ferrat, the situation was taking an unpleasant turn. High summer days in the south of France do not always conduce to sweet good temper. Where the emotions are concerned, thunderclouds may turn up at any time. On August 24, for instance, Dubuffet wrote to Matisse and said that the last thing he wanted was to have another dealer in New York. "It's completely out of the question," he said. On August 26, Matisse drove over to see Dubuffet and they had what seemed to Dubuffet to be an amicable conversation during which all differences between them were settled.

On the following day, however, Matisse wrote to him and, in effect, gave in his resignation. "Once one has been Prime Minister," he said, "one is not going to sit at the end of the table and pick up the crumbs." His decision was clearly not owed only to the previous day's conversation.

It was prompted, rather, by the Eurocentric character of Dubuffet's plans and policies as these had evolved since Cordier's arrival on the scene. Neither New York, nor the United States in general, appeared to count. What had been done for Dubuffet in past years went for nothing. So did the adulation that had been extended to him by American museums and collectors.

The talk in Dubuffet's letters had been all of new exhibitions in Germany and Italy, new agreements with Ernst Beyeler in Basel and Heinz Berggruen in Paris, prices raised in agreement with Cordier, and new publications in which Pierre Matisse, though often tapped for money, was no longer the adviser and partner of first choice. The cumulative effect was to make Matisse feel that a cabal of European dealers had had its way and that, as he put it, "I have outlived my usefulness."

Pierre Matisse was a proud man, and an almost unbearable pain can be sensed in this letter. Anyone who looks at the catalogue of his Dubuffet exhibitions, or who goes through the photographic records of them, room by room, will see that on the chamber-musical scale that he favored those shows were masterpieces of advocacy. The texts were literature, not puffery, and the installations let the pictures speak for themselves without vapid "showmanship." Nor were they

ever too crowded. There was just enough to leave the visitor eager for the next time round.

Jean Dubuffet appreciated all that, but since Daniel Cordier's arrival he had become obsessed by quite another aspect of Matisse's activity. "If I complained to you," he wrote by return mail, "it was not because of what you call 'dealer's intrigues.' It is because I have gradually come to realize, these last few years, that you are not selling many of my paintings. This cannot be a mistake, because the figures that you have just given me confirm it. It may be that my pictures do not interest the American public, but it may also be they have not seen enough of them. That is why I would wish you to organize in New York – and perhaps in other American cities – some really substantial exhibitions of my work. I continue to believe that if the American public no longer shows the lively interest in my work that it manifested a few years ago, it is because my exhibitions have been too few and too small."

To this, Matisse replied that in the coming November and December he would present in his lately enlarged gallery a full-scale retrospective of Dubuffet in which between fifty-five and seventy paintings would be double hung. This idea was well received by Dubuffet, who wrote that he would have been appalled to see the end of their long partnership. Perhaps, he added, the time had come for the publication of a major book on his work with a text in English? There was no more talk of Matisse's resignation, and the search for archival documentation continued, thanks primarily to Patricia Matisse, who had been fielding almost daily demands from Paris on that score.

All this notwithstanding, the impending break between Dubuffet and Matisse gathered momentum. Dubuffet suddenly suggested that Pierre Matisse should put his entire holding of Dubuffets on view at one and the same time at a suitable locale in New York, and to arrange for it a nationwide tour thereafter.

If realized, this idea would have resulted in a mammoth tag sale, big enough to fill the Seventh Regiment Armory. Pierre Matisse was not disposed even to discuss it, preferring to work on the retrospective of seventy-seven works that opened in the gallery in November 1959. Photographs show that this was a genuine retrospective, in which the crowded and double-hung rooms gave an effect of energy and variety that few living painters could have rivaled.

Dubuffet was pleased with the look of the show, with the range and quality of the work, with the enlargement of the gallery and with the critical reception. He was also delighted that the paintings that he himself had sent for the show had been sold. But he was not so pleased to note how many of the exhibits were lent by museums or by private collectors. Once again, it seemed to him that the

public should have been encouraged to see more of what Pierre Matisse had kept for himself. How many others could also have been sold, had they only been let out of captivity?

Pierre Matisse said, as he had said before, that around eighty percent of what he had kept for himself had already been shown at one time or another. He also said that hesitant or uncommitted clients often judged paintings by the company they kept. These loans gave a particular tone to the show, and one that he would not have wished it to be without.

A few weeks later, on December 14, 1959, Dubuffet at last had in his hands a more or less complete list of the works that Matisse had bought from him since 1947, together with the buyers' names, and where they had been sold. Predictably, he was aghast. Of 340 paintings, 94 had been sold. Of 186 drawings and gouaches, etc., 46 had been sold. In other words, 386 works in all were still with Pierre Matisse.

From that point onwards there was never any chance of mutual agreement as to the propriety of what had been done, or not done. Pierre Matisse held to his position. He was master of his own ship. He had had many years' experience of the ways of the art market. He had every right to run the gallery as he pleased. Jean Dubuffet was more than ever outraged that nearly four hundred of his works had, as he saw it, been systematically sequestered from the American public, and that the public had been offered only an incomplete and spasmodic idea of his achievement. He wrote on December 14, 1959, that there could be no question of his continuing to set aside a part of his production for Matisse.

He went on to propose that Pierre Matisse should progressively put nine-tenths of his holdings on the market, keeping only one-tenth for himself. As for the earlier works, they should be sold off at the rate of no fewer than three every month.

During the first months of 1960 there were signs that a working compromise might be reached. (Matisse and Cordier were each to have one-third of Dubuffet's output, with Dubuffet reserving the other third for himself.) But Pierre Matisse was not at all disposed to dismantle his holdings of Dubuffet. Nor did he encourage the idea of a marketing extravaganza of the kind that comes with a subliminal message that EVERYTHING MUST GO and NO OFFER REFUSED.

But he did offer to give Dubuffet a ten percent commission on the sales of any paintings dated earlier than 1953 that were in his possession. He also stepped up his activity and sold thirty-seven Dubuffets between October 1959 and March 1960. This did not, however, earn him good marks from Dubuffet, who pointed out that as Matisse had bought twenty-three more Dubuffets during those same months, the overall reduction was smaller than had been agreed.

By the summer of 1960, the arrival of a letter from Dubuffet at the Pierre Matisse Gallery had become a matter for dread and dismay. Patricia got some pretty and well-deserved compliments, but no longer did Dubuffet write to Pierre and say, "How delightful it is when two people really get on with one another!" And although Matisse could still praise the new work from a full heart, and never failed to do so, he now despaired of the human contacts that it involved.

As in 1958, the nearness in high summer of Dubuffet in Vence to Matisse in Saint-Jean-Cap-Ferrat did not bode well. On July 29, 1960, Dubuffet wrote from Vence to Patricia Matisse to say, among other things, that for a number of reasons (relentless archival activity; a many-weeks' attack of lumbago; constant distractions with the new house in Vence) he did not have enough new work for an end-of-summer distribution between Matisse and Cordier. But, he added, "I should very much like to see Pierre. Could I make a little visit next week? Not for dinner, because I now eat only a handful of rice, like an elderly Chinaman."

If that visit ever took place, it is possible that Pierre Matisse, by implication, suggested that Dubuffet had been seeing Cordier on the sly to make a separate distribution of his new work. In any case, from then on, their relations worsened rapidly. On September 3, Pierre Matisse wrote and said, in essence, "We should stop now, my dear Jean. You no longer need me." Other and newer associates had taken priority. Dubuffet's new mode of activity no longer corresponded to Pierre's ways of working. Matters had been brought to the point of explosion when Dubuffet claimed that – in accordance with the so-called letter of the law – he could dictate what should be done with the close on four hundred works of his that still belonged to Matisse. Pierre ended by saying, "So there it is, my dear Jean. 'It has been fun!' as the Americans say."

Dubuffet replied both with a letter sent at once by hand and with a longer typewritten letter, ten days later. What Pierre had had to say was pure fantasy. He had never done anything to hurt or offend him. If Cordier was coming to Vence, it was to work on exhibitions or plans for exhibitions in Frankfurt, Milan, and elsewhere. He still wished to work with Matisse in friendship and trust. The only sticking point between them was that he wanted to keep rather more of his paintings for himself than he had done in previous years. He simply needed to keep them by him for a while, and not sell them too soon.

They really had nothing to quarrel about, if only Matisse would stop being so bitter and so suspicious. "Won't you both come to dinner next week in a pleasant and friendly way? And do please stop persecuting me."

It would seem that no reunion dinner took place, though Patricia Matisse did at some time go to see Dubuffet on her own account. On September 13,

Dubuffet returned to what he had said many times before on the subject of Matisse's "sequestered" holdings. It was the function of a dealer to sell paintings, was it not? A dealer should not hoard paintings for his own advantage, any more than a publisher should hoard books. Matisse's grievances were not fantasy, as Dubuffet had always thought. They were a way of deliberately avoiding the main point, which was that he was stockpiling Dubuffet's work for his own private advantage. That was why nearly four hundred Dubuffets remained unknown to the public. Meanwhile, Matisse was sitting on a fortune of close to *"deux milliards d'anciens francs."*

In this painful matter, nobody was "wrong," and nobody was wicked. Pierre Matisse was the loyal henchman of his artists. (When Jean-Pierre Riopelle was having a very difficult time at one point in his career, Pierre Matisse said, "If you go down, I'll go down with you!" and bought up everything that Riopelle had in his studio.) He had very firm opinions as to who should be allowed to buy from him. He would not sell to dealers who had made fun of him when he was desperately trying to get Dubuffet off the ground in the United States. He would not sell to the dregs of the trade. Nor would he sell to nonentities who came sniffing round to find out what he had, and how much he was charging for it.

Sometimes he would not even sell to clients who had already bought a Dubuffet from him. "If they've already got two, and they want a third, they can't have it," he said to Dubuffet. If he kept three out of every four Dubuffets that he bought, it was sometimes because he thought that the pictures were still undervalued, but it was also because he loved them and was in no hurry to see them go. And if his archives were not always complete – well, no more were Dubuffet's, if we may judge from the months and months that he spent in straightening them out.

And Dubuffet? Undeniably it is exasperating to have to nag and nag about money, year after year. And it is unnerving to think, or to believe, whether rightly or not, that one's work is being squirreled away, unseen. But the fact is that the Pierre Matisse Gallery between 1947 and 1960 was never awash with money. There is also the fact that Matisse from long experience thought it best to underload the market. In this matter, his father was the great exemplar.

In any case, by the end of September 1960 the situation was beyond repair. Pierre Matisse likened their joint troubles to a session at the U.N., where positions are fixed and arguments all too well known. "We have to put a stop to it," he wrote on September 23. "You never listen to anyone but yourself – and, of course, to the people whose gossip amuses you.

"What you say about me is offensive in the extreme, as you well know. You like to lash out at people and make them jump rope. For you, it's nothing special, but as far as I am concerned it comes straight from the shit-house, and I see no reason to put up with it."

Finally (and that is the only word that fits) he said, "I cannot end this letter without telling you that I shall never forgive the way in which you treated Patricia when she came to see you the other day. She left our house with the best intentions, and she came back a wreck. A gallant victory for you, Jean Dubuffet!"

Many years later, Pierre Matisse told Rosamond Bernier what had happened when Patricia Matisse had been to see Dubuffet. "He tried to get her to leave me. 'What are you doing with that jerk?' he said to her. When she walked out of the house, he immediately sent Cordier to New York to get him another gallery."

That was the end both of their private and of their professional relations. But there remained a curious and (on Dubuffet's side) a characteristic epilogue. On October 29, 1972, Dubuffet was in the Drake Hotel in Chicago. Apparently on impulse, he picked up his pen and wrote to Pierre Matisse as follows:

"My dear Pierre,

"I want you to know that, from the beginning and without interruption till now, the long severance of our relations has had for me the character of a game (and rather a cruel one) that we played with one another.

"On my side, it never had anything whatever to do with personal disaffection. I have always been convinced that you saw it in the same way.

"In my feelings for you, high esteem and warm sympathy have always been uppermost, with never any abatement.

"I salute you.

"Jean Dubuffet."

This was one salute that Pierre Matisse could have done without. He took his time before answering it, but on April 25, 1973, he replied as follows:

"My dear Jean,

"Thank you for your letter, and for the feelings that prompted it.

"I have never ceased to think highly and warmly of your work.

"The cruel game that you speak of is not one that I have ever wished to play. I am not equipped to fight with cutthroat razors, blade to blade. If the razors are now back in their cases, that is a relief to me. But the memory of them is too painful for me ever to forget it.

"Pierre Matisse."

Buoyant, but Then . . . , 1948–49

The year 1948 began in buoyancy for Henri Matisse. Not only was he pleased about pretty much everything, but his health – normally precarious, and with good reason – was relatively satisfactory. For the first half of the year, virtually all his news was good. One of the beneficiaries of this was his son Pierre, in that there were six, seven, and eight full months in which Henri Matisse was a happy man.

Good news had broken out all over. In April 1948, he was to have a major retrospective at the Philadelphia Museum. Organized by Henry Clifford, then a curator at the museum, this was to include ninety-three paintings, nineteen sculptures, and eighty-six drawings, together with prints and illustrated books.

Though not announced as such, this was in effect a neighborly challenge to Dr. Albert C. Barnes. Not only did Dr. Barnes pride himself on his Matisse collection, but he had never lost an opportunity of ridiculing the Philadelphia Museum, its trustees, its policies, and its staff. Confrontations of an explosive sort were to be expected.

A particularly spectacular and much-hoped-for ingredient in the show was the first version of the Barnes mural that had had to be rejected and entirely redone when it was discovered that Matisse had been given the wrong dimensions for it. This had been for some years in the Musée d'Art Moderne de la Ville de Paris.

Henri Matisse was particularly tickled by the idea of its arrival in Philadelphia. "Just imagine Barnes's face when he hears about it!" he wrote to Pierre. But he was anxious that the loan, if effected, might affect his son's professional relations – such as they were – with Dr. Barnes. "So make quite sure," he wrote to Pierre,

"that Barnes knows that you have had nothing to do with it!"

The big first version of the Barnes mural did not, in the end, make it to Phila-delphia. But, irrespective of that, Dr. Barnes felt that he was Matisse's appointed representative on earth. His was the greatest Matisse collection. He had, in more than one sense, "written the book" (as he thought) on Matisse. He alone knew a good Matisse from a not-so-good one. All this being so, everyone concerned with the upcoming exhibition looked forward to it with a mixture of dread and delight. Nor did Dr. Barnes disappoint them. Once the show was opened, he kept up a one-man, full-time guerrilla campaign against the museum, the show, and every-one – Henri Matisse not excluded – who had had a hand in it.

On April 29, 1948, Henry Clifford wrote to Pierre Matisse and said that Dr. Barnes "criticizes everyone and everything, and is hardly flattering to your father. He says that the show is all bad and is full of exactly the pictures that should not have been chosen. So it does seem as if your father can't be much of a painter if he did so many bad pictures!" Henry Clifford added, "Many people come to the show just to see Dr. Barnes. He's in nearly every afternoon."

Those who wearied of – or perhaps had simply missed – Dr. Barnes's well-honed vaudeville act could see for themselves that the show was by no means "all bad." At that time it was not, of course, possible to borrow the great paintings from Russia. The ones in the Barnes Foundation were likewise off limits. So were the masterpieces in the Statens Museum for Kunst in Copenhagen. But it was strong in paintings that were done long after Dr. Barnes thought that he had enough Matisses already. On the cover of the catalogue, for instance, there was the *Still Life with a Magnolia* that Lydia Delectorskaya had monitored from stage to stage in 1941.

The show also harked back to the sheet of paper on which, in 1945, Henri Matisse had drawn himself several times over in a letter to his son Pierre. Though drawn from a mirror in an identical pose and from an identical distance, the self-portraits were in no way duplicated. As Henri Matisse said in the catalogue, in words that later became famous, "Exactitude is not truth." Of the drawings made in the mirror, he said, "The anatomical organic inexactitude of these drawings has not harmed the expression of the intimate character and inherent truth of the personality. On the contrary, it has helped to clarify it."

Meanwhile, Henri Matisse's latest publication, *Jazz,* had been on view in Paris in December 1947 and was also to be shown in London and New York. Originally to have been called *Circus, Jazz* was something completely new for Matisse. It was not in the winter of 1947–48, but many years later, that its meanings were to be unriddled.

Nor was it quite clear even to the sophisticated public of the late 1940s into

what category *Jazz* should fall. With its twenty stenciled plates, its text handwritten by Matisse himself, and its amalgam of visual allusions, it was at once a book, an album, and a series of plates, each one of which could lead a life of its own.

Unless it were taken apart, *Jazz* could only be studied in depth by one person at a time. It was therefore not adapted to the needs of the public that came crowding into the bookshop-cum-gallery in which it was presented by Pierre Bérès in Paris. Yet the individual plates had a concision, a vivacity, and a compelling strangeness that even after half a century can still startle. As for the way in which Matisse had worked with cut paper to produce the individual images, it led directly to the large (and sometimes very large) works in cut paper that were to crown Matisse's long career in the early 1950s.

Henri Matisse enjoyed the adulation that *Jazz* provoked, but – as he told Pierre – what really amused him was the general impression in Paris that a very old gentleman had shown unexpected powers of self-renewal. In review after review, Matisse was described at being eighty, eighty-one, or even eighty-two years old. As he had only just passed his seventy-ninth birthday, he savored every compliment.

His health held firm. Early in January he said to Pierre that he had sailed through a two-hour session in the dentist's chair during which three teeth had been extracted. Later in the month he received a pair of American spectacles that Pierre had bought for him in New York. "They are the latest thing, and they make me look much younger," he reported with evident satisfaction. "But have I paid for them? I've asked you twice about them, but you never reply. As the mother of my optician in Nice brought them over for me, I don't dare walk past their shop until I know the answer. Just think of your old father bent double as he walks along the rue Massena. (The bending is 25% my age and 25% sheer embarrassment.) For Heaven's sake let's pay up!"

The auguries were also very good for what was to be his last sustained season as a painter in oils on canvas. He had just begun a large oil painting of a pineapple nestling in sheet upon sheet of wrapping paper. "The pineapple set me back 1,000 francs," he said to Pierre, but the money could not have been better spent. Matisse was to make magic with the pineapple, whether wrapped or unwrapped, on its own or as an integral partner in the great *Large Red Interior* of 1948.

In 1947 Henri Matisse had written to his old friend André Rouveyre and said, "I'm just a crazy old man who wants to start painting again, all over, and die satisfied. It's impossible, of course, but. . . ." As it turned out, it wasn't impossible. In paintings like *Large Red Interior* and *Egyptian Curtain*, both dated 1948, he really did "start again, all over." Alfred Barr in his *Matisse: His Art and His Public,* first published in 1951, in general kept himself (as was his nature) in the

background. It was as a truthful recorder, rather than as a sweet singer, that he set down the facts. But he could barely contain himself when he came to the *Egyptian Curtain,* where he described the curtain as "a barbaric modern Egyptian cotton with the most aggressive and indigestible pattern" and the scene through the window as "an explosive palm tree with its branches whizzing like rockets from the point where the black window mullions cross."

There was no trace at that time of the Matisse who had trouble getting started on a major painting and even more trouble in finishing it. On April 5, he wrote to Pierre that in the previous four weeks he had finished one big painting and two smaller ones and almost finished a new and very large one. "As we used to say in art school, that's enough to make the packers earn their money."

Even within his own family, everything for once seemed to turn out right. He had never before spent time alone with his daughter-in-law, Teeny, but when she came to see him in March 1948 he was amazed and delighted by her efficacity. "She is 'intrepid,' as we used to say in the north of France. (*Infatigable* is the better-class French word for it.) She made the most of her every opportunity both in Paris and on the Côte d'Azur. She went to see some of the six hundred plates that Picasso has decorated in Vallauris. I have seen them, too, and I have to say that they are extraordinary. He has been working on them every afternoon for the last seven months. When Teeny was here, she spent every afternoon with me."

Teeny had brought her father-in-law some drawings by her son Peter. He pinned them up on a door, together with some drawings by Jean Matisse's son Gérard. He did this both from affection and from a certain genetic interest. What could be learned from them? "There's a complete contrast between the two," he wrote to Pierre. "Gérard hews to the classic Mediterranean canon. Peter's imagination goes off on a high-wire of his own. I could give Gérard some advice, but with Peter I'd have nothing to say. I don't know where Gérard's going, but even less do I know where Peter's going."

In Vence, in the early months of 1948, he had more than one agreeable surprise. When Ida, the daughter of Marc Chagall, came to pay Matisse a call, he had no particular expectations. But Ida Chagall was nothing if not animated, and almost at once Henri Matisse was struck by the volatility of her features. Writing to Pierre, he said that "her mobility of expression is extraordinary. It reminds me of the way sunshine can make light and shadow race across a field of poppies when the sky is slightly overcast." He asked her to pose for him, and she did, more than once.

Henri Matisse never cared for casual socializing, and Vence in itself was not the most stimulating place in the world. He was glad, therefore, to have visitors, expected or unexpected, with whom he had something in common. During the

winter of 1947–48, more than one of them came over from Saint-Jean-Cap-Ferrat, where his longtime friend Tériade had a little house, the "Villa Natacha," overlooking the harbor. As editor and publisher of the review *Verve*, and as a man of wit, tact, and tenderness, Tériade was an incomparable human resource not only for Matisse but for a wide circle of friends and colleagues who were gifted, amusing, and (like himself) staunch.

It was, on the other hand, entirely by chance that Henri Matisse fell in with André Breton. As he described it to Pierre in a letter dated January 27, Matisse was at the train station in Antibes when he saw Breton and his wife. They were clearly in trouble. Matisse approached them, and gave his name, as if doubtful that they would know who he was. Breton and his wife had mislaid the receipt for their luggage. They had been invited to stay at the nearby house of Madame Cuttoli, a person of substance whose ambition it was to persuade the best painters of the day to make designs for tapestry. But Madame Cuttoli was away. The Bretons had no one to vouch for them. Could Henri Matisse help out?

As it happened, Matisse was wary of Madame Cuttoli because he had not enjoyed the experience of working on a Beauvais tapestry commissioned by her in 1935. Nor did he really have anything in common with Breton. They had met briefly in 1923, when Man Ray was photographing Marguerite on the occasion of her marriage to Georges Duthuit. Matisse was as indifferent to the art as to the politics of Surrealism. But Breton in the 1920s and 1930s had been a big somebody in a world that was full of little nobodies. The magazine *Littérature*, for which he was largely responsible from 1919 to 1924, is to this day an astonishment for its wit, its insight, and its originality. As librarian and adviser in matters of art to the couturier Jacques Doucet, Breton did a remarkable job. (When still in his late twenties, he persuaded Doucet to buy Picasso's *Demoiselles d'Avignon* and much else besides.) In 1925, and again in 1930, his Surrealist manifestoes were key documents of the twentieth century. As poet, editor, propagandist, controversialist, and all-round irritant, he was ubiquitous. During his years in New York (1941–46), he had been on good terms with Pierre Matisse, and he had just published a monograph on Yves Tanguy for the Editions Pierre Matisse.

And, finally, all agreed that as a personality Breton was immensely impressive. He was tall, upright, unaffectedly grand, and blessed with a magnificent head. He had the stately diction of an earlier age. A young American admirer once said of him in wonder that, "He was more than polite. He was courteous!" In conversation he could give himself completely, with a candor, a commitment, and an exorbitant and almost childlike enthusiasm. (He could also strike terror, by the way.)

So Henri Matisse bestirred himself. He fixed the problem of the Bretons'

luggage, and he dropped them off at Madame Cuttoli's. It turned out that they had to live, eat, and sleep in the kitchen of the house, with no access to its other rooms. Even in the straitened postwar years, this fell some way short of full-hearted hospitality.

The weather in Antibes was terrible. When Henri Matisse invited the Bretons over to Vence, they missed the connection at Cagnes. He sent a taxi to fetch them. And the visit turned out very well. "It was so long since I had had anyone over," Matisse reported to Pierre, "that I simply couldn't stop talking. It was agreed that the next time they come Breton will do all the talking."

So the Bretons became prized visitors. Quite clearly, they enjoyed every minute of the afternoons during which the talk flowed easily for two or three hours. On February 6, Breton wrote to Pierre Matisse and said, "A few days ago, when we arrived at Antibes station from Paris, we were greeted by someone whom I had so little expected to see that he had to tell me his name. It was your father. He at once took us to the house of Madame Cuttoli, which she has put at our disposition for two or three months.

"Henri Matisse is in magnificent form. We had a long visit with him in Vence and are to go back there tomorrow. Such are his kindness and his fine manners that he often telephones to us and even wrote me a letter. During the four or five hours that we spent there last time, his verve and his gaiety were quite extraordinary. I need not tell you how much we talked about you, and – one after the other – about Jackie, Paul, and Peter. It amused him enormously – don't be angry, because

Matisse at the Jardin Zoologique, Cagnes sur Mer, n.d.

Henri Matisse letter to his son, November 1946, about his activities in Paris

it was done with great affection – to imitate Teeny's way of speaking in French. He also got you just right in your way of saying, 'Oh no, Teeny, you can't mean that, you must be doing it on purpose.'

"He was in such great form that I could hardly get a word in. I was happy to see how much he enjoyed himself. The room in which he received us – lying down – was full of the most marvelous cut papers that he can make without getting out of bed. There is something almost Surrealist about the way they are done.

"I just wanted to tell you at once that an encounter like this towers way, way above whatever other pleasures the south of France has to offer." As it turned out, those pleasures were in short supply. Life at the Cuttolis' was neither easy nor comfortable. The Bretons lived almost entirely on meat, which they got on credit

from the Cuttolis' butcher. (Vegetables at that time were more expensive than meat in the south of France.) Madame Lydia learned, while sharing the Bretons' taxi one day, that they were really very short of money. "But why don't you talk to Monsieur Matisse about that?" said Madame Lydia. "Oh no, we couldn't possibly," said Madame Breton.

There was also the problem that in Paris André Breton was no longer the formidable figure that he had been before World War II. His first appearance on returning to Paris in 1946 was to speak at a meeting at the Théâtre Sarah-Bernhardt in support of Antonin Artaud, the great man of the French avant-garde theater. But gradually he became estranged from almost all the poets and painters whom he had known in the 1920s and 1930s. The younger names whom he sought to champion were by no means of the same caliber.

In this context, as in so many others, the key figure was Picasso. The Bretons had gone up to Vallauris, only to find that Picasso was just getting into his car to go to Nice. He excused himself for not asking them in, but made no move as to a possible appointment another day.

When Henri Matisse asked why that should be, André Breton traced it back to the moment in October 1944 when it was announced that Picasso had become a member of the communist party. This was taken very badly in the American press. Breton was among the French émigrés who were asked to comment upon the news. He could have spoken up for Picasso's right to his own opinions, but he didn't. "I joined the chorus," he said to Henri Matisse. A hard-liner himself – he did not hesitate to drop Max Ernst, a friend of many years' standing, after he accepted the Grand Prix at the Biennale de Paris in 1955 – Breton in his later years found that many a French door was closed to him.

Henri Matisse knew that, but he had had fun with them, and the Bretons had had fun with him. "It was a matter of human charity," he said to Pierre. "Those poor Bretons had nowhere else to go."

After Henri Matisse had been shipping the Bretons back and forth for quite some time, it became clear that Breton wanted to write a lengthy article on Matisse for a forthcoming issue of *Verve*. Matisse and Tériade had been on the best of terms for a very long time. As a publisher, Tériade was a born poet who worked on the closest possible terms with his artists. His house in Saint-Jean-Cap-Ferrat, not far from Nice, was one of the very few to which Matisse went with unfailing pleasure. For all these reasons, and quite apart from the unexpected enjoyment that he had derived from Breton's visits to Vence, Matisse did not wish to discourage the project.

But the question remained: what could Breton possibly say? He could not speak

for the Surrealists, since he had quarreled with every one of them. Matisse himself had never had any time for them. He had treated the Bretons "royally" – as he put it to Pierre – and he had not begrudged the money that they had cost him in taxis. "And yet," he said, "I am the only artist for whom he has never said a good word in print. He may have liked what I did. So did Aragon. But when I was attacked, he never defended me. If you didn't wear their uniform, you didn't exist."

And it is perfectly true that although Breton had handed out bouquets right and left to this painter and that, he had never mentioned Matisse, except in passing and without a word in commendation. "I think," he wrote to Pierre, "that Breton is quite wrong when he tries to keep Surrealism alive. I'm assuming that his text about me will not be a polemic, and that he will not attack other artists in my name. I also assume that I shall see the text before it appears.

"But now that Tériade is working closely with Picasso he doesn't dare to have Breton anywhere around. So he won't see him again until they are both back in Paris. And, by the way, Madame Cuttoli came to see me. I don't know if she had seen Picasso, but as she had been harboring Breton she was probably too scared to try. How small all these people are!"

On that same day, March 8, 1948, Breton came to call. "He brought with him two Surrealist magazines. I read some of them, but what with the illustrations and the texts, I found them so cerebral that I could not imagine what Breton could write about me. I am so remote from Matta's work that I feel like an old peasant among people for whom 'intelligence' is the only thing that counts. It reminds me of what Picasso said – 'In painting, "intelligence" is for the birds.'"

That would seem to have been the natural end of their discussions about the projected article. But Henri Matisse could not leave it there. "He was just going out of the house," he wrote to Pierre. "We had already said our good-byes when I called him back to say that I still felt that he was entirely on the wrong track. I was not intelligent. I was passionate, and I was egoistic. Those were the foundations on which all my work had been based. Nor did I think that I had had any links whatever with Surrealism.

"He laughed and said that it was always the people of real substance who thought that they were not intelligent. He also said that during the five years that he had lived in New York the painters whom he saw had never talked about Rouault or Bonnard or the others. They talked about me. Whether I liked it or not – he said – the Surrealists were among my descendants. I didn't know how to reply. But it is Picasso, and not I, of whom that should be said. Anyway, we parted on good terms, though that last exchange cost me 3,000 francs in taxi fares. I don't know what he will write, but I imagine he will seize the opportunity

to say that the Surrealists still have good work ahead of them. I told him that none of them have the real gift, and the only one that matters. Intelligence can never replace it. He did not attempt to reply.

"Tériade seems to be satisfied, but he did not want to see Breton here. (The subject of Picasso might have struck some sparks.) What makes it worse is that he wants to write something really solid – something 'important.' This number of *Verve* will be bigger than usual, and it will have all my new paintings in color. I told Breton in passing that Tériade does not want anything polemical. (Above all, he does not want to have Picasso insulted in *Verve*.)"

Tériade at that time was getting on enviably well with Picasso. In *Verve* for April 1948, there was an elaborate survey of what Picasso had done in Antibes in 1946. In the fall of 1951 there was to be "Picasso at Vallauris: 1949–51." In the fall of 1954, *Verve* would follow through with "One Hundred and Eighty Drawings by Picasso." Tériade would have been foolish to jeopardize this sequence by publishing a lengthy article on Matisse by André Breton in the fall issue for 1948, which was to be called "Vence 1944–48: Henri Matisse."

There was the further impediment that from February 1933 until February 1939, the most spectacular Parisian review of art and literature had been *Minotaure*. From its foundation until October 1936, Tériade was the artistic director of the magazine. After that, he resigned. As of the next issue, all traces of his influence, and of his taste, were expunged from *Minotaure* and Breton was, in effect, in command.

Thereafter, Tériade very naturally saw Breton as his enemy. The last thing that he wanted was to have André Breton in his forthcoming Matisse number. At the same time, and since Matisse seemed to be enthusiastic about the idea, he did not wish to offend him.

What to do? Well, it should be remembered that Tériade was Greek. (He was born Efstratios Eleftheriades on the island of Lesbos.) He did not proceed by confrontation, but in absentia. In other words, he did nothing. He never wrote to Breton. Nor did he say to Matisse that he had abandoned the idea. He let the summer run its course. Breton had not turned in his copy. Matisse was not pleased, and he let Tériade know it. But when the Matisse issue appeared, it was so extravagantly beautiful that all was forgotten. To the end of his life, Matisse loved to work with Tériade. Their edition of the poems of Charles d'Orléans, published in 1950, was the very perfection of bookmaking.

Meanwhile, Henri Matisse was not displeased with his general condition. "The only problem is that my stomach has got so big that I can no longer walk. If I manage 100 meters, that's my limit. I stay in bed a lot, and I've never slept so well at night. I used to think that if I ever began to sleep normal hours it would

be a sign of senility. I have the masseur come every day to make sure that I don't stiffen up once and for all. He tells me that I have very fine legs and the skin of a beautiful blonde. I don't think that he exaggerates, either. So that's how it is. One keeps going as best one can. Even Mistinguette still has her beautiful legs."

News of Picasso was always carefully noted by Henri Matisse and sent on to Pierre. "When Picasso was here last and saw what I had been doing, he said that he wondered when, if ever, I'd start going downhill. Picasso is still working at Vallauris. He's buying a house there. Masson went to see him. Miró is expected. There will soon be a School of Vallauris."

Meanwhile, Henri Matisse had given up on the idea that his could be a united family, in which everyone would be happy, nothing would ever be kept back, and no wound would ever fester. What he did retain, on the other hand, was the hope of a better future for his grandchildren. In August 1948 he was thinking above all of Gérard Matisse, the son of Jean Matisse and his wife, Louise. Gérard at that time was seventeen years old. His father and mother were living apart. After many years of hard work and indifferent success, Louise had at last found a solid market for her decorative ornaments. She had also come into a substantial sum of money from her father. She could at last afford to live on her own, by her own earnings, and she saw no reason to return to her husband.

Henri Matisse foresaw that Gérard would become the victim of a tug-of-war between his parents at a time when he should be deciding what kind of person he was and what he should do about it. He therefore threw his weight in favor of what might be called the transatlantic option. He remembered how during World War II Claude Duthuit had been shipped off to the United States. Pierre Matisse had taken good care of him in New York, and Claude had written home to say that Pierre had become his closest friend and that they were in agreement upon "many an important topic." Why should something of the same kind not happen again, thereby relieving Gérard of tortures that he did not need and would find it more and more difficult to deal with?

And so Gérard was sent to New York. Once again, Pierre excelled in the role of surrogate father. On August 21, 1948, he reported to his father at length that Gérard had been "blown away" by his first few days in New York. It would take him several months to deal with the avalanche of sensations that had come his way. But he had been easy and open with Jackie, with Teeny, and with Pierre himself. He responded spontaneously to others. He took everything in, though he took his time over it.

It was Pierre's opinion that "It would be a mistake to hurry him up, but at the same time we cannot let him go to sleep." Gérard seemed to realize that the

journey would leave him lighter in spirit and more open and more agile in mind. He would also be more ready to "give out" in others' company.

But Henri Matisse was not just sitting back and waiting for news. He wanted Gérard to have quite another kind of formative experience, and one that he would tackle on his own. With this in mind, he had written to the poet Aimé Césaire, who at the time had a double role in Paris. This was a time at which the African politician, who was also a gifted poet, was a well-known and much-courted presence in the postwar Parisian scene. As the representative of Martinique in the French Chamber of Deputies, Césaire was ideally well placed to further Henri Matisse's plans for Gérard. He could, in short, foster his journey to Martinique without in any way supervising it.

This was the more timely in that Gérard's father was beginning to grumble about his being away. "Please keep it in mind," Henri Matisse wrote, "that I have certain rights where Gérard is concerned. That is why I made up my mind to send him to America, though Jean did not wish him to go."

For someone of Gérard's age to go to Martinique on his own was in the eyes of Henri Matisse a prodigious adventure. "I only hope he's up to it," he wrote to Pierre, "because his father certainly isn't." But Henri Matisse was disquieted – not to say appalled – when Gérard wrote to him to say that although he was enjoying his travels he was feeling "a little bit homesick."

So he was homesick! Henri Matisse was ready to burst. "How can he make anything of his journey to Martinique – which by the way does not come cheap – if he's bored before he even gets there? I well remember how, when the boat stopped off at Guadeloupe, there was a beautiful blue sky filled with light. Beneath it were the glorious sugarcane plantations. I drove all the way across the island. Gérard could do that, too. What a pity if he makes nothing of his journey!

"Impressions made at his present age can form him forever. It would drive me to despair if he made nothing of it. But don't say a word to him about that. That he should find it all boring and have to hide that from me is something that I wish to avoid at all costs."

Meanwhile, there was bad news of Gérard's mother. "I am afraid," Henri Matisse wrote to Pierre, "that the operation you mention in your letter was not as unimportant as you supposed. I understand from Jean, who had it from her doctor, that it was an aggravated return of the illness that she had before. I think that she knows it, or at any rate guesses it. That's why she needs to be allowed to live relatively in peace. She inherited 240,000 francs from her father.

"That's why I am anxious that Gérard should have a lasting memory of his trip. Life in Paris won't be any fun for him when he gets back here."

On August 28, 1948, Henri Matisse wrote in detail about his plans for Gérard. All was arranged, and he only hoped that Gérard was ready and willing to set out for Martinique. Aimé Césaire had welcomed the idea and Henri Matisse was confident that Gérard would arrive back in France the richer for "a thousand marvels."

"Any boat will do," he wrote, "but above all a cargo boat. He would learn much more from a cargo boat than from any banal passenger ship. He will be met at Fort-de-France. For the passage home, he can make his arrangements in Martinique. A banana boat might be the best. Roger Martin du Gard and his wife came back on a banana boat and were very pleased with it. Ida Chagall traveled on a cargo boat and told me that she had never been so well looked after. As you can well imagine, I wish I could make the same journey, and at Gérard's age."

Henri Matisse's feeling for Martinique was shared both by his new friend André Breton and by his old friend the painter André Masson. In that same year of 1948, Breton and Masson had, in fact, been partners in a new book called *Martinique: Charmeuse de Serpents.* As a whole chapter in that book had been devoted to the poetry of Aimé Césaire, it would be fair to say that in asking Césaire to look kindly on Gérard's journey to Martinique Henri Matisse had got to the right man at the right time.

In this same letter, Henri Matisse added, "Not a word from André Breton, by the way. I find him deeply unhappy and inoffensive." Two days later, he said simply that "*Verve* will not have anything by Breton. Tériade will use 40 of my drawings instead."

These on the whole had been halcyon months for Henri Matisse. *Jazz* had been a success. So had his retrospective in Philadelphia. He had painted wonderful pictures. He had been reasonably well. He had made fast friends with his daughter-in-law Teeny. He had brought off a well-executed coup on his grandson's behalf. His works in cut paper were coming out just right. He had begun discussions with a Dominican novice, Brother Rayssiguier, about the projected chapel in Vence that would eventually occupy him until 1951. There were hopes that his son Jean might relaunch himself as a sculptor in demand.

November 1948 was looking black to Henri Matisse, and it was soon to look blacker still. It cannot have surprised him that on November 15 he heard from Louise that she was asking for a divorce from Jean. But then, almost by the same mail, he heard from Pierre that he had asked Teeny for a divorce, and that she had reluctantly agreed.

That Louise should wish to divorce Jean could not surprise him. But Henri Matisse had always liked Teeny. Since she had visited Vence on her own, he had

held her in high and particular admiration. There had never been any indication that her marriage might fall apart. In Pierre's letters, they had sounded like a prototypical happy family. If there had been difficulties, they had been airbrushed out of the written record. This, surely, was the one department of the Matisse family that came through with an ideally stable marriage.

Henri Matisse was so appalled by the news that for the moment he said only, "How can I answer the letter in which you announce your coming divorce? The die is cast." And he went on to say, "I dreamed last night that my family was filing past like moving figures in a fairground, and that someone was taking potshots at them with a rifle."

Pierre had also been dealing with a rumor in the American press that Henri Matisse was of partly Jewish extraction. This was not exactly the moment to raise it, and his father wrote back that "I cannot look further than today. You surely cannot imagine that I wish to occupy myself with some old story about my ancestry. People who want to prove too much end by proving nothing. To go into the question of whether or not I have Jewish blood seems to me a waste of time.

"No matter who may have preceded me, it is I who have made an important contribution to our family tree. As I have already told you, I know of nothing which could convince me that I have Jewish blood. So for Heaven's sake let's drop the subject. Don't we have enough tragic upheavals in our family already?"

After dealing in his usual completely professional style with some complicated business matters, he said, "Chagall came to see me. I found him perfectly acceptable. People say that he's very jealous because both Picasso and I get higher prices than he does. He's very much a man of his country – and of his race."

Even in Vence, there were exasperations. On the 21st of October, Henri Matisse had reported to Pierre that a forger "of Hungarian origin" and resident in Vence had been making paintings, watercolors, and drawings that he claimed were by Matisse. Not only had he attempted to market them right there in Nice, but he had claimed that they had been consigned to him by Madame Lydia, who had had them as a present from Henri Matisse and now wished to dispose of them discreetly. As the works were palpable forgeries, and as Madame Lydia had never heard of the forger, let alone met him, he and his story were quickly discredited.

When eventually Henri Matisse broached the matter of Pierre's divorce, he took his time and chose his words with great care. "I do not need to tell you," he wrote, "that your letter on the subject of divorce opened up yet another arena for familial catastrophe. When I was going through the most terrible days of my life, there were few people who showed me any sympathy – and none, I may add, among my children. En masse, they trampled me under foot without mercy, never

thinking that they themselves might one day be faced with the same ordeal, without having either the rights that I had or any excuses that were equivalent to mine.

"When you tell me of the stormy times that you are living through, I know perfectly well that you are not asking for my advice. You simply want me to accept the reasons for which you intend to compromise (or, I would say, to destroy) your entire family. Up till now, you have made a success of your life. You had good support, here and there, and you also had certain specific advantages. The most important part of your duty has already been achieved. It called for great efforts on your part, as I well know. Your changes of mind in other contexts have given me an insight into your character.

"And now you want to start again all over. All this you state quite clearly. But what you are hiding from me is one of the motor forces behind this tragedy – the identity of the other woman. If I know her, you must tell me who she is. Until I know that, your account of yourself is incomplete. All I know is that she is younger than you are. But how much younger? Her youth may not be an asset to your association in the long term. She may still have time to grow up. So watch out!

"When you gave me your news, I answered as briefly as possible. 'The die is cast,' I said, and you will see that I am right. If you are the prey of an obsession, you are not the first to be in that impasse (or *soi-disant* impasse). Napoleon said that 'in LOVE the one who RUNS AWAY is the winner.'

"Don't forget that you have a certain experience of intense passions. Deep as they may seem at the time, they don't always last long. Do you wish that you were still married to Clorinde? Remember how I was able to stop you from running back to her. I simply had to remind you that even during your honeymoon there were moments when you couldn't bear the sight of her.

"If you want me to be able to have any idea at all of your future, and of the future of your family, you must give me the name of the young woman. I probably know her. And watch out! A young woman has young claws, well sharpened. If she has character, that is. And if she hasn't, so much the worse for you.

"And I sign: H. Matisse."

In writing to his father, Pierre had dwelt at length on Teeny's many wonderful qualities. She was beautiful – during her first pregnancy he had said that she "walked like a goddess." She had a strong character. She had done very well by both himself and their children. She was "a force of nature." She had an enviable self-confidence, a natural joie de vivre, and an all-or-nothing quality. Everyone loved her.

So what had gone wrong? That invaluable word *incompatibility* seemed to sum it up. By Pierre's account, Teeny liked to discuss anything and everything.

Business or pleasure – it was all the same. She always had an opinion, and she liked her opinion to prevail. "We all have the defects of our qualities," Pierre said, and he himself needed a lot of psychological living space in which to make up his mind by himself. All his life, he had a reflective, broody, ruminative quality. He never talked for talking's sake. Nor did he bounce ideas in conversation for the sheer pleasure of the back-and-forth that might result. On the contrary, he felt enveloped, invaded, and taken hostage when every aspect of life had to be brought out in the open and argued to a finish. So often did he get the worst of it that he finished the day drained and dizzy.

The day came when, as he said to his father, "What was bound to happen did happen." He met somebody else, in whom he glimpsed a different order of compatibility. She also seemed to him to radiate the kind of calm that he needed to carry on with what he described as a twelve-hour day at the gallery.

She felt for him – as to that, he had no doubts – as he felt for her. After three years, he saw no alternative to a separation and a divorce. He had either to go or to stay, and he couldn't bear to stay. As to the young woman in question, "her name is Patricia Echaurren. She is the former wife of Matta, and she is 25 years old."

Henri Matisse in this entire matter never reproached or found fault with his son. But he grieved. Pierre and his family had been the only remaining matrimonial Matisse flagship. Pierre's special position vis-à-vis his father had been strengthened by his exemplary behavior as a son who was also, as it were, "in the business." But it was also important that he had a family life that to date had no blemish. Henri Matisse was in no position to scold, in a matrimonial context, but it pained him enormously that this last united element in the family was going to be dispersed.

With his mother, Pierre had to deal with quite another character. Amélie Matisse had deep and true feelings and held none of them back. "I have to say," she wrote on November 17, 1948, "that you are not a man of business, except by will or from necessity."

As to his proposed divorce, she said, "You will have to struggle against someone who is regarded by everyone, either in France or in America, as being made of steel. Her reputation will do your own reputation no good. I see you as embarking on a course that is more difficult than the one that you are about to abandon, and one against which you have not the strength to struggle.

"You are 48 years old. All my affection goes to Teeny and the three children. There have been rumors about your new attachment for a long time now. It was talked about all over Paris. May you never regret what you are going to do!"

It should be said at once that although Patricia (soon-to-be) Matisse was by nature abrupt, unpredictable, and intransigent, these were not the marks of a bad character, but of a fiery particle. Nor did the fact that she had previously been married into a Surrealist milieu with which Amélie Matisse felt no sympathy necessarily make her an undesirable wife for Pierre Matisse. But, in all contexts, Amélie Matisse spoke her mind. Hers was the true, unequivocal voice of a certain France, and it had its own grandeur.

Not long after that, the familial misfortunes were redoubled.

On January 24, 1949, Jean Matisse's wife, Louise, died alone of lung and breast cancer in a hospital in Paris. Jean heard the news by telegram by the *pneumatique,* an accelerated form of letter writing then still current.

"Poor Louise," Henri Matisse wrote to Pierre, "she had had all she could take. With the cancer, and with her marriage in ruins, I think that she had had enough and had no wish to go on.

Jean also gave unforgivable offense to his family in the matter of the *faire-part* that is sent out in France to family and friends on the occasion of a birth, a marriage, or a death. Convention requires that relatives both near and distant be listed in the order of their precedence. Errors in this regard, even if venial, can give rise to lifelong enmities.

Jean cared nothing for this, and he sent out a card that maximized all its possible hurts and annoyances. In effect, Jean's father, his mother, his aunt Berthe, his brother Pierre, and his sister Marguerite, not to mention his nephews and niece, had been erased from the family tree.

Meanwhile, Henri Matisse had been thinking further about Pierre's upcoming divorce. On January 9, 1949, after Pierre had been to see him in Nice, he wrote, "Since you left, I have thought a lot about the ending of your marriage. Often – even at night – it has obsessed me. If I did not say much about it to you while you were here, it was because I try to remain outside it, given that I consider you to be responsible for your actions. But the mere fact that I think about it so often persuades me my conscience will not allow me to maintain that attitude any longer. Please believe that I do not blame you for having got yourself into this situation. I understand how it should have come about. You cannot doubt that I should be glad if you were to find happiness with this young woman. But the difference in age still makes me anxious on your behalf. Is not that difference too great for you to achieve a *lasting* relationship? I am not speaking either of her qualities or of her defects, since she suits you the way she is. But the enormous sacrifices that you will have to make can only be justified by an attachment that will be lasting.

"When I speak of sacrifices I am not thinking of Teeny. If she were the only person concerned, I could not intervene in your disagreements. But I often think of your children, whose lives will be turned upside down. Despite what you say about their understanding and reasonable attitude, they will nonetheless suffer deeply, and perhaps all the more so because their unhappiness will be concealed. I deplore this severance between you – obligatory and inevitable as it is – because I think that until now you and your children have lived on ideally good terms. This is very rare, and it should be preserved as a great treasure."

As always, Henri Matisse had managed to write what he had felt unable to say. And – also as always – he knew when to drop the subject and turn back to his professional affairs. He himself had said to André Breton that "egoism" was one of the two motor forces behind his career.

Sometimes (as in the *Oxford English Dictionary*) the word *egoism* is defined as "systematic selfishness." But there have been few great careers in art in which an armored ego did not somewhere play a part. It would be fair to say that Henri Matisse was not interested in other artists, unless he had grown up with them, like Georges Rouault, Albert Marquet, Charles Camoin, or Simon Bussy, or been threatened by them, like Pablo Picasso.

It meant nothing to him that in January 1948 his son Pierre had put on one of the key gallery exhibitions of the twentieth century. Alberto Giacometti meant nothing to him, then or later. But this was not insensibility. It was the profound inner concentration that blinded him to anything except his own work.

In February 1949, which was to end with his eightieth birthday, Henri Matisse was delighted to hear of the success of his exhibition in the Pierre Matisse Gallery. It was to be his last exhibition at the gallery – before long, the Vence chapel and the very large cut-paper works would take all his energies – and Pierre had given it his very best shot. The paintings – classics of their date, and never seen before – were hung unframed, by mutual agreement, though Henri Matisse did grump rather about the cost of the frames that had already been ordered and paid for. The big black-and-white drawings had an almost overpowering presence. The works in cut paper were, by contrast, weightless and almost immaterial. This was a major exhibition in three equal parts.

"Your installation has been perfectly conceived," Henri Matisse wrote to Pierre. "That there are no frames seems to me to work very well. That is how they looked right to me, and although I had wanted to have frames (and had them made, though they didn't come cheap) I decided not to use them. What will their eventual owners decide, I wonder? That will be another chapter.

"I am delighted by what you say about the impression that the show is making.

It is that same euphoria that I have managed to provoke with my stained-glass windows – five meters high [16 feet 40 inches]. Wait till you see the same-size ceramics!"

An important event nearer home was the exhibition of the brilliant and daring recent paintings of interiors and still-life subjects, together with works in cut paper, two tapestries made at the Gobelins workshops, and two printed linen panels with Polynesian echoes. There was also to be a group of recent illustrated books – among them *Jazz,* the poems of Charles d'Orléans, the poems of Ronsard, the *Fleurs du Mal* of Charles Baudelaire, and (perhaps most beautiful of all) the *Lettres Portugaises,* published by Tériade in 1946.

This exhibition was to open on June 1 at the new Musée National d'Art Moderne in Paris. Though not a major exhibition in terms of size, it was a display of strength and versatility, and Henri Matisse wanted it to look just right. That was all the more important in that the new museum was housed in a building that had been held over from the Paris Exposition of 1937. The range of medium, scale, and subject matter was enormous. The spaces were ungrateful. Even the catalogue would have to be fought over, since Henri Matisse was not going to be fobbed off with the starveling scraps of paper that were standard issue in the Musées Nationaux at that time.

For that matter, Henri Matisse had never thought much of the Musées Nationaux. In 1931, the year of the great Matisse exhibition (one hundred fifty paintings and one hundred drawings) at the Galerie Georges Petit in Paris, the Musée du Luxembourg had just been repainted and reinstalled. Among its visitors was Matisse's then-young friend Tériade, who reported as follows on the new acquisitions: "Two Souverbies, two Brianchons, a Peigniez, a Deshayes, a de Castro, a Picart le Doux, a Pougheon, a Sigriat and a Mac-Avoy. . . ." Anyone can make a mistake, but this does not seem an inspiring list.

Thinking over his exhibition, Henri Matisse had an idea that was a great compliment to Pierre. It was also a considerable burden to Pierre at a time when he was busy in New York with important exhibitions, due in March and April, by Balthus and Miró.

Henri Matisse approached the matter with a certain solemnity. "As you are the Emperor of installationists," he wrote, "and although I don't know what your projects for the spring may be, I should be happy if you would act for me at the Musée National d'Art Moderne. Could you arrange to be in Paris at that time? If you could, you would do me a great service, in that I should not have to be in Paris at any given time. Nor should I have to take the risk of being in Paris in May, when the weather there is still uncertain. That might disturb, if not actu-

ally interrupt, my eightieth springtime, quite apart from the exhausting work that would be involved in the organization of the show. This whole question has a certain importance, in that the run of the show is from June 1 to September 25."

In effect, every single aspect of the show was being turned over to Pierre. It was the apotheosis in professional terms of his role as the indispensable confidant of his father. Would he dream of saying No? Never! And he did his damndest to see that from beginning to end his father's eightieth springtime would not be nipped by frost.

Giacometti: The Last Years, 1951–66

After his second exhibition at the Pierre Matisse Gallery (November 1950–January 1951), the reputation of Alberto Giacometti took on a new dimension. It was as if there had come into being a multinational, unscripted, and almost wordless agreement that to be around in the lifetime of Giacometti was something to be treasured and savored.

This was not a freak of fashion. Nor was it owed to farsighted career moves. Giacometti had neither planned it nor plotted it. If anything, he downplayed it. In the summer of 1950, when he was to have represented France at the Venice Biennale, fame was his for the asking. But when his friend and senior colleague Henri Laurens was wretchedly placed in the general scheme of the Biennale, Giacometti withdrew out of sympathy for Laurens and with no thought for his own advancement. He was what the ancient Romans had called a *vir probus:* someone who was probity itself.

Where another artist might have thought primarily of how to get ahead, Giacometti would wrestle for days with the problem of what names he should give to his new sculptures. In 1950, in his second show at the Pierre Matisse Gallery, there was, for instance, a sculpture, made in that same year, of a man falling forward. It took Giacometti forever to decide on *Staggering Man* as its title. Conceivably, he chose it in part because, in 1938, he himself had been run over at night in Paris and was still very sensitive to problems of instability. ("How amazing it is to stand upright!" he would say.) But perhaps it was also because a title, no matter how well chosen, can presume to define, and thereby to diminish, the effect of a sculpture.

Giacometti was also very skeptical of any attempt to "interpret" his work in another medium. On January 9, 1951, he was in Maloja and wrote to Pierre about a young man who had wanted to make a film about him and his work. Those were the early days of the "art film," and the young man had been carried away by the fact that Giacometti so often worked late at night in his studio. "What he said about my having retouched my sculptures in ways that I owed to the late-night shadows in the studio was totally wrong – pure fantasy, in fact. Naturally I look at the shadows, when my work is done. I may in fact find them useful. But I do not 'work from' the shadows. All the same," he continued, "the shadows, like the sculpture, must play their part. It is even true that until now the shadow may be more impressive than the sculpture. But it is the sculpture that should cast the shadow, and not the other way about.

"Even less is it because of the shadows that I work late at night. It is not because of the shadows that I am writing to you now, in the studio, after midnight. Nor is it because of the shadows that I have recently been making drawings in the night. Thank heavens that you did not install my exhibition to fit in with his ideas!"

In that same letter, Alberto expressed himself as overjoyed by all that Pierre had done for his exhibition. Reasonably enough, he hoped for news, catalogues, photographs, and press cuttings related to what had been a second landmark in his New York career. In that context, every artist is like every author. He or she cannot imagine that the dealer or the publisher in question has anything to worry about other than his or her activities.

As had happened more than once with Pierre's high-energy artists, Giacometti sometimes wondered why Pierre was not more prompt with the news of his exhibitions. It was from others that he heard of his great success. On February 16, 1951, six weeks after his show in New York had closed, he wrote that although he had heard enthusiastic accounts from people who had seen the show, he had still heard nothing from Pierre. Nor had he received the catalogue, with which great trouble had been taken. Nor had Pierre sent him any money, though Giacometti had already told him how much he needed it. "I count on you absolutely not to keep me waiting any longer," he wrote.

On March 22, 1951, he had to write again. "I am perplexed," he wrote, "to have heard nothing whatever about this ghost exhibition. Not a photo, not a word from the New York press, nothing of what you had promised. Nothing but a sudden and total silence about the projected catalogue, over which we had taken so much trouble. I cannot understand how you can think it natural to leave me so completely in the dark. I have nothing more to say about this wretched exhibition."

Giacometti was particularly disappointed about all this because he had turned

away several American collectors who had passed through Paris and asked to buy something of his. In loyalty, he had referred them to Pierre. But he felt that he had lost Pierre's attention. In the end, and writing to Pierre late into the night, he used very strong language about it. Hardly was that letter sent than he could hardly believe he had written it. Could those words, scrawled at the bottom of a battered scrap of paper, really be his? By the end of a long evening of bar hopping he was not always quite himself. Eighty cigarettes a day and a succession of drinks had done their work.

And yet, Goddamn it! (not that he ever invoked the deity), he had reason to be impatient, and reason to be disappointed. He was deeply sorry for what he had said, and yet . . . there were still the bills to pay. And those bills had been incurred on professional business, not in debauch.

Pierre Matisse was heart and soul behind Giacometti, as was his wife, Patricia. But in the first months of 1951 he had crucial exhibitions of both Miró and Dubuffet in his gallery. They needed all his attention. Pierre ran a very tight ship in New York. In our own day, a fleet of deftly persuasive salespeople would have been going to work. But Pierre had a tiny staff, and he didn't really like anyone but himself to close a deal. Previous exhibitions were not forgotten, but the urgencies of the moment came first.

Giacometti in his studio, c. 1964. Photo: Budd, New York

Other problems arose. Pierre's correspondence was still largely in longhand, though the typewriter from time to time made a cameo appearance. Giacometti, for his part, was not exactly nature's accountant. The duetting of American dollar and French franc was not yet stabilized. There was, moreover, an element of human forgetfulness that could not be excluded. At the height of their disagreements, early in the year 1951, it turned out that both Annette Giacometti and Patricia Matisse remembered that in July 1950 Pierre Matisse had arrived in Giacometti's studio. "I have something for you," he had said to Giacometti as he handed over quite a sizable check. Alberto had forgotten this episode.

Both Pierre and Alberto were subject on occasion to quirks of memory. But, for Pierre, it was a recurrent problem that behind the figure of Aimé Maeght the co-partner there might lurk the figure of Aimé Maeght the competitor. This problem was heightened by the fact that it was above all Giacometti the sculptor whose work was in ever-increasing demand. When Giacometti first began to make lithographs (in 1951, at the suggestion of Pierre Loeb's brother, Edouard), it was difficult even to give them away. For years, a very good drawing by him could be had for $100. It was a sadness for Giacometti that Pierre did not always seem to respond to his paintings. The sculptures were quite another matter.

But to deal with a large body of sculptures, both present and past, and to keep tabs on every transaction that was involved – these were tasks that turned with time into a very considerable operation. There was the casting, and the patinating, and the numbering of the edition, and the possible subtle differences between one cast and another.

As time went on, and when there was a demand for some of the older sculptures to be sent to major retrospective exhibitions, there were distinctions between those that were patinated, those that were left in "natural bronze," and those that in later years were painted. There was also the damage that could be done in transport, and the difficulties of repairs. And where two dealers shared the output, a certain paranoia could intervene.

In the spring of 1952, Pierre was disconcerted not to get any new sculptures from Giacometti. He could be forgiven for thinking first of Aimé Maeght. He also thought of at least one "colleague" in New York who would have jumped at a consignment of new work. So he sent Giacometti a cable.

On May 18, 1952, when he was in Stampa, Giacometti replied to Pierre: "It is only today that I can reply to your cable. It is entirely unjust. You may be disappointed that I have not as yet sent you anything new for the exhibition in New York. I, too, am disappointed, and quite probably more so than you are. But don't talk to me about 'indifference' and about your 'colleagues'! I have given

nothing to anyone. Nor have I done anything for anyone. If I had completed anything to my satisfaction, it would have been for you. And I know that you would have been even more 'disappointed' if I had sent you something that was not an advance upon what you had seen already. If I do not believe in a sculpture, the last thing on earth that I would allow is to have it photographed and cast in bronze. I am at that stage right now, and it is more difficult than you may think to take the next step. But I hope that in June I shall have something new."

Even so, the problem of Maeght never went away. Even in what was literally a minuscule context, it could almost get out of hand. In October 1953, there was the case of a group of the very small figures that Giacometti had made during World War II in a hotel room in Geneva. They were famously, dauntingly small. Pierre had never quite dared to ask Alberto if he could show them in New York. He was appalled, therefore, to find that several of them had been seen in a vitrine in Aimé Maeght's apartment on the Avenue Foch in Paris. How could he not have been given equal access to these figurines?

"Because you never asked" was the gist of Giacometti's reply. It had more than once been a mystery to him that when Pierre came to his studio on the rue Hippolyte-Maindron in Paris he stayed forever, looked and looked with evident fascination, and yet rarely said anything. Giacometti did not expect, or want, the kind of slam-bang adulation in which some dealers specialize. But he was puzzled by Pierre's extreme discretion.

The matter of the tiny figurines was clearly a case in point. On October 16, 1953, Pierre wrote to Giacometti and said, "I waited for you to decide about the figurines because I knew that you were busy at the time with sculptures that were very much larger and that it might be a nuisance for you to be interrupted. I could not possibly ask you to stand with your back to the wall while I gave you a firm deadline. You would never have agreed to it, because you simply didn't want to. Please let me say, once and forever, that if I did not try to force your hand, it was because I felt – rightly or wrongly – that you had lived for a long time with the little friends in question and that they had become a part of yourself. I should have been embarrassed to break in upon feelings that touched you so deeply. I may add that you never gave any indication of those feelings except that you were forever 'forgetting' to decide how to show the figurines. I took that as a sure sign. But . . . I was just too reticent about it!"

Giacometti replied that he thought that it would have been better if Pierre had spoken out more freely and promptly. If Pierre had given him a firm deadline, he would have sent the figurines on time. And, while they were getting things straight between them, there was the matter of the paintings and drawings that

Pierre had had in his stock, sometimes for five or six years, and had not managed to sell. There were also the six or seven recent paintings that he had sent some time before. In his view, these were the best that he had, and he had set them aside expressly for Pierre. He could have sold them easily in Paris, and Pierre seemed to have lost interest in them. There were also the drawings – close on one hundred in all, and every one of them chosen with great care – that Pierre had been receiving from 1954 onwards. Giacometti had heard nothing of them, though they, too, could soon have been sold in Paris.

Nor was this all. Throughout the spring and summer of 1953, he could have sold painting after painting to American visitors. He had always refused. But, as Pierre did not seem to be interested in his paintings, this state of affairs was very much to his detriment. Theirs was, in other words, a unilateral situation. He could not sell his paintings, and Pierre didn't want to sell them. "I do not think that you can disagree with me on that point," he wrote, "but I'd like you to tell me what you think about it." And, he said, "perhaps you could send me a little money. I have to pay the founder, and I have to live. I must also tell you how happy I was to read that you were interested in my new sculptures, and above all that you thought that they might perhaps show some progress."

Then, as on other occasions, Pierre did send money, though not always as promptly as Giacometti would have liked. Before money could go out from the gallery, money had to come in, even if the bank could sometimes take up the slack. Pierre sometimes felt obliged, whether in duty or as a matter of courtesy, to tell his artists just how difficult it was to make every one of them financially secure. In doing so, as he wrote to Giacometti on October 14, 1954, he sometimes brought them face-to-face with "rather painful problems of which they would certainly have preferred to know nothing."

This was a delicate matter, in that Pierre and Patricia had recently become the owners of a villa in Saint-Jean-Cap-Ferrat. Those were precarious times, all over Europe. The "Villa La Punta," though by no means the largest or most luxurious house in the neighborhood, had the stamp of a certain substance.

"I think I owe you an explanation," Pierre wrote in that same letter. "To have acquired this house at a moment of great difficulty, worldwide, may have seemed to you wildly extravagant. It may even have seemed to you to have been a possibly disreputable use of the gallery's money. But the truth is that this villa was given to Patricia by her grandmother. I had nothing to do with it, and all the more so as the house was already completely furnished. We were able to walk into it as if we had rented it for the summer instead of going to an hotel. Quite apart from that, I was in a difficult position, as often happens in business. Once again, it

was Patricia, with the utmost devotion, who came to my rescue and made it possible for me to meet the most urgent of my obligations (and you know how urgent they were). All summer long, I had waited for projects to be realized that finally came to nothing. When we got back to New York, I at least had enough money to make sure that the wheels would keep turning normally. After having tried your patience so often, I thought that I owe this little explanation."

When the tiny figurines at last got to be shown in New York, they did not look like pinheads. They looked like monumental sculptures, each one of which stood upon an even more monumental land mass. Expectation was reversed, thereby. The notions of large or small, far or distant, were turned inside out. Though startling at first sight, the figurines commended themselves to some very good judges, and above all to Thomas B. Hess and his wife, who later gave a small group of them to the Museum of Modern Art.

On May 4, 1954, Pierre wrote and said, among much else, "I have just read in a newspaper that you are to have an exhibition at Maeght's on June 18th! How about that for a surprise! You must have been doing a lot of work since last February. It goes without saying that if you have made some new sculptures I should like to know what they are. I should also be much obliged if you would, as always, keep for me nos. 1, 2, and 3 of the six casts."

Year in and year out, the question of Maeght was a recurrent irritation to Pierre, who very much prized his exclusive status in New York where Giacometti was concerned. In December 1955, he complained to Alberto that one of his rivals in New York had got in first with a recent bronze by Giacometti that had not even been offered to Pierre. This was all the more exasperating in that the dealer in question had claimed that, as an old friend of Giacometti, he had been able to deal with him directly.

On Christmas Eve, 1955, Giacometti replied that he, too, was disgusted by this incident. "Never have you had so many reasons to be infuriated," he wrote. "I made the mistake of giving a new bronze to Maeght before I had sent it to you. But I never dreamed that he would immediately sell it to another dealer in New York. He should never have done it. I was suspicious when I read the words 'Fresh From Paris' in the dealer's announcement. But I could never get Maeght to tell me to whom he had sold the bronze. I shall tell him what I think of him when he gets back from the U.S.A. As for your 'colleague' in New York, it is simply disgusting (or any other word you like to use) that he should claim to have bought from me directly and that I am a close friend of his."

Giacometti was not, and never pretended to be, his own archivist. Nor did he have (or want) someone constantly at hand whose job it was to keep a detailed

record of his activity. He was quintessentially a private person who went about his private business. But by 1955 the world had caught up with him. So had a number of people who resented his new status in the hierarchy of living art. One of them was Jacques Lipchitz. "Lipchitz has always something bad to say about you," Pierre wrote on April 20, 1955, in a letter to Alberto. It appeared that on this occasion Lipchitz had said to G. David Thompson, who had bought a great many Giacomettis, that there was something wrong with the date – 1932–33 – that Giacometti himself had given in 1948 for a sculpture called *The Spoon-Woman*. This was a grand, plain, simplified vision of femininity, with some radical anatomical eliminations. It was closer to Brancusi than to the surrealizing idiom with which Giacometti had had some associations in 1932–33. Yet there it had been, in Giacometti's own handwritten list, as "1932–33," and people were beginning to make mischief.

Giacometti was in Stampa when Pierre wrote to him about it. He replied that it was quite simple. He had made a mistake. He had made the list at the last minute, in Stampa, in a great hurry. It was only after finishing and signing the list that he added *Spoon-Woman* (which he then called simply *Big Woman*) and dated it wrongly.

In Paris he had an old notebook in which he had noted down, with little sketches, almost all the sculptures that he had done since 1925. *The Spoon-Woman* ("and by the way we must change that name," he said) was right there, and dated exactly. Done between the end of 1926 and the beginning of 1927, it had been shown at the Salon des Tuileries in 1927. "I can still see the place where it stood, with Henri Laurens looking at it."

So much for those who said that it could not have been done in 1926. But Giacometti was still troubled at what he himself had said in 1948. Pierre discouraged this, and said that there was really no reason for Giacometti to offer himself as a human sacrifice because he had made a mistake. As for the hostility of Lipchitz, Pierre didn't know which of the two of them – Alberto or himself – Lipchitz disliked more. "But there's one thing," he said. "You'll never see Lipchitz in my gallery."

As will by now be clear, the role of practicalities grew ever more important in Pierre's correspondence with Giacometti. But there were still occasions on which they were kept at bay. This was especially the case in November 1956. Pierre and Patricia had gone with Alberto and Annette Giacometti to visit Balthus in the Château de Chassy, where he was then living. Balthus and Giacometti were very old friends, and Pierre had worked with Balthus since 1938. The visitors were captivated by Balthus's seignorial way of showing them round Chassy. Giacometti seemed to be rather taken with Balthus's niece by marriage, Frédérique Tison, who was living in the house. Pierre went to work with his camera. The visit was

entirely agreeable. Once he was back in New York, he had the idea that Giacometti might agree to write a short foreword for Balthus's upcoming exhibition. "Just write it like a letter," he said.

Giacometti enjoyed the holiday snapshots, taken at Chassy, that Pierre had enclosed. He thought that he himself looked awful – "in photographs, I always do," he said, and Annette was distressed that there were no photographs of Patricia. Even so, the little package was well received. But as for Alberto agreeing to write a preface, or indeed anything at all, about Balthus, the idea was just totally impossible.

"Now, more than ever," Giacometti wrote, "my work takes all my time. I never know where I am with it. Almost every day, and several times a day, I have different feelings about it. What happened even half an hour ago is just meaningless. I continually see things in a new way. This applies to what I am painting, and to everything else. It applies not only to nature but to painting itself. If I look at a painting by Rembrandt today, I never see it the way I saw it yesterday.

"All this means that I never have a fixed idea about a painting. I never know quite what I think about it, and it is quite impossible for me to write anything about the paintings of Balthus, any more than I could write about Miró or Picasso or Buffet or Dubuffet or Riopelle or anyone else. With the paintings of Matisse, or Derain, or Bonnard, I stand on firm ground. But if I were to write a preface for one of them I should get hopelessly entangled.

"I am very sorry not to be able to write about Balthus, but for the last four weeks I have been living as if in exile. It has never happened to me before. I feel as if I am running through a huge open landscape in countries I have never seen before. I continually come across new scenes where the horizon has no limit. Nothing may come of all this, but. . . .

"Do not be angry with me. If you were here and we could talk about the preface, I could explain it more clearly, and I am sure that you would agree with my decision. This evening in Paris, we can think of nothing but what is happening to the world. It's pretty terrifying."

In November 1956, when Europe was certainly in a most ominous state, something happened to the correspondence between Pierre Matisse and Alberto Giacometti. It was both constructive and confirmative, and it happened almost without either of them knowing it. In France, people can address another either as *vous,* which implies a certain distance, or as *tu,* which is a familiar usage that can cozy over into either intimacy or impertinence.

Pierre Matisse and Alberto Giacometti had been writing to one another for twenty years. Pierre in general was reserved in his demeanor. Alberto cared noth-

ing for hallowed social nuances in his relationships, whether written or spoken. There had been moments of high emotion in their correspondence, but they had kept to the *vous* form. And then, on November 29, 1956, Pierre used the word *tu* in their correspondence. "I realize," he wrote, "that the change is not as easy as I had expected. We form habits. They seem natural at one stage in life, and yet there comes a time when they no longer sound right. One thinks in terms of *tu*, and yet the pen writes *vous*. I think of how the ancient Romans addressed one another in the Senate, and of the adorable way in which Italians address one another today. How much time we others lose!" But in January 1958 the relationship between Pierre Matisse and Alberto Giacometti ran into trouble. Pierre had scheduled, announced, and advertised an exhibition of new work by Giacometti for March of that year. Expectations had been aroused. Money had been spent on publicity. Other artists had had to wait for their turn.

And now, at 3 A.M. one morning early in January, Giacometti picked up his pen and wrote to Pierre in a wild, scrawling hand. There could be no exhibition in March, he wrote. Unless he could include "five or six or, better still, eight or nine" new sculptures, he would simply be cutting the grass beneath his feet. He had never worked so hard, he was totally exhausted, and he could not possibly do what he had hoped to do in the month of January. "Little by little," he wrote, "I have had to lay aside my paintings, and the sculptures that I had begun, and concentrate entirely on a single head. This is partly, or more than partly, because we decided to have this exhibition. I have begun six sculptures that are beginning to go a little better and could easily be exhibited in an early state. I have made six plasters of the head, one of which could be sent to the foundry. Two or three others could be shown. I have worked a bit on my painting and last night I made some real progress."

Other sculptures and paintings were ready to be sent off, but they were not indispensable for the exhibition. To make an exhibition really worth talking about, he needed the new sculptures, together with the new paintings that he was doing at that moment, and twenty or so new drawings. He hated to put off the exhibition, but he needed at least two more weeks to get it ready. "It just has to be that way, even if it annoys you," he wrote, "and I count absolutely on your agreement. Not to do this show in this way would make no sense at all." These were the only conditions on which he would agree to go forward.

If he could only have as much time as he needed, he would gladly pay some of the extra expenses that would be involved. He would also give Pierre a group of earlier works. And he ended by saying, "This will be the first exhibition in which I can realize something approaching what I want, and that is the only thing

that counts. Please cable your answer, and above all don't be angry with me."

This would have been bad news for any dealer. But it was not for nothing that Pierre was the son of a great artist. He had lived, year in and year out, with the outsize dissatisfactions that have their role in creativity. He also knew that Alberto Giacometti was the real thing and the right thing.

So he took it gently. This was the third time that Alberto had asked for the exhibition to be postponed. Given the nature of the New York season, which at that time died a sudden death at the beginning of June, May 5 was the last possible opening date for the show.

"Your letter knocked me flat, at first," he wrote back to Giacometti. "You know that this is the third time that the show has been postponed. In December it was announced for March. In January it had been put back till April 15. Now you ask for May 5. All these dates have been advertised in the magazines. People will take me for a madman – or, what is even worse, for an amateur!

"Naturally you knew perfectly well that I would go along with your wishes. But now I have to find myself an exhibition for April, and I have no idea what it can be. I sent you a cable and asked you to stick to the date in May. It cannot open later than May 5, because I have to play my cards right, as a dealer, just as you have done, as an artist, in asking for more time to get the show ready. As I am leaving for Europe in the first week of June, any further postponement is quite out of the question.

"As to what will be in the show, please let me tell you that I think I know how to avoid the dangers of overcrowding. In most places, and especially in Paris, exhibitions are overloaded in the hope of impressing the public. Perhaps you could leave it to me to avoid that. Herbert Matter has just made a magnificent photograph of the nine *Women of Venice* for a double-page spread in the catalogue. But now I don't even know if they will be in the show. As I don't know what you will finally send over I don't know what to leave out of the show, but in any case I think that the nine women and the dog should be in. For the rest, we'll decide when the work gets here."

Pierre was able to fill the empty slot in March 1958 with an exhibition of sculpture and drawings by the Italian sculptor Marino Marini. Now that the date had been firmly and finally fixed, Giacometti began to have premonitions of doom. Sitting in the Coupole at one in the morning, he took out a ballpoint pen – not his favorite invention, by the way – and wrote to Pierre: "I really wonder what I've been up to these last 35 years, during which I never really looked at anything . . . I woke up at nine this morning and was terribly worried about our exhibition. I thought of writing to tell you that it was impossible, totally

catastrophic. I didn't do it, and yet 'catastrophic' may be the only word for it. These last few days I've been a wreck from exhaustion. Yet the decision to have the show has been a great help to me. I'm impatient to see what will come of it tomorrow and I shall keep up the same pressure till March."

Once again, Pierre knew exactly how to handle Alberto's agitations. "If the exhibition has to be a catastrophe," he wrote back, "then we must make sure that it's a successful catastrophe. As a catastrophe, it may have a great success and be a sellout. If it's not a catastrophe, it may be a complete failure, with nothing sold. So the best thing is for you to keep on working, as you did last year, and as you'll do again this year. Then you stop at the agreed date and send it all to me."

And, sure enough, that is exactly what happened. Giacometti wrote that he would be sending eight or nine new sculptures, plus the drawings and some paintings. There would therefore be more than enough new work for the show. He had suddenly had an intense longing to make big sculptures at top speed. Diego had prepared the armatures and made the bases or plinths, and between 8:30 one evening and 1:30 the next morning, two big sculptures were almost completed. ("You'll have nothing to do," he wrote to Pierre, "because the sculptures have to be at exactly the right height above the ground.")

At 3:30 A.M. on April 24, 1958, Giacometti wrote that he had given eleven new paintings to Lefevbre-Foinet for dispatch to New York, together with three sculptures and seventeen drawings. "This exhibition has already done me an enormous service," he wrote, "and all the more so because it had to be done in a hurry. In the last two or three days, my work has gone better and better. Appearances notwithstanding, I have never had the patience to concentrate for long enough on any one thing. . . ."

As to the exhibition, he was pleased if Pierre was (on the whole) pleased. "That is the essential for me," he wrote on May 16, 1958. "And it's enough for me, at any rate for this time round, if it makes a little money for you and is not a catastrophe. Apart from that, I can really only see how precarious was the work that I sent you. So, if it holds together even a little bit, I'm already pleased.

"Still, I can't imagine what the show looks like, because I saw it in terms of pieces that had their own separate existence. I shall be very interested to see any installation shots. And please do send the reviews – especially if they are bad, or at any rate not very good. Those are the ones that really interest me. And, by the way, don't be worried about Maeght. He didn't get as many pieces as you did."

By October 6, 1958, Giacometti doubtless thought that Pierre was back on the job after the summer hiatus. He seized the moment to say that he really

had to have some money to pay for what he owed Susse, the founder, for the many casts he had had made in the summer. "If you tell me you don't have any money," he said, "that means nothing, in this case. I simply have to pay Susse's bills. Tragic as it may be, you just have to go out and find some money by no matter what means and send it to me, SOON. I count on it ABSOLUTELY.

"I'm sorry that you left Paris so soon. I'm working harder than ever, and I'm longing to come up with something that has at least some faint resemblance to sculpture. I don't think I have ever quite done that before."

It was in December 1958, when he was in Stampa, that Giacometti was asked to consider a project mooted by the American architect Gordon Bunshaft, who was chief designer for the firm of Skidmore, Owings & Merrill. This was for a monumental sculpture, or group of sculptures, to be placed in front of the new Chase Manhattan Bank, in the Wall Street area, for which Bunshaft had been responsible.

This could have been thought of as an inspiration, in that Giacometti was by then regarded by many good judges as the poet laureate of metropolitan spaces. City squares had appeared from time to time in his sculptures from 1947 onwards. They were bare spaces, unadorned and unidentified, across which one or two people were moving. It is this very anonymity, this lack of architectural identification, that captured the imagination. The one or two people in question were absorbed with their own thoughts and their own business. There was zero contact between them. Sometimes they varied enormously in height, and it was not unknown for a very large head to join their company.

Though not in any way intended as illustrative, Giacometti's squares soon became part of the lingua franca of contemporary life on the Left Bank in Paris. In the streets and squares that he himself frequented, it was as if his sculptures had come to life and merged with the routines of the everyday. To a mysterious degree, we were his people, and they were us.

It was natural to wonder if those same figures could not be integrated on a larger scale into a specific architectural environment. When the poet Louis Aragon asked Giacometti if he would one day like to be given a city square to do with as he pleased, he said that he would enjoy it if he were given a completely free hand. He did not want his work to dominate the square. Still less did he want it to be raised high above the passersby. Nor did he hanker after a square that already had a conspicuous nobility. It was not the Place Vendôme or the Place de la Concorde that he craved. Nor was it the Place des Vosges, over which Louis XIII, King of France, presided on horseback.

What he wanted was a workaday square. He even fancied the Place Maubert, in the fifth arrondissement, which was not strictly a square at all. His sculpture

(as he then imagined it) would be the smallest thing in sight, and not the largest. It would be a tiny small figure, set down flat on the ground with a large space all around it. And, as he said to Aragon, the smaller the figure was, the larger the square would seem.

To the Swiss art historian Carola Giedion-Welcker, Giacometti said that he wanted his sculpture to take its chances in the everyday life of the city, thereby "proving its sculptural existence and dignity." But Parisian bureaucracy decreed that, on the contrary, sculpture should be set apart, both for its own security and to avoid causing annoyance to passersby.

There was never any reason to suppose that Giacometti's delicate and quietly subversive magic would suit the lower reaches of corporate Manhattan. The problem with the Chase Manhattan project was that no matter how large the sculptures were, they would still be dwarfed by the building. (Gordon Bunshaft is said to have told Giacometti that all he had to do was to take one of his existing figures and make it thirty times as high.)

Nor had it ever been Giacometti's ambition to leave his mark on an American cityscape. Joan Miró had dreamed of introducing a new and constructive playfulness to the American scene. Jean Dubuffet was curious as to every detail of American society. When Fernand Léger was in the United States as a refugee during World War II, he matched its energies with his own. But Alberto Giacometti had never been to America, and travel for travel's sake did not interest him.

Nor was he normally in the business of "public sculpture," but there was something about the Chase Manhattan proposal that caught his fancy. Ideas for it kept him busy from December 1958 until the end of April 1960. During that time, it was a recurrent subject in his letters to Pierre, though one or two fragments of noteworthy local news were also included. On March 13, 1959, for instance, Giacometti, the lifelong noctambulist, reported that there was in Paris "a wave of puritan cleaning-up that I don't care for at all. But it's not going to stop. In fact it'll go on till Paris is like Zurich!

"I'm thinking about my monument," he said, in that same letter. ("My," not "the," was already the chosen word.) "But so far I've done nothing. Maybe I should go to New York, after all?" On March 17, he said, "I work on my project almost every day, and I am eager to take it up again tomorrow. In any case, and whether or not it's what the architect wants, it's of enormous help to me in all my work and I am delighted to be doing it."

On May 3, 1959, the news was still positive. Guided to some extent by a tiny scale model of the building and its plaza, he had in mind three elements from his permanent repertory – an immensely tall standing woman, a walking man, and

an isolated head. "Since I came back to Paris, I've worked all the time and from memory on the same big figure. On Monday a week, I shall start on the other figures for the square. I want to have them all three done during the next week, directly and quite big, to see how they look, with their bases. Foinet is going to find me somewhere – maybe a courtyard – where I can set them up. It has to go very fast, or not at all. But I need another eight days for work on the big figure, and maybe on a head of Diego that I began before leaving. This is the first time since 1947 that I have been able to start again, all over – something I'd hoped to do for a long time."

But by February 2, 1960, the cream was beginning to curdle. Letters to Pierre had not been so regular, of late, but there were indications that Giacometti did not feel comfortable with the commission. It had crossed Pierre's mind that Giacometti had hesitated to identify either himself or his work with a gigantic new building that was, in effect, one of the cathedrals of American capitalism. Alberto replied that "my difficulties with the sculptures for New York have nothing to do, as you seem to think, with the fact that they are destined for a bank, or for one of the high places of capitalism. None of that troubles me in the least. It is entirely a sculptural question – a matter of dimensions, proportions and figuration.

"I had to interrupt work on this project – provisionally, at any rate – to distance myself from it. But I hope to go back to it as soon as possible. But these big sculptures have drawn me back to the very essentials of my work, and I must first of all manage to see them more clearly. Since you left, I have been working uninterruptedly on that one same head, and I'm not going to let go of it until I know exactly where I stand in relation to it.

"I wrote a long letter (9 pages, I think) to Bunshaft. But I didn't send it. It was not clear enough. I have to start it again, all over, and I'm going to write it tomorrow, so that he can read it when he arrives here. It would be easier for him to read it (translated into English) than if we were simply to talk it over. What do you think?"

Irrespective of whether or not it came to fruition, the New York project had clearly prompted a general shake-up and reordering of Giacometti's priorities. In this same letter to Pierre, he said, "This is the first time since 1935 that I am really beginning again from the beginning. I'm simply delighted about it. I'm also in a hurry to get back to painting (at my mother's, next week), and in two or three months, or even in two months, I'll see what has come of it.

"And now I have to concentrate on, and give my every effort to, just one single sculpture, no matter how long it takes. And that one sculpture must be, and can only be, a head. Once I get it right, everything else in my work will follow – even the trees, when I have to put them into a painting."

At that time, distractions, even if honorific, were unwelcome. "This very morning," he continued, "Switzerland has offered me the whole of its national pavilion for the Venice Biennale this year. What a time to choose! I sent them a laborious refusal by return mail. Let them think of it whatever they please."

And then, on April 29, 1960, Giacometti began a fateful letter to Pierre. "For the last three days," he wrote, "I've been carrying the paper for this letter in my pocket, and I can't put it off any longer. You will be very disappointed with what I have to say. You may be angry, too, as will Bunshaft also.

"The sculptures for the Bunshaft commission have been cast. I looked at them in the foundry. I had them patinated. I looked at them on the pavement of the street outside the foundry. I had them all taken – the bronzes and the plasters, cast and not cast – to Susse's garden in Garches. They may all of them have something, but every one of them falls short of what I intended (or thought I intended). They are so wide of the mark – so bad, in a word – that I simply can't send them to New York. I'd rather never make another sculpture again. In fact, I'd rather die than send these bronzes right now to New York.

"I've spent more than a year on them. I dropped everything else and kept at them. I have never worked so hard. And then, on the evening of my departure for Stampa, I sent them to the foundry. (Four of them, instead of three.) There was nothing more I could do. And now I see that they are all failures – or, rather, that they were unrealized. They are all far short of what I wanted, and there is nothing more that I could do with them. It was inevitable. I do not regret a moment of the time spent on them – on the contrary – but it is absolutely impossible for me to present them as a valid project for a sculpture on an open space. My vision was too vague. There were too many reminiscences of sculptures seen elsewhere (in Rome, above all). The dimensions were totally confused. What I had seen as small, I mistakenly tried to enlarge. There were many other complications – far too many for a single year – quite apart from the fact that one can't possibly make anything for a given site without seeing the sculptures in place. In any case, and on their own account, all three of them are total failures.

"I'm not going to abandon them completely. I'm going to begin work again, as soon as possible, on both the big woman and the head, and I hope to get them right as soon as I can. The Walking Man is more complicated and I don't as yet know if I can bring it off, but in any case I'm going to have one more try. But, for the moment, that's all I can say.

"No matter how you and Bunshaft may react to all this, I cannot do what I cannot do. All that you can do is to reproach me for my insufficiency. I cannot say anything more this evening. Please read this letter to Bunshaft. The only

thing that hurts me is that I shall have disappointed you and caused you pain.

"I shall write again very soon. I need to see my way more clearly in all this. I do not regard this as a lost year – quite the contrary – despite what came of it."

Just three days later, on May 1, 1960, Alberto wrote again to Pierre. "Several hours ago, I wanted to write to you. In fact I was writing the letter in my head. But then I went on working till after 1 A.M., and then I went out to dinner, and was interrupted by this person and that, until now it's after 3 A.M. I'm here alone, and I could write to you, but I'm tired, I'm exhausted, I lack all vivacity!!! So for the moment I shall put off for a day or two what I really want to write."

There was more to it than that. The inner subject of these letters was not despair. It was deliverance. "The only thing that I can still say," Alberto continued, "is something that cannot wait. It is this: that if I had not written to you a day or two ago, and if I had sent off the sculptures in their present state, I should not have been able to work for a very long time. I should have been completely done for, finished, and as if wiped off the face of the earth.

"Instead of that, I worked yesterday, and again this evening. What I did may have been a little better than before, and I am impatient to continue tomorrow. I have 6 or 7 sculptures en route, and I'm determined to finish them. I'll also redo the big ones at the same time. I've known this for several months, but I've only just got it clear in my head. In any case, I have no choice in these matters. I can only do what I do. I have no liberty. I am not free to send, or not to send, the sculptures.

"As a matter of fact, I have thought for a long time that the only freedom is not to be free – in this domain, at any rate. At this moment, I am as if walled up alive with the sculptures that I am working on. Either I shall get away from them for a while, or I never shall.

"That's all for this evening. I am very sorry to disappoint you."

To an artist on the make, the collapse of the Chase Manhattan project would have been a disaster. For Alberto Giacometti, it was nothing of the kind. For more than a year he had given the proposal his best shot. And, in the end, he knew that neither the proposal itself nor the solution that he had had in mind made any sense. The location was wrong, the light was wrong, the climate was wrong, and the location was ridiculous, as were the manners and the mores of Wall Street. The term *site specific* was not yet current, but it would never have applied to what Giacometti had had in mind. He did not see the end of the project as a setback, or as a failure, but as a liberation. And the project even had, in a limited sense, a happy ending, in that casts were made of more than one version of the *Big Woman,* the *Walking Man,* and the *Big Head.* They do not call out for the Chase Manhattan building, but nowhere could they look better than in the

galleries of the Fondation Beyeler building that was designed by Renzo Piano and opened in 1997 in the outskirts of Basel.

The next surviving letter from Giacometti is dated November 6, 1960. His paintings were in demand – a portrait of David Sylvester for the Musée National d'Art Moderne in Paris and a portrait of Annette for the Tate Gallery in London. He had reestablished a routine that suited him very well – work until 2:30 A.M., and dinner at 3 A.M. "It suits me splendidly," he wrote. He was back with his old friends, his old ways, and his perennial objectives. He also had had, since October 1959, a new friend and sitter, Caroline, in whom he found a limitless fascination. Though not applauded either by his family or his friends, this relationship lasted in one form or another until Caroline made uninvited appearances at Alberto's deathbed and (in deep black) at his funeral.

If there were letters to Pierre over the next ten or eleven months, none of them have survived. But in October 1961, Giacometti's American connections came to life again when he was awarded the first prize for sculpture at the Carnegie International in Pittsburgh. Pierre at once bestirred himself. He was naturally delighted that Alberto should have won the prize, which had not always been given to an artist of Giacometti's stature. "It used to be the case," he said, "that the prize consecrated the winner. But in this case, it is the winner who restores to the prize a prestige that it had lost."

Alberto was at Stampa when the news was announced. Not only did everyone in the village hear about it on the radio, but he received a visit from a Swiss television team. "You can imagine how delighted my mother was!" he wrote to Pierre. "That was what pleased me most about the prize."

In the matter of the Carnegie award, Alberto and Pierre did not altogether agree. Given the publicity that in those days went with the Carnegie International, Pierre wanted nothing so much as to have an important Giacometti exhibition at the Pierre Matisse Gallery at the earliest possible moment. December, with its built-in overtones of high spending, would be the ideal time. This was a chance that might never recur. Giacometti was the man of the hour. Pierre had the exclusivity of his work in the United States. The timing was perfect.

"If I don't have this show," Pierre wrote to Alberto on October 22, "someone else is going to have one in New York. And under what conditions! I do not want some other dealer to buy a few pieces from Maeght (by roundabout means), borrow a few others, and pull the rug from under my feet with a ramshackle anthology put together from everywhere and nowhere."

The notion of urgency in business was not one with which Giacometti preoccupied himself. He wrote back on November 6 to say that he would prefer the

New York show to be put off until the fall of the following year. What was the hurry, after all? In the fall of 1962, they could include the pick of the crop from Giacometti's upcoming show at the Venice Biennale, together with as many as possible of his most recent works. "I would naturally engage myself," he wrote, "to have this show in your gallery and nowhere else. I also engage myself to see to it that you have the exhibition in the fall of 1962 before it is seen in Paris." Meanwhile, he would see what could be done if Pierre decided to have an exhibition in 1961. And Pierre, for his part, assured Alberto on November 12, 1961, that as far as the upcoming show in New York was concerned there was nothing to worry about. This would not be an ad hoc exhibition. It would consist of sculptures and paintings that would hang together and make sense. It would in Pierre's view have been madness, both for the gallery and for himself, not to have such an exhibition at that particular moment. This was not simply a matter of business, though business was certainly hoped for. It was also a matter of profound emotional attachment to a body of work that he had always supported.

Thereafter, letters between Alberto and Pierre were fewer in number. They did not "keep up" a correspondence, though their mutual regard remained intact. Alberto did not in general write to Pierre to amuse him. Once or twice, a certain amount of detail would certainly have been welcome. "Had dinner with Igor Stravinsky last night" is all very well, and so is "He and I are now great friends," but one could wish for something more. (Some marvelous portrait drawings resulted, by the way.)

Marlene Dietrich was another case in point. In the winter of 1959–60, Alberto Giacometti was introduced to Dietrich and saw her a number of times. Vast as her experience of men had been, she had never met anyone like Alberto before. He was not above dropping her name, either. When he saw her again, in Paris in October 1962, he wrote to Pierre and said, "I spent four hours with Marlene D. the other evening. She was very, very pretty. Four hours in a café, at the same table. She had *one* cup of coffee. I had *one* aperitif. End of story."

Never, ever, did he refer to the complications of his private life. Invariably he signed off with "Annette sends her regards," as if theirs were a sedate long-running union. He was also sparing with news of his health, beyond the fact that he had worn himself out in Paris and was restored by his every visit to Stampa. But in a letter dated October 28, 1961, there was a reference to stomach pains that he had had all week. "They're nervous pains, I think," he wrote. Before long, there would be reason to remember that remark.

In general, however, Giacometti's career had reached the point at which major events piled up, one after another, irrespective of whether he willed them or not.

They were "in his honor," admittedly. But most of them were to the advantage of others. In 1962 he was given a very large space of his own at the Venice Biennale. Pierre had worked very hard indeed to get the right loans, and Giacometti himself had been at work in the gallery, day after day, before the inauguration. (He got the Grand Prize for sculpture, but at that stage in his life he hardly needed it.)

In October 1962, X-rays revealed that the "stomach pains" of which he had written a year earlier were due to "a stomach ulcer." Undeterred by this, Alberto went ahead with an enormous retrospective that was scheduled for December 1962 at the Kunsthaus in Zurich. (More than one hundred eighty-five sculptures and eighty-five paintings were on view.)

"It is much bigger than in Venice," he wrote to Pierre on December 6, 1962. "One gallery was 70 meters long and 20 meters wide! We organized it very quickly – much more quickly than the Venice Biennale. It was done by Clayeux, Diego, Dr. Wehrli (the director of the Kunsthaus), and myself. The major pieces arrived Tuesday afternoon, and the others on Wednesday. The installation was almost entirely what I had hoped for. Those were very agreeable days. Saturday I was very tired and there were enormous crowds, but I'm getting rested now."

On February 6, 1963, Alberto Giacometti was operated on in the hospital in Paris for a cancer that caused three-quarters of his stomach to be cut away. By March 22, he was able to write to Pierre from Stampa. "I don't know if I told you on the telephone," he said, "but I know perfectly well what the trouble was. I felt better, right from the first day after the operation. And now that I'm in Stampa, there's an improvement every day. I'm longing to get back to work. Yesterday and the day before, I made quite a long trip – five hours each way – to see the composer Georges Auric. He wanted me to design the decors for Alban Berg's *Wozzeck*. But I couldn't possibly get into that, with all its complications, when I have so much else to do."

At the time of his operation in February 1963, Giacometti had a little less than three years to live. They were to be fateful years. In the summer of 1963, the Giacometti collection that had been formed by his American admirer G. David Thompson was put on view at the Galerie Beyeler in Basel. This was to become the nucleus of the Giacometti Foundation in Switzerland.

In more ways than one, he really did have a great deal to do. For someone who had just undergone a major operation, and who for many years had systematically endangered his well-being, he had an astonishing resilience. He returned to Paris not long after the operation. He went back to work. When it turned out that the Museum of Modern Art in New York and the Tate Gallery in London and the Kunsthaus in Zurich were all planning major exhibitions of his work, he

saw no reason why any of them should be disappointed. (He was particularly insistent, in letters to Pierre, that he should be allowed to work on his new sculptures for New York until the very last moment that would allow them to be included in the show.)

Giacometti's mother had always been a majestic and irreplaceable presence in his life. In January 1964, she died, with all her children around her. In the summer of that year, Giacometti went to London to work on his large retrospective exhibition at the Tate Gallery. (At the inaugural dinner that was given at the Tate, Giacometti stood up and said that the tributes that had been paid to him were entirely out of place. "There is not a workman in the street – not a plasterer, not a mason, not a carpenter – who is not as much an artist as I am.")

When he thought that injustice had been done to someone he greatly admired, he did not allow himself to drift off and do nothing. In July 1964, the Maeght Foundation was opened near Saint-Paul de Vence. During the course of the more than elaborate proceedings, Aimé Maeght gave a lengthy address in which he pointedly (or, as he himself said later, absentmindedly) did not mention Louis Clayeux, the scholar–dealer whose advice had been fundamental to the growth of the Galerie Maeght. And when the time came for André Malraux, then France's minister for culture, to be escorted round the Fondation by Aimé Maeght, Maeght took Malraux by the arm and saw to it that they set off on their own.

This was thought by many of those present to be, if not an insult, at any rate an injustice to Clayeux. Giacometti had always got on very well with Clayeux, whom he greatly admired. When Clayeux resigned from the gallery, Giacometti did the same. He also took care to see that the twenty-three sculptures that he had had cast for the Fondation Maeght in 1963 were the legal property of the foundation and not of Aimé Maeght, his wife, or his gallery. (The foundation and everything in it were the property of the French state and inalienable.) To the end of his days, he was the archetypal *vir probus*.

It was inevitable that towards the end of Alberto Giacometti's life his correspondence with Pierre Matisse began to dwindle. The bond between them had been unique and indispensable. They had constituted, almost, a two-man secret society. But by the mid-1950s Giacometti was adulated, courted, and solicited the world over. The demand for his work grew greater, year by year, as did the problems of getting the right casts to the right place by the agreed date. Alberto and his gifted and indispensable brother, Diego, had no inhouse "staff" to help and protect them, though Diego in particular would stand no nonsense.

In October 1965, Alberto paid his first and only visit to the United States, where his exhibition at the Museum of Modern Art in New York had opened not

long before. Writing to Pierre and Patricia Matisse after his return to Paris, he spoke of the tumult of new impressions that he had received. "They will all come back to me," he wrote, "but slowly, and little by little. Right now, I can't make out if we were there for a very long time, or just a day or two." Not even Chase Manhattan Plaza rated a special mention, though Giacometti had made a point of going to see it, and pacing it out.

On his return from New York he went to see an exhibition of his work at the Louisiana Museum, near Copenhagen, where the combination of noble trees and breezes straight from the sea gave him great pleasure. ("A very good show in a marvelous place," he reported to Pierre.)

As he had always refused to fly, he came back to Paris by way of Hamburg and Cologne. "I was going to say that Germany was very disappointing," he wrote to Pierre. "But that wouldn't be quite right. There's just something color-less about it – like German Switzerland.

"But after all my travels," he said finally, "I am astonished and overwhelmed by the beauty of Paris. . . ."

What may have been the last of Alberto Giacometti's letters to Pierre Matisse was sent from Paris on an undated Sunday towards the end of 1965. There had been distractions since he had got back – among them the making of a thirty-minute movie, on which Ernst Scheidegger, Jacques Dupin, and Giacometti him-self had collaborated. There had been the award of the Grand Prix National des Arts from the French government. There had been a short visit to receive an honorary doctorate from the philosophy faculty of the University of Bern. The Swiss Federal President had given a dinner in his honor in Bern. Troops of enthu-siastic young people had escorted him to the train station.

But in that last letter to Pierre there was nothing about all that. "I wanted to write to you," he said, "but I let the days go by. I hardly go out, and I work all the time – more than at any time since 1940 or thereabouts, I think. I work all the time on the same sculptures, and on nothing else. I think it's beginning to go a little better. I hope to leave around the end of the week, more or less, and I'll let you know, but for the moment I simply had to stay here and work. Paris is begin-ning to empty a little, and it's very agreeable. All day long I look at the trees."

As an unspoken good-bye, this could not have been more characteristic. Giacometti was in the city that he most loved, and he was doing his work, and he was never one to complain of his health. But it was to be a matter only of weeks before he died in a hospital in Chur, in Switzerland, on January 11, 1966. On his grave, his brother, Diego, placed one of the busts of his friend Eli Lotar on which Alberto had been working during his last weeks in Paris.

Miró, 1950 Onwards

For Christmas, 1950, Pierre and Patricia Matisse went for three days to Cuba. They visited Ernest Hemingway, and Pierre knew that Miró would be interested to have news of his great painting, *La Ferme,* of 1921–22. Now in the National Gallery of Art in Washington, D.C., as a gift from Hemingway's last wife, Mary, this is in effect an encyclopedia of life in Miró's native Montroig.

Pierre wrote that "Hemingway lives in an old (18th century) house with 40 cats and close on 200 fighting cocks. He was charming, and showed us *La Ferme,* which is marvelous, as always, and in excellent condition. He sent you friendly greetings. Wifredo Lam was there, too, and we had a very happy time. At one corner of the house he is building a tower, much like the one in *La Ferme.* From the roof, he has an extraordinary view over the countryside, Havana, and the sea. He spoke of the view from Montroig, and of the similarity between the two. I shall always remember that panorama and I can see why it has such an effect upon Hemingway." In that same letter, Pierre touched upon a subject that was not going to be so much fun. When Miró had been asked in January 1950 to make a mural for the Harkness Commons dining room in Harvard, he was delighted. Harvard was Harvard, after all, and there was something irresistible to him about the idea that he would one day raise the consciousness of clever young Americans. Once the maquette had been approved and the contract signed, he proceeded at his own pace and with no particular sense of urgency.

Meanwhile, in Cambridge, Massachusetts, expectation was in the fast-forward mode. Festivities to mark the arrival and installation of the mural were already in hand. Miró's chief contact at Harvard was Walter Gropius, the founder in 1917 of the Bauhaus in Weimar (and later in Dessau). As head of the architectural

school at Harvard, Gropius had sponsored Miró's candidacy, with the support of Alfred H. Barr, Jr.

It must be said that no two men could have been more different in character and outlook than Miró and Gropius. Where Miró never begrudged time spent in what he called "getting up steam," Gropius liked to set a timetable and keep to it. Miró had sent the model for the painting to Gropius late in February 1950, but he did not begin work on the painting itself until October 18 of that year.

It had been announced in Cambridge that Miró would be coming over in February 1951 to install the painting. An exhibition of his work had been arranged at the Fogg Art Museum, with many loans from the Pierre Matisse Gallery. Pierre Matisse himself was preparing an exhibition in New York to coincide with the festivities in Cambridge. Gropius was regarded in Harvard not only as the mastermind behind the whole project but as the mainspring of the coincidental fêtes.

It was therefore deeply disquieting to Gropius that in January 1951, with Miró presumed to be coming in a few weeks' time, he had heard nothing from him since October. His recent letter to Miró, dated December 13, 1950, had gone unanswered. The problem was the more urgent in that Miró had insisted that the decoration be shown at the Galerie Maeght in Paris before being dispatched to Harvard. Gropius appealed to Pierre Matisse for help.

Pierre forthwith wrote to Miró to say that Gropius's associates in the matter of the mural were disturbed by his silence. "As Gropius bears – so to say – the responsibility for this undertaking, he would like to be able to calm the others down by letting them know exactly on what date the mural will be sent. Please be kind enough to let them know.

"As I have heard nothing from you," Pierre said, "I wonder if you still intend to come over in February, and if so on what date? There are now very severe restrictions on the entry of foreigners into the United States. People have protested vigorously about them, but they are still in force, and very disagreeable. It would be good if you were to get Gropius to send you a letter confirming your invitation. And don't forget that every visitor to America has to have with him a certificate of vaccination."

Miró appeared to take a rather nonchalant view of Harvard's problems on his account. So far from wanting to get the mural there as soon as possible, he urged that it should be shown at the Museum of Modern Art in New York before its eventual installation in Harvard. Meanwhile, he was working on the titles for the new paintings that he was producing for Pierre. "They come to me of their own accord while I'm working," he wrote on January 29, 1951. "The same is true of the exact place on the canvas at which I am to sign each picture. I cannot

decide until the right moment arrives. To do it sooner would rob the painting of all vitality and meaning. I have given great thought to that. For these present titles, I rely upon a poetic phrase, or an image, that comes to me while I'm working."

Pierre by then had realized that the installation at Harvard would have to be much later than had been hoped (and planned for). Rather than wait on the Miró mural at Harvard, Pierre went ahead with his own exhibition in New York, which turned out to be a great success. Pierre had taken particular trouble with the catalogue. The show had a unity in that it was of recent paintings only, that the exhibition of 1949 had not had. A large audience came to see it, and many of them asked if Miró was coming over. To this last point, Pierre wrote to Miró on April 19, 1951, "I have the impression that people at Harvard have been more than unhappy to find that, instead of arriving on the agreed date, the mural will be months late. This is a great pity, and I have the impression it has given serious offense. You must remember that they had organized an exhibition in your honor and were planning other celebrations on the occasion of your visit. I realize that America must seem a very long way away, and that Paris may be more interesting, but even so. . . ."

In this, Pierre was quite right. Paris at that moment was of the highest interest to Miró. On April 20, an exhibition called "Four Walls" was due to open at the

Joan Miró, n.d. Photo: F. Català-Roca

Galerie Maeght. It was of large-scale works in one or another medium by Picasso, Matisse, Braque, Léger, Chagall, and Rouault. Miró was delighted to have his Harvard mural included in what was, in effect, a show of strength by the surviving seniors of the School of Paris. As Miró was the youngest among them, he saw the show in terms of status, as well as of achievement. "The few people who have so far seen my mural find it magnificent," he wrote to Pierre.

Given that the show would run well into May, Miró thought it better not to think of coming to America until September or October. The mural finally arrived in Cambridge in June 1951, and Miró himself did not go to see it until June 1952, when he made a brief visit to Harvard, out of term.

Like the Cincinnati mural, the Harvard mural never really settled down in its initial habitat. That the murals were there at all was a tribute to the aesthetic assurance of those who commissioned them. It also spoke for the American belief that if people are shown something really good they will get to like it in time. But whether in the context of an ambitious hotel restaurant in Cincinnati or of the heartland of American academe, the two big Mirós were not a good fit. Nor could the smells of food and (in unregenerate years) the smoke of cigars and cigarettes do the paintings any good. After some nine years, the Harvard Miró was out on view at the Fogg Art Museum, and from there it went eventually to the Museum of Modern Art in New York, which acquired it in 1961.

By December 1951, Miró had clearly decided that the association between Pierre Matisse and Aimé Maeght was working smoothly and could be as much to their advantage as to his own. He had lately left eight new paintings at the Galerie Maeght. "It is clearly understood between us," he wrote to Pierre, "that nobody may see them until you and Maeght have agreed as to who gets what."

In his favorite role as long-term strategist, Miró was at his most buoyant. "This is what I think, my dear Pierre," he said. "I have every confidence that you will lend some paintings for the exhibition that Maeght and I are preparing for Paris in 1953. You will certainly understand that this show will be of the highest importance for all three of us. As of now, we must all work together towards that end. If the Maeght exhibition goes off with a big bang, its echoes will certainly be felt in New York. (And vice versa, if you make an exhibition in New York a month or two beforehand.) That is why I wanted to stand aside in the matter of the new paintings. You and Maeght can then decide for yourselves, keeping the future in mind.

"Maeght has recovered from Madame Cuttoli two very large designs for tapestry which I made in 1933. I shall suggest to Maeght that in respect of these maquettes you and he should have total freedom of action. My overall price for the two maquettes, plus the eight new paintings, will be $15,000. This should

make it easier for you and Maeght to reach a mutual agreement. In future, we might envisage something more specific, but for the moment I think that I have done my best to make things easy for you both."

On January 28, 1952, Miró confirmed that until the Paris exhibition in 1953 had taken place he would play no part in the division of his new work between Matisse and Maeght, except that from time to time he would keep one for himself. As for the present, he wrote, "The fact that neither you nor Maeght have said anything about your current share-out encourages me to think that you are working together in harmony. That is indispensable, if we are to achieve the objectives that we have in common."

Joan Miró letter to Pierre Matisse, 1951

Shortly after that, Miró may have wondered if Matisse and Maeght were not getting on rather too well. Pierre said, and Maeght said with him, that the proposed overall price of $15,000 for the two tapestry designs and the eight new paintings would be to nobody's advantage. (Pierre wrote throughout as "we" and never as "I.") Writing to Miró, with a copy to Maeght, Pierre said, "After looking at your previous prices, it seems to us that the increase in the prices of the paintings is rather too abrupt. It might, in fact, discourage both your collectors and, later, those who speculate in your work.

"Aware as we are of your spirit of fairness, and of how well you understand our problems, we propose these prices." There followed an itemized account of the ten works in question. Each came with its recommended price. The total came to exactly $10,000, as compared with the global price of $15,000 that Miró had wished to set. Pierre then continued:

"Please keep in mind that we buy all your new work, without discussion. This includes both work that is thoroughly 'finished' and work that is still relatively loose in its execution. Our experience in previous years has been that the looser, less finished works do not sell.

"Quite apart from that, the expenses of presenting the work, keeping the gallery open, designing and printing the catalogues, and publicity in general are now so considerable that they amount to twice (or more) as much as we pay you for the pictures. Yet it is in your interest that we maintain your present public image. We therefore consider that the prices that we are going to suggest would be in line with our expenses. Moreover, these price levels will be a useful basis for our future discussions. They would also simplify the level of our sale prices – something that in the past has always caused difficulties."

The underlying sense of this letter was that Matisse and Maeght were not going to allow Miró to price his work too high. Miró replied at once on February 5, 1952. "To be strictly fair," he wrote, "and in a transitional spirit, I suggest that the global price that I quoted should be reduced to $12,500.

"Given the prices that my older colleagues command, and given that at my present age I cannot rival them, I think you will agree that this is a very reasonable offer."

Matisse and Maeght in this matter were clearly acting as allies. Pierre did, however, write to Miró on that same day and say that he rather hoped that he and Miró would have no more discussions with Maeght. Maeght now had half of Miró's output, and he was taking advantage of it to make many sales to Americans who were clients of Pierre's. This was precisely what Pierre had wanted to avoid, had Pierre Loeb been in question, but Maeght was even more of a for-

midable contender. "I understand his position," said Pierre, "but you will also understand mine. But let's say no more about it for the moment."

Pierre had always hoped to revive Miró's fascination with the United States. A big new commission in New York might, moreover, help to take his mind off Maeght for a while.

It so happened that by the end of the year 1952 the principal buildings in the United Nations headquarters in Manhattan had been completed. The Secretariat, the General Assembly, and the Conference Building were in place, and a motley company of member nations was about to settle in. Afghanistan was there, and Argentina, and Belarus, and Haiti, and Iraq, and Lebanon, and Lesotho. With time, the alphabet would bulge with nations old and new. By March 1952 it was envisaged that every member nation would embellish its quarters with works of art produced within its own borders. From this, there would undoubtedly result a chaos of good intentions.

As for the spacious public areas, quite another formula was being mooted. A committee, chaired by the architect and city planner Wallace Harrison, was to invite a number of independent artists to decorate the most important locations in the U.N. buildings. Quality, not national allegiance, was to be the criterion. The committee would make its choices in private, and the sites would be assigned before any rival intentions had been formulated.

On March 19, 1952, Pierre Matisse wrote to Miró and said that the time had come for the committee to make up its mind. "In this way," he said, "the decisions will all have been made by the time that officialdom gets going. It will be faced with a fait accompli.

"For the moment," Pierre continued, "there is no budget. Nor do we know when this problem will be addressed, or how much money will be available. The idea is that when the committee has a maquette that it likes, Wallace Harrison will go out and get the money, thanks to his many connections. What this means, for you, is that if the project interests you, you should make a maquette and send it to them. There is no guarantee, on their side. Nor is any fee specified. However, you will not be submitting your maquette in competition with other artists. I made quite sure, moreover, that the room, or the space, in question would be reserved for you only."

Miró replied on March 30, 1952. "The project that you and your friends have put before me is very exciting – and very different from the commissions for churches, which I have managed to escape. Those large-scale intrusions of modern art may well be evicted one day by the Church of Rome."

As he was still wholly absorbed by the preparations for his show in Paris in

1953, Miró really did not want to give time and thought to a project that would be very demanding indeed, on a human level, and would also arouse wide public notice. But he did not reject it out of hand. "Please keep a close watch on the project and tell me how it evolves. It is obvious that I shall need to make a quick visit to New York to see the space that I shall have to decorate." (*Shall*, not *would*, was the decisive word here.)

By May 5, 1952, Miró was making plans for the visit. He left for New York on June 1, took a look at his murals in Cincinnati and Cambridge, and was back in Barcelona by June 10. Fired up by the sight of the U.N. headquarters, and by the huge responsibility (as he saw it) of his task, he set about the maquette. On October 19, 1952, he said that it would be ready "in a few days' time. Even if nothing comes of it," he wrote to Pierre, "it will have opened new horizons for me, which is very important." By November 11 it was finished. Painted on Masonite, it measured 15⅜ by 46 inches and could be taken apart and put together again.

Meanwhile, all plans for the U.N. decorations appeared to be, at best, on hold. Wallace Harrison showed no interest in the matter and appeared to think that it was for others to raise the money. ("There's no money," he said to Pierre whenever they met.) On May 16, 1953, Pierre recommended that he should withdraw Miró's maquette. The matter then rested until December 1953, when Harrison came to see Miró's exhibition at the Pierre Matisse Gallery. He came on a Saturday, when the show was crowded. "He was very impressed," Pierre reported to Miró. "For the first time, he really seemed to be somewhat excited. Of the U.N. project he said, 'Of course, there's no money.' But then he asked how much you would charge to make the decoration for which you had submitted the maquettes. For the first time, he was genuinely interested. It has always been assumed, as I told you before you came here, that someone would make a present of your decoration to the U.N. But, in any case, I don't know what will be done about that building."

Miró in point of fact had taken enormous pains not only with his maquette, but with the moral overtones of the U.N. It had disturbed him that it was too late for there to be any kind of working partnership or fruitful duet between artist and architect. "It would make no sense," he wrote, "to treat the spaces as an exhibition gallery that would be filled with huge easel paintings." Insofar as there was any monumentality about the allotted spaces, it came ready-made and could not be adjusted.

But Miró was not easily discouraged, and on November 21, 1953, he was still trying to formulate a program that would avoid the picture-gallery look. He also wanted to stay clear of the tag-sale look that would come about if every nation tried to be "fair" in its coverage of its local painters and sculptors.

Even the big clock that was already a part of the allotted space was to be given a vital role in Miró's grand design. That design had been planned in relation both to the landscape outside and to what he called "the beautiful sky and the marvelous light of New York." As for Miró's dynamic forms, they would be framed within "the stable verticals and horizontals of the overpowering city."

A good try. But "I must admit," Miró wrote on December 27, 1953, "that I have an instinctive aversion to all bureaucratic endeavors. Sooner or later, they turn into a God-awful mess. But you, who are right there in New York, are better able to know exactly what is going on. As for the fee, I think that – given the efforts that it has cost me – it should be very substantial. There should also be something to spare for the costs of the reliable assistant whom I would probably need. Anyway, if they mention it again, please let me know what you yourself think about it."

But alas! Bureaucracy had the last word, and there is nothing by Miró in the United Nations headquarters in New York.

If this was, in general, a transitional time in Miró's dealings, or lack of dealings, with America and Americans, it was not due to any falling short in Pierre's Miró exhibitions. It was owed rather to a general shift in the scope of Miró's activity. After the two major exhibitions in 1953 (Maeght opening in June and Pierre Matisse in November), he seemed to lose his way in painting. Not only was he more interested in making ceramics and sculptures, but he was between studios and had nowhere to work consistently and at full stretch on paintings.

Pierre Matisse was still beyond question Miró's long-standing dealer in America and his trusted friend. But Aimé Maeght was – almost literally – the man next door. And, like other big-time, big-money postwar dealers, Maeght knew how to make his artists feel cosseted.

Joan Miró did not aspire to "live well." But he had a sense of childlike wonder at the extravagance of others. If Miró needed a change of scene, Maeght saw to it that he and his wife were always welcome at the Colombe d'Or in Saint-Paul de Vence, with its luxurious rooms and its delicious food. If Maeght invited the Mirós to go with him to Italy, there was no nonsense about hanging around airports in the high season. They went by Rolls-Royce from door to door. Miró loved this.

Maeght had professional strategies that were the very opposite of Pierre's. He set great store by multinational exhibitions like the Venice Biennale, which in the late 1950s was at its apogee. To be at the Venice Biennale at the time of its inauguration was almost mandatory for dealer and artist alike. During those weeklong festivities, new friendships were made and old contacts reinforced. Collectors, dealers, and artists networked from morning till night. For an artist

to be nominated for his or her national pavilion in Venice was highly desirable. To win the Grand Prize for Painting at the Venice Biennale was the fast track to immortality.

Pierre Matisse didn't buy all that. He thought that big official exhibitions were gussied-up trade fairs that did very little for art. When Miró was shown at the Venice Biennale in 1954, Pierre wrote to him and said that as the continual parties were pointless and fatiguing, he himself thought of going during the following week, when normal life had been resumed.

Maeght, on the contrary, would have moved mountains, if he could, to get Miró the Grand Prize in Venice. (It was around this time that he said in Pierre's hearing that he, Maeght, had done more for Miró's reputation in just a year or two than Pierre had done in twenty years.) In the event, the Grand Prize for painting went that year to Max Ernst, and Miró was awarded the Grand Prize for graphic work. While Miró had certainly been making marvelous prints, this was not the result that had been dangled before him.

In the context of the next Carnegie International exhibition in Pittsburgh, which was due in 1955, Miró had asked Pierre to choose a painting on his behalf, as he had done on earlier occasions. This time, however, Pierre found that Aimé Maeght had got in first with a painting from his own stock. Though supported by his friend Jean Bazaine, the painter who represented France on the jury, Miró did not win the prize. "You had no luck in Pittsburgh," Pierre wrote to Miró. "I was amazed when Gordon Washburn, who was in charge of the show, told me that he already had received a painting of yours from Paris. After you were passed over in Venice, you yourself said that you had doubts about these 'great events.' Let's hope that things will go better next time."

If the correspondence with Pierre Matisse thereafter lost something of its momentum, this was not from any lack of personal affection. When their daughter Dolores got married in Barcelona, the Mirós put Pierre and Patricia Matisse very high on the guest list. When Miró received an honorary degree from Harvard, the Matisses were the people he counted on having there. He was as sensitive as ever to the quality of Pierre's attention to his work in New York.

If there was nonetheless a change in their relations, it was because Miró from 1954 until 1961 was working primarily in ways that for one reason or another did not magnetize Pierre Matisse. He had had, for instance, to tell Miró that he simply could not handle his graphic work. His was still a relatively small operation. He was not a print dealer. Prints were big trouble. What can now be called the print industry was not yet under way. Prints came in at odd intervals and in numbers not always predictable. There had been continual mishaps and misun-

derstandings when Pierre and his very small staff were doing their best to cope.

Bad feelings resulted, all around. On April 4, 1955, Miró wrote from Paris that if Pierre continued to be late with delivery of Miró's prints, he would have to make other arrangements. So Pierre asked to be relieved of Miró's prints. No less problematic was Miró's decision to begin work in February 1954 on a huge open-ended program of ceramics. Made in conjunction with Lorens Artigas, they amounted in the end to more than two hundred thirty pieces. Some were very small. Others were enormous. No one could forecast exactly how they would turn out, and it was with wonder and a wild excitement that Miró had watched the ceramics, one by one, large or small, as they came out of the kiln.

To the ceramics made between 1954 and 1956, Miró committed his whole self. Miró saw it, Rosamond Bernier wrote later, "as a pitting of himself against the primeval elements of earth, fire, and water. 'It was often a battle with the fire,' he would say when he looked back on a sustained period of work. 'We wanted to dominate the fire, but along the way there were accidents in baking and unexpected incidents of all kinds. It was magnificent!' he would say, with a more than usually emphatic click of his tongue."

Between him and Artigas there was, as always, a true partnership. There was a consummate professionalism, on the side of Artigas, and an element of last-minute inspiration on the part of Miró. Thirty years later, Artigas's son, Joan Gardy Artigas, remembered how "the ceramics of Miró and Artigas were made either of stoneware or of fireproof pâte – often tinted throughout with mineral oxides – and baked at a high temperature (1,300 degrees centigrade). After this first firing, they would be reworked by Miró. Sometimes he would add drawings. More often, he would simply add an accent of color with enamels baked at a lower temperature (960 degrees centigrade). Sometimes we would combine wood, ceramics, and iron in a single piece. . . ."

Pierre Matisse in this matter was the archetypal good soldier. In December 1956, not long after the series was completed, he put the case for Miró's new ceramics, both in the gallery and in his catalogues. But Miró had sensed that he did not entirely respond to them. In January 1957, Pierre wrote to him: "I must tell you how sorry I was that you and Artigas should have thought that your ceramics do not interest me. If I said nothing about them, it was because of a certain discretion. I prefer to leave it to the artist himself to speak to me about his work, at the moment that seems to him right.

"It is true," he went on, "that in the ceramics that you sent to me not long after the war there were forms that seemed to me to be in contradiction to the character of your other work. To be frank, I saw no future in that conception of

ceramics. Nor did I understand how it could be satisfying to you, who in matters of form and substance are invention personified. You may also remember that the vases that were sent to New York were priced fantastically high. My clients were completely put off by those prices. The pieces were then sent to Paris, as part of Maeght's first show of your work." As for the new ceramics, he had not yet seen them, but from what Miró's friend, the architect José-Luis Sert, had told him, he was very interested in the large plaques, among other elements in the new work.

And Pierre continued to defend them, no matter what private reservations he sometimes had. In December 1985, when Miró was dead and Pierre himself was eighty-five years old, he had an exhibition in New York of thirty-five Miró ceramics, dating from 1945 to 1968. By way of further solidarity, he included in the catalogue five fold-out color illustrations of the monumental walls in ceramic that Miró had made. They were, respectively, for the headquarters of UNESCO in Paris in 1957–58, for the Fondation Maeght in 1968, for the Osaka World's Fair in 1970, for the Barcelona airport in 1970, and for the Zurich Kunsthaus in 1971–72. It is doubtless a mark of American reticence in the matter that no commission on this scale had ever materialized in the United States.

These massive enterprises did not have the all-risking, hit-or-miss quality that gave a roller-coaster effect in some of the gallery exhibitions of ceramics by Miró and Artigas. Their sheer size – the wall for the Barcelona airport was 27 feet high and 135 feet wide – called for an idiom that made the same kind of sense from beginning to end. They were public art and, like many other ventures of that kind in the period in question, they were intended by their sponsors as a brevet of civic or institutional virility. But Miró also had it in mind that the people who used them – whether as commuters or as bureaucrats – would feel that they were being treated not as insensitive robots but as men and women who had fantasy as their birthright. With this in mind, he stalked the chosen site in Barcelona by night and by day, and from every possible angle. After the sleepless nights that he endured in this context, he might have sent out for maps and plans and architectural draw-ings. But not at all: one day, as he said to Rosamond Bernier, he suddenly got steam up. "I made a maquette on my floor," he said, "and it was done in half an hour."

Pierre Matisse had a long patience where Miró was concerned. He knew that Miró's career would almost certainly take a new turn after his new house in Palma, Majorca, was finished. In June 1954, Miró had bought a property on which José-Luis Sert was to build him a majestic studio on a scale that he had never before had. Apart from its other advantages, Miró would be able to go through an enor-mous accumulation of notebooks, sketchbooks, and projects, most of which he had not seen for years. Canvases by the dozen would also be released from a long

captivity. In doing all this, he would come face to face with his earlier selves, one after another. Something extraordinary was bound to come of it.

Meanwhile, Pierre in 1958 put on an exhibition of Miró's *Peintures Sauvages, 1943–53*, as if to remind the New York public that, ceramics notwithstanding, it was as a painter that Miró would ultimately take his stand.

It was in that same spirit that Pierre in 1955 had laid siege to Harvard, and to M.I.T., when a film about Miró, made by Thomas Bouchard, was presented at Harvard. Miró counted on this film to be – to quote Pierre – "a travelogue" that would cover his whole career. The audience at the opening was composed, Pierre wrote, of "students, professors, and personalities concerned with the arts." This was the kind of event that Pierre thought really worthwhile.

The film itself had – no small honor – music by Edgard Varèse. The general tone of it was brisk, in a way that matched Miró's paintings. "We came out," Pierre wrote, "after a long journey, filled with adventures brought to a successful conclusion." Those present were treated afterwards to an exhibition – built largely with loans from Pierre – that was designed to mediate between the movie and everyday life. Between them, the movie and the show summed up the career of Miró to date in a way that was wholly congenial to Pierre.

Miró's new studio, on a terrace overlooking the sea at Calamayor, just out-side Palma, was ready on time in 1956. Its glorious emptiness was unlike any-thing that he had ever had to work with before. Did he find it paradise? Would it send him straight to the easel? No, not at all. It was too new, too clean, and too perfect. Miró found it intimidating. "This is beautiful beyond words, but it isn't me!" he said to himself, and to one or two favored visitors.

According to Jacques Dupin, who was there, he wanted not just "a mess," but a meaningful mess. To begin with, he wanted to bring the outdoors indoors. "He collected objects of every kind," Dupin said. "He brought them back from farmyards, from the roadside, from village stores and shops and from the potters' workshops. On the beach, he picked up driftwood, pebbles and roots wrenched from the earth and hardened by saltwater. Before long his studio was filled with creatures – fantastic, poetic, or wildly comical. He was back among his own kind, and the studio was inhabited and ready for him to go to work."

This meant coming to terms with a thirty-years' deposit of work, finished or unfinished, notional or barely begun. Not all of it was from his own hand. The already processed image in postcards, photographs, and newspaper ads had played a great, if not immediately evident, role in major paintings in 1933. From these informative but mostly ineloquent materials, Miró had bodied forth a whole new form of poetry.

The origins of that poetry were coded, but they were well defined in 1989 by Kirk Varnedoe and Adam Gopnik in their catalogue for the "High and Low" exhibition at the Museum of Modern Art in New York. "The final results of this exercise," they said of some of Miró's paintings in 1933, "may seem to move to the primordial rhythms of the unconscious, with echoes from the underground bestiaries of Lascaux and Altamira. But the starting points dance to the tune of the Bon Marché and Sears."

It was to be three years before he painted at all in the new studio. Cardboard and sackcloth, as distinct from the perfection of perfectly stretched canvas, were among his partners in those first endeavors. But after five years, in 1961, the long patience of Pierre Matisse was rewarded by paintings – the three enormous *Blues* of 1961 – that were unlike any that Miró had painted before. (All three are now in the Musée National d'Art Moderne in the Pompidou Center in Paris.)

As to his preliminary struggles in the new studios, Miró spoke with his accustomed freedom to Rosamond Bernier in the summer of 1961. When he was at last all done with his unpacking, he went through a lengthy process of self-examination. "I 'criticized' myself coldly and objectively," he said, "like a professor at the Grande Chaumière school of art who was commenting on the work of a student. It was a shock, a real experience. I was merciless with myself, I destroyed many canvases, and even more drawings and gouaches. I would look at a whole series, and put a group aside to be burned. Then I would come back with more and – zac, zac, zac – I would destroy them. There were two or three big 'purges' like that over the next few years."

In an "airplane" with the Mirós and Patricia at a fair, 1956–57

It was fundamental to Miró's unpacking of his past in the new studio that he did not want to reprise or recycle what he had done before. When finally he came near to painting the three *Blues,* the preliminary process took a very long time – "not to paint," as he said to Rosamond Bernier, "but to think them through. It took an enormous effort on my part, a very great inner tension to reach the emptiness I wanted. It was like preparing the celebration of a religious rite or entering a monastery. Do you know how Japanese archers prepare for competitions? They begin by getting themselves into the right state, exhaling, inhaling, exhaling. It was the same thing for me. I knew that I had everything to lose. One weakness, one mistake, and everything would collapse.

"I began by drawing them in charcoal, very precisely. (I always start work very early in the morning.) In the afternoon, I would simply look at what I had drawn. For the rest of the day, I would prepare myself internally. And, finally, I began to paint: first the background, all blue; but it was not simply a matter of applying color like a house painter. All the movements of the brush, the wrist, the breathing – all these played a role. 'Perfecting' the background put me in the right state to go on with the rest. This struggle exhausted me. I have not painted anything since. These three canvases are the culmination of everything that I had tried to do up till then."

When these three mural-size canvases were shown at the Pierre Matisse Gallery in October 1961, it was plain that Pierre's all-time favorite Miró – Miró the painter, that is to say – had reached apotheosis.

And he had not said his last word, either.

Henri Matisse, 1950–54:
Triumph and Tribulation

On January 1, 1950, Henri Matisse had just turned eighty years old. Given his medical history, he was as well as could be expected. It was an agony to him that he sometimes had painful spasms in his eyes. But there were hopes that these could be corrected, thanks to an Indonesian acupuncturist who came from Paris whenever he was needed.

As much as at any other time in his long career, Henri Matisse was longing to work, and he had no lack of new ideas. It was not in his nature to "make another Matisse." Even so, it was unlikely that with his general physical condition he would ever again be able to paint in oils on canvas, and even more unlikely that he would make another sculpture.

He was, however, delighted to work with painted paper, cut with scissors or shears and pasted on white or colored paper. As a medium, and in relation to his irreducible infirmities, this was nothing short of miraculous. Though virtually weightless and in appearance almost incorporeal, it allowed him to work on a monumental scale. His *Swimming Pool* (1952), which reached the Museum of Modern Art in New York by way of the Pierre Matisse Gallery in 1975, is 7 feet 6 inches high and almost 54 feet in length. In a more traditional, Old-Masterish format, his *The Parakeet and the Mermaid,* also done in 1952 and now in the Stedelijk Museum, Amsterdam, measures 11 feet by 25 feet 4 inches.

The medium was one that he had worked with in his book, *Jazz,* in Vence between 1943 and 1946. It lent itself ideally to the maquettes for the stained-glass windows and the chasubles for the Vence chapel. But it was also to have an

independent life in images that – unlike the maquettes just mentioned – did not have a specific function. Matisse did not regard them as a new beginning, but as a culmination of everything that he had done before.

Matisse considered the image that he had cut with scissors or shears to be as much a "drawing" as anything that he had done with pencil or pen and ink on paper. As he wrote in 1950 to the director of a Danish museum that had bought his *Panel with Mask* of 1947, "With my scissors, I draw directly in color. These works cannot be reproduced in multiple copies because, as is the case with a tracing, they would lose the sensibility that my hand had brought to them." As to the status of the paper cutouts in the hierarchy of his work, Matisse wrote in 1952 to Jean Cassou, then head of the Musée National d'Art Moderne in Paris, that he considered his cutout *Sorrow of the King* (*Tristesse du Roi*) of 1952 to be the equal of any of his paintings.

As works for exhibition, the works in cut paper had made their American debut at the Pierre Matisse Gallery in New York in February 1949. Another among them, *Zulma,* caused a considerable stir at the Salon de Mai in Paris in 1950, and was bought for the Statens Museum for Kunst in Copenhagen. The year 1950 was also marked by the award to Henri Matisse of first prize at the Venice Biennale, the publication by his friend Tériade of his illustrated edition of the poems of Charles d'Orléans, and the first complete showing in Paris of the five busts titled *Jeannette,* based on the model Jeanne Vaderin, that Matisse had made between 1910 and 1916.

The design of the chapel in Vence, begun in 1948, called for a colossal effort on his part, even if a whole fleet of craftsmen was on hand to bring it into being. (He was in no way deterred when the occasion called for him to stand upright at the top of an improvised scaffold and draw on the wall with a long baton of bamboo that he had to hold at arm's length.) Due to be consecrated on June 25, 1951, the chapel had already been much talked about. But Henri Matisse hoped that it would also become very well known in the United States, preferably as the result of an exhibition of his full-size cartoons for the stained-glass windows. He also hoped that these cartoons would find American buyers, thereby raising money that could be set against the costs of the chapel itself.

He had never quite lost faith in the United States as a newfound land in which he would be the favored artist of either a private or an institutional elite. In that ambition, he counted on his son Pierre as a predestined and dexterous ally. It would be Pierre's role to secure for his father some challenging, lucrative, and highly visible commissions, either in stained glass or in ceramics. The Vence chapel would set the standard of quality, in this respect. And Pierre, with his

intimate knowledge of possible American patrons, would walk with his father, shoulder by shoulder, for as long as Henri Matisse could put one foot before another. His experience, his contacts, and above all his time would be at his father's disposal. That was the general idea.

It was on May 5, 1950, that Henri Matisse outlined to Pierre his plan for a touring exhibition in the United States of his cartoons for the Vence chapel. Money taken at the gate could be given, either entirely or in part, to offset the outstanding expenses of building the chapel. He took it for granted that an exhibition of this sort by a great painter who was much in the news would be welcomed everywhere.

Pierre had to tell him gently that this was not the case. The exhibition would be of very large works – up to 16 feet 5 inches high and proportionately wide. Not even the Museum of Modern Art in New York could rearrange its schedule at short notice to make room for such an exhibition. Galleries with a height of up to 20 feet would be called for. Where the works were made with cut papers, they would be liable to a twenty percent tax on their value at the port of entry.

Furthermore, few museums would wish to make a separate charge for the exhibition. No income might result, therefore. Nor would the cartoons necessarily endear themselves as objects to be bought and installed on permanent view, whether in the museum in question or in a private house. Pierre could have added, though he did not, that to arrange a tour of this sort – even if it were possible – would involve him in an immense amount of work and almost certainly leave him substantially out of pocket. The project went no further.

In the spring and summer of 1951 Henri Matisse continued to have serious eye trouble. On May 6, 1951, he wrote to Pierre that "just between you and me, if I want to go on working, I have to be very, very careful about my eyes. We have not yet found a way to arrest the spasms that trouble them from time to time." And on May 25, he said, "I've had my eye troubles for nearly two years now. Nobody can find a rational way to deal with them. Sometimes I can see perfectly, and then suddenly I can't complete the sentence that I've just begun to write." With an almost English understatement, he said, "It's really rather tiresome not to be able to count on one's sight from one moment to the next."

Yet, in the arena of the Matisse family, Henri Matisse was as alert as ever. He was minutely attentive to his grandchildren. If Pierre's daughter Jackie suddenly lost weight, or if his son Peter was growing up too fast, the equivalent of smoke signals would be sent out by the next mail. When Jean Matisse's son Gérard was badly injured in an accident, Henri Matisse agonized. And in January 1950, when his grandchildren were around him in Cimiez, all talking at

once, he told Pierre that the cheerful, uninhibited tumult inspired in him a wistful, unspoken melancholy that was close to poetry. "And then," he said, "And then . . . zim-boum-boum!"

The one-on-one of his correspondence with Pierre then became notably less carefree. Pierre had just returned to New York after a side trip to Barcelona. In Barcelona he had had to work with Aimé Maeght on the division of Joan Miró's recent work. "Maeght gave us an edifying account both of his tastes and of his way of life. But still . . . in business one can't be too difficult. Nor am I the only one who has had to deal with him. But I have decided once and for all that he's dangerous. He has no scruples. He is a shameless liar. His speciality is to make people roar with laughter while he quietly picks their pockets."

Pierre had also been annoyed to hear from Teeny, his former wife, that Henri Matisse had promised her that his painting, *Asia* (1946), was to be hers to sell. Had Pierre brought it back from France with him, she asked, and what did he intend to do about it? As it happened, *Asia* was a particularly seductive painting. It had been Pierre's understanding that for family reasons his father did not wish to do business with Teeny. For himself, he did not wish to do any business with her, or to enter into any joint undertaking with her. In view of what his father had apparently done, he would withdraw whatever claim he might have had to *Asia*.

"But I think," he went on, "that your point of view is dictated by a specifically French tradition – one that simplifies every problem and brings it into line with what is the accepted form in France. I am sorry that you cannot see beyond it. But let us leave it at that, for you will say that I am only 50 years old, whereas you are 80. That will not help us to understand each other better."

Quite clearly, it seemed to Pierre that in giving Teeny a very desirable painting his father was, by implication, distancing himself from Patricia Matisse, whom he had married in 1949. "I find it regrettable," he said, "that you should condemn someone whom you hardly know, and whom you have looked at through the wrong end of a lorgnette without wishing to know her better. That is very painful to me. Always the same distrustful attitude, the eternal 'You'll live to regret it' and the ingrained Catholic cynicism."

Pierre ended his long letter with many an amiability – not least, a lengthy account of the opening of the Cone Collection at the Baltimore Museum of Art, in which forty-one paintings by Matisse were on view. The veteran English art critic Clive Bell had given an address.

But this was not a letter that Henri Matisse was likely to leave unanswered. By return mail, he wrote: "Now that you have got all that off your chest, you are (as always) entirely responsible for yourself. At fifty, you are a grown man,

twice over. I am happy to know that I no longer need to have any anxieties either about yourself or about your responsibilities to your family. You will excuse a poor old European if he did not understand a young American like yourself."

He then gave his own version of the incident of *Asia*. "When you were last in Nice, Madame Lydia said to you – when I was in the room – that I had cabled to Teeny to say that *Asia* was hers. If I had decided to give her *Asia,* it was because I knew that you have difficulties right now. This was confirmed when Teeny told me that you were behind with what you have owed her since your divorce. I am happy to learn that those payments have now been brought up to date.

"As for our family differences, they would be solved faster and more easily – even in France, where all this began – if people would be good enough to mind their own business. It was a true Frenchman, André Gide – now more than 80 years old – who said, 'Families, I hate you!'" This letter ended with the words, "I embrace you with affection. Please present my respects to Patricia."

It should be said that in spite of the minimal greetings to Patricia that have just been noted, she soon won over her new father-in-law. On April 15, 1951, he ended a letter to Pierre with the words "I embrace you both, with my affection, H. Matisse."

Though affable enough with American visitors who had come with the right recommendations, Henri Matisse had never quite got reconciled to the fact that his son had become an American citizen. He would have liked his grandchildren to have grown up as French in all their ways, so that he could count on them to grow up, see sense, and come back to live in Europe. In May 1951 he wrote of his grandson Peter that he was really very good-looking. "But I'm shocked, all the same, by his American way of behaving. But that's just me – 'the little Frenchman who so quickly takes offense,' as you Americans say."

French–American relations seemed to be on firmer ground when a hundred-year-old American firm – based in Yonkers and called Alexander Smith and Sons – asked if they could reproduce Matisse's cut-paper piece, *Mimosa*, in the form of a rug. In return, they would give a substantial share of the proceeds to support the Vence chapel. There were difficulties en route – above all, when an intrusive pink shape was found to have been added in one corner. There were also troubles with a border that had been added without Matisse's permission. A first consignment of two hundred fifty rugs had to be destroyed, for that reason. "Even if they paid for the whole chapel, those rugs have to go!" said Henri Matisse. But a further consignment, revised and approved, went on sale in 1951.

Henri Matisse never spoke like someone whose days were numbered, but there were signs in 1951 that he was putting his affairs in order, once and for all.

He began to think about the eventual disposition of some of his sculptures. The ones in question ranged from the monumental *Backs* to a tiny bust of Pierre that he had made in 1904. He also began – not for the first time – to try to persuade his son Jean to behave better to his fellow members in the family.

As a part of this campaign, he asked Pierre on May 5, 1951, to pay Jean the money that he owed him as soon as he possibly could. "I know," he wrote, "that when we last talked about this I asked you not to send him money. But now I have changed my mind. Jean makes such a drama out of the fact that you owe him money, and he talks it up so widely, that I simply don't know what to do with him. I wanted to give him his studio for the work that he had done for me, but he made a drama out of that, too. So I let the idea drop."

On October 4, 1951, Pierre broached two matters of enormous importance, both to the Matisse family and to his own position within it. One of these was a formal Acknowledgment of Debt, which would relate to monies left in the United States by Henri and Amélie Matisse before the opening of World War II. These monies had later been blocked, under international law, and could not be reclaimed until 1945. Both Henri and Amélie Matisse had been surprised and displeased by this.

The other matter was the suggestion, lately mooted by Henri Matisse, that Pierre should be appointed as the executor of his will. This was a delicate question on more than one count. No one knew what Henri Matisse would say in his will. The estate of a major artist with a large family is always fraught with problems. Pierre was the second son, not the first son, of Henri Matisse. He was an American citizen, resident in the United States. It could be argued that Marguerite was better placed to undertake the responsibility.

Pierre was sensitive to all these concerns. He also remembered a conversation in the early summer of 1951 during which Henri Matisse had broached the question of Pierre's becoming his legal executor. He remembered, and Madame Lydia could probably confirm, that Henri Matisse had said, more or less, that he was showing his total confidence in Pierre "despite the way in which you made off with the money that I had entrusted to you during the war."

At the time, Pierre thought it better to let that pass, and to concentrate on the larger question of his duties as executor. "But then," he wrote, "I realized that you thought that I had simply written off the money in question and that you would never see it again. As that had never been my intention, I decided to make an Acknowledgment of Debt. This would apply not only to yourself but to the family in general. Acknowledgments of this sort can be very useful, when suspicion and jealousy may otherwise come into play. If you got my letter from

Madrid, in which I told you of my intentions, you will find that I thanked you for your confidence in me, in the matter of my executorship. I also urged you not to tell Marguerite about it. This would allow you to change your mind, if you wanted to, and to avoid pointless ill feeling. I also mentioned the Acknowledgment of Debt and said that the amount of the debt would be reduced by whatever sums of money that I could send you from time to time."

On a relatively serene level, Henri Matisse was glad to hear in November 1951 that the Museum of Modern Art in New York was having a great success with the Matisse exhibition that coincided with the publication of Alfred Barr's *Matisse: His Art and His Public*. Pierre was able to tell him that he was drawing more visitors than either van Gogh or Picasso and that Alfred Barr had surpassed himself in its planning and installation.

Even so, Henri Matisse in his eighty-third year was still looking to the future in relation to his work. And he took a particular delight in his recent cut papers. One of these, the *Creole Dancer* (June 1950), had particularly impressed Pierre when he saw it in his father's studio. In fact, he had liked it so much that he immediately asked if he could buy it, and if so for how much. Henri Matisse would not entertain that idea, and told Pierre that he did not wish to sell it.

This caused Pierre to think that his blunt, unornamented approach had offended his father. Did he think that Pierre had made a precipitate bid for something that he knew to be saleable, rather than for something that he loved and admired? Did he think that Pierre had behaved like a dealer on the make, rather than like an admiring and affectionate son? And who was Pierre, anyway, to bid for a major new work when he still owed his father money for earlier purchases?

These ideas took hold of him to such an extent that he had to unburden himself. On January 22, 1952, after a whirlwind tour of Swiss museums and collectors, he wrote to his father, "I was so carried away by the *Creole*," he said, "that I simply couldn't talk to you about it. The first time round, I was still exhausted by my journey. The second time, I was disconcerted because you said that if I had really liked it, I would have said so at once. But the truth is that when I am deeply moved I never know how to express my feelings. Please believe me when I say that it is not only the wish to make money that makes me want to buy beautiful things. If I were simply in business for the money I could do as well with mediocre pictures as with those I really like. But this is an aspect of the matter with which you have never had to concern yourself. Business is business, in your view, and that's all there is to it. And the truth on my side is that I never know how to come out with my feelings."

This question had always been the last barrier between Pierre and his father.

Pierre had won his father's confidence a hundred times over, but he would always be a dealer. And his father could never quite overcome his detestation, not of his son, but of his son's profession.

As for Pierre's inability, as he put it, to "externalize his feelings," that trait was not unique to himself in the Matisse family. The more moved he was, in any given context, the less easily could he express his feelings. And this was never more evident than when he was faced with works of art. With age, he learned to make an eloquent case in writing for works of art that he truly admired. But when faced with one of them for the first time, he fell silent. Even with Alberto Giacometti, he would sometimes spend hours in the studio without saying a word. That silence was his highest compliment, but it could be misread.

On this particular occasion, however, he had not been misunderstood. His father wrote back as follows on January 28, 1952: "My dear Pierre, I understood perfectly well that you really liked the *Creole Dancer*. I also understood that you could not spend all your reserves on my new work. But I truly really don't want to sell the *Creole*. If anyone else had asked me for it, I would have simply said No. But as it was for you my first instinct was to help you. It is always painful for me to have to fix a price when I am selling to you. But in this case I didn't even get that far. I think that it has an exceptional quality, and it is both agreeable and useful for me to keep it by me – at any rate, for a certain time.

"Do not infer from this that I want to do it all over again. I simply want to tell you that I am not certain that I can do any more work of that quality, in no matter what medium, and for that reason I want to hold on to it."

In April 1952, as part of the steady buildup of his representation in the Museum of Modern Art, Henri Matisse agreed to sell his canonical *The Moroccans* of 1915–16 to the museum. (It eventually came to the museum as a gift from Mr. and Mrs. Samuel Marx in 1955.) On April 9, Henri Matisse displayed his habitual interest in the ups and downs of his major contemporaries. "Paris at this moment is full of dramas," he wrote to Pierre. "Picasso had double pneumonia and almost died of it. He's doing well now, but Olga Picasso is bedridden and half-paralyzed after a cerebral hemorrhage. And then there's Chagall. Virginia told him that she is in love with someone else (an American photographer that you may have seen at their house when you were here last.) She has decided to leave Chagall who is apparently in total despair."

Henri Matisse was to follow the fortunes of Chagall with a lively interest, and all the more so as Chagall kept in touch with him. "Marc is more himself now," his father wrote to Pierre on April 27, 1952. "What he wants is a little girl, aged fifteen. Since his operation he feels like . . . an 18-year old." "As for the

little girls, it would not surprise me," Pierre wrote back on June 2. "We must not forget that Marc is an oriental, and that in his country 15-year old girls have other things in mind than playing with dolls, as they do here."

Though oppressed by signs of failing health, Henri Matisse was still eager to work. "At this moment," he wrote to Pierre, "it suits me rather well to make stained-glass windows. They are made in France, under my close supervision. I choose the glass. It is cut exactly according to my cartoon. I can sign it. Once the window is finished, I give the cartoon to a museum, with a note as to where the window itself can be found. (It would make no sense whatever to put the cartoon in the same building as the window.)

"Windows are not terribly expensive to make. The price varies according to the complexity of what the glassmaker has to do. To give you an approximate idea (just between us), it cost 100,000 francs [$285] to make the window of St. Eustace, plus the cost of its installation.

"If I am making a window for a client of yours, I should inevitably have to be in contact with the client for one reason or another. So I think that you should take a percentage of my fee. We could fix on $4,000 or $5,000 as the fee, with 15 percent for you. Let me know what you think.

"I should add that I cannot accept a commission that is smaller than two square meters."

These remarks were well timed, in that by February 27, 1952, Matisse had finished a stained-glass window for Time, Inc., on the theme of Christmas Eve. (Both the maquette for this and the window itself were given by Time, Inc., to the Museum of Modern Art in 1953.)

In the fall of 1952, Pierre Matisse began to negotiate with Mr. and Mrs. Sidney Brody for a projected large-scale ceramic that would be installed in the central open patio of the Brodys' house in Los Angeles. Both the Brodys were experienced collectors with strong personal tastes. It was Pierre's role to find out exactly where they would put the ceramic, and how large it should be, and what its surroundings would be like. Also to be discussed was the search for someone in California who could execute the commission there and with the techniques and the materials that Matisse called for. If the work were to be done in France, there would be problems with customs, both there and in the United States, and all the risks of damage during the journey. There was also the fact that if the Brodys should ever move they wanted to be able to pack up the ceramic and take it with them.

Age and illness notwithstanding, Henri Matisse got a tremendous charge of excitement from the very thought of the Brody commission. Everything indicated

that he was in top form. On October 12, 1952, he wrote to Pierre that Picasso had come by and seen a maquette for the Brody commission. "He never says anything, as a rule. But on this occasion he said spontaneously that it was 'very beautiful. Only Matisse can make something like that.'"

Pierre meanwhile was anxious that the Brody ceramics would be made in California. "The industry of making varnished and enameled tiles has been very much developed in California," he said, "thanks to the practice of open-air architecture. The real difficulty would arise when we want to make the tiles correspond exactly to your maquettes."

As to that, Matisse the great professional left nothing to chance. The maquettes would be quite simple, on purpose. As to how the tiles (or "plates") should be transferred, Matisse had heard of special saws that would be just right. It was vital that the plates should not shrink, to an unpredictable degree, during the firing. After the firing, the maquettes should be returned to Matisse so that he could be sure that nothing untoward had occurred.

Pierre had explained to his father in a letter dated October 8, 1952, that what the Brodys really wanted was a ceramic that would bring, in effect, an ever-lasting floral background to an outdoor sitting room, or sitting space, that was already complete with a long divan. The site had hitherto had only a touch or two of evergreen. Pierre also sent a sketch of the site that made its awkwardness quite clear. The available space was 10 feet 7 inches high, but its width had still to be decided. Pierre was somewhat disturbed to hear that although his father did not yet have the exact dimensions of the site and had not even settled on the fee, he was already racing ahead with at least one project.

Eventually, Henri Matisse came up with two successive projects, both of which were far too large for the Brody site. (He had had no contract with the Brodys, and had never asked them exactly what they wanted.) *Large Decoration with Masks,* now in the National Gallery of Art in Washington, D.C., measured 11 feet 7 1/4 inches by 32 feet 8 inches. *Decoration: Fruits,* which measured 13 feet 5 inches by 28 feet 6 inches, is now in the Musée Matisse in Cimiez. By mid-May of 1953, he had also completed another large decoration, called *Apollo,* which is now in the Moderna Museet in Stockholm. This measured 10 feet 8 inches by 13 feet 10 inches. Very grand they were, all three of them, but none of them suited the Brodys, who had never been consulted about them.

It was not until May 1953 that the Brodys came to Nice and paid a call upon Henri Matisse. On May 18 he wrote to Pierre: "The two Californian giants, Mr. and Mrs. Brody, came to see me. Their first visit was discouraging. They seemed to be completely unresponsive, looked at nothing when they walked around the

apartment and were in no way stirred or enthused when they came to the maquette for their ceramic.

"They told us how much they had liked a bas-relief that they had seen at Saint-Paul de Vence and how much they would like to have something like it. We assumed that they must be thinking of a bas-relief by Léger at the Colombe d'Or.

"The next time they came, they confirmed that my maquette was much too large for their wall. I told them that it was theirs, if they wanted it. But if they didn't want it, that was of no importance, because I would keep it for myself.

"On the next day, we were able to show them the new samples of ceramics that had just been delivered. They were simply thrilled with them, and decided to ask their architect for the exact dimensions of their space, in hopes that I would be able to make something for them.

"Their whole manner had been transformed since the previous day. They could not have been warmer, and seemed ready to take anything that I chose for them. They did say, though, that they would like something quite simple – a vivid scatter of color on a white background.

"The price was not discussed. All went well, they left us with a very good feeling about them, and as soon as I have the right dimensions I'll do something for them. As they are staying for several weeks in Europe, you may run across them, unless your paths cross in the sky."

It was within a very short time that Henri Matisse was able to produce *The Sheaf (La Gerbe)* (1953), which measures 12 feet 7 inches by 11 feet 5 inches. (It is now in the UCLA Art Galleries in Los Angeles.) It was precisely the "scatter of color" that the Brodys had hoped for. It can be read as a bouquet, but not as one in which the blooms come bunched. There are more than forty individual flowers, and each goes its own way in an aerial and uncluttered space.

That the Brodys did not respond to his earlier designs for them might have been a blow to Henri Matisse, who had been very high on the *Large Decoration with Masks*, in particular. "It's a complete success," he had written to Pierre on November 2, 1952. "I think it will be my last work in this genre. I have given it all my strength, and I shall not try to do anything better. As you know, I only ever made *one* theater decor, *one* chapel . . . and now this *one* ceramic.

"If I go on in this same vein, new ideas will come to me. But I don't think I can go on. I'm terribly tired. My age is against me, I have asthmatic crises that are very exhausting and call on all my reserves to keep going. I give my doctors a lot of trouble, because they have to work on me 'with their fingertips,' as one of them used to say. I have exaggerated reactions – whether for better or for worse – to all their medications."

By November 12, Henri Matisse was in quite another frame of mind. "My attacks of asthma have come almost to an end," he wrote to Pierre, "and I am on the way up again. My anxieties fade away when I am taken to see the maquette for the ceramic panel. It's so clear and so strong. The combination of the masks and the flowers is something that has never been done before. It is such a consolation for me to have achieved this at the end of my life. As I already told you, both Picasso and Jacques Prévert liked it very much. So did the General of the Dominicans, who saw it the day before yesterday, and Father Couturier, who came today. I felt that they really admired it."

Just two days earlier, the Musée Matisse had been inaugurated at Le Cateau-Cambrésis, where Matisse had been born. There was already a small municipal museum in Le Cateau, but early in 1952 a delegation from the town visited Henri Matisse and told him how much they hoped that his work could be represented in his birthplace. Not only did he welcome this idea, but he gave the museum a careful choice of thirty-eight drawings, five sculptures, two paintings, a tapestry, twenty-seven engravings, ten illustrated books, and twenty-five documentary photographs. The ensemble was conceived by Henri Matisse as a general introduction to his career to date.

The town forthwith made over to him the large reception room – 100 square meters in all – on the second floor of the French Renaissance town hall. This continued to function as the Salle d'Honneur in which marriages were celebrated. (In the museum's initial phase, the role of curator was filled by a local pastry cook who happened to be a painter.)

Henri Matisse had always been sensitive to the region in which he had been raised. Already in March 1944 he had inscribed a copy of his *Les Lettres Portugaises* and sent it to the museum in Lille. The inscription read: "In homage to the Musée des Beaux-Arts de Lille in which for the first time, just fifty years ago, I came face-to-face with real painting, in Goya's *Young and Old Women*."

By now thoroughly fired up, Henri Matisse in his eighties sent for floor plans and photographs and planned the installation down to the last inch. In doing this, he remembered the words *Dépêche-toi!* that were heard from morning till night in the Le Cateau of his boyhood. (In local usage, they did not so much mean "Hurry up!" as "Get on with it!" or "Keep going!")

He himself could not supervise the installation, but Madame Lydia saw to it that his instructions were carried out. He chose the frames and the mats. He planned every double row of drawings. He had never stopped working, and he made sure that the museum would prove it.

At the time of its inauguration in 1952, the museum had an almost magical

effect upon relationships within the Matisse family. (It was to become, in fact, a kind of family tabernacle, towards which generous loans were to flow.) What happened at the inauguration was this. Marguerite and her son Claude had been there. So had Jean and his son Gérard. Marguerite and Jean had long been estranged. They had had no neutral ground on which to meet. But on that day in Le Cateau, and on the journey back to Paris, a new cordiality arose. The weather was horrible, and the road dangerous, but Jean went so far as to compliment Claude, who was driving, on his demeanor at the wheel.

"How I wish that I could have been there," Pierre wrote to his father, "to witness the reconciliation of Marguerite and Jean. I hope that this brief reunion will bear fruit, and that they will draw near to one another, and rediscover the secret feelings that still bind them together." And Pierre went on to outline a "new adventure" that he had been hatching for his father.

Henri Matisse replied forthwith, on November 22, 1952. "I have just read your letter, this instant," he began. "It did me an immense amount of good. I am still convalescent – which means that I am frightened of everything. I have lost all confidence and I can't sleep. Your letter gave me back my confidence. A wholly sleepless night had laid me out flat. And yet your letter put me back on my feet. How was that possible? Was it because you offered me such a great new opportunity, even if it was still only a project? Or was it because of what you said about our family? I think it was for the second of these two possible reasons.

"In your letter, you put your finger on many important things – especially the severance of all ties between Marguerite and Jean, who fundamentally adore one another, and the hardening of the heart that finally destroys us one and all. We end by saying to ourselves, 'Let them work it out among themselves. We don't want to enter that swampy and pestilential terrain. We all of us have our lives to lead.' That way, a universal misery lies."

Henri Matisse then showed to what an extent he had sometimes been misled by Pierre's apparently impassive but inherently stoical bearing. "Your letter shows," he went on, "that you are not made of stone, as one might sometimes believe. You bear within you wounds that call out for healing. When faced with your indifference – or with your determination to protect yourself and not get involved – people used to say, 'Pierre doesn't give a damn.' They meant to say that you were like a heavy and immovable stone that just sat there while all around you other members of the family were gasping for breath. Your letter showed me a very different Pierre. If there were walls between us, they came tumbling down. I cannot say anything more now, but we will speak of it again."

Henri Matisse. *Interior with an Egyptian
Curtain.* 1948. Oil on canvas, 45¾ x
35⅛" (116.2 x 89.2 cm). The Phillips
Collection, Washington, D.C.

PLATE 41

Henri Matisse. *Ivy in Flower.* 1953.
Colored paper, watercolor, pencil,
and brown paper tape on paper
mounted on canvas, 112 x 112"
(284.5 x 284.5 cm). Dallas Museum
of Art. Foundation for the Arts
Collection. Gift of the Albert and
Mary Lasker Foundation. 1963.68FA

PLATE 42

Henri Matisse. *Nude with Oranges*
(*Nu aux oranges*). 1953. India ink,
gouache, cut and pasted paper on
canvas, 61 x 42½" (155 x 108 cm).
Musée national d'art moderne.
Centre Georges Pompidou, Paris

PLATE 43

Yves Tanguy. *The Mirage of Time.*
1954. Oil on canvas, 39 x 32"
(99.1 x 81.3 cm). The Metropolitan
Museum of Art, New York. George
A. Hern Fund, 1955 (55.95)

PLATE 44

Raymond Mason. *The Crowd*. 1968.
Bronze, 82⅜ x 45¼ x 116½" (210
x 115 x 296 cm). Fonds national
d'art contemporain. Ministère de la
culture, Paris

PLATE 45

Joan Miró. *Bleu II*. 1961. Oil on
canvas, 106¼ x 139¾" (270 x 355 cm).
Musée national d'art moderne.
Centre Georges Pompidou, Paris

PLATE 46

Loren MacIver. *Fermeture Annuelle.*
1966. Oil on canvas, 45 x 57½"
(114.3 x 146 cm). Courtesy Tibor
de Nagy Gallery, New York

PLATE 47

Zao Wou-Ki. *April 15, 1977.* 1977.
Oil on canvas, 78¾ x 62½" (200 x
161.3 cm). Private collection

PLATE 48

The "great new adventure in question" that Pierre had set before his father was a projected commission from Mrs. Albert Lasker, whose husband had died not long before. What she had in mind was a mausoleum in Newport, Rhode Island, that would not be sad and dreary, but predominantly light and gay. Pierre went on to say of Albert Lasker that he was "a man who loved life, in the good sense of that phrase, and had a particular way of stimulating everyone with whom he came into contact. This happened in matters of business, but it also happened when he turned to the disinterested causes for which he was often solicited. On all such occasions, he inspired confidence and created that faith in life which lightens its problems. I should add that towards the end of his life, he had a particular passion for your paintings. That is why you are being asked to bring to this mausoleum the radiant lightness of spirit for which Albert Lasker is remembered by everyone who knew him."

Pierre then went into the proposition with a degree of detail that shows how anxious he was that his father should accept it. He sent photographs of the building and explained that it was built with a marble from Tennessee that turned rose-pink in wet weather. The facade was to have a bronze door, backed with glass. Passing to "the backside, if I may so call it, of the edifice," where the projected Matisse window would be, he said that it faced due south. The window was to be 11 square feet. The window would occupy the entire wall. There was a plan to plant yew trees, to avoid any excessive glare from the south light. Henri Matisse would be consulted about the placing of these trees.

"As to the proportions of the window," Pierre wrote, "you do not have to keep to the dimensions that I have just mentioned. You may prefer its proportions to harmonize with the front door. The bronze door offers a clear view through to the window at the other end of the mausoleum so that the visitor could look straight through and see the window beyond. Mrs. Lasker would be delighted if you would like to design the bronze door yourself, with that in mind. This would seem to me logical. In any case, they would welcome your views.

"If you would like the interior of the mausoleum to be animated by the colored light reflected from the window, that is for you to decide. They would just like to remind you that the light in Newport, as you may remember, is very white. In fact it is quite different from the Mediterranean light. The colors that work so well in the Vence chapel would not suit in Newport. They suggest 'reds and blues.' (I am passing this on in their own words. Please do not think that I am presuming to encroach upon your domain.)"

There remained the matter of money. It was suggested that Henri Matisse would submit a maquette for which he would receive an agreed fee, whether or

not it was used. "I told them," Pierre wrote, "that it would be out of the question for you to submit a small-scale maquette. You could not possibly submit a sketch on little sheets of paper. (Léger could, but, thank God, you are not Léger.) Your way of working was to work – as had happened in the Vence chapel – on the actual scale of the commission. You worked as a sculptor works in direct carving, to full scale.

"So the maquette would be slightly more than 3 square meters. Madame Lydia would take photographs of it, and these would be sent to Mrs. Lasker for her approval. If the project is turned down, the maquette would remain your property and you would be paid $5,000 for your work and your time. If it is accepted, you will receive the agreed fee, net to you, and they would pay for the execution of the window.

"I know what you will say – that you will be handing over a whole slice of your life, and that you don't even know if you could undertake it, or whether you have the strength to carry it through, and so on. But you will understand that I do not wish to go into those intimate matters with them. They can only be understood by those who love you and who understand your complexities.

"So that's how it is. Please think it over and let me know. We can then act upon your comments."

This was the kind of commission that Henri Matisse craved especially at this stage in his life. He was offered a free hand in a prestigious enterprise. It would be, in effect, a small-scale reprise in the United States of his chapel in Vence. It would be devotional, but not drab. It would be planned by himself, to the nearest fraction of an inch, and executed by reliable craftsmen in an idiom that he understood completely. It would be talked about, and it would bring in some money. Apart from everything else, it would ideally complement the Brody commission. And – let us make no mistake – the two commissions were the more congenial in that Pierre Matisse knew all the people concerned and could see to it that everything went smoothly. Henri Matisse took it for granted that if problems arose Pierre would sort them out.

As for the Lasker mausoleum, it revived Henri Matisse's everlasting confidence in the possible role of the United States in the evolution of his career. It should be remembered that he had never received in France the kind of support that he had received in Russia before 1917, or in Scandinavia, or in the United States. French museums had lagged far behind. French collectors, though enlightened, had been a small minority.

He had not long emerged from a period in which there had been virtually no demand for his work in France. So a proposition from the United States came to

him almost as a lifeline. "What you say about the Lasker project delights me," he wrote to Pierre. "I almost have to tie myself hand and foot to prevent myself from starting work at once. I see nothing wrong with their conditions, and I can already imagine the lofty style that will be called for if I am to match the feelings that prompt the commission. I don't know what will come of the idea, but I am very grateful to you for pointing me in that direction."

The project made a very promising start. Henri Matisse was delighted. Mrs. Lasker seemed to be delighted. Only the practicalities remained to be settled. Pierre had telephoned to Mrs. Lasker and told her that his father would accept the project, but that he needed to be absolutely clear as to what he would be doing and how much he would be paid for it.

Pierre wrote on November 28, 1952, to suggest that his father should undertake to make a maquette for the stained-glass window and have the window made in France. Next he should design the bronze door – or, to be more precise, the motifs for the grille. He should give some advice about the yew trees. He should not forget to say that he was agreeing to work on the mausoleum because of Albert Lasker, who had been so great an admirer of his work. He should also remember that the project had been suggested to Mrs. Lasker by Alfred Frankfurter, the editor of *ARTnews* magazine, and that Henri Matisse had told them that Pierre should be his intermediary in this matter.

As for the price, Pierre suggested $25,000 for the full-scale maquette and the drawing for the bronze door. His father would, of course, supervise the making of the window. Pierre also suggested that the maquette should be included in the price. If at any time the window should be damaged, or even destroyed, it would then be possible for it to be remade from the original maquette.

And if, finally, Mrs. Lasker should turn down the maquette and abandon the project, Henri Matisse would receive either a third or a quarter of the full fee.

The *Christmas Eve* window that Henri Matisse had designed for Time, Inc., was put on view in the reception center of the Time-Life Building in New York. Henri Matisse had written to Alfred Barr to say that, "I hope you will agree with me that a maquette for a stained-glass window is like a musical score, and that the window itself is like a performance by a full orchestra."

The window had precisely the festive, not to say jubilant, character that was appropriate to an evening on which the world was believed to have taken a definitive turn for the better. In the upper air, stars soared and tumbled. The window was 10 feet 7 inches high and 4 feet 5 inches wide, and it was the epitome of Christmas. Henri Matisse had written to Pierre on November 27, 1952, and said that the window "is exactly as I wanted it to be, and it will bring to New York

– that 'city of cold light' – a taste of the brilliant and sun-warmed light of Nice."

But had he, perhaps, gone too far? "I'm afraid, between ourselves," he continued, "that I may have pitched my color chords just a little too high. It's like Wagner, or like very modern music: just a bit too much. Please tell me what you think, and how it strikes people whose opinion counts."

As to that, Pierre sent some news on January 3, 1953. After wishing his father "A Happy New Year, a better New Year, and the best of everything in your work," he said that he had been waiting for quite some time for a firm answer from Mrs. Lasker. "These great ladies are full of good intentions," he wrote, "but they are also very busy. They need time to think things over, and time to get their ideas together, etc., etc. On the day that I went to see your window in Rockefeller Center, I met Mrs. Lasker. She was walking out just as I was walking in. When we exchanged a few words, I sensed in her a certain reticence. As to why this was, I finally discovered yesterday, when she came to see me with Alfred Frankfurter, who seems to play a part in this story. (I shall not call it 'this affair.') Her reticence can be explained by the fact that she does not want the window for the mausoleum to have the same character as the window for Time-Life. She very much prefers the two twinned windows behind the altar in the chapel in Vence. She thinks that the motifs in the Time-Life window do not work very well together, and this has somewhat put her off the whole idea.

"Frankfurter and I had been planning our defenses before she came, and we said spontaneously that the Christmas project had nothing whatever in common with the one for the mausoleum. Other questions arose – for instance, will the windows be made in France or in America? All this has to be carefully studied. Frankfurter is to write me a letter, setting it out in full. Quite apart from that, Mrs. Brody from California will be here next week, and I shall certainly see her before she leaves for Europe." And Pierre signed off by saying that the problems posed by Mrs. Lasker would "certainly be solved before long."

In this, he was too sanguine. The problem of Mrs. Lasker would go on forever, more or less, and would never be satisfactorily resolved.

But by April 3, 1953, Henri Matisse was confident that he had solved the problem of the mausoleum window. (The maquette for this, *Ivy in Flower*, is now in the Dallas Museum of Art.) "I really think it's very beautiful," he wrote to Pierre. "It has a new harmony: on a background of buttercup-yellow frosted glass, I have laid a lot of big purple and green ivy-like leaves, with purple-violet seeds of ivy scattered in and out of them. It's very rich, and very beautiful. The square format is very good, too. And now I'm going to take a day or two off, so as not to get too tired, and then start on the grille for the bronze door."

From this point onwards, it was difficult to get an answer from Mrs. Lasker as to whether or not she liked the maquette for the window. On April 18, 1953, she wanted it to be sent to her before she left for England at the beginning of May. This would have meant sending it by air. As it could not be sent rolled up and would have to be laid down flat, it would be too large for any civil aircraft.

Unlike many a more experienced client, Mrs. Lasker was ready to say Yes or No on the basis of a color photograph. But Henri Matisse very naturally wanted to see the photograph before it was sent, and in the end it arrived in New York some time after she had left for London. It also became clear that Henri Matisse would insist on the window being made in France, and not in the United States, and would lower his price to cover the costs of its journey to the United States.

These were matters that fostered irritability. Henri Matisse did not enjoy his period of "rest." He knew that his window could be one of the grandest of his late works. It might also be one of the last of them. He did not care to be kept waiting for an answer. Pierre, for his part, was terrified that his father would mention the Lasker project to some of his visitors. Even worse would be for him to show the maquette to some privileged visitor. As Mrs. Lasker had not yet given her formal acceptance, a word in the newspapers with her name attached to it could cause untold trouble. Meanwhile, Henri Matisse went ahead with his design for the front door of the mausoleum, which was in the form of a slightly arhythmical chain link that would keep out any intruder and yet allow a clear view through to the far window.

In October 1953 Henri Matisse returned to Nice from Vence, where he had been for the previous three months. He looked again at his maquette for the Lasker mausoleum, and he thought it was beautiful. It was therefore both hurtful and an intense exasperation to him to find that Mrs. Lasker had turned it down on the strength of a color photograph. "What she has to say is quite unjustified," he wrote to Pierre. "It is not 'all yellow,' as she says. The major part of the surface is covered with green and blue leaves, together with clusters of red forms that suggest seeds of ivy.

"Yellow plays almost no part in the maquette, and I am simply furious that Mrs. Lasker should have turned it down. By the side of the maquette is the big drawing (black on white) for the grille on the bronze door. It is designed to allow the visitor to see through to the window and I think it will work very well. Is it conceivable that Mr. Frankfurter, who knows what he is looking at, cannot convince Mrs. Lasker of its great qualities? No one can judge the maquette without having seen it, as Mr. Frankfurter has. So I count on him to win her over. It is a miserable business that I should be treated like this at my age, and with all my

past work to speak for me. In any case, one thing is certain – that I am not going to begin all over again."

Just four days later, Pierre replied. "A few moments after your letter came, I had Frankfurter on the telephone. He told me that Mrs. Lasker wants to see both the maquette and the drawing for the door. He said that he had told her how beautiful the project was and how difficult it was to ask an artist to start again all over on a work of such quality, etc., etc. It seems that she has already found a space for the maquette in the United Nations headquarters in New York. So I have at once cabled to you to ask you to get the maquette packed and ready. I have to see Frankfurter in a day or two to finalize the plans for its dispatch. I think that all this points to an eventual happy ending to this story, and I knew that the enthusiasm of Frankfurter would be a trump card in our hands.

"You speak bitterly of Mrs. Lasker's comments on the maquette. But I don't think that you should let yourself be too upset by the limited understanding of people like Mrs. Lasker. She's crazy about painting – and about yours in particular – but everybody here agrees that she is absolutely impossible and has no taste whatever. 'Pearls before swine,' in fact! There are really very few connoisseurs in this town – a handful, at most. But let's wait for the arrival of the big package, and I think that with Frankfurter we shall persuade Mrs. Lasker to change her mind. In any case, don't begin again."

The truth was that, for whatever reasons, Mrs. Lasker had given up on the idea of the mausoleum, with or without a window by Henri Matisse. Her lawyers gave formal notice of this on March 12, 1954, almost sixteen months after Pierre had first sounded her out in the matter. What this meant was that almost through-out the last phase in his long career Henri Matisse had wasted much of his time. He would never again be able to put forward a comparable effort in a context that initially had seemed to be ideal. These were, in fact, to be the last months of his life. In writing to Pierre at this time, Henri Matisse downplayed his physical distresses. If he had a tickle in his throat and it went away, he would mention it. But in general, more serious matters were passed over, in favor of family news, for which he had a great appetite.

As has already been said, Patricia in the fall of 1953 inherited from her family a very handsome though not at all flamboyant villa that looked out across the harbor at Saint-Jean-Cap-Ferrat. This was a piece of news as to which all were free to speculate. Envy and jealousy were on the alert. As Henri Matisse was a favorite guest at the "Villa Natacha," a little house by the harbor that belonged to his friend Tériade, he knew the terrain and was eager to see the new acquisition.

It was on Pierre's mind that his father might assume that he, Pierre, had

bought the house. As he had owed his father a lot of money for quite a long time, the last thing he wanted was to seem to have spent a fortune on a house by the sea instead of paying his debts (or even some of them) to his father. So he wrote off forthwith and said that he himself had not spent a penny on the transaction.

Curiosity led Henri Matisse to hightail it to "Villa La Punta" as soon as he could. On November 30, 1953, he told Pierre what he thought of it. "I was there more than a month ago," he wrote. I thought the house quite extraordinary – princely, almost. I understand the surprise of our friend Tériade, whose house is so much more modest – almost a peasant's house, in fact, by comparison. I didn't stay long – just half an hour or so. I was very much struck by the terrace, though I had only a first glance at it and have to see it again. The staircase beneath the stained-glass window is a marvel of wrought iron, probably of 1900 or so. So there it is – I haven't a lot to say, as yet, but I was surprised by the sumptuosity of the house, despite its modest dimensions."

Pierre was relieved to read this, and chose his words carefully. "I wasn't sure what you would think," he wrote on December 9, 1953. "The house has echoes of the classic Côte d'Azur, and it has none of the simplicity of the houses that are now being built in the Provençal style. And the decoration matches the house. Once we have simplified that, the house will take on a new character – and all the more so because, as you say, its dimensions are modest. Of course the panoramic view from the terrace will always be astonishing. And of course the Tériades' house is more livable. In fact, it's rather like his gardener's house, except for the treasures that he has indoors."

As part of his long-running ambition to leave his affairs in good order, Henri Matisse wrote as follows to Pierre on June 6, 1954: "I have decided to help out by giving all three of you – yourself, Jean, and Marguerite – a certain sum of money. After thinking it over, I have decided to cancel what you owe me for *The Pineapple*. I shall then give to each of the others the equivalent of that same sum. I hope that you will make the best possible use of it. Remember that this is an exceptional gift. Please make it last.

"My health, which for some very long weeks has left something to be desired, is now gradually improving, and I hope to be able to leave for the country before long and complete my recovery."

Not everyone was so confident. Towards the end of June, Henri Matisse had a visit from the Dominican nun, Soeur Jacques-Marie, who had been his intermediary with the Dominicans throughout the construction of the Vence chapel. Before taking the veil in 1944, she had served him as his night nurse from 1942 onwards, under her previous name, Monique Bourgeois. (In 1942 she had also

sat for both paintings and drawings, all of which revealed a particular depth of scrutiny, eyeball to eyeball, on Matisse's part.)

When hiring a night nurse, Henri Matisse always asked the agency in question to send him "someone young and pretty." With Monique Bourgeois, he was lucky twice over, in that – as Lydia Delectorskaya was to say later – Monique had both "a lively mind and a noble physique." Later, as Soeur Jacques-Marie, she was to be indispensable to him in his relations with the Dominicans, not all of whom liked or approved of the chapel. It was a grief both to her and to Henri Matisse when her duties took her away from Vence.

In her long experience, she had never seen him as the legendary and forbidding "man from the North." On the contrary, she always remembered him as thoughtful, tender, and solicitous. So it was an appalling shock to her when she paid a rare visit to Nice towards the end of June 1954. In her book, *Henri Matisse: La Chapelle de Vence*, she wrote that, "I never expected to see him in such a state. There was nothing left of him but a poor old man, hunched and huddled. It was as if he could no longer see, and could hardly speak. What had happened to my invalid, who had been so lively even in his eighties? Gone was the mischief in his eyes. I could not understand this terrible change, though I learned later that he had passed a bad night, with asthma and insomnia in combination."

It would seem that Soeur Jacques-Marie caught Henri Matisse at an unusually bad moment. Throughout that summer, he dealt with business matters as briskly as ever. News of his family was always welcome, and promptly acknowledged. When he mentioned his own health, it was almost always to say that he was "a little better."

He made a small stained-glass window for the "Villa La Punta." He sat repeatedly for Alberto Giacometti, who made drawings of him in Cimiez for a medal commissioned by the French Mint. He worked on a design for the rose window of the Union Church of Pocantico Hills, New York. When Pierre's daughter, Jacqueline, became engaged to Bernard Monnier, a young Parisian banker, he asked them down to Nice and saw them for two successive days with every sign of enjoyment.

Pierre thought it prudent to tell his father that when he had bought Jackie a lot of linen and other essentials for her new household, he had managed to cut the costs without any loss of quality. "But after all," he said, "it's not every day that one's daughter gets married. Noblesse oblige!" With that, and not least with the accent on thrift, Henri Matisse was in full agreement.

He also expressed an interest in the bust of him that had been made by his son Jean and was soon to be installed in Le Cateau-Cambrésis. Pierre had seen it,

and reported on September 30 that, "It's really very good. It has a great deal of strength, and for something that has been worked up from photographs and from the depths of memory, it has a great deal of personality." (As this terrifying bust speaks all too clearly for a long lifetime of resentment on Jean's part, it may be fortunate that Henri Matisse never saw it.)

In his last letter to Pierre, dated October 4, 1954, Henri Matisse was as crisp and as concise as ever. "My health continues to be good," he said finally, "and this encourages me to hope for a good winter."

But on November 1, 1954, he had a cerebral micro-embolism. In the epilogue to her book, *Contre Vents et Marées* (1997), Lydia Delectorskaya wrote that the doctor had taken her aside and said, out of his patient's hearing, "This is the end."

Matisse lived on until November 3, in the belief that he was simply "out of sorts." Madame Lydia told him that he was heading for his annual attack of influenza and had to stay in bed.

"On November 2," she remembered, "I washed my hair. With my hair wrapped in a towel, turban-style, I came back to see him and, to lighten the atmosphere, I laughed and said, 'Any other day, you would have asked me for some paper and a pencil.'

At Henri Matisse's funeral, November 1954. From left to right: Georges Duthuit, Pierre Matisse, Jean Matisse, Marguerite Duthuit, Marie Matisse (Mme. Jean Matisse). Photo: Dmitri Kessel

"With a very serious look, he answered, 'Bring me some paper and a pencil.'

"I brought him some paper and a ballpoint pen.

"And he began to draw me. He made four sketches of my head and shoulders. Each image was about six inches high. He took a fresh sheet of paper each time.

"When he had finished, he gave me the sheets of paper and the pen. Then he asked to see the last of the four drawings once again. He held it before him, not quite at arm's length. He looked it over, severely. Then he said, 'It's good!'"

On those two words – "It's good!" – Henri Matisse had staked his whole career. He had never used them lightly. Nor had they ever misled him.

The next day, November 3, 1954, Henri Matisse died.

A New Cast of Characters,
1954–90

The postman's knock can be heard on almost every page of this book (and sometimes more than once). The auctioneer's gavel may be heard from time to time, but the postman (now known as the letter carrier, and no longer always male) takes precedence.

The book is powered by letters, and every one of them had demanded to be written. Putting pen to paper involved in almost every case a weighed and measured confidentiality. Every letter had a natural urgency and a one-on-one, all-or-nothing character. This was true of the letters between Pierre Matisse and his family, and it was also true of the letters between Pierre and his artists.

In the family letters, Henri Matisse was always somewhere around. Directly or indirectly, named or unnamed, his was the mighty, insistent, round-the-clock presence. At his anger, all others trembled. At his grief, every head was bowed. At his often frantic attempts to proffer a true and lifelong devotion, wonder and astonishment were mingled on occasion with disbelief.

Letters between Pierre and his father in the Pierre Matisse Gallery archives totaled well over eight hundred and twenty-nine. During the long lifetime of Henri Matisse, his was the emotional drumbeat to which no ear could be stopped. And it was to Pierre Matisse that, as has been seen, he spoke most freely in his letters. With his death in November 1954, something akin to amputation came over the family correspondence.

After that date, no one who had been around Henri Matisse was ever quite the same again. Anxieties long harbored became obsolete. Burdens borne for

half a lifetime were suddenly missed. Roles perfected over the years no longer had an audience.

In this context, one of the most terrifying photographs of its kind was taken at the funeral of Henri Matisse. Jean Matisse, Georges Duthuit, and Pierre Matisse, each in a heavy black greatcoat, stand shoulder to shoulder. Seated behind them is Marguerite Duthuit. On her left is Marie (Madame Jean) Matisse. These are stricken human beings whose interaction, year by year, has been anything but easy. Now that Henri Matisse is no longer there, what remnant of an endgame can lie before them?

One of them wanted to turn himself inside out, at this time, and to be acknowledged as having done so. Jean Matisse had been famously difficult, all his life. In no time at all, after the funeral, he transformed himself into an exemplary servant of his father, bent upon compiling a single-handed catalogue raisonné of the sculptures of Henri Matisse. It was as if he wished to serve his father in death as he had never managed to serve him in life. In the matter of the estate, he never stinted in his search for an absolute fairness in all matters with which he was concerned. What he strove for was to be, at last, the archetypal good son.

He also made a point of keeping Pierre in touch about family occasions that he had necessarily missed. After the first anniversary of Henri Matisse's death he wrote to Pierre on November 28, 1955, and said that the anniversary Mass in Nice had been as simple as possible, and that only a few people had been there. ("The newspapers missed the point," he added.) Plans for their father's tomb were going forward. He, Jean, was designing it, and he had asked Georges Duthuit and his son Claude to approve of them, which they had.

Someone who was not invited to the funeral of Henri Matisse was Lydia Delectorskaya. But during the last months of the life of Henri Matisse, and for nearly forty years after his death, Lydia Delectorskaya never lost touch with Pierre Matisse. At least one other family member might see her as an emanation of the devil, but Pierre was not going to take sides in the matter of his father's long attachment to Madame Lydia. And she, for her part, was not going to let her knowledge of his father go to waste.

Pierre was his most careful self when dealing with Madame Lydia, whom he would later describe as "the green-eyed dragon." Yet hers was, after all, a unique situation. For the last twenty years of Matisse's life she had been almost continually at his side. She had followed his activity in the studio in its every least detail. Not only had she been his studio assistant, but when he came to make his works with cut paper she was a full partner in the process. She had also monitored the progress of the Vence chapel from beginning to end. She had an

excellent memory, and she was absolutely disinterested. She had arrived with nothing in 1933, and she walked out with nothing in November 1954. Nor was she ever indiscreet.

If she wrote to Pierre Matisse, it was because she felt that she still had a duty to Henri Matisse, and that nobody was so well equipped as she to carry it out. The Vence chapel, for instance, was not a museum. It was a working chapel. People were constantly trooping in and out, in the course of their devotions. Before long, tourists were coming in large numbers. For many of them, the chapel was as much a seductive curiosity as a place of worship. It was inevitable that the upkeep of the chapel would occasionally fall short of perfection. When that happened, Madame Lydia spotted it. Not only did she grieve, but she reported it to Pierre. Hers were exemplary reports. No detail was omitted.

But where the chapel was concerned, Pierre was not the Master of the Household, and it was not for him to scold. He was more interested in the life of the studio – how, for instance, his father would say, *Mon champagne fout le camp!*" ("There goes my champagne!") when he couldn't find a blank page in his notebook.

Even more engrossing were her memories of their joint work on the cut papers. It appeared that Pierre's father would suddenly say, for instance, "Make some blue." At the second or third try, Madame Lydia would arrive at his preferred density of color on the paper. When he got carried away, as he often did, he would soon use up all the available sheets of paper. Then he would say, "Just bring me any sheets of blue, even if they're not quite right." But once the scissors had modeled the form there was no way to replace the substitute paper.

In preparing the cut papers, individual colors often had problems all their own. For emerald green, for instance, Madame Lydia said that when they were aiming at a color that was not clogged, they had to be careful not to spread it too evenly. She also said that in the *Sorrow of the King* (*Tristesse du Roi*) of 1952 – by common consent one of the great cut-paper works – there was a particular green that had come about accidentally. It consisted of a *vert Japon clair,* spread lightly on a paper that was just slightly beige.

All this was not put forward as kitchen gossip. Pierre knew that for quite some years to come Madame Lydia would be the adviser of first choice when one of Matisse's works in cut paper needed to be repaired or restored. It was, after all, in the interest of the heirs of Henri Matisse that the cut papers should not fall apart. For that, they needed Madame Lydia.

Their correspondence continued, therefore, even when Madame Lydia spent two months in Russia in 1957. (At the time, she was translating the memoirs of

Konstantin Paustovsky into French – no small task, by the way.) She was at all times an honored guest in the great Russian museums to which she had given – and was to continue to give – everything by Matisse that he had given her from time to time.

As time went on, Madame Lydia wanted to see her knowledge put to more use. On December 20, 1973, she wrote to Pierre, "I feel myself getting old, and I'd like to see to it that all the cut-paper pieces are made secure once and for all. Yours need it, but Marguerite's and Jean's do not." Pierre thanked her warmly for her offer, and said that he valued every last piece of information about the cut papers that she could supply.

In 1980 Madame Lydia turned seventy. On March 9, 1981, she made a proposal that caused a considerable stir among the heirs of Henri Matisse. She offered, in short, to catalogue the archives of Matisse in the areas in which she had a unique knowledge.

This letter was not acknowledged. On May 20, 1981, Madame Lydia wrote and said that she had now taken on other work and would no longer be free to work on the archives. It was not until June 10, 1981, that Pierre replied to Madame Lydia. His letter was clearly the work of a committee on which one or more lawyers had sat. All the material in question, he said, was now in the hands of Madame Duthuit, who was working on it.

By implication, there could be no question of Madame Lydia's having access to the archives. "But all the heirs agree," Pierre said, "that for the last years of Henri Matisse you may have something of value to contribute." This sentence should live forever in the annals of understatement.

On June 25, 1981, Madame Lydia wrote to Pierre as follows: "My last letter – doubtless too 'Russian,' and too abrupt – led you into error. I did not ask to be a paid consultant. I have done that for nothing for the last twenty-five years. What I had in mind was simply to bring order, like a kind of housekeeper, and in no way to profit by getting into the archives."

On July 15, Marguerite wrote to Pierre that, "In view of her strong reaction, it is logical to assume that our reply put a stop to projects that have long been under way. I will explain to her what I need to know about the years of which – because she was always there – we know little or nothing. We will then see what can be arranged between the two of us."

As it happens, Marguerite Duthuit and Madame Lydia were two magnificent human beings. When encountered individually, they personified both a grandeur of spirit and a total dedication to Henri Matisse. But that they could have any kind of rapprochement was out of the question.

During the early years of the Pierre Matisse Gallery, the postman's knock was all-important. In all dealings with his artists, Pierre Matisse preferred a conversational relationship. This was in part because, in the 1920s and 1930s, the world of contemporary art was still very small. Dealers were few. So were collectors. Committed curators did not exactly line the streets. Even in their fifties and sixties, neither Piet Mondrian nor Paul Klee was a "celebrity." Pierre Matisse had started his gallery at a time when the world of contemporary art was still a private place, in which dealer and artist had to band together to break down the indifference of the world around them. Each needed not to feel alone. A letter, well written and well timed, could be decisive. To Pierre, writing was a crucial act. The artists gave it their best shot, and so did Pierre Matisse in his replies.

In Pierre's case, there was even more to it than that. He had every reason to know that writing often answered a need that could not be satisfied in speech. Pierre Matisse had learned this at a very early age. And when dealing with his artists he tried to assemble a second family in which all could speak (or write) as equals. In letters, he and his artists could lead a second and a fuller life. A certain slowness – now vanished – was built into it by the postal conditions of the day. But that slowness could double as luxuriance.

At the end of World War II, a faster, greedier, more frantic climate began to prevail in the international art world. On the cusp of a new age, new names were bound to appear. There was a scramble to find them. This was the heyday of the informed rumor, and of the costly and often misdirected courtship.

In that regard, Pierre Matisse was not in a hurry. As of 1946, he had a glorious team. He had scheduled the *Constellations* by Miró (1945), the American debut of Jean Dubuffet (1947), the first-ever retrospective of Alberto Giacometti (1948), and the revelation of Henri Matisse's recent paintings, black ink drawings, and works in cut paper (1949). Later in 1949 would come the return of Balthus (with a catalogue preface by Albert Camus).

Pierre also had unfinished business to complete. Among the classmates of his father in the studio of Gustave Moreau, he had never given up on Georges Rouault. On a good day, Rouault could be a majestic letter writer, with layer upon hand-written layer heaped every which way on big sheets that almost defied deciphering.

The Pierre Matisse Gallery had done well by Rouault in 1933, in 1937, and again in 1939, and Rouault had not forgotten it. On the very eve of World War II, Pierre had been inspired by the masterpieces from the Prado that were on view in Geneva to suggest to Rouault that he should take on a major subject on the scale of Titian or Velásquez. The Crucifixion? Or the Stations of the Cross? Was it not time that these great subjects were reinterpreted? Pierre would be happy

to buy outright, and at any price, whatever came of this idea. He also had hopes of a three-year contract with Rouault.

Nothing came of this. Rouault never liked other people to give him ideas as to what he should paint. And, with the outbreak of World War II now clearly imminent, he was frantically trying to find safekeeping for his work. He was also in great agony of mind because his dealer, Ambroise Vollard, had been killed in a car smash. Control of Vollard's vast holdings of Rouault would pass to his heirs, who were on their way from Madagascar. "I am on the rack," he wrote to Pierre.

Contact was not quite lost, however. In May 1941, when Rouault was living in unoccupied France, at Golfe-Juan in the Alpes-Maritimes, he wrote to Pierre in New York and said that if he could send or take a message from Amélie Matisse to Henri Matisse, he would gladly do so. On another occasion, Pierre also asked his father to look after a Rouault called *The Manager and the Circus Girl* (1941). (Henri Matisse hung it for a while, and then put it in a closet. "It was just too poignant," he said to Pierre.)

After that, there was a gap until May 24, 1945. During the German occupation of France, the Rouaults' house in the country had been vandalized over and over again by German soldiers ("Iconoclasts of high quality," Rouault called them). "Many of my paintings were slashed or chopped up for use in civil defense. Frames by the dozen were stolen, furniture was brutalized, drawers pulled out and ransacked, the kitchen wrecked . . . All this was kept from me for fear that it would upset me. But I was like the animals who can feel the earthquake coming. . . .

"Knowing, as I now do, what was done to your mother and your sister, I cannot possibly complain about what happened to us. Always, and without end, there are people who suffered infinitely more than we did. I can still think straight," he added, "even if my carcass is not as strong as it used to be and I am no longer 'indefatigable' – the word your father used for me when we were both in Paris."

Rouault's troubles with the Vollard estate were far from over. "You may know," he wrote to Pierre, "that during the First World War I was able to shelter the entire Vollard collection at a time when the Hindenburg Line was being broken and there was not an empty house to be found anywhere. For a whole year, I looked after the Cézannes, the Degas, the Renoirs, and the rest. I never expected to be thanked, but now I wonder if I can be dreaming when I learn from the lawyers of the heirs of Vollard that I have no 'moral rights' in my own paintings and am not allowed to photograph them. I have had to bring a lawsuit against them." (This lawsuit dragged on till 1947, when it was settled in Rouault's favor.)

Rouault's letters to Pierre were not primarily about business, or about "making a career." They were about feeling, and truth, and fellowship fondly

remembered. Rouault liked to tell Pierre about Gustave Moreau. Had he not been stricken by cancer, Moreau would have liked to give up teaching in Paris and retire to a little town, somewhere in Italy, where Rouault could have joined him, instead of wasting his time on a third attempt to win the Rome Prize.

In those days, Rouault had been a high-spirited young man with flame-red hair. But now, he was (by his own account) half-mummified, weak in the legs, and with his back bent. Times were hard, and he and his family were overjoyed to get food parcels from Pierre. As for the socks that Pierre had sent him, they were – just imagine! – exactly the right size and fitted like velvet gloves. It was thanks in part to this continuing friendship that Pierre was able to have a fourth and last Rouault show in 1947.

In the 1950s, Pierre began to look around for senior artists who for one reason or another had never been properly shown in New York. One of them was Naum Gabo, the Russian-born Constructivist sculptor (1890–1977) who in 1920 had published his "Realistic Manifesto" (also signed by his brother, Antoine Pevsner) in Moscow. This was one of the most brilliant and caustic things of its kind.

On the evidence of the manifesto, Naum Gabo was just about the last person on earth whose work one would have expected to see at the Pierre Matisse Gallery. Pierre's father was, after all, a great colorist. As a sculptor, he was a master of mass. He also said – not once, but repeatedly – that he wanted his paintings to have a soothing, and even an emollient, effect at the end of a long day's intellectual activity.

In the "Realist Manifesto," Gabo by contrast had called for the renunciation of color as a pictorial element. In sculpture, he called for the rejection of mass. Of art in general, he said that it should no longer be "a sanctuary for the idle, a consolation for the weary, and a justification for the lazy." As for the past, we should put it behind us as carrion. "It is by the present day," Gabo and Pevsner had said, "that we take our stand."

After 1920 Naum Gabo was to have his full share of the multiform diaspora of the European Jewish avant-garde in the first half of the twentieth century. But in the United States from 1946 onwards, and as an American citizen from 1952, honors and security at last came his way. To that extent, Pierre's show could not have been better timed.

The fifteen works in Gabo's show in April 1953 at the Pierre Matisse Gallery show ranged in date from 1920 to 1953, thereby touching on Gabo's whole career. There could have been something daunting, not to say freakish, about Gabo's persistent use in his sculptures of celluloid, perspex, nylon thread, nylon monofilament, stainless steel wire, rhodoid, aluminum, gold-plated phosphor bronze, wire

mesh, and springwire. But it is clear from installation photographs that, so far from being arid and unsmiling, the general effect was feather-light, aerial, and frown-free. This was, in fact, one of the many shows at the Pierre Matisse Gallery in which unexpected material turned out to be perfectly at home.

In 1953 a new era began to assert itself. A competition for a "Monument to the Unknown Political Prisoner" was organized by the Institute of Contemporary Art in London. Sculptors from all over were welcome to compete. This was a moment at which the international art world had not yet redefined itself. Nor had the international art market. England was regarded as relatively neutral territory, on which all competitors for the "Unknown Political Prisoner" prize could count on fair treatment.

For this and other reasons, the prize was much coveted. Sculptors the world over – among them, Jean Matisse – had thought of putting in for it. A multinational jury, chaired by Alfred H. Barr, Jr., had had a multinational entry to choose from. They awarded the first prize to a forty-year-old Englishman called Reg Butler, who had not even begun to study sculpture until 1950. (One of the five runner-ups, by the way, was Naum Gabo.)

Butler had been trained both as an architect and as an engineer, and he knew how to build complicated structures that would make sense and stand up straight. He also knew how to uncomplicate them, and his competition entry made perfect sense without being in any way rhetorical, let alone illustrative. It was essentially constructivist in its idiom. Line, not mass, worked upon the viewer's imagination. It had light and air all round it, and Butler had distanced himself from melodrama.

As the first-prize winner, Butler was a hot property. In his nature, honesty, straightforwardness, and plain speaking were paramount. These traits made it easy and pleasant for Pierre to recruit Butler for his gallery. Pierre bought Butler's sculptures in quite large numbers. Business for some time was brisk.

But these were not settled times. Other kinds of sculpture were coming into favor, and Reg Butler's time at the top did not last long. In 1964 he wrote to Pierre of his delight in what he called "hand work" – small bronzes of the human figure. "Yet does anyone really respond?" he wrote.

On March 1, 1965, he met with a serious rebuff. An exhibition of "British Sculpture" had just opened at the Tate Gallery in London. And he, Reg Butler, wasn't in it. "All 'Statue Makers' and especially me (who once made constructions) are more or less dismissed. And I was once so very avant-garde! 'Relaxed' constructions of vast size made from structural sections are the new classicism. I fear I shall remain a 'statue maker,' but perhaps. . . . No, I like the feel of stuff in my hands too much."

An undated letter of around 1969 records that when Reg Butler studied the current level of his sales in America he was horrified. But Pierre remained loyal to him, not least when in 1973 he produced a series of life-size bronze nudes of young women, each fitted out with real hair in all the places where real hair should be. "About the hair," Butler wrote. "The hair is hair for the simple reason that I can buy real hair and shape it myself. But the breasts are painted bronze for the simple reason that I have not found it possible to buy breast material." Himself the son of an artist, Pierre knew what it was like to fall from favor. He also remembered that as recently as 1935 Henri Matisse had found it very difficult to make any sales.

Even so, an agreement between Pierre and an artist was sometimes severed by mutual agreement and with no ill feelings. This happened, for instance, with Pierre Matisse and Le Corbusier. As Le Corbusier saw it, he had been a serious painter since 1920. And yet his paintings had been consistently ignored, if not actually derided, by painters, critics, and curators, and perhaps above all by his fellow architects. When he got together with Pierre Matisse in 1955 he had not shown his paintings in thirty years. He saw himself as particularly isolated in Paris. ("There are 100,000 artists in Montparnasse," he once wrote to Pierre, "and only one of them is me.")

Pierre had met Le Corbusier through his friend Tériade. After a studio visit in September 1955 he wrote on October 1, 1955, to say that he would like to show the paintings in his gallery and hereafter to represent him in America.

Le Corbusier was naturally delighted. As catalogue material he sent an essay by Herbert Read, who spoke of Le Corbusier as a *"uomo universale"* – a man who could do anything and excel in all of it. Le Corbusier had also sent a French text by his friend François Le Lionnais. He, too, did not hedge with his high-flying remarks – as when, for instance, he said that if Le Corbusier the painter were ever to lose his sight, he would deal with the handicap as Beethoven had dealt with deafness.

But, as is well known, "fine words butter no parsnips." Le Corbusier's show at the Pierre Matisse Gallery in January 1956 was not a success. The work was priced way above what anyone would pay for it. Pierre told Le Corbusier that the prices had to come down by thirty percent if he was ever to have a foothold in the United States.

Le Corbusier took it well. "In your letter of January 25, 1956," he wrote, "you speak of modifying our agreement about prices. I am not a picture dealer. You are an honest man, and so am I. Do whatever is useful, but do not undermine the market value of my paintings. Ours is a 'gentleman's agreement,' and you are master of the situation."

Pierre replied as gently as he could that in reality there was no established market for Le Corbusier's paintings. James Johnson Sweeney had floated the idea of a Le Corbusier room at the Guggenheim Museum, but he had not even been to see the exhibition in New York. A year later, nothing had changed. Project after project had never been followed up. "These people are all the same," Pierre wrote to Le Corbusier on March 18, 1957. "They're always in a hurry, they make promises right and left, and they're always full of ideas. But when you call them up, they're always out of town."

It was a further obstacle that it was not in Le Corbusier's character to sweet-talk new American acquaintances. When he had first landed in New York, he took one look at the fabled scene and said, "There are too many skyscrapers here, and they're all too small." It was for this reason that Pierre was almost afraid to let Le Corbusier loose in the United States. "Your way of speaking your mind would disconcert them," he said.

With time, there came a shared awareness that Le Corbusier the painter was not going to make it. As always, he behaved ideally well. On November 19, 1962, he wrote:

"Dear Monsieur Matisse, we have to see things as they are. America now sees itself as the top nation in painting. This claim is based upon an aesthetic that is entirely new. That aesthetic is incompatible with my own. You cannot in all decency represent two tendencies that are in such opposition to one another. So I think that the natural thing will be for each of us to take back his liberty vis-à-vis the other. I would ask of you that this will in no way affect our friendly relations. You and Madame Matisse have always been very kind to me. I am not a businessman, and I feel no resentment towards you. I am sure that you feel the same way towards me." In this way, the "gentleman's agreement" between Pierre Matisse and Le Corbusier came to a gentlemanly end.

Already in 1962, there was a danger signal in Le Corbusier's friendly adieu. That "America now sees itself as the top nation in painting" was undoubtedly true. That the new aesthetic could coexist on equal terms with an earlier one had yet to be seen.

As will by now be clear, Pierre Matisse liked to write as friend to friend when corresponding with his artists. But among the new cast of characters whom he introduced, one by one, after the end of World War II, the role of letter writing was often reduced almost to insignificance.

This was due in part to the alternative modes of communication that soon put both bottle of ink and blotting paper out of business. But it was also a generational matter. Younger people did not feel like putting themselves out in the hope

of mutual comprehension. Human exchanges had a new ease and a new fluidity. Dealer and artist rarely saw themselves as partners in perpetuity. Twelve-page handwritten letters had become a quaint survival, like playing the theorbo or mastering the gavotte.

Between 1947 and 1970, Pierre Matisse was to present a whole new cast of characters. They included an American sculptor, Theodore Roszak; an American painter, Loren MacIver; an English sculptor, Reg Butler; a Canadian-born painter, Jean-Paul Riopelle; a French sculptor, Ipousteguy; an Italian movie director, Federico Fellini; a Chinese-born painter, Zao Wou-Ki; a Mexican painter, Rufino Tamayo; an English painter, Leonora Carrington; a Greek painter, Manolis Calliyannis; and a French painter, André Manessier. Later newcomers included an English sculptor, Raymond Mason; a group of Spanish painters (among them, Manolo Millares, Antonio Saura, and Manuel Rivera); an American painter, Sam Francis; and a young French painter, François Rouan, who had been backed by Balthus and was to endear himself to Pierre.

Lists make dull reading, and I shall confine myself here to just two artists who excelled in correspondence. Neither of them went along with the idea that a new aesthetic had made every other one look paltry and out of date. By choosing only two of Pierre's artists I do not mean to downplay artists like Zao Wou-Ki and Jean-Paul Riopelle, who were longtime favorites of Pierre Matisse. But they did not reveal themselves in letters. Others were captivating talkers who rarely took the time to pick up a pen. The ones whom I have chosen were entirely present in their letters.

In 1966, when Balthus was having a show of drawings and watercolors at the Galerie Janine Hao in Paris, Pierre Matisse went to see it. While there, he made the acquaintance of Raymond Mason, an English sculptor, born in 1922, who had been living in Paris since 1946. He was not the kind of Englishman who maundered around postwar Paris, doing a little bit of this and a little bit of that. Never had anyone been less of a dilettante.

His was not easy work to make. Nor was it always easy to look at. But in 1965, as a foreigner in Paris, Mason had produced a very large sculpture called *The Crowd*. First shown in plaster at the Galerie Claude Bernard in 1965, it was later bought for the French state at the instigation of André Malraux, who was at that time the preponderant figure in French cultural life. It was the first of the monumental sculptures in which Mason addressed major public themes. As Mason saw it, the crowd is the prime subject of the twentieth century. It is the volatile and sometimes all-powerful human mass. It is the chorus that comments, as in Greek tragedy, on the key events of the day. It can be jubilant beyond description, but it can also stand for the huge company of the disinherited, the

exiled, and the lost.

Mason's crowd was of no one age, no one people, no one place. It is a huge, disorderly, self-contradicting torrent of humanity, united only inasmuch as it is on the move, whether in euphoria, in disarray, or in dread. It looked its very best when it was niched in the Jardin des Tuileries in Paris in 1986, where the head-long downhill tumble of bronze – sometimes legible, sometimes not – was offset by the chalk-white and fastidious architecture of the Jeu de Paume.

Raymond Mason once pointed out that the Tuileries site was "the very epi-center of the French Revolution. The guillotine was at those doors of the gardens, and the revolutionary crowd —which is, after all, the great crowd of history— came and surged and went in front of the very spot where my sculpture stands." It is not surprising that he also said that *The Crowd* has "soaked up so many years of my life."

The Crowd, with some of its many related drawings, was the centerpiece of Raymond Mason's first show at the Pierre Matisse Gallery in New York in October–November 1968. By 1971, when he had his second exhibition, a fateful change had come over a part of Paris that he had come to know inch by inch and face by face. This was the market of Les Halles, which had as its neighbor the great church of St. Eustache. The traffic in and out of Les Halles had become an ever greater encumbrance, both by day and by night, and in the late 1960s it was decided that the market should move to Rungis, not far from Orly Airport. Raymond Mason then set to work on a three-dimensional elegy for the loss of an irreplaceable element in the social structure of Paris.

Unlike *The Crowd, The Departure of Fruit and Vegetables from the Heart of Paris, 28 February 1969* was an uncomplicated many-colored statement. The move may have simplified marketing, but in social terms it was all loss. No one could have said that better than Mason himself:

"It was a place of joy," he wrote. "Powerful and vast, Les Halles made an endless number of people happy, and many tears would flow at the thought that it would cease to be. The work there was hard. The cold and rain to be endured were also hard. There were some very hard and tough men and women to be found in the place. However, its magic was such that this hardness transformed itself into a strange gentleness and the most fearsome character became peaceable. Of course, it was the pleasure of working together, but it was subtly ennobled by the fresh beauty of that country produce. The Halles Centrales market was the last image of the Natural in the City. It is now a Paradise Lost."

Mason grieved for the loss of a certain lifestyle, and for the men and women whom it had nurtured for centuries. "It is the man of the Middle Ages who is

leaving," he wrote. "The 'little vegetable' of our species, he came from the earth and assumed a form as best he could. But he was a natural man and he always grew. We will never see a face like his again. We will never again see his kind."

Those men and women had had a special relationship to the church of St. Eustache – "the sole witness," as Mason put it, "of the centuries now passed." But "witness" did not seem to him quite right. St. Eustache was a participant, not simply a witness. The church was, in fact, "herself an actress, and no doubt the leading actress" on a stage that had played to full houses for hundreds of years. "I wish," Mason also said, "that my little procession from Les Halles would never have to leave it for good."

Anyone who goes into St. Eustache will find that it has not quite gone for good. In 1976 a version of Mason's *Departure* was installed in the chapel of St. Joseph. What we see there is on one level an encyclopedia of nature's abundance. There are no fancy fruits or high-priced designer vegetables. But orange and asparagus, fennel and leek, artichoke and cauliflower are held high as trophies and emblems of honor. And Mason saw to it that the viewer's eye moves back and forth, inside and around and out again, until chaos turns into carnival. There is something in this of the Mason who once described himself as a "distant descendant of Hogarth." But in the stage management of the tumultuous and exuberantly colored scene we also recognize the Mason who in 1959 had designed the stage set and costumes for a production of Racine's *Phèdre* in which Marie Bell, the ranking Phèdre of the day, was to appear. Year by year, throughout the 1960s, 1970s, and 1980s, Mason was to take the whole of Paris for his stage.

It was in November 1940 that Loren MacIver had her first show at the Pierre Matisse Gallery. She was to show there until 1981. Born in February 1909, MacIver's entire formal training as a painter began and ended when she was ten years old. After a year (Saturday morning classes only) at the Art Students League in New York, she found her own way, unaided. "I never thought of painting as a career," she once said. "I cannot tell you how casual it was. I never intended to be a painter. I just liked to paint."

As a human being, she was irresistible. She never grumped or groused. She was neither envious nor competitive. Hers was a quiet art, and she saw no need for amplification. (As a lifelong admirer, William S. Lieberman, once said, "Overstatement is alien to her eloquence.") In life, she had both a gamine's good looks and a magical sense of fun. As a letter writer, she was up there with the best. She had a very happy life with Lloyd Frankenberg, the poet, critic, and French scholar, whom she married in 1929. Though never ambitious to be in the avant-garde, let alone to be at what is now called "the cutting edge," she had a flock of

loyal admirers. ("Your admirers are certainly wonderful to do business with," Pierre wrote to her after her show in 1956, "and so prompt in sending their checks!")

She also got the right kind of attention at the right time. As early as 1934, Alfred Barr chose a painting by her called *Shack* for the Museum of Modern Art. During the Depression, Loren MacIver had an assignment for the WPA from 1936 till 1940. When she had her first exhibition at the Marian Willard Gallery in 1938, a doughty and difficult judge whose name was Alfred Stieglitz said in the catalogue that, "This girl should be given a chance to paint, if anybody should be given a chance to paint."

In December 1940, a major poet, Marianne Moore, went to the Pierre Matisse Gallery to see Loren MacIver's paintings. She described them in a letter to a friend as being "restrained, unaggressively concealed almost, but unmistakable poems." Every one of her picture-poems began from a straightforward everyday subject and was magicked in ways peculiar to herself. Marianne Moore singled out, for instance, "a parallelogram of reeds in blue waters without any large object as a pretext for it, entitled *The Waters*."

MacIver had a wide acquaintance among poets and patrons. Elizabeth Bishop (herself a closet painter) more than once had plans for "little books" that she and Loren would make together. Loren painted portraits of both Elizabeth Bishop and e.e. cummings. Her poet friends were often way ahead of professional critics of art in their brief summations of what made MacIver's paintings memorable. Elizabeth Bishop, for one, hit the mark with her reference to the "out-of-focus dream detail" in her paintings, and their "divine myopia . . . even marvelous myopia."

Pierre Matisse allowed MacIver's reputation to grow at its own pace. But in 1946 she was included in the latest in the groundbreaking series of group shows that had been organized since 1942 by Dorothy Miller, and it put MacIver side by side with Arshile Gorky, Robert Motherwell, Isamu Noguchi, Theodore Roszak, Mark Tobey, and others. To be included in one of Dorothy Miller's shows was a landmark in many a long career.

Pierre's personal relations with MacIver took on an altogether different energy after his marriage to Patricia Echaurren in October 1949. Patricia Matisse and Loren MacIver had Irish forebears in common. They also shared a gift for instantaneous rapid-fire communication by mail, often couched and punctuated in ways that were unique to Loren. In June 1961, after a client by the name of Upjohn had bought a MacIver, Patricia sent the good news, together with "an enclosure," to Loren. Her reply read: "Completely swept off my tootsies by your newly arrived letter and enclosure. Astonished, STUNNED, ELATED, etc. etc. etc.

UpJohn and at 'em!"

At this point in time, the MacIvers did not have to stint on hotels. In August 1961 Loren wrote from the Grande Bretagne in Athens, not long after there had been talk of Pierre's sailing his boat in the eastern Mediterranean: "Chers Matelots, Fully expected to find you in the harbor of PIRAEUS, vying with that old fox Odysseus. We are beckoned towards Istanbul on Monday the 7th, we'll be there – except for swimming the Dardanelles – until our return to this Albergo on Aug. 21st. Leaving Athens with some sponge sellers and pistachio merchants on Aug. 26. Thence towards France. Toujours with love."

In London, the Stafford Hotel, off St. James's Street, took rank as a tolerable perch. In October 1961, to Pierre: "Fog-bound but VERY comfy in this hotel, centrally heated bath towels and all. But wish you and Patricia were here to pep things up and make several welkins ring, as you always do." And, later that month: "This hotel is comfortable, rather like a tea-cosy. There must be an Italian baker somewhere – the rolls are good, and scandalously shaped."

Those were very good years for Loren MacIver. She was buoyed up by her retrospective exhibition at the Whitney Museum in New York (1953), by her first prize at the Corcoran Biennial in Washington, D.C. (1957), and by her membership in the American Academy of Arts and Letters (1959). While living in Paris in 1962, she heard that she had been chosen by the Museum of Modern Art to represent the United States at the 31st Venice Biennale. (There was at that time

Loren MacIver with Alexander Calder at an opening at the Pierre Matisse Gallery, 1968

no higher mark of favor.) In 1965, the Phillips Collection in Washington gave her, for the second time, a retrospective exhibition. In 1968 the Musée des Beaux-Arts in Lyon organized an exhibition called "Homage to Loren MacIver," which was later shown at the Musée National d'Art Moderne in Paris.

There seemed no reason why she should not be for the rest of her life an American painter whose work a great many people wanted to see. She was selling nicely and at good prices. She and her husband were best friends with Pierre and Patricia Matisse and could never see them often enough.

In Paris in 1962 they were ideally happy. In March, she wrote to the Matisses, "Have tossed CAUTION to the SO-CALLED WINDS and decided to really extend and S-T-R-E-T-C-H our stay till the printemps of 63.

"Have just staggered in, bursting with champignons, radis, fromage, Bourgueil, etc., etc. The rue de Buci market on Sunday morning is not to be missed. It rivals the Commedia dell'Arte. Complete with a demonstration of the latest method of making omelettes, a donkey selling lavender, a goat logically selling chèvre, and a monkey in a fur coat and cap selling a pine candy for coughs, snorts, gurgles."

Between herself and Patricia Matisse, there was many a delirious message. "Tackled SKIRT PLACE," she wrote in October 1966. "Blast. No more of that model, and impossible to order. The line is fini. How impractical can one be? Shrugs. Other models swung out, none as nice. A rather Dionysian atmosphere prevails." Skirts did not go away, however. A day or two later, Loren wrote, "Off to DEBS this afternoon on a skirt mission. Tiz easy. Got a black one several days ago, after our splurge, SILVER HOOKS and all." And in November 1966: "L'affaire JUPE is terminée for the present. KILT invasion has reached alarming proportions and the ruffle just below the navel has reached some proportions as well."

Good times continued. Loren loved the look of France – the country around Bourges, for instance, with its echoes of Alain-Fournier's novel *Le Grand Meaulnes* and its reminders of the wines she liked most – Sancerre, Pouilly, Quincy, Chavignol. But she did not "paint France." She painted the happiness of being in France, as in *La Bonne Table* of 1963, in which two classic bistro menus, rendered in black and red ink, are lying on opposite sides of a French bistro table. She found happiness even during the period known as the "Fermeture Annuelle," when all France brings down the shutters after July 14. When she painted a picture called *Fermeture Annuelle* in 1966 she did not resort to anecdote, but instead she evoked an empty town, all barred and bolted, that sat there sunning itself among souvenirs of recent festivity.

But it was beginning to get through, even to Le Castellet, a village in Provence where she and Lloyd had begun to spend their summers, that big changes were

imminent in the American art scene.

"Who *is* Bill Rubin, anyway?," she wrote to Pierre in 1967, and it was not a stupid question. As Director of Painting and Sculpture at the Museum of Modern Art, William Rubin was to have a predominant influence there until his retirement in July 1997. Another crucial appointment was that of Henry Geldzahler, in 1967, as head of the 20th Century department at the Metropolitan Museum. There were powerful people who thought that the twentieth century had no business being in the Metropolitan Museum at all, but Geldzahler knew that with one big bang he could open the museum to both the present and the future of American art. This he did in 1969 with an enormous exhibition called "New York Painting and Sculpture 1940–1970."

With 408 works on view, this was an overwhelming show of strength in a setting that had never before witnessed anything of the kind. Many visitors found themselves – I quote here the title of a painting by Hans Hofmann in the show – "in the wake of a hurricane." The map of contemporary American art had been redrawn. The new painters and sculptors came in as an army of occupation.

Like many another established American artist, Loren MacIver was given no part in this enterprise. It had simply no role for her. The new art had an aggressive signature, a one hundred percent recognition factor and high-pressure critical promotion. With all that, Loren MacIver's reticent and elliptic proce-dures could not compete.

Anyone who has ever been "somebody" will know how unpleasant it is to wake up and find that one is nobody. In November 1969 she wrote to Pierre Matisse and said that she was "writing a little thesis on Mr. Geldzahler. But," she said, "I'm still too CLOBBERED to send it." In October, Patricia had sent a check for $5,000 by way of an "advance." Comforting as this was, it meant that Loren then owed the gallery a total of $13,000. In May 1970, Pierre Matisse gave warning that "times, my dear Loren, are very bad, and have been very bad for quite some time. The situation in this country is very tense. Wall Street is on the skids and confidence in Washington is shaky. We should consider every enterprise as risky."

In December 1971, Pierre wrote and told her that, "due to expenses," the gallery would in future have to charge fifty percent commission on all sales. Moreover, three paintings – *Fermeture Annuelle* among them – would be taken over in payment of Loren's debts to the gallery.

These were grueling times for Loren, in that her husband had had very heavy hospital expenses since the fall of 1971. In March 1972, after three opera-tions, he owed the hospital $3,648 and was quite unable to pay it. In negotiating the payment, Pierre Matisse wrote to the hospital and said that Loren's income

had been drastically reduced by "a radical change in contemporary artistic fashion, combined with the recession of the last three years."

The "radical change in artistic fashion" that Pierre mentioned was there to stay. (He did not, by the way, let Loren MacIver down. Nor did William S. Lieberman, who bought nine paintings by MacIver for the Met in 1992.) His artists were what he had always hoped for – a second family whom he nurtured, year in and year out. And he kept them before the public. During the years from 1970 to 1989, he showed Miró thirteen times, Chagall seven times, Riopelle five times, François Rouan four times, Loren MacIver three times, Raymond Mason three times, and Zao Wou-Ki twice. Balthus, Dubuffet, Wifredo Lam, and Reg Butler were shown once each.

In October 1972, Patricia Matisse died of a cerebral hemorrhage. Theirs had been a tumultuous union. Patricia had likes and dislikes, and no one can say that she saw to it that meals came on time. But she could inspire everlasting friendships, and act upon them.

After her death, Pierre was bereft. One of his best friends at that time was Frank Perls, a dealer in Los Angeles who was very deft in all matters pertaining to human relationships. In 1973 he suggested that Pierre should consider inviting a well-born, multilingual young German called Maria-Gaetana von Spreti to join his staff. She had been raised in a diplomatic household and knew something of life at an ambassadorial level. She had also had some experience of the art business.

As Frank Perls had suggested, she was ideally suited to the gallery. After a while there were indications that she was also ideally suited to its owner. Pierre had been the first to sense this, and in 1974 he asked her to marry him. This was universally welcomed by his friends, and both he and they were proved to have been right.

In 1987, Pierre and Tana went with Pierre's daughter Jackie and Rosamond Bernier and myself to see the Matisses in the Hermitage. Previously, in the late 1950s, Pierre had been to the Hermitage on his own. With characteristic modesty he had not told anyone in the museum that he was coming. When he got there, the galleries were closed. He turned right around and headed back for Paris. When he told the Intourist guide of his disappointment and said "You see, I am Matisse's son," she said, "Next thing, you'll tell me that you are Picasso's nephew."

Later, during the Gorbachev days, all went well. They knew we were coming, and when we had a first look at the great Matisses the director was expecting us at noon for "refreshments." Pierre could hardly wait. The Hermitage is thirsty work and he liked a drink before lunch. I shall never forget the look on

his face when we walked into the director's office and saw only a display of little cakes and a big samovar. We had forgotten that Gorbachev had given orders that no alcohol was to be served on governmental property before 2 P.M. "Tea or coffee?," we were asked. Pierre could barely reply.

In spite of this, he remained fully alert in all professional contexts. It was of course well known, or at any rate widely surmised, that the inventory of the Pierre Matisse Gallery was very large indeed. During the boom years of the 1980s, other dealers had dreams of buying into it. Some of them imagined that to come sniffing by with "cash and carry" as their policy would be a good idea. Others knew that to be able to say that "This came from Pierre Matisse" was an impressive provenance, and one not to bargain about.

Of his professional dealings, Pierre said to Rosamond Bernier, "I never bought with other dealers. I preferred to work alone with my collectors. There was a collectors' market and a dealers' market. The dealers' market was a hard place. To be part of it, you had to have a certain gift. Otherwise you couldn't sell a piece of the Brooklyn Bridge to someone fresh from the sticks. I did not have that gift. If I'd had it, I would not be here. I would be the owner of the Fuller Building and I'd be playing golf in Florida."

That had never been his ambition. For Pierre, his gallery was his empire, his spiritual and corporeal domain. His idea of a perfect Sunday was to be in the gallery by himself and hang the next exhibition. Even well into his seventies, he liked to hang every picture himself and climb every ladder to adjust the spotlight. This was a world over which he had complete control.

He went on to say that "after World War II the first wave of modern collectors had aged and gone quiet. The new collectors were young people who had invented some gadget or other and made millions. They had changed houses and changed wives. They had houses in the country. They traveled. They had everything, but they had nothing to put on the walls. Meanwhile, everyone had heard of Picasso, Matisse, Léger, and Braque. So these new people began where the others had left off.

"It was easier to sell pictures to them than it had been in the 1930s. But you had to find pictures from the 1920s and 1930s, and that was getting harder. Matisse and Picasso were the old guard, but Léger had his own style, which was very different. It was like a castle. The main windows had been opened, but there were lots of others, so we opened one window one day, and another one later. . . ."

But Pierre Matisse was wary of being taken in by a fast-moving market. Speculation was foreign to him. It was fundamental to his career that after his first years in business he had not only made money by selling pictures. He had

made money by not selling pictures.

That was why he was often delighted to buy back something that he had sold years before and had very much missed. It was why, in his last appearance in the auction business, he bid up a painting by Riopelle to a very high price. (Pierre at that time owned several hundred Riopelles.)

As the inventory of his gallery was sold after his death in August 1989 to Sotheby's and the Acquavella Gallery for $142.8 million, it cannot be said that he had not thought ahead, and wisely.

Adieu

Pierre did not boast of his achievements. (In a many-years' acquaintance I never heard him speak of them in the first-person singular.) Nor did he ever pull rank on account of his father's name. "I am 77 years old," he once said in that context, "and I have never thrown 'the Matisse family' in anyone's face. Nor do I think about, or believe in, the 'Pierre Matisse legend.' Nor did I ever try to build one up."

He had had, even so, a grand strategy ever since he first opened the Pierre Matisse Gallery in 1931. He wanted American museums to have the works of art in which he most deeply believed. Once there, they would gradually enter the national awareness and make the United States a better place to live in.

As a project, it had a very long way to go. The Museum of Modern Art in New York was at that time only two years old and was not to have a building of its own until 1939. Pierre's gallery was still losing money. There were days when nobody came to call, let alone to buy. But Pierre kept, even then, to his long-term strategy. He did not expect that unfamiliar and possibly difficult works of art would immediately find their way into museums. His aim was to set up a climate of acceptance in which people in ones and twos would be happy to get in first with the good news.

When seen here and there, privately, those works of art would set up a buzz. Others would covet them (or something related to them). And eventually there would come into play the mysterious and admirable all-American element of civic self-respect. Not to have major works of a still unfamiliar sort would be regarded as a failure of imaginative energy. "This town simply *has* to have this work," one or two people would say. And they would act upon it.

Initially it was difficult to negotiate directly with museums as civic entities.

399

Individuals were vastly more promising. Pierre chose his collectors with great care from what was initially a very small pool of possibles. And then, as has been seen, one after another of them was happy to be hooked.

It was essential to his strategy that his collectors should not be satisfied with agreeable sitting-room pictures. He wanted them to have big, strong, difficult works that would one day hold their own in any company. Very often, as can be seen from the color plates in this book, they were the works before which visitors now stand in exhilarated silence. This is true of Henri Rousseau's *Fight of a Tiger and a Buffalo* (1908) in Cleveland, of the Miró *Head of a Woman* (1938) in Minneapolis, and of the Dubuffet *Coffee Grinder* (1945) in the Metropolitan Museum of Art in New York, of the Picasso *Plaster Head and Bowl of Fruit* (1933) in the Fogg Art Museum in Harvard, and of Balthus's *The Mountain* in the Metropolitan Museum of Art.

Pierre Matisse with his daughter, Jackie Matisse, at the Hermitage, 1987. They are looking at a painting by Henri Matisse of Amélie Matisse. Photo: Rosamond Bernier

Pierre Matisse being interviewed by Rosamond Bernier at Saint-Jean-Cap-Ferrat, 1987. Photo: Tana Matisse

Pierre clowning with Tana Matisse's little dog, with John Russell on the right. Taken at the Matisse's home in New York, 1989. Photo: Rosamond Bernier

The same thing is self-evidently true of the Matisse *Dance (I)* (1909) in the Museum of Modern Art in New York. Thanks to the initiatives of Pierre Matisse, the Museum of Modern Art built up over the years what could almost be called a museum within the museum.

These transactions took time. Even the Matisse *Dance* of 1909 was on the market for years before Nelson A. Rockefeller bought it for the Museum of Modern Art in honor of Alfred H. Barr, Jr. There were also great works of art that left the country, like the Degas *Coiffure* of c. 1896, that Pierre sold to the National Gallery in London in 1937. But Pierre was loyal to his ideals, just as he was loyal to his artists, his clients, and his staff, and in the end his long patience paid off.

Nothing has ever been named after Pierre Matisse, and you may look hard and long before you find his name on a museum label. But in museum after museum, throughout the United States, there are works of art that passed through the Pierre Matisse Gallery that now stop us dead in our tracks.

Index

79, 84, 95, 397, 399–400; death of, 398;
details handled by, 95, 99, 121, 153–54,
164, 248, 263–64, 278, 284, 321; divorce
of, 311–16; family background of, 9–12;
finances of, 53, 82; first marriage of,
25–26, 43, 44, 313; first New York
exhibit of, 37–38, 46; first U.S. visit of,
30–33, 34–42; gallery job of, 28–30;
gallery of, *see* Pierre Matisse Gallery; as
Henri's confidant, 42, 103, 183–84, 197,
234, 245–46, 314, 379; and Henri's
estate, 191, 217, 220, 361–62, 375;
Henri's loans to, 53, 83; as Henri's son,
40, 47, 50, 63, 137, 276, 314, 329;
Henri's work shown and sold by, 52, 82,
95, 96–97, 151, 263, 356, 383, 402; as
installationist, 99, 316, 317–18; military
service of, 16, 17, 23, 77, 179; and par-
ents' disagreements, 174, 177–81; as pub-
lisher, 95, 247–48, 291; and Valentine
Gallery, 48–49, 50–54; and violin, 23;
wives of, 26, 396; *see also* Matisse, Patri-
cia; Matisse, Teeny; as young man, 17–26
Matisse, Tana, 396, *401*
Matisse, Teeny: and Barnes, 66, 77; and
Calders, 99; children of, 129; dissolution
of marriage of, 164, 311–12, 313–14, 360;
and Henri, 302, 311–12, 316; and Henri's
work, 193, 195, 198, 359, 360; and Miró,
255, 256; and Pierre's work, 254, 255
Matisse family, *14;* finances of, 15, 197, 361;
and Henri's death, 379–80; misunder-
standings in, 43–44, 164, 177–78, 219–20,
227; and Musée Matisse, 367–68; paint-
ings as part of, 54–56, 89, 267; and
Parayre family, 11, 13; Pierre as mediator
in, 41–42, 361; and Pierre's work, 39–40,
115; reticence of, 15, 41, 56, 218,
221–22, 362–63
Matta (Roberto-Sebastian Matta Echaurren),
87, 156, 161, 167, 202, 203, 210–11,
307; *Xspace and the Ego (pl. 31)*
Metropolitan Museum of Art, The, New
York, 80, 137, 145, 395, 400

Miller, Dorothy, 392
Millet, Jean-François, 48, 88–89
Miró, Joan, 85, 98, 110–32, 209, 249–71,
250, 341–55, 343, 354; artworks by, *see*
Miró, Joan, artworks by; Balthus portrait
of, *pl. 34, 136;* correspondence of, 114,
345; death of, 284, 352; early years of,
115–16; finances of, 124, 131, 249, 251,
264–65, 268, 271, 346; and Giacometti,
150, 171; and Loeb, 111–15, 118–20,
124, 128, 131, 255, 259–63, 271, 346;
and Maeght, 171, 243, 269–70, 287, 288,
343–47, 349–50, 359; in Palma, Majorca,
132, 250, 252, 352–55; and Picasso, 116,
118, 129, 256, 309; Pierre's illegal efforts
for, 243, 244, 253–55; and Spanish civil
war, 120–21, 124, 130; and U.N.,
347–49, 352; and World War II, 130–32,
249–52, 255–56, 265
Miró, Joan, artworks by: *Bleu II (pl. 46),*
354–55; ceramics, 251–52, 257–59, 349,
351–52; collectors of, 77, 84, 86–87, 91,
93, 116, 118, 123, 127–28, 400; *The
Escape Ladder (pl. 22),* 252; exhibits of,
77, 95, 96, 112–13, 115, 118, 119, 120,
121–24, 132, 151, 154, 249, 259, 263,
265, 266, 269, 271, 342–45, 348, 349,
352–54, 355, 396; *The Farm,* 93, 96, 110,
126, 127, 341; *The Farmer's Wife* (detail),
131; frieze for Matisse children, 129–30;
Head of a Woman (pl. 26), 400; murals,
265, 266, 267–68, 341–43, 344, 348; and
New European school, 256–57; Pierre as
dealer for, 52, 95, 110–15, 119–28,
131–32, 171, 249–71, 342–55, 383; *Por-
trait of E. C. Rickart (pl. 17); The Potato
(pl. 19); The Red Sun (pl. 24); Rope and
People I (pl. 20),* 121, 123; sculpture,
250, 255, 256–57, 259, 332, 349; *A Star
Caresses the Breast of a Negress (pl. 21);
Symbols and Love Constellations (pl. 23),*
132, 252–53, 257, 258, 267, 383; *The
Tilled Field (pl. 18),* 110
Moderna Museet, Stockholm, 366

409

204–10, 209, 211, 303; *Fille au cheveux rouges (pl. 25); The Mirage of Time (pl. 44); My Life, White and Black (pl. 29)*

Tapié, Michel, 286, 287, 291

Tate Gallery, London, 338–39, 386

Tchelitchev, Pavel, 202

Tériade, M., 303, 306–8, 311, 317, 357, 374–75, 387

Thompson, G. David, 84, 326, 338

Time-Life Building, New York, 364, 371–72

Tzara, Tristan, 100, 118

U

UCLA Art Galleries, Los Angeles, 366

Ulysses (Joyce), 107–9

UNESCO, Paris, 352

United Nations, New York, 347–49, 374

United States: American vs. French art, 83, 97–98, 256; art world in, 31, 39, 53, 276, 395; Henri's visit to, 60–62; as market for Henri's work, 106, 357–58; Miró's visit to, 264–65, 268; Pierre's disenchantment with, 56–57; Pierre's first visit to, 30–33, 34–42; public collections in, 80–81; *see also specific cities*

Utrillo, Maurice, 52, 80, 88

V

Vaderin, Jeanne, 357

Valentine Gallery, New York, 48–49, 50–54, 80, 92, 112

van Gogh, Vincent, 19, 20, 36, 48, 49, 88–89

Vauxcelles, Louis, 24

Vence: chapel in, 311, 316, 356, 357, 358, 360, 369, 376, 381; Dubuffet in, 293; forger in, 312; Henri's residence in, 235–37, 302–3, 308

Venice Biennale, 259, 319, 334, 337, 338, 349–50, 393–94

Vlaminck, Maurice de, 19–21, 40, 47, 228, 231

Vollard, Ambrose, 17, 19, 21, 22, 49, 68, 90, 115, 199, 384

W

Wadsworth Atheneum, Hartford, 85, 139, 203, 208

Weyhe, Eberhard, 37

Whitney Museum of American Art, New York, 83, 393

World War I, 116, 192, 384

World War II: art trade in, 87, 95, 128, 131–32, 151–52, 214; censorship in, 220, 249; end of, 235–48; in France, 77, 131–32, 172–73, 186–92, 224, 225, 227, 228, 235–42, 249, 251, 260, 272, 274, 384; in Germany, *see* Germany; Jewish refugees in, 225–26, 260; and Matisse finances, 361; outbreak of, 95, 130–32, 172–73, 213; postwar art market, 88, 163, 171, 286–87, 383, 397; prewar fears, 113, 139

Z

Zadkine, Ossip, 201, 202

Zao Wou-Ki, 259, 389, 396; *April 15, 1977 (pl. 48)*

Zervos, Christian, 100, 115, 125, 128, 239, 255, 292

Zwemmer's, London, 121

Credits

The author and publisher have made every effort to reach copyright holders of text and owners of illustrations, and wish to thank those individuals and institutions for granting permission to reproduce text and images in this book, as noted below.

Illustration Credits

Black-and-white illustrations: Pages 2, 73, 223, 305, 347: Courtesy The Pierre Matisse Gallery Archives. Gift of the Pierre Matisse Foundation, 1997. The Pierpont Morgan Library, New York. MA 5020. Photograph: Joseph Zehavi; 10: © 1999 Succession H. Matisse, Paris/Artists Rights Society (ARS), New York; 14: Photograph: Eric Pollitzer; 20: © 1999 Succession H. Matisse, Paris/Artists Rights Society (ARS), New York. Photograph © 1999 The Museum of Modern Art, New York; 97, 107, 209, 232, 250: Courtesy The Pierre Matisse Gallery Archives. Gift of the Pierre Matisse Foundation, 1997. The Pierpont Morgan Library, New York. MA 5020; 131: © 1999 Artists Rights Society (ARS), New York/ADAGP, Paris. Courtesy The Pierre Matisse Gallery Archives. Gift of the Pierre Matisse Foundation, 1997. The Pierpont Morgan Library, New York. MA 5020. Photograph: Joseph Zehavi; 138, 143: Photograph: Loomis Dean, LIFE MAGAZINE © Time, Inc.; 147: © Artists Rights Society (ARS), New York/ADAGP, Paris. Courtesy The Pierre Matisse Gallery Archives. Gift of the Pierre Matisse Foundation, 1997. The Pierpont Morgan Library, New York. MA 5020. Photograph: Eric Pollitzer; 169: The Pierre Matisse Gallery Archives. Gift of the Pierre Matisse Foundation, 1997. The Pierpont Morgan Library, New York. MA 5020. © 1999 Artists Rights Society (ARS), New York/ADAGP, Paris; 170: Photograph © Fred Stein, New York; 202: Photograph © George Platt Lynes II; 204: Courtesy The Pierre Matisse

Gallery Archives. Gift of the Pierre Matisse Foundation, 1997. The Pierpont Morgan Library, New York. MA 5020. Photograph © Fred Stein, New York; 225, 236: Photograph © Henri Cartier-Bresson. Magnum Photos; 278 (right): © 1999 Artists Rights Society (ARS), New York/ADAGP, Paris. Photograph: Photothèque des collections du Mnam-Cci; 278 (left): © 1999 Artists Rights Society (ARS), New York/ADAGP, Paris. Photograph: Oliver Baker, New York; 345, 400: Courtesy Rosamond Bernier; 377: Photograph: Dmitri Kessel, LIFE MAGAZINE © Time, Inc.

Color plates: Plate 1: Photograph © Photothèque des Musées de la Ville de Paris; 2: Photograph © The National Gallery, London; 3: Photograph © 1999 The Cleveland Museum of Art; 4, 19: © 1999 Artists Rights Society (ARS), New York/ADAGP, Paris. Photograph © 1988 The Metropolitan Museum of Art. Photograph: Malcolm Varon; 5, 28, 30, 36, 37, 46: © 1999 Artists Rights Society (ARS), New York/ADAGP, Paris. Photograph: Photothèque des collections du Mnam-Cci; 6: Photograph © 1999 The Art Institute of Chicago. All Rights Reserved; 7: © 1999 Estate of Pablo Picasso/Artists Rights Society (ARS), New York. Photograph © President and Fellows, Harvard College, Harvard University Art Museums; 8, 24, 26, 33: © 1999 Artists Rights Society (ARS), New York/ADAGP, Paris; 9: © 1999 Succession H. Matisse, Paris/Artists Rights Society (ARS), New York. Photograph: Ted Dillard; 10, 13, 15, 41, 42: © 1999 Succession H. Matisse, Paris/Artists Rights Society (ARS), New York; 11, 12, 14: © 1999 Succession H. Matisse, Paris/Artists Rights Society (ARS), New York. Photograph © 1999 The Museum of Modern Art, New York; 16: © 1999 Succession H. Matisse, Paris/Artists Rights Society (ARS), New York. Photograph: Bob Kolbrener; 17, 22, 34, 40: © 1999 Artists Rights Society (ARS), New York/ADAGP, Paris. Photo-

413

André Breton, "Des tendences les plus récentes de la peinture surréaliste," © les ayants droit d'André Breton, in *Minotaure,* 3, nos. 12–13 (May 1939): 16

André Derain, *Lettres à Vlaminck,* Flammarion, 1955: 161

Jacques Dupin, *Joan Miró, Life and Work,* Abrams, 1962: 462, 478

Jack D. Flam, *Matisse, the Dance,* National Gallery of Art, 1993: 46

Jeanne Robert Foster, "A Plea to the Executors of the Quinn Estate" (October 18, 1924), quoted in Judith Zilczer, *"The Noble Buyer": John Quinn, Patron of the Avant-Garde,* Smithsonian Institution Press for the Hirshhorn Museum and Sculpture Garden, 1978: 60

Soeur Jacques-Marie, *Henri Matisse La Chapelle de Vence,* Grégoire Gardette, c. 1992: 151–52

Julien Levy, *Memoir of an Art Gallery,* G. P. Putnam & Sons, 1977: 267

Albert Loeb, *il y a cent ans . . . Pierre et Edouard Loeb,* Galerie Albert Loeb, 1977: 31, 34, 38

Henry McBride, *The Flow of Art, Essays and Criticisms of Henry McBride,* © 1975 Maximilian H. Miltzlaff as literary executor for Henry McBride, reprinted by permission of Atheneum Books: 416

John O'Brian, ed., *Clement Greenberg, The Collected Essays and Criticism,* University of Chicago Press, 1986: vol. 1: 207; vol. 2: 90, 124, 206, 207; vol. 3: 157

Margit Rowell, ed., *Joan Miró, Selected Writings and Interviews,* trans. French by Paul Auster, trans. Spanish and Catalan by Patricia Mathews, G. K. Hall & Co., 1986: 52, 65, 71, 83, 100, 101, 102, 151, 175, 197, 232

James Johnson Sweeney, *Alexander Calder,* The Museum of Modern Art, 1951: 26

Kirk Varnedoe and Adam Gopnik, *High and Low: Modern Art and Popular Culture,* The Museum of Modern Art and Abrams, 1990: 305

Patrick Waldberg, *Yves Tanguy,* André De Rache, 1977: 96

Exhibition catalogues from the Pierre Matisse Gallery, by author:

Alberto Giacometti, preface to *Alberto Giacometti Exhibition of Sculptures, Paintings, Drawings*

(Jan. 19–Feb. 14, 1948). Reprinted by permission. © 1998 Artists Rights Society (ARS), New York/ADAGP, Paris

Ernest Hemingway, preface to *Miró Paintings* (Dec. 29, 1933–Jan. 18, 1934). Reprinted by permission. © Ernest Hemingway's Sons

Raymond Mason, preface to *Le départ des fruits et légumes du coeur de Paris, le 28 février 1969* (Nov. 1971). Reprinted by permission of the author

Joan Miró, "I dream of a large studio," in *Miró Early Paintings 1918 to 1925* (Mar. 12–Apr. 6, 1940). Reprinted by permission. All works and documents by Joan Miró © 1998 Estate of Joan Miró/Artist's Rights Society (ARS), New York

Jean-Paul Sartre, "The Search for the Absolute," in *Alberto Giacometti: Exhibition of Sculptures, Paintings, Drawings* (Jan. 19–Feb. 14, 1948). Reprinted by permission. © Editions Gallimard, 1949

James Thrall Soby, "Europe," in *Artists in Exile* (Mar. 3–28, 1942). Reprinted by permission of Peter Soby

———, preface to *Balthus Paintings* (Mar. 21–Apr. 16, 1938). Reprinted by permission of Peter Soby

James Johnson Sweeney, preface to *Calder Mobiles* (Apr. 6–28, 1934)

———, preface to *Miró Paintings* (Dec. 29, 1933–Jan. 18, 1934)

Editor: Ruth A. Peltason
Editorial Assistant: Julia Gaviria
Designer: Judith Hudson

*Library of Congress
Cataloging-in-Publication Data*
Russell, John, 1919–
Matisse : father & son / by John Russell.
 p. cm.
"The story of Pierre Matisse, his father, Henri
Matisse, his gallery in New York, and the
artists that he introduced to America—among
them, Joan Miró, Alberto Giacometti, Balthus,
and Jean Dubuffet. Based on unpublished cor-
respondence."
ISBN 0–8109–4378–6 (hardcover)
1. Matisse, Pierre, 1900–1989. 2. Matisse,
Henri, 1869–1954. 3. Fathers and sons—
France—Biography. 4. Pierre Matisse Gallery
(New York, N.Y.) I. Title.
N8660.M28R87 1999
709'.2'2—dc21
[B] 98-29571

Printed and bound in Spain

Harry N. Abrams, Inc.
100 Fifth Avenue
New York, N.Y. 10011
www.abramsbooks.com